MONET

MONET

A RETROSPECTIVE

Edited by Charles F. Stuckey

Hugh Lauter Levin Associates, Inc., New York

Distributed by The Scribner Book Companies

ISBN 0-88363-385-X
Printed in Hong Kong
© 1985 Hugh Lauter Levin Associates, Inc., New York
Monet paintings © SPADEM, Paris/VAGA, New York, 1985

Jean Renoir, *Renoir, My Father*, Paris, Hachette, United States edition published by Little, Brown. Copyright © 1958, 1968 by Jean Renoir. Reprinted by permission of A.D. Peters & Co., Ltd.

Paul Mantz, "The Salon of 1865," *Gazette des Beaux-Arts*, July 1865.

Félix Y, *La Vie parisienne*, May 5, 1866.

Bertall, "The Salon of 1866," *Le Journal amusant*, May 12, 1866.

André Gill, "The Joke Salon," *La Lune*, May 13, 1866.

Émile Zola, "My Salon: The Realists at the Salon," *L'Événement*, May 11, 1866.

W. Bürger, *Salons de W. Bürger: 1861 à 1868*, Paris, Librairie de Vᵉ Jules Renouard, 1870.

Félix Fénéon, *Bulletin de la vie artistique*, March 28, 1914. Courtesy Librairie Droz S.A.

Émile Zola, "Les Actualistes," *L'Événement*, May 24, 1868.

Léon Billot, "Fine Arts Exhibition," *Journal du Havre*, October 9, 1868.

Philippe Burty, "News of the Day," *La République française*, April 16, 1874.

Louis Leroy, "The Impressionist Exhibition," *Le Charivari*, April 25, 1874.

Jules Castagnary, "The Exhibition on the Boulevard des Capucines," *Le Siècle*, April 29, 1874.

Ernest Chesneau, "Around the Salon," *Paris-Journal*, May 7, 1874.

Albert Wolff, "Paris Calendar," *Le Figaro*, April 3, 1876.

Stéphane Mallarmé, *Art Monthly Review and Photographic Portfolio*, September 1876.

Georges Rivière, *L'impressionniste*, April 6–28, 1877. Reprinted in Venturi, *Archives de l'impressionnisme*, Durand-Ruel Éditeurs, Paris—New York, 1939. Translated by Catherine J. Richards.

Georges Rivière, "Claude Monet in the Impressionist Exhibitions," *L'Art vivant*, January 1927. *La revue encyclopédique*, 1893. Ed. Larousse. Courtesy Librairie Larousse.

Théodore Duret, *Peintres Impressionnistes*, Paris, Librairie Parisienne, H. Heymann and J. Pebois, 1878, May.

Jean-Pierre Hoschedé, *Claude Monet ce mal connu*, © Pierre Cailler, Genève, 1960.

Tout Paris, "Impressions of an Impressionist," *Le Gaulois*, January 24, 1880.

Théodore Duret, *Le Peintre Claude Monet*, Paris, La Vie Moderne, G. Charpentier Éditeur, 1880.

Émile Taboureux, "Claude Monet," *La Vie moderne*, June 12, 1880.

Philippe Burty, "The Salon of 1880," *La République française*, June 19, 1880.

J.K. Huysmans, "The Exhibition of the Independents of 1881" (published in *L'art moderne*, 1883). Courtesy Union Générale D'Éditions.

Gustave Geffroy, "Claude Monet," *La Justice*, March 15, 1883.

Philippe Burty, "The Landscapes of Claude Monet," *La République française*, March 27, 1883.

Alfred de Lostalot, "Exhibition of the Works of M. Claude Monet," *Gazette des Beaux-Arts*, April 1883. Translated by Catherine J. Richards.

Guy de Maupassant, "The Life of a Landscapist," *Le Gil-Blas*, September 28, 1886. Translated by Catherine J. Richards.

Albert Wolff, "International Exhibition," *Le Figaro*, June 19, 1886.

Celen Sabbrin, *Science and Philosophy in Art*, Philadelphia, Copyright © Wm. F. Fell, 1886.

Gustave Geffroy, *Pays d'Ouest*, Paris, 1897. Reprinted in *Monet: sa vie, son oeuvre*, Copyright © Macula, Paris, 1980.

Georges Jeanniot, "Notes on Art, Claude Monet," *La Cravache parisienne*, June 23, 1888. Translated by Catherine J. Richards.

Oscar Reutersward, *Monet*, Stockholm, Albert Bonniers Förlag, Copyright © Oscar Reutersvärd, 1948.

Theodore Robinson, "Claude Monet," *The Century Magazine*, September 1892.

Gustave Geffroy, *Monet: sa vie, son oeuvre*, Copyright © Macula, Paris, 1980.

Octave Mirbeau, "Claude Monet," *L'Art dans les deux mondes*, March 7, 1891.

Gustave Geffroy, "Claude Monet Exhibition," *L'Art dans les deux mondes*, May 1, 1891, Paris, Courtesy Durand-Ruel. Translated by Catherine J. Richards.

W.G.C. Byvanck "Un Hollandais à Paris en 1891," preface to Anatole France, *Sensations de littérature et d'art*, Paris, 1892.

Georges Clemenceau, "The Cathedrals Revolution," *La Justice*, May 20, 1895.

Lilla Cabot Perry, "Reminiscences of Claude Monet from 1889 to 1909," *The American Magazine of Art*, volume XVIII, number 3, March 1927, pp. 119–125. Courtesy of the American Federation of Arts.

Maurice Guillemot, "Claude Monet," *La Revue illustrée*, March 15, 1898.

William H. Fuller, *Claude Monet and His Paintings*, New York, 1899.

François Thiébault-Sisson, "Claude Monet: An Interview," translation of an article published in *Le Temps*, November 27, 1900.

Arsène Alexandre, "Le Jardin de Monet," *Le Figaro*, August 9, 1901. Courtesy, Le Figaro.

Arsène Alexandre, "News from Our Parisian Correspondents," *Courrier de l'Aisne*, volume 38, number 133, June 9, 1904.

Gustave Kahn, "L'Exposition Claude Monet," *Gazette des Beaux-Arts*, July 1, 1904, II, pp. 81–89. Copyright © Gazette des Beaux-Arts, Paris.

Wynford Dewhurst, *Impressionist Painting: Its Genesis and Development*, London, George Newnes, 1904.

Maurice Kahn, "Claude Monet's Garden," *Le Temps*, June 7, 1904. Louis Vauxcelles, "Un après-midi chez Claude Monet," *L'art et les artistes*, volume 2, number 9, December 1905.

Marcel Proust, "Splendors," *Le Figaro*, June 15, 1907. Translated by Catherine J. Richards.

"Destroys His Paintings," *Washington Post*, May 16, 1908.

"The Conscientious Artist," *The Standard-London*, May 20, 1908.

Walter Pach, "At the Studio of Claude Monet,"

Scribner's Magazine, volume XLIII, number 6, June 1908, pp. 765–67.

Roger Marx, "M. Claude Monet's 'Water Lilies'," *Gazette des Beaux-Arts*, June 1909. Translated by Catherine J. Richards.

André Arnyvelde, "At Home with the Painter of Light," *Je sais tout*, January 15, 1914.

Lucien Descaves, "At Home with Claude Monet," *Paris-Magazine*, volume 2, number 30, August 25, 1920.

François Thiébault-Sisson, "Claude Monet's Water Lilies," *La Revue de l'art ancien et moderne*, June 1927.

Michel Georges-Michel, *De Renoir à Picasso*, Copyright © 1954 Librairie Arthème Fayard.

François Thiébault-Sisson, "Claude Monet," *Le Temps*, April 6, 1920.

François Thiébault-Sisson, "A Gift of Claude Monet to the State," *Le Temps*, October 14, 1920.

Marc Elder, *À Giverny, chez Claude Monet*, Paris, Bernheim-Jeune, 1924.

René Gimpel, *Diary of an Art Dealer*, Paris, Calmann-Levy, 1963. English edition translated by John Rosenberg as *Diary of an Art Dealer*, New York, Farrar, Strauss and Giroux, 1966. From *Journal d'un collectionneur*, published in the English language as *Diary of an Art Dealer*, by René Gimpel; by permission of Jean Gimpel; Copyright © Jean Gimpel.

George Truffaut, "The Garden of a Great Painter," *Jardinage*, number 87, November 1924. Courtesy Librairie Plon. Translated by Catherine J. Richards.

Marthe de Fels, *La vie de Claude Monet*, Paris, Copyright © Éditions Gallimard, 1929.

Trévise, "Pilgrimage to Giverny," *La Revue de l'art ancien et moderne*, volume LI, January 1927; February 1927. Translated by Catherine J. Richards.

François Thiébault-Sisson, "About Claude Monet," *Le Temps*, December 29, 1926.

François Thiébault-Sisson, "About Claude Monet," *Le Temps*, January 8, 1927.

Henry Vidal, "Remembering Claude Monet," *La France de Marseille*, February 19, 1947.

Georges Clemenceau, *Claude Monet*, Paris, Gallimard, 1929. Courtesy, Librairie Plon.

William Seitz, "Monet and Abstract Painting," *College Art Journal*, volume 16, Fall 1956. Reprinted from the *College Art Journal*. Published by the College Art Association of America.

Clement Greenberg, "Claude Monet: The Later Monet," *Art News Annual*, 1957. Copyright © Clement Greenberg.

With love for my mother and father

For their talented contributions and gracious assistance in the preparation of this volume, I wish to thank, first of all, researchers Marie-Thérèse Berger, Stephanie Carroll, and Vivien Sirotto, and photo researcher Ann Levy. Grateful acknowledgement is also due, for additional assistance in obtaining photographs, to Daniel Wildenstein, Ay-Wang Shia of Wildenstein and Co., Inc., Nancy Little of M. Knoedler and Co., Inc., William Beadelston, William Acquavella, Robert Schmit (Paris), and Martin Summers and Desmond Corcoran of the Lefevre Gallery of London. For their translations, I am indebted to Alexandra Bonfante-Warren, Asti Hustvedt, Timothy Johns, Richard Miller, Catherine Richards, Michele Sevik, and Thomas Spear.

For their production of this book, I thank the staff of Harkavy Publishing Service for their industry and editorial expertise, and Philip Grushkin for his handsome design. The composition was beautifully executed by A & S Graphics of Wantagh, New York.

Hugh L. Levin, as the publisher who ushered the book along with a most accommodating and pleasant manner, deserves great credit and my sincerest thanks.

CHARLES F. STUCKEY

CONTENTS

CHRONOLOGY

1840
NOVEMBER 14. Oscar-Claude Monet born in rue Laffitte, Paris.

1845
His family moves to Le Havre, where Monet's father enters the business of his more successful brother-in-law, Jacques Lecadre, a ship chandler and grocer with a weekend house in the beach-resort suburb of Sainte-Adresse.

1851–56 or 57
Attends public school in Le Havre, where he learns drawing from François-Charles Ochard.

1856–8
Becomes locally well-known for his caricatures, exhibited in the window of an art supply shop. Eugène Boudin (1824–98), who shows landscapes in the same display window, persuades Monet to work out-of-doors with him and to try pastels and oils.

1857
JANUARY 28. Mother dies.

1858
AUGUST–SEPTEMBER. Makes his debut at a municipally sponsored art exhibition in Le Havre with a landscape in oils.

SEPTEMBER 30. Jacques Lecadre dies. His childless widow, Monet's Aunt Sophie, oversees his adolescence.

1859
MAY. Moves to Paris to study painting. Impressed at Salon with works by Troyon (1810–1865), whose advice he seeks. Boudin's pastel studies of skies are praised in a review by Charles Baudelaire. Rather than enroll as a student of Thomas Couture as his family wishes, Monet attends the "Académie Suisse," where without formal guidance artists study from life models. Meets Camille Pissarro there. Frequents the Brasserie des Martyrs, meeting place for realist artists and writers.

1860
Hopes to earn money as a newspaper caricaturist, but only one of his drawings is published.

1861
MARCH. Selected by lottery for military service.

JUNE. Joins his regiment, the Chasseurs d'Afrique, in Algeria.

1862
SUMMER. Given six months convalescence leave in Le Havre after falling sick. Meets Jongkind.

OCTOBER. His Aunt Sophie pays for Monet to be released from his five remaining years of military obligation. Monet returns to Paris to enroll for formal art instruction under Charles Gleyre.

1863
Becomes friends with fellow Gleyre students Bazille, Renoir, and Sisley.

APRIL. Visits Chailly-en-Brière, a village in the forest of Fontainebleau, to paint landscapes with Bazille during Easter school holidays; he stays on after his colleague returns to Paris.

1864
Returns to Chailly-en-Brière for Easter school holidays.

MAY. Bazille and Monet paint along the coast at Honfleur, visiting Saint-Siméon, an inn long popular with landscape painters of Boudin's and Jongkind's generation.

OCTOBER. Submits a still life to an exhibition in Rouen. M. Gaudibert, a Le Havre shipowner who supported Boudin, becomes his first patron.

1865
Shares studio with Bazille at 6 rue Furstenberg in Paris. Submits two seascapes to Salon. Returns to Chailly to begin a large out-of-doors work for the next Salon: *Luncheon on the Grass*.

WINTER. Returns to Paris after a trip to Trouville, where he meets Whistler.

1866
JANUARY 15. Forced to move into new studio on Place Pigalle. Temporarily abandons *Luncheon on the Grass*, which cannot be finished by deadline for Salon entries. Quickly undertakes *Woman in the Green Dress (Camille)* to submit instead, along with a small Chailly landscape. His model is Camille Doncieux, his mistress.

Encouraged by Salon success, they rent a house at Sèvres, near Ville d'Avray, where she models out-of-doors for *Women in the Garden*. Courbet visits.

SUMMER. Forced to leave Sèvres to escape creditors, Monet goes to Honfleur, where he finds Courbet and Boudin. Begins large seascape for forthcoming Salon.

1867
Bazille allows penniless Monet to stay at his rue Visconti studio, where Renoir too has refuge. Monet's works refused by Salon jury; *Woman in the Garden* exhibited in window of an art supply shop owned by Latouche. Bazille decides to acquire this work, paying Monet in monthly installments. Monet and Renoir paint views of Paris.

AUGUST 8. Camille gives birth to a son, Jean. To save money, Monet spends most of the year with his aunt at Saint-Adresse, leaving Camille in Paris.

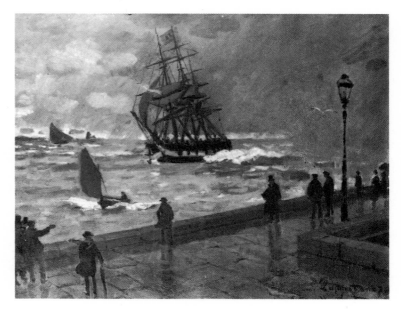

The Jetty at Le Havre in Bad Weather. 1867.
19¾ × 24″ (50 × 61 cm). Collection Gabriel Sabet, Geneva. Photograph: A.C. Cooper Ltd., London. Courtesy Christie's, London.

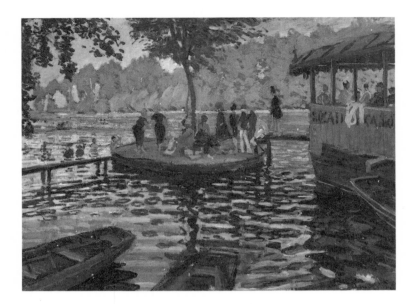

La Grenouillère. 1869. 29⅜ × 39¼″ (74.6 × 99.7 cm). The Metropolitan Museum of Art, New York; Bequest of Mrs. H.O. Havemeyer, 1929. The H.O. Havemeyer Collection.

1868

Only one of Monet's two large paintings of the port of Le Havre is accepted by the Salon jury.

SPRING. Takes a room in village of Bennecourt on Seine, but money runs out.

Encounters Courbet and Alexandre Dumas at Le Havre.

JULY–OCTOBER. Five paintings by Monet included in International Maritime Exhibition in Le Havre. He wins a silver medal, but his works are seized by creditors, from whom Monet's patron Gaudibert buys them back.

DECEMBER. Monet joins Camille at Étretat.

1869

JANUARY. Dealer Latouche shows one of Monet's views of Paris in his shop window.

APRIL. Monet's works refused by Salon jury. Latouche again lets Monet show in his window, this time a Sainte-Adresse scene.

SUMMER. Renoir and Monet work together at La Grenouillère, a bathing and boating center on the Seine. Monet envisions a Salon painting on this theme.

1870

SPRING. Again refused at the Salon. Daubigny resigns from the jury in protest.

JUNE 28. Marries Camille. They summer at Hôtel Tivoli in Trouville, where Monet paints on beach with Boudin.

JULY 7. Death of aunt, Sophie Lecadre.

JULY 19. Outbreak of Franco-Prussian War.

SEPTEMBER. Unable to pay hotel bill and feeling no military obligation, Monet goes to London.

NOVEMBER 18. Bazille killed in action.

In London, Monet introduced by Daubigny to dealer Paul Durand-Ruel, who has taken refuge there and opened a gallery.

DECEMBER 10. Durand-Ruel exhibits *Entrance to Trouville Harbor* in London.

1871

JANUARY 17. Father dies.

JANUARY 28. Armistice between France and Germany.

SPRING. Visiting London museums with Pissarro, Monet studies works by Constable and Turner. Like Pissarro, Monet is refused when he submits works to Royal Academy exhibition in London.

MAY. Durand-Ruel lends two paintings by Monet to the international exhibition at the South Kensington Museum. Leaves London to paint in Zaandam, Holland.

AUTUMN. Returns to Paris.

DECEMBER. Rents house in Argenteuil on the Seine.

1872

Exhibits works at municipal exhibition in Rouen. Durand-Ruel begins to buy dozens of Monet's paintings, some of which are exhibited in London. Monet buys a boat and converts it into a floating studio.

1873

APRIL. With Pissarro, Sisley, and Renoir, Monet begins to plan a society of independent artists to present works outside the Salons.

DECEMBER 27. Monet's circle of artists adopts a charter as the Société Anonyme Coopérative d'Artistes-Peintres, -Sculpteurs, -Graveurs.

1874

Returns to Holland.

APRIL 15–MAY 15. First group exhibition at Nadar's former photography studio on the boulevard des Capucines. A critic, on the basis of one of Monet's works, listed in the catalogue as *Impression: Sunrise*, gives the group the name "impressionists," which the press often uses derisively thereafter. In financial difficulty, Durand-Ruel is unable to continue purchases, leaving Monet poverty-stricken again.

SUMMER. Evicted from his house in Argenteuil, Monet, with Manet's help, finds another in the same village. Monet, Manet, and Renoir paint together at Argenteuil.

DECEMBER. The Société Anonyme is dissolved, bankrupt.

1875

MARCH 24. Impressionists auction works at the Hôtel Drouot, where police restrain a mocking public. Bids are low.

Poplars. 1875. 21½ × 25¾″ (54.5 × 65.4 cm). Museum of Fine Arts, Boston; Bequest of David P. Kimball in memory of his wife, Clara Bertram Kimball.

1876

FEBRUARY. Through Cézanne, Monet meets collector Victor Chocquet.

APRIL 15. Second impressionist exhibition at Galerie Durand-Ruel with 18 works by Monet. Again, public response is mostly hostile. Becomes friends with department store magnate and art speculator, Ernest Hoschedé, to whose summer chateau the painter is invited as a guest, as is Manet. Hoschedé commissions Monet to paint large decorative works for his dining room there. Caillebotte, a wealthy painter, begins to buy works from Monet. Camille becomes seriously ill, possibly from an attempted abortion.

1877

JANUARY. Caillebotte rents a small studio for Monet near the Gare Saint-Lazare, which Monet portrays in a series of a dozen paintings.

APRIL 5. Seven *Gare Saint-Lazare* pictures are among 30 works by Monet in the third impressionist exhibition.

AUGUST 24. Hoschedé declares bankruptcy.

1878

Leaves Argenteuil with financial help from Manet and Caillebotte.

MARCH 17. Birth of second son, Michel.

JUNE 5–6. At auction of Hoschedé's collection, works by Monet and his associates are sold dirt-cheap.

AUGUST. Monet and his family take a house in Vétheuil on the Seine and are soon joined by Hoschedé, his wife, and their six children. Monet commutes to Paris to find buyers for his paintings, but cannot find enough even to cover expenses. Camille's weakened health deteriorates.

1879

APRIL 10–MAY 11. Financially backed by Caillebotte, the impressionists hold fourth group exhibition, including 29 works by Monet.

SUMMER. Collectors begin to suspect that Monet is working too fast, given his pressing need to make sales.

SEPTEMBER 5. Camille dies after long suffering.

1880

JANUARY. Monet paints the dramatic ice floes and floods following the freezing and thawing of the Seine.

MARCH. Like Renoir, Monet decides to submit two paintings to the Salon rather than participate in the fifth impressionist exhibition. Jury accepts only one, which is hung inconspicuously.

JUNE 21. Exhibition of 18 Monet works at office gallery of *La Vie moderne*, an illustrated arts and society magazine owned by Renoir's patron, Charpentier, whose wife buys Monet's Salon painting as a present for her husband.

AUGUST 5. Three works by Monet included at municipal exhibition in Le Havre.

1881

MARCH. Having decided to exhibit neither at the Salon nor at the sixth impressionist exhibition, Monet paints on the Normandy coast with expenses advanced by Durand-Ruel.

AUGUST. Returns to paint on Normandy coast.

DECEMBER. Monet moves to Poissy. Against her husband's wishes, Alice Hoschedé and her children follow him there, leaving no doubt about her relationship with the painter.

1882

FEBRUARY. Because one of his most important backers goes bankrupt, Durand-Ruel cuts his financial support. Monet at work in Dieppe and Pourville.

MARCH 1. Seventh impressionist exhibition shows 35 works by Monet.

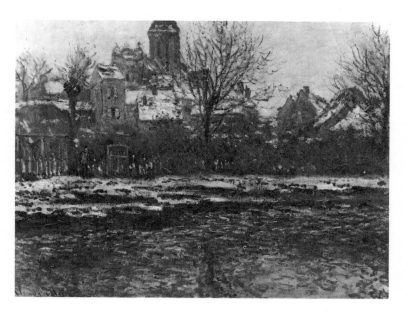

The Church at Vétheuil: Snow. 1879. 20⅞ × 28″ (53 × 71 cm). Galerie du Jeu de Paume, Musée du Louvre, Paris. Photograph: Musées Nationaux, Paris.

JUNE–OCTOBER. Returns to Pourville, accompanied by his family and Alice Hoschedé's.

1883

JANUARY 25. Monet returns to Channel coast, working mostly at Étretat.

FEBRUARY 28. Monet's first one-man exhibition at Galerie Durand-Ruel.

APRIL. Leases a new home in Giverny.

MAY 3. Returns to Paris to be a pallbearer at Manet's funeral.

SPRING. Undertakes still lifes to decorate doors for Durand-Ruel's private apartment.

DECEMBER. Short trip with Renoir to explore Mediterranean motifs and to visit Cézanne at L'Estaque.

1884

JANUARY 17. Returns to Bordighera, just across the Italian border, for three months' work.

NOVEMBER 17. Durand-Ruel introduces Monet to Mirbeau, in thanks for whose support in *La France*, Monet gives him *The Customs Officers' Cabin*.

1885

MAY 15. Ten works by Monet included in fourth Exposition Internationale de la Peinture at the Galerie Georges Petit in Paris.

AUTUMN. Returns with family to Étretat, staying at a house put at their disposal by Faure, the singer. Monet stays on for three months.

1886

FEBRUARY 6. Ten works included at exhibition of Société des XX in Brussels.

FEBRUARY 19. Returns to Étretat.

APRIL. Forty-nine works by Monet included in first New York exhibition of impressionist art organized by Durand-Ruel at American Art Association. This successful exhibition is extended through the summer. Publication of Zola's novel *L'Oeuvre*, with its painter protagonist based in part on Monet.

APRIL 27. Monet makes short working trip to Holland.

MAY 15. Eighth and last impressionist exhibition opens without the participation of Monet.

JUNE 15. Thirteen works by Monet included in fifth Exposition Internationale at Galerie Georges Petit.

SEPTEMBER—NOVEMBER. Working trip to Belle-Île-en-Mer. Meets Gustave Geffroy. Mirbeau visits him there.

1887

MAY 8. *Belle-Île* paintings exhibited with great success at Galerie Georges Petit's sixth Exposition Internationale.

MAY 25. Twelve works by Monet included in Durand-Ruel's second impressionist exhibition at the National Academy of Design in New York.

NOVEMBER 25. Thanks to Whistler, two works by Monet are included in an exhibition of the Royal Society of British Artists in London.

1888

JANUARY—APRIL. Paints at Antibes and Juan-les-Pins. Breaks business relations with Petit.

JUNE. One-man exhibition of ten Antibes landscapes at the Boussod and Valadon gallery, directed by Théo van Gogh.

JULY. Visits London. Refuses Legion of Honor.

AUTUMN. Begins *Haystacks* series.

1889

FEBRUARY. Exhibition of 20 works at Goupil gallery, London. Monet visits poet Rollinat at Fresselines in the Creuse valley in central France. Exhibits four works in Brussels with Société des XX.

MARCH—MAY. Returns to the Creuse to paint.

MAY 21. Three paintings included in the Exposition Universelle in Paris.

JUNE. Monet's largest and most successful retrospective to date organized at Galerie Georges Petit in tandem with a Rodin exhibition.

AUTUMN. Monet organizes private subscription to buy Manet's *Olympia* for the Louvre.

1890

Begins *Poplars* series on the banks of the Epte river.

NOVEMBER. Buys house and property at Giverny and starts improvements on garden, which will become a passion in ensuing years.

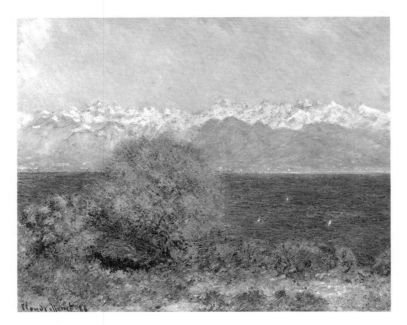

View of the Maritime Alps and the Bay of Antibes. 1888. 25¼ × 31⅛″ (64 × 79 cm). Hill-Stead Museum, Farmington, Connecticut.

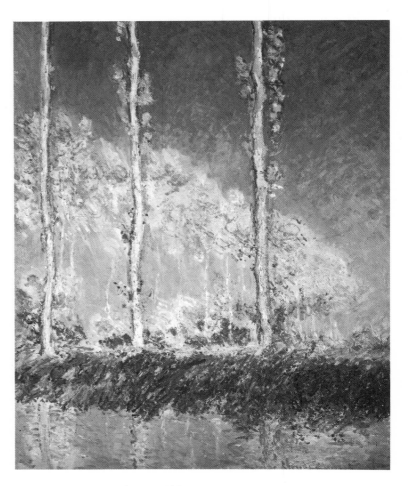

Poplars. 1891. 36¼ × 28¾″ (92 × 73 cm). Philadelphia Museum of Art; Gift of Chester Dale.

1891

MARCH 18. Death of Ernest Hoschedé.

MAY 4—16. Exhibition of 22 recent works, including 15 *Haystacks* in Galerie Durand-Ruel.

AUGUST. In order to continue work on his series, Monet buys a row of poplars from the town of Limnetz.

DECEMBER. Visits London briefly.

1892

FEBRUARY. Begins *Cathedrals* series in Rouen.

FEBRUARY 29. Fifteen works, including six *Poplars*, exhibited at Galerie Durand-Ruel.

JULY 16. Marries Alice Hoschedé.

JULY 20. Monet's stepdaughter, Suzanne, marries American painter, Theodore Butler.

NOVEMBER. Passed over for nomination as muralist for Paris City Hall.

1893

JANUARY. Seine freezes over, providing Monet with new motif.

FEBRUARY 5. Buys land across railroad tracks where he will create water garden after townspeople's objections to exotic flowers are laid to rest.

FEBRUARY—APRIL. Returns to Rouen to continue *Cathedrals*.

MAY 1. Included in Chicago World's Fair exhibition of foreign artists in American collections.

1894

FEBRUARY 21. Death of Caillebotte, whose bequest to France of his collection of impressionist painting, including 16 works by Monet, causes bitter controversy that recalls the public outrage in 1874.

APRIL. Durand-Ruel is reluctant to pay Monet's price of 15,000 francs for each *Cathedral*, but the collector Camondo buys four.

NOVEMBER. Cézanne visits and paints in Giverny, staying at Hôtel Baudy. Monet introduces him to Clemenceau, Rodin, and Geffroy.

1895

JANUARY–APRIL. Monet visits his stepson Jacques Hoschedé at Sandviken, Norway, near Oslo.

MAY 10. Exhibition of 50 paintings, including 20 of the *Cathedral* series at Galerie Durand-Ruel. Begins painting *Water Lilies* in Giverny garden.

1896

FEBRUARY–MARCH. Paints previous motifs at Varengéville, Pourville, and Dieppe (Normandy).

MARCH 9. Exhibition of Monet's *Cathedrals* in New York. Begins *Mornings on the Seine* series.

APRIL. State accepts only 40 of the works from the Caillebotte bequest, including eight by Monet, for the modern art museum at the Luxembourg Palace.

OCTOBER–DECEMBER. Works exhibited in Berlin.

1897

JANUARY. Paints at Pourville.

MARCH. Controversy over installation of the Caillebotte bequest at the Luxembourg Museum.

AUGUST. Monet shows earliest studies for *Water Lilies* decorations to reporter Maurice Guillemot.

1898

JUNE 1. Major one-man exhibition at Galerie Georges Petit, with 61 works, including 18 *Mornings on the Seine*.

1899

Exhibitions at Galerie Durand-Ruel, Galerie Georges Petit, and the Lotus Club in New York.

SUMMER. Paints water garden canvases.

AUTUMN. Begins to paint views of the Thames from a room in the Savoy Hotel in London.

1900

FEBRUARY–APRIL. Returns to London to continue *Thames* series.

Three early works chosen for the Exposition Centennale.

SUMMER. Temporary loss of sight in one eye after an accident retards progress on water garden paintings.

Paints at Vétheuil.

One-man exhibition of recent works, including 13 water garden paintings at Galerie Durand-Ruel.

1901

Continues work at Vétheuil.

SPRING. Returns to London, where he collapses from overwork.

NOVEMBER. Diverts the Epte, a small river, to flow through his pond so his rare plants will thrive.

1902

Begins painting the *Water Lilies* series.

FEBRUARY 20. Galerie Bernheim-Jeune presents an exhibition of recent works by Monet and Pissarro, including six new views of Vétheuil.

1903

Works on his London scenes from memory, forsaking his principle to paint only directly from nature.

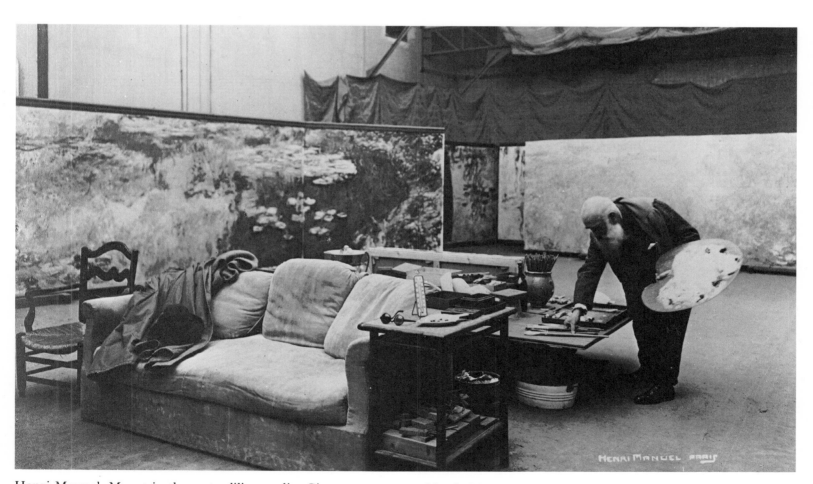

Henri Manuel. Monet in the water lilies studio, Giverny, 1924–25. Musée Marmottan, Paris.

1904

MAY 9. Thirty-seven views of London exhibited at the Galerie Durand-Ruel.

OCTOBER. Trip to Madrid by automobile with his wife to see the treasures of the Prado Museum.

1905

FEBRUARY. Durand-Ruel organizes a large exhibition of impressionist paintings at the Grafton Galleries in London, including 55 by Monet.

1906

Slow progress on *Water Lilies* series with frequent repainting. Destroys some works in frustration. Monet postpones projected exhibition of this series.

1907

Clemenceau elected Premier. The State buys a *Rouen Cathedral* for the Luxembourg Museum.

1908

Bad health and eye problems.

AUTUMN. Long working trip to Venice with wife. Stays at the Palazzo Barbaro, owned by Mr. and Mrs. Ralph Curtis, American friends of Sargent; relocates to Grand Hotel Britannia.

DECEMBER. Upon returning to Giverny, Monet works on the *Water Lilies* series in his studio.

1909

Alice becomes ill.

MAY 6 – JUNE 5. Forty-eight *Water Lilies* pictures exhibited at Galerie Durand-Ruel.

AUTUMN. Wants to return to Venice.

1910

Enlarges his water lily pond.

1911

Eyesight deteriorates.

MAY 19. Death of Alice Hoschedé Monet, plunging the painter into a long period of grief.

Works on his Venetian canvases from memory.

AUGUST. One-man exhibition of 45 paintings at Museum of Fine Arts, Boston.

1912

MAY 28 – JUNE 8. Exhibition of 29 paintings of Venice at the Galerie Bernheim-Jeune.

JULY. An eye specialist in Paris diagnoses double cataracts.

1914

FEBRUARY 10. Monet's son Jean dies after a protracted illness. Blanche Hoschedé, Jean's widow and Monet's stepdaughter, becomes his permanent housekeeper and confidante.

Encouraged by Clemenceau, Monet begins a series of mural-sized versions of *Water Lilies*. To accommodate the large canvases, Monet begins construction of a third studio.

JUNE. Monet's works put on view in the Louvre as part of the Camondo bequest.

JULY. Outbreak of World War I; departure of Michel and Monet's stepdaughters' husbands from Giverny to join ranks.

1916

New studio completed.

Rodin's gift of his studio-home, the Hôtel Biron, accepted by the State as a museum for his sculptures.

1917

Work on murals continues. Paints three self-portraits, destroying two of them and giving the third to Clemenceau.

OCTOBER. Visits Le Havre, Honfleur, Étretat, and other Normandy coast sites familiar from his youth.

1918

NOVEMBER 11. Armistice.

NOVEMBER 18. Clemenceau and Geffroy visit Giverny to persuade Monet to offer his still unfinished murals to the State.

1919

Despite worsening sight, Monet fears that an operation might leave him blind.

1920

JANUARY 17. Clemenceau defeated in his bid to become President.

OCTOBER 15. Official announcement of Monet's intention to donate 12 large *Water Lilies* paintings to the State. A pavilion is to be erected for them in the gardens of the Hôtel Biron (Rodin Museum).

Monet refuses nomination into prestigious Institut de France.

1921

JANUARY 21 – FEBRUARY 2. A retrospective exhibition is held at the Galerie Bernheim-Jeune.

FEBRUARY 8. State buys *Women in the Garden* from Monet for 200,000 francs.

State refuses to fund Hôtel Biron building for Monet's murals; offers space in the Orangerie des Tuileries instead.

1922

APRIL 12. At Vernon, Monet signs official agreement to submit his gift to the State in April 1924. Almost blinded by cataracts, Monet feels pressed by this deadline to continue work on murals.

1923

JANUARY. Operation only partially restores sight in his right eye.

JULY. Second operation for right eye.

1924

JANUARY. Large retrospective exhibition at Galerie Georges Petit.

FEBRUARY. Durand-Ruel exhibits recent *Water Lilies* paintings in New York.

Clemenceau arranges an extension of deadline for completion of Monet's murals and Monet gets corrective glasses.

1925

Monet delays delivery of murals to State for a final attempt to complete them satisfactorily with the aid of the eyeglasses.

1926

Severe respiratory illness.

DECEMBER 5. Monet, aged 86, dies at noon at Giverny with Clemenceau at his side.

1927

MAY 17. The *Water Lilies* murals are dedicated in the Orangerie.

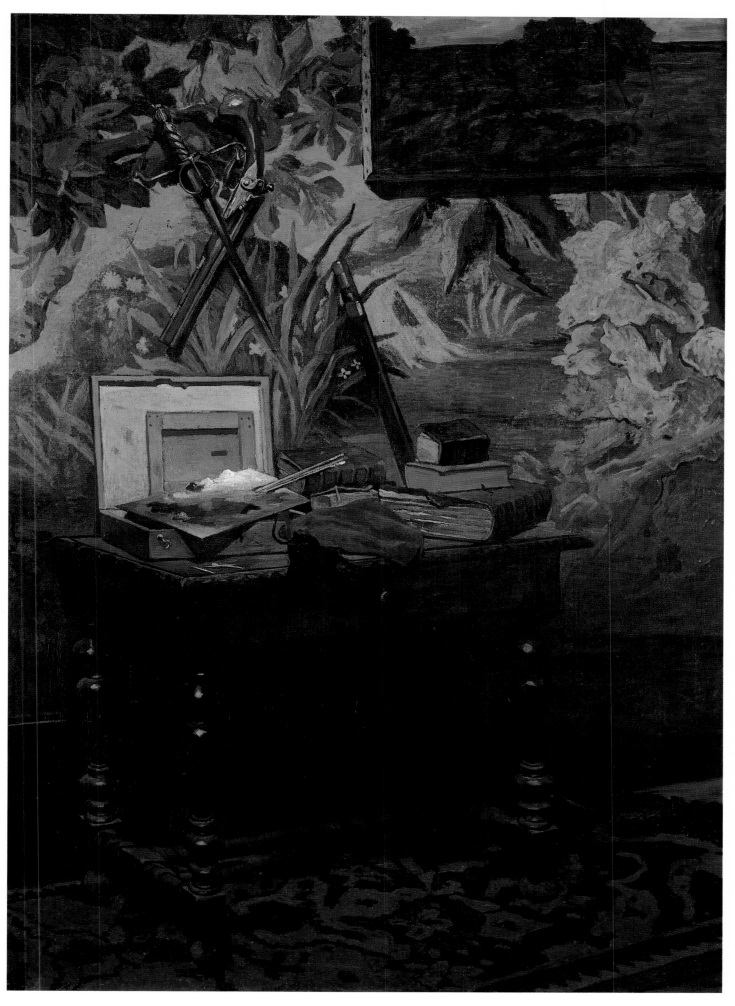

COLORPLATE 1. *In the Studio*. 1861. 71⅝ × 50″ (182 × 127 cm).
Galerie du Jeu de Paume, Musée du Louvre, Paris. Photograph: Musées Nationaux, Paris.

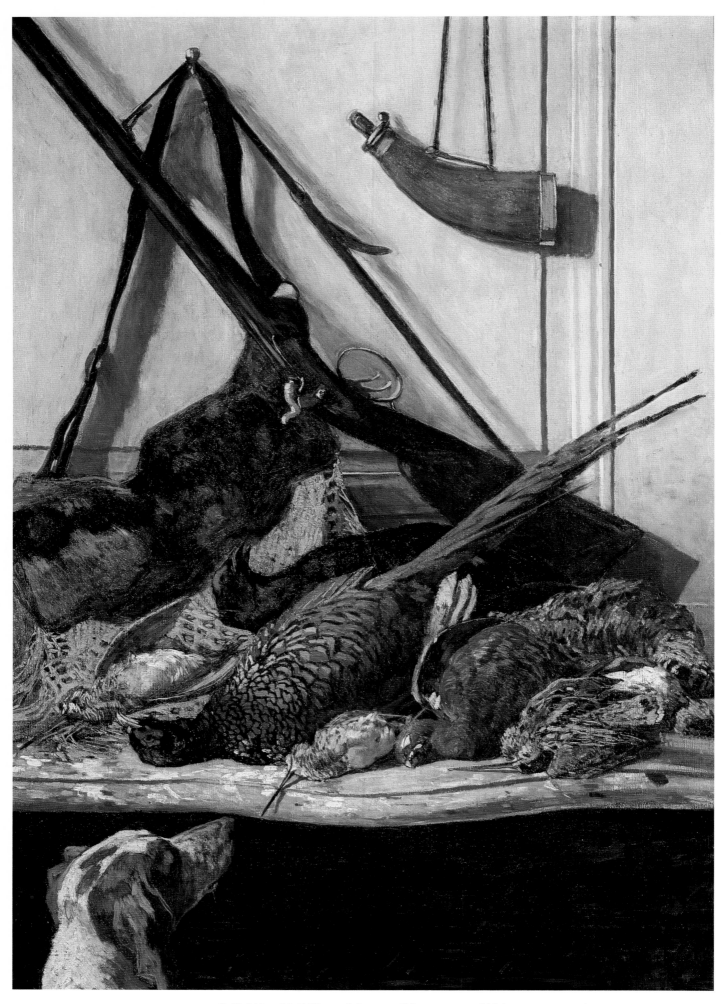

COLORPLATE 2. *Still Life with Rifle and Game.* 1862. 41 × 29½″ (104 × 75 cm).
Galerie du Jeu de Paume, Musée du Louvre, Paris. Photograph: Musées Nationaux, Paris.

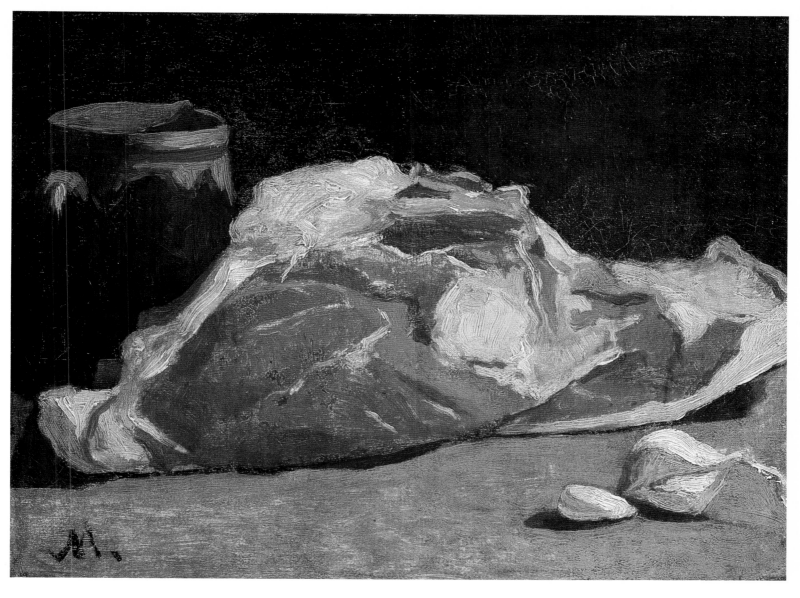

COLORPLATE 3. *Still Life with Meat*. 1864. $9^{7}/_{16} \times 12^{9}/_{16}''$ (24 × 32 cm).
Galerie du Jeu de Paume, Musée du Louvre, Paris. Photograph: Musées Nationaux, Paris.

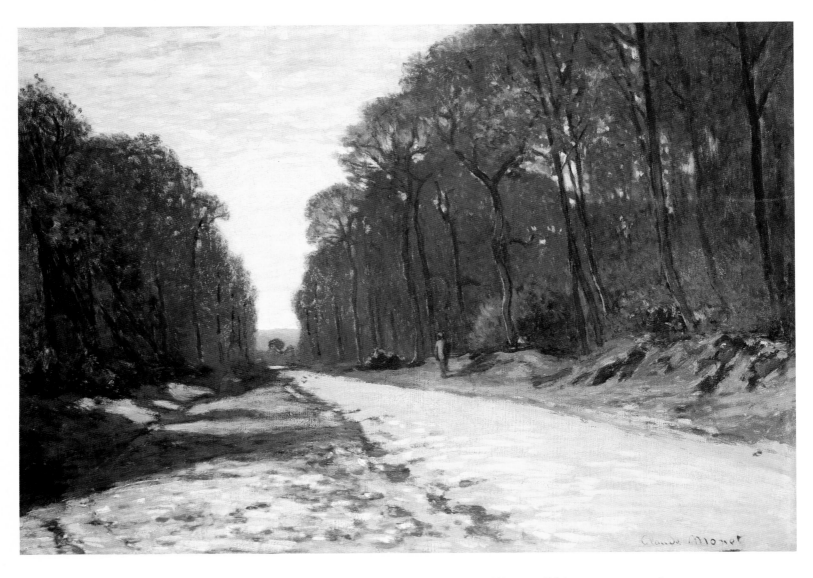

COLORPLATE 4. *Road in the Forest of Fontainebleau.* 1864. 16½ × 23⅜″ (41.9 × 59.4 cm).
Private Collection. Photograph: Fondation Wildenstein, Paris.

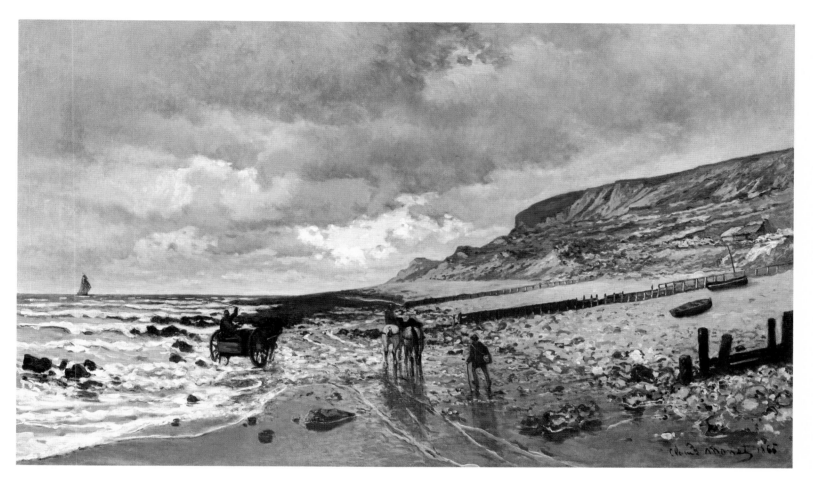

COLORPLATE 5. *La Pointe de la Hève at Low Tide*. 1864–5. 35½ × 59¼″ (90.2 × 150.5 cm).
Kimbell Art Museum, Fort Worth, Texas.

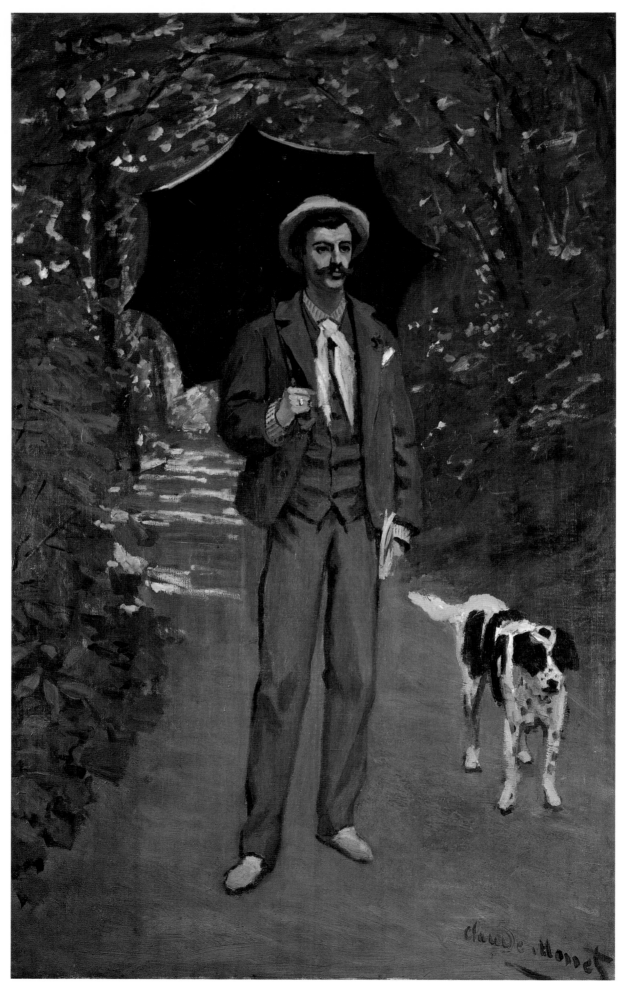

COLORPLATE 6. *Portrait of J.F. Jacquemart with an Umbrella.* 1865. 41⅜ × 24⅜″ (105 × 62 cm).
Kunsthaus Zürich.

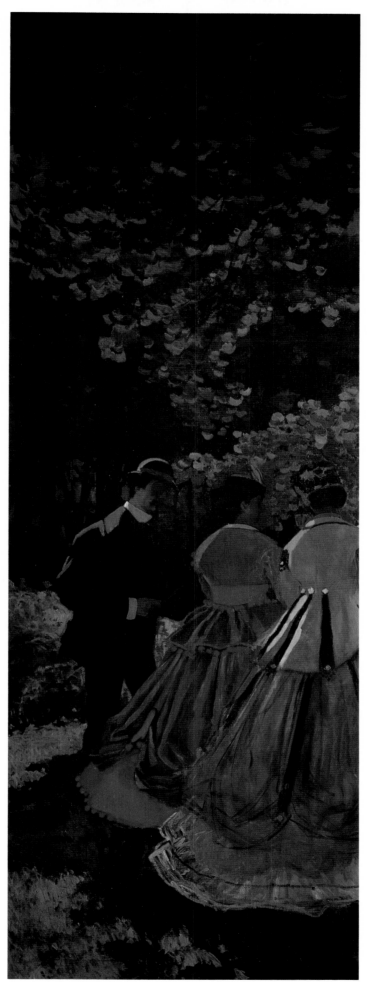

COLORPLATE 7. *Luncheon on the Grass* (left fragment). 1865/66. 164½ × 59″ (418 × 150 cm).
Galerie du Jeu de Paume, Musée du Louvre, Paris. Photograph: Musées Nationaux, Paris.

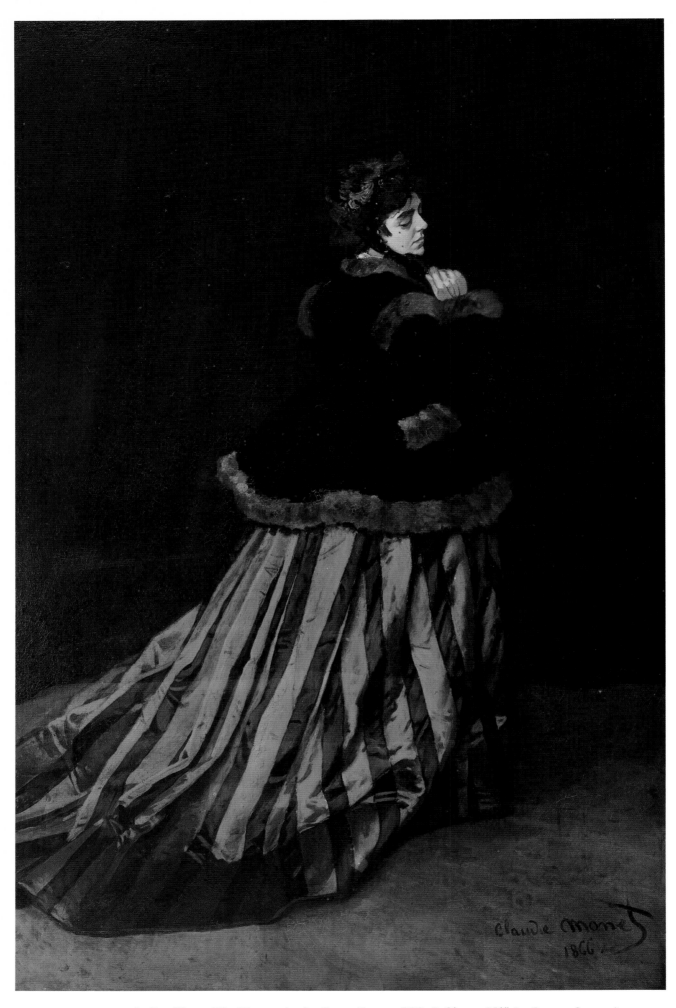

COLORPLATE 8. *Camille* or *The Woman in the Green Dress*. 1866. 89¾ × 58⅝″ (228 × 148.9 cm).
Kunsthalle Bremen.

INTRODUCTION

As surely as Monet's canvases satisfy a human need to have the world's sensory richness interpreted artistically, they arouse curiosity about the man himself and his lifelong dedication to painting the visual world with uncanny truth. This anthology of writings about Monet was carefully selected to give the best possible introduction to the man. Here, often, are his own words as recorded by journalists or remembered by close friends. They capture his pride, his determination, his gentleness, and even his despair. The finest standard accounts of Monet have been consulted extensively: John Rewald's classic *History of Impressionism*, first published in 1946 by the Museum of Modern Art in New York, and Daniel Wildenstein's extraordinary multivolume *Claude Monet: Biographie et catalogue raisonné* (Lausanne and Paris, La Bibliothèque des arts, 1974–1985), which includes Monet's complete correspondence. We have included a number of newspaper reviews of the exhibitions in which Monet presented his paintings to the public. Yet we have tried here neither to evaluate the shifting theories concerning his art, a subject already treated exhaustively in Steven L. Levine's *Monet and his Critics* (New York, Garland Publishers, 1976), nor to analyze Monet's achievement. This retrospective account is for the most part designed to present Monet without hindsight, as he was presented in his own lifetime. Only two influential modern essays have been included to exemplify how Monet's art has taken on the proportions of a modern legend.

A brief explanation about the traditions of art exhibition and of landscape painting to which Monet was heir will enhance the following accounts of Monet for many modern readers. It may come as a surprise that not until Monet's generation was the simple art of landscape painting widely appreciated as a complex, challenging, and spiritually fulfilling form of painting. Monet did more than anyone to change attitudes about landscape painting. He broke the time barrier in art, so to speak, developing skills to record the unique appearances of passing moments more effectively than any camera in the last century could do. If Monet never expressed a Faustian willingness to sell his very soul to make time stand still, he nevertheless staked his creative, as well as his mundane, existence on just such a venture. In the end, after considerable hardship, he won fame and fortune not simply because he came as close to success as can be imagined, but because in his firmness of purpose he further synthesized the twinkling, momentary quality of ordinary vision with the studied finesse of great painting.

Wide-scale art patronage began much later in France than in Italy. It was 1648 when Colbert founded a State Academy of Fine Arts to educate and sustain native artists, whose eventual accomplishments would reflect the high cultural ideals of the rule of Louis XIV. Predicated on the esteemed traditions of court art in Florence and Rome, the Academy encouraged artists to represent the highest human virtues recorded in ancient literature and history. Such idealized or allegorical subjects, which sought to portray abstract truths, were considered to be the greatest test of any artist's genius. Painters who were content to depict everyday life were taken less seriously. To be acceptable to the Academy, landscape painting had to evoke the Golden Age, the timeless imaginary setting for the heroic actions of history painting. The celebrated landscapists Nicolas Poussin (1594–1665) and Claude Lorrain (1600–1682) transformed the Italian countryside, filling it with evocations of the classical past, omitting too-humble details, refining contours, combining elements observed in various locales, and bathing these artificial compositions in a soft immutable light removed from the flux of time.

Given its commitment to abstract truth, the French Academy was unable to appreciate the commonplace, matter-of-fact landscape paintings of the seventeenth-century Dutch masters. But the simple beauties of these pictures eventually prevailed, and poets such as Wordsworth, Byron, and Goethe convinced readers at the outset of the nineteenth century that mere mortal eyes can perceive spiritual truths in humble natural settings unaltered by the questionable values of urban civilization.

Many French artists were inspired by English landscape painters such as John Constable, whose Wordsworthian works were acclaimed in Paris at the Salon of 1824 for their sincerity of feeling. To many viewers, the little white highlights speckled across the surfaces of Constable's paintings appeared incoherent when viewed from close up, but from a distance this "snow," as detractors referred to it, created an illusion of shifting, sparkling daylight never before captured in painting. Seeking to celebrate present-day France as they themselves observed it first-hand, Camille Corot (1796–1875), Charles Daubigny (1817–1878), Narcisse Diaz (1808–1876), Jean-François Millet (1814–1875), Théodore Rousseau (1812–1867), and Constant Troyon (1810–1865) set out to dispense with the models and props and controlled studio conditions of Academic painting and to portray the sustaining beauties of the French soil as observed out-of-doors. At first their canvases were acclaimed at the Paris Salons—those prestigious, if somewhat sprawling, and highly attended government-sponsored exhibitions of contemporary art held nearly every year. But during the later 1830s and 1840s, the selection juries, which were composed of Academy-taught artists who felt threatened by this anti-traditional development, rejected these Barbizon artists, so-called because they frequently found their motifs in the wooded countryside around that rustic little Norman village.

Especially after Louis-Philippe came to power in 1830, the juries faced a problem of allotting the available wall space among a swelling number of artists submitting works. Meanwhile, public interest in the Salons increased, along with newspaper coverage. The wider exposure inevitably made jury decisions into matters of heated controversy. The repeated exclusion of the Barbizon artists unintentionally drew attention to them, and their advocates came to see them as misunderstood prophets seeking rustic truths or as idealistic rebels in league with disenfranchised laborers of the land. Beginning in the 1850s, artists such as Courbet and Manet apparently sought publicity by baiting the juries, submitting to the hallowed Salons pictures that described the vulgarities of modern life in rural as well as in urban France. Eloquently supported in the press by maverick friends like Baudelaire, these refused painters developed their own alternative exhibitions with the help of art dealers.

Boudin, who would introduce the teenaged Monet to painting, came to know many of the Barbizon and realist artists when he and a partner opened an art suppy business in Le Havre, filling the needs of artists who stalked the English Channel coast. It should be pointed out that these mid-nineteenth-century landscape painters' needs revolutionized the art supply business with the introduction of pre-stretched canvases and prepared oil colors packaged in portable tin tubes. Although not burdened with the overhead for large studios and models, landscape artists faced different sorts of problems. They needed not only to limit the materials to be carried to their sites—along with food and umbrellas for protection from sun and rain alike—they had to work simply and quickly, for valuable time would be lost in getting back to the same remote location if too many sittings were required for any single painting. And unlike history painters in Paris studios, itinerant painters could not work on large canvases since these became veritable sails in the wind, impossible to steady, much less transport. Furthermore, they had to endure unruly locals with a distrust of strangers. Understandably, the landscape paint-

ers, who sought out one another for companionship as well as convenience, developed a reputation for rugged individualism.

Encouraged by such artists as Troyon and Millet, Boudin introduced Monet to more than the techniques of painting out-of-doors; he introduced his young friend into a persevering confraternity that was distrustful of the Academy and the art schools that emphasized hackneyed traditions at the expense of sincere, untaught ways of looking at the world and inventing new ways to express a personal vision.

Immeasurably less exuberant than Monet, Boudin won notoriety among liberal-minded artists and their supporters at the time of the 1859 Salon. Baudelaire, in his role as newspaper art critic, was dissatisfied with what he saw on exhibit, and so he followed his crony, the boisterously controversial realist painter Courbet, to Boudin's studio to see a series of sky studies in pastel, each inscribed with the date, time of day, and wind conditions it depicted. "In the end," Baudelaire told his readers, who could not see such simple marvels at the Salon, "all these clouds with fantastic and luminous forms of black or violet satin . . . mount to my brain like a heady dream or like the eloquence of opium."

What Boudin had been able to catch in small-scale pastels, Monet would find a way to paint with slow-drying oils on large canvases that he lugged to almost inaccessible sites. Monet adopted the Barbizon creed to paint nature directly in a strictly literal way and boasted that he would never merely make sketches or notes to consult away from the site as the basis for large Salon paintings, as his mentors of necessity often did. To challenge himself still further, he tackled the most difficult conceivable motifs—slapping, churning, rippling water, and snowy landscapes with dozens of delicate, barely differentiated white tones to be recorded in finger-numbing cold, and splinters of light showering through summer leaves in patterns so complicated as to defy the most patient concentration.

But such goals, formulated upon Boudin's example, conflicted with the wishes of Monet's father and aunt, who quite understandably insisted that he study basics with a recognized teacher. To do so, however, was to embarrass himself in the eyes of his heroes Courbet and Manet, who emboldened him to develop his incredible natural talents independently. Throughout the 1860s, Monet tried to win acclaim at the Salons to reassure his family, while striving to win the esteem of these role models. Working as they did, without the use of drawings or preliminary studies which might detract from spontaneity, Monet at first attempted vast figure subjects and marines that consumed virtually all of his time from one year's Salon to the next.

These works were far too grand to go entirely unnoticed in the 1860s, especially since Monet's signature was nearly identical to that of the intentionally controversial Manet, with whom he was often confused. But it would be incorrect to take the caricatures based upon Monet's Salon paintings as blunt attacks against him, for such spoofs, which had become widespread during the 1840s, targeted conventional and unconventional artists alike. Sympathetic to Monet's struggles, later writers have sometimes neglected to explain the original tone of early critical accounts, which, though they could be damaging, were primarily intended to be witty. Likewise it is seldom mentioned, for example, that Louis Leroy, whose review of the first impressionist exhibition in 1874 has been widely quoted, was a professional satirist writing for a lampoon journal. Considering how sharply Leroy caricatured the blustering Academic painter into whose mouth he put the diatribe against Monet's art, it seems unfair to read the famous article as a serious, one-sided condemnation. It should also be remembered that, then as now, many art critics were working against press deadlines, which to some extent accounts for, though it never can excuse, their thoughtless remarks.

Of course these journalists did not have tape recorders, so the quota-

tions of Monet's own words were recorded from notes or memory after the actual conversations and must be taken as somewhat inaccurate. Arnyvelde's interview for *Je sais tout* gets almost everything wrong, slightly, and not surprisingly this writer has been completely forgotten. In a photograph for Arnyvelde's original article, Monet, standing next to the journalist, is grimacing. Sadly, as the result of bad experiences with hack reporters, Monet refused to welcome some gifted writers, including Marcel Proust.

Many scholars doubt whether the long, eloquent quotations in Roger Marx's extraordinary 1909 article are genuine. Yet, evidently, neither Monet nor his dealer protested when this "interview" was published in the prestigious *Gazette des Beaux-Arts*. Fully aware of the problems that writing about contemporary artists involved, Trévise submitted his manuscript to Monet for approval prior to publication.

Many of the interviewers posed the same questions rather than presenting Monet with new ones. To some extent, the aged painter probably kept returning to favorite stories. But it should also be considered that each successive interviewer read earlier articles in preparation and then inadvertently stressed already familiar material. As a result, posterity has inherited more detailed accounts of Monet's youth than of his maturity, despite the fact that Monet was seldom interviewed before he was sixty.

Such shortcomings notwithstanding, these early accounts of Monet and his art remind us of important concepts that have largely been forgotten. Four terms appear over and over with regard to his landscapes: *motif, effect, fairylike,* and *decoration.* Committed to painting the facts and never composing landscapes with elements taken from different locales, Monet chose his subjects, or *motifs*, with care, often stationing himself where he could see the general lines of the landscape lock together into structural patterns. Silhouettes that form arabesques, reflections, and other inherently pictorial elements appealed to Monet. Troubling to find the best such motifs was simply crucial to painting successful landscapes. In 1866, Cézanne even planned a picture of his two associates, Marion and Valabregue, their canvases on their backs, as they seek out a suitable motif to paint. As for Monet, to gain access to a special motif he might con railroad officials at the Gare Saint-Lazare or disturb strangers on holiday so that he could use their balcony to paint the flag-cluttered street below. Scaling the sheer cliffs at Étretat or paying six gardeners to cultivate and maintain blossoming harmonies and geometries was the high price he was willing to pay for astounding motifs.

Broadly speaking, motif is to drawing what effect is to coloring, for the term *effect (effet)* refers to a particular light condition. Unlike earlier landscape painters who had a fairly limited repertoire of effects—dawn, daylight, stormy darkness or dusk—Monet distinguished hundreds of different ones. He carried his realism so far as to refuse to continue painting as soon as a given light effect changed—after a few minutes in some cases, hardly time enough to make substantial progress. This meant that he needed to develop the ability to analyze and transcribe what he saw—his impressions—with lightning speed. And it meant that he needed to return many times over to the same site and wait for the return of a particular effect in order to bring some pictures to completion. Challenges were irresistible to him, and eventually he began to take several canvases to a single spot, starting them all in turn as one effect was replaced by another. When it was possible to have dozens of canvases at hand, as at Giverny when he painted the *Haystacks* and *Poplars*, or in the upper-story rooms across from Rouen Cathedral, or at the Savoy Hotel overlooking the Thames, Monet could and did try to record each slight variation in effect. With this common-sense system of changing canvases and returning to them on subsequent days, Monet made time for himself to paint the most transient beauties in time-consuming detail. For better or worse, Monet's decision to paint effect variations on a single motif and to exhibit them together has been one of the single most influential ideas

in the subsequent history of modern art. Oblivious to Monet's original rationale, virtually every artist, including nonrepresentational ones, seems to feel a responsibility to investigate any chosen theme in different colors and to exhibit the results together, *à la* Monet.

Fairylike (*féerique*) denoted the interaction of motif and effect to suggest the spirit of *The 1,001 Nights*, a book cherished by Monet and many of his associates. Later in his career especially, the strict realist was obsessed with genuine observations that were charged with strange effects of light, almost misleading or miragelike, such as stone dissolving in colored fogs for the *Rouen Cathedral* paintings or water on fire for some of the *Thames* canvases. These works celebrate something that is to be seen and marveled at, but never understood, since our eyes ask us to believe perceptions that are contrary to logic. With an openness to phenomena an adult can recapture the wondrous perceptions of childhood, and Monet disciplined himself to discover and share such enchantments in all their purity.

Decoration is perhaps the most complex of these four terms. The French word refers to several related but significantly different concepts, including (1) ornamentation, with its abstract design qualities (stylization, repetition, flatness), (2) stage sets with their coarse artificiality, and (3) mural ensembles conceived to elicit particular moods, depending on the nature of the room. At first, Monet's calming *Water Lilies* were intended as decorations for a dining room; only later did the painter agree to continue these decorations for a temple of peace.

Since decorations must make sense regardless of an ambulant spectator's position in the room, the artist cannot represent space using conventional perspective predicated on a unique vantage point. Wherever one casts an eye upon Monet's *Water Lilies*, space seems to extend in opposite directions and never to demand focus. Furthermore, since large decorations are generally intended to be seen, as theater sets are, from a more distant vantage point than an easel painting would be seen, sharply indicated details get lost. Broad, open, suggestive brushwork is more convincing. As Monet realized, the thick, irregular ridges of his broken brushstrokes would catch the light in the rooms where his paintings were displayed and thus contribute to the paintings' effects.

This last principle of decoration is fundamental to Monet's easel painting, too, as critics noticed as early as 1874. Like the scientific neo-impressionists associated with Seurat, who subsequently referred to the visual phenomenon that is heightened by the viewer's distance from the art as "optical mixture," Monet learned the basic principles of color vibrancy from magnificent murals that Delacroix executed for the church of Saint-Sulpice in Paris (unveiled in 1861), decorations enchanted with light. Seen close-up, Monet's paintings, like Delacroix's, tend to break into little incoherent bits, like spilled mercury in different colors. Many who viewed Monet's paintings from the proper distance for viewing an Italian Renaissance picture of the same size complained that Monet had failed to represent convincingly what he saw. But seen from further away, Monet's landscapes give an illusion of spatial depth as impressive as the stereoptical photographs then popular as parlor novelties. As a result, any work by Monet can be seen as pure painting or pure illusion alternatively, depending on the viewer's point of view.

Adhering to these French art terms was part of our decision to keep the translations straightforward and literal, occasionally allowing inelegance or quaintness, perhaps, but retaining as well the spirit of the original, clumsy prose. Annotations have been kept to a minimum and, unless otherwise cited, my sources for the information in them were Rewald and Wildenstein, as well as Sophie Monneret's useful four-volume *L'Impressionnisme et son époque* (Paris, Denoël, 1978–81).

CHARLES F. STUCKEY

JEAN RENOIR

RENOIR, MY FATHER

1958

Jean Renoir (1894–1979), prize-winning film director and son of the painter.

Their convictions did not hinder Monet, Sisley, Bazille and Renoir from regular attendance at the school run by old Gleyre. After all, the cult of nature was not incompatible with the study of drawing. Monet amazed old Gleyre. Everyone, in fact, was impressed, not only by his virtuosity but also by his worldly manner. When he first came to the school, the other students were jealous of his well-dressed appearance and nicknamed him "the dandy." My father, who was always so modest in his choice of clothes, was delighted with the spectacular elegance of his new friend.

"He was penniless, and he wore shirts with lace at the cuffs!"

Monet began by refusing to use the stool which was assigned to him when he first entered the classroom. "Only fit for milking cows." As a rule, the students painted standing up, but they had the right to a stool if they wanted it. Until then it had never occurred to anyone to bother about these stools one way or the other.

Good old Gleyre had the habit of getting up on the little platform on which the model posed, and giving advice from that vantage point to this or that novice. One day he found Monet installed in his place. Monet's explanation was that he needed to get nearer the model in order to examine the texture of the skin.

Except for his friends in the "group," he looked upon the rest of his fellow students as a sort of anonymous crowd—"just a lot of grocers' assistants," he called them. To a rather pretty if somewhat vulgar girl who started to make advances to him, he said: "You must pardon me, but I only sleep with duchesses—or servant-girls. Those in between nauseate me. My ideal would be a duchess's servant."

* * *

After Renoir had given up his decorating work entirely, he and Monet shared lodgings. They managed to eke out a living by doing portraits of small tradespeople. Monet had a knack for arranging the commissions. They were paid fifty francs for each portrait. Sometimes months would go by before they were able to get another commission; nevertheless, Monet continued to wear shirts trimmed with lace and to patronize the best tailor in Paris. He never paid the poor man, and when presented with a bill treated him with the haughty condescension of Don Juan receiving Monsieur Dimanche.

"Monsieur, if you keep insisting like this, I shall have to withdraw my custom."

And the tailor did not insist, for he was overcome with pride in having a gentleman with such elegant manners as his customer.

"He was born a lord," said Renoir.

All the money the two friends could scrape together went to pay for their studio, a model, and coal for the stove. For the problem of food, they had worked out the following scheme:

Since they had to have the stove for the girl who posed for them in the nude, they used it at the same time for cooking their meals. Their diet was strictly spartan. One of their sitters happened to be a grocer, and he paid them in food supplies. A sack of beans usually lasted about a month. Once the beans were eaten up, the two switched to lentils for a

Charles Gleyre (1806–1874) came to Paris from his native Switzerland in 1825 to pursue an art career. He travelled to the Near East and Egypt in 1837 and made his Salon debut in 1840. His Lost Illusions, *exhibited there in 1843 and purchased by the State (and now in the Louvre), launched his success. A staunch Republican, he boycotted the Salons during the Second Empire and refused to accept the Legion of Honor, as Monet would do later.*

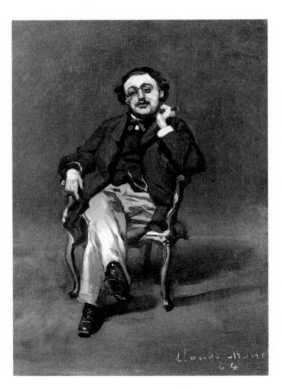

Dr. Leclenché. Circa 1864. 18 × 12¾" (45.7 × 32.4 cm). The Metropolitan Museum of Art, New York; Gift of Mr. and Mrs. Edwin C. Vogel.

change. And so they went on confining themselves to starchy dishes which required little attention while cooking. I asked my father if eating beans at every meal had not been hard on their digestion.

"I've never been happier in my life. I must admit that Monet was able to wangle a dinner from time to time, and we would gorge ourselves on turkey with truffles, washed down with Chambertin!"

PAUL MANTZ

GAZETTE DES BEAUX-ARTS

"The Salon of 1865"

1865

Paul Mantz (1821–1895), art historian and critic who became General Director of the Ministry of Fine Arts in 1882.

Here we must mention a new name. We were not aware before of M. Claude Monet, creator of *Pointe de la Hève* and *Mouth of the Seine at Honfleur.* These works mark, we believe, his debut, and they lack the finesse that comes only after lengthy study. But the sensitivity to color harmony in the play of related tones, the feeling for values, the startling appearance of the whole, an audacious manner of seeing things and of commanding the observer's attention—these are virtues which M. Monet already possesses to a high degree. As we passed along, his *Mouth of the Seine* brought us to an abrupt halt, and we shall never forget it. As a result, we shall follow the future efforts of this sincere seascapist with great interest from now on.

COLORPLATE 5
(Authors' references to paintings that are included among color plates in this volume are indicated throughout, as here.)

Mouth of the Seine at Honfleur. 1865. 35½" × 59⅛" (90 × 150 cm). Norton Simon Museum of Art at Pasadena, California.

FÉLIX Y

LA VIE PARISIENNE

May 5, 1866

Manet [sic]. Gamille. Happy in her striped dress without crinoline, sucks her thumb contentedly.

Caricatures of Salon paintings began to appear frequently in periodicals beginning in the 1840s, lampooning public favorites as well as controversial avant-garde works. Founded in 1863, La Vie parisienne, was a heavily illustrated weekly covering art, theater and social fashions.

COLORPLATE 8

BERTALL

LE JOURNAL AMUSANT

"The Salon of 1866"

May 12, 1866

Camille, or the *Cavern*, by Claude Monet.

Bertall was the pseudonym of Charles Albert d'Arnoux (1820–1882), who had studied painting with Drolling, but was best known as an illustrator of Balzac's works and a caricaturist for periodicals. Le Journal amusant, was a weekly satirical journal that included caricatures of dozens of works from each year's Salon in its spring issues.

ANDRÉ GILL

LA LUNE

"The Joke Salon"

May 13, 1866

Monet or Manet? —Monet. But it is to Manet that we owe this Monet. Bravo Monet! Thank you Manet!

Andre Gill: pseudonym of Louis-Alexandre Gosset de Guines, specialized in caricature journalism. He was among the artists who gather at the inn of Mère Toutain at Saint-Siméon in Normandy during the early 1860s when it was "discovered" by the painter Boudin, who brought his protégé Monet there.

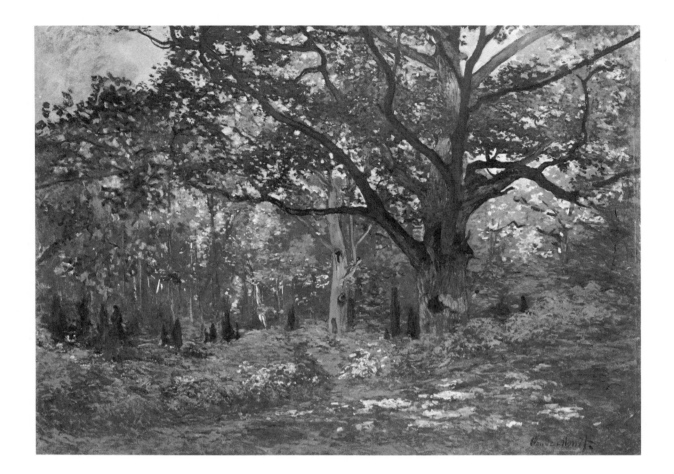

The Bodmer Oak,
Fontainebleau Forest.
1865. 37⅞ × 50⅞"
(94.9 × 129.2 cm).
The Metropolitan
Museum of Art,
New York; Gift of
Sam Salz and
Bequest of Julia W.
Emmons, by
exchange, 1964.

ÉMILE ZOLA

L'ÉVÉNEMENT

"The Realists at the Salon"

1866

*Émile Zola (1840–1902),
controversial novelist and journalist,
who came to Paris in 1858 from Aix-en-
Provence and urged his closest boyhood
friend, Cézanne, to join him there. Zola
would be dismissed from* L'Événement
*for his firebrand support of Manet.
published serially as part of the same
Salon review included here.*

I confess the painting that held my attention longest is *Camille,* by M. Monet. Here was a lively, energetic canvas. I had just finished wandering through those cold and empty rooms, sick and tired of not finding any new talent, when I spotted this young woman, her long dress trailing behind, plunging into the wall as if there were a hole there. You cannot imagine what a relief it is to admire a little, when you're sick of splitting your sides with laughter and shrugging your shoulders.

COLORPLATE 8

I don't know M. Monet, I don't even think I've ever seen a single canvas of his. Yet I almost feel like one of his old friends, and that's because his painting speaks whole volumes to me about energy and truth.

Oh, yes, here is someone with a temperament, here is a *man* among all these eunuchs. Look at the paintings nearby and see how crestfallen they look next to this open window on nature! Here we have more than a realist, someone who knows how to interpret each detail with delicacy and power, yet without lapsing into tediousness.

Notice the dress, how supple it is, how solid. It trails softly, it is alive, it declares loud and clear who this woman is. This is no mere doll's dress, not one of those muslin shifts to dress up a dream; this is real silk, as good as new, which would be much too heavy for any of M. Dubufe's cream puffs.

*Édouard Dubufe (1818–1883), a
popular portrait painter.*

34

W. BÜRGER

SALONS DE W. BÜRGER 1861 À 1868

1870

W. Bürger: pseudonym for Théophile Thoré (1807–1869), lawyer and political activist, who began to write art criticism in the 1830s and became a pioneering historian of seventeenth-century Dutch art.

But wait! Here is another very young man, M. Claude Monet, more fortunate than his near-homonym Manet . . . who's had the good luck to get his *Camille* accepted—a large portrait of a standing woman seen from behind, trailing a magnificent green silk dress, fully as dazzling as the fabrics painted by Veronese. I'd like to reveal to the jury that this opulent painting was done in four days. When you're young you don't stay cooped up in a studio, you go out gathering rosebuds. The deadline to submit to the Salon was approaching. Camille was there, fresh from gathering violets in her lawn-green train and velvet jacket. Henceforth Camille is immortal, and is known as the *Woman in the Green Dress*.

COLORPLATE 8

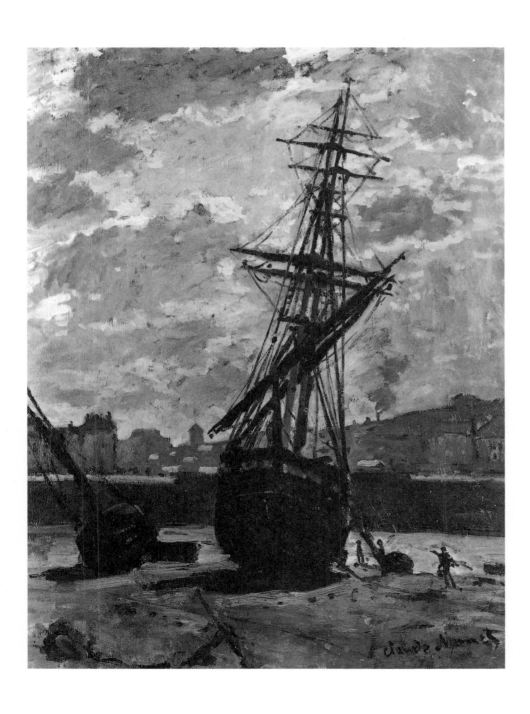

Boats at Fécamp. 1868. 29½ × 22½" (75 × 57 cm). Private Collection. Photograph: Fondation Wildenstein, Paris.

FÉLIX FÉNÉON

BULLETIN DE LA VIE ARTISTIQUE

March 28, 1914

Félix Fénéon (1861–1944), brilliant analytical and critical proponent of Seurat and the neo-impressionists. Fénéon worked selflessly to help publish writings of his symbolist friends. In 1906, he became director of the Galerie Bernheim-Jeune. See John Rewald, "Félix Fénéon," Gazette des Beaux-Arts, *vols. 32–33 (1947–48).*

Latouche, color merchant, rue Lafayette, counted Pissarro, Monet, and their friends among his clients. In late afternoons, people would sometimes go by to chat in his boutique. One day in 1865 or 1866, Daumier came in. Pointing to a painting in the window, he said, "Hey, Latouche, take that garbage out of your window; it's disgraceful!" and he left. The picture was Monet's *Le Jardin de L'infante*. The young Monet was present, and was shocked.

COLORPLATE 12

A few days later, Latouche and Monet, looking out the window, saw Diaz shaking his head acquiescently, and stopped on the sidewalk in front of the very same painting. Latouche asked him in, introduced everyone, and Diaz exclaimed, "Very good, young man; you will go far." In other circumstances, Daubigny as well made known his approval. But how much more Monet would have preferred to receive the endorsements of Daumier or of Corot instead of these!

Corot, however, who was passionately admired by these new painters, did not at all understand the importance of their innovations. Guillemet, at first friendly to them, and who, notably, worked in the company of Cézanne, had settled down and had been admitted into the Salon. Corot, all excited, said to Vollon, who had advised and backed the candidate, "Well, this little Antonin, saved at last! When he was with that dirty gang, I thought he was lost forever."

Antoine Guillemet (1842–1918), who studied landscape painting under Corot, often had works refused by the Salon juries during the 1860s.

Antoine Vollon (1833–1900), painter friend of Daubigny and Boudin who served as a juror for the Salon of 1874, at which Guillemet, after refusing to exhibit independently with the impressionists, received acclaim.

On the other hand, toward 1866, Courbet was encouraging Monet and, contrary to his renowned stinginess, insisted on making money available to the beginner. Here's how their relations began: a certain Grasset, an excellent man but a bit wacky, had spoken about Monet to Courbet and had declared, "A young man who does something different! I love it!" After the luncheon at which Grasset had for the first time assembled all of them, Courbet had declared, "Now we are going over to the young man's place." At the time, Monet was working on his *Luncheon on the Grass* (the sketch for which is in the Serge Stschoukine collection). "Young man," Courbet said, "it's very good. However, you should change this and that, as well as that. . . . It would be infinitely much better. Then, I'll come back and see you. But you'll not have finished in time for the Salon. Even I couldn't make it." Monet transformed his work, and, realizing himself that he would not be able to finish it soon enough, abandoned it momentarily to paint, in four days, *Woman in the Green Dress*, which can be seen at the museum in Bremen.

COLORPLATE 7

Sergei Shchukin (1854–1937) began collecting in Paris in 1897, eventually amassing a notable group of works by Gauguin and Matisse. That collection was nationalized in 1918 and is now divided between the Hermitage in Leningrad and the Pushkin Museum in Moscow.

COLORPLATE 8

Monet already knew Jongkind. Toward 1862, upon his return from the army, he was doing *plein air* studies in pastel at Sainte-Adresse. An ungainly Englishman with an artist's look, carrying his portfolio under his arm, stared at him painting an impatient cow. "Wait! I'll steady her for you!" He took it by the horns. Bullfight, then conversation: "Do you know the painting of a certain Jongkind?" asks the cow tamer. "Yes. Really talented. I've seen some of his works at a framer's in Le Havre." "Well then, I'm going to invite him to lunch if you want to join us." On that occasion, Jongkind saw Monet's paintings, liked them, and concluded, "Let's work together." The following days Jongkind and Monet worked side by side, the former with watercolors, the latter with pastels. The older man surprised the younger by the liberty he took to group in one watercolor elements gathered from every direction. "I've met a great

painter," the young Monet announced to his parents. Although he already had the mania of believing that people wanted to poison him, Jongkind accepted their invitation. He was accompanied by Mme Fesser. When, during the meal, his hosts, referring to her, said, "Your wife!" all of a sudden, he said, "This woman is not my wife; this woman is an angel." At this point he told the story of how having drunk too much, too fast, he had had to enter the hospital, an alcoholic, and how this angel had (temporarily) cured him.

We have these anecdotes directly from Monet. Two of them offer consolation to young painters for the injustices meted out by the elders.

Luncheon on the Grass (central section). 1865. 97⅝ × 96⅛″ (248 × 217 cm). Private Collection. Photograph: Paul Rosenberg & Co., New York.

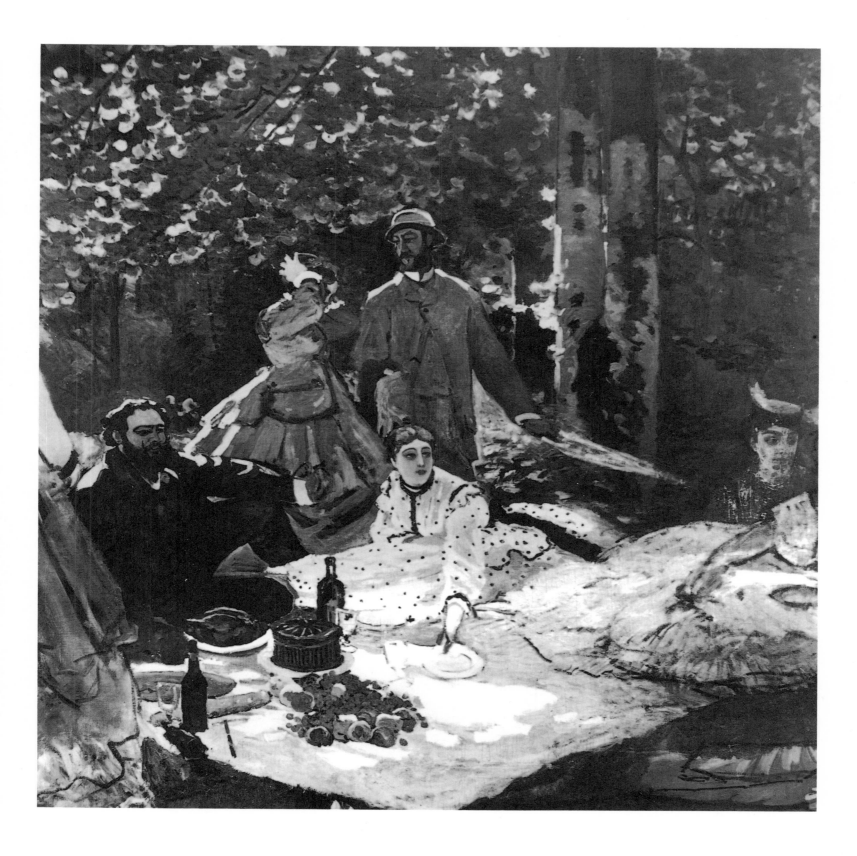

ÉMILE ZOLA

L'ÉVÉNEMENT

"The Actualists"

1868

Those painters who love the times they live in from the depths of their hearts and minds as artists, perceive everyday realities in a different way. Above all, they try to penetrate the exact meaning of things. Not content with ridiculous *trompe-l'oeil,* they interpret their era as men who feel it living within themselves, who are possessed by it and happy to be. Their works have nothing in common with those stupid, trite, fashionable illustrations and sketches of daily life you find in the magazines. Their works are alive, because they have taken them from life and painted them with all the love they have for modern subjects.

In the front rank of these painters I name Claude Monet. Here is a man who has nursed at the breast of our times, who has grown up and will grow still more in his affection for his surroundings. He loves the horizons of our villages, the splashes of gray and white that houses make against the clear sky; he loves those busy men in overcoats running in the streets; he loves the racetracks; he loves the aristocratic avenues and their bustling traffic; he loves our women, their umbrellas, their gloves, their lace, even their false hair and their face powder—everything that makes them the daughters of our civilization.

As for the countryside, he prefers an English garden to a forest retreat. He delights everywhere in finding a trace of the human and wants to live forever in our midst. Like a true Parisian, he takes the city with him to the country, and cannot paint a landscape without putting in men and women dressed in their finery. Nature seems to lose its interest for him as soon as it no longer bears the stamp of our mores.

He is a first-rate painter of seascapes. But he understands the genre in his own special way. And here again I find a profound love of living realities. In his seascapes, you can always spot the edge of a jetty, the corner of a dock, something that fixes it in time and place. He seems to have a weakness for steamships. And it must be added that he loves water as one loves a sweetheart. He knows every inch of a boat's hull, and could rattle off the names of each and every rope in the masting.

This year he had only one painting accepted, *Boats Leaving the Docks at Le Havre.* Trailed by a steamer, a three-master fills the canvas. The dark, monstrous hull looms above the greenish water; the sea swells and heaves in the foreground, still groaning beneath the massive weight cleaving it in two.

What struck me the most about this painting, was the frankness, indeed, the very harshness of the touch. The water is acrid, and the horizon extends with harshness. You sense there the presence of the high seas; you feel that a squall could suddenly darken the sky, whiten the waves. We're facing the ocean; before us is a ship smeared with tar; we hear the muffled, gasping cry of the steamer filling the air with its sickening fumes. I saw those harsh hues; I smelled that salty air.

* * *

He's one of the only painters who can paint water without a silly limpidity or mendacious glitter. With him, water is alive, profound, and above all, real. It slaps against the sides of boats in greenish surges,

COLORPLATE 12

COLORPLATE 8

Although Manet and his friend Degas painted racetrack scenes beginning around 1864, this is the only reference suggesting that Monet may have done the same.

Indeed, after 1865, Monet had stopped painting at the forest of Fontainebleau, which had become overcrowded with would-be artists and tourists.

COLORPLATE 9

COLORPLATE 10

COLORPLATE 11

COLORPLATE 13

stripped of any fleecy luster; it lies flat in glaucous ponds, rippled suddenly by a breeze; it elongates the masts reflected on its surface, while shattering their image; it has dull, pale shades that brighten with shrill lights. It is not the pure, crystal-clear, imitation water of the studio painter; it is the stagnant water of ports, besmeared with patches of oil; it is the great, livid water of the vast ocean wallowing in its bed as it shakes off its grimy foam.

The other painting by Monet (which the jury refused) of a jetty at Le Havre, is perhaps more characteristic. The long, narrow jetty juts out into the grumbling sea, lifting against the pale horizon the thin, dark silhouettes of a row of gas lamps. A few people stroll along the jetty. A bitter, harsh wind is blowing from the main, buffeting skirts, ploughing deep furrows into the sea, and dashing the muddy waves, yellowed by the basin's bottom, against the concrete blocks. These are the dirty waves, these surges of grubby water, which no doubt frightened members of the jury long accustomed to the tinkling, shiny wavelets of sugar-coated seascapes.

But anyway, one shouldn't judge Claude Monet by these two paintings alone and thereby risk forming a very incomplete picture of him. I hate to study works in isolation; I prefer to analyze a personality, anatomize a temperament—which is why I so often go looking outside the Salon for works not included there, which, taken together, can ultimately explain an artist as nothing else can.

I have seen canvases of Claude Monet that are indeed his flesh and blood. Last year his figure painting of women dressed in their summer whites, picking flowers in garden paths was refused. The sunlight falls directly on their brilliant white dresses; the tepid shadow of a tree cuts across the garden paths, across the sunlit dresses, like a big gray tablecloth. No effect could be stranger. An unusual love for one's times is required to risk such a *tour de force*, with these fabrics divided into sunny and shady halves, and these ladies placed in a garden plot well groomed by a gardener's rake.

COLORPLATE 9

I've said it before: Claude Monet has a special affection for nature that the human hand has dressed in a modern style. He has painted a series of canvases, executed in gardens. I know of no paintings that have a more personal accent, a more characteristic look. The flower beds, dotted with the bright reds of geraniums and the flat whites of chrysanthemums, stand out against the yellow sand of the path. Basket after basket is laden with flowers, surrounded by strollers dressed in elegant informality. I would love to see one of these paintings at the Salon, but it seems that the jury is there to scrupulously prohibit their admittance. But so what? They will endure as one of the great curiosities of our art, as one of the marks of our era's tendencies.

This is the first published reference to Monet's marked preference for working on series of related pictures. But only a few known works correspond to Zola's descriptions, and there is no trace of the painting that showed strollers on paths lined with baskets of flowers.

Of course, I would hardly admire these works if Claude Monet were not a true painter. I have simply wanted to point out the sympathy that directs him to modern subjects. But if I commend him for seeking his point of view in the world he inhabits, I congratulate him even more for knowing how to paint, for having an exact and candid eye, for belonging to the great school of naturalists. What distinguishes his talent is an incredible ease of execution, a supple intelligence, a lively and quick comprehension of any subject.

I'm not pained on his behalf. He will conquer the crowd when he chooses to. Those who smile at the willful harshness of this year's seascape should remember his woman in a green dress of 1866. When one can paint fabric like that, one is in full possession of his art, one has assimilated all the latest styles, and one does what he wants. I expect nothing from him but the good, the accurate, and the true.

COLORPLATE 8

LÉON BILLOT

JOURNAL DU HAVRE

"Fine Arts Exhibition"

October 9, 1868

M. Monet is from Le Havre. The good things we have to say about this artist require us to make the preliminary declaration that we do not have the honor of knowing him personally. We have only caught sight of him once. It was during winter, after several snowy days, when communications had almost been interrupted. The desire to see the countryside beneath its white shroud had led us across the fields. It was cold enough to split rocks. We glimpsed a little heater, then an easel, then a gentleman, swathed in three overcoats, with gloved hands, his face half-frozen. It was M. Monet, studying an aspect of the snow. We must confess that this pleased us. Art has some courageous soldiers. In one of our next articles, where we will be concerning ourselves with seascapes, we will have reason to reconsider M. Monet, who we believe occupies a distinct place in painting. Today, we have only to look at *Camille;* the most splendid dress of green silk ever rendered by a paintbrush. The color, fabric and creases caused by the habits of the woman, who serves as the pretext for this dress, are all exposed with an exceptional joy, vigor and veracity. On the other hand, critics could find a lot to say about this lady's head. A head which is obviously only a sketch. Had the lady only consented to the exhibition of the painting in the Salon, on the condition that she could not be recognized?; and M. Monet, who is not a man who would alter a head created by the good Lord, could he not have found another stratagem than that of creating no head at all? Mystery! The fact remains that from Camille's gait and the provoking way in which she treads upon the sidewalks, one has no trouble guessing that Camille is not a woman of the world, but [just] a Camille.

COLORPLATE 17

COLORPLATE 8

Road in front of the Saint-Siméon Farm, Honfleur. 1867. 21½ × 31¼" (54.6 × 79.4 cm). Fogg Art Museum, Harvard University, Cambridge, Massachusetts; Granville L. Winthrop Bequest.

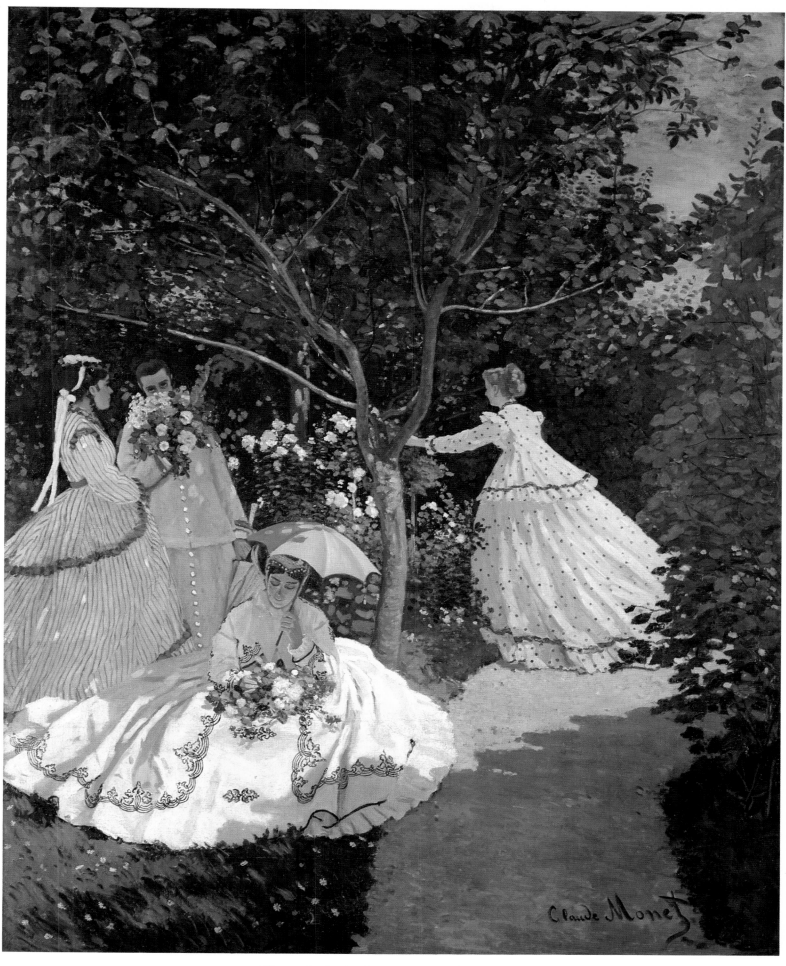

COLORPLATE 9. *Women in the Garden.* 1867. 100¾ × 81⅞″ (256 × 208 cm).
Galerie du Jeu de Paume, Musée du Louvre, Paris. Photograph: Musées Nationaux, Paris.

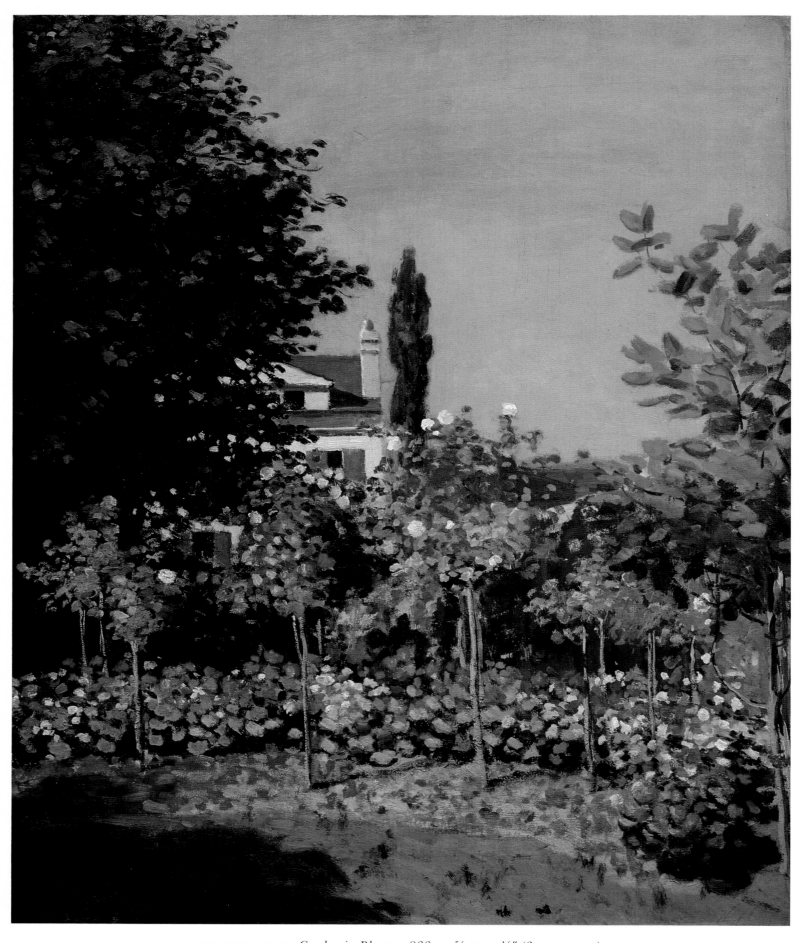

COLORPLATE 10. *Garden in Bloom.* 1866. 25⅝ × 21¼″ (65 × 54 cm).
Galerie du Jeu de Paume, Musée du Louvre, Paris. Photograph: Musées Nationaux, Paris.

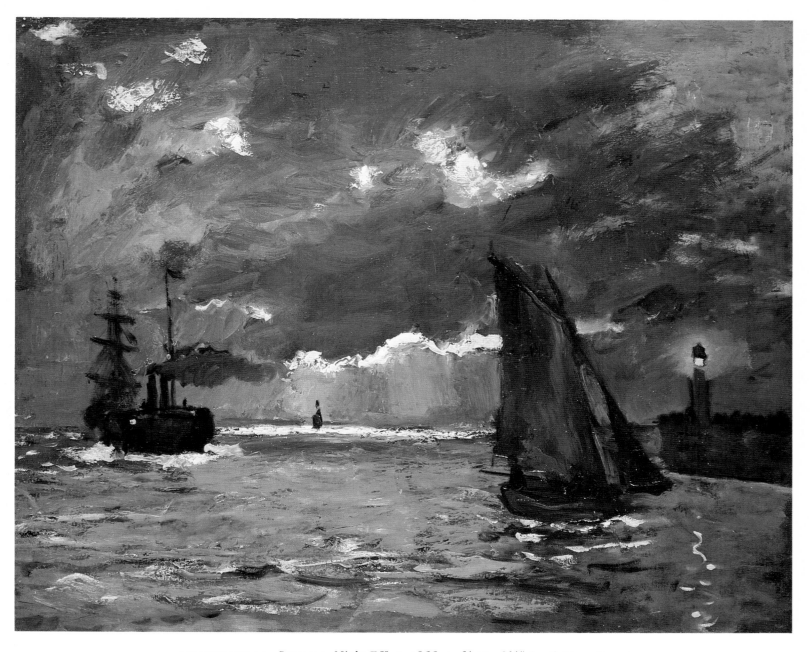

COLORPLATE 11. *Seascape: Night Effect.* 1866. 22¾ × 28¼″ (57.8 × 71.8 cm).
National Galleries of Scotland, Edinburgh.

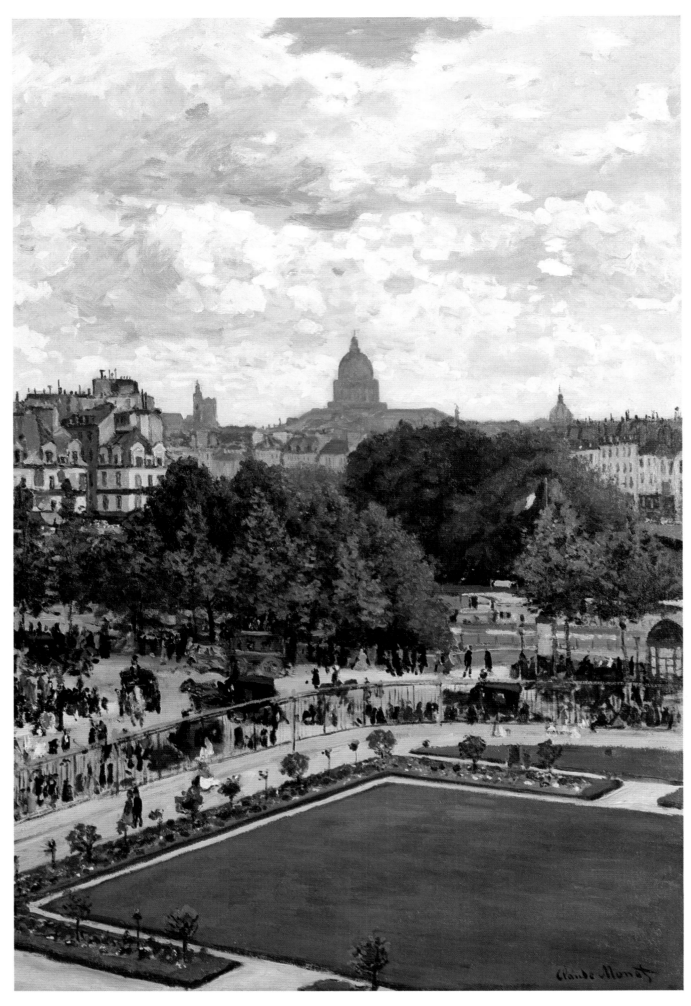

COLORPLATE 12. *Le Jardin de l'Infante.* 1867. 36⅛ × 24⅜″ (91.8 × 61.9 cm).
Allen Memorial Art Museum, Oberlin College, Oberlin, Ohio; R.T. Miller, Jr. Fund.

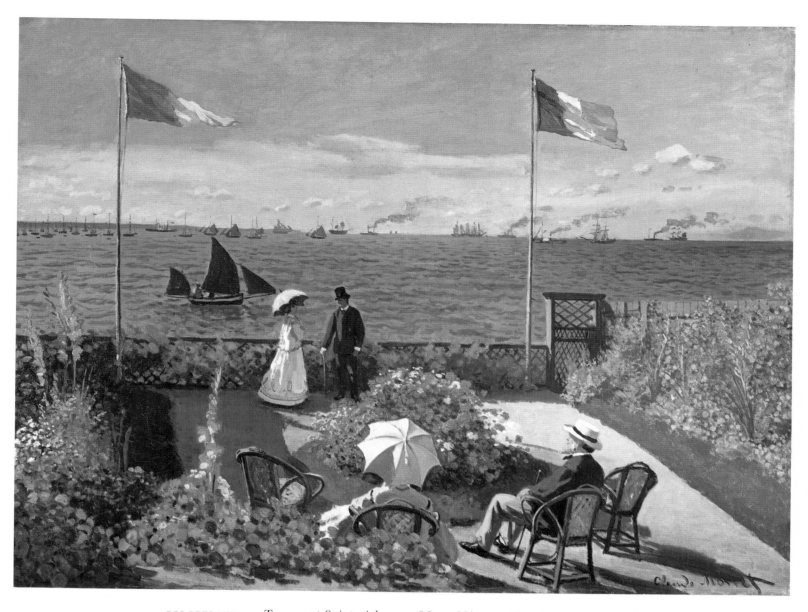

COLORPLATE 13. *Terrace at Sainte-Adresse.* 1867. 38⅝ × 51⅛″ (98.1 × 129.9 cm).
The Metropolitan Museum of Art, New York; Purchased with special contributions and purchase funds
given or bequeathed by friends of the Museum, 1967.

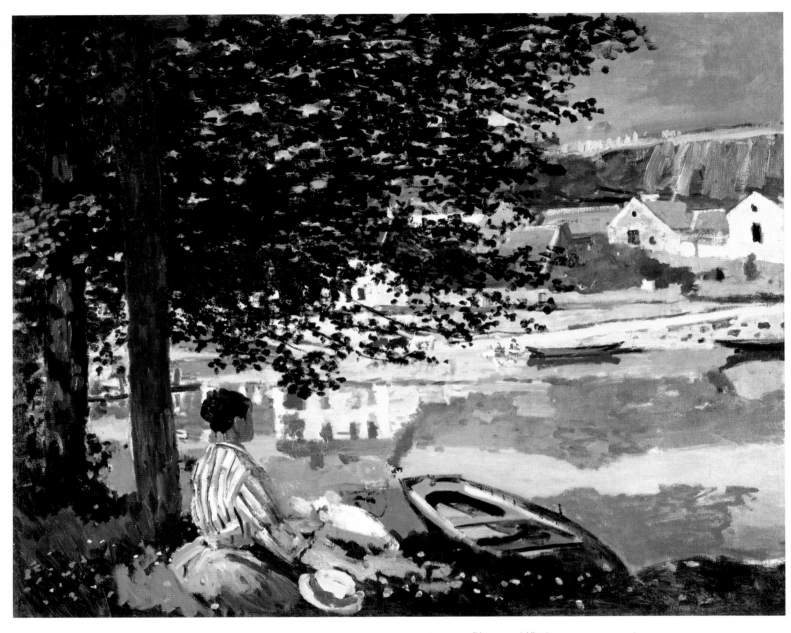

COLORPLATE 14. *On the Seine at Bennecourt.* 1868. 31⅞ × 39½″ (81 × 100.3 cm).
The Art Institute of Chicago; Potter Palmer Collection.

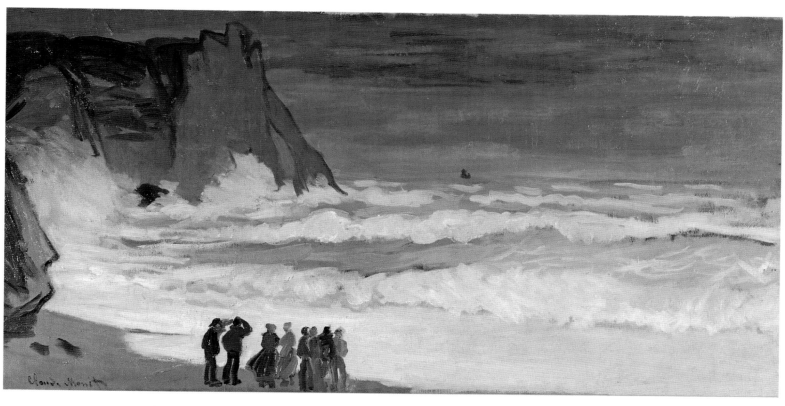

COLORPLATE 15. *Stormy Sea at Étretat.* C. 1868. 26 × 51⅝″ (66 × 131 cm).
Galerie du Jeu de Paume. Musée du Louvre, Paris. Photograph: Musées Nationaux, Paris.

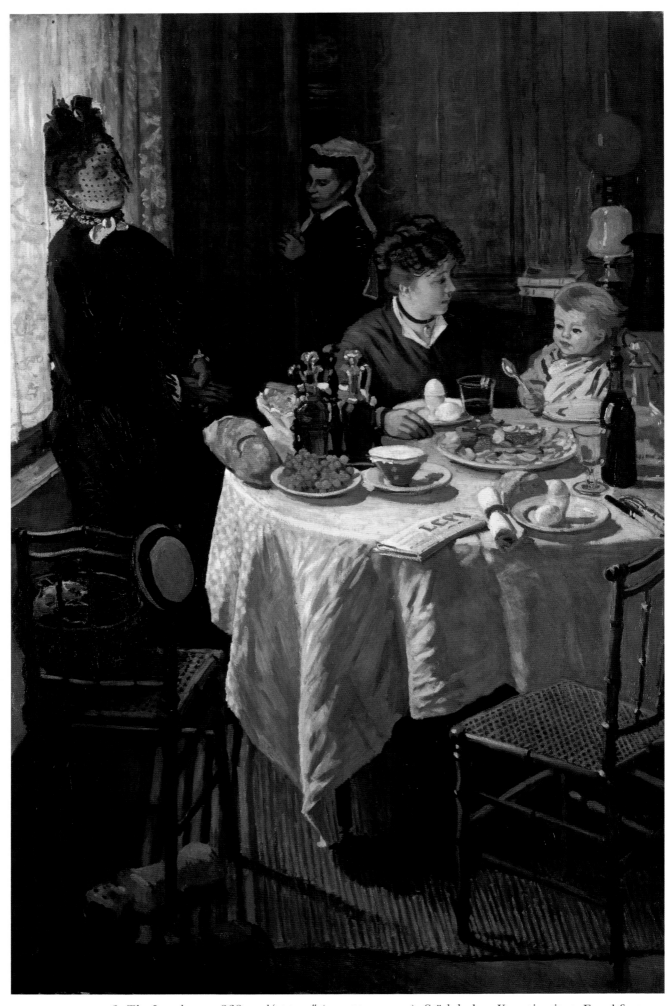

COLORPLATE 16. *The Luncheon*. 1868. 90½ × 59″ (230 × 150 cm). Städelsches Kunstinstitut, Frankfurt.
Photograph: Artothek, Munich.

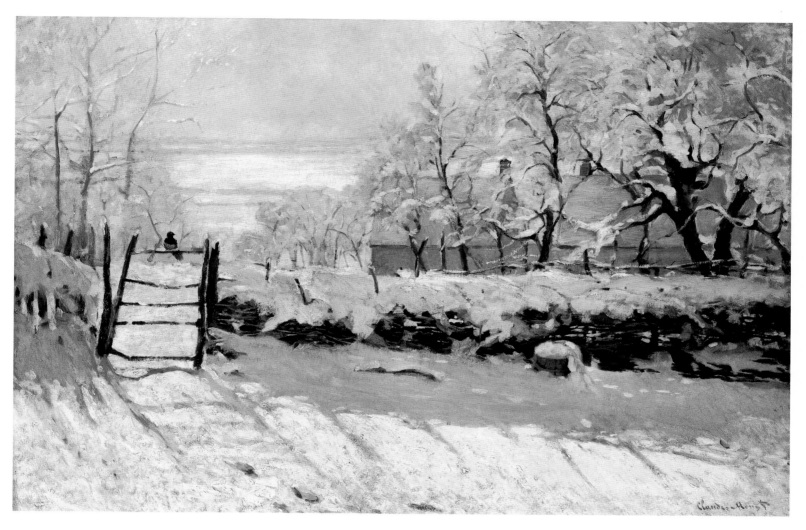

COLORPLATE 17. *The Magpie: Snow Effect.* 1869. 35⅛ × 51⅛″ (89 × 130 cm).
Private Collection. Photograph: Musées Nationaux, Paris.

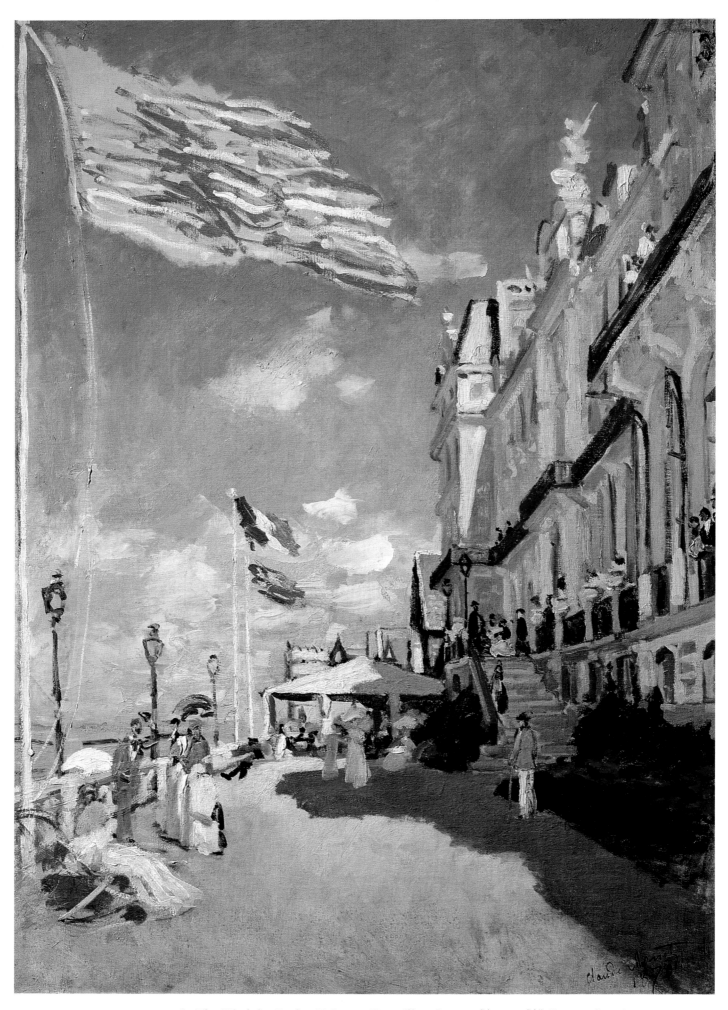

COLORPLATE 18. *The Hôtel des Roches Noires at Trouville.* 1870. 31⅞ × 22⅞″ (81 × 58 cm).
Private Collection, on loan to the Musée du Louvre, Paris. Photograph: Musées Nationaux, Paris.

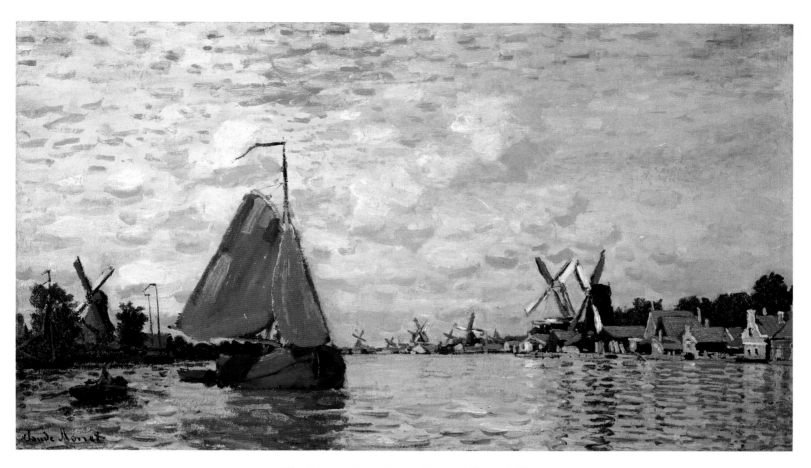

COLORPLATE 19. *The Zaan at Zaandam*. 1871. 16½ × 28¾″ (41.9 × 73 cm).
Private Collection. Photograph: Acquavella Galleries, New York.

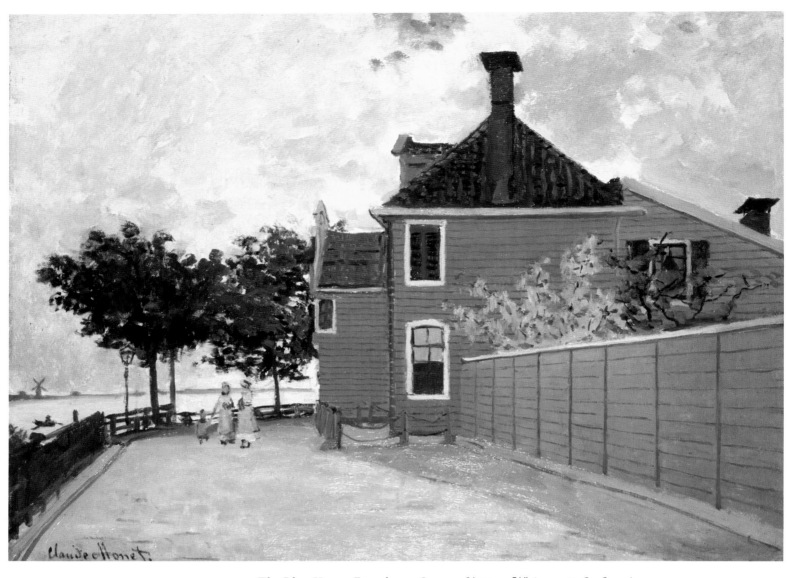

COLORPLATE 20. *The Blue House, Zaandam.* 1871. 17¾ × 23⅞″ (45.1 × 60.6 cm).
Private Collection, London.

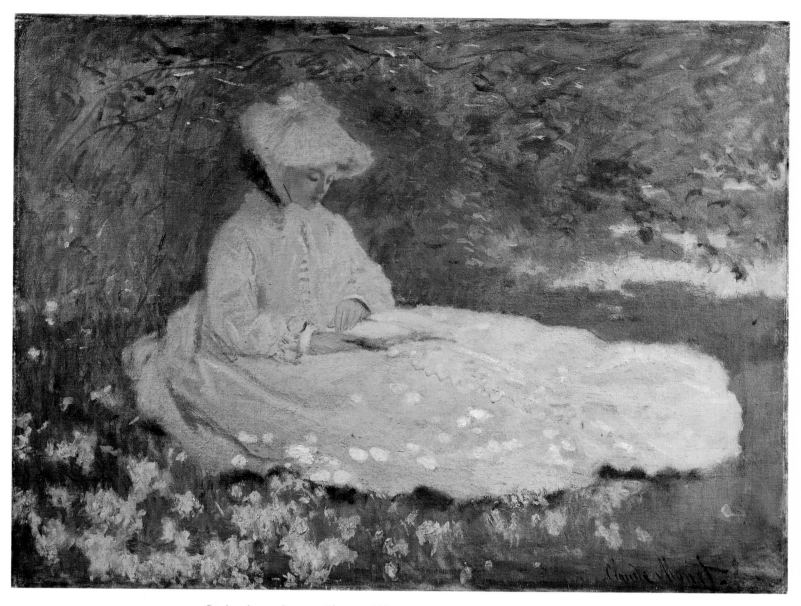

COLORPLATE 21. *Springtime.* 1872. 19⅝ × 25⅝″ (50 × 65 cm). The Walters Art Gallery, Baltimore.

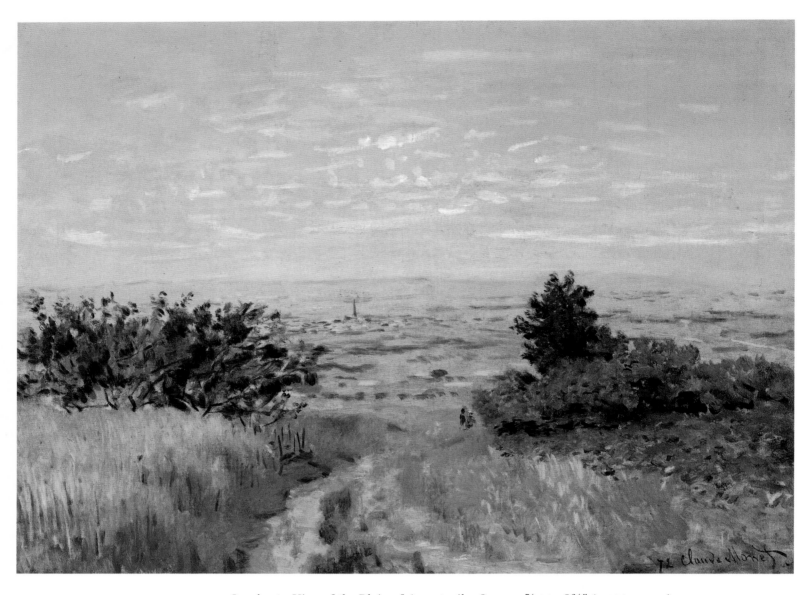

COLORPLATE 22. *Landscape View of the Plain of Argenteuil.* 1872. 20⅞ × 28⅜″ (53 × 72 cm).
Galerie du Jeu de Paume, Musée du Louvre, Paris. Photograph: Musées Nationaux, Paris.

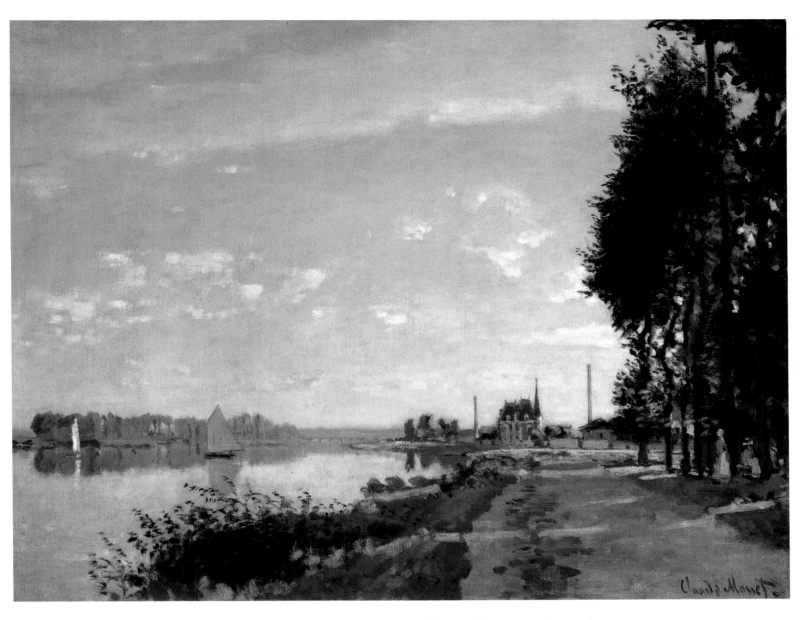

COLORPLATE 23. *Argenteuil*. 1872. 19⅞ × 25⅝″ (50.4 × 65.2 cm).
National Gallery of Art, Washington, D.C.; Ailsa Mellon Bruce Collection.

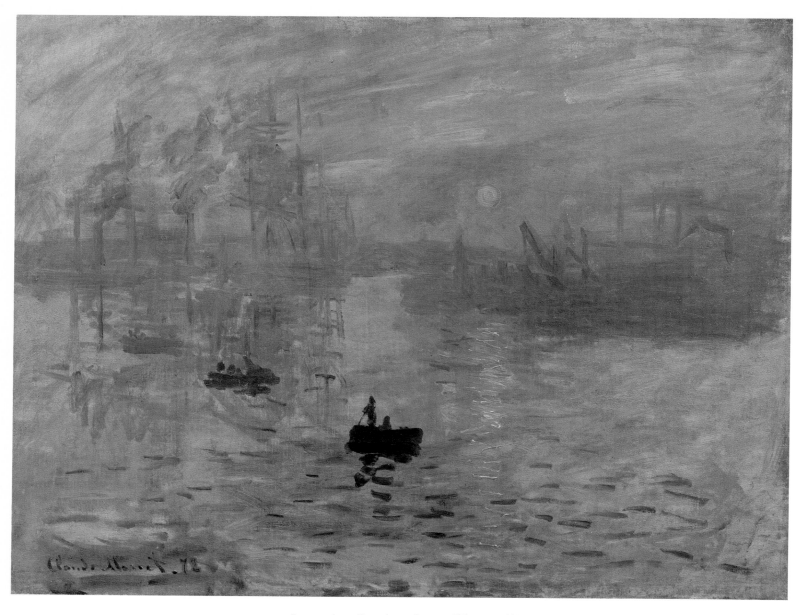

COLORPLATE 24. *Impression: Sunrise.* 1872. 18⅞ × 24¾″ (48 × 63 cm).
Musée Marmottan, Paris. Photograph: Georges Routhier, Studio Lourmel, Paris.

PHILIPPE BURTY

LA RÉPUBLIQUE FRANÇAISE

"News of the Day"

April 16, 1874

Today, Wednesday, at Nadar the photographer's former shop on the boulevard des Capucines, opens the show whose organization has been our subject for the last few days. Once again, this art exhibit is open during the day, from 10 to 6, and at night from 8 to 10.

The walls of the rooms, covered in brownish red woolen fabric, are extremely well suited to paintings. The daylight enters the rooms from the sides, as it does in apartments.

Philippe Burty (1830–1890), art historian and critic who defended Manet as early as 1864 and actively supported the etching revival that took place during that decade. He was among the first collectors of Japanese art in Paris.

Nadar: pseudonym for Félix Tournachon (1820–1910), a prolific journalist, caricaturist, and photographer who actively promoted balloon aviation. In 1860, he moved his shop to the fashionable boulevard des Capucines and remained at that location until 1872, after which he sublet the premises to different groups.

LOUIS LEROY

LE CHARIVARI

"The Impressionist Exhibition"

April 25, 1874

The poor man was peacefully raving in this fashion, and nothing led me to foresee the misfortune that was to ensue from his visit to this revolutionary exhibition. He even tolerated, without major damage, the sight of M. Claude Monet's *Fishing Boats Leaving Port*, perhaps because I tore him from this dangerous contemplation before the small, offensive figures in the foreground could affect him. Unfortunately, I was careless enough to leave him too long in front of the same painter's *Boulevard des Capucines.*

"Ha ha," he laughed diabolically, "this one's pretty good! . . . Here's an impression if I don't say so myself. . . . Only, tell me what these countless little black licking marks are at the bottom of the painting."

"Those? They're people strolling."

"Is that what I look like when I stroll down the boulevard des Capucines? . . . Hell and damnation! Are you trying to make a fool of me?"

"I assure you, Monsieur Vincent . . ."

"But these blotches were done the way they whitewash granite for a fountain: slip! slop! vlim! vlam! Any old how! It's unheard of, dreadful! It's going to give me a stroke!"

"Ah! This is it, this is it!" he cried in front of n. 98. "This one is Papa Vincent's favorite! What is this a painting of? Look in the catalogue."

"Impression, Sunrise."

"Impression—I knew it. I was just saying to myself, if I'm impressed, there must be an impression in there. . . . And what freedom, what ease in the brushwork! Wallpaper in its embryonic state is more labored than this seascape!"

Louis Leroy (1812–1885), a landscape painter who was better known for the lampoons that he published regularly in satirical newspapers. Often incorrectly credited with inventing the term "impressionist," he certainly helped to popularize it with this review, written as an imaginary dialogue with an old-fashioned painter who, having studied under classical landscape painter François-Édouard Bertin (1797–1871), is at first shocked by the works of Monet and his associates.

COLORPLATE 24

57

"But what would Michalon, Bidault, Boisselier, and Bertin have said about this impressive painting?"

"Don't even mention those repulsive old fossils!" shouted Papa Vincent. "When I get home, I'm going to rip off their fire screens!"

This unhappy man was renouncing his gods!

JULES CASTAGNARY

LE SIÈCLE

"The Exhibition on the Boulevard des Capucines"

April 29, 1874

M. Monet has some passionate touches that are marvelously effective. To tell the truth, I couldn't find the vantage point from which to view his *Boulevard des Capucines*; I believe that I would have had to cross the street and look at the painting from behind the windows of the house across the way. But the still lifes in his *Luncheon* are superbly and boldly painted, and his *Sunrise* in the mist echoes like the tones of the morning reveille.

The consensus that unites [these painters] and makes them a collective force in our disintegrated age, is their determination not to seek an exact rendition but to stop at a general appearance. Once that impression is captured and fixed, they declare that their part is played. The epithet of Japanese, which was applied to them at first, was meaningless. If we must characterize them with one explanatory word, we would have to coin a new term: *impressionists*. They are impressionists in that they render not the landscape but the sensation evoked by the landscape. The

Achille Etna Michalon (1796–1822), Jean-Joseph-Xavier Bidault (1758–1846), and Antoine-Félix Boisselier (1790–1857) were, like Bertin, advocates of the principles of Italianate, seventeenth-century landscape painting. Their varnished works were muted in color compared to Monet's, thus the reference to removing the screen to see the fire's full brilliance.

Jules Antoine Castagnary (1830–1888), a politician who began writing art criticism in 1857 to bolster his friend Courbet and who early recognized the promise of Manet and Monet.

COLORPLATE 16

COLORPLATE 24

For a revealing discussion of the term "impression" as it was used during the nineteenth century, see Richard Schiff, "The End of Impressionism: A Study in Theories of Artistic Expression," The Art Quarterly (Autumn, 1978).

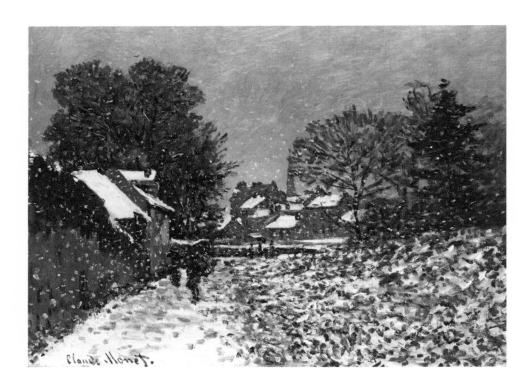

Snow at Argenteuil. Circa 1874. 22½ × 29" (54.9 × 73.7 cm). Museum of Fine Arts, Boston; Bequest of Anna Perkins Rogers, 1921.

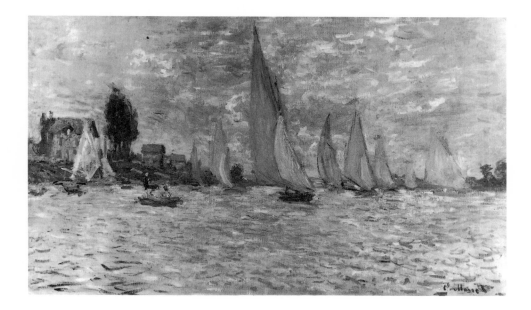

Boat Races at Argenteuil. 1874. 23⅝ ×
39⅜″ (60 × 100 cm). Galerie du Jeu de
Paume, Musée du Louvre, Paris.
Photograph: Musées Nationaux, Paris.

very word has entered their language: not *landscape* but *impression*, in the
title given in the catalog for M. Monet's *Sunrise*. From this point of view,
they have left reality behind for a realm of pure idealism.

COLORPLATE 24

Thus, the essential difference between them and their predecessors
is a question of more and of less in the finished work. The object to be
represented is the same, but the means by which it is translated is mod-
ified, debased, some would say.

Such is the endeavor, the whole endeavor, of the impressionists.

ERNEST CHESNEAU

PARIS-JOURNAL

"Around the Salon"

May 7, 1874

*Ernest Chesneau (1833–1890), who
served in the Ministry of Fine Arts until
the fall of the Second Empire in 1870,
was an advocate of English and Japanese
art. His novel* La Chimère *(1879)
describes the life of an impressionist artist.*

Well, in this exhibit, I find a dozen or so works that positively open un-
expected perspectives on the wealth of lifelike effects that can be ob-
tained with color.

For example, never before has the northern daylight in our homes
been rendered with the power of illusion displayed in M. Manet's [sic]
painting entitled the *Luncheon*. Never—the amazing animation of the
street, the teeming crowds on the sidewalks and the cars on the pave-
ment, the trembling trees of the boulevard in the dust and the light—
never has movement, elusive, fleeting, instantaneous, been captured and
fixed in its amazing fluidity as it has in this extraordinary, marvelous
sketch that M. Manet [sic] lists under the title *Boulevard des Capucines*. At
a distance, in this streaming life, in this shimmering of great shadows and
of great lights spangled with deeper shadows and more vivid lights, we
salute a masterpiece. As you approach, everything vanishes; there re-
mains only a chaos of indecipherable palette scrapings.

COLORPLATE 16

Obviously, this is not the last word in art, nor even of this particular
art. He must reach the point of turning a sketch into a finished work.
But what a clarion call for those with ears to hear, and how it echoes into
the future!

ALBERT WOLFF

LE FIGARO

"Paris Calendar"

April 3, 1876

Albert Wolff (1835–1891), influential critic who supported the quasi-photographic precision of paintings by Jean-Léon Gérome (1824–1904) and Jean-Louis Meissonier (1815–1891) and was outspokenly hostile towards the broadly treated style favored by the impressionists.

Sunday 2. —Rue le Peletier is having a streak of bad luck. First there was the fire at the opera, and now disaster has struck the area again. An exhibition, said to be of painting, has just opened at Durand-Ruel's. The innocent passerby, drawn by the flags that adorn the gallery's facade, enters, and a cruel sight greets his terror-stricken gaze. Five or six lunatics, including one woman—a group of wretches touched by the madness of ambition—have joined to show their work there.

Some people burst out laughing at the sight of these things, but they just leave me heartsick. These self-declared artists style themselves the intransigents, the impressionists; they take canvas, paint, and brushes, throw some color on at random, and sign the result.

I know a few of these distressing impressionists; they are charming and very earnest young people who truly believe that they have found their direction. This is as painful as the sight of the poor madman I beheld at Bicêtre: in his left hand he held a coal scoop against his chin like a violin, and, with a *baguette* that he believed to be a bow, he played, he said, the "*Carnival of Venice*," which he claimed to have played with some success before all the crowned heads. If one could place this virtuoso at the entrance to the exhibition, the artistic farce on rue le Peletier would be complete.

The old opera house, which burned down in October 1873, was located near Durand-Ruel's gallery on rue le Peletier, where the impressionists held their second group exhibition in 1876.

Bicêtre: a large lunatic asylum outside of Paris.

STÉPHANE MALLARMÉ

ART MONTHLY REVIEW AND PHOTOGRAPHIC PORTFOLIO

September 1876

Stéphane Mallarmé (1842–1898), not yet recognized as a leading symbolist poet in the 1870s, visited Manet's studio on a daily basis and became an intimate friend of Renoir, Monet, Morisot, and Degas.

One of his [Manet] habitual aphorisms then is that no one should paint a landscape and a figure by the same process, with the same knowledge, or in the same fashion; nor what is more, even two landscapes or two figures. Each work should be a new creation of the mind. The hand, it is true, will conserve some of its acquired secrets of manipulation, but the eye should forget all else it has seen, and learn anew from the lesson before it. It should abstract itself from memory, seeing only that which it looks upon, and that as for the first time; and the hand should become an impersonal abstraction guided only by the will, oblivious of all previous cunning. As for the artist himself, his personal feeling, his peculiar tastes, are for the time absorbed, ignored, or set aside for the enjoyment of his personal life. Such a result as this cannot be attained

all at once. To reach it the master must pass through many phases ere this self-isolation can be acquired, and this new evolution of art be learnt; and I, who have occupied myself a good deal in its study, can count but two who have gained it.

Here Mallarmé, speaking for Manet, seems to refer to Monet and Renoir.

* * *

Claude Monet loves water, and it is his especial gift to portray its mobility and transparency, be it sea or river, grey and monotonous, or coloured by the sky. I have never seen a boat poised more lightly on the water than in his pictures, or a veil more mobile and light than his moving atmosphere. It is in truth a marvel.

GEORGES RIVIÈRE
L'IMPRESSIONNISTE
April 6–28, 1877

Georges Rivière (1855–1943), a civil servant working at the Ministry of Finance, was one of Renoir's closest friends and the godfather of Cézanne's son. In 1877, he published four issues of L'impressionniste, *a newsletter promoting the third group exhibition. Later on, one of his daughters married Cézanne's son, and the other daughter married a son of Renoir's.*

"Ball": reference to Renoir's Bal du moulin de la Galette *(1876), now in the Louvre.*

M. Monet, whose works we are about to describe, seems to be the very antithesis of M. Renoir. The strength, the animation, in short, the life that the painter of the *Ball* infuses into people, M. Monet infuses into things; he has endowed them with a soul. In his paintings, water laps, locomotives move, wind fills sails; plots of land, houses, everything in this great artist's work has an intense and personal life that no one before had discovered or even suspected.

M. Monet not only depicts the imposing power and grandeur of nature, he also pictures it as being charming and pleasant, very much as a happy young man might see it. No gloomy thought ever grieves the spectator standing before the canvases of this powerful painter. After the pleasure of admiring them, our only regret is being unable to dwell forever in the luxuriant nature that blossoms in his pictures.

This year, M. Monet gives us several canvases depicting locomotives.

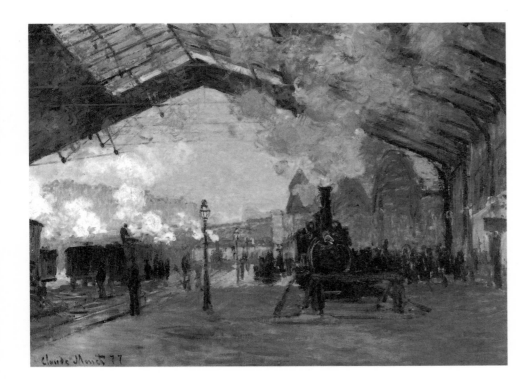

Gare Saint-Lazare: The Train for Normandy. 1877. 23½ × 31½" (59.7 × 80 cm). The Art Institute of Chicago; Mr. and Mrs. Martin A. Ryerson Collection.

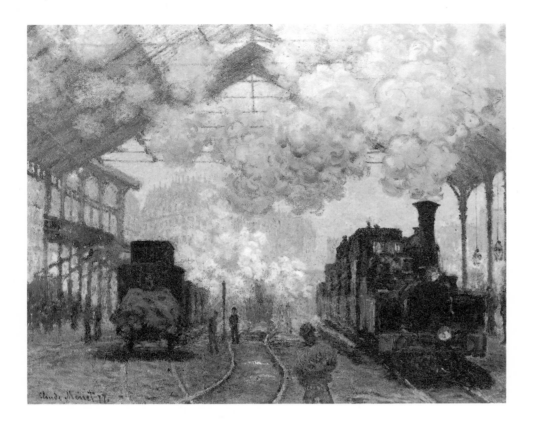

Some are standing alone, others are coupled to a string of cars in the
Gare Saint-Lazare. Despite the monotony and aridity of the subject, there
is astonishing variety in these pictures. Evident here, more than in any
other of Monet's paintings, is the science of composition, of arranging
on the canvas, which is one of the masterful qualities of M. Monet.

In one of the largest canvases, a train has just pulled in and the en-
gine is about to leave again. Like an impatient, spirited beast, stimulated
rather than tired by the long journey it has just finished, it shakes its
mane of smoke, which strikes against the glass roof of the great station.
Men swarm on the tracks around the monster, like pygmies at the foot
of a giant. On the other side, locomotives wait at rest. One can hear the
shouts of railroad employees, the strident warning whistle of locomo-
tives, the incessant clanking of iron and the overpowering gasps of steam.

One can see the enormous, maddening commotion of a station, its
floor trembling with every turn of the wheels. The platforms are moist
with soot, and the atmosphere reeks with the acrid odor of burning coal.

Looking at this magnificent picture, one is taken with the same emo-
tion that nature would arouse, but more strongly perhaps because the
artist's emotion is also apparent in the painting.

Near this picture is another of the same size showing, the arrival of
a train, in bright sunshine. It's an animated, joyful canvas; people hur-
riedly leave the cars; smoke belches out toward the back where it rises
higher; and the sun, shining through the glass panes, gilds the engines
and the gravel on the tracks. In several pictures, fast, powerful trains,
enveloped in light smoke rings, disappear down the platform. In others,
large, motionless locomotives, dispersed here and there, await depar-
ture. In all of them, these objects are animated by the same power that
only M. Monet can convey. Next to these engines running down endless
tracks, next to the smoke and the black dust, there are lighthearted
landscape paintings, full of calm and joy, such as the corner of a pond
lined with dahlias, the garden of a country house, or the banks of a pond
with deep blue water reflecting tall trees. The Tuileries Garden, with
Paris submerged in the golden dust of the setting sun, is quite re-
markable; a sketch of this same picture is particularly charming for its
modesty.

COLORPLATE 40

COLORPLATE 38

GEORGES RIVIÈRE

L'ART VIVANT

"Claude Monet in the Impressionist Exhibitions"

January 1927

To flee an unbearable tyranny, Monet suggested to his friends (victims like himself) to exhibit together outside of the official Salon and to abandon it once and for all. Bear in mind that at the time there was only one Salon, and individual exhibits were rare.

Renoir, Pissarro, Degas, Sisley, and Guillaumin welcomed Monet's proposition, but they didn't all accept it without restrictions. Renoir didn't want to forfeit his chances of ever again exhibiting in the Salon because he couldn't accept the idea of giving up any freedom. Degas reckoned that an exhibit that included only Monet and his friends was bound to be a failure and would be too limited in character. He therefore proposed to add a certain number of already-known artists, which would take away much of the exhibit's appeal as a protest.

Right away Monet proposed to prepare a new exhibit for the following year [after the 1874 group exhibition] to include only his friends: Renoir, Degas, Cézanne, Sisley, Pissarro, Berthe Morisot, and Guillaumin would appear. This project failed for lack of time and perhaps also because some of the future exhibitors were badly set back from the assault they had recently undergone.

*　　*　　*

Beginning in 1876, Monet's action was effectively backed by a few friends: first Renoir and then Caillebotte, who brought to the young group the financial assistance that it needed.

Thanks to Caillebotte's connections, the impressionists were able to exhibit in April of 1877 at 6, rue le Peletier, under exceptionally favorable conditions, a group of works that made this show the culminating point of Impressionism as a coherent group.

Claude Monet exhibited the most canvases—thirty. There were seven views of the Saint-Lazare train station included. They marked a stage in Monet's career and formed the first of the series on a same subject seen from different angles or at different hours of the day.

The great decorative panel *Turkeys* ("Unfinished Decoration," the catalog noted) had another sort of facture, broader, yet still retaining many subtleties.

The ensemble of these thirty paintings produced a feeling of joyous strength and great richness. The white turkeys had one panel of the room all to themselves.

I'll only quote, as a reminder, a small weekly tract, *L'impressionniste*, which I put out during the exhibit, the publishing costs of which were financed by Renoir and myself. It wasn't expensive, in any event, because each issue hardly cost us a hundred francs, even though it was always illustrated with an original drawing by one of the exhibiting artists. This small journal was sold on the streets by peddlers who yelled out its title. It provoked the wrath of literati who frequented Tortoni's and Café Riche. These gentlemen felt that some sort of provocation was directed at them by the calling out of *"L'impressionniste."*

COLORPLATE 40

COLORPLATE 39

Another proof of the success of the 1877 exhibit is that it excited the verve of Ludovic Halévy who composed from it, with the collaboration of Henri Meilhac, a comedy called *La Cigale* (The Grasshopper), which played at Variétés during the following winter. José Dupuis played the part of an impressionist painter whose paintings could be turned in any position without the spectator ever being able to recognize what they represented, but in which the artist would see at times a setting sun over the sea, at other times a mountainous landscape, or a wheat field. It wasn't really ill intentioned, and in the play satire was done in a light-hearted manner. Halévy was a friend of Degas and treated his colleagues accordingly.

In 1880 Monet exhibited on his own a series of canvases at [the office gallery of] *La Vie moderne,* an illustrated review founded by the publisher, Émile Charpentier, and directed by Émile Bergerat. The review's offices were installed temporarily in the boutique of a merchant of wines from Champagne, located on the boulevard des Italiens at the beginning of the passage des Princes—tiny and badly lit, but in an excellent location.

Ludovic Halévy (1834–1908), a schoolmate of Degas who went on to be a successful dramatist and librettist, collaborating with Meilhac on many of Jacques Offenbach's popular 1860s operettas.

* * *

Monet, however, seemed to rise above all contingencies. He put on his best clothes, ruffled the lace at his wrists, and twirling his gold-headed cane went off to the offices of the Western Railway, where he sent in his card to the director. The usher, overawed, immediately showed him in. The director asked Monet to be seated. His visitor introduced himself modestly as "the painter, Claude Monet." The head of the company knew nothing about painting, but did not quite dare to admit it. Monet allowed his host to flounder about for a moment, then deigned to announce the purpose of his visit. "I have decided to paint your station. For some time I've been hesitating between your station and the Gare du Nord, but I think that yours has more character." He was given permission to do what he wanted. The trains were all halted; the platforms were cleared; the engines were crammed with coal so as to give out all the smoke Monet desired. Monet established himself in the station as a tyrant and painted amid respectful awe. He finally departed with a half-dozen or so pictures, while the entire personnel, the director of the company at their head, bowed him out. Renoir concluded: "I wouldn't have dared to paint even in front of the corner grocer!"

COLORPLATE 40

JEAN RENOIR

Renoir, My Father

1958

One fine day he said to Renoir triumphantly:

"I've got it! The Gare Saint-Lazare! I'll show it just as the trains are starting, with smoke from the engines so thick you can hardly see a thing. It's a fascinating sight, a regular dream world."

He did not, of course, intend to paint it from memory. He would

paint it *in situ* so as to capture the play of sunlight on the steam rising from the locomotives.

"I'll get them to delay the train for Rouen half an hour. The light will be better then."

"You're mad," said Renoir.

THÉODORE DURET

LES PEINTRES IMPRESSIONNISTES 1878

Théodore Duret (1838–1927), art critic and collector, who, after meeting Manet in Madrid in 1865, became his leading advocate and the first historian of impressionism.

The impressionists did not create themselves. They did not grow like mushrooms. They are the product of the steady evolution of the modern French school. "Natura non fecit saltum," not more so in painting than in anything else. The impressionists are the descendants of the naturalist painters. Their forefathers are Corot, Courbet, and Manet. The art of painting is indebted to these three masters for introducing simple techniques and spontaneous methods of painting which have withstood the test of time. They are responsible for providing us with light paintings, free, once and for all, of lead monoxide, bitumens, chocolates, chigoe juice, siennas, and gratin. It is to them that we owe the study of broad daylight; the sensation, not only of color, but of the slightest nuances of color and tone, as well as the investigations of the rapport between the state of the atmosphere, which lights up the painting, and the general tonality of the objects depicted. The impressionists received all this from their predecessors and were also influenced by Japanese art.

If you walk along the banks of the Seine—at Asnières, for example—in a single glance you will be able to see the red roof and brilliantly white fence of a cottage, the pale green of a poplar, the yellow road, and the blue river. In the summer, at noon, all the colors will seem raw, intense, impossible to tone down, or enveloped by an encompassing semitint. Well! These may seem strange, but nothing could be more realistic. It required the presence of Japanese prints for one of us to dare to sit by the edge of a river and juxtapose a bright red roof, a white fence, a green poplar, a yellow road and blue water on a canvas. Before Japan, this was impossible. The painter always lied. The straightforward colors of nature would blind him. All we ever saw on a canvas was attenuated colors drowning in a predominant halftint. Only after having seen the Japanese pictures, on which the most contrasting and intense colors are set side by side, did we finally understand that there were new techniques worth using for the reproduction of certain aspects of nature that had been neglected or considered impossible to render until this day. These Japanese pictures, which so many people initially chose to think of as gaudy, are actually strikingly faithful reproductions of nature. Let us ask those who have visited Japan. For my part, at every instant I would discover the exact sensation of a Japanese countryside, reproduced on a fan or in an album. I look at a Japanese album and I say: "Yes, this is exactly how Japan appeared to me. It is exactly thus, beneath a luminous and transparent atmosphere that the blue and multicolored sea appeared. Here are the roads and the fields surrounded by the lovely cedars, whose branches have such strangely angular shapes. Here is Mount Fuji, the highest volcano, and the masses of light bamboo which cover the hillsides. And finally, here are the teeming and picturesque inhabitants of the cities and countrysides." Japanese art rendered par-

Although a few artists, such as Félix Bracquemond, had admired the Japanese woodblock prints used to pack china imported to France in the 1850s, the rage for oriental prints, objets, *and fabrics in Paris coincided with the opening of La Porte Chinoise in 1862, a boutique specializing in such merchandise.*

ticular aspects of nature with bold new techniques of coloration. It could not help but impress artists with open minds, and it strongly influenced the impressionists.

The impressionists adopted the techniques used by their immediate predecessors of the French school: their earnest manner of painting in broad daylight, their spontaneity, and their vigorous application of paints. They understand the bold new Japanese techniques of coloration. They have gone on to develop their own originality and to revel in their own sensations.

The impressionist sits on the bank of a river. The water takes on every possible hue according to the state of the sky, the perspective, the time of day, and the calmness or agitation of the air. Without hesitation, he paints water which contains every hue. The sky is overcast and it is rainy: he paints water that is glaucous, thick, and opaque. The sky is clear and the sun is bright: he paints the reflections seen in the agitated water. The sun sets and hurls its rays at the water: to depict these effects, the impressionist covers his canvas with yellows and reds. And so the public begins to laugh.

Winter is here. The impressionist paints snow. He sees that, in the sunlight, the shadows on the snow are blue. Without hesitation, he paints blue shadows. So the public laughs, roars with laughter.

Certain parts of the countryside are covered with clay that produces a purple tint. The impressionist paints purple landscapes. So the public begins to get indignant.

In summer sunlight reflected by green foliage, skin and clothing take on a violet hue. The impressionist paints people in violet forests. So the public loses all control. Critics shake their fists and call the painter a vulgar scoundrel.

The unhappy impressionist can protest that his sincerity is absolute. He can declare that he reproduces only what he sees and that he remains faithful to nature. But the public and the critics condemn him. They have no way of knowing whether the things they see on the canvas correspond to those actually seen by the painter in nature. For them, only one fact pertains: the things that the impressionists put on their canvases do not correspond to those found on the canvases of previous painters. It is different, and so it is bad.

Claude Monet

Monet (Claude-Oscar), born in Paris, the fourteenth of November 1840. Has exhibited at the Salons of 1865, 1866, and 1868. Has been rejected at the Salons of 1867, 1869, and 1870. Has exhibited at the three impressionist exhibitions on the boulevard des Capucines in 1874, at the gallery of M. Durand-Ruel in 1876, rue le Peletier in 1877.

If the word "impressionism" has been found to be a good one and definitely accepted as designating a group of painters, it certainly is the particularities of Claude Monet's paintings that first suggested it. Monet is a true impressionist.

Claude Monet has successfully depicted the evasive impressions that the painters who preceded him had neglected or considered impossible to render with a paintbrush. He has seized the thousands of nuances that are taken on by the waters of rivers and seas, the light playing on the clouds, the vibrant coloration of flowers, and the mottled reflections of the foliage caused by the rays of an ardent sun, in all their veracity. In painting a countryside and including not only that which is motionless and permanent but also the evasive aspects it takes on with the changes in the atmosphere, Monet imparts the scene with a singularly lively and startling sensation. His paintings communicate impressions very realistically. One can say that his snows make us cold and his light-filled paintings are warm and surround us with sunlight.

Claude Monet had first attracted attention with his paintings of fig-

ures. His *Woman in the Green Dress*, which now belongs to M. Arsène Houssaye, had been the cause of great excitement at the Salon of 1865, and we had been pleased to predict that the artist's career would resemble the one of M. Carlos-Duran. Since then, Monet has abandoned the figure, which plays only a secondary role in his paintings. He has become almost exclusively devoted to the study of broad daylight and to the painting of landscapes.

Monet is hardly attracted to rustic scenes. You will not find any of these in his paintings of untamed fields. You will discover no cows or sheep, and even fewer peasants. The artist is drawn toward ornate depiction of nature and urban scenes. He prefers to paint flowering gardens, parks, and groves.

Nevertheless, water takes pride of place in his work. Monet is the painter of water *par excellence*. In older landscape paintings, water looks motionless and monotonous with its "water" color, like a simple mirror to reflect objects. In Monet's paintings, water no longer has its own unvaried color. It takes on an infinite variety of appearances according to the condition of the atmosphere, the type of bed over which it flows, or the silt that it carries along. It can be clear, opaque, calm, agitated, fast-flowing, or sleepy, depending on the temporary conditions observed by the artist as he sets his easel before its liquid surface.

COLORPLATE 8

Arsène Houssaye (1815–1896), influential novelist, playwright, editor, and theatrical producer, who was one of Monet's very first patrons. He purchased this work in 1866 after its success at that year's Salon.

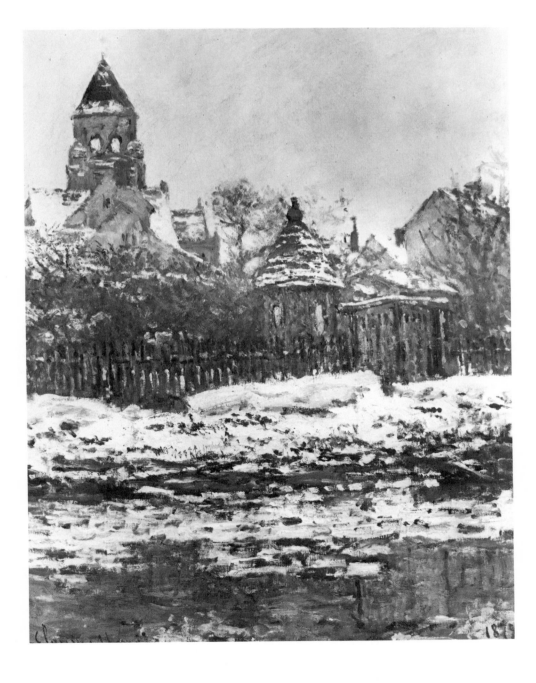

The Church at Vétheuil (Winter). 1879. 25⅝ × 19⅝" (65 × 50 cm). Galerie du Jeu de Paume, Musée du Louvre, Paris. Photograph: Musées Nationaux, Paris.

JEAN-PIERRE HOSCHEDÉ

CLAUDE MONET CE MAL CONNU

1960

*Jean-Pierre Hoschedé (1877–1961),
Monet's youngest stepson.*

It was in 1876 that I saw Monet for the first time. I was only eleven years old, but I remember well his arrival at Montgeron at my parents' house. He had been described to me as a tall artist with long hair. That impressed me, and I quickly grew fond of him, for one could feel that he liked children. He was a great tease.

He thus arrived at Montgeron, where he stayed for some time to paint. It was there that he painted, among other works: *The Hunt, The Yerre House, Turkeys*, and the portrait of my younger sister Germaine (with her doll), who was then only three years old. In the fall, when we were back in Paris, we often saw each other with the Edouard Manet family. Once there was a dinner at my parents' house with a horrible face theme, where Monet showed up with Renoir, both having covered their faces with fake welts. Renoir had painted a cat face on Mme Gustave Charpentier, which was a great success. At this dinner there were many artists with whom my father loved to surround himself. He personally had a very impressive art collection.

COLORPLATE 39

I had always admired a small painting showing a woman seated in the grass, I pointing to, as I later found out, Mme Monet. The dress was dotted with sunlight, a fact which particularly struck me. I saw that painting again at an exhibit at Petit's place in, I believe, 1889. I do not know where it is at present. In 1878 and 1879, we were good friends with the Monets, who then had two children, and we often met with them at the Parc Monceau where Monet painted that canvas. We would also see each other in his workshop. Around July of 1878, our families each decided to rent a place in Vétheuil for the summer, where we stayed for three years. It was here that Monet painted many of his now well-known masterpieces. Yet he was not terribly well-off, and neither were we, for my father's business was doing poorly. It was also in September of 1879 that Mme Monet died.

COLORPLATE 21

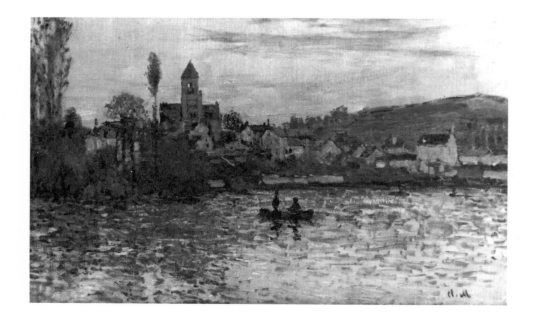

The Seine at Vétheuil. 1879. 16⅞ × 27½″ (43 × 70 cm). Galerie du Jeu de Paume, Musée du Louvre, Paris. Photograph: Musées Nationaux, Paris.

LE GAULOIS

"Impressions of an Impressionist"

January 24, 1880

In a few days, admirers of the "new school" of painting will receive, by mail or otherwise, a letter that reads as follows:

The impressionist school has the honor of informing you of the grievous loss it has suffered in the person of M. Claude MONET, one of its revered masters.

The funeral for M. Claude MONET will take place on May 1 next, at ten o'clock in the morning—the day after the opening at the church of the Palais de l'Industrie—in M. Cabanel's gallery.

You are requested not to attend.

De Profundis!

On behalf of M. Degas, head of the school; M. Raffaelli, successor to the deceased; Miss Cassatt, M. Caillebotte, M. Pissarro, M. Louis Forain, M. Bracquemond, M. Rouard, etc. . . . , his ex-friends, ex-students, and ex-supporters.

This mock funeral announcement anticipated Monet's withdrawal from the impressionist circle to show for the first time since 1868 at the Salon, held by that time at the Palais de l'Industrie.

Indeed, in a few days, M. Claude Monet, impressionist *par excellence*, will desert the friendly camp to throw himself, body, soul, and brushes,

Into the bosom maternal
Of Monsieur Cabanel . . .

Yes, tremble, children of the new school. . . . Your friend is abandoning you; he is deserting, he is surrendering his impressionist brush to the amiable new rule of the no less amiable M. Lafenestre, *approved by* Turquet.

There was a similar desertion two years ago. M. Renoir abandoned the impressionist camp in order to submit his paintings to the academic spectacles of the members of the Salon jury.

But at the time the new Turquet-Lafenestre rule had not yet emerged from the double and powerful brain of those eminent administrators; M. Renoir could almost be excused.

The loss that the new school suffers with the loss of Claude Monet will be, if not actually detrimental, certainly perceptible, for Claude Monet is an artist with real talent, and his work has received considerable notice in recent years.

Forty years old, black hair falling in curls over his forehead, a bushy beard, a lively eye; always dressed in a navy blue jacket and chestnut-

Alexandre Cabanel (1824–1889), celebrated history painter whose powerful influence as a jury member thwarted Monet and his colleagues' attempts to show at the Salons during the 1860s.

Henri Turquet (1836–1914), an undersecretary in the Ministry of Fine Arts, and Georges Lafenestre (1837–1919), a poet and art historian serving in the same Ministry, who initiated an unpopular reform for the Salon of 1880. This exempted many artists from the necessity of jury approval and called for the installation of works according to whether artists were or were not (as was Monet's case) exempt, rather than arranging the works alphabetically according to the artists' last names, as had previously been done.

colored felt hat worn jauntily on the back of his head, and with a pipe in his mouth—this is Claude Monet, who divides his time between his art and his family: a charming wife and two pretty babies of seven and eight years old. Monet lives far from the bustle of Paris, in Vétheuil, in a little white cottage where he receives his friends and admirers. One of these is Hoschedé! Hoschedé—well known to anyone who holds a brush—was once wealthy. He ruined himself—the dear man—buying, for very high prices, impressionist paintings by every discount-studio dauber who came to show him his work. Today, Hoschedé, now a Platonic art lover, is making up for his bad luck by spending his life at Monet's studio. The artist clothes him, houses him, feeds him, in short, puts him up and . . . puts up with him.

Ernest Hoschedé (1837–1891), department store magnate and art speculator, whose bold support for Monet and his friends came to a sudden halt when he went bankrupt in 1877. He arranged for his wife and six children to stay with Monet's family in Vétheuil in 1878. After the death of Monet's wife in 1879, Mme Hoschedé took charge of raising both families, and she married the painter in 1892.

THÉODORE DURET

LE PEINTRE CLAUDE MONET

1880

After Corot, Claude Monet is the artist who has made the most inventive and original contribution to landscape painting. Were we to classify painters according to the degree of novelty and the unexpected contained in their works, Monet's name would indubitably be included among the masters. However, because the public at large always feels a certain instinctive revulsion when it comes to any new and original work, the very personality that should have sufficed to make him popular has actually been the reason why both the public and the majority of critics have so far kept him at arm's length. We maintain, however, that in the future Claude Monet will be ranked alongside Rousseau, Corot, and Courbet among landscape painters, and the following remarks are advanced in justification of that opinion.

If we consider modern landscape painters as a whole, we see that they have shared a common desire to penetrate nature and set up the closest of relationships with it. Since the renewed interest in landscape painting during the Restoration, their joint efforts have led to procedural advances that have resulted in fixing the exterior world upon the canvas with an ever-greater degree of truth.

Let us briefly examine the change that has gradually occurred in the way our landscape artists paint. First, Théodore Rousseau.

Face to face with nature, in field or forest, Rousseau assembles all kinds of data: with his drawing, he sets down the shapes of the trees, the structure and shape of the terrain; with quick sketches he records precisely the type of foliage or undergrowth; using watercolor or pastel, he notes the play of light in the clouds, the tints of the earth, sky, and water. Back in the studio he then composes and paints a picture with the assistance of the data amassed.

After him, Corot and Courbet began to employ a different procedure. In order to lessen the distance separating preliminary studies and their work in the studio, they sketched in oil on the canvas out of doors, in the presence of nature. And those preliminary studies, brought to conclusion in the studio, would become pictures or serve as the bases for enlarged and more developed canvases.

Thus Corot and Courbet partially bridged the distance separating the study made on the spot from the painting of the picture itself: they began to turn two successive operations into one simultaneous act. Claude Monet, who follows them, has succeeded in accomplishing what they began. In his case there are no longer masses of preliminary sketches, no more pencil or watercolor drawings to be used in the studio, but, rather, one integral oil painting begun and completed out of doors in nature, in the presence of the subject, which is interpreted and rendered at first hand. And it is for this reason that he has become the leader of what has quite rightly been dubbed the "outdoor school" of painting.

While landscape painters were getting used to painting as one process, in the presence of nature, another revolution was being carried out: dark painting grew lighter. Were we to be transported back to a Salon of thirty years ago we would be greatly amazed at the change that has taken place in the overall color tone. In those days painters used to spread a veritable sauce onto the surface of the canvas, preparing their ground coats with bitumin, litharge, and chocolate brown, then gingerly add a touch of color, soon to be vitiated or overwhelmed by the overall darkness of the underpainting. They seem to have lived in caves, blinded by the light of day and brilliant color. It is to a few highly gifted men—Delacroix in particular—that we owe the beginnings of a return to the kind of bright and vividly colored painting upon which the eye can truly feast. In the mural paintings in Saint-Sulpice we can see the degree of brightness Delacroix finally achieved toward the end of his life. Among the living, no one has done more than Edouard Manet to create a taste for brighter painting; although many people made fun of them, clever painters took advantage of his use of a whole palette of vibrant tones and made it their own to varying degrees.

The appearance on the scene of Japanese prints and watercolors completed the change by introducing us to a totally new system of coloration. Without the techniques revealed by the Japanese, a whole methodology would have been closed to us. There must be something psychological about it: the special acuity of the Japanese eye, exercised in admirable light and in an atmosphere of an extraordinary limpidity and transparency, has discerned in nature a gamut of clear tonalities that the European eye has never captured—and that, left to itself, it would probably never have discovered. In his observation of nature the European landscape-painter seemed to have forgotten the real color of things; he had barely managed to distinguish light and shade, most frequently the latter. Thus, under the brushes of a vast number of painters the outdoor world was overlaid with a dark opaqueness, with eternal shadows. But the Japanese did not regard nature as a place of mourning, as veiled; on the contrary, to them it was vivid and full of light. Their eyes captured the coloration of objects, and they knew how to harmonize and juxtapose, on silk or paper, the most divergent and varied tonalities they perceived in the natural world around them.

Among our landscape painters Claude Monet was the first to have the boldness to go as far as the Japanese in the use of color. It was this pursuit that aroused the loudest scoffing, because the lazy European eye—notwithstanding its utter truth and great delicacy—still finds the breadth of colors employed by the Japanese artists somewhat gaudy.

Let us now watch Claude Monet as he takes up his brush. To do so we must accompany him into the fields and face being burnt by the blazing sun, or we must stand with him knee-deep in snow—for despite the season he leaves his studio and works outdoors, under the open sky. He sets a white canvas on his easel and suddenly begins to cover it with patches of color that correspond to the areas of color he discerns in the natural world before him. The first attempt often ends with nothing but

a rough sketch. Upon returning to the same spot the next day he adds to the first sketch; details begin to stand out, objects begin to take shape. He follows this procedure for as long as it takes to produce a picture that satisfies him.

While using this method of painting in direct contact with the observed scene, Claude Monet was quite naturally led to take into account effects overlooked by his predecessors. The fleeting impressions once garnered by the landscape artist sketching out of doors and then lost and forgotten in the process of transforming the sketch into a picture in the studio can now be seized by the artist working in nature; he can rapidly capture the most ephemeral, the most delicate effect at the very moment it appears before him. Thus Monet has succeeded in rendering all the play of light and the tiniest reflections of the ambient air. He has reproduced the ardent colors of sunset and the varied tonalities with which the dawn light infuses the mist rising from the water or lying above the countryside. He has rendered all the harshness of midday light falling upon objects and eradicating their shadows. He has known to cast his eye across the whole gamut of gray tonalities of clouds, rain, or fog. In brief, his brush has caught those myriad fleeting impressions communicated to the spectator's eye by changes in the sky, in the weather. It was to describe him that the term *impressionist* was first, quite aptly, created.

Claude Monet was born in Paris in November 1840. Thus, he is not yet forty. At his age, Corot was still unknown and ignored by opinion makers and critics.

Monet has devoted the larger part of his career to painting the area around Paris. He has lived, successively, in Argenteuil and Vétheuil, where the Seine provided him with the capricious, changeable waterscape of which he is especially fond. He has also made frequent trips to the Channel coast and has painted in England and Holland. He has already produced a considerable body of work, extremely varied in both choice of site and type of subject. It includes every kind of landscape, seascapes, snow effects, urban scenes, still lifes, pictures that depict garden flowers in all their vivacity of colors and variegated effects, and the elegant foliage of the woods and the huge trees of the forest of Fontainebleau. No artist has been less monotonous, for, working in nature and in intimate contact with it, he can seize upon all its changing aspects and thereby perpetually renew himself.

Monet has great facility with his brush; his touch is broad and swift; the labor and effort involved in the making of his works are not apparent, given the facture. Each time he has turned to a new subject he has managed to invent, quite naturally, an appropriate method for treating it.

So talented an artist needed only the requisite willpower in order to succeed in producing any kind of painting required to suit the public's taste. And, in fact, at the outset of his career at the 1865 Salon, he exhibited *Woman in the Green Dress*, today in the possession of M. Arsène Houssaye, which was a sensational success. However, he was not the man to go on repeating the kind of work that had won him a first success—paintings of elegantly dressed women—committing himself to a career in which many other painters have found favor and fortune. He turned his back on that facile genre and devoted himself wholly to landscape painting, to which he felt himself irresistibly drawn. He is one of those artists who follows a straight course, uncaring of the judgment of the Philistines, certain that one day his accumulated works will, quite naturally, come into their own.

COLORPLATE 8

COLORPLATE 25. *Houses at Argenteuil.* 1873. 21¼ × 28¾″ (54 × 73 cm).
Nationalgalerie, Staatliche Museen Preussischer Kulturbesitz, West Berlin.
Photograph: Bildarchiv Preussischer Kulturbesitz, West Berlin.

COLORPLATE 26. *Yacht Races at Argenteuil.* 1872. 18⅞ × 29½″ (48 × 75 cm).
Galerie du Jeu de Paume, Musée du Louvre, Paris. Photograph: Musées Nationaux, Paris.

COLORPLATE 27. *The Red Hood—Madame Monet.* 1873. 39½ × 31½″ (100.3 × 80 cm).
The Cleveland Museum of Art; Bequest of Leonard C. Hanna, Jr.

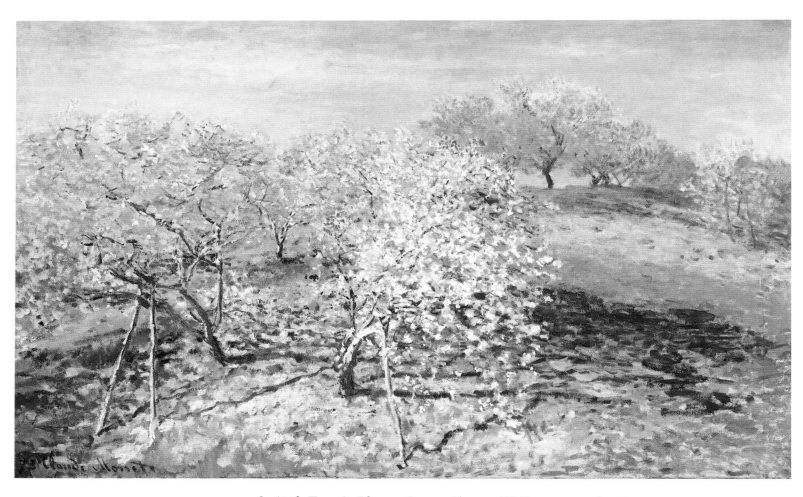

COLORPLATE 28. *Apple Trees in Bloom.* 1873. 24½ × 39⅝″ (62.2 × 100.6 cm).
The Metropolitan Museum of Art, New York; Bequest of Mary Livingston Willard, 1926.

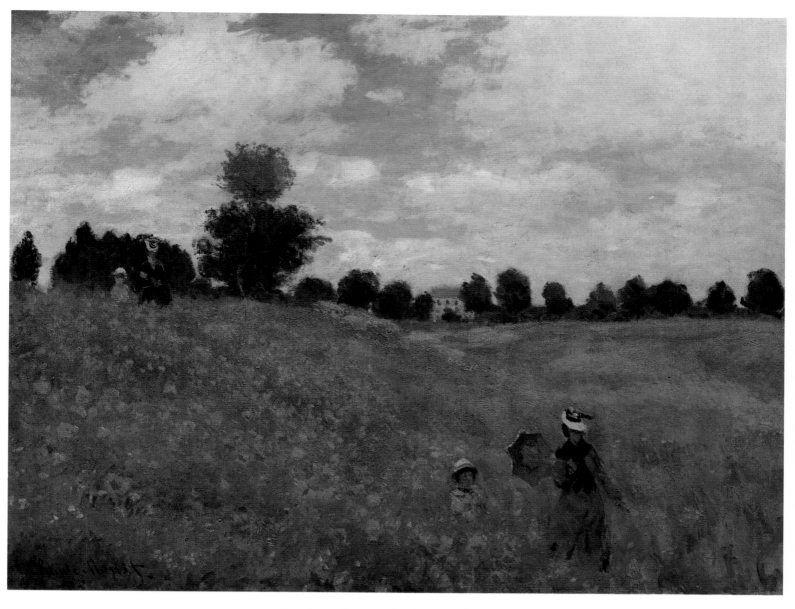

COLORPLATE 29. *Poppies at Argenteuil.* 1873. 19⅝ × 25⅝″ (50 × 65 cm).
Galerie du Jeu de Paume, Musée du Louvre, Paris. Photograph: Musées Nationaux, Paris.

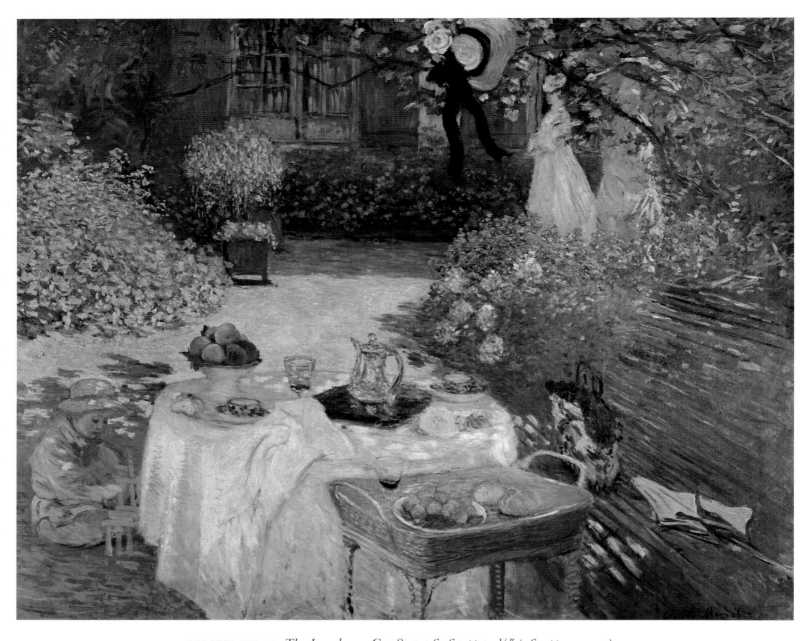

COLORPLATE 30. *The Luncheon.* C. 1872–76. 63 × 79⅛″ (160 × 201 cm).
Galerie du Jeu de Paume, Musée du Louvre, Paris. Photograph: Musées Nationaux, Paris.

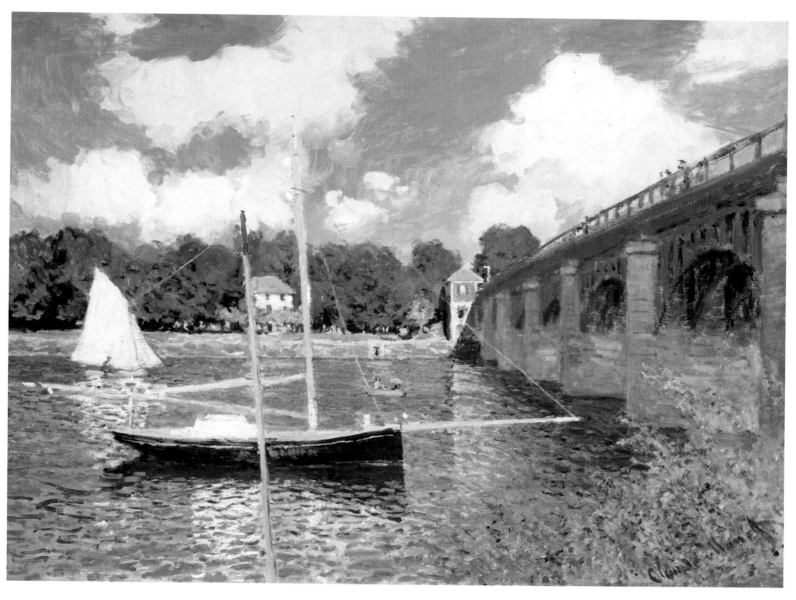

COLORPLATE 31. *The Bridge at Argenteuil.* 1874. 23⅝ × 31⅜″ (60 × 79.7 cm).
National Gallery of Art, Washington, D.C.; Collection of Mr. and Mrs. Paul Mellon.

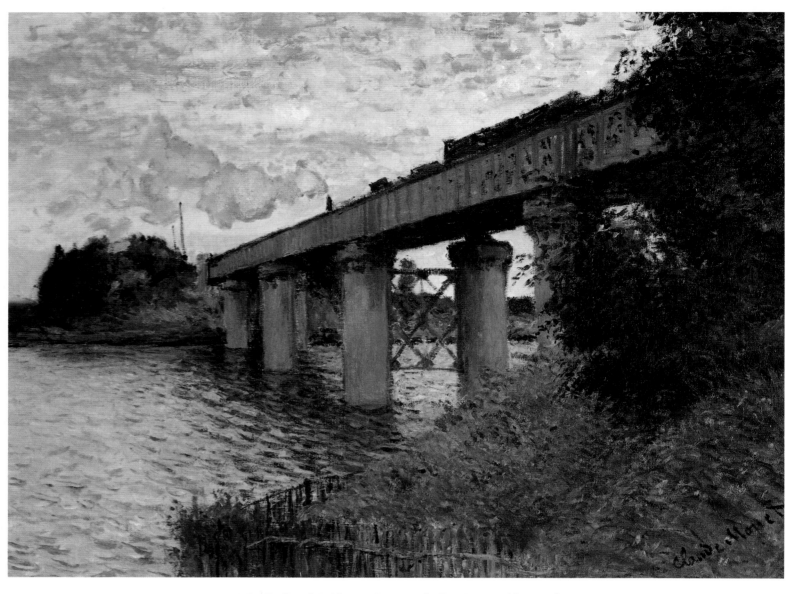

COLORPLATE 32. *The Railroad Bridge at Argenteuil.* C. 1873. 21¼ × 28″ (54 × 71 cm).
Galerie du Jeu de Paume, Musée du Louvre, Paris. Photograph: Musées Nationaux, Paris.

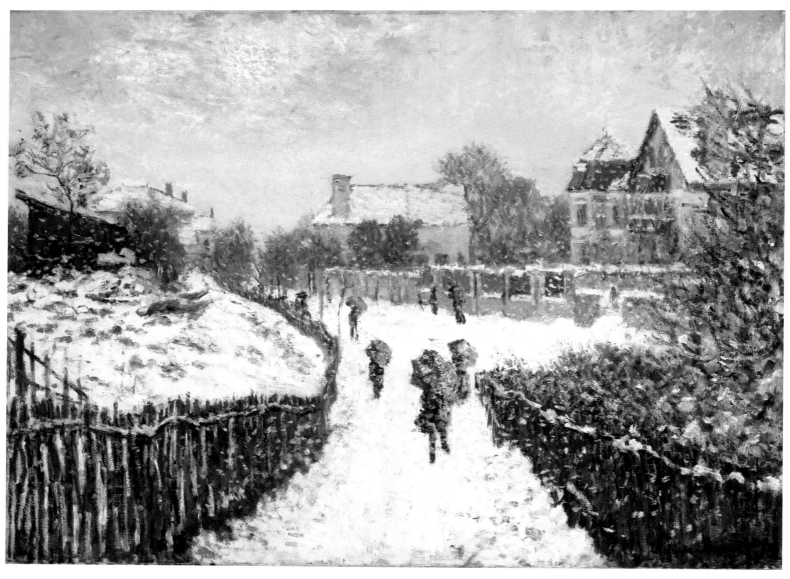

COLORPLATE 33. *Boulevard Saint-Denis, Argenteuil, in Winter*. 1875. 24 × 32⅛″ (61 × 81.6 cm).
Museum of Fine Arts, Boston; Gift of Richard Saltonstall, 1978.

COLORPLATE 34. *Apartment Interior.* 1875. 31½ × 23⅝″ (80 × 60 cm).
Galerie du Jeu de Paume, Musée du Louvre, Paris. Photograph: Musées Nationaux, Paris.

COLORPLATE 35. *Women among the Dahlias*. 1875. 21¼ × 26″ (54 × 66 cm). National Gallery, Prague.

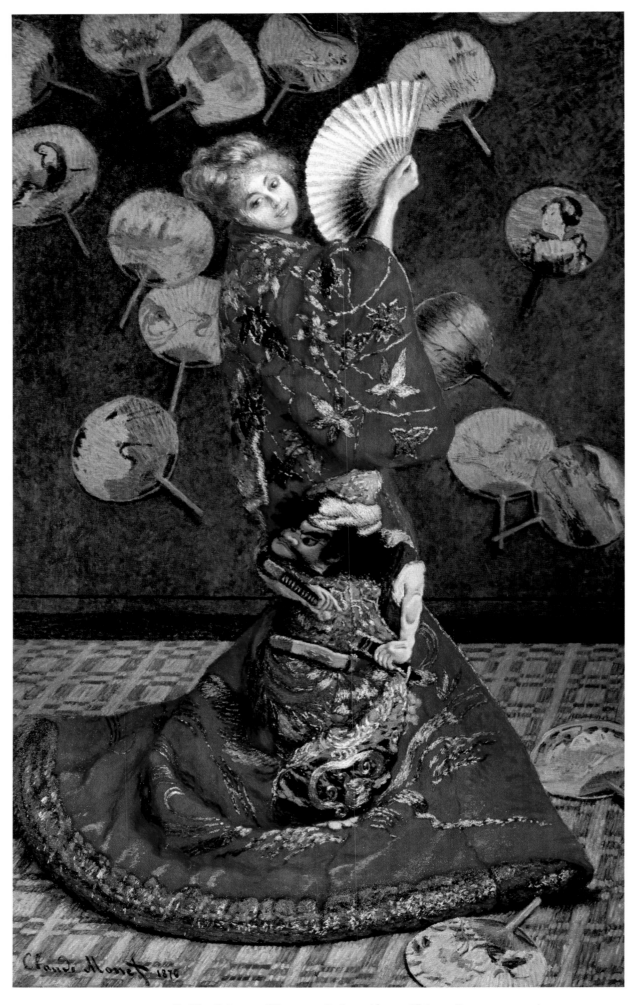

COLORPLATE 36. *The Japanese Woman.* 1876. 91⅛ × 56″ (231.6 × 142.3 cm).
Museum of Fine Arts, Boston; 1951 Purchase Fund.

COLORPLATE 37. *The Studio-Boat.* 1876. 31½ × 39⅜″ (80 × 100 cm).
Private Collection. Photograph: Galerie Schmit, Paris.

COLORPLATE 38. *The Tuileries* (Study). 1875. 19⅝ × 29½″ (50 × 75 cm).
Galerie du Jeu de Paume, Musée du Louvre, Paris. Photograph: Musées Nationaux, Paris.

COLORPLATE 39. *Turkeys.* 1877. 68½ × 68⅛″ (174 × 173 cm).
Galerie du Jeu de Paume, Musée du Louvre, Paris. Photograph: Musées Nationaux, Paris.

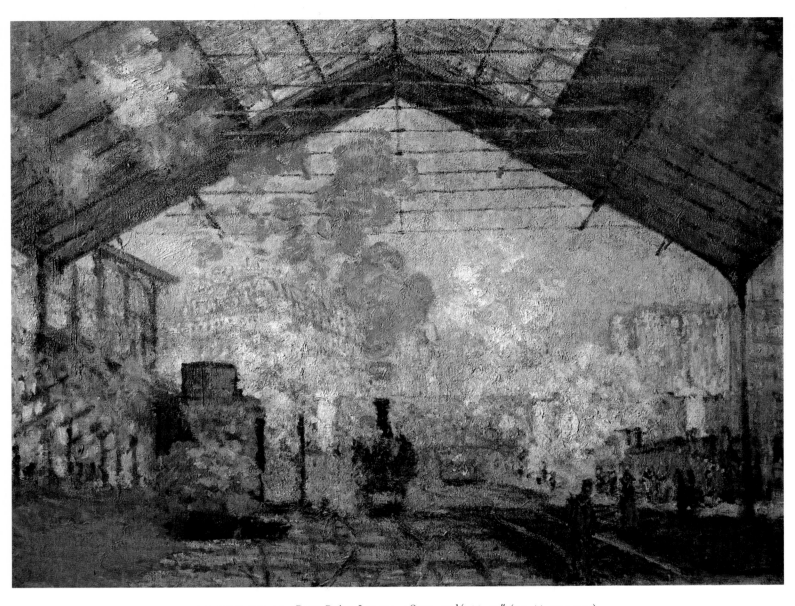

COLORPLATE 40. *Gare Saint-Lazare.* 1877. 29½ × 41″ (75 × 104 cm).
Galerie du Jeu de Paume, Musée du Louvre, Paris. Photograph: Musées Nationaux, Paris.

ÉMILE TABOUREUX
LA VIE MODERNE
"Claude Monet"
June 12, 1880

Claude Monet is a man whom one would judge at first to be about thirty-five years old. He lives in Vétheuil, a little market town about six miles [nine kilometers] from Mantes-la-Jolie. Few Parisians know about Vétheuil, which is perhaps why it is one of the most charming spots I've ever seen. I too was unaware of Vétheuil before this last trip, which I was inspired to take by the thoroughly understandable desire to see at first hand one of those savage beasts of art known as impressionists. You know where I met Monet? On what he rather loftily calls his "port." Note that this "port" of his consists entirely of a few heavy planks hammered roughly together, encircled by a primitive railing, next to which three or four boats are rocked by the waves of the Seine. Two of them belong to Monet: the one he goes out in to work up an appetite before dinner, and the one he works in. I won't describe them in detail, dear reader, because there is nothing that really distinguishes the boats that belong to M. Monet from those boats that do not belong to him. As I say, he was there on his port, where long before the boatman paddling me had pointed him out from the middle of the Seine. At that moment, Monet was standing in the glare of a light that did little to conceal the more than rustic simplicity of his clothes. A couple of children were chatting with him, and a pair of dogs began barking frantically at the sight of me. I jumped nimbly from the boat to Port Monet, and introduced myself. And here I think I ought to give the man his due: he didn't exactly throw his arms around my neck. Monet is wary in the extreme; no doubt he's been fooled on more than one occasion. But, as I was in high spirits that

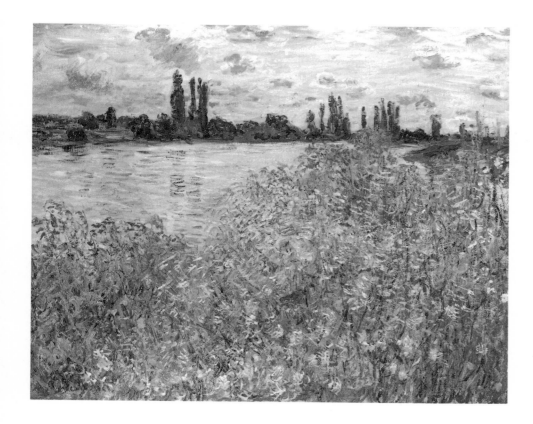

Flowers on the Banks of the Seine near Vétheuil. 1880. 26 × 32″ (66 × 81.3 cm). The Metropolitan Museum of Art, New York; Bequest of Julia W. Emmons, 1956.

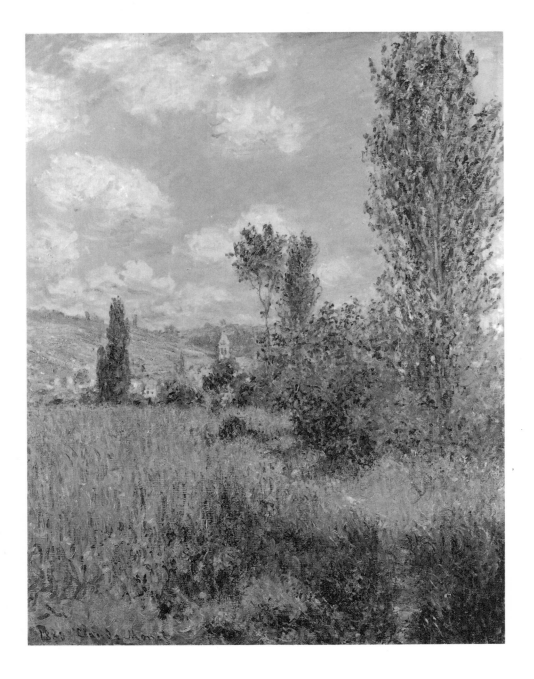

Path in the Île Saint-Martin, Vétheuil. 1880.
31½ × 23¾" (80 × 60.3 cm). The
Metropolitan Museum of Art, New York;
Bequest of Julia W. Emmons, 1956.

day, I managed to get him to understand that I had nothing whatso-
ever in common with the Beauveau Strangler. And in his efforts to be-
lieve *that* (I say this in all good faith), he displayed no small measure
of condescension.

"Now then," I said without further ado, "perhaps you would be so
kind as to show me to your studio?" At the sound of *that* word, sparks
flew from Monet's eyes.

"My studio! But I never have *had* one, and personally I don't under-
stand why anybody would want to shut themselves up in some room.
Maybe for drawing, sure; but not for painting."

And with a gesture as expansive as the horizon, encompassing the
entire Seine, now flecked with the golds of the dying sun; the hills,
bathed in cool shadows; and the whole of Vétheuil itself, which seemed
to be dozing in the April sunlight that sires white lilacs, pink lilacs, pri-
maveras, and buttercups:

"That's *my* studio!"

What could I say to that?

"But surely," I said, afraid of touching on a sore point, "you must
have a place to live in besides *this*?" And I pointed to the boat that had
attracted my attention.

"Good Lord, yes!" he replied. "I live just over there."

It was a charming house, completely modern, where you and I, my dear editor-in-chief, could live the comfortable, middle-class life we deserve.

"And I suppose," he added in a tone that was hardly the most engaging, "I could manage to show you around—that is, if you want to."

I entered his lair without crossing myself, not wanting to make a display of my superstitions.

To tell the truth, I was expecting to find wild, savage things. Alas! I found myself in an interior furnished with only the most elementary, primitive objects: a bed, a chest of drawers, a wall cupboard, a table that was not exactly loaded down with books (I think I spotted, so help me God, a directory of addresses), and, hanging on the walls there (the totally vulgar wallpaper left me cold), were paintings by Monet!

I began by declaring to my unprepared host that I had no special or technical knowledge of painting. Perhaps that explains why we talked about it so much. And in the course of our conversation, in which I managed to introduce, with an effrontery that even as I write makes me blush, everything I knew about pictorial logomachy, I committed so many blunders that Monet, no doubt his mind resolved on the subject of my competence, proposed an outing in the boat.

I say *boat* because, in the eminently impressionistic society in which I found myself, I would never have dared to hazard the word *dinghy*, which is not "natural."

Ah, it was above all on the water that I learned how to get to know Monet!

Appearing all the while to be ecstatic over a dull little island we were skirting (you know, with willows, cane apples, and nettles where grass snakes unfailingly pullulate), I examined my painter.

Here was a big, strapping fellow, hale and hearty, with a matching trim of beard, a nose like any other nose, and eyes as limpid as spring water.

Monet is a true freshwater sailor.

He might easily have been one on saltwater too, because a large part of his childhood was spent at Le Havre. It was there that he did his first two paintings, if I'm not mistaken, which won awards at the Salon of 1865 to the most enthusiastic critical acclaim. What's more, Monet owes his first laurels to the genre of seascape—or rather, to *his* seascapes. Since then, he's simply managed to put a little less salt in his water.

What most interested me, among the hundreds of idle remarks we exchanged, was to know how Monet had become an impressionist. I risked asking him this question.

"I didn't *become* one," he answered with superb serenity. "As long as I can remember I've always been one."

"But still, didn't you belong to a school?"

"Sure. I was a student of Gleyre for three months . . . to please my family."

Well, well! There's still *some* goodness left among the impressionists.
"And then?"

"Then I met Manet, Courbet, and several others."

"Courbet's a wonderful painter, isn't he?"

"Good Lord, yes!"

"And how did you get to know Manet?"

"I never did get to know him. We met."

"But to talk about more serious matters, when you impressionists brought on that split between you and the jury who were imposed on you, did you have any particular reasons?"

"Yes, quite a few. At first the judges really did want to accept some of my canvases, some of the ones there'd been a lot of hoopla over. You want me to tell you about my 'green lady'?"

"No, no, thanks all the same. I read a few articles about it, and as soon

"Green lady" refers to Camille *(Colorplate 8).*

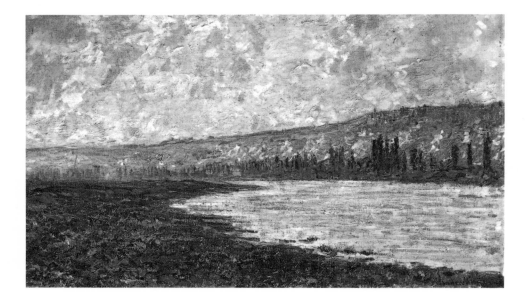

as I saw how they were running you down, I said to myself, 'Here's a guy who must have a lot of talent'."

Monet, who is intensely modest, didn't even bother to acknowledge such base flattery with a nod. He didn't get angry either—which doesn't mean I wasn't telling the truth.

"Please go on," I asked.

"For a long time my friends and I had been systematically rejected by those very same judges. What could we do? It's not enough to paint: you have to sell them, you have to live. The dealers wouldn't have anything to do with us. And yet we *had* to exhibit. But where? Rent a space? As deep as we dug we could hardly raise enough between us to rent a box seat at the theater in Cluny. Nadar, the magnificent Nadar, who is as good as good bread, *lent* us the space. So we, whom poor Duranty had labeled *The Batignolles School*, we made our debut in the artistic firmament as independent stars. For my own part, I was about as successful as I could have wanted, which is to say I was energetically booed by all the critics of the time. But I consoled myself on Manet's breast, who had just sent his seconds over to a journalist who had gone so far as to find one of his paintings 'admirable.' "

I interrupted: "Nowadays you seem to be keeping to yourself. I no longer see your name on the roster of 'impressionist' events."

"You're wrong. I still am and always will be an impressionist. I am the one after all who invented the word, or at least, with a picture that I exhibited, gave some reporter from *Figaro* the chance to fan that flame. He was rather successful, as you can see. I tell you, I'm an impressionist. But, except on rare occasions, I hardly see my colleagues anymore—male or female. Our little temple has become a dull schoolroom whose doors are open to any dauber. And the public, which started laughing before a grotesque painting, even if the exhibition has the nerve to call itself 'impressionist,' doesn't stop splitting its sides until it is back out on the street. Hey, will you look at that sunset!"

I should tell you that we were at Lavacourt, a little town opposite Vétheuil. The light was soft and serene, and the last, broad rays of the sun were spreading over the village, spangling the silk of the Seine with its lights and fending off the shadows that were lightly blurring the treetops and enveloping the foliage with a darkening green.

With Monet, one is never bored; but we had to get back.

Together we returned to his house. The trellis fence overlooking the Seine opened, and we entered a small garden with nothing but wildflowers . . . impressionistic ones, of course! At the entrance, an apple tree, no doubt trained to it, bends its branches down over the main path (the

only one), so that one has to stoop down to get in. As good a way as any of paying one's respects, whatever else may be said. Monet led me back into the same room I'd seen before, and there, as I told him of my desire to write an account of the visit for Bergerat, and at the same time to do a study of him as a painter (a pretention all the more outrageous for my not knowing a thing about painting), he placed in my hands a stack of journals and said:

"You'll find all the documentation you want here."

I took the documents back to my hotel and went to bed after writing this article; and tomorrow morning I'll return these highly interesting papers Monet lent me, without having read a single word.

And generally that is the way we treat our friends, isn't it, Monet?

PHILIPPE BURTY

LA RÉPUBLIQUE FRANÇAISE

"The Salon of 1880"

June 19, 1880

In order to be accepted, Claude Monet thought that it was enough to have his art exhibited. This is a big mistake. But that is hardly bothersome. He is a man beyond compromise who wants to make peace with the jury. The jury hung his painting six yards high in the uppermost row, whereas on the rue des Pyramides, he would have enjoyed eye-level placement and could have been studied at ease. All the qualities of freshness in his *Lavacourt* disappear when seen this way next to canvases painted with shoe polish. M. Claude Monet is now exhibiting about twenty compositions on the ground floor of *La Vie moderne*. Some of these, like the *Débâcle* and *Paris Decked with Flags* are indisputably powerful pieces. This is where one has to judge this master of a dissident school.

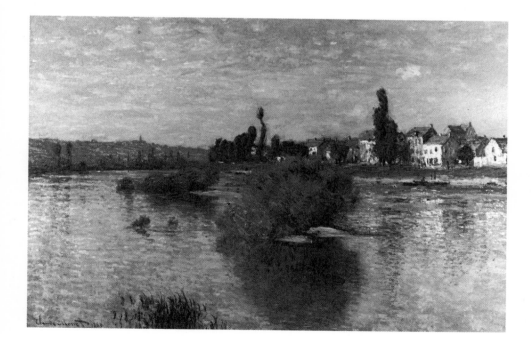

The Seine at Lavacourt. 1880. 38¾ × 58¾" (98.4 × 149.2 cm). Dallas Museum of Fine Arts; Munger Fund.

J.K. HUYSMANS

L'ART MODERNE CERTAINS

"The Exhibition of the Independents of 1881"

1883

Joris-Karl Huysmans (1848–1907), decadent realist novelist with ultra-Catholic beliefs.

With M. Pissarro and M. Sisley, Monet is the landscape painter for whom the term *impressionist* was coined.

M. Monet has been spattering for some time, dropping little improvisations, botching bits of landscapes, bitter salads of orange peels, green onions, and hairdresser-blue ribbons that simulated the flowing waters of a river. One thing was certain: this artist's vision was high-strung; but it is equally true that he displayed a carelessness, an all-too-obvious lack of training. Despite the talent that some of his sketches showed, I admit that, more and more, I lost interest in his sloppy and hasty painting.

Impressionism, as practiced by M. Monet, led straight into an impasse; it was realism's perpetually half-hatched egg, the real work approached and always abandoned halfway through. M. Monet is without a doubt the man who has most contributed to the public's conviction that the word *Impressionism* described only a style of painting that never advanced beyond a confused rudiment, a vague rough sketch.

Fortunately, this artist has undergone a reversal, as if he had decided no longer to daub piles of canvases haphazardly. It seems to me that he has collected himself, and he has done well, for this time he has offered us some very beautiful and very finished landscapes.

His ice floes under a russet sky are intensely melancholy, and his sea studies, with the waves breaking against the cliffs, are the most realistic seascapes I've ever seen. And besides these paintings, there are land-

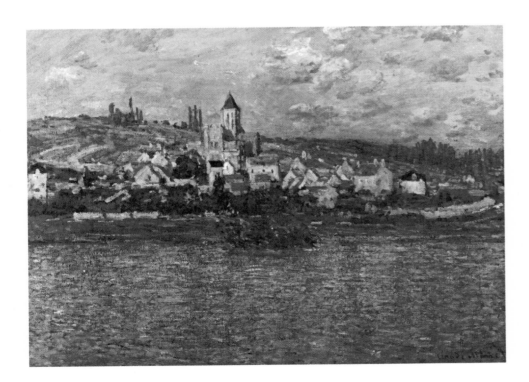

Vétheuil. 1878. 23⅝ × 32⅛" (60 × 81.6 cm). National Gallery of Victoria, Melbourne; Felton Bequest 1937.

scapes, views of Vétheuil, and a poppy field flaming under a pale sky of a wonderful color. The painter whose brush shaped these works is unquestionably a great landscape artist, whose eye, now healed, captures all the phenomena of light with startling fidelity. How real the spray of his waves whipped by a ray of light; how his rivers flow, speckled by the teeming colors of the things they reflect; how the light, cold gusts rise from the water in his paintings, into the leaves and through the blades of the grass! M. Monet is the greatest of seascape painters! His works, like those of M. Pissarro, have come into their own. How far we have come now from his former paintings, in which the element of water seemed made of glass threaded through with streaks of vermilion and Prussian blue; how far also from his fake Japanese woman, exhibited in 1876, in her Mardi Gras costume, surrounded by screens, and whose robe was so hammered in red that it looked like brickwork in cinnabar.

It is with joy that I can now praise M. Monet, for it is mainly due to his works and those of his fellow impressionist landscape painters that the art of painting has been redeemed.

COLORPLATE 36

GUSTAVE GEFFROY

LA JUSTICE

"Claude Monet"

March 15, 1883

Gustave Geffroy (1855–1926), a reporter for Clemenceau's La Justice *who became close friends with Monet after they met by chance on Belle-Île in 1886. He eventually became the painter's official biographer.*

The works of M. Claude Monet have replaced those of M. Eugène Boudin in the exhibition rooms on the boulevard de la Madeleine. Fifty-six paintings, countrysides and still lifes, are on view there.

For a long time it was fashionable to laugh at this painting. We

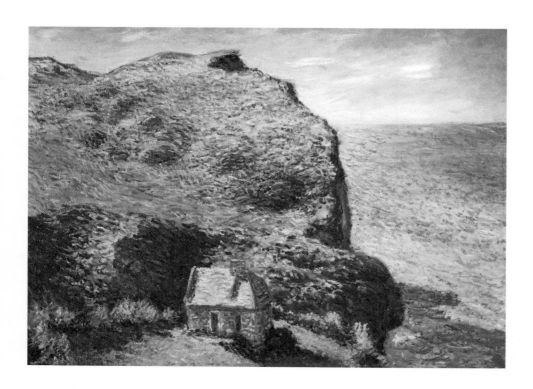

The Customs Officers' Cabin at Varengéville. 1882. 32 × 23¾" (81.3 × 60.3 cm). Philadelphia Museum of Art; William L. Elkins Collection.

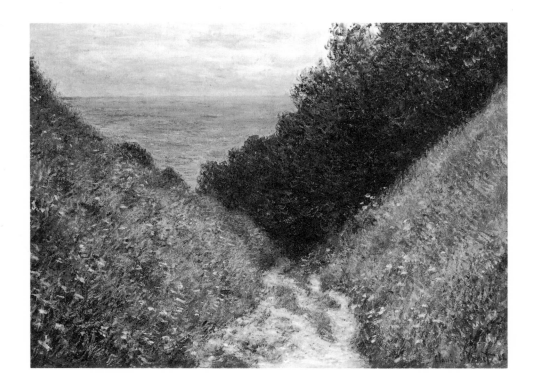

Road in the Hollow, Pourville. 1882. 23¾ × 32⅛″ (60.4 × 81.5 cm). Museum of Fine Arts, Boston; Bequest of Mrs. Susan Mason Loring.

laughed at them until the day when successful prize-winning Salon painters, the students of the Beaux-Arts school themselves, took it into their heads to adopt the simple and accurate methods of the impressionists. As the taste for bright painting spread, those who had initiated the movement saw their works attracting greater attention and more serious discussion. Study has replaced the jests. Original artists like Jongkind, Degas, Claude Monet, Edouard Manet, and Eugène Boudin are, as of now, on their way to claiming their rightful places in the history of the art of our nineteenth century.

In France, Claude Monet has certainly been one of the landscape painters able to analyze the state of the atmosphere and the quality of light with the greatest sagacity. One only needs to pass by the paintings that he is exhibiting, to be convinced of this. For the most part, these depict seashores and riversides. Here the sky and water are gray, the fog in suspension. There the sun plays across the humid air and brings everything fully to light; and the gradations of light, the transparency or opacity of the atmosphere, and the density of the air around objects are always expressed with infinite delicacy.

In general, the drawing is a summary. The painter sees the entirety of things. I suppose that he sketches only a few lines on the bare canvas; several very simple planes, a line for the horizon, and the painting is constructed. It is then that the painter exhausts himself to render the nuances of the color, all the accidents of the light. With the juxtaposition of pure colors, he succeeds in expressing planes and a sense of relief, distance, and movement. He successfully analyzes the constantly changing and moving color of the flowing water, which crashes and foams at the foot of boulders and cliffs. He shows how the color is determined by the state of the watery depths, the condition of the sky, and the reflections of objects. He studies the land, the sunken dunes, and the sides of cliffs like a geologist. With the tip of his brush, he illuminates all the stones, all the minerals, and all the veins within the rocks. He considers all external influences. He paints the grass that has been dried by the wind and drenched by the rain. He skillfully reproduces the wet rocks, uncovered by the low tide, upon which the sea has left clumps of sticky weeds.

One will recognize the quality of M. Claude Monet's drawings in

Sunken Path in Pourville, for example—a painting composed of three straight lines, two leafy, grassy slopes whose bases intersect with the sea in the background—or in *Station of the Customs Officers*, where the huge cliff is foreshortened and the sea is seen from above; these are effects that have never before been attempted. Everywhere one will admire the color blended with light in the countrysides of Normandy, prairies with dense grasses; in the summits of cliffs dried by the wind and burnt by the sun; in the dainty countrysides along the banks of the Seine, the elegant bridges spanning the water, the brightly colored boats as they wend their way between the abundant, graceful greenery of the shores. The artist is enamored, and he causes us to become enamored, with the sadness of the fog, the icy dawns, the roads congested with muddy snow. In the *Fog Effect at the Seashore*, the *Morning*, the *Trawlermen*, the painted reality has nightmarish aspects.

There is also the *Train*, the *Pont de l'Europe*, made from nothing, but lacking nothing, marvelous indications that give the sensation of a train that jerks or snakes along, with its huge metallic machinery and smoke that spreads into the air. He tries to convey the impression of the crowd on the *Boulevard des Capucines*. This *Boulevard* has been used by critics for a long time as an example of M. Monet's painting. Fortunately, one eventually understands that to portray a crowd is not the same thing as painting a man's portrait. The precise work it takes to reproduce the features of a model and the individual characteristics of a countenance is not applicable here, where there are houses massed together, carriages crossing in front of one another, and circulating pedestrians. Here, one does not have the time to distinguish one man or one carriage, and the painter who lingers over these details will not be able to grasp the confusion of movements and the multiplicity of specks which constitute this ensemble. M. Claude Monet did not make this kind of error. His painting is as lively and restless as the Parisian scene that inspires it.

M. Claude Monet's fault lies in the fact that sometimes he puts his faith in a technique rather than in the attentive and sincere study which has produced his most beautiful paintings. At times, the light, refined to an excessive degree and penetrated by colors, ends up changing the nature of objects, which become transparent as though illuminated from within by an intense light that rivals the daylight. Some apples—very beautiful, to be sure, round and hard, nicely filling a basket—play this role, as if they were lanterns. Some cliffs sparkle like a bunch of precious gems, while others seem to be liquid.

I spoke about the *Apples* by M. Claude Monet. As a matter of fact, there are several still lifes adjacent to the beautiful landscapes previously discussed. M. Claude Monet, this wonderful master of landscapes, is also a master decorator who—and this is rare—has respect for reality. There are gladioli, pears, grapes, chrysanthemums, sunflowers, and an incomparable cake. The sunflowers are ablaze; the gladioli, with their straight green stems, blossom with the languid nuances of aquatic plants; the grapes are ripe, golden, and moist with syrup; and the freshly baked cake, golden and crisp, reminds us of the immortal brioche by Chardin.

J.B.S. Chardin's still life, La Brioche, *entered the collection of the Louvre in 1869.*

PHILIPPE BURTY

LA RÉPUBLIQUE FRANÇAISE

"The Landscapes of Claude Monet"

March 27, 1883

In the same exhibition rooms on the boulevard de la Madeleine, where M. Boudin recently exhibited an important series of his latest works, M. Claude Monet is in turn exhibiting about sixty landscapes. They stem from a more agitated aesthetic sense. In execution, they are completely modern.

Amongst the impressionists, no other is gifted with such spontaneity and such lively impressions, and no other is able to express them with as much breadth and charm.

The number of M. Claude Monet's clients will increase without bounds. Critics of his work are becoming less and less caustic. The day following the opening night, where the elite among critics as well as collectors were assembled, he said to us, "No one laughed in front of any of my paintings." But how much bitterness was contained in this ingenuous outburst! Every base insult was endured by these artists at their debut, at the private exhibitions that they tried to set up here and there at their own expense, and at the shops of the dealers with enough temerity to welcome them. But nothing discouraged them. On the contrary, the struggle against all these social forces attracted the attention of the artists enrolled at official schools and forced them to modify their palettes. Refined collectors took up their cause, so much so that an academic review *par excellence*, the *Gazette des Beaux-Arts*, gave them recognition. While bracing themselves, they developed their natural talents.

Notably, M. Claude Monet has made indisputable progress. He is no longer enslaved by the necessity of hasty production, provoked by the day-to-day need to sell paintings, by the absence of any official purchase at the Salons, and by the systematic exclusion from awards and from acquisitions by the Luxembourg Museum, where foreigners go to form an opinion of our schools. By selling at higher prices, he can now work longer on a painting, revealing more precise intentions, and he can even rest on days when reverie or fatigue overtake him. He is entering into a new phase. We ascertain this with a pleasure increased by the fact that we have had complete confidence in him from the beginning. We knew what obstacles he had to fight, and our only worry was that, as in the year before when he tried to show at the Salon, he would make too many concessions, thus sacrificing the honor of his cause.

Claude Monet is a Parisian, brought to Le Havre as a very young child. His father was in the business of selling supplies to outward-bound ships. As soon as he was strong enough, he had to help his father. But commerce, with its physical fatigue and offer of only limited horizons, inspired only repugnance in this sensual and independent spirit. At the age of fifteen, hardly out of school, to have a bit of money that he could spend as he pleased, Monet drew caricatures with huge heads (like those made fashionable by Daumier's *Representatives Represented*) of the regulars at the harbor cafes, the brokers and captains of the coastal trade. He would supply himself with vellum, pencils, and penknives at Boudin's stationery store. The owner, whose kindness and reserve we outlined recently, even framed these caricatures, appreciating their allure while finding the drawing technique somewhat insufficient.

A reference to Burty's February 3, 1883 article in La République française, *devoted to Boudin's one-man exhibition at the Galerie Durand-Ruel, which had opened on January 31.*

Honoré Daumier (1808–1879) published Représentants Représentés, *a series of political caricatures in lithograph, beginning in 1848.*

The Pianist. Circa 1858. Black pencil. 12⅝ × 9⁷/₁₆″ (32 × 34 cm). Musée Marmottan, Paris. Photograph: Georges Routhier, Studio Lourmel, Paris.

One day, when M. Boudin was going to the country to paint, Monet accompanied him. He had never seen a canvas being covered—a spectacle that can fascinate anyone with a vivid imagination. To watch as a dab of paint becomes the shore, another the sea, with the sky descending to the edge of the horizon and the clouds rolling and pursuing one another, as tints accentuate one another; as planes take on definition, as trees brighten and sailboats appear like stars on the distant waters: this is to witness a curious and amusing operation. It achieves its grandeur when the light has defined the forms, when color has translated the infinite effects of hues drowned in a unity of relationships, and when a penetrating poetry betrays the state of the artist's soul in a reflection on nature.

Claude Monet was deeply moved by what he assimilated in this session. He wanted to paint. He painted with extreme diligence, careful to render every detail. One of the paintings in this exhibition, the *Pointe de la Hève* (belonging to M. Faure, a collector particularly well attuned to modern art) dates from 1864 and provides us with a documentation of the painter's initial style. It was not exempt from a certain aridity, but the cliffs, carpeted by grasses, are already a substantial piece of work, so subtle and delicate that it should give those among our colleagues, who

COLORPLATE 5

gratuitously assume that the impressionists have never been able to draw, something to think about.

Monet came to Paris. At the Salon of 1865, he was able to have *The Terrace at Sainte-Adresse* accepted, a painting that hardly deviated from the mainstream style. He had his vision on the road to Damascus in his studio. This bold painting, which excluded intermediary colors and clearly acknowledged light, moved him and pointed him in the direction of unbeaten paths. He sent a large painting which produced great excitement to the next Salon. *Camille* is of a tall, supple woman, posing in a green and black striped dress, whose trailing skirt fills the entire foreground with its opulent folds and pleats. The "moderns" were still barely acceptable. Hamon and M. Gérôme, leader of the "neo-Greeks," had made the school and the public insipid. *Camille* caused a scandal, and the Salon would inexorably close itself to the young artist. We did not see any of his work there again until 1880. Then the *Village by the Water* was hung among anemic works at a height that defied observation by the excellent landscape artists making up the hanging committee.

In 1874, M. Claude Monet, in the company of M. G. Nittis (who was soon to leave this undesirable association), M. Degas (who was said to cause trouble with his nervous temperament), MM. Renoir, Pissarro, Sisley, Colin, Boudin, and Lépine, took part in the open exhibition in the smaller rooms of the Maison Nadar on the boulevard des Capucines. This attempt to decentralize the artistic world was met by an anger like that aroused by Courbet. Only the *République française* was favorable to him. The great citizen, who was the director, had understood right away that politics had no part in the event and that the new formulas that replaced the old-fashioned techniques, were, in art as in science, the measure of the true progress and privilege of the French genius.

We do not consider restating that which we have previously written. The sincerity of our convictions has been recompensed by signs of sympathy which follow and confirm our point of view. We perceived this when we were asked once again to express our opinion of M. Monet's aesthetics during a modest, yet inspiring exhibition which took place at the headquarters of *La Vie moderne*, then situated on the corner of the passage des Princes.

M. Monet has traveled to England and to Holland. He lived in Poissy and then by the ocean in Brittany and by the Channel coast in Normandy.

Everywhere this warm and vibrant character has harmonized with the booming sounds, the evasive lines, the moving effects of the prairies, the waves, and the skies. "He paints from afar," one of his colleagues said to me, describing in a striking way his technique, which in fact does not consist in hunching over an easel tracing the contours of objects with a paintbrush, but rather in laying down the touch that must evoke the idea of the hue rather than the memory of the details. It is from afar that these paintings must be judged, and the nearsighted or insensitive will only perceive a confused, mixed-up, rough or shaggy surface resembling the underside of a Gobelin tapestry, with an excessive use of chromium yellows and orange-yellows. But at a distance, in normal daylight, the effect is manifested through the science of lines, the calm of the tones, the amplitude of the masses, the intensity of the sun's rays, and the softness of the fall of night.

Is this technique self-consistent? Certainly, since the one who invented and uses it derives such moving results from it. Will others be able to make it their own? On this point, we are absolutely indifferent, believing that real art is a completely spontaneous phenomenon that can only be reproduced with the help of general rules, allowing for quite significant variations. There have been great Dutch landscapists—whose work bears no resemblance to the art of Constable or Crome—masters who inspired Théodore Rousseau without Courbet having adopted his

grandiose preoccupations from him. Indeed, nature in France, all the way to the south, is gentle poetic, graceful, very strong in its foundations and extremely captivating on the surface. We should give recognition to the artists who pursue nature in all its freshness: its gentle dawns, the troubled tides of its shores, the pastoral greenery interspersed with a thousand flowers, and the rich foliage of its trees. They are reacting against the depictions of arid rocks, dried-up beds, walls cooked and re-cooked, trees made of zinc, waters of lapis-lazuli, and weather-beaten peasants that the poor laureates of the École and the Salons import from Italy. We are not Greeks. We are not Romans. We do not drink wine that smells like tar. We eat brie that runs. As we build our republican edifice, stone by stone, let us remember that art is called upon to provide it with a definitive appearance. The Greek temples have had their day. Who would wish to see them now, at the end of the rue Royal, resting above the colonnade like the smashed silhouette of a Greek policeman's hat?

I have described crumbling cliffs, sunken paths, Norman farmhouses and yellowing poplars. Upon reflection, I believe this is the wrong way to proceed. Such a personal kind of painting requires spectators who are truly directed by their own sentiments who stop only before that which they admire. I will only make one exception: a seascape where the waves shatter on black reefs. The *Rocks of Pourville* evokes the many varied sensations and stubborn laments of the rising tide, the salty mists which sting the lips, the vague desire for a long voyage to unknown lands, and all in all, a wordless conversation with an intelligent and beloved being.

ALFRED DE LOSTALOT

GAZETTE DES BEAUX-ARTS

"Exhibition of the Works of M. Claude Monet"

April 1883

Alfred de Lostalot de Bachoué (1837–1887), critic and author of books on engraving and wood sculpture.

M. Claude Monet occupies a special place in the world of art; he has his own vision, which is different from the world's, and he does not care to falsify his feelings, although it would be to his advantage to play to more widespread concerns. Perhaps this is why the public treats him so severely. They showed little interest in most of the paintings he exhibited last month in the apartment on boulevard de la Madeleine, which M. Durand-Ruel has turned into a gallery; but those paintings deserved attention. It is not fair to condemn a painting sight unseen, so we have taken pen in hand to respond to this injustice. Is the unfortunate lighting of the gallery to blame? M. Bonvin too, a true artist, and truly original, exhibited there a few days earlier, with no greater success. The crowd's disdain seems to have brought these new galleries bad luck: perhaps branch shows of the watercolor exhibition held here could exorcise that bad luck, but I don't believe that is what M. Georges Petit intends to do.

François Bonvin (1817–1887), self-taught painter of everyday genre scenes and still lifes.

Georges Petit, son of an art dealer, opened a sumptuous commercial gallery on the London model in Paris in 1882, where he invited successful artists of many different stylistic persuasions to exhibit at international group shows, temporarily luring away some impressionists who had been receiving support exclusively from Durand-Ruel.

Nevertheless, M. Monet enjoys the esteem of painters and the enthusiasm of a small group of art lovers who are grateful that he does not pursue facile successes. Certainly no one can accuse him of ignorance, as one has done—with good reason, we must admit—with most of the painters who call themselves impressionists. It has been rumored that he always paints outdoors and directly from life—it's quite true; his paintings are all studies, not merely copies of sketches composed and polished in the easier light of a studio. There are lovers of art who believe that nature's beauty is sovereign; they are less interested in the material embellishments brought to it by an artist who draws from the wellsprings of his predecessors and his contemporaries. These art lovers—and they are not legion—value M. Monet's paintings highly. They claim to find in them a lofty sentiment peculiar to him, and something more: a precious assurance of precision, which no other trademark can guarantee to the same degree.

I believe they are justified in their opinion, at least insofar as it addresses M. Monet's personal sentiment; that sentiment is undeniable. As for their belief in the precision of his copies from nature, I think it rests on a misconception. M. Monet's precision is relative, as it is for all painters and all paintings, both ancient and more recent. Perhaps this artist's visual acuity allows him to capture nature's phenomena more accurately than another, but like the others, he encounters the ultimate powerlessness of his art. The implacable rigor of science proves it: the colors of the painters are but muffled echoes of natural tints; the former have none of the latter's brilliance in the light tones, none of their depth in shadows. They are a keyboard missing the upper and lower octaves. Any painter who lays claim to absolute realism pursues a chimera. It is, however, possible to attain realism of impression: because painting is an act of transposition, the artist who is skilled enough will give us the lines and harmonies of the piece transposed in all their integrity. A melody is no worse in a lower range; it may lose its *brio*, but its essential expressive qualities remain unaltered.

There is no question that M. Monet is able to transfer onto his canvases impressions analogous to those nature inspires in him: he is a feeling artist who makes us feel. Why does popular acclaim seem to elude him, when it so easily finds the approximators? Why do so few of the recognized art critics appreciate him? No one can accuse him of the assaults on common sense and good taste that quite rightly shame most of the alleged followers of the Impressionist school. Everything he paints is appropriate; he is sensitive to beauty in nature, and there is nothing apocalyptic about his perspectives; the feelings he selects and expresses are refined and poetic.

Could it be the style in which he paints? Yet, there is nothing excessive there, not even—which would be far worse—anything new. M. Monet paints as many excellent masters have painted and do paint: he lays on just enough color to express not merely the object's color but the coloration it takes on, for him, at a given distance and in given surroundings. He achieves his ends by applying the rules of contrast, of complementary colors, of irradiation—in short, all the secrets of nature that Veronese and Rubens (to name but two respected examples) discovered and applied long before science thought to legislate them. Undoubtedly, M. Monet's application of the laws of color has aspects that are radical enough to frighten the timid. But, if not to the great masters cited above, may he not refer to a painter working today, one who ranks high in the public's opinion? M. Monet's daring choices are evident as well in M. Millet's pastels, the most astonishing, the most masterly lesson in painting we have seen in some time; and yet these magnificent works are well received on the contemporary market.

We have, then, a painter whose expertise, taste, and inspiration are above dispute. He paints subjects that touch those who are the most in-

different before nature itself, and yet the public remains cold, mistrustful, even hostile. Only a few connoisseurs and a few more painters proclaim his worth, waxing enthusiastic for the least of his works. And therein lies an odd circumstance, whose cause we would ascertain. In our view, M. Monet paints, so to speak, in a foreign language, to which only he and some few initiates hold the key. It is not a language that can be learned; it is instinctive, and those who understand it are not aware of the abundance of their riches, if indeed that is what it is. An entirely physical reason allows us, perhaps, to explain, all at once, the painter, his admirers, and his critics. M. Monet's eyesight is highly unusual; he sees in a way that most human beings do not, and, because he is sincere, he attempts to reproduce what he sees. We know that the solar spectrum includes a range of rays that the cornea intercepts, and that, therefore, the retina does not receive. This range is called ultraviolet, because it extends beyond the violet range that everyone sees. It does play a significant part in nature, but its effects are not optical. Recent experiments by M. Chardonnet, however, have proven positively that some people respond strongly to this invisible part of the

Louis Bernigaud de Chardonnet (1839–1924), inventor of artificial silk, who submitted papers on ultraviolet radiation to the Academy of Sciences.

Monet in 1883. Collection Viollet, Paris. Photograph: Schaarwachter.

spectrum. Without a doubt, M. Monet belongs to this number; he and his friends see ultraviolet: the masses see something different. Hence the misunderstanding.

I beg M. Monet's pardon for subjecting his talents to scientific investigation, and I ask him to see only a gesture of goodwill in the reflections it evokes. I am very touched by the poetry that stands out in his works; I admire the daring and the sobriety of his technique, and I find astonishing the plastic results he obtains. His harmonies are exquisite and irreproachably correct; but . . . but I am often astonished, even shocked, by the pieces' tonality: my first impression is of something strange and implausible, because it shatters nerves that are all but still when I contemplate nature.

Some of M. Monet's paintings manage to please everyone, except, perhaps, himself. They are painted in subdued light, filtered by a mist-saturated sky that by and large intercepts the violet rays. The *View at Rouen* is one such, with its deep, molten, amber-colored sky that seems to be taken from a painting by Cuyp; also his *Views of Holland*, his *Effect of Snow at Argenteuil*, his *Church at Varengéville* in sunset, and *Low Tide*, with the impressive Varengéville cliffs covered with moss and mirrored in the still water, filtered through the sand of the shore. A marvelous impression, a painting of rare charm and precision: everything is in place and true to its coloration, shape, and natural consistency.

The public's eye rebels when M. Monet pitches battle with the sun. The brilliance of the yellow rays stimulates the painter's nervous sensibility, then blinds him; at that point he undergoes a well-known physiological phenomenon: the complementary color is evoked; he sees violet. Those who are fond of this color will be pleased: M. Monet executes for them an exquisite symphony in violet. The motif is always well chosen—for instance, a mighty cliff, its twisted vegetation seared by the sea air; here and there, the cliff reveals its vigorous ossature and contemplates the silhouette of its shadow in the blue waters. To one side stands a red-roofed cottage, as if setting the pitch.

If one is to see M. Monet's paintings properly and appreciate their exceptional qualities, one must go beyond the first impression. For many, it is outside the known range, the range considered the natural one; it is not long, however, before the eye becomes accustomed and the spirit wakens: the charm takes hold. It is then that one asks, Who but M. Monet, among contemporary landscape artists, can express nature's harmonies with such lofty intuition? And—as one examines the detail—Who but he draws with such sureness of taste and hand the fleeting lines of greenery in motion, or the ridges and relief of mountains and lowlands? When one opens oneself to such questions, the answers are rarely unfavorable to the painter.

In short, M. Monet, however extraordinary his vision and his expression of it, seems to us to unite all those qualities that delight in a painter: nature impresses him, and he impresses; he knows his craft and applies it generously, disdaining the petty resources of the studio, and unconcerned with any damage his disdain could wreak to his professional interests. It seems to me that this description accords with earlier ideas of what a true artist was. We felt it appropriate to inscribe this painter's name in a magazine that considers itself a conservative journal of art; that is, we refuse to see in him an anarchist among painters. The truth is that we are frightened by the ever-increasing number of painters and the extremely rare incidence of artists. Is it not, then, our clear duty to welcome with goodwill any artists who appear, even if the externals are not entirely to our taste?

COLORPLATE 19

COLORPLATE 20

For the best discussion of the opinion that the impressionists' vision was abnormal, see Oscar Reutersward, "The 'Violettomania' of the Impressionists," Journal of Aesthetics and Art Criticism *(December 1950).*

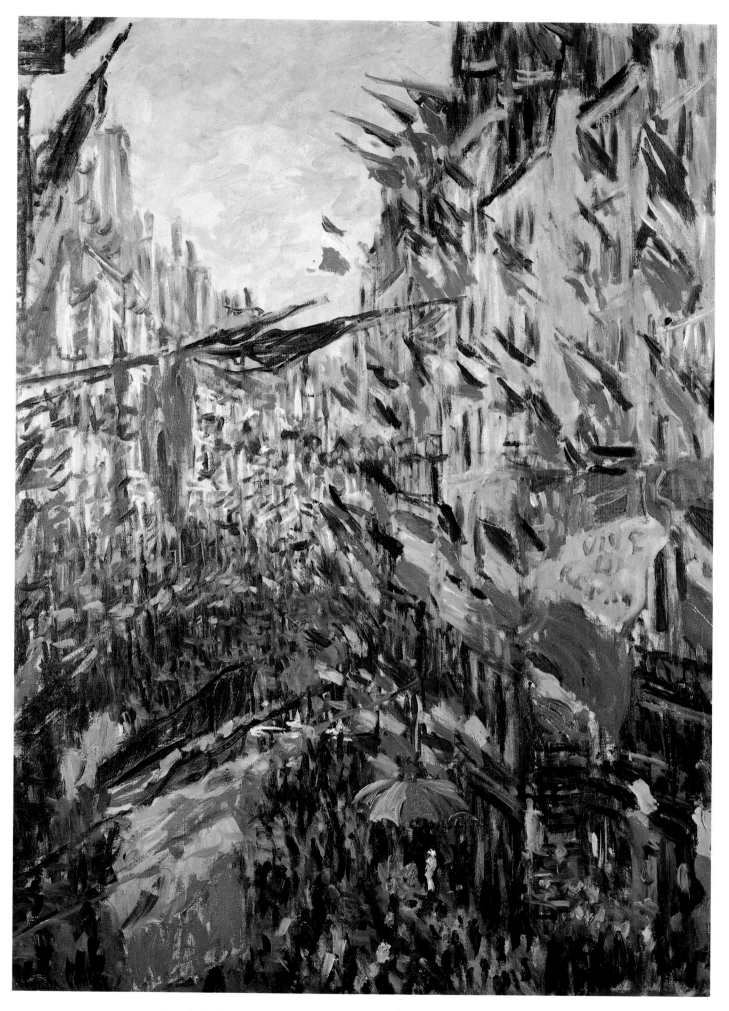

COLORPLATE 41. *Rue Saint-Denis Festivities on June 30, 1878 (Rue Montorgueil Decked with Flags)* 1878.
30 × 20½″ (76 × 52 cm). Musée des Beaux-Arts, Rouen. Photograph: Musées Nationaux, Paris.

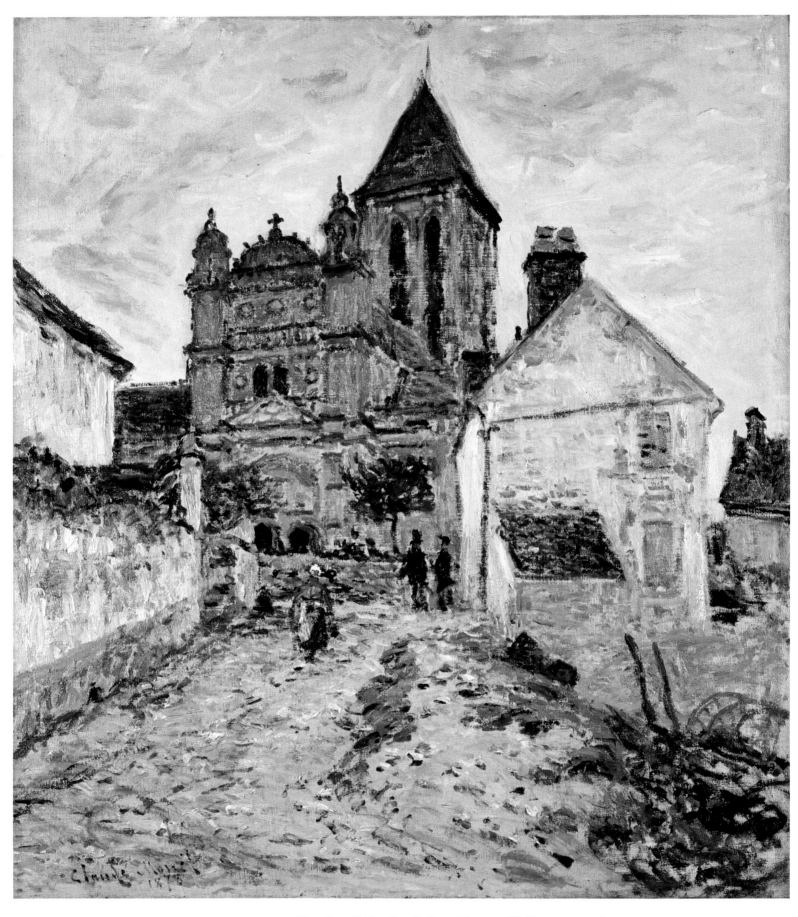

COLORPLATE 42. *Church at Vétheuil*. 1878. 25⅝ × 21⅝″ (65 × 55 cm).
National Galleries of Scotland, Edinburgh.

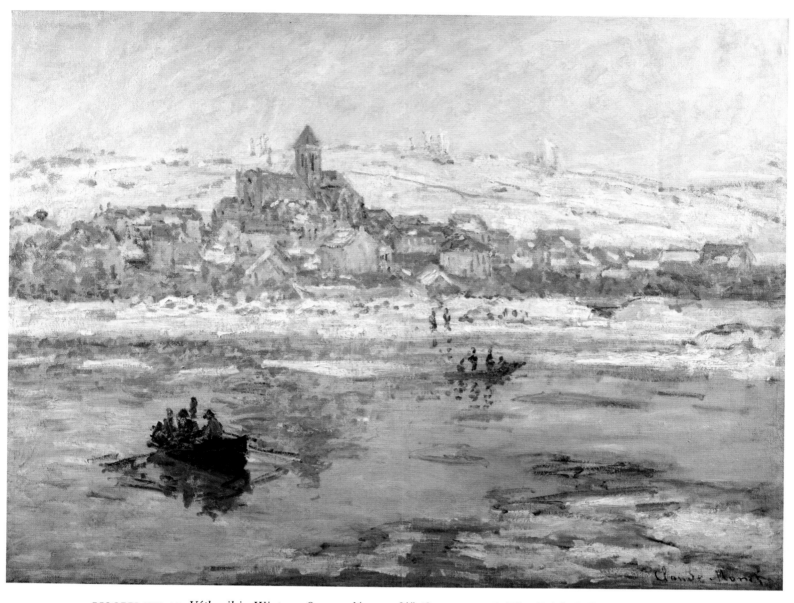

COLORPLATE 43. *Vétheuil in Winter.* 1879. 27⅛ × 35⅜″ (69 × 90 cm). The Frick Collection, New York.

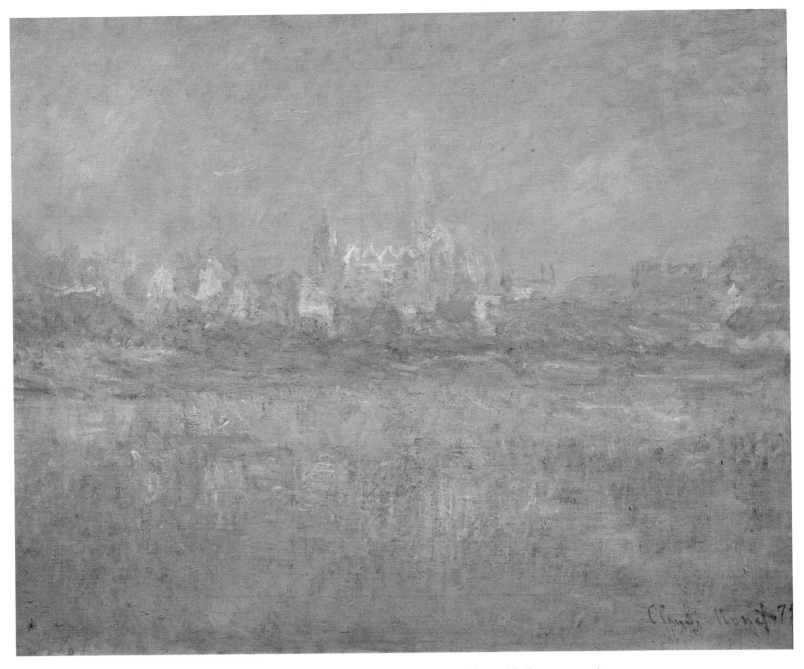

COLORPLATE 44. *Vétheuil in the Fog.* 1879. 23⅝ × 28″ (60 × 71 cm).
Musée Marmottan, Paris. Photograph: Georges Routhier, Studio Lourmel, Paris.

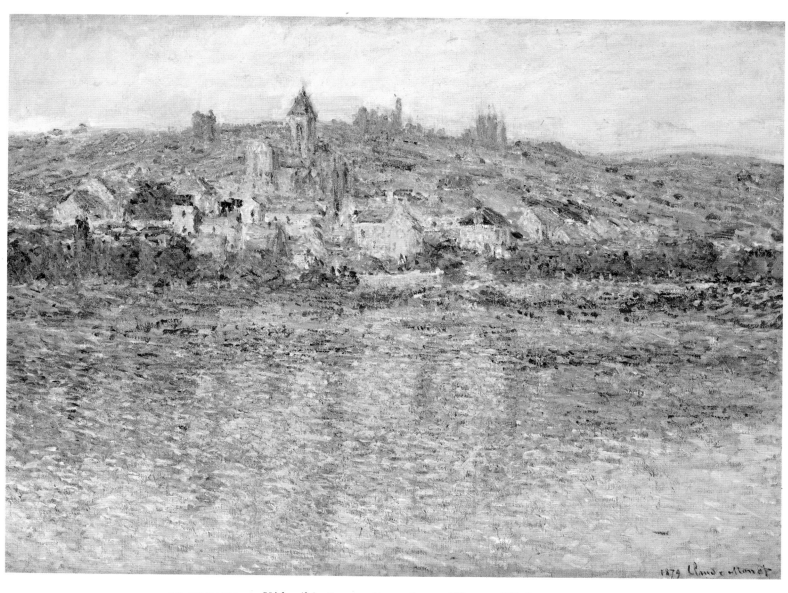

COLORPLATE 45. *Vétheuil in Summertime.* 1879. 26¾ × 35⅝″ (67.9 × 90.5 cm).
Art Gallery of Ontario, Toronto; Purchase 1929.

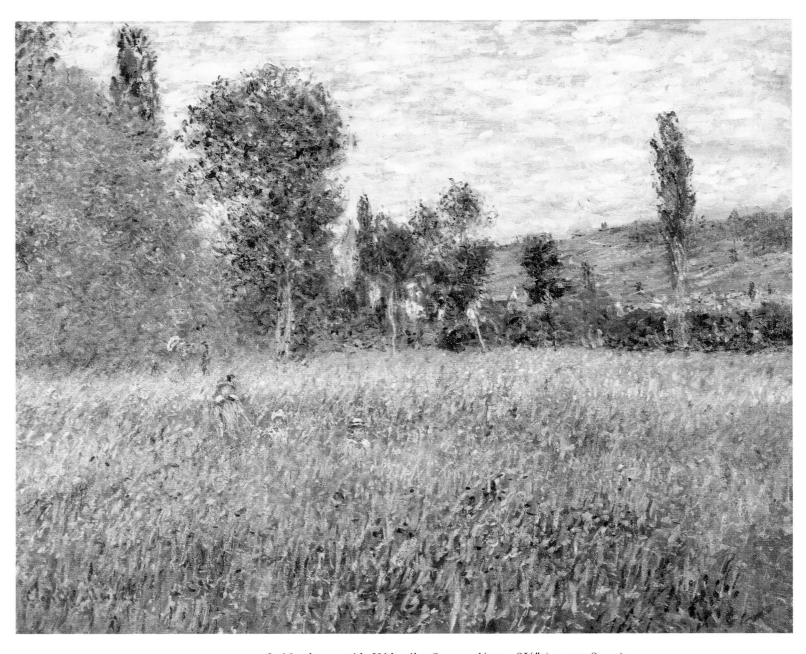

COLORPLATE 46. *Meadow outside Vétheuil.* 1879. 31⅛ × 38⅝″ (79 × 98 cm).
Joslyn Art Museum, Omaha, Nebraska.

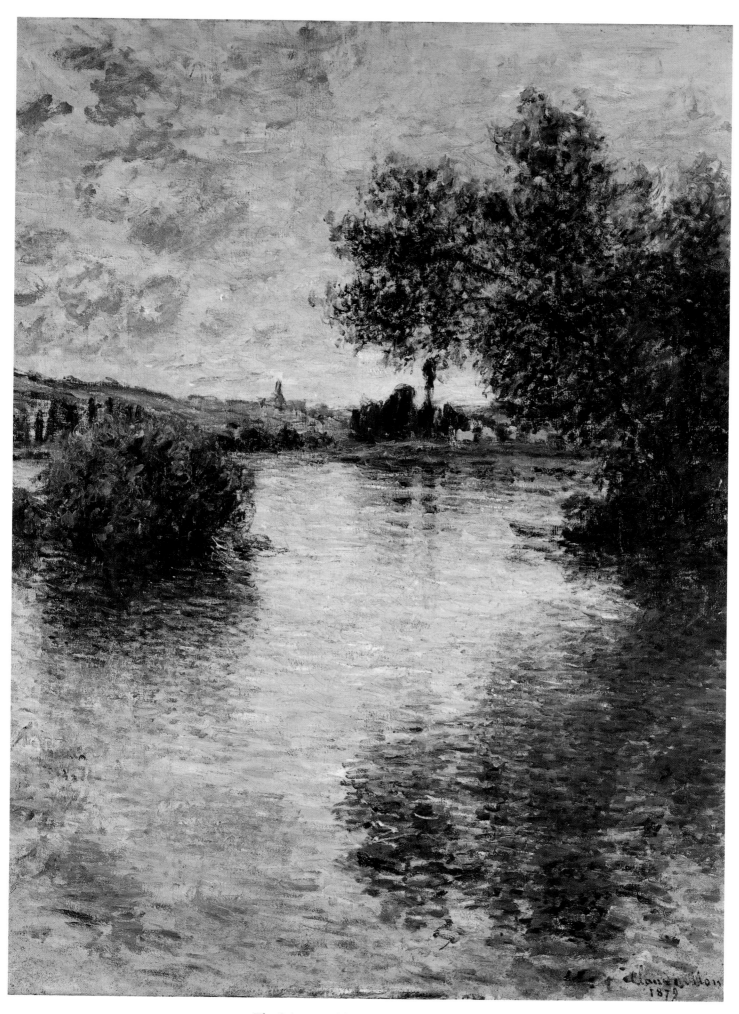

COLORPLATE 47. *The Seine at Vétheuil.* 1879. 31½ × 23⅝" (80 × 60 cm).
Musée des Beaux-Arts, Rouen. Photograph: Musées Nationaux, Paris.

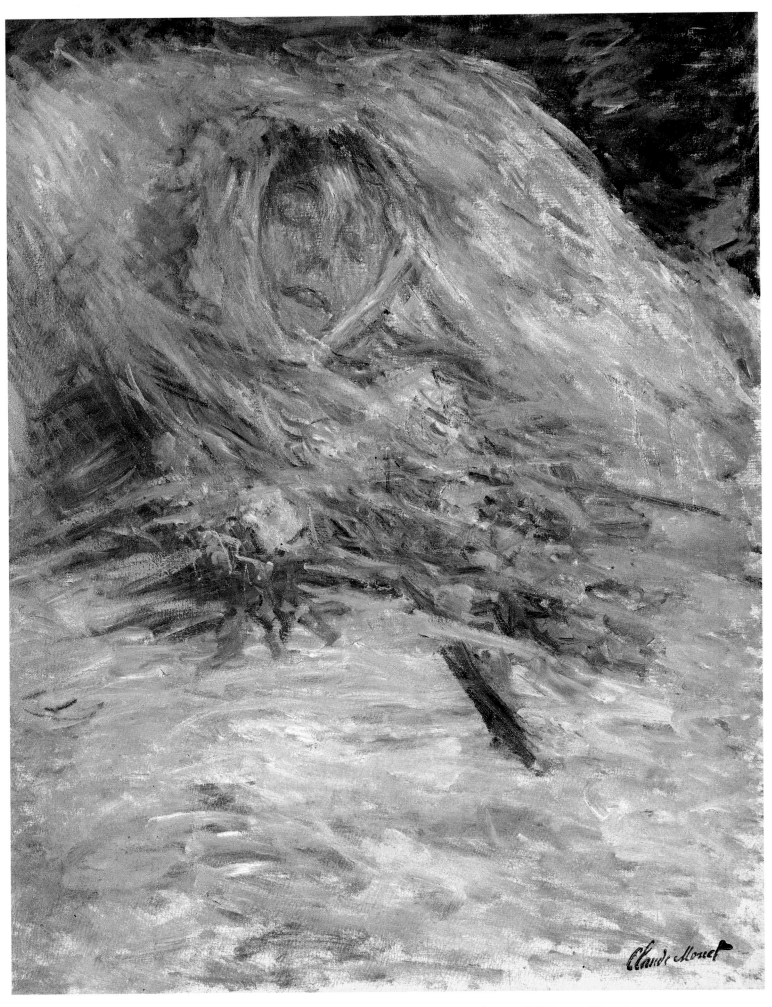

COLORPLATE 48. *Camille Monet on her Deathbed*. 1879. 35⅜ × 26¾″ (90 × 68 cm).
Galerie du Jeu de Paume, Musée du Louvre, Paris. Photograph: Musées Nationaux, Paris.

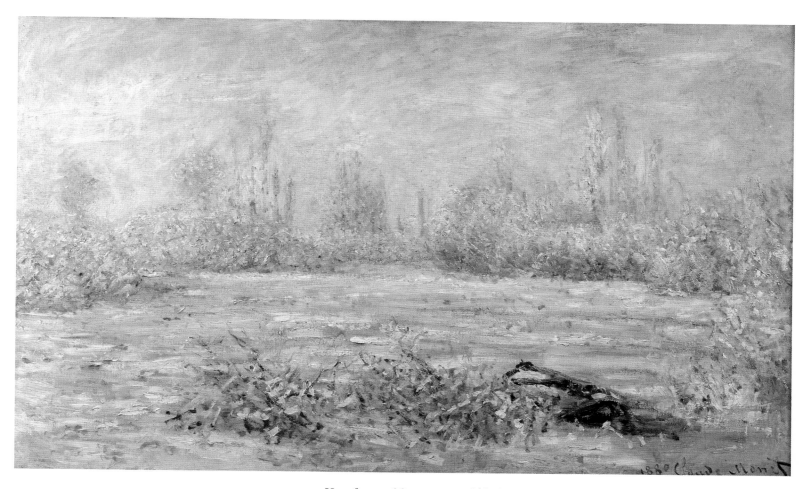

COLORPLATE 49. *Hoarfrost.* 1880. 24 × 39⅜″ (61 × 100 cm).
Galerie de Jeu de Paume, Musée du Louvre, Paris. Photograph: Musées Nationaux, Paris.

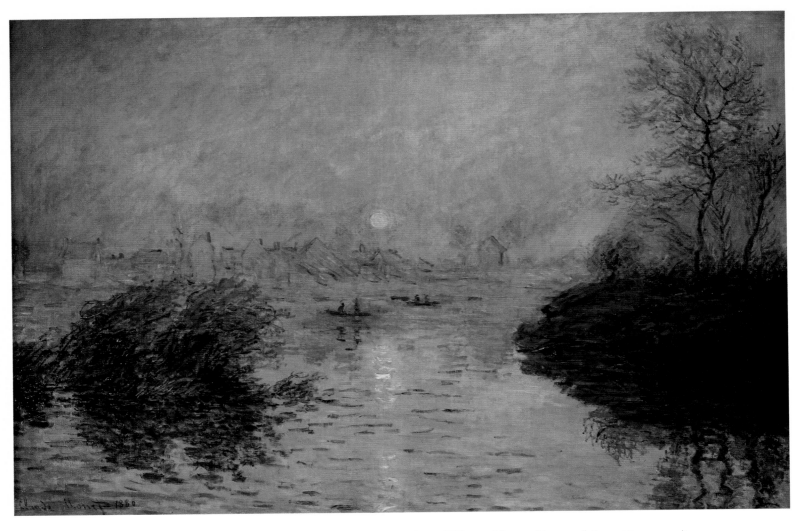

COLORPLATE 50. *Sunset on the Seine at Lavacourt: Winter Effect.* 1880. 39⅜ × 59″ (100 × 150 cm).
Musée du Petit Palais, Paris. Photograph: Musées Nationaux, Paris.

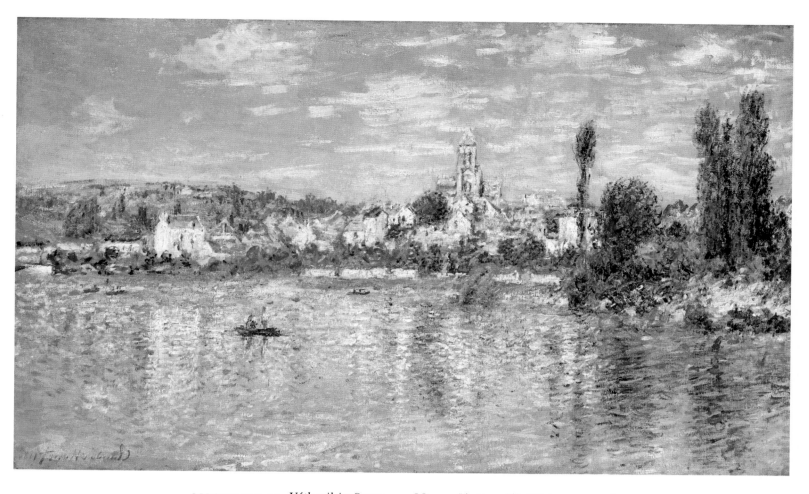

COLORPLATE 51. *Vétheuil in Summer*. 1880. 23⅝ × 39¼″ (66 × 79.7 cm).
The Metropolitan Museum of Art, New York; Bequest of William Church Osborn, 1951.

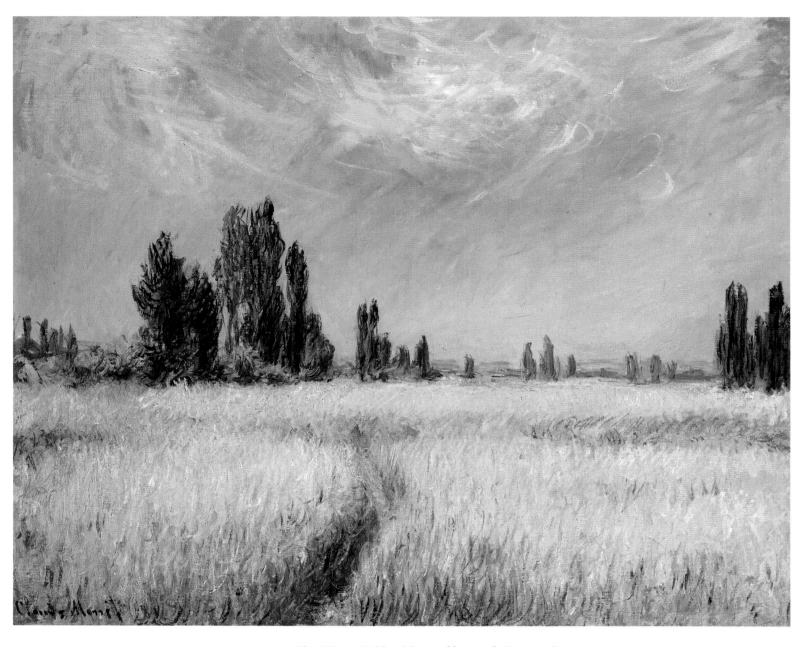

COLORPLATE 52. *The Wheat Field.* 1881. 25¾ × 32″ (65.4 × 81.3 cm).
The Cleveland Museum of Art; Gift of Mrs. Henry White Cannon.

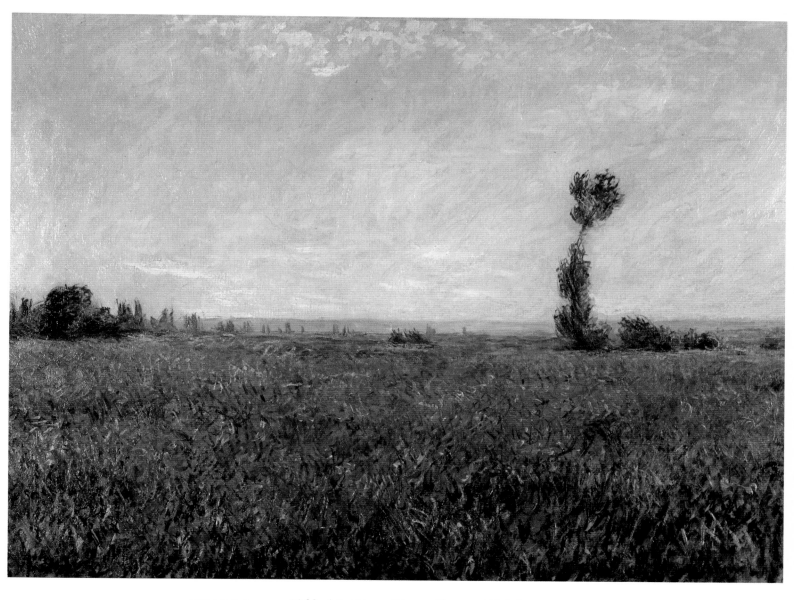

COLORPLATE 53. *Field of Poppies.* 1881. 22⅞ × 31⅛″ (58.1 × 79.1 cm).
Museum Boymans–van Beuningen, Rotterdam.

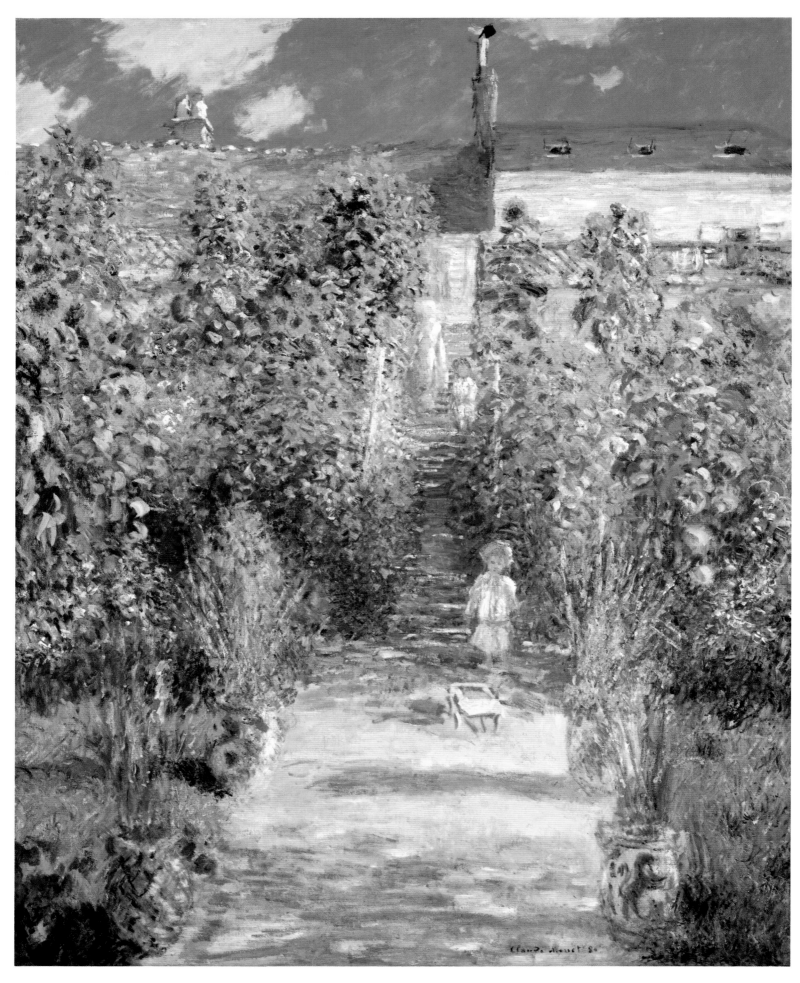

COLORPLATE 54. *The Artist's Garden at Vétheuil.* 1880. 59⅝ × 47⅝″ (151.5 × 121 cm).
National Gallery of Art, Washington, D.C.; Ailsa Mellon Bruce Collection.

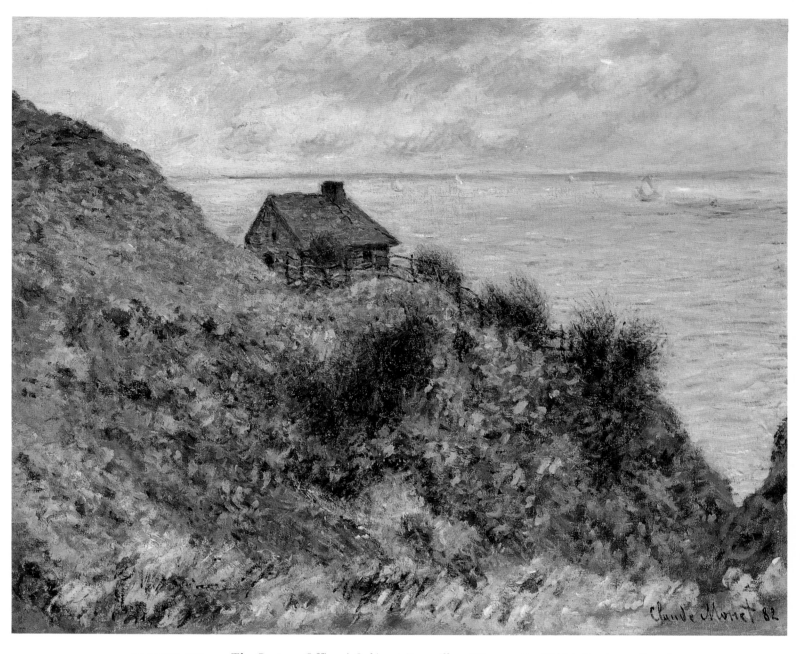

COLORPLATE 55. *The Customs Officers' Cabin at Pourville.* 1882. 31 × 38½″ (78.7 × 97.8 cm).
Private Collection. Photograph: William Beadleston Fine Art, New York.

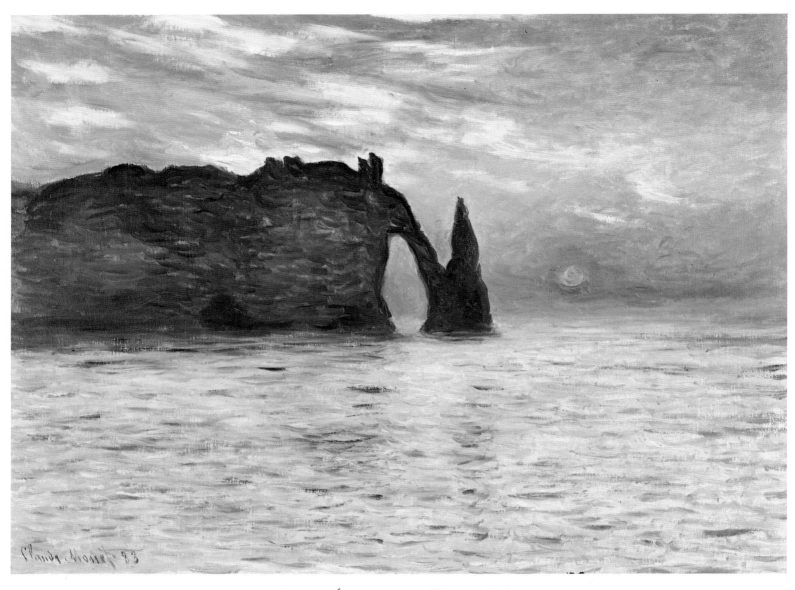

COLORPLATE 56. *Sunset at Étretat.* 1883. $25^{13}/_{16} \times 32^{3}/_{16}''$ (65.4 × 81.9 cm).
North Carolina Museum of Art, Raleigh; Purchased with funds from the State of North Carolina.

GUY DE MAUPASSANT

LE GIL-BLAS

"The Life of a Landscapist"

September 28, 1886

Guy de Maupassant (1850–1893), poet, novelist, and master of the short story, was familiar from youth with the Normandy coast. He later fraternized with many of the impressionists and their disciples.

Étretat, September

Dear friend,

Thank you for your letter with news from Paris. I was glad to receive it and was surprised by it. It was as though it had come from another, long-ago world. Do you mean to tell me that all those people you mention are not dead, that they're spending time on the same trifles! The fashionable world is stirred up about the same nonsense; society is still concerned about Monsieur X's sleeping with Madame Z. The stupid political scene, manipulated by the same idiots, goes from rut to rut, and every day solemn-looking gentlemen write innumerable columns about the same subjects, which the simpleminded discuss heatedly, unaware that they have already read the same thing hundreds of times!

What you tell me about the exhibit of the Society of

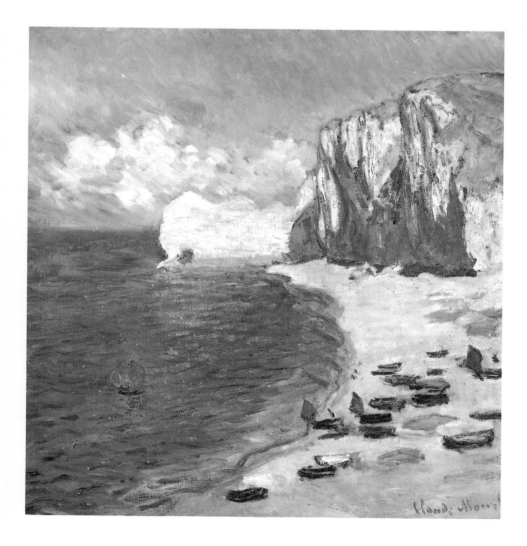

Étretat. 1883. 26½ × 25⅜″ (67.3 × 64.5 cm). The Art Institute of Chicago; Gift of Mrs. John H. Winterbotham in memory of John H. Winterbotham.

Independent Artists at the Tuileries interests me. We must keep an eye on all those who attempt something new, on all those who strive to perceive the unseen in nature, on all those who make a sincere effort to avoid old routines. But why this exhibit in the middle of summer? No doubt the government lends the facilities only during this season. The government is always idiotically the same: powerful and dictatorial. Some day, for the same reason that compels it to sponsor art exhibits during the dog days, we'll see it decree that the owners of bathing establishments must provide diving and swimming lessons in the Seine only during the months of December, January, and February.

So, you say, there are some interesting things in that gallery, surprising ones. Good; I'll go when I get back to town.

Right now, like fish in water, I am immersed in painting. How surprised most people would be to know what color means to us and to experience the profound joy it gives to those who have eyes to see!

It's true; I live only through my eyes. From morning to evening I go through fields and woods, by rocks and gorse, in search of pure tones, of unnoticed nuances—all the things we never learned at school, subjected as we were to a classical education that put blinders on us, preventing us from knowing and fathoming.

My eyes, open like a hungry mouth, devour earth and sky. Yes, I have the clear and profound sensation that my eyes are consuming the world and that I am digesting colors much as one digests meat and fruit.

And this is new to me. I have been sure of my work until this moment, but now I am a seeker. Old boy, you don't know, you'll never know, what a lump of earth is, what is contained in the small shadow it casts upon the ground. A leaf, a small pebble, a ray of light, a clump of grass stop me for an infinite length of time; and I study them eagerly, more excited than a gold miner who finds an ingot; I savor a mysterious, delightful joy as I separate their imperceptible tones and their elusive reflections.

And I realize that I had never really looked at anything. Ever. That's all to the good, you know, better and more useful than aesthetic small talk as people sit in front of stacks of coasters that show the number of beers consumed.

Sometimes I stop, stunned suddenly to discover dazzling things the existence of which I had never suspected. Just look at trees and grass in full sunlight and try to paint them. You'll try. Everyone has done landscapes in the sun, because everyone is blind. Dear friend, leaves, grass, everything the sun strikes is no longer colored; but shining, and they shine in such a way that nothing can reproduce them. In fact, what shines cannot be painted; it isn't even possible to create the illusion.

Last year, right here, I often followed Claude Monet, who was in search of impressions. Actually he was no longer a painter but a hunter. He went along followed by children who carried his canvases, five or six canvases all depicting the same subject at different hours of the day and with different effects.

He would take them up in turn, then put them down again, depending upon the changes in the sky. Standing before his subject, he waited, watched the sun and the shadows, capturing in a few brushstrokes a falling ray of light or a passing cloud and, scorning false and conventional techniques, transferred them rapidly onto his canvas.

Société des Artistes Indépendants: organization founded by artists who petitioned the government for alternative exhibition space after they had been refused by the jury for the Salon of 1884. The second Indépendants exhibition, held from August 20 to September 27, 1886, included works by Seurat, Signac, and Pissarro.

Monet's family accompanied him to the Normandy coast in early October 1885.

In this way I saw him catch a sparkling stream of light on a white cliff and fix it in a flow of yellow tones that strangely rendered the surprising and fugitive effect of that elusive and blinding brilliance.

Another time he caught with both hands a torrent of rain on the sea and flung it on his canvas. It was truly rain that he had thus painted, nothing but rain throwing a veil over the waves, rocks, and sky, which could scarcely be discerned under this deluge.

And I remember other artists I saw at work long ago in the valley of Étretat.

One day when I was still very young, I was walking along the Beaurepaire ravine, when I saw on a farm, a small one, an old man in a blue smock painting under an apple tree. He looked quite little, hunched over on his folding stool, and, emboldened by his peasant smock, I came closer to look at him. The courtyard was on a slope surrounded by tall trees, which the sun, as it disappeared, pierced with its slanting rays. Yellow light flowed on the leaves, penetrated them, and fell on the grass in small, weightless drops.

The old man did not see me. He was painting on a small, square canvas, gently, peacefully, almost motionlessly. His hair was white, quite long; his face was gentle and smiling.

I saw him again the next day in Étretat; the old painter's name was Corot.

Another time, two or three years later, I had gone to the beach to see a hurricane. A raging wind was hurling against the earth an unleashed sea of huge, frothy waves that slowly, ponderously, followed one after the other. Then suddenly striking the beach's steep shingle, they backed up, curled over in arches, and crashed with a deafening sound. And from one cliff to another, the foam, plucked from whitecaps, flew off in a whirlwind toward the valley and was carried off by gusts of wind above rooftops.

Suddenly a man near me said, "Come and see Courbet; he is doing wonderful things." The remark was not addressed to me, but I followed, because I was slightly acquainted with the artist. He lived in a small house looking directly out to sea and resting against the western cliff [falaise d'aval]. This house had once belonged to the seascape painter, Eugène Le Poittevin.

In a large bare room, a fat, greasy, and dirty man was pasting slabs of white paint with a kitchen knife onto a large, bare canvas. Every now and then he would go put his face against the window and look at the storm. The sea came so close it seemed to beat against the house, which was enveloped in foam and noise. The saltwater hit the windowpanes like hailstones and poured down the walls.

On the mantel stood a bottle of cider next to a half-full glass. From time to time Courbet would go to take a few gulps then come back to his work; it was later entitled *The Wave* and acquired a certain renown.

Three men were talking in a corner of the studio. If I'm not mistaken, Charles Landelle was there. Courbet also talked, ponderous and cheerful, bantering and coarse. He had a slow, precise mind full of a good peasant sense, which he concealed in jests. He would say, standing before a "Holy Family," which a colleague was showing him: "That's beautiful; you must have known these people to do their portrait like that."

How many other painters I've seen in this little valley, who were doubtless drawn by the quality of the light, which is truly

COLORPLATE 65

Eugène Le Poittevin (1806–1870), prize-winning Salon artist.

Courbet worked at Étretat in 1869. The painting known today as The Wave *is in the Nationalgalerie in Berlin. A closely related painting, shown at the Salon of 1870, belongs to the Louvre.*

exceptional! For within a few miles, light varies as much as do the wines of Bordeaux. Here the light is brilliant without being harsh; everything is bright without being merciless, and everything blends admirably.

But one must see, or rather, discover. The eye, that most wonderful of human organs, is infinitely perfectible, and it can attain, when intelligently trained, a marvelous acuity. The ancients knew only four or five colors. Nowadays we can distinguish countless tones. Real artists, great ones, are moved more by the modulations and harmonies achieved in a single note than by the brilliant effects that appeal to the masses.

All the awesome conflict that Zola recounts in his admirable *L'Oeuvre*—the endless struggle between man and his intellect, the great and frightful battle between the artist and his idea and the picture glimpsed but out of reach—I can see all these and I participate in them; and I am frail, powerless, and just as tortured as is Claude by imperceptible tones, by indefinable harmonies that only my eyes, perhaps, observe and note. And I spend anguished days looking at the shadow of a milestone on a white road, realizing that I am unable to paint it.

L'Oeuvre: *Zola's controversial 1886 novel about a suicidal modern artist—the fictional Claude Lantier—whose character is in large part based upon Zola's knowledge of the struggles of Cézanne, Manet, and Monet.*

La Manneporte, Étretat. *1885. 25¾ × 32″ (65.4 × 81.3 cm). John G. Johnson Collection, Philadelphia. Photograph: Philadelphia Museum of Art.*

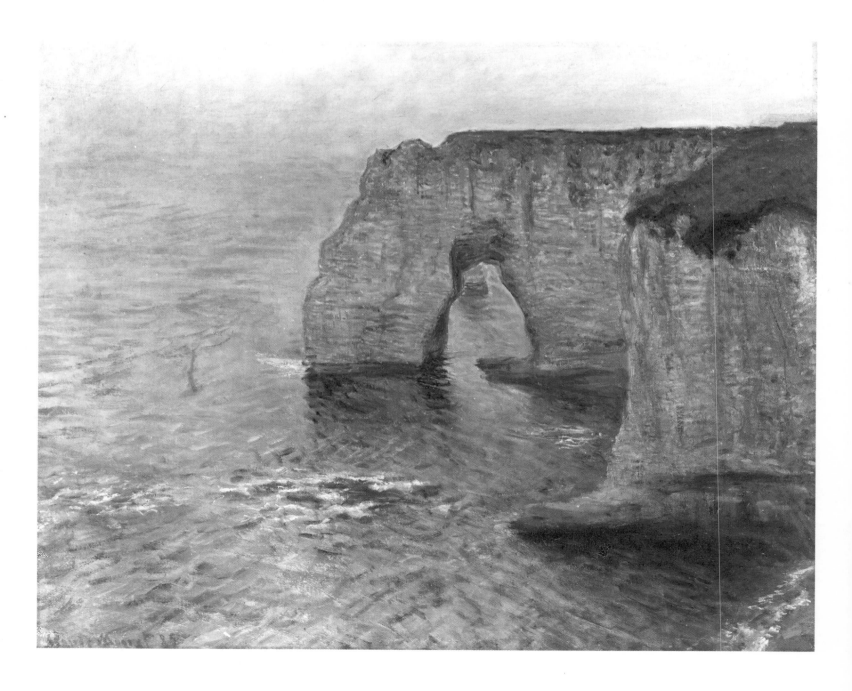

ALBERT WOLFF

LE FIGARO

"International Exhibition"

June 19, 1886

I shall devote the remainder of the space allotted me to a painter who is very much appreciated by some, very controversial to others. Oddly enough, both sides are right, for it happens, in the rather rare case of M. Monet, I admit, that he shows some originality and a good deal of talent; just as at other times he remains among the ranks of inferior professional impressionists who are content with something less than perfect.

M. Monet is always a strange artist. Some look upon him as a naturalist, but basically he is a dreamer. His landscapes are usually a slap in the face of nature, as painters say, and the landscapes look less like nature than like a species of vegetation glimpsed by someone who is hallucinating. We have all seen in Holland those fields of tulips that add such a cheerful touch to the environs of Haarlem. They form a sparkling yet soft and subtle harmony with green fields. In M. Monet's paintings they are as outrageously gaudy as is his road to Monte Carlo; this looks like a torrent of currant jelly cutting a path through the verdure. Yet the true artist emerges from these untidy canvases. M. Monet is like a man who tells cock-and-bull stories in the middle of which he occasionally inserts a delightful sentence.

Such is the art of this landscapist; of the thirteen canvases on show, only one is really good. However, *The Sea at Étretat* does not belong to the naturalist school. It is a fairyland lake. Prince Charming could easily

COLORPLATE 72

COLORPLATE 63

Fields of Tulips in Holland. 1886. 26 × 32¼" (66 × 82 cm). Galerie du Jeu de Paume, Musée du Louvre, Paris. Photograph: Musées Nationaux, Paris.

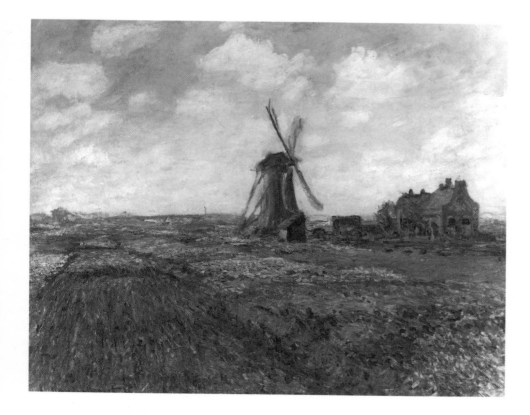

appear from the background in his boat without arousing any surprise. And so it is a fantasy sea rendered in fantasy, albeit very distinguished, colors with fantasy rocks. Please note that it is not my intention to criticize M. Monet, for this view of Étretat is truly charming and such as I should wish the painter to do often. I must convince him that I have no preconceptions in matters of art. Last year I was delighted to praise an excellent seascape of his; this year I am equally happy to discover something truly pretty in his disjointed exhibit; for M. Monet is a man of talent; I shan't say of unequal talent, for inequality presupposes a certain balance between a painter's qualities and his shortcomings. Such is not the case here. M. Claude Monet, more often than not, is on the wrong track in his preconceived notions and drowns his qualities in a totally incomprehensible form of art. A real pity.

Wolff wrote a review of Petit's fifth international exhibition for Le Figaro, *May 15, 1885.*

CELEN SABBRIN

SCIENCE AND PHILOSOPHY IN ART

1886

Celen Sabbrin: pseudonym for Helen Abbott (1857–1904), an American who studied piano in Paris from 1878–1881 and later became a biochemist and doctor.

The color scale of Monet's pictures is original, and essentially calculated to produce upon the observer an intense psychological impression. Monet's pictures, 270, "Poppies in Bloom," and 212, "Landscape at Giverny," are companion pictures, inasmuch as one is the continuation of the other, and an expression of philosophical thought. The prevailing color tones of the two pictures are brilliant reds, and peculiar bluish greens. Attention was called above to this color rule, as being used in what are most properly the highest philosophical studies of this artist. As art expressions of scientific and philosophical thought, these two pictures occupy the most prominent place of any in the collection.

COLORPLATE 62

COLORPLATE 61

No. 270 is the best illustration of the theory of triangulation to be found in Monet's pictures. From the foreground and running diagonally from left to right is the poppy field, and the ground rising above it forms a green, grassy amphitheatre, closing out from sight all objects beyond the foreground, thus inviting to progress. The narrow expanse of sky is seen above the hilly bank. Its depth is interminable, and a sense of solemnity steals over the observer. He is brought most terribly near the source and origin of things. The sky is in marked contrast to the poppy field and hill, where it is the present that offers. Here is the beginning of life's course. Unconscious of what is back of the hill, the soul is absorbed by the immediate; though she may step forward, through the gay-flowered field, onward to her future, the past is locked in mystery. Nature throws no obstacle to her progress; there is no warning hand to hold the soul from running to her own destruction; and the indifference of nature to suffering or happiness is terrible to contemplate. The grassy bank is covered with many colored grasses, the different colors giving the effect of light and shadow. These different patches are formed like triangles. The entire picture can be looked upon as the interior of a geometrical solid. The poppy field is a parallelogram; diagonal lines run across it from one to the opposite corner, and these large triangles can in turn be divided into smaller ones. The effect of triangulation can be well seen at a distance, but is very much plainer by a near inspection of the canvas. It is significant that in one of Monet's highest expressions of thought the unbending principles of geometrical form are the most clearly discernible. It may be claiming too much to say that mathemati-

cal principles are the basis of all truth, but that the two are nearly related must be acknowledged.

No. 212, "A Landscape at Giverny," is an expression of hopelessness, of the unattainableness of absolute truth, and a confirmation of science's teachings, in the ultimate uselessness of human effort. To the appreciative such a picture would be unbearable as a constant companion; though it is the crowning effort of Monet's genius, and proclaims him the philosopher of the impressionist school.

The mathematical principles are fully expressed in this picture, and vivify the thought that geometry is soulless, and that natural forces are relentless and pitiless. In the immediate foreground runs a gay poppy field, which might well be the poppy field of No. 270 continued, and we may accept it as the continuation of the soul's history. Bounding this field, along a diagonal line, are some deserted houses; beyond, and to the right, are a series of fields and lines of trees alternating. A bright light strikes one of these fields, and gives the effect of water. On and on the eye travels to the right corner of the background, where the deep blue of the hill range looms up. Above all, lowers a heavy gray sky, blank and cheerless. Speculation can go no further; what is beyond these hills may never be known. The heart weakens and the soul is faint at what she sees. It is the end of the struggle of the human race; all work and thought have been of no avail; the fight is over and inorganic forces proclaim their victory. The scene is a striking reality. Nature is indifferent, and her aspects are meaningless, for what indications of the unavoidable end come from seeing that gay flowered field? It is a mockery, and that mind which has once felt the depth of the thoughts expressed in this painting, can only seek safety in forgetfulness.

Monet does not offer any solution to the result to which his pictures lead. He is occupied in giving expression to the most serious truths of our life. He is recording the chronicles of modern thought.

GUSTAVE GEFFROY

PAYS D'OUEST

1897

Kervillaouen

For the last two weeks, at the inn where he's hurriedly getting set up, a man has been living who perhaps will finally be recognized, after twenty years of raillery and resistance, as one of the great landscape artists of his time: Claude Monet. The painter came here drawn by the almost totally unknown and unexplored poetry of Belle-Île-en-Mer. We are fortunate that an artist has managed to guess from afar from the sinuosities of a map, through the descriptions of a guide book, how admirable this country is. We already knew each other, after the exchange of an article and a letter, at the time of an exhibition on boulevard de la Madeleine several years ago, and the meeting was quickly arranged.

Reference to Geffroy's review of Monet's one-man exhibition at the Galerie Durand-Ruel, published in La Justice, *March 15, 1883.*

Pointe des Poulaines

Surrounding the rocks, the water is a bluish black, like certain inks, and the breakers contain dark transparencies. Only in Brittany, where the bottom is rocky, does the sea take on this particular hue. Monet is very keen on observing the profound difference between this long, luminous

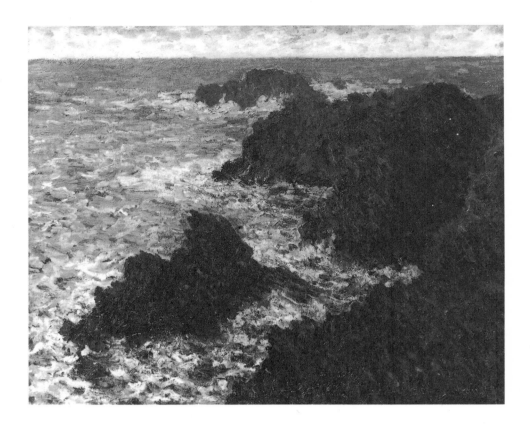

Rocks at Belle-Île. 1886. 25⅝ × 31⅞" (65 × 81 cm). Galerie du Jeu de Paume, Musée du Louvre, Paris. Photograph: Musées Nationaux, Paris.

surge and the thick, choppy billows of the Channel, with its pale green so often muddied by yellow from the bottom . . .

Claude Monet

Claude Monet works before these rocky cathedrals at Port-Domois in the wind and the rain, necessarily clad like the men of the coast, covered in sweaters, boots, and wrapped in a hooded slicker. Sometimes a gust of wind will snatch his palette and brushes from his hands. His easel is lashed down with ropes and stones. No matter, the painter holds his own and proceeds to his work as into battle. Human will and courage, artistic passion and sincerity—these are the qualities that characterize that fine, rustic family of landscape artists whose works honor this century's art and constitute its claim to originality. Monet will be in the first rank of this group. Since 1865 he has been assaulted by animosities, spared no measure of carping criticism, and has had to struggle against spite and inertia. It is not difficult to predict that habits of taste and thinking will change, that it will be for Monet as it has been for so many others who have gone unappreciated and scorned. Here, in front of these masterfully, concisely designed canvases of such bold exactitude, before these luminous works, so steeped in the surrounding atmosphere and permeated by the light, where the colors disperse and mingle through the inexplicable magic of an alchemist; before these cliffs, which give the impression of the weight of the earth; before this sea, where all is continuous motion—the shape of the waves, the transparent depths, the variety of foam, the reflections of the sky—one has the feeling that something new, something great, has made its appearance in art.

 But it is not possible, in this note scribbled at the end of a day, to describe in detail the coast and the sea at all times and in all weather, as they are depicted by the brush of a distinguished artist. The canvases painted at Belle-Île will be seen in Paris. Suffice it to have mentioned the deeply felt love of nature that drives Claude Monet to attempt to reproduce, on his canvases, the unchanging lines and the fugitive effects, the boundless expanses of the sea and the sky, and the velvet of a mound of clay blanketed by damp moss and withered flowers.

COLORPLATE 69

GEORGES JEANNIOT

LA CRAVACHE PARISIENNE
"Notes on Art: Claude Monet"
June 23, 1888

Georges Jeanniot (1848–1934), painter, best known for his illustrations for novels and magazines, including La Vie moderne. He became friendly with Degas and Manet in the early 1880s.

At the Goupil Gallery (19, boulevard Montmartre), ten paintings by Claude Monet, done in Antibes.

The very name of this artist is a drawing card; the works of this well-known personality arouse strong passions, for or against, in people who are interested in painting. The aforementioned pictures are on view in the mezzanine of the gallery. They occupy two badly lit adjoining rooms. However, his paintings survive the inadequate lighting.

* * *

Is Monet conscious, as he paints, of the strange affinity between perfumes, sounds and colors? He must be. His brushstrokes make the Mediterranean sound like the murmurs of lovers, whereas they make the ocean howl and sound like cries of the shipwrecked. In the pictures of Belle-Île the cold salty wind of the ocean strikes one's face; those from Antibes bestow a warm, scented caress.

Should the painter's technique be mentioned? It is quite simple. Monet never works beyond the limit that time (and its attendant atmospheric changes) imposes upon his subject—even if it lasts only ten minutes—and he always works from nature. He paints with a full brush, with unmixed colors, using four or five clear ones; he juxtaposes or superimposes raw tones.

He does not have a studio as such. Living in the magnificent countryside of Giverny, not far from Vernon, he paints from morning to night. He remains out of doors in any sort of weather. A kind of barn into which a wide bay window has been cut serves as a storage place for his canvases; they are hung or piled up in corners there. Many of these will one day be sold for their weight in gold. In this building where there is no floor, just beaten earth, he is content to smoke his pipe as he examines sketches, searching for the cause of a defect or talking about what he plans to do if the weather is favorable.

He almost always has two or three canvases under way; he takes them with him and makes changes depending upon the weather conditions. This is his method. He never touches up his work in the studio. He has produced very few pictures based upon preliminary studies.

Everything interests him. During a walk we took together he would stop in front of the most unlikely subjects, would speak admiringly, pointing out to me how noble and unexpected nature is. Bounded fields smelling of wild mint, planted with willows or poplars, are as dear to him as wide horizons. As soon as he stands before his easel he attacks the painting all at once, having brushed in a few charcoal lines. He handles his long paintbrushes with surprising deftness and sureness of stroke. His landscape is quickly set down and often remains unchanged after the first session, which lasts the length of the atmospheric conditions, hardly an hour and sometimes much less.

All this is within everybody's reach; in fact it is the simplest way of working fruitfully out of doors. I mention this to show that painters' ways of working are independent of the results they achieve. Others use different methods and are successful; but very few of them, I am sure, are as skilled as Claude Monet in capturing the actuality of a scene and distilling its harmony. This is what sets great masters apart.

Adolphe Goupil (1806–1893) began a lucrative art dealer's business in Paris in 1827, adding branches from Berlin to New York and creating a market for art reproductions. One of his daughters married the Academic painter Gérôme, and another married Étienne Boussod, who continued the business in partnership with Valadon, keeping the Goupil name.

OSCAR REUTERSWARD

MONET

1948

Oscar Reutersward (Reutersvärd)
(b. 1915), distinguished professor of art
history at the universities of Stockholm and
Lund, and an artist in his own right.

One Swedish painter saw the exhibition and was fascinated. It was Prince Eugen. He has left a short, candid description of his visit to the art gallery on boulevard Montmartre.

> I have a good recollection of my first encounter with Monet's art. It was almost by chance that I became acquainted with it, and it happened in Paris in the spring of 1888. I was working at my easel on one of my last days at the art school when a number of students suddenly and unexpectedly began to pack up for the day. The student next to me informed me that they had managed to obtain a promise of an advanced view of several paintings that were to be displayed and were expected to cause a sensation. My curiosity was roused, and when I was asked if I cared to come along, I naturally accepted with enthusiasm. We went together in a group to the exhibition salon, which was in the Opéra Quarter. It was directed by Théo van Gogh, who at that time did not yet enjoy the renown that his brother would soon earn him. The actual objective of my companions' trip was an inner room on the premises where several canvases stood arrayed along the walls. They were all works by Monet, which he had just finished and were not yet framed. I fell back at the sight. Finally, I was seeing samples of paintings by the controversial artist, and for a moment it was kind of hard for me to take in the vehemently articulated pictures. They were for the most part coastal scenes with richly colored, silhouette-like cliff formations and surf scintillating

Prince Eugen (1865–1947), youngest son
of King Oscar II of Sweden and Norway.
He came to Paris to continue his art
studies in 1887, preparatory to his
distinguished career as a muralist.

Théo van Gogh (1854–1891), Vincent's
devoted younger brother, who began
working for Goupil's branch gallery in
Brussels in 1873 and joined the Paris
branch in 1878. There he was put in
charge of developing a clientele for
contemporary impressionist and post-
impressionist art. See John Rewald, "Théo
van Gogh, Goupil, and the
Impressionists," Gazette des Beaux-*
Arts, (January and February 1973).

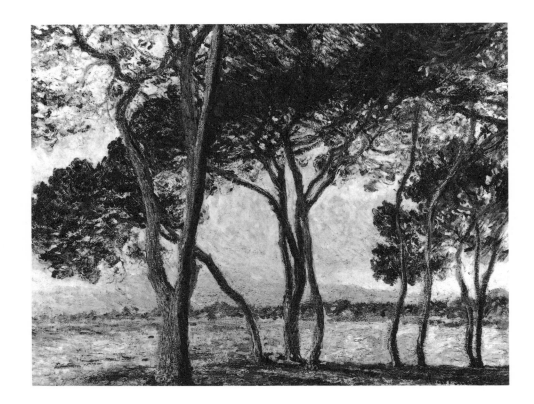

Beneath the Pines: Day's End. 1888. 28¾ × 42⅞″ (73 × 109 cm). Private Collection. Photograph: A.C. Cooper Ltd., London.

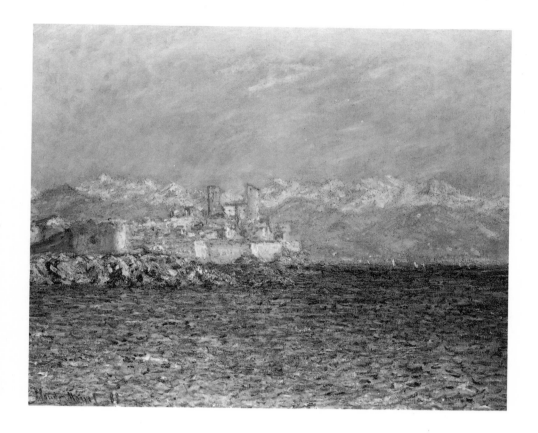

The Old Fort at Antibes. 1888. 26 × 32½″ (66 × 82.5 cm). Museum of Fine Arts, Boston; Gift of Samuel Dacre Bush.

with light. I recall particularly a view out over the sea, with blue as the dominant element and a rose-colored coast section in the foreground. It gave me a good deal to think about, and I have often since wished I could see it again. The blue seemed to be produced by a jumble of different nuances of ultramarine. But it generated an intensity the like of which I had never seen before and which I had not thought possible to bring forth.

I now had a good opportunity to listen to the opinions of these somewhat older friends of mine about Impressionism. They were all indignant over what they saw and passionately opposed Monet's way of eliminating form-fixing detail and freeing himself of all rules that prevailed in the art schools. On me, the canvases had quite a different effect. As soon as I had recovered after the initial astonishment, my eyes were opened to what was new in them, and I was filled with spontaneous enthusiasm. In that crowd of annoyed, protesting colleagues, I established my admiration for Monet's painting.

While we were in the room, Théo came in to us. He was a small, slight man with reddish hair, gaunt face, and lively eyes, not unlike his famous brother. When he heard my companions' judgment of repudiation, he dismissed it with a shrug of his shoulders. I interpreted that as an expression of regret on his part, and in order to give him what I thought would be another and more favorable view of us, I hastened to assure him of my undivided enthusiasm. Imagine my surprise when he repeated the same evasive gesture as before. He had apparently not yet formed an opinion of the pictures that had been entrusted to him.

JEAN-PIERRE HOSCHEDÉ

CLAUDE MONET CE MAL CONNU

1960

Ever since our first day at Giverny, we have been local foreigners to its inhabitants. We have been considered "artists", and the word is somehow deprecatory, for it means "comedian" rather than "painter," or maybe it indicates people who dress in a different style, casually, with clothes of lively and sharp colors, with hats (which is what people wore then), not caps, of all colors and without a brim that looked like a bell. This is indeed how we were all dressed every single day. I recall very well my hat, which I thought was so handsome. Its color was a light pink and I was quite proud of it. But the village people kept a wary eye on us, as they do on all foreigners. Our reputation was not so favorable when we could have used a better one.

At once the villagers considered Monet a proud man—that is to say, a man with few friendly ties, who did not chat and who especially avoided gossips and useless banalities. My mother, my brothers and sisters managed to gain quickly a better reputation. The two children, Michel and me, went to the local school. The teacher was a chorister at church (at the time, there was no intolerance between believers and nonbelievers). So things got better, but it did not prevent the local people from taking advantage of out-of-town people that we were, using or inventing all kinds of pretenses. For instance, we had to pay a toll to walk all in one line between two fields on our way to the Seine river, where Monet painted his boats and landscapes. Walking on the field did not endanger crops, but still the fields' owners required a fee—which we paid, because we were afraid not to see the Seine again and to have to say farewell to boats and swimming. Several times we lost our "Norwegian," a light boat with a round deck floor, because the willow branch attached to it had been cut off. The boat then had gone adrift. We had to go look for it, and sometimes we would find it as far down the river as the Port-

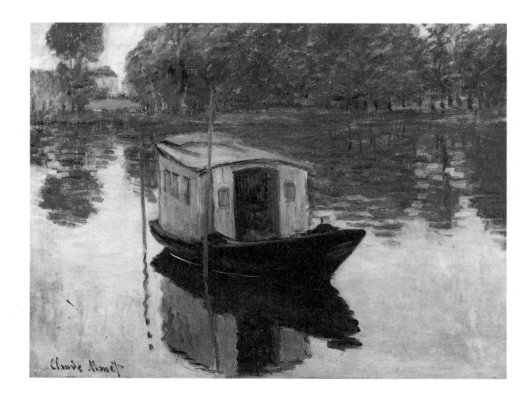

The Studio-Boat. 1874. 19¾ × 25¼″ (50 × 64 cm). Rijksmuseum Kröller-Müller, Otterlo.

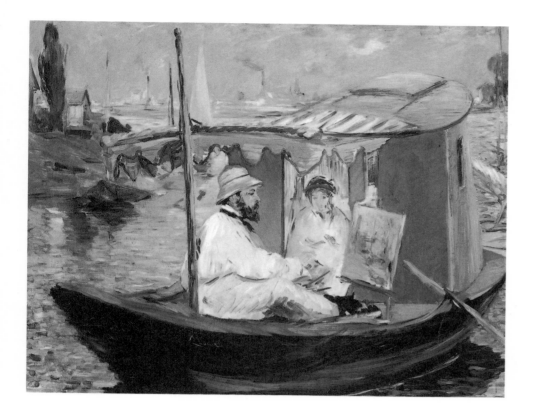

Édouard Manet. *Claude Monet in his Studio-Boat.* 1874. 31½ × 38⅝". Neue Pinakothek, Bayerischen Staatsgemaldesammlungen, Munich.

COLORPLATE 37

Mort floodgate. In order to cut short these mishaps, Monet had to buy part of a field called the Poison Ivy Island at the mouth of the river Epte and had a small harbor shed built, where he put two mahogany yawls, the oars, and many other things. There we built ourselves a genuine pier where the "Norwegian" and the large boat with a cabin were fastened (the one which later was called the "workshop boat," which all books about Monet do not fail to mention; Édouard Manet did a painting of this with a view of Monet and his canvas). Now on his own land, Monet started to be well-respected, even though a few thefts and robberies still took place in his shed once in a while.

More serious and expensive difficulties were provoked by the farmers. Here are several: One day, as he was on his way to paint *The Haystacks*, Monet learned that his subject was going to be destroyed the next day. He had to pay to obtain a postponement of the grindstone removal. Another time, arriving on his rowboat on the river Epte to paint a series of *Poplars*, he noticed that all the trees were marked at the base of the trunk. Monet then found out that the trees were to be cut off shortly, and, of course, he had to pay a fee to get another delay.

Here is another story, this one communal. There was a rumor—and Monet was aware at once—that the Rémy starch-works factory was going to buy part of the swamp to build a new factory there. Monet feared that the rumor was genuine and that this charming little bend of the Epte would be disfigured. Doing all he could to prevent the building of the factory, Monet proposed to the communal council that he pay for the draining of the swamp on the condition that the land not be sold to the Rémy factory. The council naturally accepted.

The draining work was done, but the villagers did not understand Monet's goal (no factory at Giverny). It cost him 10,000 francs, which was a bundle at the time, and it was this amount, paid without a visible profit, that really astonished the village people.

A propos of this swamp, here is a short story dating back to the time before the draining illustrating how unscrupulous—mean even—the farmers were in their schemes to get us to pay fees. Here is the nasty story: in winter the swamp, which was overflowed, became a splendid skating rink where all the children and grownups—including Michel, my

inseparable friend, and me—spent most of their free after-school time with their skates on, sometimes even pushing the good times well into the night as we organized parties on the ice. These parties attracted many curious people from Vernon. But it happens that the communal swamp was rented annually to a farmer, so that in summer he could let his herds graze while letting the soil rest in winter. Since this farmer rented the swamp, he decided one morning to sublet it to us to skate. We were forced to comply. Meanwhile, Monet had little by little transformed his property. His garden had become a wonder. It even impressed the farmers, who were generally rather insensitive to decoration or to the beauty of flowers, which, since they did not grow any produce, were considered useless. How many times did I hear this argument, and not only at Giverny where Monet eventually imposed a love for flowers? However, he had yet to make his old dream of building an artificial lake come true.

This dream became real, but it was not without difficulty: he needed the authorization of the communal council to start building his pond. In order to achieve this, Monet bought part of the field in front of his property and beyond the road (called the path of Kings) and the railroads (Pacy-sur-Eure-Gisors), and also beyond the tiny extension of the Epte, a bare stream called the Ru, which ran through the open country to finally throw itself into the Seine before Manitot. This done, Monet dug the pond in the middle of the land he had just bought. The small stream had to be diverted, turned to the other side of the property; in its place now stands the path which leads from the gate to the pond. The water of the pond was taken directly from the stream, but it had to be changed regularly. This was done using two watergates, one upstream, one downstream, so that it was possible to renew the water easily. It was then that the drama began. Monet almost saw his dream crumble. I remember that during the studies made prior to the construction, a farmer, as always, incessantly repeated: "Me, I oppose this," without explaining why nor what. From that day on, our family only referred to that farmer as "Me, I oppose this" to ridicule him. Other people, more positive and less ridiculous, claimed that no one knew what kind of plants would be growing at the bottom of the pond. They might lead to a poisoning of the pond water. That way the stream itself would become hazardous. What would happen to the livestock which drank there twice a day? But given the sheer absurdity of some objections uttered against the building of the pond and the refusal to renew the pond water through the stream, and also given the support Monet had within the council, he was finally awarded the go-ahead. The communal council authorized the project; the water could flow freely to and from the stream.

The opposition to the creation of the pond marked the end of the period of difficulty Monet knew from the village people. Indeed, when he later saw the plants in his garden sprinkled with dust blown by the growing number of cars and had the road tarred in front of his house to stop the dust, nobody in Giverny protested. A few years later, the tarring of roads was under way through the services of the Public Works Department. In Giverny, then, people realized that "Monsieur" Monet was not just anybody, and that an artist could actually make some money as well as spend it. He was then highly regarded; he was even told that at the next local elections he could be elected deputy clerk or mayor, an outcome he would not accept.

Successive acquisitions he made were also noted: small sheds that were built on the property were at once demolished and replaced by new ones, including a second workshop. All the professionals in Giverny and Vernon, farmers, masons, blacksmiths, carriers, all found a business in the alterations Monet made to his house and garden. In a word, thanks to him, prosperity had come to Giverny, which was then invaded by a crowd of American painters. For the local villagers, it was terrific luck.

Everybody indeed profited, directly or indirectly, from this era of prosperity due entirely to Monet's presence. His reputation in the village was growing steadily. Admiration, not for his paintings, of course, but for his energy and honesty, was unanimous. Even more so, since he always paid everything without bargaining, never had trouble with anybody, and also because he was always generous. He was no longer a local foreigner, but Giverny's glory.

I never heard Monet say about one of his paintings, even the most beautiful, that it was "finished." The word "finished" did not exist in his vocabulary; he generally did not sign his paintings in advance, but would do it when they were sold or exhibited. Then it was a mandatory procedure because the buyers often gave more importance to his signature than to the painting itself. He was used to never entirely completing his paintings, and he usually left parts unpainted all around the canvas. Monet painted these last parts only when the time for signing had come, which I almost describe as a chore, for he was enthusiastic and fast in front of his subject but often lazy about such details as the signature. Many people feel that the unpainted parts in a Monet painting signify that it is not completed. It is not so, however. It was just Monet's routine. Besides, Monet believed that many of his sketches, on which he had worked only once or twice (first impression), were more valuable than some of his "overworked," and, as he used to call them, "damaged" paintings.

THEODORE ROBINSON

THE CENTURY MAGAZINE

"Claude Monet"

September 1892

Theodore Robinson (1852–1896), American painter who studied with Gérôme and Carolus-Duran in Paris in the late 1870s before converting to impressionism. In 1887, he moved to Giverny to join the growing colony of Monet's admirers.

When the group of painters known as impressionists exhibited together for the first time twelve or fifteen years ago, they were greeted with much derision. In fact they were hardly taken seriously, being regarded either as mountebanks or as *poseurs* who served the purpose of furnishing the quick-witted but not infallible Parisians with something to laugh at once a year. But they have seen their influence increase steadily in a remarkable manner, first, as is always the case, with the painters, and latterly with the public.

* * *

Of them all M. Claude Monet is the most aggressive, forceful painter, the one whose work is influencing its epoch the most. If he has not, as M. Guy de Maupassant says with enthusiasm, "discovered the art of painting," he has certainly painted moving waters, skies, air, and sunlight with a vividness and truth before unknown. Though occasionally painting indoors, he is, in my opinion, most original as an open-air painter, and he has scored his greatest success in that line. No one has given us quite such realism. Individual, and with the courage of his opinion, from the first, his work, while remaining substantially the same in intention, has become larger and freer. In the beginning there was a visible influence of Corot, and certain mannerisms which have disappeared with increasing years. Superbly careless of *facture*, or at least with no preoccupation in that direction, he has arrived at that greatest of all *factures*, large, solid,

and intangible, which best suggests the mystery of nature. And all painters working in the true impressionist spirit, absorbed by their subject, must feel that neat workmanship is not merely not worth the while, but is out of the question. "No man can serve two masters," and this noble indifference to *facture* comes sooner or later to all great painters of air, sea, and sky.

Most painters have been struck by the charm of a sketch done from nature at a sitting, a charm coming from the oneness of effect, the instantaneousness seldom seen in the completed landscape, as understood by the studio landscape-painter. M. Claude Monet was the first to imagine the possibility of obtaining this truth and charm on a fair-sized canvas with qualities and drawing unattainable in the small sketch. He found it attainable by working with method at the same time of day and not too long, never for more than an hour. Frequently he will be carrying on at the same time fifteen or twenty canvases. It is untrue that he is a painter of clever, large *pochades*. The canvas that does not go beyond the *pochade* state never leaves his studio, and the completed pictures are painted over many times.

Though these details may be of some interest, it is, of course, the spiritual side of the painter's work that is really worth dwelling on. M. Claude Monet's art is vital, robust, healthy. Like Corot's, but in more exuberant fashion, it shows the joy of living. It does not lack thought, and many of his pictures are painted with difficulty; but there is never that mysterious something which often gets into a picture and communicates itself to the spectator, a sense of fatigue, or abatement of interest in the motive. There is always a delightful sense of movement, vibration, and life. One of his favorite sayings is "La Nature ne s'arrête pas." Clouds are moving across the sky, leaves are twinkling, the grass is growing. Even the stillest summer day has no feeling of fixedness or of stagnation; moving seas, rivers, and skies have a great charm for him.

"La Nature ne s'arrête pas" (Nature does not stand still).

* * *

While the movement is much in sympathy with the naturalistic movement in literature, yet I should rather insist on its resemblance to that brought on by Constable. In independence of thought and intense love of nature, in the treatment received from public and critics, and in their immediate influence on the younger painters of their day, there is a remarkable similarity between Constable and M. Monet. In Leslie's "Life" Constable preaches against *chic*, then called *bravura*, "an attempt to do something beyond the truth. Fashion always had and always will have its day, but truth in all things only will last and can only have just claims on posterity." "The world is full enough of what has been already done." "My execution annoys the scholastic ones. Perhaps the sacrifices I make for lightness and brightness are too great, but these things are the essence of landscape."

In 1824 some of his landscapes exhibited in Paris made a sensation. The French artists "are struck by their vivacity and freshness, things unknown to their own pictures—they have made a stir and set the students in landscape to thinking. . . . The critics are angry with the public for admiring these pictures. They acknowledge the effect to be rich and powerful, and that the whole has the look of nature and the color true and harmonious; but shall we admire works so unusual for their excellencies alone—what then is to become of the great Poussin—and they caution the younger artists to beware of the seduction of these English works." But a few years later the younger artists began to profit by Constable's ideas, and the noble school of 1830 appeared, carrying the art of landscape-painting another step in advance.

It is not perhaps too soon to prophesy that in the same manner the influence of M. Claude Monet on the landscape art of the future will be strongly felt.

Charles Robert Leslie (1794–1859), expatriate American genre painter whose Memoirs of the Life of John Constable, *published in 1843, was largely based on the landscapist's correspondence.*

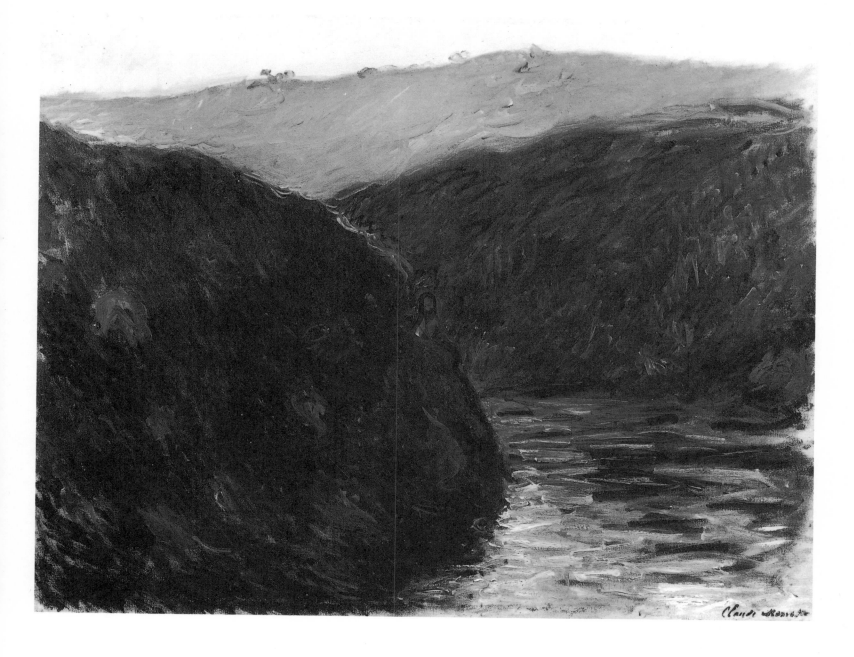

GUSTAVE GEFFROY

MONET: SA VIE, SON OEUVRE

1924

In 1889, I dragged Monet to visit Maurice Rollinat in the Creuse, knowing that he would paint some wonderful landscapes there. We left one January day, with Louis Mullem and Frantz Jourdain. The welcome extended by Rollinat and his companion, Cécile, to La Pouge, as they called their thatched cottage, stayed in their visitors' memory as much as that magical country where the poet had elected his rustic domicile. We knew perfect days of walking, of conversation, and of feasting, over which Rollinat presided with justified self-confidence. In the evening, he sang songs he had written setting to music Baudelaire's poems and his own, which are "naturist," melancholy, and through which thread the sadnesses of solitude, the hallucinations of the countryside, as well as the feelings of serenity that are born of renunciation. We passed our eve-

Maurice Rollinat (1846–1903), poet of both rustic and macabre psychological songs, whom Monet visited at his remote home in the Creuse in 1889.

137

nings that way, until far into the night, when the guests were escorted back to the inn by lantern light, in the icy January night.

The day after we arrived, we took an outing with Monet across the stunning and gloomy beauty of the two Creuses, to the Puyguillon Ravine, to the village of Vervit, to where the rivers called "Confolans," or Eaux-Semblantes, meet, and which is one of the strangest and most beautiful sights there is. Monet stood a long while to contemplate the shallow, foaming waters that merged across the rocks, over a bed of pebbles. A sort of beach formed, and a hoary old tree, solitary and terrible, spread its gnarled branches above the crashing of the two rivers that tumbled like torrents. The froth of the water rolled in at our feet like sea waves. The stony hills, covered with mosses and heathers, rose on every side, forming a bleak arena for the waters' combat. The sight was wild and infinitely melancholy.

In another direction, the village, with its sullen roofs, burrowed into hollows in land and rock, above the water that groaned as it passed, leaped the weirs, murmured over smooth stones, roared over obstacles, flowed past its banks. The thatched roofs above the ravine, the low, barely visible fronts of the houses, the winking points of light from the few windows in which the glinting daylight lingered, where here and there a fire was lit on a smoke-blackened hearth—all inspired the idea of endless solitude, a never-ending winter's sleep.

That day, we returned to Fresselines along a path that led uphill; Rollinat was surrounded by his dogs, and the rest of us mused on the life of the poet of *Névroses*, a life tucked away in this setting of melancholy grandeur. In the evening, La Pouge was bright with fine fires in the great fireplaces, with our joyous dinner, conversation, and songs into the night. We were leaving the next day, and Claude Monet, won over by the landscape and by the host who did its honors, promised to return.

And he did return, spending nearly three months there, from March of 1889 until that May, lodging at Mother Baronnet's Inn, with his painter's tools and his pile of canvases, taking his meals and passing his evenings with Rollinat. The painter and the poet became friends. For both of them, those were unforgettable times, and I never see Monet without thinking of them. And I remember too, soberly and distinctly, that Pistolet—one of Rollinat's dogs—adopted Monet, never leaving him for an instant, following him to the motifs from which he worked, staying by him to protect him, defend him, and keep him company; every evening the dog accompanied him to the inn, every morning he returned to the inn at his appointed time to lay down on the mat to await his new friend. The memory of Monet always stayed with this faithful beast, and, after Monet left, every time Rollinat said his name—"Where is he? Where is Monsieur Monet?"—Pistolet's ears perked up, he became agitated, jumped, yapped, and cried.

This letter that Monet sent me from the Creuse gives an idea of how he thought about nature in his work, of his conscientiousness, of his gnawing anxiety:

Fresselines, April 24, 1889

Dear friend, I am heartbroken, almost discouraged, and so weary that I am a little sick with it. I am not doing any good work, and despite your faith in me, I am very afraid that all this effort will come to naught! Never have I had such bad luck with weather! Never three good days in a row, so that I have to be continually correcting, because everything is growing, and turning green. And I had so dreamed of painting the Creuse as we saw it!

COLORPLATE 74

COLORPLATE 75

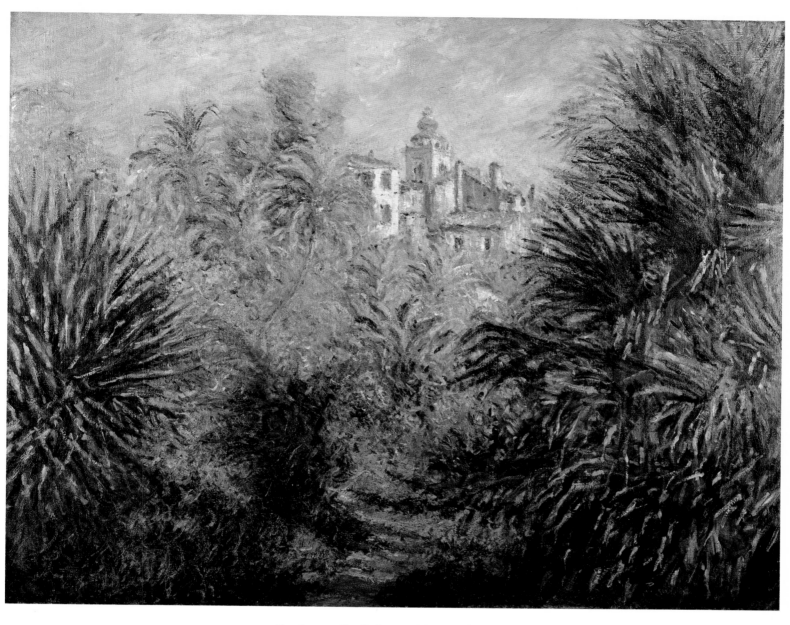

COLORPLATE 57. *Gardens at Bordighera.* 1884. 28¾ × 36⅝″ (73 × 93 cm).
Norton Gallery and School of Art, West Palm Beach, Florida.

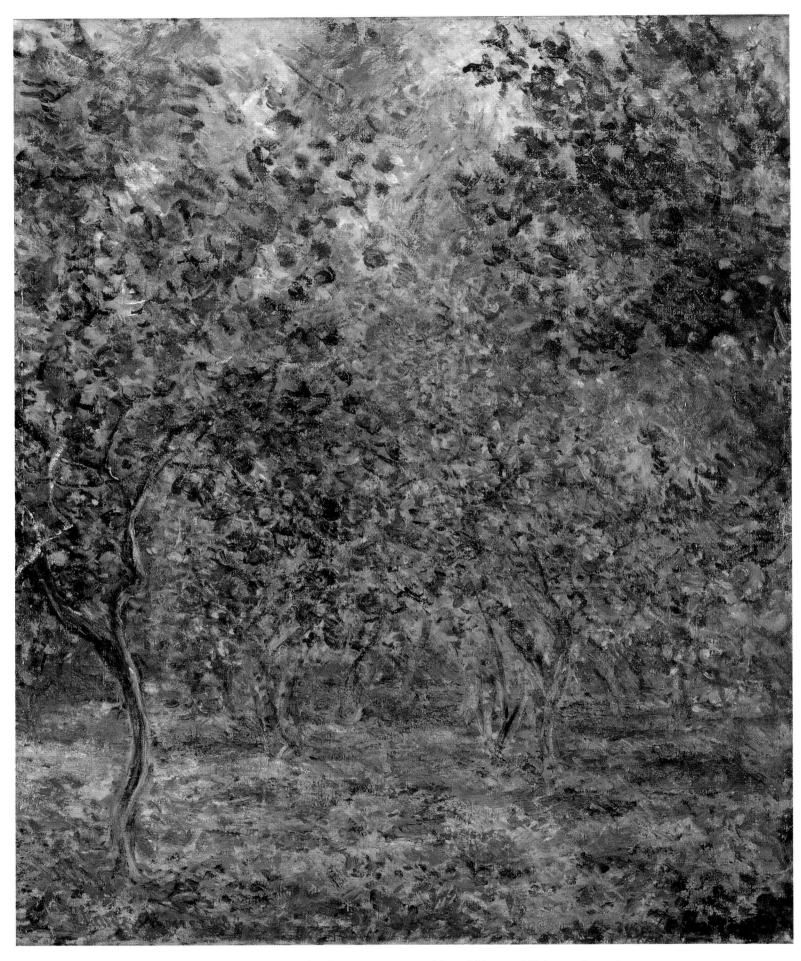

COLORPLATE 58. *Under the Lemon Trees.* 1884. 28¾ × 23⅝″ (73 × 60 cm).
Ny Carlsberg Glyptotek, Copenhagen.

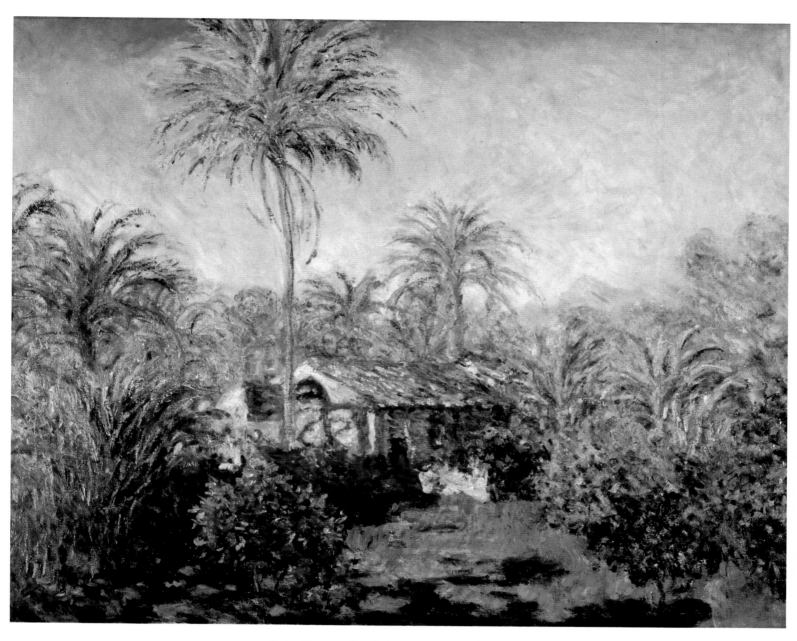

COLORPLATE 59. *Palm Trees at Bordighera*. 1884. 28¾ × 36¼″ (73 × 92 cm).
Joslyn Art Museum, Omaha, Nebraska.

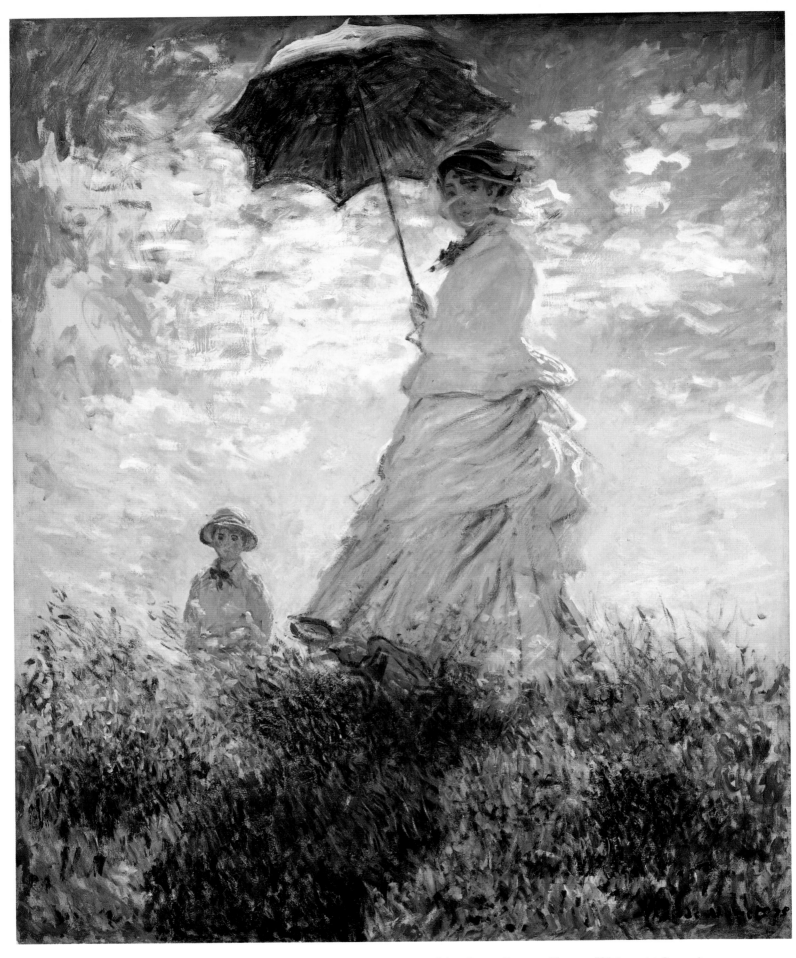

COLORPLATE 60. *Woman with a Parasol—Madame Monet and her Son*. 1875. 39⅜ × 31⅞″ (100 × 81 cm).
National Gallery of Art, Washington, D.C.; Collection of Mr. and Mrs. Paul Mellon.

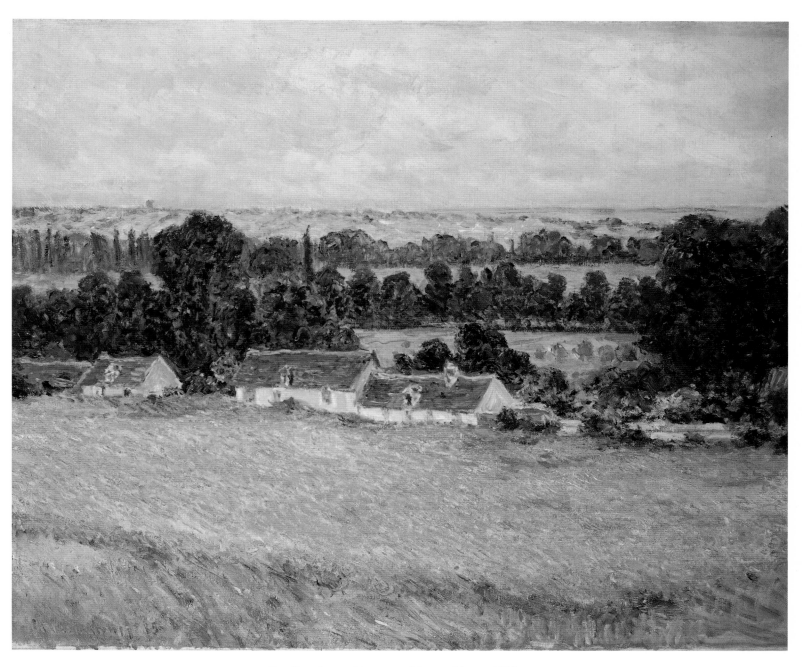

COLORPLATE 61. *Poppies at Giverny.* 1885. 23⅝ × 28⅞″ (60 × 73 cm).
Collection Mr. and Mrs. Paul Mellon, Upperville, Virginia.

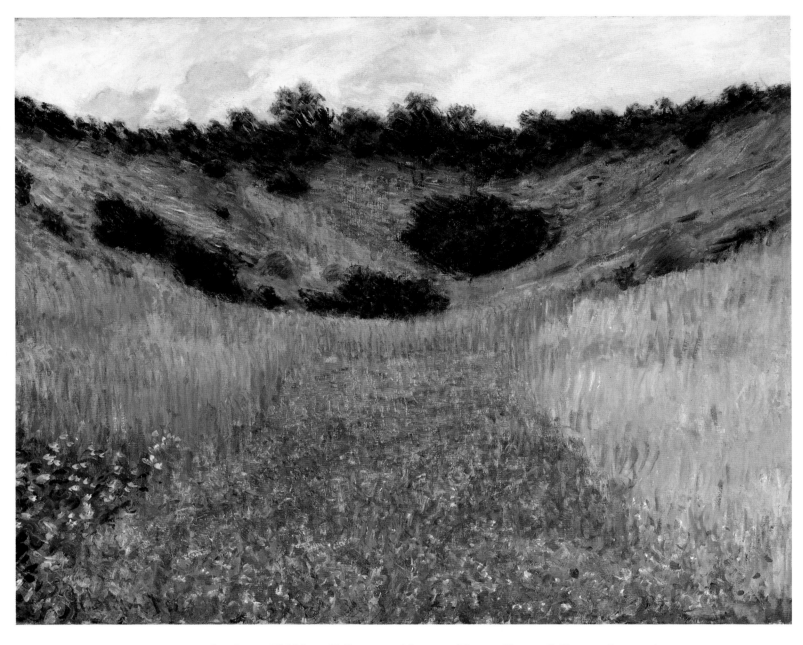

COLORPLATE 62. *Poppy Field in a Hollow near Giverny*. 1885. 25⅝ × 32″ (65.2 × 81.2 cm).
Museum of Fine Arts, Boston; Juliana Cheney Edwards Collection, Bequest of Robert J. Edwards in
memory of his mother.

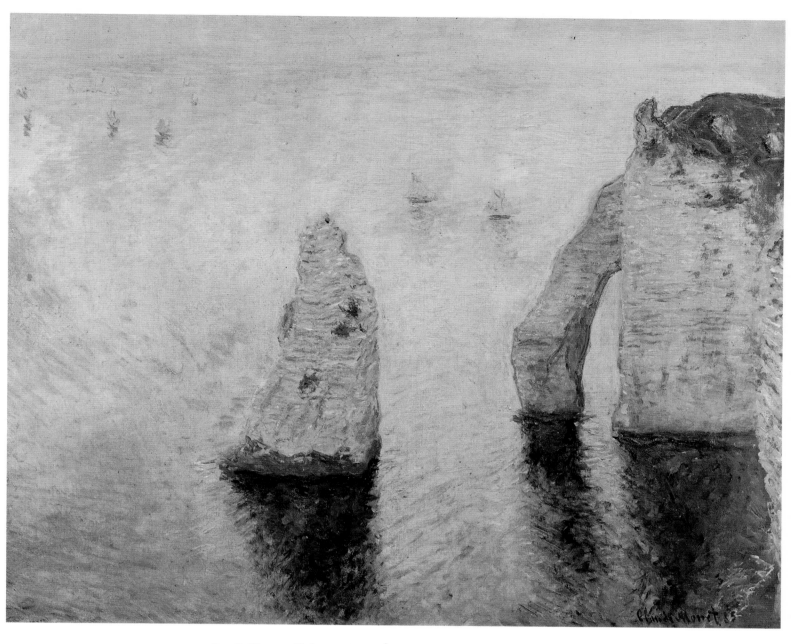

COLORPLATE 63. *Sailboats off the Needle at Étretat.* 1885. 26⅜ × 32¼″ (67 × 81.9 cm).
Private Collection. Photograph: Galerie Schmit, Paris.

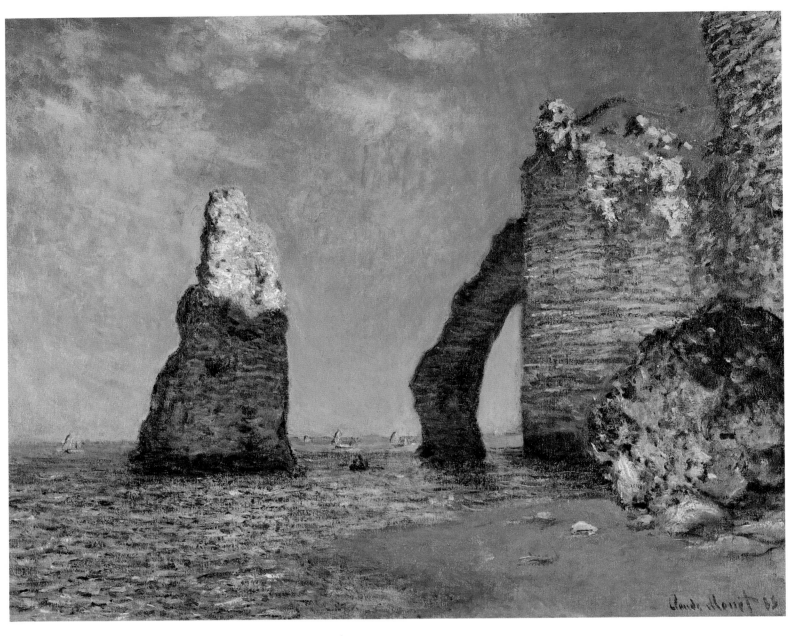

COLORPLATE 64. *The Cliffs at Étretat.* 1885. 25⁹⁄₁₆ × 31¹⁵⁄₁₆″ (64.9 × 81.1 cm).
Sterling and Francine Clark Art Institute, Williamstown, Massachusetts.

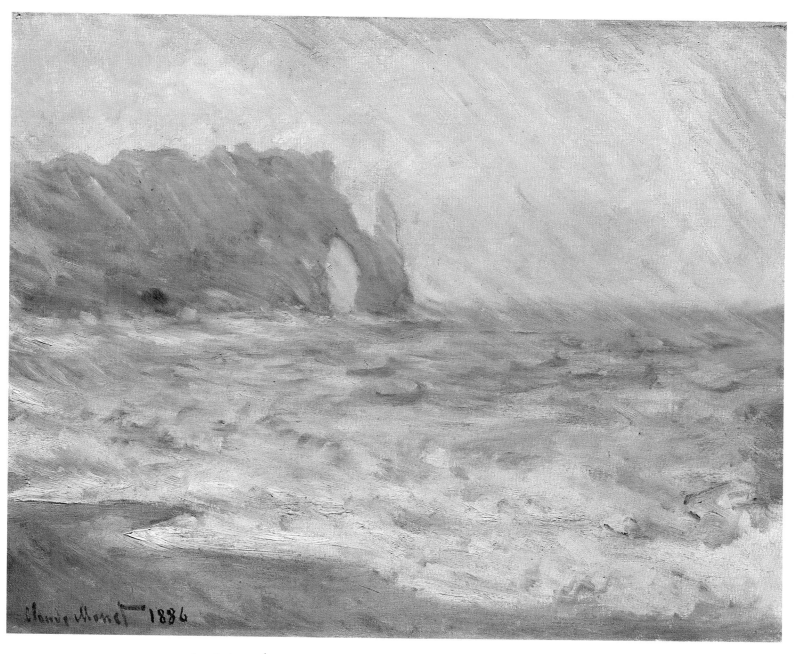

COLORPLATE 65. *Rain at Étretat.* 1886. 23⅞ × 29¾″ (60.6 × 75.6 cm). National Gallery, Oslo.

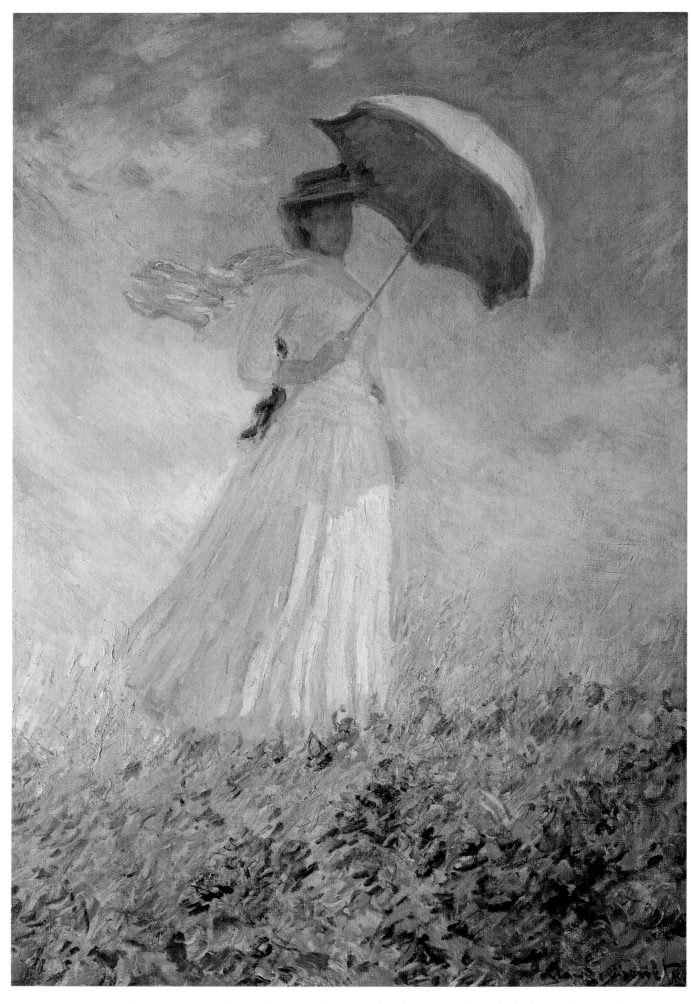

COLORPLATE 66. *Woman with Umbrella Turned to the Right: Attempt at Figure Painting Outdoors.* 1886.
51⅝ × 34⅝″ (131 × 88 cm). Galerie du Jeu de Paume, Musée du Louvre, Paris.
Photograph: Musées Nationaux, Paris.

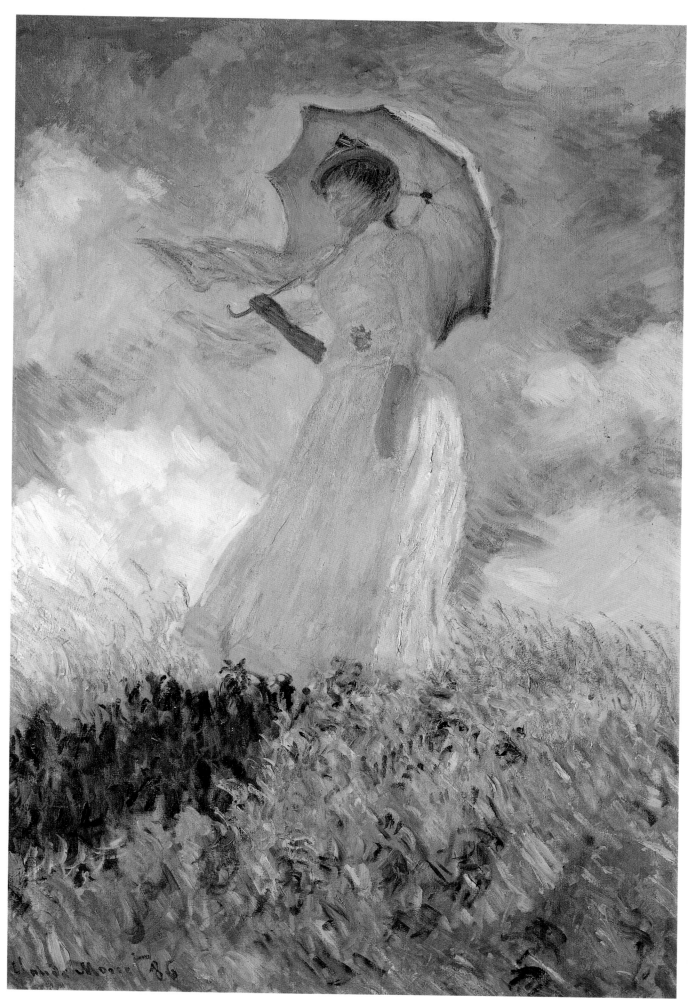

COLORPLATE 67. *Woman with Umbrella Turned to the Left: Attempt at Figure Painting Outdoors.* 1886.
51⅝ × 34⅝″ (131 × 88 cm). Galerie du Jeu de Paume, Musée du Louvre, Paris.
Photograph: Musées Nationaux, Paris.

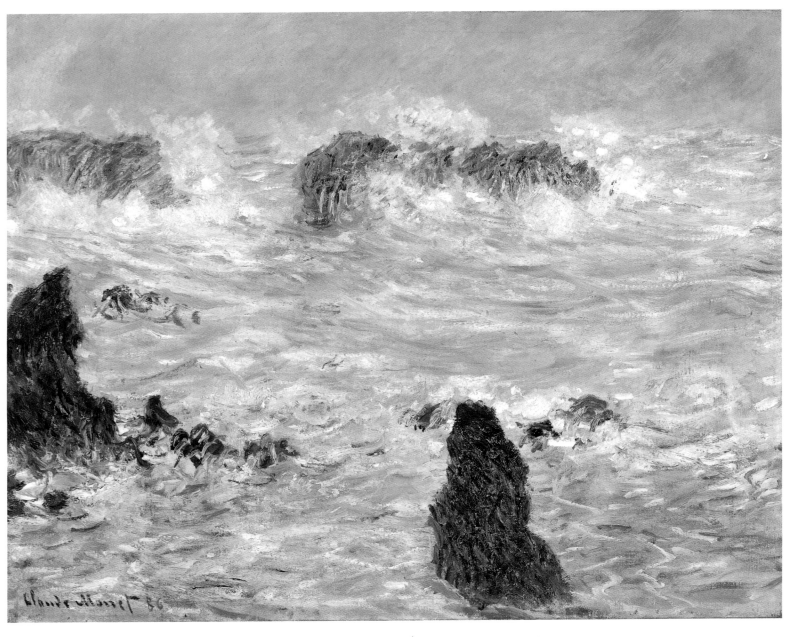

COLORPLATE 68. *Tempest on the Coast of Belle-Île.* 1886. 25⅝ × 32¼″ (65 × 82 cm).
Galerie du Jeu de Paume, Musée du Louvre, Paris. Photograph: Musées Nationaux, Paris.

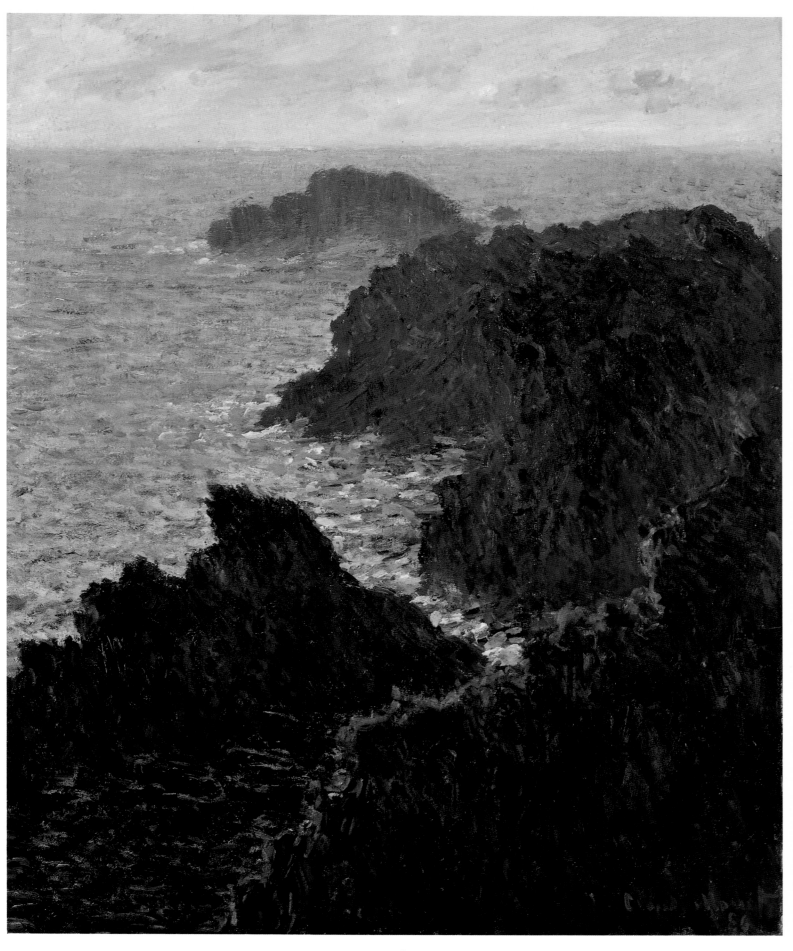

COLORPLATE 69. *Rocky Headland at Belle-Île*. 1886. 31⅞ × 25⅝″ (81 × 65 cm).
The St. Louis Art Museum.

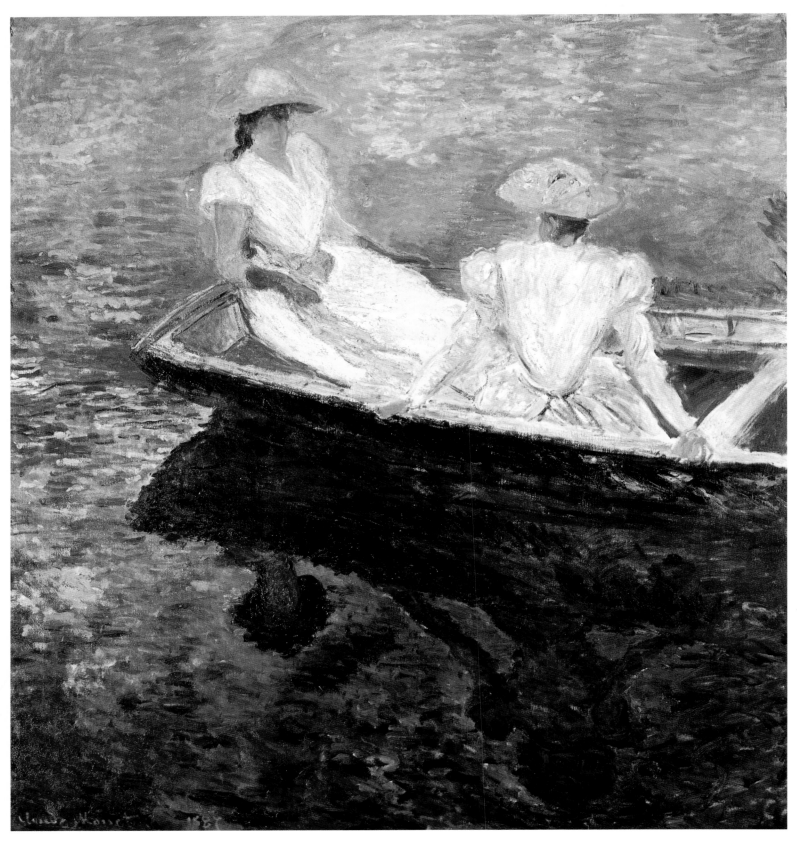

COLORPLATE 70. *Young Women in Boat.* 1887. 57⅛ × 52″ (145 × 132 cm).
The National Museum of Western Art, Tokyo.

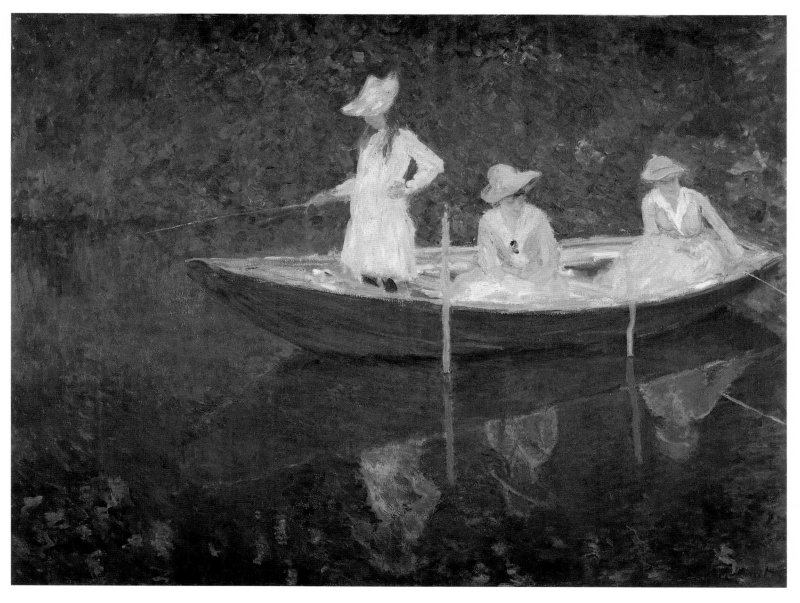

COLORPLATE 71. *The Boat at Giverny.* 1887. 38⅝ × 51⅝″ (98 × 131 cm).
Galerie du Jeu de Paume, Musée du Louvre, Paris. Photograph: Musées Nationaux, Paris.

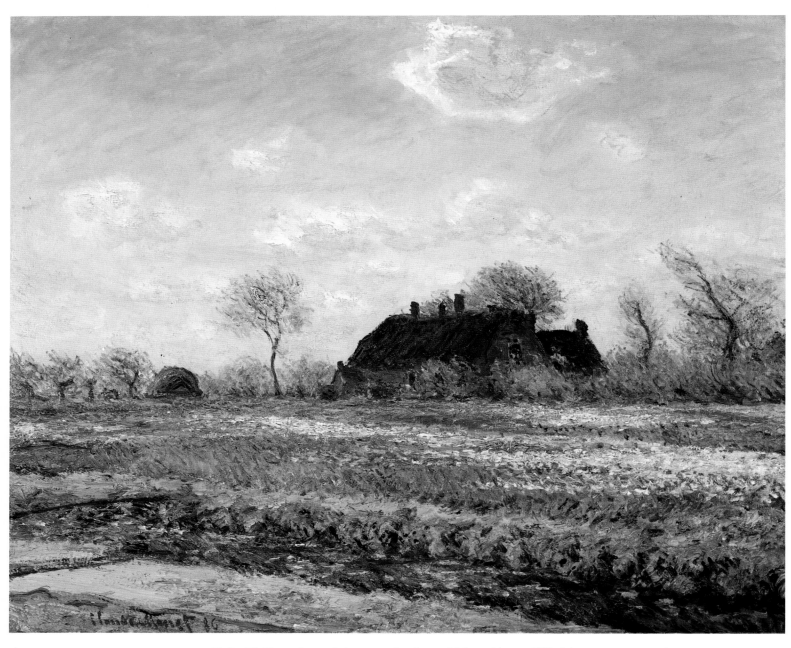

COLORPLATE 72. *Tulip Fields at Sassenheim, near Leyden.* 1886. 23½ × 28¹³/₁₆″ (59.7 × 73.2 cm).
Sterling and Francine Clark Art Institute, Williamstown, Massachusetts.

In short, with all this correcting, I am tracking nature without being able to capture it; and then there is the river, which is low, then high again, green one day, then yellow, sometimes dry, and tomorrow a torrent, after the terrible rain that is falling now. In a word, I am very anxious. Write me; I very much need cheering up, and you can understand that Rollinat is not the one to buck me up! When I tell him my concerns, he just tries to outdo me, and while he is well aware of the difficulties of his own art, he doesn't realize how hard it is for me to do what I do; he sees only the strange side of painting!

The methods of the painter from Paris kept the country folk amused for a long time: when he was almost finished with the portrait of the old tree whose branches reached out over the river, hadn't he taken it into his head to have the green shoots removed as they began to brighten that old skeleton that was always ready to renew itself? And hadn't he had the barber come to cut his hair as he worked, so as not to waste time, while Pistolet, solemnly seated, observed the scene?

What Monet saw and painted at the Creuse was virtually unknown in Paris. This unique series immediately found buyers—in America. As it almost always does when faced with the powerful expressions of a personality, the French state stood aside.

* * *

It was in the period from 1890 to 1894 that, through Monet, I met the impressionist painters. I had the honor to be included in their monthly dinners, held at the Café Riche. Besides Claude Monet, those present at these dinners were Camille Pissarro, Auguste Renoir, Alfred Sisley, Gustave Caillebotte, Dr. de Bellio, Théodore Duret, Octave Mirbeau, and, sometimes, Stéphane Mallarmé.

They were evenings of conversation, where the events of the day were discussed with the openmindedness of artists far removed from any official organizations. I must admit that the company of impressionists was

Georges de Bellio (1828–1894), Rumanian-born physician who was one of the few early collectors of impressionist works. He was a financial mainstay for Monet, Renoir, and Pissarro, especially during the difficult years from 1874 to 1880.

Landscape. 1889. 29 × 36¼″ (73.7 × 92.1 cm). Philadelphia Museum of Art; William L. Elkins Collection.

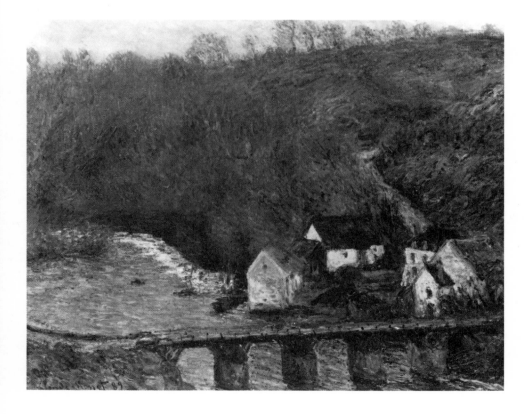

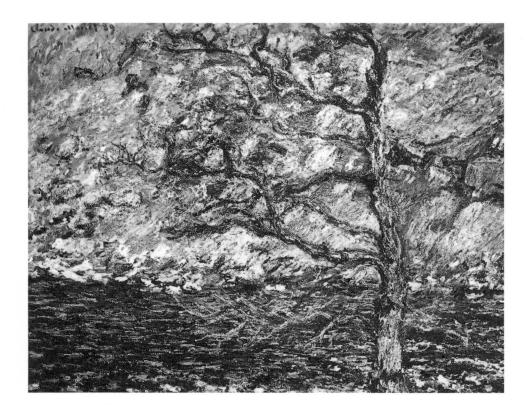

Old Tree at Fresselines. 1889. 31⅞ × 39⅜″ (81 × 100 cm). Destroyed during World War II. Photograph: Fondation Wildenstein, Paris.

a fairly boisterous one, and that these men, relaxing from their cares and their work, displayed the high spirits of children off from school.

* * *

[Like Caillebotte] . . . Pissarro and Monet were also avid readers, and the taste of both refined and discerning. I remember a heated debate for and against Victor Hugo, wherein all our passions came into play, all our ardor, and all our wisdom; we left, reconciled, to go sit at some outdoor café or other and wonder at the ever-enchanting fairy-tale spectacle of Paris at night. On other occasions, our discussions carried us out the door onto the boulevard, and I do believe that some never ended at all.

* * *

In 1890, Monet begins his studies for the Water Lilies. His first report to me, dated 22 June 1890, on these Water Lilies, or Water Landscapes, shows him aware of the dream that haunts him, and of the difficult task he must fulfill:

> Once again, I have taken on something impossible: water with grasses undulating on the bottom. . . . it is wonderful to look at, but maddening to want to render it. But then, I am always tackling something like this!

COLORPLATE 77

And, indeed, these works do not paint themselves, as many of those who look and render hasty judgments on the results of such toil can well believe. A month later, on 21 July 1890, Monet writes again:

> . . . I am feeling very low and profoundly disgusted with painting. It is nothing but constant torture! Don't expect to see any new works; the little I have managed to do is destroyed, scraped off, or staved in. You have no idea of the dreadful weather that we have had for two months straight. It is enough to make one raving mad, when one is trying to render the weather, the air, the atmosphere.
> With all of this, all of these miseries, I have contracted a

stupid rheumatism. I am paying the price for all those times under the rain and snow, and what distresses me is the thought of having to give up braving all weathers and working outside, except when the weather is fine. Life is so stupid!

Well, enough complaining; come see me as soon as you can. Affectionate regards.

Leaving off the Water Landscapes, Monet has returned to work on the *Haystacks*. There, too, he is in despair, but he is excited about his work, and, at the same time, excites his friends. A letter dated 7 October 1890:

> . . . It is a grind; I am determined to capture a particular series of different effects [of the haystacks], but at this time of year, the sun goes down so fast that I cannot keep up. . . . I despair at how slowly I work, but as I go on, I see more and more clearly that I will have to work hard to render what I am after: that "instantaneity," above all, the envelope, the same light spreading all about, and, more than ever before, I am disgusted with the easy things that come at the first attempt. In short, I am more and more driven by the need to render what I feel, and I pray that I may continue to live not too helplessly, because it seems to me that I could make some progress.
>
> As you see, I am in good humor. I hope that you, too, who are young, will have shaken your doldrums and will turn out something great! Write to let me know when you are coming back and also what you are doing.
>
> Mirbeau has become a "master gardener." That is all he thinks about, that and Maeterlinck the Belgian; it sounds wonderful—I mean to read it. Affectionate regards.

Maurice Maeterlinck (1862–1949), Nobel Prize-winning Belgian writer and dramatist whose stories were often set in exotic, enchanted locales.

OCTAVE MIRBEAU

L'ART DANS LES DEUX MONDES

"Claude Monet"

March 7, 1891

Octave Mirbeau (1848–1917), novelist, art critic, gardener, and friend of Geffroy, Mallarmé, and Rodin. He became a confidant of Monet's beginning in the late 1880s.

A pink-stuccoed house, at the bottom of a garden always radiant with flowers.

It is springtime.

The wallflowers are exhaling the last of their fragrance; the peonies—the divine peonies—are fading; the hyacinths are dead. The nasturtiums are already showing their young bronze greenery, the eschscholtzias, their long, tapered leaves of a delightful acid green; in the wide beds that they border, against a background of flowering orchards, the irises raise their strange, curling petals, frilled with white, mauve, lilac, yellow, and blue, streaked with brown stripes and crimson-purple markings. Their elaborate depths evoke mysterious analogies, dreams of temptation and perversity, like those that emanate from the disturbing orchids. . . . From the tops of their supple stalks, the day lilies bow their fragrant calyxes; and the poppies on their villous stems open wide vermilion cups and wind around their horizontal stakes. The great blossoms of the clematis spangle the surrounding greenery, the sky of their

Monet's house at Giverny. Lilla Cabot Perry Papers (1889–1909), Archives of American Art, Smithsonian Institution, Washington, D.C.

immaculate, white corollas touched with a mere breath of azure and pink. And the summer plants, between the brightening borders, everywhere prepare for the joy of coming into bloom.

It is summer.

On either side of the sandy path, nasturtiums of every hue and saffron eschscholtzias collapse into dazzling heaps. The surprising fairy-tale magic of the poppies swells on the wide flower beds, covering the withered irises; it is an extraordinary mingling of colors, a riot of pale tints, a resplendent and musical profusion of white, pink, yellow, and mauve, an incredible rolling of blond flesh tones, against which shades of orange explode, fanfares of blazing copper ring, reds bleed and flare, violets disport themselves, black-purples are licked with flame. And here and there, rising from this marvelous wave, from this marvelous flow of flowers, the hollyhocks dress their masts with exquisitely rumpled fabrics, as light and vaporous as gauze, their creases satin-brilliant; they bear little dancers' skirts that balloon and billow. The suns of the Texas roses reach out their long bracts heavy with buds, and the great California sunflowers leap, shoot their green eyes upward, their tousled flower heads crested with gold, like fabulous angry birds. In the air, the fresh breath of the mignonette mingles with the nasturtiums' peppery scent.

It is autumn.

The nasturtiums have overgrown the path, and their blossoms, multiplied to infinity, have consumed the yellowing leaves in their radiance. The sumptuous fairyland of dahlias has succeeded that of the poppies, their fluted ruffs preciously edged with fine gold, with bleeding crimson, with tender lilac; they are overlapping tufts of every bright color and every subtle shade; they are stars that tremble and twinkle atop fragile branching stems, charming in their airy, bold grace; they are tatters of ancient silks, their tints dimmed, their embroidery charmingly faded; they are huge plumes, their slashed petals tapering, spreading, twisting into scarlet manes. At their feet, the China asters open, radiantly fresh, their ruffs of antique lace; the snapdragons gloss the speckled, parti-colored velvet of their masks, like ravenous beasts; the Japanese anemones, in their attitudes of devotion, sway slender white corollas like nuns' coifs; the artless corymbs of the phlox smile from the profusion of their tiny, ingenuous eyes; the late gladioli bear their sumptuous cups, reach their

lily-like throats to the bees' infatuated flight. The air is filled with so much glimmering, so much quivering, so many pollens, and the towering sunflowers turn their yellow discs, they blaze and glow, and the tall tufts of the harpaliums pour out the gold of their inexhaustible flowering.

Behind the pink-stuccoed house lie the undulating hills, their slopes robed in the changing motley of the harvests; in front of the garden, always radiant with flowers, stretches a succession of meadows, vast and deep; meadows where rows of poplars, in the dusty mist of the Normandy climate, form charming, dreamlike backdrops; meadows where the Epte meanders, sinuous and melodic, between shaded banks, between golden colonnades bearing supple arches and light-pierced canopies, trailing the swaying grace of the creepers and the mobile whimsy of the hops.

This is where Claude Monet lives, in this neverending feast for the eyes. It is just the environment one would have imagined for this extraordinary painter of the living splendor of color, for this extraordinary poet of tender light and veiled shapes, for this man whose paintings breathe, are intoxicating, scented; this man who has touched the intangible, expressed the inexpressible, and whose spell over our dreams is the dream that nature so mysteriously enfolds, the dream that so mysteriously permeates the divine light.

<center>* * *</center>

. . . And who better than this painter of the western mists, of snowy winters glittering with frost, of the ocean's vast and terrible rhythms; who better than this bard inspired by rose-pink springtimes and mother-of-pearl dawns, by the restless glimmers of transparent waters; who understands and renders better the hard terrains and immense deserts of the southern skies, its glossy greenery, the olive trees' twisted bronze, all that classical theatrical decor, grand and spare, still haunted by the voices of Virgil and Lucian.

<center>* * *</center>

. . . I think that the critic faced with these works, which through their singular visual pleasure whisper to the spirit of the noblest, highest, most far-reaching ideas, must renounce his petty, curt, and sterile analyses;

Monet's studio seen from across the garden. Lilla Cabot Perry Papers (1889–1909), Archives of American Art, Smithsonian Institution, Washington, D.C.

only the poet has the right to speak and to sing, for Claude Monet—who brings no direct literary concerns into his works—is, with Puvis de Chavannes, perhaps the painter who most directly and eloquently speaks to poets. What a delightful, thrilling stroll it is, full of surprises for the mind, to follow him through the world of nature recreated through his incomparable genius, a nature of passion, turbulence, and flow, wherein, at every caressing and sensual step, the dream lurks, waiting to capture you, take you off to the mysterious, profound, and ever-renewed festival of the hours. What is enchanting about Claude Monet is that, although he is obviously a realist painter, he goes beyond the mere representation of nature and its chromatic and plastic harmonies. Just as with a human face, one sees and feels all the emotions, the hidden passions, the moral tremors, the buoyancies of inner joy, the sadness and sorrows, all the energies of the soul that nature stirs in us, all that is infinite and eternal, greater than ourselves, all that is immortalized in nature. Claude Monet's landscapes illuminate, so to speak, the planet's states of consciousness and the suprasensible shapes of our thoughts. And he has no need to vary his themes and change his settings in order to inspire in us a panoply of impressions. A single theme—as in his stunning series of haystacks in winter—is enough to allow him to express the manifold and so various emotions that the drama of the earth undergoes from dawn to nighttime.

And with how many meteoric episodes, beyond anything imagined by his predecessors, has he not endowed the art of painting? What has he not rendered of quivering air and wave, of celestial rhythms, of the sweet tones of the atmosphere, of transparencies peopled with unseen shapes?

For example:

In light-colored dresses, two young girls, charming in their grace and lithe abandon, are seated in a skiff that floats on almost-black water, on the deep water of a shaded river, its banks out of our field of vision, cut off as they are by the frame. The current is swift, it flutters the mauve and rose reflections of their dresses among the spangled sunlight and the mobile greens of the reflected leaves. But the drama lies elsewhere. The foreground is all water, its mirrored surface brilliant and coursing; the eye gradually sinks into this streaming freshness, discovering through its flowing transparences the riverbed of golden sand, a whole life of interlacustrine flora, of extraordinary underwater vegetation, of long, stringy, tawny, greenish, crimson-purple algae; in the current's thrust they tumble, twist, whip, spread, and gather, like flaccid and bizarre manes; they undulate, weave, flow back on themselves, stretch, like strange fish, like the fantastic tentacles of sea monsters.

Or:

On a sunlit hillside—we see only the summit, the rose-pink earth, the dry grasses—against the sky, against the sweet-toned sky, among the white and rose clouds that race across the azure of the firmament, a woman makes her way, slender, light, imponderable; a gust of wind is in the fluttering chiffon of her veil, the bottom of her dress is raised in back, tossed by the flight of her stride; she seems to skim across the grass. In her modernity, she has the distant grace of a dream, the unexpected charm of an airy apparition. Observe her closely. It is almost as if she will be gone shortly. The parasol she carries, with her arm in a delightful attitude, bathes her face in golden shadow, and blossoms over her like a great flower. No arabesques, nothing but simple, straight, fleeting lines of extraordinary elegance, of truly masterly and surprising purity and sensitivity and breadth of drawing. These are exquisite landscapes, this woman's supple body, and this dress made of an unnameable fabric of fused reflections, gentle shadows, and vivid light.

Or else:

Out of the shadows, out of mystery, out of the shadows that bathe her

COLORPLATE 77

COLORPLATE 66

Portrait of Suzanne with Sunflowers. 1890. 63¾ × 42⅛″ (162 × 107 cm). Private Collection. Photograph: Fondation Wildenstein, Paris.

completely, out of the deep and transparent shadows, appears a young woman, seated, her elbows propped on a lacquered table. Her dress is mauve, a mauve that becomes more violet as it melts, with its outlines, into the violet shadows; her dress reveals her gently curved nape and the base of her throat. Her beauty is delicate and sad, infinitely sad. She is enigmatic, her eyes are vacant, one of her arms hangs, her posture is apathetic—languid and charming. What is she thinking? We do not know. Is this ennui, sorrow, remorse? What is her soul's secret? We do not know. She is as strange as the shadows that envelop her completely, that, like her, are disturbing and a little terrifying. But stranger still are the three immense sunflowers surging out of a vase that stands near her on the lacquer table: they rise, they spin above and in front of her forehead, like three rayless stars of an unusual green flecked with metallic glints, like three stars from somewhere; they add an auroral mystery, a

shrinking back of shadow, to the mystery, to the shrinking back of the ambient shadows. The effect is compelling. One is reminded despite oneself of a Ligeia, ghostly and real, or of certain images of women, specters of the soul, like those evoked in certain of Stéphane Mallarmé's poems.

* * *

I imagine that Claude Monet is harboring still other surprises for the public who only know his wonderful landscapes. But to those of us who know of the dreams that haunt his great and indefatigable creator's mind, there will be no surprises, only the planned, logical, and inevitable materializations of long-cherished intentions, the natural coming to fruition of the dreams that haunt his vast genius, which could only express all that is expressible in life by living several human spans. And therein lies one of his greatest torments: "There is no time for anything!" he often says sadly. And yet, still young, vigorous, with a long working future still ahead of him, he is of all the artists of this century, perhaps, the one who has already produced the greatest body of work.

How far he has come from *The Port at Honfleur* and *The Church of Saint-Germain-l'Auxerrois*—both so beautiful in the classical mold, and reminiscent of Canaletto's finest works—to the extraordinary haystacks of this past winter! What conquests from one year to the next! Not an instant of weakness, not an instant of hesitation or of regression in Claude Monet's upward, direct, unswerving, and swift course toward what lies beyond progress itself. It is something rare, deserving of the highest praise, this ceaseless outpouring of masterpieces, this magnificent moral health that nothing enervates, nothing defeats. I love this man, who could aspire now to all the vain pleasures that fame bestows on its chosen ones; I love to see him, between projects, in shirt-sleeves, his hands black with soil, his face tanned by the sun, happy to be planting seeds, in his garden always radiant with flowers, against the modest and cheerful background of his little pink-stuccoed house.

GUSTAVE GEFFROY

L'ART DANS LES DEUX MONDES

"Claude Monet Exhibition"

May 9, 1891

This preface, written by our associate, M. Gustave Geffroy, is taken from the catalog of works that make up this remarkable exhibit.

The grouping together of fifteen canvases of haystacks, each representing the same subject, with a rendition of the same landscape, is an extraordinarily victorious artistic demonstration. For his part, Claude Monet has been able to substantiate the continuous appearance in new aspects, of immutable objects, the uninterrupted flood of changing and interrelated sensations, apparent in the face of a changeless spectacle. He substantiates the possibility of summing up the poetry of the universe within a circumscribed space.

For one year, the traveler has given up his travels, the hiker has forbidden hiking. He dreamed about the places he had seen and transcribed: Holland, Normandy, the south of France, Belle-Île-en-Mer, the

COLORPLATE 78

COLORPLATE 79

Creuse, the villages on the Seine. He dreamed as well of places he had only visited but to which he would like to return: London, Algeria, Brittany. His fancy roamed over vast expanses and zeroed in on special areas that attracted him: Switzerland, Norway, Mont-Saint-Michel, the cathedrals of France, as lofty and beautiful as the rocks on promontories. He regretted being unable once more to capture on canvas the hurly-burly of cities, the movement of the sea, the loneliness of the sky. But he knows that an artist can spend his life in the same place without exhausting the possibilities of the constantly renewed scene around him. And right there, two steps from his tranquil house, its garden ablaze with flowers, there he stopped on the road one summer evening and looked at the field with haystacks, a humble piece of land adjoining some low cottages, surrounded by nearby hills, decked out with the unbroken procession of clouds. He stayed at the edge of this field that day and returned the next day and the day after and every day until autumn and through the whole of autumn and the beginning of winter. Had the haystacks not been removed he could have continued for an entire year recording the seasons, showing the infinite changes wrought by the weather on the eternal face of nature.

These haystacks, in that deserted field, are transitory objects on which are reflected, as on a mirror, the influences of the surroundings, atmospheric conditions, random breezes, sudden bursts of light. They are a fulcrum for light and shadow; sun and shade circle about them at a steady pace; they reflect the final warmth, the last rays; they become enveloped in mist, sprinkled with rain, frozen in snow; they are in harmony with the distance, the earth, and the sun.

They first appear during the calm of beautiful afternoons. Their edges are fringed with rosy indentations of sunlight; they look like gay little cottages set against a background of green foliage and low hills covered with rounded trees. They stand erect beneath the bright sun in a limpid atmosphere. On the same days, as evening approaches, the light on the downside of the hills has turned blue, the ground is speckled, the hay is dappled with purple, their contour is silhouetted with an incandescent line. Then there are the multicolored, sumptuous, and melancholy festive days of autumn. When the sky is overcast, trees and houses seem remote, like phantoms. In very clear weather, blue shadows, already cool, extend along the pink earth. At the close of warm days, after

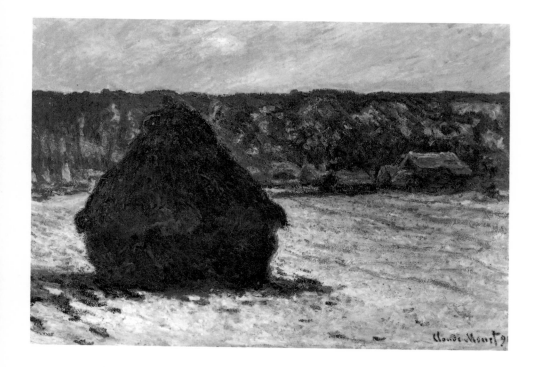

The Haystacks in the Snow: Overcast Day. 1891. 25³/₁₆ × 36¼" (64.1 × 92.1 cm). The Art Institute of Chicago; Mr. and Mrs. Martin A. Ryerson Collection.

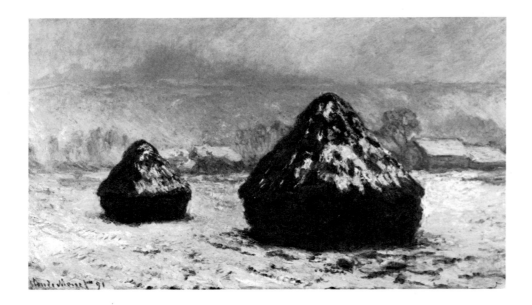

Haystacks: Snow Effect. 1891. 23⅝ × 39⅜″ (60 × 100 cm). The Shelburne Museum, Shelburne, Vermont.

a persistent sunlight that appears to depart reluctantly, leaving behind a sprinkling of golden dust on the countryside, the haystacks glow in the confusion of evening like heaps of somber gems. Their sides split and light up, revealing garnets and sapphires, amethysts and topazes; the flames scattered in the air condense into violent fires with the gentle flames of precious stones. These red-glowing haystacks throw lengthening shadows riddled with emeralds. Later still, under an orange and red sky, darkness envelops the haystacks, which have begun to glow like hearth fires. Veils of tragedy—the red of blood, the violet of mourning—trail around them on the ground and above them in the atmosphere. Finally it is winter, with its threatening sky and the white silence of space; the snow is lit with a rosy light shot through with pure blue shadows.

With all of its faces, this same place emits expressions comparable to smiles, frowns, serious looks, mute amazement; they express force and passion, moments of intoxication. Here nature's mysterious enchantment murmurs incantations of form and color. A refined and exalted vision takes shape; a spirit hovers amid the reflections of multiple colors, and in this matter illuminated with sparks, pointed bluish flames, scattered phosphorescent and sulfurous flashes make up the phantasmagoria of the countryside. An unquiet dream of happiness emerges in the roseate softness of day's end, rises in the colored smoke of the atmosphere, and blends in as the sky passes over objects.

The same message conveyed by the light in the haystack landscapes is transmitted in the other canvases that Claude Monet added to this significant series exhibited here. Whether he spreads before us a meadow reddened with flowers, a field of light oats; whether he enframes a lump of earth, this massive hilltop; whether he presents these figures of airy, rhythmic girls, rising willowy in the golden sunshine and the passing clouds—he is always the incomparable painter of earth and sky, preoccupied with fleeting light conditions on the permanent background of the universe. He conveys the sensation of the ephemeral instant that comes into existence and departs and never again returns, and at the same time, he constantly evokes in each of his canvases—through the weight, the power that comes out from within the curve of the horizon, the roundness of the terrestrial globe—the course of the earth through space. He unmasks changing portraits, the faces of the landscape, the manifestations of joy and despair, of mystery and fate so that we invest everything around us with our own image. He anxiously observes the differences that occur from minute to minute, and he is the artist who sums up meteors and elements in a synthesis. He tells tales of mornings,

COLORPLATE 66

COLORPLATE 67

164

noondays, twilights; rain, snow, cold, sunshine. He hears the voices of the evening and he makes us hear them. Pieces of the planet take shape on his canvases. He is a subtle, strong, instinctive, varied painter, and a great pantheistic poet.

W.G.C. BYVANCK

UN HOLLANDAIS À PARIS EN 1891

1892

Willem Geertrud Byvanck (1848–1925), Dutch essayist concerned with historical, literary, and political topics.

I must confess that from the first moment I entered the gallery where the paintings of Claude Monet were on display, I felt rather out of place. I had come on a general invitation from the painter, which in a sense I could consider a personal one; and no sooner had I arrived but I immediately felt like leaving. Those loud colors, those zigzagging lines, blues, yellows, greens, reds, and browns, dancing a mad saraband on the canvases, hurt my eyes, accustomed as they are to the grays of our national painting.

COLORPLATE 78

COLORPLATE 79

The gallery was still empty, so I had time to reflect and choose a good vantage point. There were fifteen paintings there of the same haystack, painted at different times of the day and during different seasons of the year. After painting Norman landscapes and the bustle of great capitals, the artist had devoted an entire year of his life to observing the existence of a single haystack amid the fluctuations of reflecting light. He had chosen one very simple object close to his house, which at any given moment was close at hand.

One of these paintings displayed the haystack in its full glory. The purple and gold rays of an afternoon sun ignited the straw, and the burning stalks blazed with a dazzling brilliance. The hot air visibly vibrated and bathed objects in a transparent, blue haze.

Truly this painting triumphed over all objections one might have opposed to the art of the master, and the observer's eye was irresistibly compelled by this medley of colors to recreate the artist's vision.

This canvas taught me how to see the others; it awakened them to life and to truth. After hesitating at first to cast my eyes about me, I now felt a rare delight in perusing the series on display and the range of colors they showed me—from the scarlet purple of summer to the chilly gray of a winter evening's dying glow.

At that moment, Claude Monet walked into the room; and for what it was worth, I gave him my impression.

"You're right," he said with the candor becoming of a great artist who can appreciate the sincerity of other people's remarks to him. "That's what I was after. Above all I wanted to be truthful and exact. For me a landscape hardly exists at all·as a landscape, because its appearance is constantly changing; but it lives by virtue of its surroundings—the air and light—which vary continually. Did you notice those two portraits of a woman above my Haystacks?

COLORPLATE 66

COLORPLATE 67

"It's the same woman, but painted in a different atmosphere. I could have done fifteen portraits of her, just like with the haystack. To me, only the surroundings give true value to the subject.

"When you want to be very accurate, you suffer terrible disappointments in your work. You have to know how to seize just the right moment in a landscape instantaneously, because that particular moment will never come again, and you're always wondering if the impression you got was truthful.

"And the results? See that painting over there in the middle—the one that attracted your attention from the very beginning? That one alone is completely successful—maybe because the landscape at that time yielded all it was capable of yielding. As for the rest, there are some that really aren't bad, but they only acquire their full value by comparison and in the succession of the full series."

For those who would find an analogy between the literature and the art of an era, there might be something in the common tendency of both to observe and express the "fact" in its own surroundings as faithfully as possible—an accurate analysis that only takes on its full significance as it is applied to impressions of the same class. And then, such an analysis has value only by virtue of the synthesis the artist has us make for ourselves.

A promising idea, if I'm not mistaken, and one that I will try to put to the test.

OSCAR REUTERSWARD

MONET

1948

* * *

Monet had finally reached the end of his work but intended to go for ten weeks' recreational sojourn abroad before he set about preparing the exhibition; it was postponed until spring, to the end of April. He was of two minds where to go. The choice was between Venice, where Boudin wanted to lure him, and Norway, where his stepson, Jacques Hoschedé, had secured a position.

Refers to the exhibition of his Rouen Cathedral *paintings, to open at the Galerie Durand-Ruel on May 10, 1895.*

In the middle of all this, Puvis de Chavannes' seventieth birthday was celebrated at Hôtel Continental in Paris with a glittering banquet attended by all the celebrities of art and literature. There, Monet met Fritz Thaulow, in whom he confided his travel speculations and his indecision. The mighty Norwegian became all fired up. Of course, Monet should take his trip to Norway! It was a magnificent thought to exchange the polluted atmosphere of France for the crystal-pure air of the Nordic countries! And for the light of winter, the hoarfrost effects, the snow-covered mountains, their majestic silhouettes. In eloquent terms, Thaulow spread Norway out for Monet's inner eyes as the promised land of painters. In his capacity as a Norwegian and the *personnage principal* of Scandinavian artists in Paris, he bid Monet welcome to Norway right then and there. Thaulow's irresistible perspective of his homeland indubitably had the effect on the master of white paint, so that he made up his mind; four days later, on January 21, Monet informed Durand-Ruel of his decision to go to Norway on the 28th.

Puvis de Chavannes' seventieth birthday fell on December 14, 1894.

Fritz Thaulow (1847–1906), internationally successful landscape painter, active in France during the 1890s.

And Thaulow sent the big news to his artist friends in Kristiania. Andreas Aubert posted an article in *Dagbladet* under the headline CLAUDE MONET COMING, in which he said: "He is coming to paint our winter in all its light and glory . . . and this year, of course, we have a real winter to offer." Aubert then went into an exposition of Monet's importance to modern painting and entertained his Norwegian readers with his memoirs of café debates in Paris. Among other things, he spread the by-then-traditional fallacy about Monet's "connection to scientists" in the field of optics and color theory, "Chevreul, Brücke, Helmholtz," and so forth. Aubert finally expressed the hope that the great Frenchman might honor the national spring exhibition in Kristiania by participating with some of his winter pictures.

Andreas Aubert (1851–1913), influential historian of nineteenth-century art in Scandinavia and Germany.

It was at the last moment that Monet reached Malmö, Sweden. Already the same day, it was announced officially that all Swedish and Norwegian ports were icebound. After that, during most of February, Scandinavia was isolated from the continent as an enormous North Polar expedition would be, with the telegraph alone as a line of communication. The artist's train through Sweden was repeatedly halted by the unusually heavy snowdrifts on the rails, so his stay in our country became more protracted than planned. The welcoming committee made up of artists, which was on hand at Kristiania's East Railway Station on the morning of February 1 in time for the usual arrival of the express from Sweden, had to wait until evening, and the welcome breakfast for the Frenchman at Holmenkollen turned into a welcome supper.

Monet settled down in Grand Hotel on the Karl Johan and immediately began to inspect the city's surroundings. These initial excursions were as usual tinged with indecision and uncertainty. He was confused by all the snow that sprawled over everything in sight, flattening out the contours of the landscape, and he felt thoroughly disappointed in what he saw. Nature did not offer the stimulating vistas that the excellent Thaulow had sketched for him. In the company of a young painter, Otto Valstad, he went to Sandviken on the Kristiania fjord, a bit south of the capital. At that time this spot was much favored by Norwegian painters and was a special place of sojourn for the so-called "Lysaker clique" of Werenskiold, Munthe, Thaulow, Eilif Peterssen, and Christian Skredsvig. This place won Monet's approval. Here he had the genuine elements of Norwegian nature concentrated all around him: to the west, the mountainous stretches of the hinterland, with the dark cone of Kolsaas as the principal feature; to the east, the fjord and the coastline. He kept his hotel suite in the city but stayed on in Sandviken. He took a lodging with Jenny Bjørnson, Bjørn Bjørnson's first wife, whose house was outside the community proper and with whom artists and writers used to stay. Among Monet's fellow lodgers was Hermann Bang, who had just arrived there from his unsuccessful theater management in Paris. He was the only one who had a command of the French language, and the meals were for the most part characterized by the dialogues between him and Monet, which were incomprehensible to the others.

Otto Valstad (1862–1950), self-taught Norwegian painter and illustrator.

Scandinavian painters:
Erik Werenskiold (1855–1938)
Ludvig Munthe (1841–1896)
Eilif Peterssen (1852–1928)
Christian Skredsvig (1854–1924)

Bjørnstjerne Bjørnson (1832–1910), leading Norwegian novelist, poet, and dramatist.

Hermann Bang (1857–1912), Danish journalist and novelist. Tine first appeared in 1889.

Norwegian Landscape: Björnegaard. 1895. 25⅝ × 31⅞" (65 × 81 cm). Musée Marmottan, Paris. Photograph: Georges Routhier, Studio Lourmel, Paris.

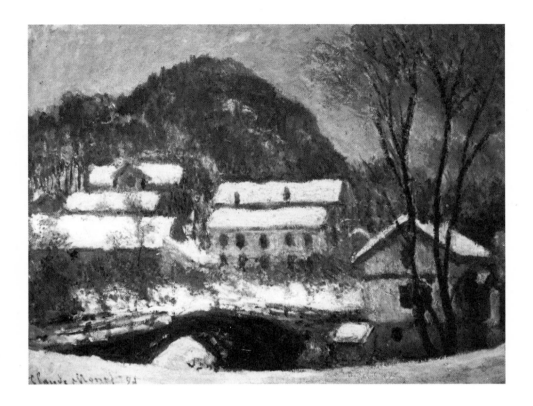

Sandviken, Norway: Snow Effect. 1895. 28¾ × 36¼″ (73 × 92 cm). Private Collection. Photograph: Sotheby's, New York.

By the middle of the month came the February storms, which blew the snow from the trees and the mountainsides and made the views exciting and rich in contrasts. Monet was delighted and regained his resolution. He posted himself out in the snow with his painting gear. He only asked for a few angles of vision and soon established them. His first observation point was the southern bank of the Sandvik River, at the exact spot by Løkke Bridge where the clustered plants of Sandvikens Jernindustri now rear their concrete walls. From there he had a brilliant view over the community of villas at the foot of Løkkaas and the jolly cast-iron bridge over the river. While he was working, the snow was gradually dusted from the mountain crests, and the cold intensified. Toward the end of the month, the average temperature was a good minus-thirty degrees Celsius. But in no way did that cool the artist's inspiration, and he did not leave his place at the easel.

COLORPLATE 86

Sandviken, via Christiania, February 26, 1895

Dear friend, a brief note just to assure you of my fate, so that you don't suppose that I have died from the cold.

I am filled with wonder by all that I see in this marvelous country. I have been on four-day outings by sleigh, in the mountains, over fjords, on the lakes; it's fantastic! With all this accomplished with the average temperature being 25° at noon, still I have never suffered, to the great amazement of the Norwegians, who are more sensitive to the cold than I am! I am in very good health, in spite of the atrocious food, but very annoyed at not being able to paint all that I see! I did not know where to look and became so discouraged that on several occasions I almost took the train back home.

At last I have found a suitable location in which to settle, and here I am at work, though it has only been for a few days. I have started eight paintings, and if I am not too thwarted by the weather, they will give you some impression of Norway and the area surrounding Christiania, a country less terrible than I had imagined. I would have liked to have gone farther north, but it is hardly possible in this season. However, it is terribly

beautiful all the same. I was not able to see even a small bit of sea or any water whatsoever. Everything is frozen and covered with snow. One should live here for a year in order to accomplish something of value, and that is only after having seen and gotten to know the country.

I painted today, a part of the day, in the snow, which falls endlessly. You would have laughed if you could have seen me completely white, with icicles hanging from my beard like stalactites.

<div style="text-align:right">

Your faithful friend,
Monet

</div>

Saturday March 3 was to be the opening day of the spring exhibition in Kristiania. In Sandviken, Monet received an invitation for specially invited guests to view the exhibition on the day before the opening. Bang was also invited, and they went together to the grand event. The show was set up in "Tivoli," a now-vanished amusement place adjacent to the National Theater. What Monet got to see was not a representative survey of painting in the United Kingdoms of Scandinavia. Many of the big Norwegian artists, Thaulow among them, did not participate that year, and the Swedes were represented by only a few names. Nevertheless, Monet became well enough acquainted with the Nordic sentimentality of the 1890s. The greater part of the pictures on display evoked dusky dreams and tired evening chords. There hung Eilif Peterssen's summer evenings; Munthe's saga moods, with glaring color contrasts and baroque drawing; Gabriel Kielland's mystic fjord poems. And among the Swedish: some of Eugène Jansson's blue April nights over Stockholm, and Hanna Pauli's picture from Visby, *The Old City Wall*. Monet went around and looked closely at everything. Following on his heels were the gentlemen of the committee, reverential and dressed to the occasion. They were expecting compliments from their famous French guest, but he did not emit a single word.

Hermann Bang recounts: "The committee was furious. I told him later, as we were walking together to the post office in Sandviken: 'You know you offended the gentlemen.'

'My dear Bang!' he said. 'What would you like me to have said about all those colors?' "

Gabriel Kielland (b. 1871), Norwegian painter and architect.

Hanna Pauli (b. 1864), Swedish painter.

It may be pointed out, by the way, that Monet did not, as Andreas Aubert had hoped, send any canvases for the exhibition.

One day, it all of a sudden dawned on Monet who Bang was, that fascinating and strange man whom he had involved in such long conversations over his meals. Christian Krogh has reproduced the exchange between Monet and Bang when they had sat down at Jenny Bjørnson's breakfast table the morning after Monet's discovery:

Christian Krogh (1852–1925), controversial Norwegian realist painter whose novel Albertine, *an exposé of prostitution, was banned.*

Monet: You are a poet, aren't you?
Hermann Bang: Yes.
Monet: You have never mentioned that to me.
Hermann Bang: No.
Monet: Why not?
Hermann Bang: I didn't think it could be of more interest to you than the neighbor's cat.
Monet: Among the books that were sent to me from Paris there is your *Tine* in French translation. Now I'd like to tell you something: Do you think I'm a great impressionist painter?
Hermann Bang: Yes, Monsieur Monet!
Monet: Good! Then my answer to you is that *Tine*, as an impressionist work of art, figures among the very best!

And Bang once gave his word that the comment Monet made on that occasion was more important to him than all the fame he later earned during his successful life. After that, the painter and the poet always went together to the post office in Sandviken, the former to study it from an artistic point of view, the latter to pick up the daily mail.

Monet had promised his art dealer to return by the middle of March in order to have enough time to prepare the showing of the cathedrals. But his experience in the "pays de septentrion" so captivated him that he decided to prolong his stay, even though he again risked having to postpone the exhibition. He wrote to Geffroy asking him to put in a good word with Durand-Ruel and get his assent to it. When a reply did not immediately arrive, he wrote to the art dealer personally:

Sandiken (Christiania) March 9, 1895

Dear Mr. Durand,

Several days ago, I wrote to Geffroy requesting that he visit you to ask you, in my stead, if it would not be inconvenient to delay my exhibition by two weeks, for this would allow me to complete several paintings which I am still working on. I have not received an answer, and I fear that Geffroy did not receive my letter. I am therefore begging you to send a response by telegram to the above address. I am in a marvelous country and would like to be able to render all that I see, so I was very distracted, and at first I was discouraged and could do nothing. Things are starting to go better, but it's the weather that worries me, and I would be happy if I could extend my stay a little. Therefore, I impatiently await your answer. I have just learned of the death of Mrs. Manet. It is a great sorrow to me and an even greater loss for her friends.

Reference to the death of fellow impressionist Berthe Morisot (-Manet) on March 2, 1895.

In haste, with
best wishes, yours sincerely,
Claude Monet

The second important observation point the artist chose for working was by Helgerud, with a view toward the mighty porphyritic mass of Kolsaas. This was the motif he used for his most extensive and well-known Norway series, *Mount Kolsaas*. Bang followed his "co-impressionist's" work on this project with fascination, and at an artists' party at Thaulow's much later on, he told the Norwegian painters about it, enraptured:

"I don't know what it was called. It was a mountain. It looked like a human being. He painted the mountain as though it were many different figures. In one picture it had like a coat of snow slung on top of it; it was like an ermine mantle aslant over it."

Bang stood up from the table and placed his napkin from the right shoulder down over his chest—and Christian Krogh felt he thereby became a striking reminder of Monet's Kolsaas.

Bang continued: "It was magnificent! It was a wrathful queen standing there. Or Tragedy, risen to her feet with her head raised. And he painted more. The same mountain—an old, weather-beaten hag. The same mountain—a young, white-clad bride."

Before Monet left the place, he also did some studies at Sandviken's piers, "au bord du fiord." Some were views out over the water and the offshore islands—Snarøen, Kalvøen, and others—and some were views of the fjord toward Kristiania as seen from Snarøen, where he had been taken by boat.

Prince Eugen came into personal contact with Monet in Kristiania, at a time in Norway of great political unrest. The national mood was one of agitation, and ideas of rebellion against Sweden and of war were being

thrown around. Even in responsible circles the possibility of separation by force was discussed. There had been a long, acute government crisis, and in order to calm the general atmosphere, the king was staying in Kristiania together with Crown Prince Gustav and Prince Eugen. The latter has told of his meetings with Monet in Norway. Their first direct contact can be fixed on the day of March 2, as Prince Eugen recounts:

It was in Kristiania. The French artist had been persuaded by Thaulow to come to Norway instead of going to Italy, as he had planned to do. Monet spent his time—to begin with, at least—relatively isolated from us painters, and for a long time I knew of his presence in the country only by hearsay.

I remember my first meeting with him the best. I had accompanied my father to the train, and on the way back I was stopped by Thaulow, who was always equally ready for action.

"Would the prince like to meet Claude Monet?" he asked. "I have been shadowing him and know he is in the city just now. A visit would pay!"

Thaulow confided in me that Monet had brought with him from France a small selection of his paintings, and if he were in the right mood, he would show them to us. I gave this opportune suggestion my hearty approval. As a confidential friend of Monet, Thaulow was the best conceiveable introducer and companion. We went off to Grand Hotel, where Monet had some rooms at his disposal. He received his unexpected guests with friendliness and great refinement. Thaulow introduced me—in his usual dramatic manner—and Monet asked me to step into a room arranged as a small salon. There, to be sure, were several older canvases, and Thaulow asked Monet to show them to me.

"With pleasure, if it may please Your Royal Highness," he answered.

He was "in the right mood." He took out the paintings one by one and made his comments about them in the simplest of words and with such extraordinary humility toward his own art that I was quite captivated. It appeared to me as though he was unaware of how ingenious and important his paintings were. After that, he went on to talk about his stay in Norway and gave an emphatic picture of how he had arranged things for himself.

"The hotel is my headquarters, while Sandviken is the real base of operations. From there, I make my excursions with palette and brushes to the mountains and the fjord. Your Highness may find my habits a bit ceremonious, but in the same way as I need my nature motifs I also require a place to which I can withdraw and sort out my impressions."

While I listened to the master, my eyes wandered through the half-open door to the adjoining room. It was clearly Monet's just-mentioned "meditation room." In it I saw, among many scattered, unfinished paintings, a large canvas showing a sculptured stone facade, seen almost without perspective and distance, a visionary picture of a church facade—incredible, fascinating, fantastic as an idea. The painting was in progress. I understood that I was seeing a sample of Monet's by-then-nearly-legendary series of the Rouen Cathedral. I drew our host's attention to what I had happened to glimpse. Monet opened the door hesitantly.

"I shouldn't be showing that picture in this state," he explained. "I'm trying to get it into shape. It is costing me a great deal of difficulties."

When we had left and were down on the street, Thaulow remarked: "I guess we just penetrated the holy of holies of Monet's 'headquarters.' But it has some advantages to be able to steal a first peek at something. For we are without doubt the first to have seen a Monet cathedral."

Aside from this, I have only fragmentary recollections of Monet in Norway. During my visits to the painters' colony in Sandviken, I ran into him on his excursions in search of motifs. I also saw him a few times at work by his easel out in the cold, clad in Thaulow's splendid bearskin coat. This famous garment—which among the artists was known as "the studio"— also frequently graced my shoulders during my time in Norway. On one of the last occasions that I glimpsed Monet at his post in the snowy landscape, he was engaged in a description of Kolsaas.

Little did Prince Eugen suspect, when he became the first Swede to see a sample of the legendary Cathedral series in Kristiania, that he shortly afterward would be providing Swedish art viewers the same sight. That same year, he became the highest-ranking executive of the art section of the Stockholm Exhibition in 1897 and took an active part in the selection of non-Scandinavian artists to be invited to participate. Formal invitations were made in the spring, and in order to influence those invited through personal contact and induce them to send works to Stockholm, the prince undertook a trip around Europe. He recounts:

In Paris I visited most of the famous masters of the time in their studios. My opinions as to which artists were worthy of an invitation were shared neither by the majority of the corps of artists nor by the museum people in Sweden, and it was actually on my own responsibility that I obtained on this occasion contributions from Monet, Pissarro, Rodin, and Gauguin. I did not, however, have the fortune to meet Monet personally. I got the word from Giverny that he had gone on a painting expedition and was not expected back until the fall. I was directed instead to his art dealer in Paris, Durand-Ruel, who took care of such business as I was on.

At Durand-Ruel's I obtained a promise of a good selection of works from their storeroom, above all a couple of versions of the Rouen Cathedral. But at the end of the year, the exhibition management received a message from Durand-Ruel that they could not send any cathedrals to Stockholm. For some reason or another, the 1897 international art show in Venice—our very competitive fellow-angler for artists—had a first right to them. I was, however, very anxious that Monet should be represented in Stockholm and therefore wrote to him myself in Giverny. I implored him to see to it that a collection as eloquent as possible be sent to the exhibition.

This letter had its effect. In mid-November 1896, Monet had indicated to Durand-Ruel his indifference to the prospect of showing at a Swedish exhibition: "You can send whatever you want to Stockholm, for I am not in the least interested in sending anything there personally."

Six weeks later, Monet's previously slumbering interest was aroused:

Dear Monsieur Durand!

I thought I'd just write you to ask for information regarding the exhibition in Sweden, for I have received a letter from Prince Eugen, with whom I made acquaintance in Kristiania and who is the exhibition's executive, and I think I should

personally send something in addition to whatever you have decided to dispatch. I should therefore like to know which canvases you have chosen and when you intend to send them.

Prince Eugen continues his narrative:

When the foreign materials arrived here in the spring of 1897, it came to light that Monet had selected purely representative canvases, among them one *Rouen Cathedral*, which he took from his private collection.

Besides the cathedral painting, Monet's collection was composed of *Haystack. Sunset*; *View from Kolsaas near Kristiania. At Dusk*; [Ditto]. *Sun Effect*; [Ditto]. *Cloudy Weather*; and *View from Sandviken. Sunset*.

I made sure that they were placed in an advantageous spot in the large French room of the exhibition pavilion. Nevertheless, they were completely overshadowed.

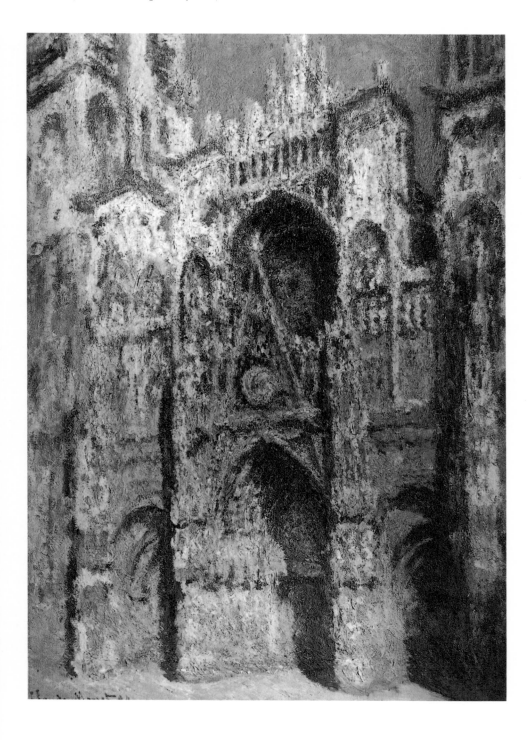

Rouen Cathedral: The Portal and the Tower of Saint-Romain, Full Sunlight—Harmony in Blue and Gold. 1894. 42⅛ × 28¾″ (107 × 73 cm). Galerie du Jeu de Paume, Musée du Louvre, Paris. Photograph: Musées Nationaux, Paris.

GUSTAVE GEFFROY

MONET: SA VIE, SON OEUVRE

1924

* * *

In 1894, Monet again saw his friend Cézanne, who came to stay at the inn in Giverny. Monet invited some friends to welcome him, and on 23 November he wrote:

> . . . We are on for Wednesday.
> I hope that Cézanne will still be here and that he will join us, but he is so peculiar, so timid about seeing new faces, that I am afraid that he might not be of the company, despite his desire to meet you. What a tragedy that this man has not had more support in his life. He is a true artist, who has come to lose too much faith in himself. He needs to be cheered up, so he very much appreciated your article!

* * *

And so, Cézanne returned to Monet, after years of separation. He settled in at the inn, painted in the neighborhood, accepted an occasional invitation from the comrade he had once again found, and thus one day met Rodin, Clemenceau, Mirbeau, and me. He struck us all, at once, as an odd character, timid and violent, and emotional to an extraordinary degree. One time, among others, he gave us to understand the measure of his innocence—or of his confused mental state—when he took Mirbeau and myself aside to announce, with tears in his eyes: "Monsieur Rodin is not a proud man, he shook my hand! A man who has been decorated!!!" Better still, did he not, after lunch, get down on his knees before Rodin, in the middle of a path, to thank him again for shaking his hand? When we heard such things, we could feel nothing but sympathy for Cézanne's primitive soul. At the moment of which I write, however, he was as sociable as he knew how to be, and his laughter and his sallies showed that he was enjoying the people around him. Clemenceau, especially, whom Cézanne later went to visit, had the knack of opening him up, putting him at his ease, entertaining him with his wit. [Yet] Cézanne told me one day that he could never be close to Clemenceau, something, moreover, that I had never asked him about. He gave me the following astonishing reason: "Because I am too weak! . . . And because Clemenceau could not protect me! . . . Only the Church can protect me!"

Georges Clemenceau (1841–1929), physician, statesman, publisher (founded La Justice *in 1881), essayist, and Premier. He first met Monet in the early 1860s and renewed contact after 1886, becoming his closest friend and most energetic supporter.*

GEORGES CLEMENCEAU

LA JUSTICE

"The Cathedrals Revolution"

1895

Professionals will please excuse me, but I can't resist the desire to establish myself as an art critic for a day. It's Claude Monet's fault. I entered Durand-Ruel's gallery to leisurely look again at the studies of the cathedrals of Rouen, which I had enjoyed seeing at the Giverny studio. And that's how I ended up taking that cathedral with its manifold aspects away with me, without knowing how. I can't get it out of my mind. I'm obsessed with it. I've got to talk about it. And, for better or worse, I will talk.

I present myself simply as one of those beings with two feet whose principal merit is to rove my pair of eyes about the earth, ready to relish all of the feasts the divine light has to offer us. And, first of all, I have a few things to say about this. How can so many people pay such dear prices for many good or bad paintings (more often bad than good) and probably wind up enjoying them, whereas they would be incapable of stopping seriously for five minutes in front of a landscape or a face, the representation of which easily carries them away? I'm well aware of what we're told: that painters have *their* part in this. But it's not always the best thing they do, and *The Embarkation for Cythera* itself only seduces us because it evokes emotions of realities.

In this multiple world, precisely that which should charm us is the unstable vibration of life that animates the sky, the earth, the sea, all of living nature and all of inert nature. Well, of all the spectacles of the luminous planet—this ever-moving marvel that springs up in front of our eyes; this changing miracle that doesn't stop except to give birth to other miracles; this intensity of life that comes to us from man or beast but also from grass, wood, and stone—the earth squanders this ceaseless feast upon us without ever tiring. And there's no need at all to be a millionaire to obtain the joys of art, superior to those of the unfortunate enthusiast, condemned to use, for twenty years, the same, sterile epithets on the same, obstinately immobile paintings.

While the unfortunate person shrinks, his faculties of sight and hearing becoming callous, his potential for seeing and feeling emotion becoming powerless and petrified, I go throughout the world inquisitively examining things, trying to capture their fugitive characteristics, to put myself in harmony with them and to penetrate their ineffable mystery, to enjoy the moving spectacles with an acuity of feeling that I let the moving world eternally renew. I then realize that, while my sad priest tortures himself to wonder at miracles that don't exist, I, myself, live surrounded by an eternal prodigy that maddens and intoxicates me with miraculous realities.

Yes, humanity lives in a miracle, in a real miracle, from which it can extract ceaselessly incredible joys, only it doesn't realize this, or to be more precise, it hardly begins to formulate the notion. After thousands and thousands of years, the human eye is in opposition to the planet, which sends back all of the palpitating waves of life, spewn from the so-

COLORPLATE 82

COLORPLATE 83

Watteau's The Embarkation for Cythera *(c. 1715–16), first hung in the Louvre in 1795, was Monet's favorite painting.*

lar fire. Everything that has come to us of the monuments of art—since the primitive ax of happy proportions and powerful coloration, since the profiles of bears and mammoths that a Stone Age Leonardo drew on the bones in the Saint-Germain museum, to Monet's cathedral—allows us to appreciate and survey the phases of vision through which our race has passed.

* * *

We know that what struck our forefathers first was life in its most boisterous manifestations. The overall form, the summary model, an average coloration vaguely perceived without precisions of tone or values—isn't this today the same vision of the child as he models, draws, or colors? We know that the ancients—Asians, Egyptians, or Greeks—although their mythologies testify to a strong impression of the phenomena of the world and of the changing aspects of earth, did not conceive the need to express, as we do, the sensations received from the spectacle of things. Examine the Greek vases, of which many are reproduced by some of the most famous paintings of antiquity; look for a landscape, a tree, a rock, a sea, water running or calm.

For a long time, no doubt, poets stressed their strong perceptions of certain aspects of things that today we summarize in the comprehensive term *nature,* but the sensation was not sufficiently defined in order for Zeuxis to go beyond the effort of still lifes. Virgil sang of the fields; what Latin tried to paint them? Do we have to speak of the primitives, of their trees, of their rocks, of their meadows? Look at the strange landscape that the great Leonardo of the Renaissance gives as a background to his *Mona Lisa*.

"At present, the countryside isn't very much in bloom." According to the comment by Théophile Gautier, this is the only impression that Molière's genius ever transmitted to us of his rural contemplations. We have to wait for Rembrandt, La Fontaine, and Rousseau to fall in love with the earth. How can we appreciate today the composed landscape of Poussin?

I don't want to give the history of landscape here; it's enough for me to say, as Gustave Geffroy does, that the sun, which shines for all the world, has hardly shone in painting: "In Ruysdael and Hobbema's paintings, if you want the names of great landscapists, the metallic, lacy foliage is ink colored; the sun went out. Everything appears illuminated by the somber daylight of the studio." Corot had the emotion of light; the eye's education was slowly taking place. As Geffroy justly said in this admirable study of impressionism, which has struck us all so vividly: "The sense of light could not exist in art while it didn't exist in our knowledge. . . . Painting, like the rest of human expression, had to reflect the slow discovery of things and of the self, which is at the base of human destiny."

With the impressionist school, the sovereignty of light is at last asserted. Light explodes, it invades the being, it imposes itself as conqueror, it dominates the world, which is a support to its glory, an instrument of its triumph.

Who does not understand henceforth that today the eye sees differently than yesterday? It has, after long efforts, discovered nature, dark at first, now luminous. That's not all. Who can say what joys are in store for the refinement of sight, by the ulterior evolution of our sense of sight?

When I saw Monet with his three canvases in front of his poppy field, changing his palette as the sun ran its course, I had the feeling of a study of light all the more precise because the immobile subject underscored luminous mobility more strongly.

It was the beginning of a revolution, a new way of seeing, of feeling,

COLORPLATE 80

176

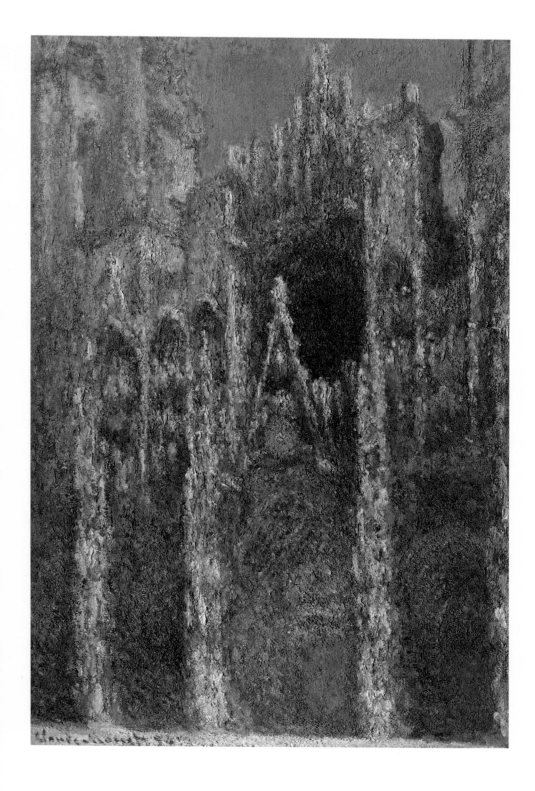

of expressing. That poppy field, bordered by its three elms, marked an
era in perception as well as in the expression of things.

The haystacks, the sheaves, the poplars followed. The same hay-
stack, the same sheaves, the same poplars at sunrise, sunset, and noon,
in the fog and the sun, in the rain and the wind. And then it was Ver-
non bursting with light or molten in the fog.

Then the artist realized that it was a relatively summary analysis of
the luminous phenomena, and that if in an equal day of light, the morn-
ing joins the evening through a series of infinite transitions, each new
moment of each variable day constitutes, under the mobile light, a new
state of the object which never has been or never will be again. The per-
fect eye should be as apt to grasp that state as the hand to render it.

Isn't this a really new conception of feeling and expression?

The dark object in itself receives all life from the sun, all power to

COLORPLATE 85

visually impress. But these luminous waves that envelop it, that penetrate it, that make it radiate in the world, are in perpetual turbulence, affected by high blades, sprays, or tempests of light. What will be the model under that fury of live atoms, through which it is visible to us, through which it really is for us? That's what we have to see now, that which must be expressed through painting, that which the eye must decompose and the hand recompose.

This is in effect what the audacious Monet set out to do with his twenty paintings of the cathedral of Rouen, divided into four series that I would call gray series, white series, rainbow series, blue series. With twenty paintings of differing effects, precisely chosen, the painter has given us the feeling that he could have, should have, made fifty, one hundred, a thousand paintings, as many as he had seconds in his life, if his life lasted as long as the stone monument and he could fix on a can-

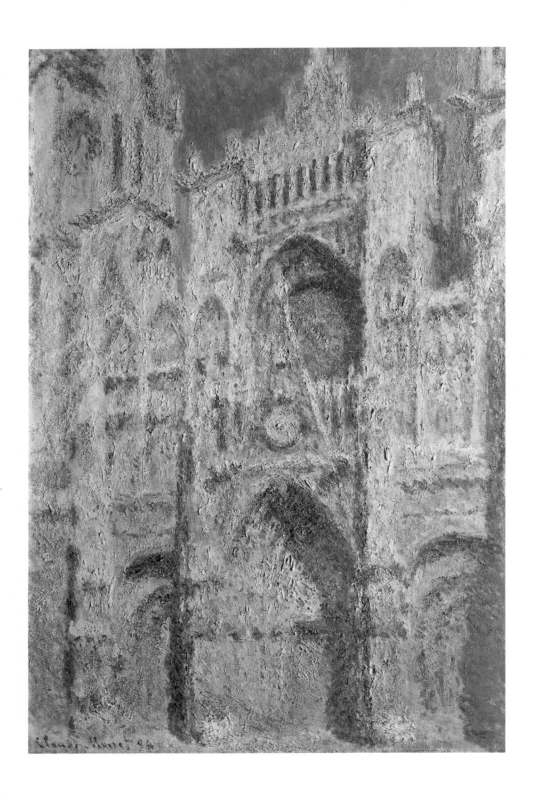

Rouen Cathedral. 1894. 39¼ × 25⅞″ (99.7 × 65.7 cm). The Metropolitan Museum of Art, New York; The Theodore M. Davis Collection, Bequest of Theodore M. Davis, 1915.

vas as many different moments as he had heartbeats. As long as the sun will shine on it, there will be as many manners of being of the cathedral of Rouen as the divisions man will be able to make of time. The perfect eye would distinguish all of them, because they summarize themselves in the perceptible vibrations, even for our present-day retina. Monet's eye, a precursor, is ahead of us and guides us in the visual evolution that renders our perception of the world more penetrating and more subtle.

Thus art, by trying to express nature with an ever-more-perfect position, teaches us to see, to perceive, to feel. And from the ever-denser expression springs forth the ever-more-acute sensation. The marvel in Monet's sensation is to see the stone vibrate and to give it to us, vibrating, bathed in luminous waves that collide in splashing sparks. That was the end of painting as immutable as death; now, even stone lives. One can feel the stone moving with the life that precedes and the life that will follow. It is no longer as if immobilized for the spectator; it proceeds, one sees it proceeding.

* * *

I won't speak of technique, it is not my business. I do not know anymore which painter of antiquity, unable to render the froth of an unmanageable horse, threw his brush and, hitting the panel, realized by chance that which art had not been able to do. Looking closely at Monet's cathedrals, they seem to be made of I-don't-know-what multicolored masonry, crushed on the canvas in an attack of fury. All this savage impulse is no doubt made of passion, but of science as well. How the artist can become aware, at several centimeters from his canvas, of an effect both precise and subtle that one wouldn't be able to appreciate and see without the distance of several meters—*there* is the disconcerting mystery of his eye.

All that I'm concerned about is that I see the monolith surging in its powerful unity, in its sovereign authority. The tight, clear, mathematically precise sketching testifies to the geometrical conception of the whole, and to the masses that order themselves and the strong arris that stand out of the sculptural confusion on which the statues are set. The stone is hard and resistant under the weight of centuries. The mass holds its ground, solid in blurring fog, made tender under the changing skies, bursting into a powdery stone flower in the flaming sun. Flower of vibrant stone, sun-drenched in living light, gives to the kisses of the sun its troubling scrolls of joy and, spurting out living, voluptuous caresses of gold upon a bit of dust.

Skillfully chosen, the twenty states of light, the twenty paintings, are ordered, classified, and completed in an achieved evolution. The monument, great witness of the sun, shoots into the sky the impulse of its authoritarian mass, joining the battle of lights.

Into its depths, into its protrusions, into its powerful folds or its living edges, the surge of the immense solar tide coming through the infinite space breaks in luminous waves, battering the stone with all of the fires of the prism, or subsiding in bright obscurities. That encounter comprises the changing day, the living day, the black day, gray, white, blue, purple, the whole gamut of light. All the colors are burned in brightness, "brought back," according to Duranty's expression, "to that luminous unity that melts its seven prismatic rays into one colorless beam, which is light."

Hung as they are, the twenty paintings are twenty marvelous revelations for us, but the narrow relation that ties them together escapes the fast observer, I'm afraid. Ordered according to their function, they could appear as the perfect equivalence of art and phenomena: the miracle. Imagine them aligned on the four walls, as today, but serially, according to transitions of light: the great black mass in the beginning of the gray series, constantly growing lighter, to the white series, going from the

molten light to bursting precisions that continue and are achieved in the fires of the rainbow series, which subside in the calm of the blue series and fade away in the divine mist of azure.

Then, with one big, circular glance, you would have a stunning perception of the monster, a revelation of the prodigy. And these gray cathedrals, which are purple or azure man-handled by gold; and these white cathedrals with porticos of fire, burning with green, red or blue flames; and these rainbow cathedrals that seem to be seen through a turning prism; and these blue cathedrals, which are pink— would give you all of a sudden the lasting vision, not of twenty, but of a hundred, of a thousand, of a million versions of the eternal cathedral in the immense cycle of the suns. That would be life itself as the feeling can be given to us in its most intense reality—the ultimate perfection of art never before achieved.

* * *

That's what I saw in Monet's cathedrals, and that's how they should be arranged by Durand-Ruel to make them felt and understood in the harmony of their whole. I found out by the catalog that one collector will buy one of these paintings that seduces him in a very special manner. And another buys another one. How can this be! Not one millionaire has understood, not even vaguely, the meaning of these twenty juxtaposed cathedrals and said, "I'll buy the whole lot," as he would have done with a stock issue. It puts the profession of the Rothschilds to shame.

And you, Félix Faure, my sovereign for a day, you who rule graciously in Mme de Pompadour's [palace] with Roujon and Poincaré at your sides to guide you in your art appreciations, I have read that you had made I-don't-know-what personal purchases at I-don't-know-what art market; that's your business.

But you aren't just Félix Faure, you are the president of the republic, and the French Republic at that. It's in this title, obviously, that you went the other day to visit Napoleon's night table, as if it were there that the great man had left his genius. How could you not have, instead, the idea of going to look at the work of one of your contemporaries, on whose account France will be celebrated throughout the world long after your name will have fallen into oblivion? What did Poincaré do, what did Roujon say? Could they have been invaded by the restoring sleep of Kaempfen? Don't awaken those good sleepers; and because there is in you a bit of fancy, go and look at this series of cathedrals, as the good bourgeois that you are, without asking anyone's opinion. Perhaps you might understand and, remembering that you represent France, perhaps you will consider endowing France with those twenty paintings that, together, represent a moment for art—in other words, a moment for mankind himself, a revolution without gunfire.

Know that history will remember these paintings. And if you have the legitimate ambition of living in the memory of men, hang on to Claude Monet's shirttails, the peasant from Vernon. They're more reliable than the vote of congress or Alexandre Ribot's policies.

Félix Faure (1841–1899), President of the French Republic from 1895 until his death, which was reputed to have occurred under morally compromising circumstances.

Henri Roujon (1853–1934), Director of the Ministry of Fine Arts under Faure.

Raymond Poincaré (1860–1934), Vice-President of the Chamber of Deputies under Faure.

Albert Kaempfen (1826–1907) was appointed Director of French national museums and the Louvre in 1887.

Alexandre Ribot (1842–1923) became President of the Council of State in 1895.

LILLA CABOT PERRY

THE AMERICAN MAGAZINE OF ART

"Reminiscences of Claude Monet from 1889 to 1909"

March 1927

Lilla Cabot Perry (1848–1933), American painter.

MONET is dead! How well I remember meeting him when we first went to Giverny in the summer of 1889! A talented young American sculptor told my husband and me that he had a letter of introduction to the painter, Claude Monet. He felt shy at going alone and implored us to go with him, which we were enchanted to do, having seen that very spring the great Monet-Rodin exhibition which had been a revelation to others besides myself. I had been greatly impressed by this (to me) new painter whose work had a clearness of vision and a fidelity to nature such as I had never seen before. The man himself, with his rugged honesty, his disarming frankness, his warm and sensitive nature, was fully as impressive as his pictures, and from this first visit dates a friendship which led us to spend ten summers at Giverny. For some seasons, indeed, we had the house and garden next to his, and he would sometimes stroll in and smoke his after-luncheon cigarette in our garden before beginning on his afternoon work. He was not then appreciated as he deserved to be, in fact that first summer I wrote to several friends and relatives in America to tell them that here was a very great artist only just beginning to be known, whose pictures could be bought from his studio in Giverny for the sum of $500. I was a student in the Paris studios at that time and had shown at the Salon for the first time that spring, so it was natural that my judgment should have been distrusted. Only one person responded, and for him I bought a picture of Étretat. Monet said he had to do something to the sky before delivering it as the clouds did not quite suit him, and, characteristically, to do this he must needs go down to Étretat and wait for a day with as near as possible the same sky and atmosphere, so it was some little time before I could take possession of the picture. When I brought it home that autumn of 1889 (I think it was the first Monet ever seen in Boston), to my great astonishment hardly any one liked it, the one exception being John La Farge.

This intense artistic conscientiousness was one of Monet's most marked traits. About 1906 I took a friend to his studio, she was much taken with a certain picture and tried hard to buy it, but he said he could not sell it until the series was finished as he did not feel sure it was up to his standard. A year or two later he dropped in one afternoon and casually mentioned that he had burnt up over thirty canvases that morning. I asked him whether Mrs. Blank's picture was among those destroyed and he admitted that it was. "I must look after my artistic reputation while I can," he said. "Once I am dead no one will destroy any of my paintings, no matter how poor they may be."

His opinion of his own work was not, however, always calmly judicial. On one occasion, particularly disgusted at his own inadequacy, he decided to give up painting altogether. He was painting from his boat at the time, so overboard flew the forevermore useless paint box, palette, brushes and so forth into the peaceful waters of the little Epte. Needless to say, the night brought counsel and the following morning he arose, full of enthusiasm, but without any painting materials! It was, of course,

John La Farge (1835–1910), painter son of French emigrants to the United States. He studied under Couture in 1856 and later became a leading advocate of Japanese art and the importance of the applied arts.

The first studio, Giverny, Circa 1905–6. Photograph Courtesy The Museum of Modern Art, New York.

a Sunday (such things always take place on Sundays), but a telegram to Paris sent a sympathetic color man flying to his shop and a complete kit left by the next train for Normandy where a reconverted painter awaited its arrival with savage impatience.

There were two pictures on the walls of his studio which I particularly liked. They were of his step-daughter in a white dress, a green veil floating in the breeze under a sunshade, on the brow of a hill against the sky. He told me that an eminent critic called them the Ascension and the Assumption! Seeing me looking at them one day with keen admiration, he took one down off the wall and showed me a tremendous crisscross rent right through the center of the canvas, but so skilfully mended that nothing showed on the right side. I exclaimed with horror, and asked what on earth had happened to it. With a twinkle, he told me that one afternoon he had felt thoroughly dissatisfied with his efforts and had expressed his feelings by putting his foot through the canvas. As he happened to have on *sabots*, the result was painfully evident at the time.

Monet was a man of his own opinions, though he always let you have yours and liked you all the better for being outspoken about them. He used to tell me that my forte was "plein air," figures out-of-doors, and

COLORPLATE 66

COLORPLATE 67

once in urging me to paint more boldly he said to me: "Remember that every leaf on the tree is as important as the features of your model. I should like just for once to see you put her mouth under one eye instead of under her nose!"

"If I did that, no one would ever look at anything else in the picture!"

He laughed heartily and said:

"Vous avez peut-être raison, Madame!"

In spite of his intense nature and at times rather severe aspect, he was inexpressibly kind to many a struggling young painter. He never took any pupils, but he would have made a most inspiring master if he had been willing to teach. I remember his saying to me:

"When you go out to paint, try to forget what objects you have before you, a tree, a house, a field or whatever. Merely think here is a little square of blue, here an oblong of pink, here a streak of yellow, and paint it just as it looks to you, the exact color and shape, until it gives your own naive impression of the scene before you."

He said he wished he had been born blind and then had suddenly gained his sight that he could have begun to paint in this way without knowing what the objects were that he saw before him. He held that the first real look at the *motif* was likely to be the truest and most unprejudiced one, and said that the first painting should cover as much of the canvas as possible, no matter how roughly, so as to determine at the outset the tonality of the whole. As an illustration of this, he brought out a canvas on which he had painted only once; it was covered with strokes about an inch apart and a quarter of an inch thick, out to the very edge of the canvas. Then he took out another on which he had painted twice, the strokes were nearer together and the subject began to emerge more clearly.

Monet's philosophy of painting was to paint what you really see, not

A Morning on the Seine. Circa 1897. 34½ × 35¼" (87.6 × 89.5 cm). The Art Institute of Chicago; Mr. and Mrs. Martin A. Ryerson Collection.

what you think you ought to see: not the object isolated as in a test tube, but the object enveloped in sunlight and atmosphere, with the blue dome of Heaven reflected in the shadows.

He said that people reproached him for not finishing his pictures more, but that he carried them as far as he could and stopped only when he found he was no longer strengthening the picture. A few years later he painted his "Island in the Seine" series. They were painted from a boat, many of them before dawn, which gave them a certain Corot-like effect, Corot having been fond of painting at that hour. As he was showing them to me, I remarked on his having carried them further than many of his pictures, whereupon he referred to this conversation and said again that he always carried them as far as he could. This was an easier subject and simpler lighting than usual, he said, therefore he had been able to carry them further. This series and the "Peupliers" series also were painted from a broad-bottomed boat fitted up with grooves to hold a number of canvases. He told me that in one of his [Poplars] the effect lasted only seven minutes, or until the sunlight left a certain leaf, when he took out the next canvas and worked on that. He always insisted on the great importance of a painter noticing when the effect changed, so as to get a true impression of a certain aspect of nature and not a composite picture, as too many paintings were, and are. He admitted that it was difficult to stop in time because one got carried away, and then added:

"J'ai cette force-là, c'est la seule force que j'ai!" And that from the greatest landscape painter in the world! I give his exact words, they show his beautiful modesty, as great as his genius.

"J'ai cette force-là. . ." (It is in my power to do that. It's the only power that I can claim).

One day he referred to the many criticisms of his work, comparing it to worsted work and so forth, on account of his dragging the color on to the canvas with the long flexible brushes he had made to order for his own use. He said he was sure some of Rembrandt's pictures had been painted even more thickly and heavily than any of his, but that time with its levelling touch had smoothed them down. In illustrating this, he took out one of the grooved boxes in which he kept his pictures a view of the Rouen Cathedral that had been kept in the box practically ever since it had been painted and put beside it one that had been hanging on the wall of his studio for some two or three years. The difference between the two was very marked, the one which had been exposed to the air and to the constant changes of temperature had so smoothed down in that short space of time that it made the other one with all its rugosities look like one of those embossed maps of Switzerland that are such a delight to children.

He said he had never really seen these Rouen Cathedral pictures until he brought them back to his studio in Giverny as he had painted them from the window of a milliner's shop opposite the cathedral. Just as he got well started on the series the milliner complained bitterly that her clients did not care to try on their hats with a man about, and that he must go elsewhere to paint, since his presence interfered with her trade. Monet was not to be daunted, he persuaded her to let him build a little enclosure shutting him off from the shop, a small cell in which he could never get more than a yard away from his canvas. I exclaimed at the difficulty of painting under such conditions, but he said that every young painter should train himself to sit near his canvas and learn how it would look at a distance, and that with time and practice this could be done. Monet had already had experience of this sort in painting on sixteen or more canvases one after the other for a few minutes at a time from his small boat on the Epte. Later on, in his water garden pictures he made good use of this same power. He had grooved boxes filled with canvases placed at various points in the garden where there was barely room for him to sit as he recorded the fleeting changes of the light on his water-lilies and arched bridges. He often said that no painter could paint more

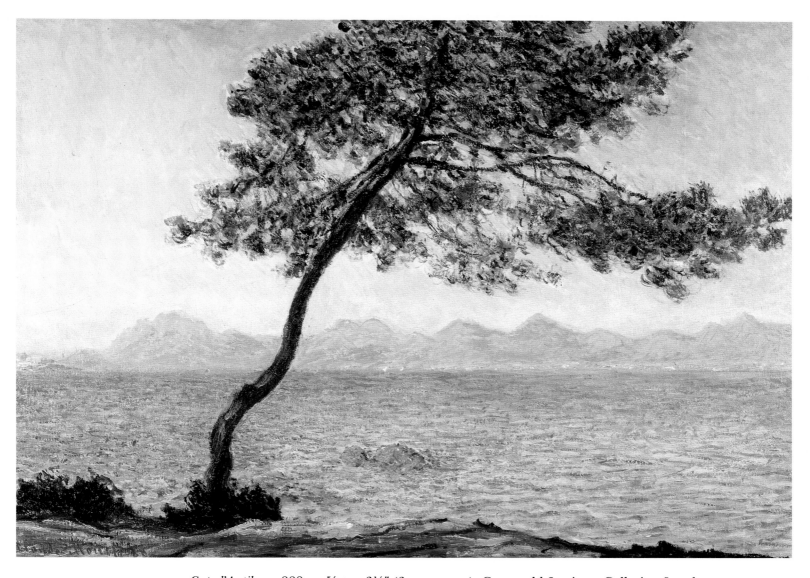

COLORPLATE 73. *Cap d'Antibes*. 1888. 25⅝ × 36¼″ (65 × 92 cm). Courtauld Institute Galleries, London.

COLORPLATE 74. *Sunset in the Creuse Valley.* 1889. 29⅝ × 27½″ (75 × 70 cm).
Musée d'Unterlinden, Colmar. Photograph: Musées Nationaux, Paris.

COLORPLATE 75. *Torrent, Creuse.* 1888–89. 25½ × 36½" (64.8 × 72.7 cm).
The Art Institute of Chicago; Palmer Collection.

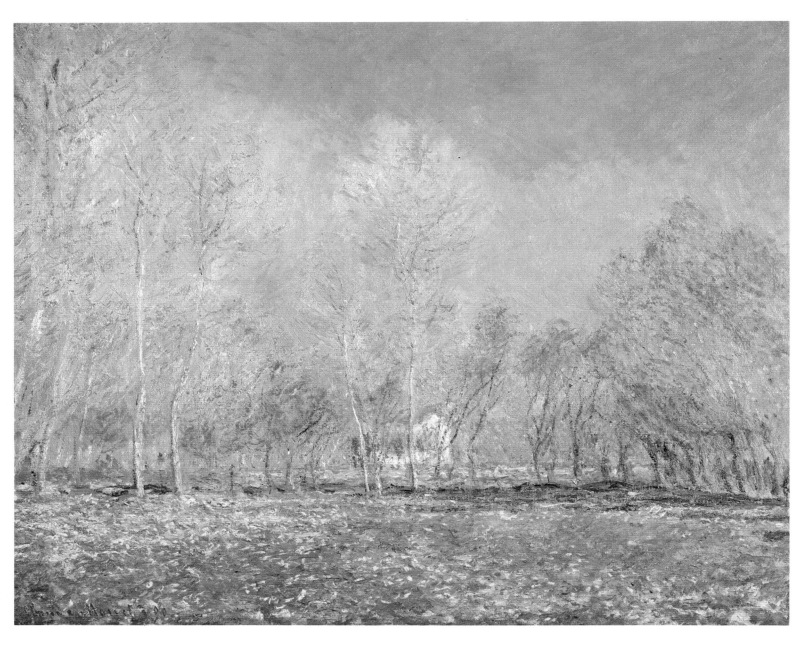

COLORPLATE 76. *Spring in Giverny.* 1890. $25^{11}/_{16} \times 32''$ (65.4 × 81.3 cm).
Sterling and Francine Clark Art Institute, Williamstown, Massachusetts.

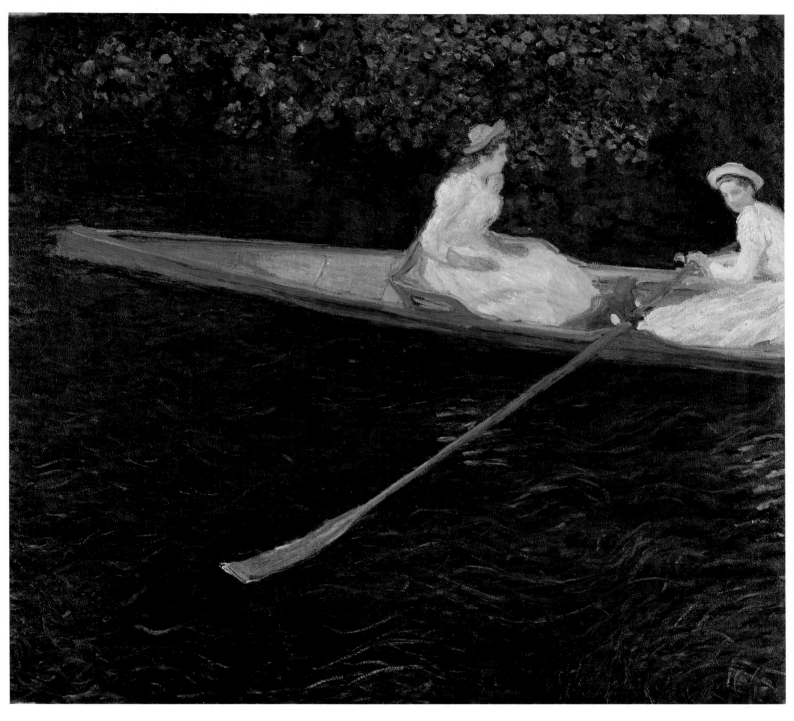

COLORPLATE 77. *In a Canoe on the Epte*. 1890. 52⅜ × 57⅛″ (133 × 145.1 cm). Museu de Arte, São Paulo.

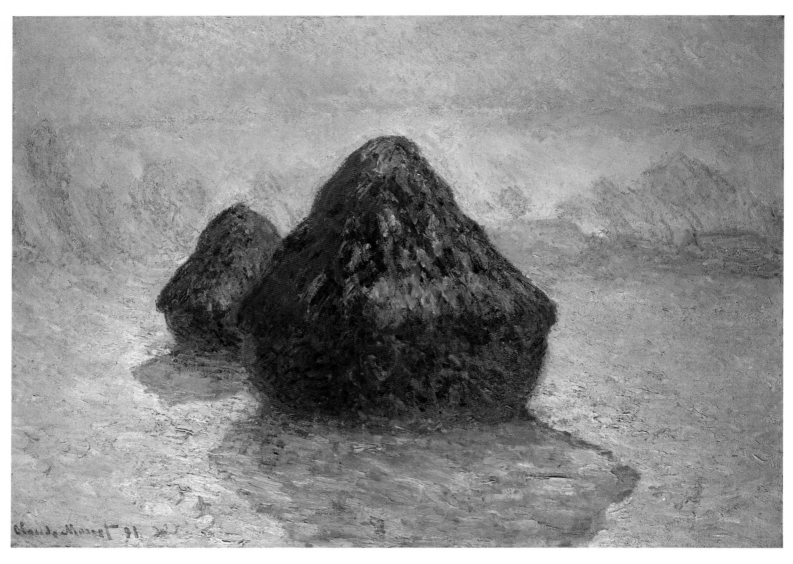

COLORPLATE 78. *Haystacks: Snow Effect*. 1891. 25⅝ × 36¼″ (65 × 92 cm).
National Galleries of Scotland, Edinburgh.

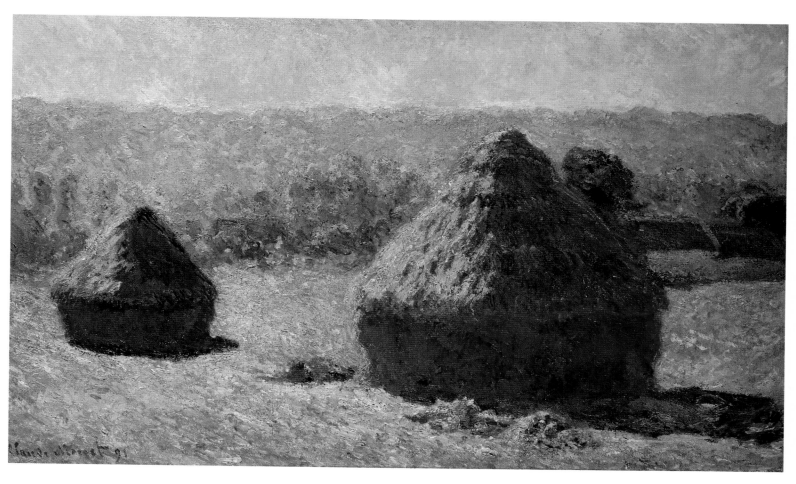

COLORPLATE 79. *Haystacks.* 1891. 24 × 39¾″ (61 × 101 cm).
Galerie du Jeu de Paume, Musée du Louvre, Paris. Photograph: Musées Nationaux, Paris.

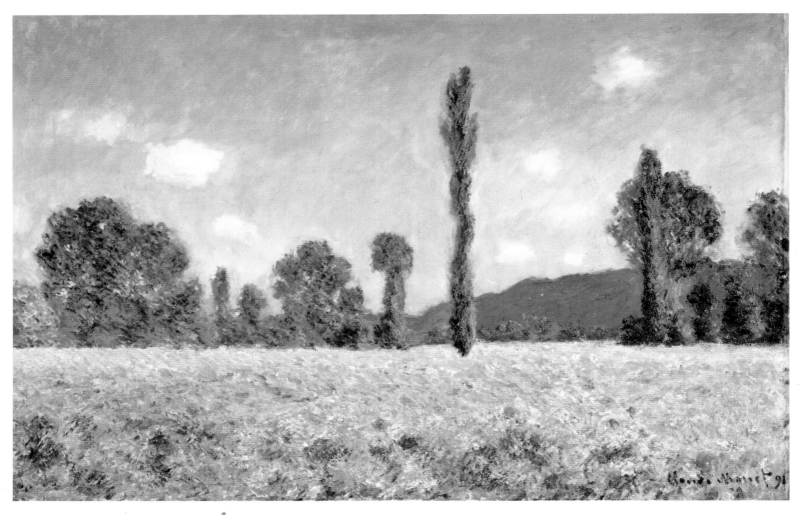

COLORPLATE 80. *Poppy Field*. 1890. 24 × 38″ (61 × 96.5 cm).
The Art Institute of Chicago; W.W. Kimball Collection.

Rouen Cathedral. Photograph: H. Roger-Viollet, Paris.

than one half hour on any outdoor effect and keep the picture true to nature, and remarked that in this respect he practiced what he preached.

Once and once only I saw him paint indoors. I had come to his studio and, finding him at work, was for going away at once, but he insisted on my coming in and sitting on the studio sofa while he went on painting. He had posed his step-daughter, a beautiful young girl in her 'teens, in a lilac muslin dress, sitting at a small table on which she rested one of her elbows. In a vase in front of her was one life size sunflower, and she was painted full length but not quite life size as she was a little behind the sunflower. I was struck by the fact that this indoor picture was so much lower in key, so much darker than his out-door figures or than most studio portraits and thought of this some years later when he paid the usual penalty of success by having many imitators. One day as he came back from a visit to the Champ de Mars Salon I asked him how he liked the outbreak of pallid interiors painted in melted butter and spinach tones for which he was indirectly responsible. As he sat there with his hands upon his knees I shall never forget the impetuous gesture with which he clasped his hands to his head and growled despairingly:

"Madame, des fois j'ai envie de peintre *noir!*"

My husband and I were much interested in the reminiscences of his

"Madame des fois. . ." (My dear woman, at times I've wanted to paint all in black).

193

early struggles. He told us that his people were "dans le commerce" at Havre and when, a boy in his 'teens, he wished to become a painter, they opposed him vigorously in the approved traditional manner. He went through some very hard times. He painted portrait heads of sea captains in one sitting for five francs a head, and also made and sold caricatures. Boudin saw one of these caricatures in a small shop, sought his acquaintance and invited him to go out painting with him. At first Monet did not appreciate this unsought privilege and went reluctantly, but after watching Boudin at work and seeing how closely his landscapes resembled nature, he was only too glad to learn all he could from the older man. There are still some early Monets extant which plainly show Boudin's influence. Even after he had painted many landscapes that were purely in his own style, the young Monet had the utmost difficulty in selling them at the modest price of fifty francs apiece.

Faure, the singer, who was by way of being a collector, bought a landscape about this time for, I believe, the sum of one hundred francs, but brought it back a few days later and asked for his money back. He said he liked the picture himself, but his friends laughed at him so much that he could not keep it on his walls. Monet said he then and there made up his mind never to sell that picture, and he never did, though often offered large sums for it by rich Americans and others. He told me he had "la mort dans l'âme" when that picture was brought back and that he would sell the last shirt off his back before he would sell it! When we left Giverny in 1909, it was still hanging on the walls of his studio, a charming view of the Church at Vétheuil, seen across the Seine on a misty winter's day with cakes of snowy ice floating in the water. It is called "Les Glaçons" [Ice floes], and is a most exquisite and exact portrayal of nature. One can only wonder why Monsieur Faure's friends laughed at it, and laugh at them in return.

Monet was most appreciative of the work of his contemporaries, several of whom had been less successful than he in obtaining recognition during their lifetime. In his bedroom, a large room over the studio, he had quite a gallery of the works of such Impressionists as Renoir, Camille Pissarro, a most expressive picture of three peasant women done during his *pointilliste* period, a charming hillside with little houses on it by Cézanne, about whom Monet had many interesting things to say. There was also a delightful picture by Berthe Morisot, the one woman of his set I have heard him praise. And richly she deserved it! I met her only once, at Miss Cassatt's, she was a most beautiful white-haired old lady. She died shortly afterward and Monet and Pissarro worked like beavers hanging her posthumous exhibition at Durand-Ruel's. It was a wonderful exhibition, and I think that the picture Monet owned was bought at this show. Monet was a most devoted friend to dear old Pissarro, whom no one could help loving, and after his death he acquired another of his pictures which was kept in the studio and shown and praised to all visitors.

Monet was one of the early admirers of Japanese prints, many of which decorated his dining room walls. The walls were painted a light yellow which showed up the prints' delicate tonality admirably and also the blue china which was the only other decoration in the room. It was a charming room with long windows opening on the garden windows left open at mealtimes to permit countless sparrows to come in and pick up a friendly crumb. He pointed out to me one little fellow that had lost a leg and had come for three years in succession.

This serious, intense man had a most beautiful tenderness and love for children, birds and flowers, and this warmth of nature showed in his wonderful, warm smile, a smile no friend of his can ever forget. His fondness for flowers amounted to a passion, and when he was not painting, much of his time was spent working in his garden. One autumn we were at Giverny I remember there was much interest in a new green-

Jean-Baptiste Faure (1830–1914), internationally renowned baritone and major collector who supported Manet, Degas, and the impressionists and speculated in their works.

COLORPLATE 44

house. The heating must have been on a new plan, for when the plants were all in place and the heater first lit, Monet decided he must watch it throughout the night, to be sure everything went smoothly. Once his mind was made up there was little hope of moving him, so Madame Monet speedily acquiesced, and made her own plans for sharing his vigil. When the daughters heard of this there were loud outcries. What! Let their parents sit up all night with no one to look after them? Unheard of neglect! It ended by the entire family spending the night with the gloxinias. Fortunately, the heater was impeccably efficient so the adventure did not have to be repeated.

When I first knew Monet, and for some years later he used a wheelbarrow to carry about his numerous canvases. Later on he had two beautiful motor cars to take him about, but that is not the measure of his achievement, nor is it to be measured by the fact that he lived to see the French government build proper housing under his directions for his latest pictures. His real success lies in his having opened the eyes not merely of France but of the whole world to the real aspect of nature and having led them along the path of beauty and truth and light.

MAURICE GUILLEMOT

LA REVUE ILLUSTRÉE

"Claude Monet"

March 15, 1898

Maurice Guillemot (b. 1859), political and arts essayist.

The crack of dawn, in August, 3:30 AM.

His torso snug in a white woolen hand-knit, his feet in a pair of sturdy hunting boots with thick, dew-proof soles, his head covered by a picturesque, battered, brown felt hat with the brim turned down to keep off the sun, a cigarette in his mouth—a spot of brilliant fire in his great, bushy beard—he pushes open the door, walks down the steps, follows the central path through his garden, where the flowers awaken and unfold as day breaks, crosses the road (at this hour deserted), slips through the picket fence beside the railroad track leading from Gisors, skirts the pond mottled with water lilies, steps over the brook lapping against the willows, plunges into the mist-dimmed meadows, and comes to the river.

There he unties his rowboat moored in the reeds along the bank, and with a few strokes, reaches the large punt at anchor which serves as his studio. The local man, a gardener's helper, who accompanies him, unties the packages—as they call the stretched canvases joined in pairs and numbered—and the artist sets to work.

Fourteen paintings have been started at the same time—a study in scales, as it were—each the translation of a single, identical motif whose effect is modified by the time of day, the sun, and the clouds.

This is where the Epte River flows into the Seine, among tiny islands shaded by tall trees, where branches of the river, like peaceful, solitary lakes beneath the foliage, form mirrors of water reflecting the greenery; this is where, since last summer, Claude Monet has been working, his winters being occupied by another series, the cliffs at Pourville, near Dieppe.

It is a curious work method. The artist told me:

COLORPLATE 89

COLORPLATE 91

COLORPLATE 87

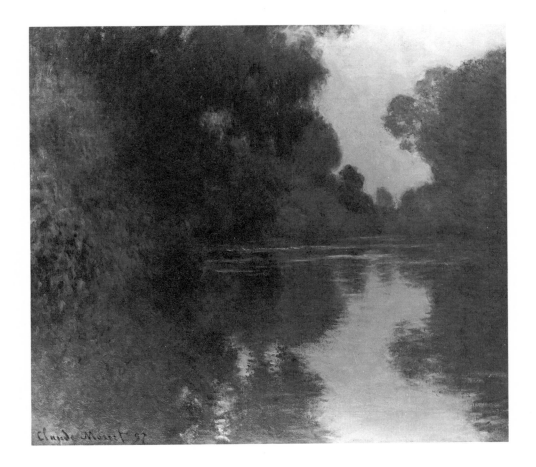

Branch of the Seine near Giverny, II. 1897.
32 × 36½″ (81.3 × 92.7 cm). Museum of
Fine Arts, Boston; Gift of Mrs. Walter
Scott Fitz.

In the old days, we'd all make rough sketches. Jongkind,
whom I knew very well, used to note things down in watercolor
so that later he could enlarge them in his paintings. Corot, with
his quickly brushed studies from nature, would assemble those
composites that his admirers fight over, and in some of them
you can actually see evidence of the combination of the original
documents. . . . A landscape is only an impression, instantan-
eous, hence the label they've given us—all because of me, for
that matter. I'd submitted something done out of my window at
Le Havre, sunlight in the mist with a few masts in the
foreground jutting up from the ships below. They wanted a
title for the catalog; it couldn't really pass as a view of Le
Havre, so I answered: "Put down *Impression*." Out of that they
got impressionism, and the jokes proliferated. . . .

COLORPLATE 24

The distance is great between today's work and that of days gone by.
"Here is my first rejection!" I found myself looking at a vast canvas of a
picnic on the grass, old-fashioned in appearance and costume, with a
woman dressed in crinoline, an ample white skirt dotted with black em-
broidery. It's toward the end of the Second Empire, the painter having
left the Salon after 1868.

> *Monsieur Monet, que l'hiver ni*
> *L'été sa vision ne leurre,*
> *Habite, en peignant, Giverny,*
> *Sis auprès de Vernon, dans l'Eure.*

> [Monsieur Monet, whom winter nor
> Summer his vision can allure,
> Lives, while painting, in Giverny,
> Close to Vernon, in l'Eure.]

Such was the address in rhyme by Stéphane Mallarmé. To these four lapidary lines inscribed on an envelope, let us add a few details.

An hour's train ride punctuated by a stop at Mantes-la-Jolie, darkened by the long tunnel at Bonnières, and one arrives at Vernon. At the station exit, amidst the assault of coachmen for hire, a sort of delivery van drawn by a white horse is waiting to take me to Giverny. We pass through the town, a little provincial hole-in-the-wall with quiet streets, (badly paved), and before the shiny new bridge, much less picturesque than the old one, whose ruined arches—crumbling to rubble beneath the parasitic vegetation—come into view in front of an old mill, we turn right at Vernonnet, following the course of the river.

It's a delightful road, with its adjacent fields where livestock graze on rich, already nearly Norman, pastures, and with its little stream glimpsed here and there, animated with washerwomen. On the other side up on the hill, the open wounds of sandstone quarries plummet down in streams of gray or white.

Beneath the sun, the ribbon stretches for four kilometers. We pass a peasant woman leading her cow; we leave behind us a grain cart drawn by a team of tinkling horses. In the distance, a wisp of smoke from a train is unraveling in the sky. This is the real countryside; Paris is forgotten, a dim memory.

Roofs begin to appear, more and more group themselves together. Walls with moss-grown tops border the road; orchards now surround the dwellings: this is the village of Giverny. A detour up a steep lane, and behind the laundry woman's cart we stop at the door of a prominent house. The shutters are green, but a very pale, bluish green, which Jean-Jacques wouldn't have cared for; and the house is big, with an extensive facade, bigger than the fantasy of the philosopher of Ermenonville. Greenhouses, an aviary, wide, trellised avenues, sheds, etcetera: everything testifies to the fact that this country retreat is already old, enlarged, constantly embellished. "All the money I earn goes into my garden. . . ." The master of the house has a passion for flowers, and he reads more horticultural articles and price lists than articles by aesthetes. One can hardly blame him.

The sun is too piercing, so we must put off the tour of the garden until later and take refuge in the cool studio—or sitting room rather, since our open-air painter works only out of doors. Indeed it is more accurately a museum, considering the contents. Except for one photo-

Jean-Jacques Rousseau (1712–1778), philosopher who advocated a return to nature as a tonic for civilized thinking. Ermenonville is the village outside of Paris where he spent his last years.

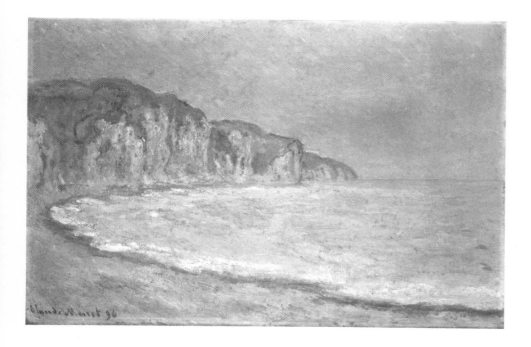

The Cliffs at Pourville. 1896. 25¾ × 39¾″ (65.4 × 101 cm). The Metropolitan Museum of Art, New York; Gift of Mr. and Mrs. Charles S. McVeigh, 1961.

graph of Gustave Geffroy, the judicious critic, a Rodin bronze, and a few ceramic pieces—pottery and filigree vases with rare irises watering in them—there are only paintings by Claude Monet: works of all periods, a kind of showcase sampling of his entire career. Three rows of unframed canvases hang all around the room, and when one's eyes, initially dazzled by this apotheosis of light, come to rest on one piece or another, they begin to recognize, here, ice floes adrift in a desolate winter scene; there, palm trees of Bordighera; rocks at Antibes swept by the blue sea; golden haystacks in the sunlight; a portal of a church in a fog; and then, snow-covered villages, sunny cliffs, wild oceans, calm Mediterranean sites, corners of parks all abloom, with quick, rough brushstrokes, the colors in relief. And as for the figure painter, he no longer wishes to be, but was at one time (see the Caillebotte Collection in Luxembourg). There are some specimens here: profiles of women in bright meadows, portraits in the Whistlerian half-light of an interior, and unfinished rowers reminiscent of his masterpiece, *Le Pont de Poissy*.

"I would like to paint the way a bird sings." The phrase, formulated long ago by the artist, comes to mind as he shows me his fourteen studies in progress, retrieved from the boat and placed for the moment upon easels. It is a marvel of contagious emotion, of intense poetry, and unless one already knew—from certain disclosures in the course of our interview—about the prolonged, patient labor, the anxiety about the

When the impressionist painter Caillebotte died in 1894, his collection was offered to the State, which refused to accept it in its entirety for the national museum of modern art in the Luxembourg Palace.

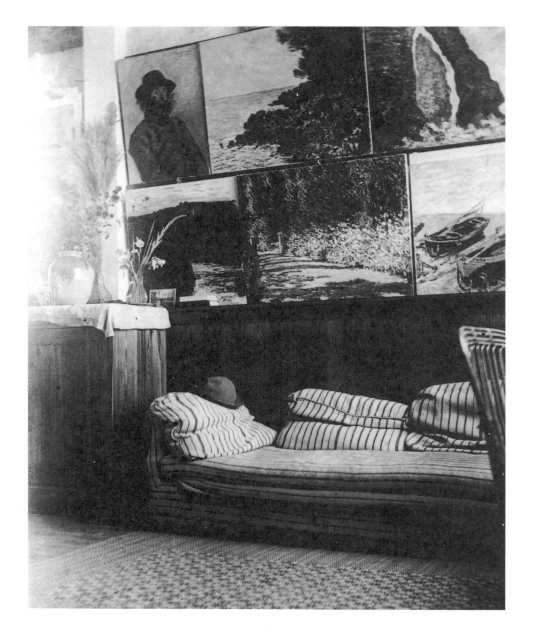

The first studio, Giverny. Circa 1905–6. Lilla Cabot Perry Papers (1889–1909), Archives of American Art, Smithsonian Institution, Washington, D.C.

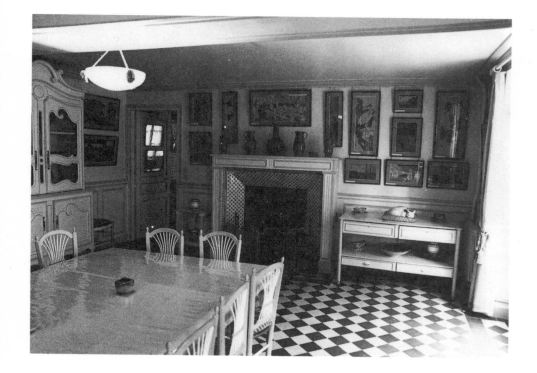

The yellow dining room. H. Roger-Viollet, Paris.

results, the conscientious study, the feverish obsession with the work of two years, one would be astonished by his wish: "I'd like to keep anyone from knowing how it's done."

"The poplar," wrote Victor Hugo, "is quite possibly the only stupid tree. . . . It is, like the alexandrine, one of the classical forms of boredom." This might well have served as an epitaph for the exhibition of 1892: the motif was most unpromising (from the public's point of view). After the *Ice Floes*, the *Haystacks*, the *Cliffs*, and the *Cathedrals* come, most recently, the *Mornings*, which will perhaps be shown in 1898. Affirming an absolute mastery, they will be labelled masterpieces by posterity, and will doubtless excite the wild prices currently reserved for Corot, Rousseau, and Daubigny.

Daumier's June 8, 1865 caricature of visitors to the Salon turning away from a painting of poplars suggests how little esteem this tree had where art was concerned.

The bell rings; we must tear ourselves from contemplation and consider "necessity's sharp pinch," as they say at intermission in the Comédie-Française: lunch is served.

The dining room at Giverny, which has already served as a model for others, is ingeniously laid out: the walls, the sideboards, the cupboards are all in a pale, almost washed-out yellow to which the porcelain fireplace lends its transparent glow; numerous Japanese prints, mounted simply beneath glass, do little to disturb the impression of brightness. The opposing back sides of the doors, according to the law of shadows, are painted violet. Filtered through the closed shutters, the afternoon sun radiates a warm glow, and a strange, soft light plays over the facets of the glasses, over the tooling on the silverware, then expires on the Russian-embroidered tablecloth.

The harmony of color runs throughout the entirety of this original artist's house. One sees it mounting the polished wood staircase, with Chérets on either side; in the bathroom where photographs of Manet and the lithograph of his Pulcinella evoke a dear memory; and in the bedroom, a veritable gallery of precious works, over which Claude Monet makes a quite legitimate fuss.

Jules Chéret (1836–1893) elevated the art of posters to the status of mural painting, according to Geffroy.

There, even more, perhaps, than in the new gallery containing the famous bequest to the Luxembourg Museum—the bequest one should never mention to Gérôme—one is struck with admiration for this flowering of art, which some have dared to deny. The commitment to truth, to light, to sincere, healthy painting outside the academies but related to the most beautiful things that we know from the past, is enchanting—

Bench in the garden overlooking the water lily pond. Lilla Cabot Perry Papers (1889–1909), Archives of American Art, Smithsonian Institution, Washington, D.C.

these Degases, these Renoirs, these Cézannes (from whom Gauguin drew inspiration), these Berthe Morisots, these Boudins, these Pissarros, these Manets, and these Monets.

It was with a respectful emotion that the master of the house showed me all of that; and the initial astonishment one felt at the very special esthetic gave way to veneration, as we stood looking at the walls of this sanctuary where every frame evoked the towering figure of an independent artist, freed from the atmosphere of the academy, carrying his work forward along new paths with the utmost conviction.

We spoke of these things for a long while under the parasol beside his pond.

Beyond the road and the unweeded path of the railroad track, along a brook flowing between the willows, Claude Monet has had a pool dug out, spanned by a wooden bridge in the Japanese style. Upon that immobile mirror float water lilies, aquatic plants, unique species with broad, spreading leaves and disquieting flowers of a strange exoticism. On either side are locks to allow a daily change of water. The locals were opposed at first, suspicious of this unfamiliar flower, claiming that the artist was poisoning the countryside, that their cows would no longer be able to drink.

The oasis is [the most] charming of all the models he decided on; for these are the models for a decoration, for which he has already begun to paint studies, large panels, which he showed me afterward in his studio. Imagine a circular room in which the dado beneath the molding is covered with [paintings of] water, dotted with these plants to the very horizon, walls of a transparency alternately green and mauve, the calm and silence of the still waters reflecting the opened blossoms. The tones are vague, deliciously nuanced, with a dreamlike delicacy.

"He is *par excellence*, the painter of water," said Théodore Duret in his *Critique d'avant-garde*. "In older landscapes, water appeared in a fixed and predictable manner, with its 'water color,' simply as a mirror to reflect objects. In the work of Monet, it assumes an infinite variety of appearances depending on atmospheric conditions, the nature of the riverbed over which it flows, or of the silt it carries with it; it is limpid, opaque, calm, turgid, flowing, or dormant, according to the momentary

Duret's Critique d'avant-garde, *published in 1885, was an anthology of his newspaper criticism.*

aspect the artist finds in the particular surface of water before which he has planted his easel."

This decorative vision is a relief after one has wandered through the garden, laid out as it is like a palette, where the flower beds are arranged in magically brilliant colors, and where one's glance is dazzled by polychromatic vibrations.

This whole establishment at Giverny represents an ambience which the painter has arranged for himself; and for him, to live there is a constant advantage for his work. During periods of inactivity—he can go for months without doing a thing—he continues his work, without appearing to, if only by going out for a walk; his eye contemplates, studies, and stores. . . .

His workshop—is nature itself.

WILLIAM H. FULLER

CLAUDE MONET AND HIS PAINTINGS

1899

William Henry Fuller (1836–1902), an early American collector of impressionism who organized an important exhibition at the Lotus Club in New York in 1899.

Monet's method of work is simple. He uses canvases that are very smooth and very white. He sketches his subjects in charcoal, then rapidly lays in the colors until he has secured the general aspect of the scene, after which he proceeds with the greatest care until the altered conditions of light warn him to desist. The canvas is then put aside for another day with similar conditions, when he resumes his work. This process he continues until his picture is finished. He frequently paints the same subject many times, and these varied paintings are known as Monet's "series"—as, for example, "The Haystacks," "Floating Ice," "Étretat," "Pourville," "Antibes," "Belle Isle," "Le Petit Creuse," "The Tulips of Holland," "The Rouen Cathedrals," and many more—and yet in every series no two pictures are alike. I suppose he has painted "The Haystacks," one of his most famous subjects, at least twenty times. They stood in a neighbor's

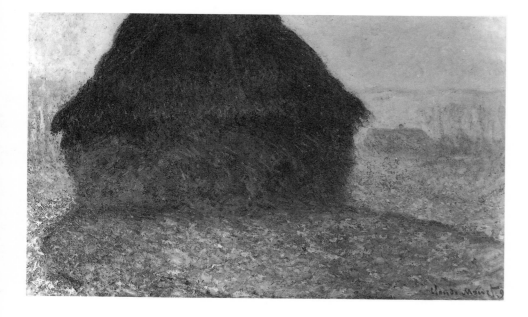

Haystack in the Sun. 1891. 23⅝ × 39⅜" (60 × 100 cm). Kunsthaus Zürich.

field close to Monet's house. He began to paint them when they were first made. He portrayed them in summer, in the autumn, and in winter; in the morning, at noon, and at twilight; sometimes sparkling with dew, sometimes enveloped in fog, sometimes covered with frost, sometimes laden with snow; and though each picture was different from all the rest, one scarcely knew which to choose, they were all so true and beautiful.

It was the same with "Cathedrals." Monet spent two successive winters at Rouen painting that series; and while it is his favorite, and is considered by him his finest work, it is probably the one least understood or cared for by the public. They suppose that Monet was trying, with little success, to paint curious architectural forms; but in fact, his object was to render the marvelous play of light and color which different conditions of atmosphere and time of day produce upon the Cathedral's imposing facade.

The manner of painting nature that Monet has adopted discloses an absolute sincerity of purpose in his art, and, besides, reveals to us many a hidden charm which has been passed unnoticed by less sensitive and observant eyes. Moreover, the limitations he has imposed upon himself involve a prodigious amount of labor, and, it may be added, some failures as well. But these failures are never taken up, revised, and finished in a studio, and then offered for sale. Last summer he made a bonfire of a lot of unfinished paintings which he thought were not worthy of his name. But when he has been able to finish his pictures as he likes; when he has fully expressed all that he saw and felt in the beginning, what a splendid success he attains!

* * *

Moreover, every picture that Monet paints is distinguished, among other qualities, for its pictorial unity. He sees nature synthetically; he paints it pictorially. Indeed, the true function of a landscape painter is to express the noble truths of nature, rather than to record the mere physical facts that he sees before him. This, at least, is Monet's method of interpretation. His landscapes, therefore, possess the potent charm of simplicity and dignity unmarred by perplexing details. Nor is this pictorial quality the result of a lucky accident or a happy choice of subject. Nature never presents to an artist a perfectly completed picture, leaving to him the simple task of copying it on his canvas. The fund of material that she furnishes is exhaustless, but the use which the artist makes of it determines the value of his performance. When Monet paints a landscape he keeps steadily in view the dominant motive of his picture, to which all minor details are made subordinate. These serve a useful part, it is true, but it is one of appropriate contribution to enhance the value of the work as a whole. To secure this result he knows what to leave out—a rare virtue in landscape art—as well as what to emphasize in his picture. This method of treatment involves an intelligent comprehension of his subject, an easy command of his brush, an orderly and artistic arrangement of the various parts of his picture, and calls into play one of the highest and most pleasurable functions of the human mind. In his early life, as he once remarked to me, he often completed a canvas at a single sitting; "but now," he modestly added, "I am more exacting, and it takes a long time for me to finish a picture." In his efforts to realize the complete pictorial aspect of his subject, Monet does not neglect the truthful portrayal of any object that forms a constituent part of his work. Test it by the pictures in this exhibition. Run your eye over them with a little care and note with what wonderful fidelity he has painted water, snow, ice, fields of grain, rocks, fog, sunshine, atmosphere, mist, breaking waves, fleeing clouds, and the bending sky. But in all this wonderful variety of subjects one lovely phase of nature is missed. When I asked Monet if he had ever painted a moonlight picture, he said:

"I greatly admire moonlights and from time to time have made stud-

COLORPLATE 11

Claude Monet in 1899. Photo collection, Durand-Ruel, Paris.

ies of them; but I have never finished any of these studies because I found it so difficult to paint nature at night. Some day, however, I may finish such a picture."

* * *

I cannot close this brief and altogether inadequate notice of Monet's works without repeating his frank, almost pathetic, words concerning himself:

"It is not agreeable to talk of one's self; and then upon certain points my memory fails. What I *do* know is, that life with me has been a hard struggle, not for myself alone, but for my friends as well. And the longer I live and the more I realize how difficult a thing painting is, and in one's defeat he must patiently strive on."

Ah, yes, painting grows more and more difficult as year by year one's ideals reach a loftier height and demand a nobler interpretation. For nearly thirty years Monet was fighting his own battle, with little to sustain him but a stout heart and an absorbing love of his art.

FRANÇOIS THIÉBAULT-SISSON

CLAUDE MONET: AN INTERVIEW

Translation of an article
published in *Le Temps*

November 27, 1900

*François Thiébault-Sisson (b. 1856),
already introduced to Degas in the late
1870s, became an important innovator as
a critic, especially in the genre of the
interview.*

There has just been opened in Mr. Durand-Ruel's Galleries, Rue Laf-
fitte, an exhibition of from twenty-five to thirty canvases by Claude Mo-
net, in which a decided change of the artist's manner is noticed. Here we
see the most varied aspects of nature reflected in pictures, both serene
and striking in their breadth of interpretation. From the abrupt pali-
sades of the Fjords or from the steep declivities of Norman cliffs, from
the ravines in the valley of the Creuse, or from the dreamy banks of the
Seine, from ponds peopled with waterlilies, or decked with the purple
of the Iris, there emanates the same comprehensive impression, most
unique and powerful in its synthetical qualities. The filmy transparency
of mists and the subtlety of atmospheric effects spread over the vivacity
of color, over the wildness or mildness of the subjects, a peaceful soft-
ness that acts as a charm, and the landscape thus treated becomes en-
nobled and rises to a singular loftiness. All the elements of nature are
transposed; they are metamorphosed into a personal interpretation,
where naught is admitted but that which is expressive, into a compre-
hensive view, where alone the essential characters appear, and their re-
union, dictated by selection, constitutes the most penetrating and the
most real, the most poetical and the most moving of decorations.

Unless I am much mistaken, this Exposition will be followed and
studied with passionate interest, even by those who still argue against this
rare and original talent.

Now is the time, it would seem, or never, to make known to the
readers of *Le Temps* otherwise than by the review of his works, the mas-
ter who has given to Impressionism its doctrine and who has furnished
its most frank and fearless examples. He came out of his retreat at Gi-
verny for one day. He gave himself the satisfaction of being present at
the opening of his Exposition. I met him there by chance, and in spite
of his resistance, dragged him to my lair. There, fixing upon me his blue
eyes, eyes which flash like those of a man of twenty, and stroking with
one hand the silky waves of his long beard, where a few blond threads
still linger in the snow with which three score years have sprinkled it, he
briefly told me his history.

"I am a Parisian from Paris. I was born there in 1840, under good
King Louis-Philippe, in a circle entirely given over to commerce, and
where all professed a contemptuous disdain for the arts. But my youth
was passed at Hâvre, where my father had settled in 1845, to follow his
interests more closely, and this youth was essentially that of a vagabond.
I was undisciplined by birth; never would I bend, even in my most ten-
der youth, to a rule. It was at home that I learned the little I know.
School always appeared to me like a prison, and I never could make up
my mind to stay there, not even for four hours a day, when the sun-
shine was inviting, the sea smooth, and when it was such a joy to run
about on the cliffs, in the free air, or to paddle around in the water.

"Until I was fourteen or fifteen years old, I led this irregular but

thoroughly wholesome life, to the despair of my poor father. Between times I had picked up in a hap-hazard way the rudiments of arithmetic and a smattering of orthography. This was the limit of my studies. They were not over tiresome for they were intermingled for me with distractions. I made wreaths on the margins of my books; I decorated the blue paper of my copy-books with ultrafantastical ornaments, and I represented thereon, in the most irreverent fashion, deforming them as much as I could, the face or the profile of my masters.

"I soon acquired much skill at this game. At fifteen I was known all over Hâvre as a caricaturist. My reputation was so well established that I was sought after from all sides and asked for caricature-portraits. The abundance of orders and the insufficiency of the subsidies derived from maternal generosity inspired me with a bold resolve which naturally scandalized my family; I took money for my portraits. According to the appearance of my clients, I charged ten or twenty francs for each portrait, and the scheme worked beautifully. In a month my patrons had doubled in number. I was now able to charge twenty francs in all cases without lessening the number of orders. If I had kept on, I would to-day be a millionaire.

"Having gained consideration by these means, I was soon an important personage in the town. In the show-window of the only framemaker who was able to make his expenses in Hâvre, my caricatures arrogantly displayed themselves five or six in a row, framed in gold and glazed, like highly artistic works, and when I saw the loungers crowd before them in admiration and heard them, pointing them out, say: 'That is so and so:' I nearly choked with vanity and self-satisfaction.

"Still there was a shadow in all this glory. Often in the same show-window, I beheld, hung over my own productions, marines that I, like most of my fellow citizens, thought disgusting. And, at heart, I was much vexed to have to endure this contact, and never ceased to abuse the idiot, who, thinking he was an artist, had enough self-complacency to sign them,—this idiot was Boudin. In my eyes, accustomed as they were to the marines of Gudin, to arbitrary colorations, to the false notes and fantastical arrangements of the painters in vogue, the sincere little compositions of Boudin, with his little figures so true, his ships so accurately rigged, his skies and his water so exact, drawn and painted only from nature, these had nothing artistic, and their fidelity struck me as more than suspicious. Therefore his painting inspired me with an intense aversion, and without knowing the man I hated him. Often the framemaker would say to me: 'You should make the acquaintance of Mr. Boudin. You see, whatever they may say of him, he knows his trade. He studied it in Paris, in the studios of the *École des Beaux-Arts*. He could give you some good advice.' "

"And I resisted with silly pride. What indeed could such a ridiculous man teach me?

"Still the day came, fatal day, when chance brought me, in spite of myself, face to face with Boudin. He was in the rear of the shop, and not noticing his presence, I entered. The framemaker grasped the opportunity and without consulting me presented me: 'Just see, Mr. Boudin, this is the young man who has so much talent for caricature'—and Boudin, without hesitation, came to me, complimented me in his gentle voice and said: 'I always look at them with much pleasure, your sketches; they are amusing, clever, bright. You are gifted; one can see that at a glance. But I hope you are not going to stop at that. It is very well for a beginning, but soon you will have enough of caricaturing. Study, learn to see and to paint, draw, make landscapes. They are so beautiful, the sea and the sky, the animals, the people and the trees, just as nature has made them, with their character, their real way of being, in the light, in the air, just as they are.' "

"But the exhortations of Boudin did not take. The man, after all, was

Théodore Gudin (1802–1880), highly regarded Salon artist who specialized in dramatic scenes taken from naval history.

pleasing to me. He was earnest, sincere, I felt it but I could not digest his painting, and when he offered to take me with him to sketch in the fields, I always found a pretext to politely decline. Summer came—my time was my own—I could make no valid excuse—weary of resisting, I gave in at last, and Boudin, with untiring kindness, undertook my education. My eyes, finally, were opened, and I really understood nature; I learned at the same time to love it. I analyzed it in its forms with a pencil, I studied it in its colorations. Six months later, in spite of the entreaties of my mother, who had begun to seriously worry because of the company I kept, and who thought me lost in the society of a man of such bad repute as Boudin, I announced to my father that I wished to become a painter and that I was going to settle down in Paris to learn.

" 'You shall not have a cent!'

" 'I will get along without it.'

"Indeed I could get along without it. I had long since made my little pile. My caricatures had done it for me. I had often in one day executed seven or eight caricature-portraits. At twenty francs apiece, my receipts had been large, and I had made it a practice from the start to entrust my earnings to one of my aunts, keeping but paltry sums for pocket money. At sixteen one feels rich with two thousand francs. I obtained from several picture lovers who protected Boudin and who had relations with Monginot, with Troyon, with Armand Gautier, some letters of introduction and set out post-haste for Paris.

"It took me some little time at first to decide on my line of action. I called on the artists to whom I had letters. I received from them excellent advice; I received also some very bad advice. Did not Troyon want me to enter the studio of Couture? It is needless to tell you how decided was my refusal to do so. I admit even that it cooled me, temporarily at least, in my esteem and admiration for Troyon. I began to see less and less of him, and, after all, connected myself only with artists who were seeking. At this juncture, I met Pissarro, who was not then thinking of posing as a revolutionist, and who was tranquilly working in Corot's style. The model was excellent; I followed his example, but during my whole stay in Paris, which lasted four years, and during which time I frequently visited Hâvre, I was governed by the advice of Boudin, although inclined to see nature more broadly.

"I reached my twentieth year. The hour for conscription was about to strike. I saw its approach without fear. And so did my family. They had not forgiven me my flight; they had let me live as I chose during those four years, only because they thought they would catch me when the time came for me to do military duty. They thought that once my wild oats were sown, I would tame down sufficiently to return home, readily enough, and bend at last to commerce. If I refused, they would stop my allowance, and if I drew an unlucky number they would let me go.

"They made a mistake. The seven years of service that appalled so many were full of attraction for me. A friend who was in the regiment of the *Chasseurs d'Afrique* and who adored military life, had communicated to me his enthusiasm and inspired me with his love of adventure. Nothing attracted me so much as the endless cavalcades under the burning sun, the *razzias*, the crackling of gunpowder, the sabre thrusts, the nights in the desert under a tent, and I replied to my father's ultimatum with a superb gesture of indifference. I drew an unlucky number. I succeeded, by personal insistence, in being drafted into an African regiment and started out.

"In Algeria, I spent two really charming years. I incessantly saw something new; in my moments of leisure I attempted to render what I saw. You cannot imagine to what extent I increased my knowledge, and how much my vision gained thereby. I did not quite realize it at first. The impressions of light and color that I received there were not to

Charles Monginot (1825–1900), a student of Couture who put his studio at Monet's disposal when he first came to Paris in 1859.

Armand Gautier (1825–1894), realist-inclined Salon painter to whom Monet turned on the advice of his aunt, Sophie Lecadre, when he first arrived in Paris in 1859.

classify themselves until later; but they contained the germ of my future researches.

"I fell ill at the end of two years, and quite seriously. They sent me home to recuperate. Six months of convalescence were spent in drawing and painting with redoubled energy. Seeing me thus persisting, worn as I was by the fever, my father became convinced that no will could curb me, that no ordeal would get the better of so determined a vocation, and as much from lassitude as from fear of losing me, for the Doctor had led him to expect this, should I return to Africa, he decided, towards the end of my furlough to buy me out.

" 'But it is well understood,' he said to me, 'that this time you are going to work in dead earnest. I wish to see you in an *atelier*, under the discipline of a well-known master. If you resume your independence, I will stop your allowance without more ado. Is it a bargain?' This arrangement did not more than half suit me, but I felt that it was necessary not to oppose my father when he for once entered into my plans. I accepted. It was agreed that I should have at Paris and in the person of the painter Toulmouche, who had just married one of my cousins, an artistic tutor, who would guide me and furnish regular reports of my labors.

"I landed one fine morning at Toulmouche's with a stock of studies which he declared pleased him very much. 'You have a future,' he said, 'but you must direct your efforts in some given channel. You will enter the studio of Gleyre. He is the staid and wise master that you need.' And grumbling, I placed my easel in the studio full of pupils, over which presided this celebrated artist. The first week I worked there most conscientiously, and made with as much application as spirit a study of nude from the living model, that Gleyre corrected on Mondays. The following week, when he came to me, he sat down, and solidly planted on my chair, looked attentively at my production. Then—I can see him yet—he turned round, and leaning his grave head to one side with a satisfied air, said to me: 'Not bad! not bad at all, that thing there, but it is too much in the character of the model—you have before you a short thickset man, you paint him short and thickset—he has enormous feet, you

Auguste Toulmouche (1829–1890), student of Gleyre whose success at the Salon of 1861, after which he married a cousin of Monet's Aunt Sophie, singled him out as the proper "guardian" for Monet's studies after his discharge from the army.

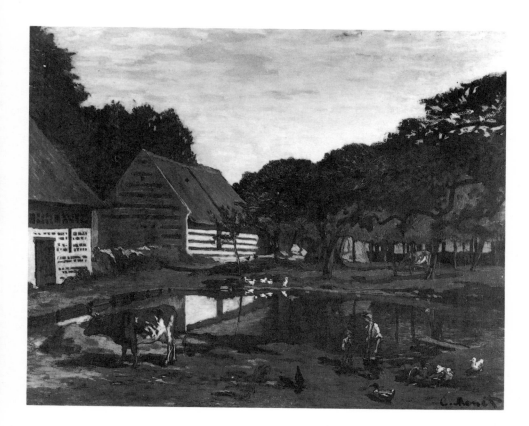

Farm Courtyard in Normandy. 1863. 25⅝ × 31½" (65 × 80 cm). Galerie du Jeu de Paume, Musée du Louvre, Paris. Photograph: Musées Nationaux, Paris.

render them as they are. All that is very ugly. I want you to remember, young man, that when one executes a figure, one should always think of the antique. Nature, my friend, is all right as an element of study but it offers no interest. Style, you see, style is everything.'

"I saw it all. Truth, life, nature, all that which moved me, all that which constituted in my eyes the very essence, the only *raison d'être* of art, did not exist for this man. I no longer wished to remain under him. I felt that I was not born to begin over again in his wake the *Illusions Perdues* and other kindred bores. Therefore, why persist?

"I nevertheless waited several weeks. In order not to exasperate my family, I continued to appear regularly at the studio, remaining only just long enough to execute a rough sketch from the model, and to be present at inspection, then I skipped. Moreover, I had found in the studio congenial companions, natures far from commonplace. They were Renoir and Sisley, whom I was never thereafter to lose sight of—and Bazille, who immediately became my chum, and who would have become noted had he lived. None of them manifested, any more than I did, the least enthusiasm for a mode of teaching that antagonized both their logic and their temperament. I forthwith preached rebellion to them. The exodus being decided on, we left, Bazille and I taking a studio in common.

"I forgot to tell you, that a short time before, I had made the acquaintance of Jongkind. During my furlough of convalescence, one fine afternoon I was working in the neighborhood of Hâvre, in a farm. A cow was grazing in the meadow; I conceived the idea of making a drawing of the good beast. But the good beast was capricious, and every moment was shifting its position. My easel in one hand, my stool in the other, I, following, was trying with more or less success to regain my point of view. My evolutions must have been very amusing, for I heard a hearty burst of laughter behind me. I turned round and beheld a puffing colossus. But the colossus was good natured. 'Wait a minute,' he said, 'I will help you.' And the colossus in huge strides, comes up with the cow, and grabbing her by the horns, tries to make her pose. The cow, unused to such treatment, takes it in bad part. It was now my turn to laugh. The colossus, quite discomfited, lets go the beast and comes over to chat with me.

"He was an Englishman, a visitor, very much in love with painting and very well posted on what was going on in our country:

" 'So, you make landscapes,' he said.

" 'Well, yes.'

" 'Do you know Jongkind?'

" 'No, but I have seen his work.'

" 'What do you think of it?'

" 'It is very strong.'

" 'Right you are. Do you know he is here?'

" 'You don't say!'

" 'He lives in Honfleur. Would you like to know him?'

" 'Decidedly yes. But then you are one of his friends?'

" 'I have never seen him, but as soon as I learned of his presence, I sent him my card. It is an opening wedge. I am going to invite him to lunch with you.'

"To my great surprise the Englishman kept his promise, and the following Sunday we were all three lunching together. Never was there a merrier feast. In the open air, in a country garden, under the trees, in the presence of good rustic cooking, his glass well filled, seated between two admirers whose sincerity was above suspicion, Jongkind was beside himself with contentment. The impromptu of the adventure amused him; moreover he was not accustomed to being thus sought after. His painting was too new and in a far too artistic strain to be then, in 1862, appreciated at its true worth. Neither was there ever any one so modest and retiring. He was a simple good-hearted man, murdering French

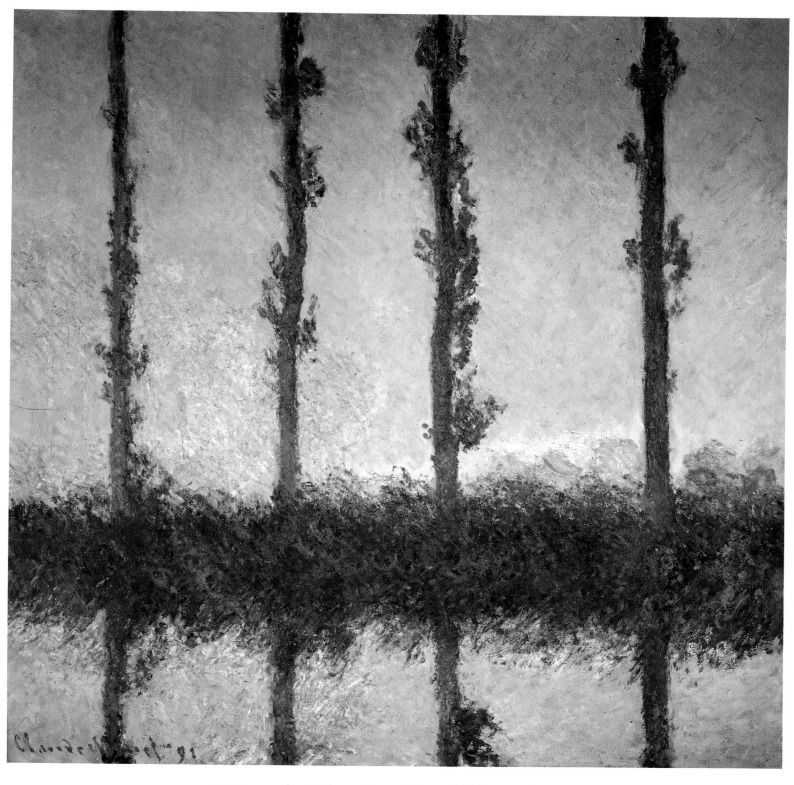

COLORPLATE 81. *Poplars.* 1891. 32¼ × 32⅛″ (81.9 × 81.6 cm).
The Metropolitan Museum of Art, New York; Bequest of Mrs. H.O. Havemeyer, 1929.
The H.O. Havemeyer Collection.

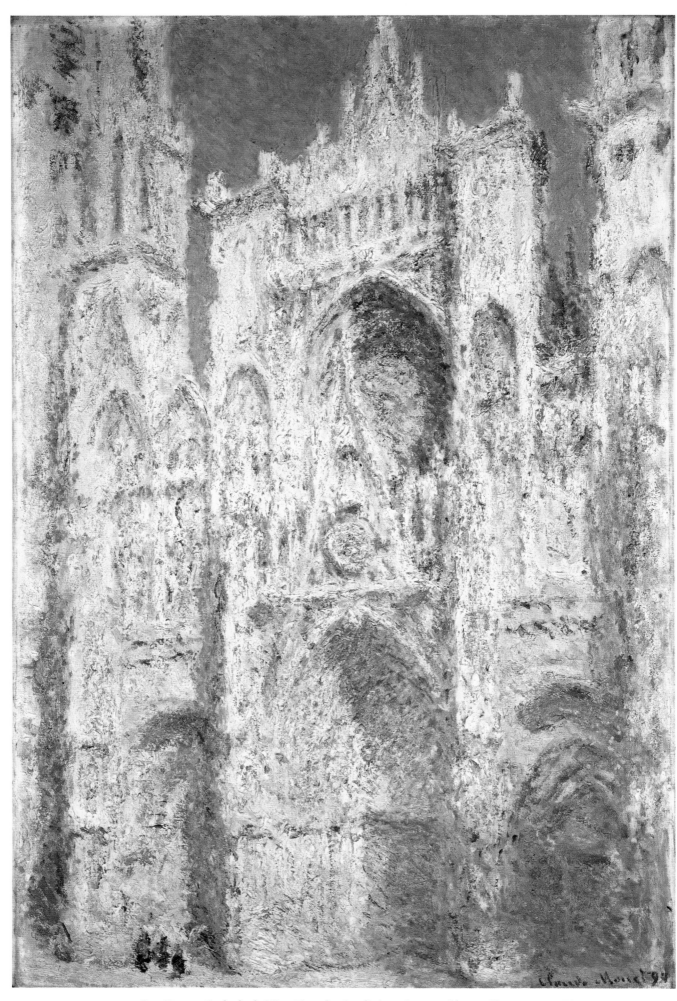

COLORPLATE 82. *Rouen Cathedral, West Facade, Sunlight.* 1894. 39½ × 26″ (100.2 × 66 cm).
National Gallery of Art, Washington, D.C.

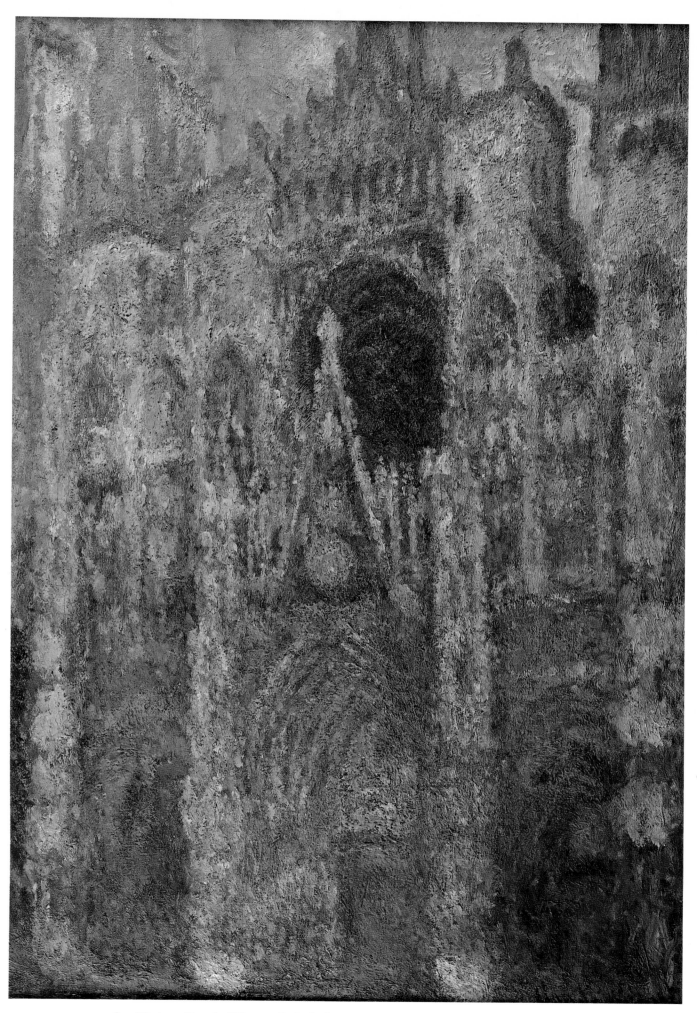

COLORPLATE 83. *Western Portal of Rouen Cathedral—Harmony in Blue.* 1894. 35⅞ × 24⅞″ (91 × 63 cm).
Galerie du Jeu de Paume, Musée du Louvre, Paris. Photograph: Musées Nationaux, Paris.

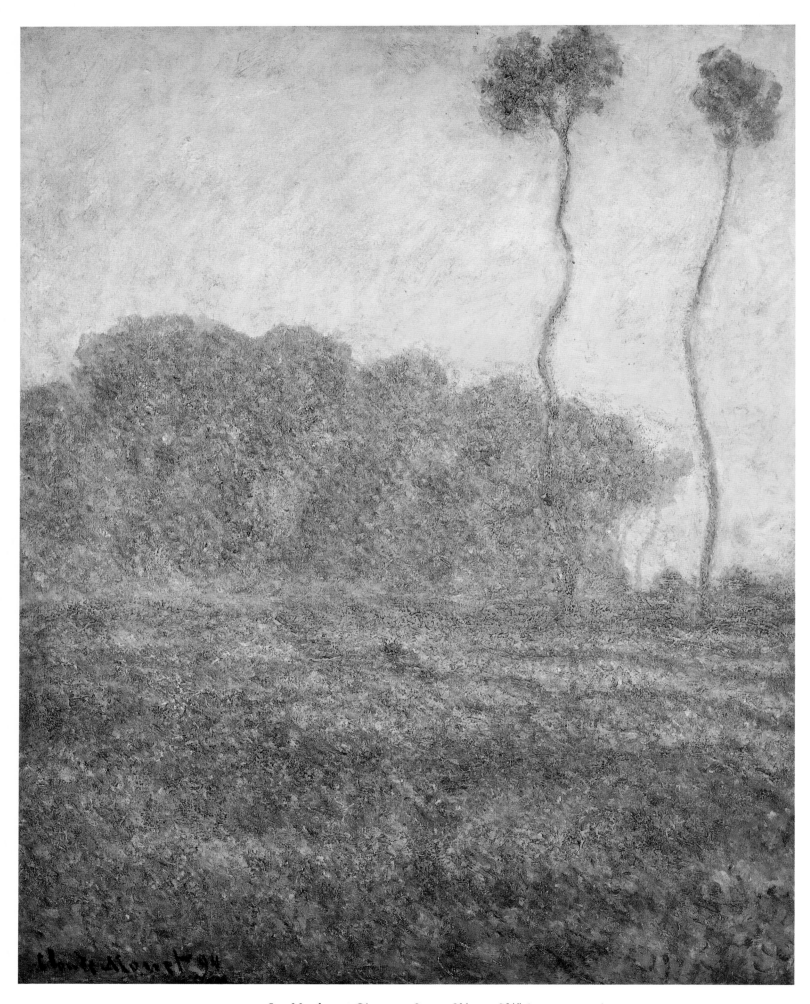

COLORPLATE 84. *Meadow at Giverny*. 1894. 36¼ × 28¾" (92 × 73 cm).
The Art Museum, Princeton University; Bequest of Henry K. Dick.

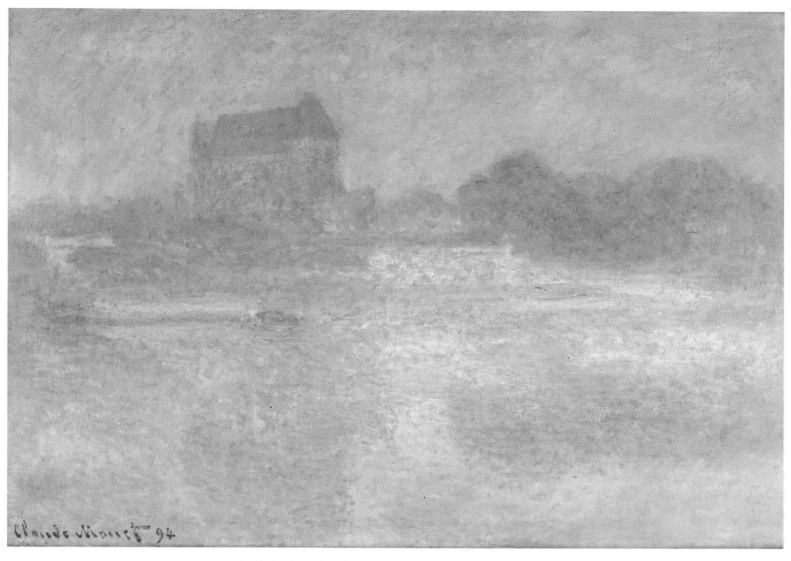

COLORPLATE 85. *The Church at Vernon: Fog.* 1894. 25⅝ × 36¼″ (65 × 92 cm).
Shelburne Museum, Shelburne, Vermont.

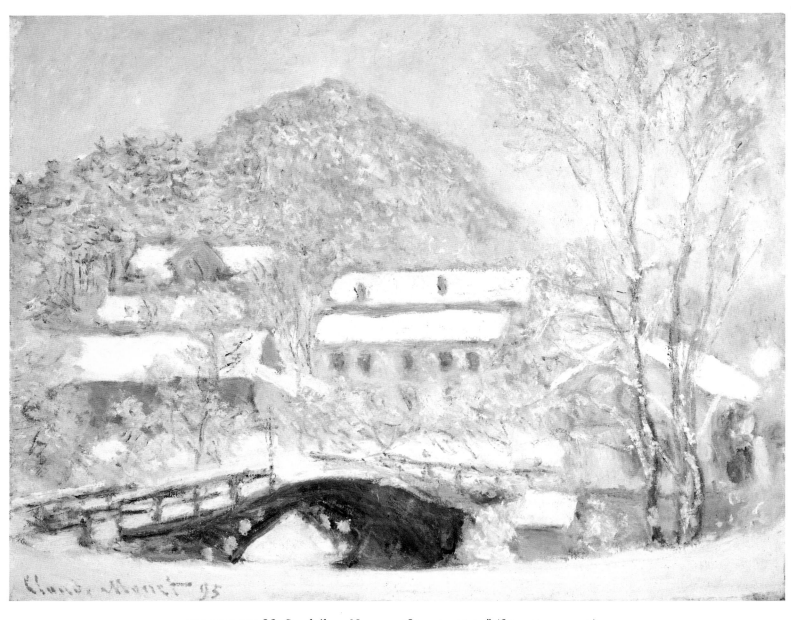

COLORPLATE 86. *Sandviken, Norway.* 1895. 25 × 39″ (63.5 × 99.1 cm).
The Art Institute of Chicago; Gift of Bruce Borland.

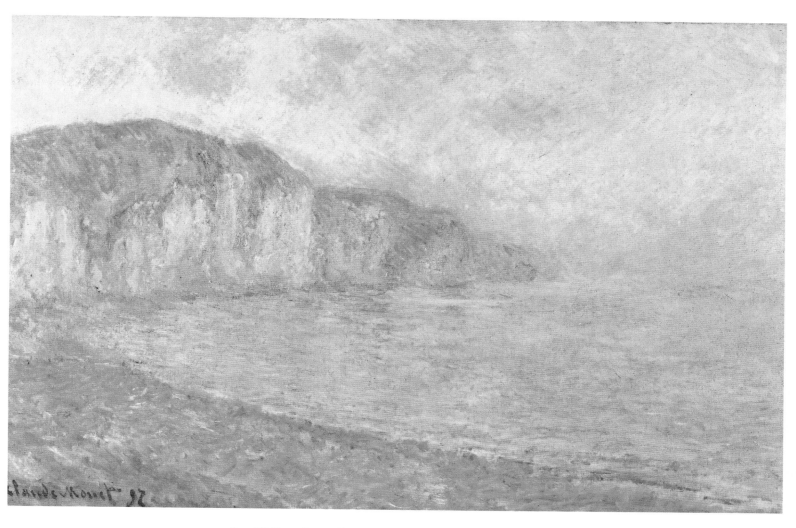

COLORPLATE 87. *Cliffs at Pourville: Morning.* 1897. 25⅝ × 39⅜″ (65 × 100 cm). The J. Paul Getty Museum, Malibu, California.

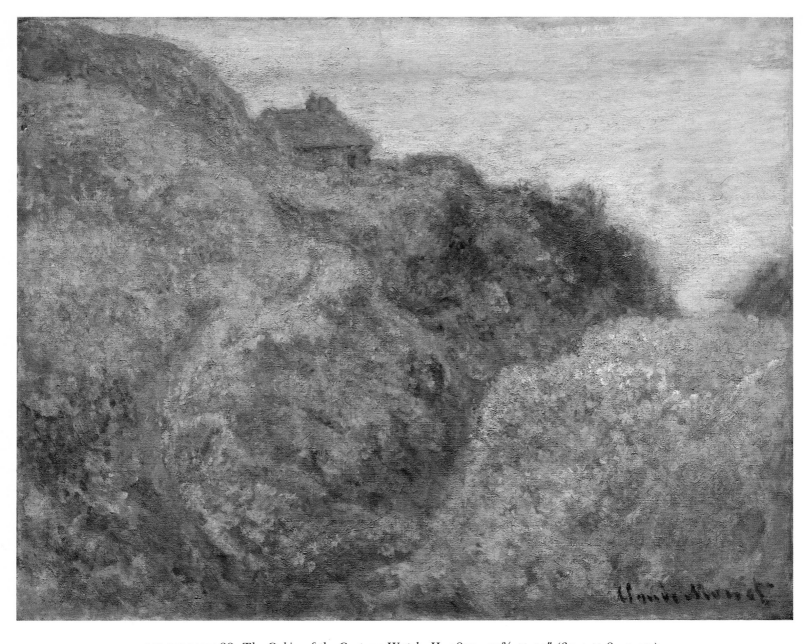

COLORPLATE 88. *The Cabin of the Customs Watch, II.* 1897. 25¾ × 32″ (65.4 × 81.3 cm).
The Metropolitan Museum of Art, New York; Gift of Mr. and Mrs. Richard Rodgers, 1965.

atrociously, and very timid. That day he was very talkative. He asked to see my sketches, invited me to come and work with him, explained to me the why and the wherefore of his manner and thereby completed the teachings that I had already received from Boudin. From that time on he was my real master, and it was to him that I owed the final education of my eye.

"I frequently saw him again in Paris. My painting, need I say it, gained by it. I made rapid progress. Three years later, I exhibited. The two marines that I had sent were received with highest approval and hung on the line in a fine position. It was a great success.—Same unanimity of praise in 1866, for a large portrait that you have seen at Durand-Ruel's for a long time, the "Woman in Green." The papers carried my name even to Hâvre. My family at last gave me back their esteem. With their esteem came also a resumption of my allowance. I floated in opulence, temporarily at least, for later on we were to quarrel again, and I threw myself body and soul into the *plein air*.

COLORPLATE 5

COLORPLATE 8

"It was a dangerous innovation. Up to that time no one had indulged in any, not even Manet, who only attempted it later, after me. His painting was still very classical and I have never forgotten the contempt that he showed for my beginnings. It was in 1867; my manner had shaped itself, but, after all, it was not revolutionary in character. I was still far from having adopted the principle of the subdivision of colors that set so many against me, but I was beginning to try my hand at it partially and I was experimenting with effects of light and color that shocked accepted customs. The jury that had received me so well at first, turned against me and I was ignominiously blackballed when I presented this new painting to the Salon.

"Still I found a way to exhibit, but elsewhere. Touched by my entreaties, a dealer, who had his shop in the Rue Auber, consented to display in his window a Marine that had been refused at the *Palais de l'Industrie*. There was a general hue and cry. One evening, that I had stopped in the street, in the midst of a group of loungers, to listen to what was being said about me, I saw Manet coming along with two or three of his friends. They stopped to look, and Manet, shrugging his shoulders, cried disdainfully: 'Just look at this young man who attempts to do the *plein air!* As if the ancients had ever thought of such a thing!'

"Moreover, Manet had an old grudge against me. At the Salon of 1866, on varnishing day, he had been received from the very moment of his entrance, with such acclamations as: 'Excellent, my boy, your picture!' And then handshakings, bravos and felicitations. Manet, as you may well believe it, was exultant. What was not his surprise, when he noticed that the canvas, about which he was being congratulated was by me! It was the "Woman in Green." The saddest part of it all was that in hurriedly taking his leave he should fall upon a group of painters among which were Bazille and I. 'How goes it?' said one of he crowd. 'Ah! my boy, it is disgusting, I am furious. I am being complimented only on a painting that is not by me. One would think it is a mystification.'

"When Astruc told him the next day that he had given vent to his ill humour before the very author of the picture, and when he offered to introduce me to him, Manet, with a sweeping gesture, refused. He felt bitter towards me on account of the trick I had unconsciously played upon him. Only once had he been congratulated for a master-stroke and that master-stroke had been made by another. How bitter it must have been for a sensitiveness always bared to the quick as his was!

"It was in 1869 only that I saw him again, but then we at once became fast friends. At our first meeting he invited me to join him every evening in a café of the *Batignolles,* where he and his friends gathered after working hours, to talk. There I met Fantin-Latour and Cézanne, Degas, who soon after arrived from Italy, the art critic Duranty, Émile Zola who was then making his *début* in literature, and several others. For

my part I took there Sisley, Bazille and Renoir. Nothing could be more interesting than these *causeries* with their perpetual clash of opinions. They kept our wits sharpened, they encouraged us in sincere and disinterested research, they provided us with stores of enthusiasm that for weeks and weeks kept us up, until the final shaping of the idea was accomplished. From them we emerged tempered more highly, with a firmer will, with our thoughts clearer and more distinct.

"War was declared with Germany. I had just married. I went over to England. In London, I found Bonvin and Pissarro. I suffered want. England did not care for our paintings. It was hard. By chance I ran across Daubigny, who formerly had manifested some interest in me. He was then painting scenes on the Thames that pleased the English very much. He was moved by my distress. 'I see what you need,' he said; 'I am going to bring a dealer to you.' The next day I made the acquaintance of Mr. Durand-Ruel.

"And Mr. Durand-Ruel for us was a saviour. During fifteen years and more my paintings and those of Renoir, Sisley and Pissarro had no other outlet but through him. The day came when he was compelled to restrict his orders, make his purchases less frequent. We thought ruin stared us in the face: but it was the advent of success. Offered to Petit, to the Boussods, our works found buyers in them. The public began to find them less bad. At Durand-Ruel's the collectors would have none of them. Seeing them in the hands of other dealers they grew more confident. They began to buy. The momentum was given. To-day nearly everyone appreciates us in some degree."

Paul Durand-Ruel (1831–1922), son of an art dealer, supported Delacroix and the Barbizon painters as well as academic Salon painters. Beginning in 1870, he became the staunchest supporter of the entire impressionist group.

GUSTAVE GEFFROY

MONET: SA VIE, SON OEUVRE

1924

> Everything has a shape: look at smoke.
> —INGRES

When Claude Monet was working on his views of the Thames in 1900, Clemenceau and I went to visit him, and the three of us spent a few days seeing the city, the museums, the exhibitions, the theater. But the painter never neglected his work, and gave it whatever time it required. Several times we saw him set up on the balcony of his room overlooking the Thames—Charing Cross Bridge on his right, Waterloo Bridge on his left. He remained faithful to his method of working, which no one laughs at anymore, given the results, and that is to work directly from nature. There are other ways to create a masterpiece: from memory or with a knowledge of composition, but these will not create *those* masterpieces, which are easily as great and which express what no one had ever known how to express to such a degree: the magnificent poetry of the passing moment, of life as a continuum. Impressionism has been wrongly—but insistently—considered a slapdash study of detail, while it is exactly the opposite, as I will never cease repeating. It is a synthesis of universal existence, surprised at a certain point and stage of its evolution. Many painters have attempted this synthesis, but they stopped at a rough sketch, because they lacked Claude Monet's perceptivity, which enabled him to understand that the same fleeting moments arise, again and again, almost identical, and that he could extract the epitome and the compo-

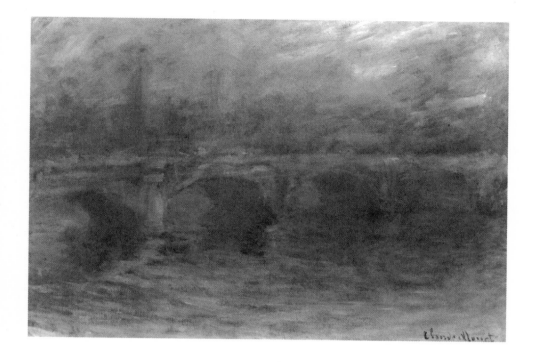

Waterloo Bridge, London, at Sunset. 1904.
25¾ × 36½" (65.5 × 92.7 cm). National
Gallery of Art, Washington, D.C.;
Collection of Mr. and Mrs. Paul Mellon.

sition of these moments on the spot, while others pursued the same end in their studios, with a great to-do of theories.

So, Monet was working on his views of the Thames. He laid brush-stroke on brushstroke, as one may see in the paintings; he laid them on with a marvelous unerringness, knowing exactly which phenomenon of light each stroke represented. Now and then he would stop, saying, "The sun is gone." In front of us, the Thames rolled its waves, almost invisible in the fog. A boat passed like a ghost. The bridges were barely discernible in that space, and on them an all-but-imperceptible movement gave life to the mist's opacity: trains passing each other on Charing Cross Bridge, buses streaming across Waterloo Bridge, wafts of smoke that soon disappeared into the thick and livid vastness. It was an awe-inspiring, solemn, and gloomy spectacle, an abyss from which came the bustle of activity. One could almost believe that everything was about to vanish, disappear into that colorless obscurity.

Suddenly, Claude Monet grabbed up his palette and brushes. "The sun is out again," he said, but at that moment he was the only one who knew it. Look as we might, we still saw nothing but that gray-muffled space, a few hazy shapes, the bridges that seemed to hang in nothingness, the smoke that rose only to quickly dissolve, and a few surging waves of the Thames, visible at the river's edge.

ARSÈNE ALEXANDRE

LE FIGARO

"Monet's Garden"

August 9, 1901

Arsène Alexandre (1859–1937), critic, art historian, and collector who is credited with introducing the term "neo-impressionist."

A man is known by the company he keeps, as the wisdom of the ancients has it; and it is true. And one may know a man better still if one knows his house: what is called a civilized human being's "interior," but

what is, in reality, his *exterior*, that is, the material reflection of his tastes, his desires, his quirks, and his cultural level. Thus, a good reporter never fails to describe in detail the homes of those whom he interviews.

Now, however, I have learned that you cannot claim to know a man until you have seen his garden.

A chance summer outing, among the noble and whimsical and charming folds of this wonderful valley of the Seine led me to this truth when it took me to Giverny. I thought that I knew Claude Monet well, having admired him for twenty years, defended him before it was the thing to do, met him many times in Paris, studied his work thoroughly, known his friendships and his enmities. . . . Well, this man, this artist, was, behind the deceptive mask of familiarity, a complete stranger. I had not seen his garden!

One leaves Vétheuil, that agreeable hamlet, whose whimsical and delicate outlines—spread over the hillside and coyly reflected in the mirror of the Seine—he has more than once portrayed; one follows a rather odd road through a constant contrast of barrenness and fertility. For, while on the left there are lush meadows and dense orchards perpetually nourished by the river's waters, on the right, tall chalk cliffs rise, like those of the Normandy coast, whose harbingers or doubles these appear to be. Then there comes a succession of villages and roads and flat, open country and small woods. On the way, if one were to stop and climb one of these cliffs, one would enjoy the incomparable sight of a valley as grand as it is gentle—a veritable fairyland of tranquillity.

Finally, Giverny appears along the road, which passes through it; the village is pretty but somewhat characterless, being partly rural and partly middle-class. Suddenly, just as one has reached the end of the village and is about to proceed on toward Vernon—not having been drawn by any desire to stop—a new and extraordinary pageant greets us with the unexpectedness of all great surprises. Imagine every color of a palette, all the tones of a fanfare. This is Monet's garden.

Because it is longer than it is deep, and its length is parallel to the road, and the artist who created it closed it off with only a very low wall and a very plain gate—from either generosity or coquetry, or both—the passerby can enjoy nearly all of its splendor. Yet though the effect from the outside is dazzling enough, the sensation on entering is even more intense, even more surprising.

The horticultural exhibitions held in the Tuileries gardens might give one an idea, but, while those brilliant beds last only four or five days, there is no rest for the flowers of the garden at Giverny. Everywhere you turn, at your feet, over your head, at chest height, are pools, festoons, hedges of flowers, their harmonies at once spontaneous and designed and renewed at every season. You can set your imagination free and picture yourself as a Parsifal, helpless in the intoxicating wiles of the Flower Maidens, or, among the flaming spears of gladioli, that you are a Siegfried about to discover the sleeping Valkyrie amidst the dazzling profusion.

More simply—and more truly—when you explore these impressions and their causes, you find that you are in the domain of a master gardener.

Indeed, what is most remarkable about Monet's garden is not the plan but the planting, a play on words that nevertheless describes the principle behind these floral fireworks. The garden is divided into tidy "squares" like any truck garden of Grenelle or Gennevilliers. Substitute flowers for carrots and lettuce, in rows just as close together, and you can work wonders—if you know how to play the floral almanac like a keyboard and are a great colorist. It is this profusion, this teeming aspect that gives the garden its special quality. The flowers are not overgrown. They do not choke each other, as people ignorant about gardening, like ourselves, might expect, even if they are as crowded as heads of grain in

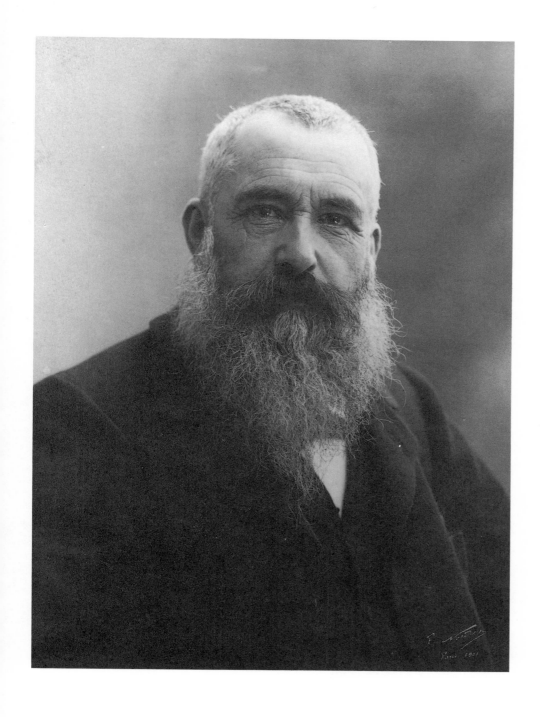

Nadar. *Monet in 1901*. Musée Marmottan, Paris.

a field. I had, with some surprise, noticed this effect in another garden once, one that would be interesting to describe as well: Clemenceau's garden at Passy. Monet wants as many flowers in his garden as a space can hold.

He also wants, perhaps above all, his flower palette before him to look at all year round, always present, but always changing. Everything is designed in such a way that the celebration is everywhere renewed and ceaselessly replaced. If a certain flower bed is stilled in a certain season, borders and hedges will suddenly light up. The other day, what dominated—or at least most charmed one's gaze—were the broad but subtle harmonies of yellows and violets.

This last helps to describe the master's creation; the effect is explosive and joyful, and every effect is planned.

There is also a second garden, which one does not see when passing by the first, because the former lies below a small railroad spur that runs parallel to the road.

This is the famous water lily garden, with its little green Japanese bridge spanning the ornamental lake surrounded by willows and other trees, either fancifully shaped or rare. When the sunlight plays upon the

water, it resembles—damascened as it is with the water lilies' great round leaves, and encrusted with the precious stones of their flowers—the masterwork of a goldsmith who has melded alloys of the most magical metals.

This garden has inspired legends. They used to say that Monet, one day, "had his land flooded," just like that, because the fancy took him, as they say in the Midi, and that he "had aquatic plants sown" there; then, that the following season he had scrubbed the series that he exhibited last spring. Well, the pond has been there for ten years, and the series has been in progress for ten years, on and off. And this is yet another reason why it was useful to see the painter's garden, in order to truly understand his work.

Sometimes he works in the garden, exhilarating his eyesight and his imagination with the elusive glints that play on this marquetry of great full-blooming flowers and [the reflections colored like] molten metals. Sometimes, more often, he works in the large studio set amidst his flowering truck garden, like a combination market stall and observatory.

The same man we find to be somewhat laconic and cold in Paris is completely different here: kindly, unperturbed, enthusiastic. When he has reason to come into the land of the boulevards, his smile is more than

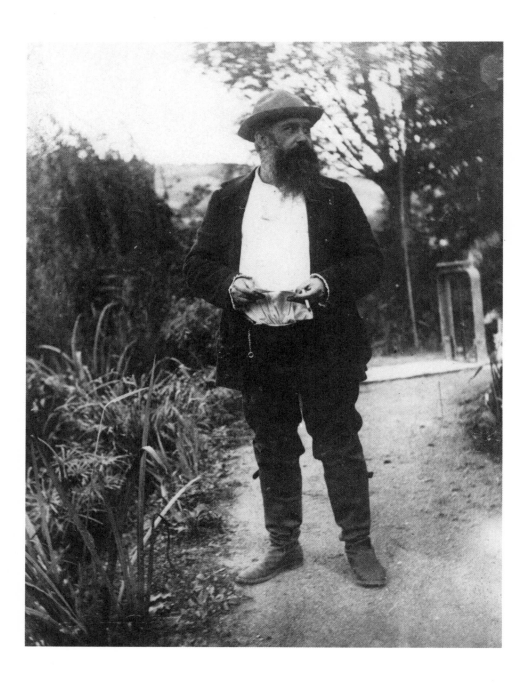

Lilla Cabot Perry Papers. 1889–1909. Archives of American Art, Smithsonian Institution, Washington, D.C.

a little mocking and sarcastic; in his garden, among his flowers, he glows with benevolence. For months at a time, this artist forgets that Paris even exists; his gladioli and dahlias sustain him with their superb refinements—but cause him to forget civilization.

This, then, is why I say that the garden is the man. Here is a painter who, in our own time, has multiplied the harmonies of color, has gone as far as one person can into the subtlety, opulence, and resonance of color. He has dared to create effects so true-to-life as to appear unreal, but which charm us irresistibly, as does all truth revealed.

Who inspired all this? His flowers. Who was his teacher? His garden.

He owes it a great debt, he is proud of it, and freely introduces passersby to his mentor. Such is the lesson that a plot of earth, artfully sown, can teach. Such is the light that a mere hour's visit can shed on a man's character and career. Does this mean that anyone who cares to see this creation ought to make this visit? I would not advise it; rather, I invite you to take my word for it. For there is a gate! . . . and it is not always open, even if one may always look through it.

This was, finally, not the least of the lessons learned on our excursion: great artists, superior men, can live in glass houses. One may see through glass—but not pass through it.

ARSÈNE ALEXANDRE

COURRIER DE L'AISNE

"News from Our Parisian Correspondents"

June 9, 1904

This week, M. Claude Monet returned to his garden at Giverny, near Vernon, in the Eure. Actually, this is simply a manner of speaking, since M. Monet is practically always in his garden, and it is easy when one knows this garden to understand why he leaves as seldom as possible. Only this week, a 20-day-long exhibition which excited considerable interest drew to an end, leaving the artist somewhat upset by a heavy schedule. This exhibition of the renowned landscapist's most recent works, including a series of views of the Thames, dazzled every observer with the subtlety of their effects, the richness of their colors, the astonishing rendering of the sun through the mists, and the enchantment of the atmosphere. I will not elaborate, since I am not an art critic, but I felt that this was indeed an artistic event.

In fact, people are starting to knock at the gates of Monet's famous garden. Many reporters have come in search of his marvelous flower beds, and articles are beginning to appear about his graceful irises. They tell about the ponds full of water lilies, the little Japanese bridge, and all sorts of familiar things, as though they were new. However, it always pleases us to hear about them again.

It was probably assumed that, like most artists, Monet stayed in Paris for the duration of his exhibit, so that once it was over, he could be interviewed without the risk of missing him at home. But a bit of research would have revealed the fact that M. Monet had hardly been away from

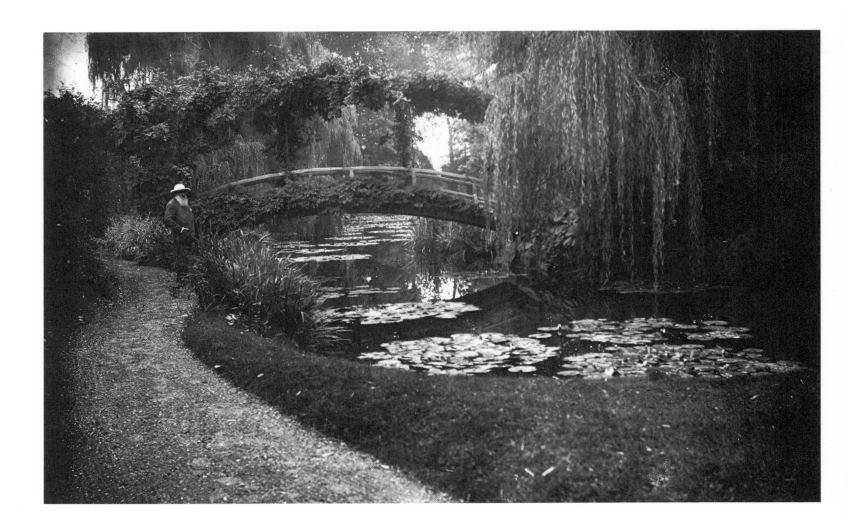

Giverny, since one cannot leave a place such as this in mid-spring, when it is the most beautiful. He participated as little as possible at the opening and during the days that followed, and when it was necessary for him to be in Paris for the sale of his paintings, this is how he proceeded (a historical detail overlooked in all the articles written until this one): he would leave Giverny by car between 5 and 6 o'clock in the morning in order to arrive at the rue Laffitte at 9 AM. After the indispensable exchange of words with his agent, he would leave to be back at Giverny by noon. Thus, he successfully avoided acquaintances and rushed home at 80 kilometers per hour, which is an agreeable diversion in itself. All in all, he had been away from his garden for the shortest possible time.

Now one must acknowledge that this behavior is very understandable. One can as easily understand why the journalists seeing this garden for the first time are so enchanted by it. Even the memory of the place is enough to provide the spirit with a lasting spectacle.

Monet's garden has nothing in common with the Parc Monceau or Kew Gardens near London. I do not want to slander Kew Gardens or the Parc Monceau, because, along with the garden at Versailles, they are delightful in their own way. But the garden at Giverny, which bears them no resemblance at all, is astonishing. It is not overly sophisticated in the least. One cannot see any rounded flower beds arranged to look like bouquets or Italian mosaics. It has none of the conventionally picturesque style that is the glory of specialists who are all more or less Lenôtre's heirs.

Monet's idea had been to create a garden like no other garden in arrangement and extent. For example, he had a profusion of plants thrown into vast squares like squares of cabbages, beans, or carrots. The result is of an unbelievable intensity. Nothing is left to chance. As in his paintings, where everything appears to be spontaneous and haphazard but is

Monet by the water lily pond with the footbridge in the background. Photograph: H. Roger-Viollet, Paris.

André Lenôtre (1613–1700), master gardener to Louis XIV and his court.

not, the garden is planned with a great deal of calculation, experience, and knowledge of the laws of harmony. Not many people could use the space so wisely. However, even though the method has been revealed, I would not advise my readers to try to grow a garden like Monet's, as skilled in gardening as they may be. To begin with, the cost of such an enterprise is staggeringly expensive.

But for Monet, this was a necessary expense. First, because he is a man who appreciates splendid things, a fact clearly demonstrated by his passion for the most ostentatious of flowers. Furthermore, the garden is of admirable assistance to him in his work. It is a priceless collection of the most intense and rare harmonies; an unequaled palette. Thus, with this palette in hand, or rather in sight, Monet was able to paint, on the banks of the Seine at Giverny, all of the wonders of the Thames from which he had merely taken notes in London. It is an opus which brought much suffering to Monet. The splendidly colored fogs hovering above the Thames almost destroyed his health. For a great part of the time he spent in London, Monet seemed to be close to death. When he finally returned to Giverny, it must have felt like a soothing haven of infinite happiness. Of course, many critics maliciously claimed that the theory of impressionism had been undermined, since the paintings of the Thames had not been achieved on location. However, this would lead to a lengthy discussion that would be quite ridiculous, given the quality of the *Thames* paintings. Monet would be the first to laugh at these objections, and with good reason. For when one owns such a beautiful garden, one can afford to laugh at such trivialities. I believe that this is the moral of *Candide*.

GUSTAVE KAHN

GAZETTE DES BEAUX-ARTS

"The Claude Monet Exhibition"

July 1, 1904

Gustave Kahn (1859–1936), journalist, art historian, and symbolist poet who staunchly supported the neo-impressionists and the post-impressionists.

One of the most famous episodes in the history of impressionism is the trip that Claude Monet and Camille Pissarro took to London early in their careers, in the full youth of their art. They were captivated by Turner's precise yet fairy-tale magic, won over by the vast city and its sky of soot and mother-of-pearl, iridescent with its many atmospheric variations, gray with every kind of smoke, which formed a canopy—constantly changing, distanced, drawn near, darkening, mottled—above the factory chimneys and cottage roofs, a gloomy cover, a vaporous halo, a slack and mobile awning; won over by the dense or else glowing fog, where the wind ceaselessly stirs up, unfurls, or lowers variegated mantles of brown dust or rose sunshine.

As for Claude Monet, he liked a decor where the light may reign freely, without anything to distract the oberver from the fairy play that the light acts out with its opposite numbers: the mists and smoke, which it reflects in the Thame's great waters, and refracts on the piers of the bridges and the stones of the monuments. It is an illusion of gems and nosegays, of everchanging phantasmagoria, wherein colors become hues, various and shifting, muted in the fog that skims the water and, flick-

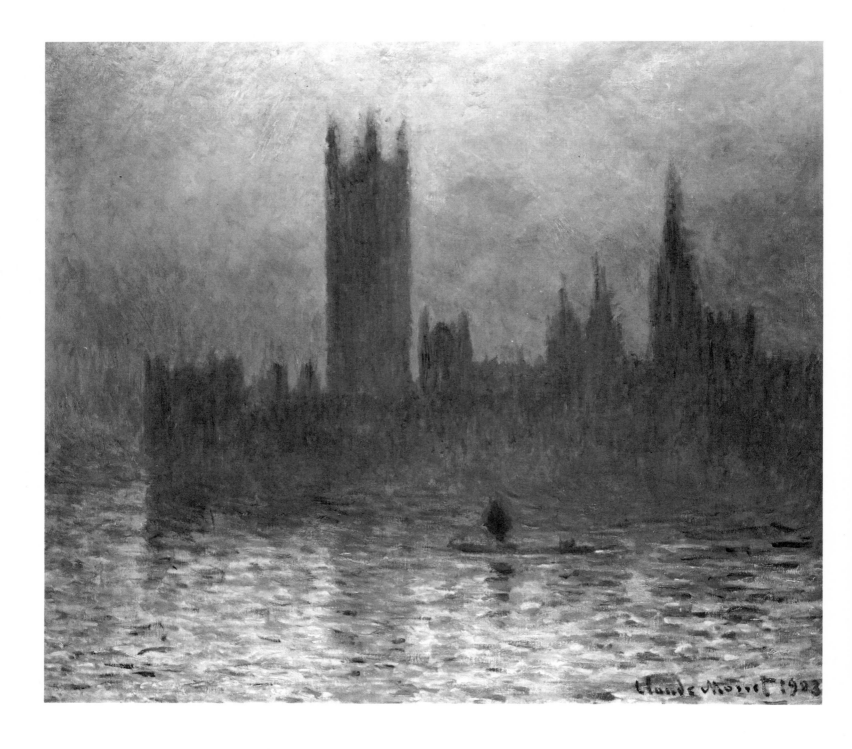

ering, retreats toward the towers of buildings and factories, toward the clouds.

Claude Monet took note of rare, perhaps unique, moments so rich in beauty, in diversity, in luxury, that they seem—for an instant—as unreal as the realm of Queen Mab; and before these pyrotechnics of gold, of rose-pink, of rose-red, of rose dotted with red, of purple, of meadow-green, of gilded or deep blue-green, one could believe—for an instant—that this sight must be based on some principle of polychrome decoration rather than caused by an absolute obedience to nature. One could believe these to be harmonies on a theme born in the very moment the sketch is drawn, in the hour's graces and blend of colors, harmonies played not by a virtuoso, but by a master composer of symphonies, one gifted with great depth of feeling and with an imagination infinitely fresh, robust, and inventive. But none of these is the case. These paintings are meticulously crafted from precise notations; they are a struggle with the atmosphere's elusive mobility, with the protean light

The Houses of Parliament at Sunset. 1903. 19⅛ × 36⅝" (81.3 × 92.5 cm). National Gallery of Art, Washington, D.C.; Chester Dale Collection 1962.

that continually banishes new beauties and the tints of reflections into the death of time.

If it is true that Turner liked to compare certain Turners to certain Claude Lorrains, then one might place certain Monets beside certain Turners. One would thereby compare two branches, two moments of impressionism, or rather—because the names of schools are deceptive, and *impressionism* only has meaning in the wake of the echoes it evokes (including the very present influences of Vermeer, Ingres, Delacroix, Corot, Turner, and of the new landscape art, as well as new studies of roads and cities)—it would integrate two moments in a history of visual sensitivity.

Claude Monet explored three themes for his views of the Thames: Charing Cross Bridge, Waterloo Bridge, and Parliament.

Parliament appears as though [constructed] of different densities. Here, in the sunset, it looks like a great green forest; its pinnacles, in their hazy outlines, look like foliage; thick clouds—violet, green, blue, streaked with purple and blood—roll across calm waters that reflect both the building and the sky, in a convent-like peace and solitude. And here, it appears woven in violet mist; behind it, in deep perspective, the forest of factory towers; it looks like a palace of Thule, a temple of silence, mystically conjured up, outlined, in the magic of the hour, in the ringing and brutal city, by Claude Monet's precise art. The heavily rolling waters at the foot of Westminster evoke the representation of water in the legends of the North—the green-mantled nixies, their hands playing silver harps. Monet's waters wear just such an emerald mantle, drifting into silver tassels touched with prismatic glimmers. In one of these *Sunsets*, the star is a visible, heavy disk from which emanate the most subtle variations of color; elsewhere, it spreads like brimstone, like the sulfurated smoke over Gomorrah, in clouds of violet, crimson purple, and orange, and its reflections lap on a heavy water of rose, blue, green, with mica glints of rose everywhere bloodied with points of red. The sun breaches the fog, illuminating melded flakes of air and water, sweeping in a single rhythm, in which the star streams, lighting—on every surface, on every glimmer of these luminous wisps—what appear to be an infinity of lamps, each one varied and filtered by weightless veils and an infinity of hues.

Waterloo Bridge carries a stream of cars, under skies of different moods; a fairy-like play of light rushes under the violet shadow of its arches, and strokes of sunshine light, in the windows of a factory tower, a beacon in the weightless smoke.

J.M.W. Turner (1775–1851), England's greatest landscape painter, bequeathed the vast majority of his controversial, dashingly rendered, color-charged output to the National Gallery in London. In his will, Turner stipulated that two of his paintings be permanently installed adjacent to works by Claude Lorrain (1600–1682) that had been a challenge and an inspiration for him.

Claude Lorrain (1600–1682), with Poussin, was renowned as a master of Italianate classic landscape painting.

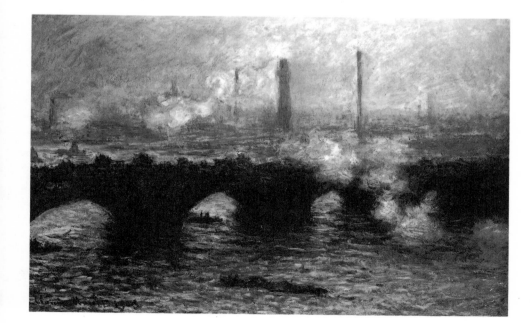

Waterloo Bridge: Gray Day. 1903. 25⅜ × 39⅜" (65.1 × 100 cm). National Gallery of Art, Washington, D.C.; Chester Dale Collection 1962.

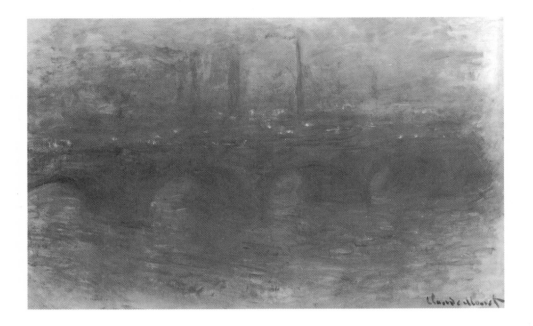

Waterloo Bridge, London, at Dusk. 1904. 25⅞ × 40″ (65.7 × 101.6 cm). National Gallery of Art, Washington, D.C.; Collection of Mr. and Mrs. Paul Mellon.

This crowd, these waters, this background of houses and factory chimneys, are all constantly changing. Here, the water drifts languorously; there, it rushes in a massy flow; there, it is oily and gentle, caressing the wavelets' tips with little skimming tufts. It looks torn by a powerful rake that reveals its shining jewels; or, as the light glances off the river, through the fleecy, mottled wall of fog, its waves move in slow procession, their slow crests strewn with bouquets.

In *Gray Weather,* violet smoke from an invisible boat drifts and expires by the bridge's gray and blue arches; on the bridge, the rushing press of the omnibuses, seen against the distant line of the riverbank, takes on the semblance of a massing crowd, almost of a hum, a murmur that dissolves into a sort of abyss beneath the crisp, strong bars of work smoke. When the sun shines, the traffic takes on a festive air; rose and red, the cars pass, bright, almost golden, while the Thames looks like a lake in flames beneath light blue and pale green clouds, or seems to swell in its opaque and glimmer-spangled mantle, as in the vision so beautifully and faithfully offered us, with all the water's charm and slow mobility, in the reproduction by the master-engraver Waltner. The line of cars appears cast upon the bridge like a long, jeweled necklace upon a table, its gems different in their color and their depth, yet all awakened by the light. In *Sun in Fog,* the bridge drops off to sleep in a deep blue, into which melt long, green-tinted gleams. A stray ray of crimson purple, of brimstone, drifts—the color of the Styx—to fall asleep beneath an arch, where its glint seems to blacken. To complete this feeling of doleful nightfall, the resemblance to the Phlegethon, a boat glides or rises like a purplish shadow, so that—with the setting created by the neighboring canvases, so brilliant, so supple in their light-filled iridescences, vibrant with shining sparks, golden spangles that will melt into veiled, twilight-tinted blues—one cannot help but be reminded of Baudelaire's landscape verses in his evening "Contemplation" of the things and the souls in the town where he describes the dying sun dropping to sleep beneath an arch, and elaborates, for his beloved, the image of this distant rumble toward this silent peace:

Charles Waltner (1846–1925).

> And like a long shroud trailing toward the East
> Hear it, my dear, hear the steps of gentle Night.

The Charing Cross Bridge series numbers the fewest paintings. The motif for it is given in an airy vision of the river, where one seems to see, lightly passing, mobile and brief, the fragile shades of dawn. The water

is like a mirror on which vaporous shadows chase and succeed one another—fragile, slow harmonies, like those of Schumann, if you will, or of Fauré. Trains arrive, their gray columns of smoke turning to violet as they rise toward the sky and billow into heavy, then powdery sashes. Like another strain in the symphony, the fog blurs a part of the bridge, consumes it, bites the green reflection that cuts the waters like a rigid bar. Here, the pillars of the bridge cast diffuse shadows, like great, moving, trembling leaves on the green water. The most beautiful of the eight paintings that speak the splendor of Charing Cross Bridge is the one that seems most unreal. In this one, the decor is broadened to include the view of another bridge in the distance, isolated in a joyful sky. The water everywhere sparkles beneath the thick convolutions of smoke, which curl like violet fleeces, sparkle in bursts of glory, in rose and orange-tinted leaps, in a simultaneity of flashes that run through the entire enchanted, misty vision and seem to run toward the sea in the rhythms of a festive procession and an endless murmur of luminous pearls.

WYNFORD DEWHURST

IMPRESSIONIST PAINTING: ITS GENESIS AND DEVELOPMENT

1904

Claude Monet is enthusiastically in love with London from the painter's point of view. From the balconies of the Savoy Hotel the French master has watched the tidal ebb and flow of the great grey river, with its squalid southern banks shrouded day by day in white mist and brown smoke, the warehouses and chimneys coated in a veil of soot, the legacy of ages. The autumnal fogs, which harmonise discordant tones, round off harsh outlines, cloak the ugly and create the beautiful, are to the foreigner London's greatest charm, although to the inhabitant they are a deadly infliction.

No writer ever expressed this fascination more eloquently than the "Wizard of the Butterfly Mark," who wrote: "And when the evening mist clothes the riverside world with poetry, as with a veil, and the poor buildings lose themselves in the dim sky, and the tall chimneys become campanili, and the warehouses are palaces in the night, and the whole city hangs in the heavens and fairyland is before us—then the wayfarer hastens home; the working man and the cultured one, the wise man and the one of pleasure, cease to understand, as they have ceased to see; and Nature, who, for once has sung in tune, sings her exquisite song to the artist alone, her son and her master—her son in that he loves her, her master in that he knows her."

With these thoughts Claude Monet is in perfect agreement. He is amazed at the apathy and indifference of British artists, blinded no doubt by familiarity, in allowing so fertile a field of labour to remain comparatively unexplored, not only with regard to the river scenes, but to the Metropolis as a whole. Whistler was fascinated, so was Bastien-Lepage, so is Claude Monet; but the Englishman remains unmoved.

A chapter could be written upon the artist possibilities of the city, and the fringe of the subject would have been then but touched. Where, asks Monet, can more soul-inspiring subjects for the brush be found than in

Wynford Dewhurst (1864–1941) studied art in Paris with major academic painters Gérôme and W. A. Bougereau before becoming an impressionist. He chronicled the original members of the group in articles and books for the English-reading public.

COLORPLATE 97

COLORPLATE 100

COLORPLATE 101

Reference to James Whistler (1834–1903), expatriate American artist closely associated with the French realists and impressionists. Whistler's "Ten O'Clock" lecture (1885), quoted here and translated by Mallarmé in 1888, is the most eloquent account of the notion of art for art's sake.

Jules Bastien-Lepage (1848–1884), acclaimed in Paris for his large realist peasant paintings, sought international success in London in the 1880s.

the Strand from morning to night, in the movement of Piccadilly, in the evening colour of Leicester Square, the classic sweep and brilliancy of Regent Street, the bustle of the great railway termini, the dignity of Pall Mall and the sylvan glades of Kensington? They offer themes in such variety that the devotion of a lifetime would not give adequate realisation.

It was during his visit to London with Pissarro and other painters in 1870 that Monet carried an introduction from Daubigny which led to his acquaintance with M. Durand-Ruel, expert connoisseur and most celebrated of all the Parisian art dealers. It proved to be the commencement of a life-long friendship, and established business relations which meant the actual necessities of existence, bread and butter itself, to the struggling Impressionists. During this visit, which had such auspicious results, Monet studied with profound admiration the canvases of Turner in the National Gallery, and he was also able to increase very largely his knowledge of the art of Japan.

* * *

Of the last exhibited group of "effects," the series known as *Les Cathédrales* of Rouen, exhibited at the Durand-Ruel gallery in the spring of 1895, Monet writes in a personal note to the author: "I painted them, in great discomfort, looking out of a shop window opposite the Cathedral. So there is nothing interesting to tell you except the immense difficulty of the task, which took me three years to accomplish." Despite the immense difficulties involved in their production, Monet considers them to be his finest works. On the other hand, they are the works least understood by the public.

The series consists of twenty-five huge canvases, a feat requiring considerable physical endurance and indomitable perseverance. Each canvas demonstrates the fact that the painter possesses eyes marvellously sensitive to the most subtle modulations of light, and capable of the acutest analysis of luminous phenomena. The façade of the ancient

Hyde Park, London. 1871. 15¾ × 28⅞″ (40 × 73.3 cm). Museum of Art, Rhode Island School of Design, Providence; Gift of Mrs. Nancy Danforth.

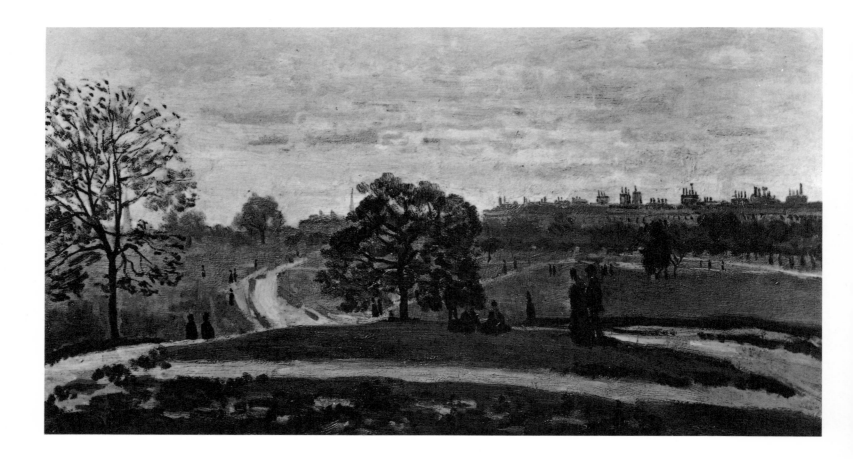

Norman fane is depicted rather by the varying atmospheric effects dissolved in their relative values, than by any actual draughtsmanship of correct architectural lines. It is very regrettable that the series was not purchased "en bloc" for the French nation. The opportunity has been lost. The canvases realised enormous prices, and are now scattered over two continents.

In years to come visitors to Rouen will be shown with pride the little curiosity shop "Au Caprice" on the south-west side of the "Place," from the windows of which Claude Monet evolved these world-famous paintings of Rouen Cathedral.

<p style="text-align: center;">* * *</p>

Monet is seen in his most genial moods when, with cigar for company, he strolls through his "propriété" at Giverny, discussing the grafting of plants and other agricultural mysteries with his numerous blue-bloused and sabotted gardeners. He settled with his family at Giverny in 1883; and Stephen Mallarmé, his old friend the poet, has given us the address for his letters:

> *Monsieur Monet, que l'hiver ni*
> *L'été sa vision ne leurre,*
> *Habite en peignant, Giverny,*
> *Sis auprès de Vernon, dans l'Eure.*

He is now sixty-two years of age, in the prime of his powers, active and dauntless as ever. Each line of his sturdy figure, each flash from his keen blue eyes, betokens the giant within. He is one of those men who, through dogged perseverance and strength, would succeed in any branch of activity. Dressed in a soft khaki felt hat and jacket, lavender-coloured silk shirt open at the neck, drab trousers tapering to the ankles and there secured by big horn buttons, a short pair of cowhide boots, his appearance is at once practical and quaint, with a decided sense of smartness pervading the whole.

Monet has the reputation of being surly and reserved with strangers. If true, this manner must have been assumed to repel those unwelcome visitors who, out of thoughtless curiosity, invade his privacy to the waste of valuable time and the gradual irritation of a most sensitive nature.

Determination is the keynote of Monet's character, as the following anecdote (told me on the spot by the poet Rollinat) shows. In the spring of 1892 [sic—1889] the artist was busily occupied painting in the neighbourhood of Fresselines, a wild and picturesque region of precipitous cliffs and huge boulders in the valleys of the Creuse and Petit Creuse. A huge oak-tree, standing out in bold relief against the ruddy cliffs, was occupying Monet's whole attention. Studies of it were taken at every possible angle, in every varying atmosphere of the day. Bad weather intervened, wet and foggy, and operations were suspended for three weeks. When Monet set up his easel again the tree was in full bud, and completely metamorphosed. An average painter would have quitted the spot in disgust. Not so Monet. Without hesitation he called out the whole village, made the carpenter foreman, and gave imperative orders that not a single leaf was to be visible by the same hour on the following morning. The work was accomplished, and next day Monet was able to continue work upon his canvases. One admires the painter, and feels sorry for the unhappy tree.

After painting, Monet's chief recreation is gardening. In his domain at Giverny, and in his Japanese water-garden across the road and railway (which to his lasting sorrow cuts his little world in twain), each season of the year brings its appointed and distinguishing colour scheme. Nowhere else can be found such a prodigal display of rare and marvel-

Monet by the water lily pond.
Photograph: Ets J.E. Bulloz, Paris.

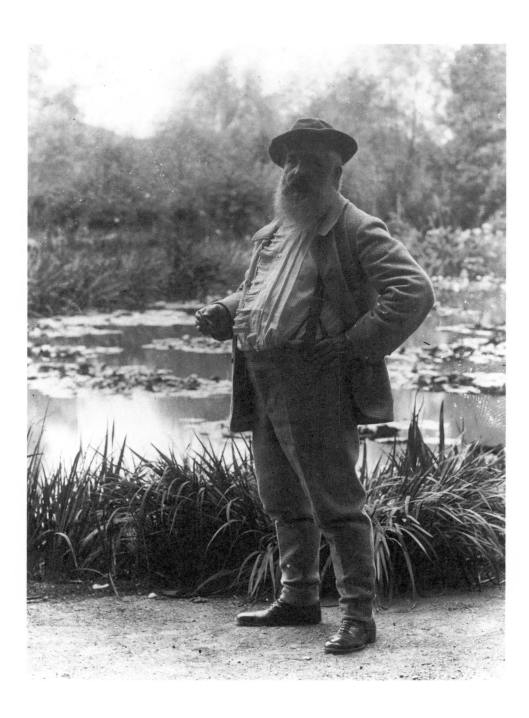

lously beautiful colour effects, arranged from flowering plants gathered
together without regard to expense from every quarter of the globe.

Like the majority of Impressionists, Monet is most pleased with
schemes of yellow and blue, the gold and sapphire of an artist's dreams.

In the neighbouring fields are hundreds of poplars standing in long
regimental lines. These trees, which inspired *Les Peupliers*, [*The Poplars*]
were bought by Monet to avoid the wholesale destruction which threat-
ened every tree in the Seine valley a few years ago. The building au-
thorities of the Paris Exhibition required materials for palisading,
and thousands of trees were ruthlessly felled to make a cosmopolitan
holiday.

In the distance are the mills, subjects of the master's admiration
and reproduction, yearly copied by the scores of students and amateurs
who, year by year, during the summer, journey through this delightful
country.

In the peace of Giverny we leave the great painter. He is one of the
few original members of the Impressionist group who has lived to see the
almost complete reversal of the hostile judgment passed upon his can-
vases by an ill-educated public. Now he is able to enjoy not only the sat-

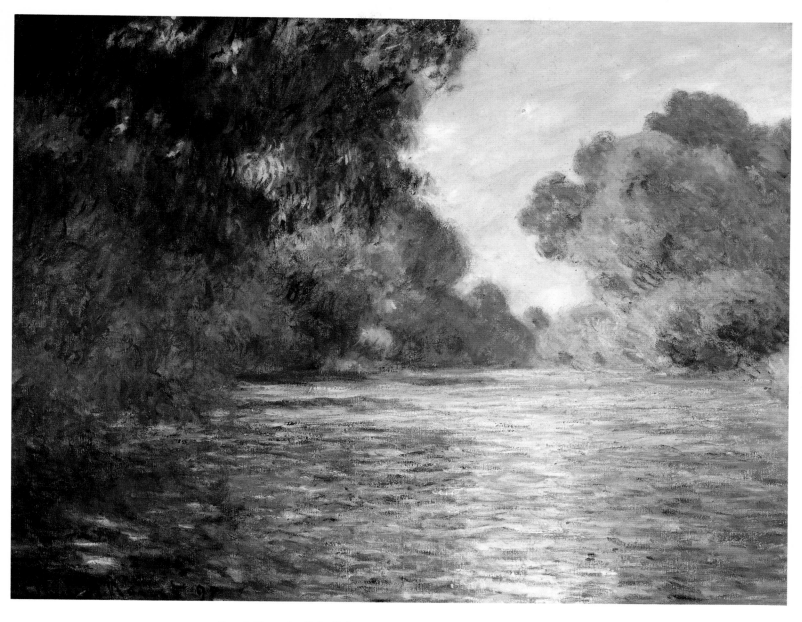

COLORPLATE 89. *A Branch of the Seine near Giverny*. 1897. 29½ × 36⅝″ (75 × 93 cm).
Galerie du Jeu de Paume, Musée du Louvre, Paris. Photograph: Musées Nationaux, Paris.

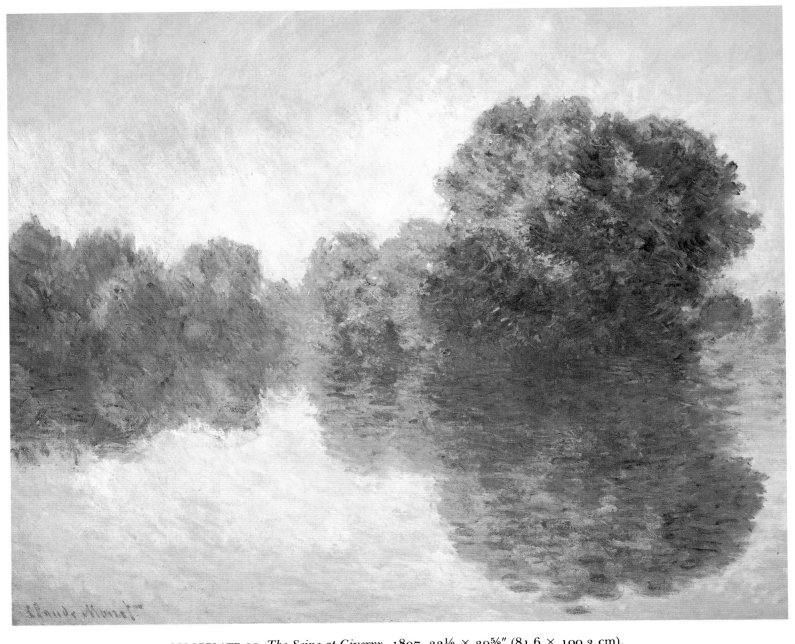

COLORPLATE 90. *The Seine at Giverny.* 1897. 32⅛ × 39⅝″ (81.6 × 100.3 cm).
National Gallery of Art, Washington, D.C.; Chester Dale Collection.

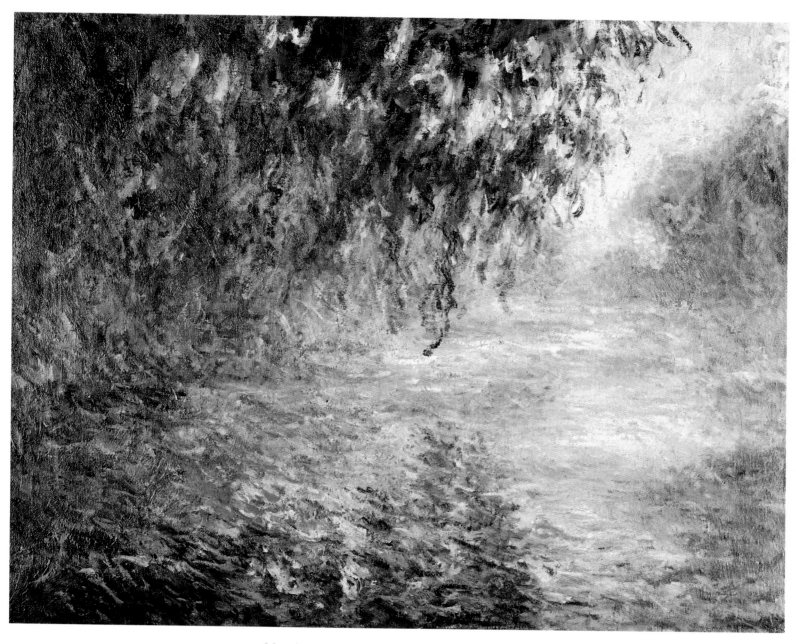

COLORPLATE 91. *Morning on the Seine: Rain.* 1898. 28¾ × 36¼″ (73 × 92 cm).
The National Museum of Western Art, Tokyo.

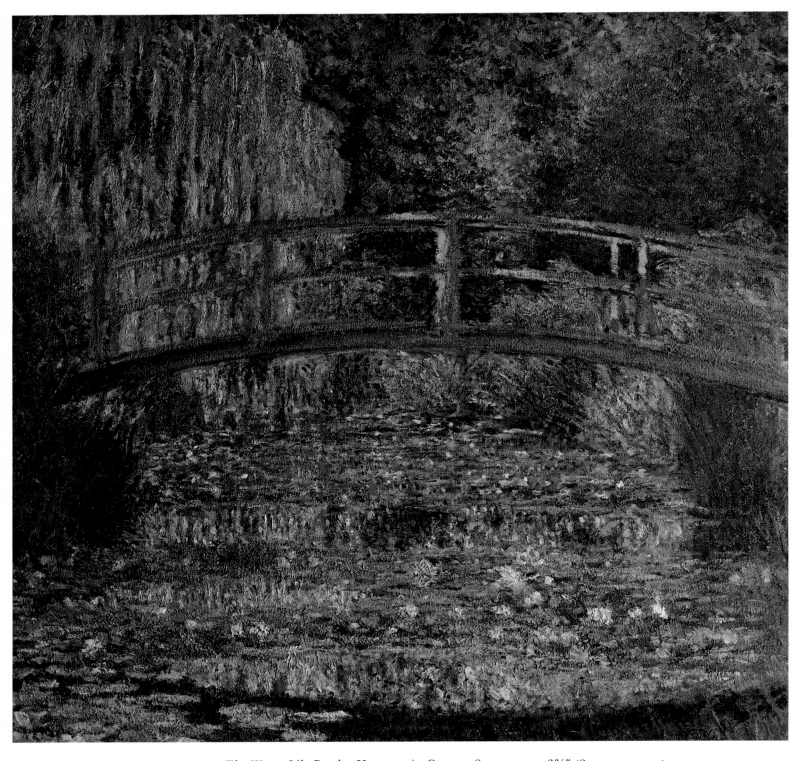

COLORPLATE 92. *The Water Lily Pond—Harmony in Green*. 1899. 35 × 36¾″ (89 × 93.5 cm). Musée d'Orsay, Paris. Photograph: Musées Nationaux, Paris.

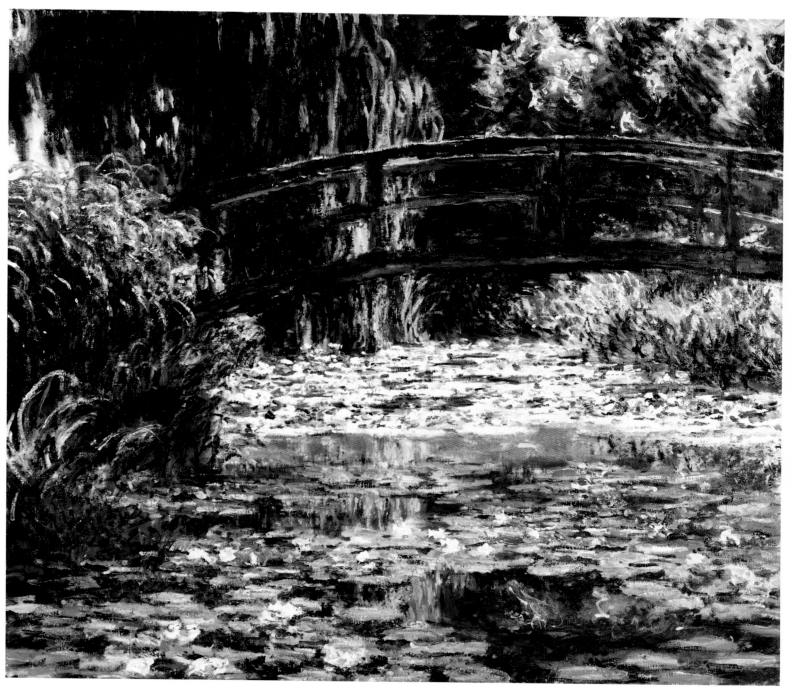

COLORPLATE 93. *Japanese Bridge at Giverny.* 1900. 35⅜ × 39¾" (89.9 × 101 cm).
The Art Institute of Chicago; Mr. and Mrs. Lewis Larned Coburn Memorial Collection.

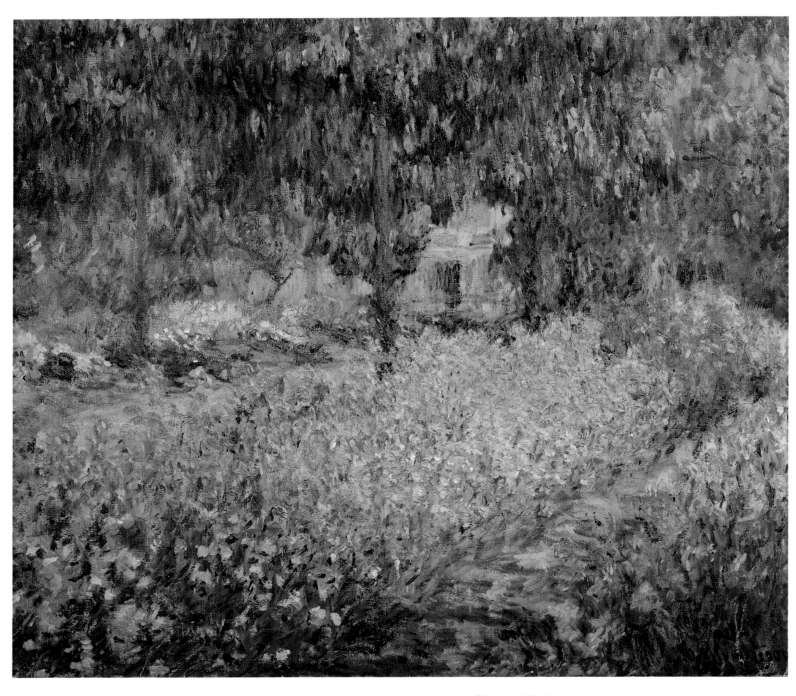

COLORPLATE 94. *Monet's Garden at Giverny.* 1900. 31⅞ × 36¼″ (81 × 92 cm).
Musée d'Orsay, Paris. Photograph: Musées Nationaux, Paris.

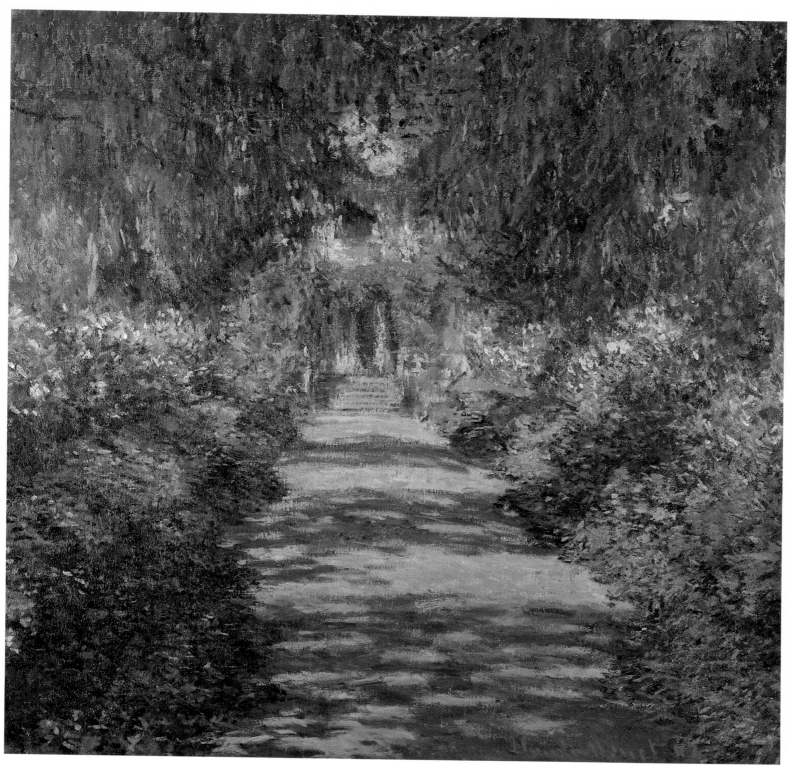

COLORPLATE 95. *The Garden Path at Giverny.* 1902. 35 × 36¼″ (89 × 92 cm).
Kunsthistorische Museum, Vienna.

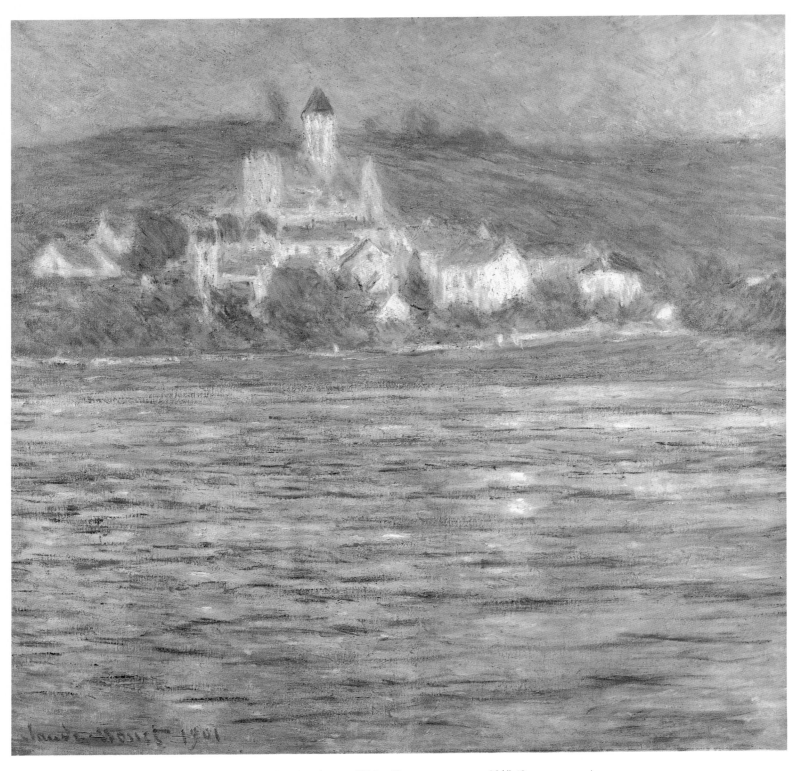

COLORPLATE 96. *Morning at Vétheuil.* 1901. 35 × 36¼" (89 × 92 cm).
Musée des Beaux-Arts, Lille. Photograph: Musées Nationaux, Paris.

isfaction of having his principles acknowledged, but also the receipt of the material fruits of a world-wide renown. Not often do pioneers succeed so thoroughly.

Success in the sale-room is not always the same thing as artistic success, but some information as to the prices Monet now commands may prove of value. The *New York Herald*, referring to the well-known Chocquet auction, says: "It will be observed that the works by Monet are sought after and purchased at high prices, which are moreover justified by collectors as well as by dealers." At the present moment a small example (about 26 in. by 32 in.) can be had for any price from four hundred guineas upwards.

After the Chocquet sale, dealers of all nationalities flocked down to Giverny. Two series of impressions, entitled *Water Lilies* and *Green Bridges*, were carried off, and the art public were deprived of seeing them exhibited as a whole, their creator's original intention.

The dealers were ready to buy every canvas Monet had in his studio, even down to the numerous studies he had condemned. Needless to say that with regard to the latter they were disappointed, and the destroying fires will still claim their own. In discussing with the writer this sudden and extraordinary popularity, Monet remarked: "Yes, my friend, today I cannot paint enough, and make probably fifteen thousand pounds a year; twenty years ago I was starving." Only artists can fully appreciate the philosophy of this short sentence.

MAURICE KAHN

LE TEMPS

"Claude Monet's Garden"

June 7, 1904

The first American painter to make the pilgrimage to Giverny discovered to his discomfort that following in Monet's footsteps was not as simple a matter as he had supposed. As for Monet, with a bad grace that shocked his would-be disciple, he did absolutely nothing to make things easier for him. I was told that he refused to give him lessons or even advice, telling him that everything he did was "just fine," that he had a "great deal of facility." The disciple was keenly disappointed.

Other American painters followed after him, imagining they would have better luck. But no—Monet continued to be deaf to their pleas. "I live in the country so as to be left alone," he would tell them. "It's hard for me to work, and I don't have the time to teach students. Do as I do: work, experiment." And he would shut the door.

Some of them, thus discouraged, returned to America. The more persevering among them, however, stayed on in Giverny and daubed away at canvases showing views of the town and its environs.

These attempts to study with Monet therefore did have some results: a veritable American colony sprang up in Giverny. Only a handful of painters were stubborn enough to stay on, but they were joined by friends devoid of artistic yearnings who came simply to live there in the company of their compatriots. I know some who used to lodge at the inn for eight or ten months of the year and some who came only for the summer. Some settled down in the region and bought or rented houses.

Victor Chocquet (1821–1891), customs official who was among the very first active supporters of the impressionists. His extraordinary collection was sold at auction in Paris in 1899.

The most complete discussion of the Americans at Giverny is William H. Gerdts, American Impressionism (New York: Abbeville, 1984).

I am told that the end result is that the cost of living has trebled!

The invasion has, however, had a further unfortunate result: Monet has become extremely wary of visits from strangers. In the countryside he has created for himself—voluntarily, no doubt—the reputation of being extremely ill-tempered. I was therefore hesitant to knock at his door.

When the maidservant ushered me into a small room with Japanese decor, mauve woodwork, and sky blue frescoes, its floor covered with matting, I was a bit ill at ease as I waited while she went to look for her master. In the library I could see books by Flaubert and the de Goncourts, works by Zola, Mirbeau, Jules Renard, Théodore Duret's *Critique d'avant-garde*, and many of the books by foreign writers once published by the *Revue Blanche*. On the walls and the doors kakemonos grimaced or smiled in the bright light. Outside, a light breeze fluttered among the irises.

Monet appeared at the bottom of the garden. He was walking slowly up the sloping path, his tread heavy. Of average height, sixtyish, with a long gray beard that was turning white, of solid build, he seemed, the more clearly the closer he came, to be bored and resigned.

He climbed the wooden stairs and stopped on the threshold. With a polite smile, his voice at once courteous and somewhat shy, he said, "Shall we go to the studio?"

The studio is in a separate building next to the house. It is a huge square room raised slightly above ground level, and it is lit by two large bay windows, one facing the north and the road, the other the south and the garden.

The walls are covered with canvases. One of them, a very large one, depicts a scene in the forest of Fontainebleau. The composition, the green of the trees, the flesh tones of the subjects, and their dress as well, reminded me oddly of Édouard Manet.

"That was the first of my canvases to be rejected by the Salon," Monet told me. "It dates from 1865 or 1866. I didn't know Manet. The one next to it"—which was equally as large but more diffuse, with less relief—"is part of a huge, still-earlier composition, probably around 1864. I found it not very long ago when I was moving house. It had been rolled up, and part of it was damaged, so I cut that part off."

There were also studies, "effects" of the sun or sunset, views of Le Havre, of Fontainebleau, Vétheuil, the region around Giverny. There were three of the famous paintings of Rouen Cathedral in three different lights—one in the pink of the setting sun, one in the golden light of high noon, and the third lost in greenish shadows. And then there was the series of water flowers, the so-called *nymphéas*, with an incredible variety of elusive nuances . . . yet the eye of the artist had seized them, and his palette had obeyed his eye.

We know the very personal way in which Monet works. He sets up his easel out of doors. He has a dozen or so canvases with him on which to work, and he takes up each of them in turn. Each canvas records a moment in the day, a particular effect of light. Each can be worked on only for a limited time. Aside from those appropriate moments, the artist never touches them. By the end of the day all his canvases—or almost all, depending on the weather—will have been worked on. Thus, it can be said that a particular work by Monet consists of the number of canvases it takes to fix the varied moods of a certain landscape. Is it possible to carry impressionist scruples further?

The views of the Thames upon which our eyes were allowed to feast this year for all too short a time, with their true and vivid colors, were done—all thirty-seven of them—in the same way, over the course of four years of painstaking effort, and they have a fairly curious history.

Monet happened to go to London by chance. He had gone to look into a school for his youngest son, not intending to do any painting, and

Here Kahn confuses two paintings. The picture done at Fontainebleau was not the first of Monet's works to be rejected at the Salon; Women in the Garden *(Colorplate 9) was. For the fascinating history of the former, see Joel Isaacson,* Monet: Le Déjeuner sur l'herbe *(London: Allen Lane—The Penguin Press, 1972).*

he had brought with him only a few small canvases "for sketching." He had planned to be there for only a week.

He checked into the Savoy Hotel, and his room there faced the Thames: on the right was Charing Cross Bridge, and on the left was Waterloo Bridge; there, close by, were the Houses of Parliament, and the whole scene was bathed in a unique ambiance.

He stayed for a month. He returned and stayed for three months more. For four years running, he kept returning.

"I had a devilishly hard time of it. I ruined more than a hundred canvases. It kept changing all the time, and from one day to the next I would never find the same landscape. What a blessed country! After four years of work and retouching on the spot, I had to resign myself only to making notes and to doing the real work here, in the studio."

Behind his words I could detect a tone of regret. For Monet, painting in the studio is hardly painting at all. . . .

And for that matter, the room in which we were standing is more like a museum—a room for looking and conversing—than like a workroom. The sun-drenched verdure, the flowers, all of the natural world that sang from within the frames hanging all around us revealed the artist's true preferences.

My eyes fell upon the large painting with human figures. Strangely enough, Monet stopped doing human studies because of a chance occurrence too. "In the beginning I had no money, and models are very expensive. So I turned to painting models that cost nothing, and I have stayed with them with a passion."

We went out into the garden.

"Look there," Monet said; "that was once an orchard. The trees were all dead or had been lopped off."

The fruit trees have been replaced by groupings of the most sumptuous and varied species of flowers, irises, tulips, Japanese peonies. Blue, violet, yellow, and pink flowers are blended together in clumps of dazzling tones among the green of leaves and stems. There are no plots of grass, no baskets, no fenced flower beds—none of those arrangements that are held to be the summit of the gardener's art and that give flowers the artifical appearance of bouquets or parlor knickknacks. Here,

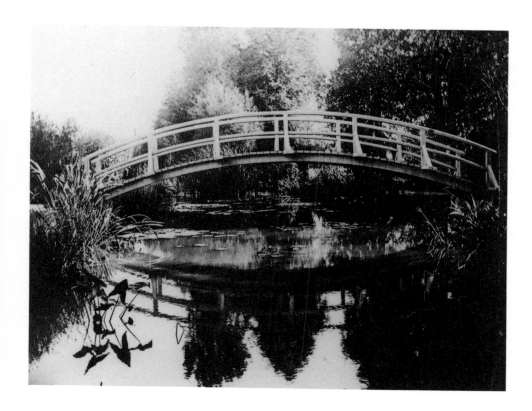

The Japanese bridge before the trellis was added in 1901. Lilla Cabot Perry Papers (1889–1909). Archives of American Art, Smithsonian Institution, Washington, D.C.

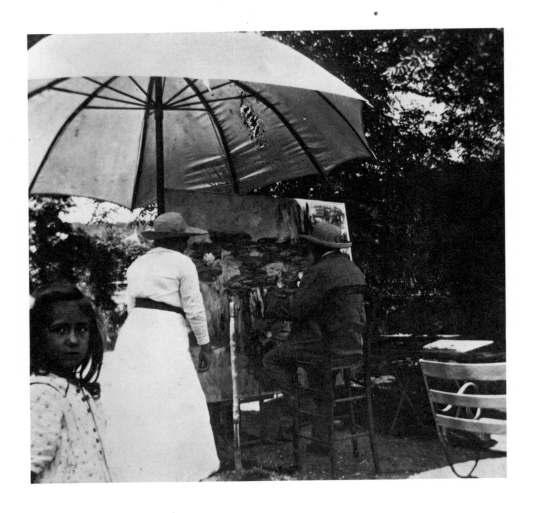

Monet painting *Water Lilies,* now in the Portland Museum of Art, on an afternoon in July 1915. Blanche is at his side and Nitia Salerou, his step-granddaughter, is in the foreground.

clumped freely together on each side of the long, straight paths, the flowering plants present themselves impetuously alive.

The garden is not the luxury hobby of some property owner, created to show off the quality of his seeds; it is the retreat of an artist, and the flowers are his companions. He wants to be able to caress them as he goes by, to feel them close to him, surrounding him, friendly and beneficent parts of his life.

On the other side of the road and beyond the railway line the garden extends into a field that Monet has recently purchased [1893] in order to transform it according to his taste.

A small branch of the Epte flows through this field. It has been diverted to nourish an artificially excavated pond, upon which float the smiling water lilies I had earlier admired in the studio: spreading nenuphar lilies with huge leaves, flowers of the richest and most delicate hues; there are pink, yellow, and white varieties.

A small wooden bridge painted green extends across the pond. A boat is moored to it. All around the pond are water irises, and behind them are azaleas, tamarisk trees, a weeping willow.

The overall aspect of the garden—and particularly the little green bridge—has caused it to be named the "Japanese Garden." Mr. Hayashi, the Japanese commissioner at the 1900 World's Fair, was also struck by the resemblance, which Monet maintains is quite unintentional.

Yet he has a deep love for Japan.

"They are a profoundly artistic people. I once read something that struck me: a bricklayer was building a wall, and he placed a rose in front of him so that from time to time he could look at it and inhale its scent as he worked, and as his wall progressed he would move the rose so that it was always there before him. Don't you find that charming?"

Monet has surrounded his house with flowers. Wherever he happens to be, beauty soothes his eyes and its life flows into him.

Tadamara Hayashi (1853–1906) came to Paris for the World's Fair of 1878 and remained as a dealer of Japanese art objects, often trading these with other connoisseurs such as Degas and Monet, thus developing a remarkable collection of impressionist works.

In the summer, sitting beneath his vast parasol at the edge of his pond, bent over his beloved water lilies, he attempts to capture the shimmer of the water, the reflections of the broad leaves, the capricious play of the light.

"Aside from painting and gardening," he said to me, "I'm good for nothing."

After having seen Claude Monet in his garden, one has a better understanding of why such a gardener is also such a painter. This great man is an unabashed lover of life. And painting is for him a way to create living beauty.

LOUIS VAUXCELLES

L'ART ET LES ARTISTES

"An Afternoon Visit with Claude Monet"

December 1905

Louis Vauxcelles (b. 1870), critic and art historian.

Claude Monet is far from being the simple, somewhat gruff, and countrified painter people in Paris imagine him to be. No similarity can be found between his life and that of a man like Jean-François Millet, whose undeserved poverty forced him to live at the edge of the Bas-Bréau in Barbizon; or like Alfred Sisley, scraping away at a meager existence in a tumbledown shack close by the church in Moret-sur-Loing. Monet did have a difficult early life; he experienced struggle, the jeers of spectators, financial hardship. He remembers those days, and he has in no way turned his back on them. However, although he once slaved away in Belle-Île, fighting the waves and reefs of Port-Domois and Port-Goulphar, ceaselessly analyzing the broken rocks and the foam-streaked moss and lichen-covered cliffs—those granite bastions beaten by the waves— and although with his infallible brush he once tirelessly depicted the copses of Antibes and Bordighera, the black pines and pale silver olive trees, the indigo sky—today he lives where he settled some twenty years ago, in the gracious region of the Vexin that he knows leaf by leaf, wood and meadow.

Notwithstanding his sixty years, Claude Monet is robust and hearty as an oak. His face has been weathered by wind and sun; his dark hair is flecked with white; his shirt collar is open; and his clear, steel gray eyes are sharp and penetrating—they are the kind of eyes that seem to look into the very depths of things. Physically, he reminds us of Meissonier. He has the exquisite and affable manners of a gentleman farmer.

When Félix Borchardt, the handsome German impressionist painter, and I arrived in Giverny, the master, wearing a suit made of some tweedy material in a beige check, a blue pleated silk shirt, a hat of tawny suede, and high-cut shoes of reddish leather, took us briefly into a first studio whose walls were hung with what looked like a resumé of his artistic life. The room contained some thirty paintings, ranging from sketches resembling Manets to canvases from the *Haystacks*, *Cathedrals*, and *Water*

Jean-Louis Meissonier (1815–1891), internationally esteemed for his precisely detailed Napoleonic battle scenes (which were the antithesis of impressionism), took pride in his physique, especially his legs.

Lilies series. However, because it was already four in the afternoon, and because "the water lilies close before five in the summertime," he led us down to the second garden. You know that, after having purchased a large field across the road from his property, Monet had flooded a part of it to create a river. He sprinkled a profusion of water lilies across that river. The leaves lie flat upon the surface of the water, and from among them blossom the yellow, blue, violet, and pink corollas of that lovely water flower. [The pond is spanned by] an arched wooden bridge painted green, near which Monet sets up his easel. Weeping willows and poplars abound, and on the banks of the stream he has planted hundreds of flowers—gladioli, irises, rhododendrons, and some rare species of lily whose petals are tipped with brown. The whole thing comes together to create a setting that enchants us rather than inspiring our awe, a dreamlike setting that is extremely oriental.

We went into the second studio, spacious, with high ceilings. Borchardt and I stood motionless, struck dumb. The light there is a vast improvement on the light in M. Durand-Ruel's cellars! We found ourselves surrounded by the cliffs of Dieppe and Étretat, the tulip fields of The Hague, the meadows near Vétheuil, the sea, the sky. Ghostly churches emerged from the mist. Here was a second series of *Water Lilies* captured at all hours of the day: the pale lilac of early morning, the powdery bronze glow of midday, the violet shadows of twilight. The freshness of tone, the subtlety, the transience of the captured impression are unparalleled.

Hanging in a prominent position at eye level is a huge canvas (the first of Monet's pictures to be rejected by the Salon) showing girls wearing crinolines and protecting themselves from the sun with tiny ivory-handled parasols; patches of light are cast upon their dresses, their faces. This canvas, painted out of doors, was rejected principally because of the influence of M. Jules Breton, at the time an influential member of the jury, who believed he was safeguarding true art by keeping out this daring and innovative work. . . .

There is a library containing few books, but good ones; there are photographs of friends—Stéphane Mallarmé, with his drowsy dreamer's expression; the sweet and weathered face of Gustave Geffroy; Mirbeau, with his forehead showing creases deep as saber cuts.

COLORPLATE 9

Jules Breton (1827–1906), pietistic realist painter of rural life who gained public favor during the 1850s, while Courbet's blunter realism was condemned.

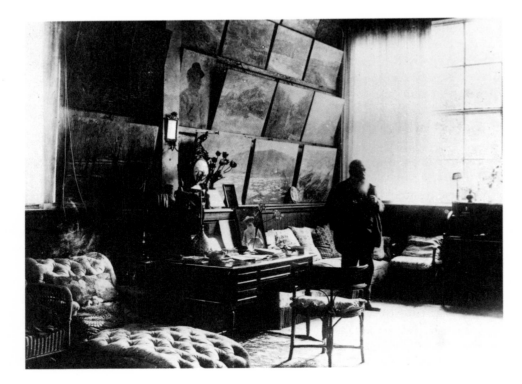

Monet in the first studio, Giverny. Collection Viollet, Paris.

246

We seated ourselves on a large cream-colored mohair sofa and, through a cloud of cigarette smoke, Claude Monet, smiling, relaxed, mischievous and modest, reminisced and spoke about his life.

He hates Paris, were it's impossible to go half a block without being harassed by some pest, some silly ass, some loud-mouthed or dull-witted snob. Sometimes he doesn't set foot on the boulevards for eight or ten months. He is above cliques, he ignores the salons, the Institute. He prefers his gardens and his work. It's not that he hates big cities: some years ago he lived peacefully, alone and unbothered, in London while painting his series of canvases of the Thames.

Claude Monet spoke of his early days as a painter, a period, by the way, in which he was far from unsuccessful. He had even managed to gain admittance to the Salon! Suddenly, however, he had been overcome by a desire to paint figures and objects out of doors, and his yearning had led to revelation. From that day, he was lost—at least in the eyes of serious art lovers. His name appeared in the Salon catalog for the last time in 1868, when he submitted *Boats Leaving the Docks at Le Havre.* Had he not stubbornly continued to pursue the new course he had chosen he could have had a worldwide success, commissions, medals. Encouraged by his companions, dissident students at the Gleyre studio— Bazille, Renoir—he stood firm. Manet, whom Claude Monet profoundly admired (he used to drink steins of beer at the Café Bade in order to listen to the painter of *Olympia* chat with Baudelaire), was wildly jealous of him. Daubigny was among the first to understand him and even resigned from one of the Salon juries because Monet and his friends had been rejected. His defenders were few and far between: Burty, Duranty, Castagnary, Théodore Duret.

"Was Daubigny the only one to support impressionism in the beginning? What did the famous masters have to say at the time?"

"Well, I remember that we were showing our things, Renoir and I, in a little shop. My picture was in the window. One day—I happened to be there—who should go by but Daumier, a revered figure. He stopped and peered in and said to the proprietor: 'Someone must be forcing you to display such horrors to the public!' That evening I went home with a heavy heart. On the other hand, Diaz liked the same landscape very much and shook my hand and predicted a brilliant future for me. And I'd much rather the praise had come from Daumier and the adverse criticism from Diaz."

"And what about old Corot, who had welcomed Pissarro's early work?"

"One evening, Corot told Guillemet: 'My young Antoine, you did well to escape from that crowd.' "

In those days, when we were selling our canvases for forty francs, I knew only one sincere and unselfish art lover: M. Chocquet.

Briefly, Claude Monet described Chocquet for us—a man who used to rummage around almost as though he were clairvoyant, who had managed, despite having very little money, to get hold of the best works of van Gogh, Cézanne, Pissarro—a true friend to painters and to painting. "The only men I knew who were real art lovers and not speculators were Chocquet and Georges de Bellio."

At the height of his fame Claude Monet seemed to be a man devoid of illusions. "Do the people who follow us today understand us any better than the people who used to heap insults on us in the past? If you erased the signatures on the paintings, which of these snobs would risk buying our 'masterpieces'? Indeed, our value is exaggerated. And some of the young painters who show at the *Salons des Indépendants,* instead of experimenting like we did thirty years ago, are making the mistake of studying too slavishly our technique, our methods of working. They are thus ruining any chance they have to form their own personalities. They plagiarize our work knowingly and on purpose. Once, when I was going

into Durand-Ruel's gallery, I caught a glimpse of a man who was trying to avoid me. It was M. Loiseau. . . ."

I happened to mention the recent Gauguin exhibition at the Vollard Gallery.

"Gauguin," Monet said, "is a person I do not understand. I can see what he owes Puvis de Chavannes, Cézanne, the Japanese, but I don't see much that is just *him*. Of course, I never really took him seriously. And don't mention Gauguin's name in front of Cézanne! I can still hear him yelling in his heavy southern accent: 'Gauguin—I could wring his neck!' "

I took the liberty of telling Monet that I thought he was being unfair.

Then I mentioned Albert Besnard.

"I didn't have time to go to his exhibition."

Other names were greeted with a pregnant silence.

"Vuillard—a very acute eye. Maurice Denis—a pretty talent, and so crafty!"

Monet, however, is uncomfortable with such talk and prefers to reminisce, so we went back to talking about the good old days.

"We were disgusted with the salons and the juries, so we formed a little group and showed at a dealer's. Manet, who preferred for himself to struggle within the Salon, in enemy territory—like Zola trying to force his way into the *Académie*—used to call us cowards. And even after he had had a bit of success—it was with his *Le Bon Bock*, thanks to the subject matter—he continued to be angry with Berthe Morisot, Renoir, and me, always asking, 'Why didn't you stick with me? As you can see, I made it.'

"My first success dates from an exhibition at Georges Petit's. Because M. Durand-Ruel didn't get us a cent from America, I finally gave in to Petit's urging: I had to earn money somehow. I showed at the International Exhibition. Its regulars very politely asked me not to hang my canvases too close to theirs. Cazin graciously accepted the proximity of my works. However, at seven the next morning he showed up, took down his landscapes, and moved them twenty feet away. . . . The critics very solemnly noted that I had grown in wisdom; only Geffroy really stood up for us, but his paper, *Le Voltaire*, was not widely read. Then I showed with Rodin. Before the opening Georges Petit, with his nose for success, said, 'I think we're going to get *Le Figaro* on our side. . . . And while we're on that subject, Albert Wolff asked me to extend an invitation to lunch to both you and Rodin. He expects you the day after tomorrow.' I refused on the spot."

"And Rodin?"

"I don't recall. . . ."

Then Monet spoke about Cézanne. He admires him greatly and regards him as one of the great contemporary painters.

"Would you like to see my Cézannes, my collection?"

We accepted with joy and followed the master up the stairs. We arrived in his bedroom. Above the wide, low bed hung a beautifully voluptuous Renoir. There was a velvety portrait of a young woman by Manet, and Cézanne's *Nègre*, a great masterpiece: it is the portrait of a black, naked to the waist and wearing blue trousers, a work worthy of Delacroix. There was a landscape by Pissarro, vibrant with light; some domestic scenes by Berthe Morisot; a woman bathing by Degas; Cézanne's apples and a view of L'Estaque, as well as his *Snow-Covered Forest*; and two portraits of Claude Monet, one by Renoir—the Monet of Fantin in the Batignolles studio—and another very unusual portrait by de Séverac showing an adolescent Claude Monet with curly hair falling over his high forehead.

However, the most outstanding picture was the one framed by the open window: the hillsides of Giverny in the golden twilight.

We went back downstairs and traversed two small rooms, decorated with Japanese prints of strange beasts and dragons, to the bright, cheer-

Gustave Loiseau (1865–1935), a close follower of Monet's style whose works were shown at the Galerie Durand-Ruel after 1895.

Albert Besnard (1849–1934), successful painter who executed numerous mural commissions largely derivative in style from impressionist works.

Maurice Denis (1870–1943), successful symbolist painter and muralist, diarist, and theoretician.

Manet's Le Bon Bock, *a public favorite at the Salon of 1873, is today in the Philadelphia Museum of Art.*

Jean-Charles Cazin (1841–1901), landscape painter who was friendly with the realists in the 1860s and whom Degas hoped to invite to join the impressionist exhibitions.

Reference to Fantin-Latour's famous group portrait of Manet in his studio, surrounded by admirers, including Monet. This painting, exhibited at the Salon of 1870, is today in the Louvre.

Photograph of haystacks in field near Monet's house. From the article by Louis Vauxcelles, "An Afternoon Visit with Claude Monet."

ful dining room, like one of Whistler's monochromatic paintings with its bright yellow buffets, chairs, and table.

We then returned to the studio. Monet talked to us about his method of painting. In London, in the days when he was painting the *Thames* series, he had set up in his hotel all his easels in a suite of rooms from which he had had the furniture removed, and in that way he had been able to work on a hundred or so canvases at once! He would work for a bit, making a few touches to a river view, say fifteen minutes on a study depicting the effect of the light and weather at nine in the morning, and then he would move on to the next, and so on.

Claude Monet paints the same picture many times, and never—this became clear as we were looking at the dazzling *Water Lilies*—never is there the slightest trace of fatigue. With some of his canvases one could swear that they had been dashed off in a single afternoon, whereas in reality the master has sometimes worked on them for several years.

He paints in spurts, working in fits and starts as the fancy takes him. When he feels in the mood to paint, no one is allowed to disturb him— friends, visitors, buyers—no one. And then he will let a week go by without touching his brushes.

Evening falls. . . . A butler in full regalia lays the table on the terrace overhung with Virginia creeper, wisteria, Aristolochia. . . .

Claude Monet accompanies us to the gate with that lord-of-the-manor courtesy that has always been his. And then he goes off to give instructions to the gardener, who is out on the pond in a barge removing the dead vegetation from among the water lilies.

On the way back, Félix Borchardt and I exchange impressions of our visit:

"A great man, a happy man . . ."

"And a wise man."

MARCEL PROUST

LE FIGARO

"Splendors"

June 15, 1907

Marcel Proust (1871–1922), author of Remembrance of Things Past, *a seven-part psychological novel of French society.*

* * *

If, through the kindness of M. Jean Baugnies, I can someday see M. Claude Monet's garden, I feel sure that I shall see something that is not so much a garden of flowers as of colors and tones, less of an old-fashioned flower garden than a color garden, so to speak, one that achieves an effect not entirely nature's, because it was planted so that only the flowers with matching colors will bloom at the same time, harmonize in an infinite stretch of blue or pink. This clearly manifest painterly intent has neutralized, to a certain extent, everything that is not the same color. The picture consists of land flowers as well as of water flowers, those soft white water lilies that the master has depicted in sublime canvases, of which this garden is like a first and living sketch, or at least, like the palette already artfully made up with the harmonious tones required to paint it. The garden itself is a real transposition of art, rather than a model for a painting, for its composition is right there in nature itself and comes to life through the eyes of a great painter.

WASHINGTON POST

"Destroys His Paintings"

May 16, 1908

MONET, THE FRENCH ARTIST, WRECKS WORKS WORTH $100,000.

IMPRESSIONIST MASTER ON EVE OF EXHIBITION RUINS HIS NEW PICTURES. CRITICS PRAISED THEM.

SPECIAL CABLE TO THE WASHINGTON POST.

Paris, May 15.—Pictures with a market value of $100,000 and representing three years of constant labor were destroyed yesterday by Claude Monet, the French impressionist master, because he had come to the conclusion that they were unsatisfactory.

The pictures destroyed had already been seen by the friends of the artist and by leading critics, who had pronounced them to be among the best works that M. Monet had ever accomplished.

They were to be the feature of an exhibition of this master's work, which was announced to open next week in the galleries of Durand-Ruel.

The exhibition, which already had been advertised in the French newspapers, had aroused unusual interest among artists and amateurs, as it had been a long time since any new works by M. Monet had been placed on public exhibition.

At the last moment, while he was reviewing the pictures and super-

intending framing them, the artist became discouraged. He declared that none of his new works was worthy to pass on to posterity. With a knife and paint brush he destroyed them all, despite the protests of those who witnessed his act.

Pictures by M. Monet are currently selling at from $6,000 to $10,000 each.

THE STANDARD

"The Conscientious Artist"

May 20, 1908

I have inquired to-day into a story which was circulated in London a few days ago concerning the pictures of M. Claude Monet, the impressionist landscape painter. The story was that M. Monet destroyed a score of his works because they did not satisfy his ideal. One report, I believe, went so far as to mention the price of the pictures destroyed—£20,000. A friend who has a close acquaintance with M. Claude Monet told me to-day that there is some truth in the story, although it is greatly exaggerated. M. Monet has not sold or delivered a picture since 1904, but ever since then has secluded himself in his country house at Giverny, on the Seine, between Mantes and Vernon, and has troubled little about exhibitions and festivities in Paris.

All this time he has been engaged on a new work—one which, I believe, no other artist has developed—the painting of clouds reflected in the water. Early in spring M. Monet had about thirty canvases in a more or less finished state, and it was arranged that he should exhibit two dozen, or as many as he could finish, in Paris, at the end of last month. Some little time before the exhibition, however, M. Durand-Ruel, with whom the exhibition was to be held, was asked to postpone it for three weeks. The exhibition should, indeed, have been opened last week. Only a day or two beforehand, and when all arrangements had been made, M. Durand-Ruel received a letter from M. Monet, cancelling the exhibition. I understand that all those who saw the pictures in February and March considered them "overworked," that is, they showed too plainly how long they had stood on the easel. One of M. Monet's friends even went so far as to say that there were four or five different pictures on each canvas. M. Monet admitted this himself, and stated how dissatisfied he was with his work. As the time for the exhibition came nearer, however, he worked harder than ever.

Partly because of overstrain, partly because of dissatisfaction, M. Monet became extremely irritable and morose, and at last actually cut a few of his canvases to shreds. The majority remain, however. Persuaded by his friends, M. Monet has decided to turn them to the wall—a familiar process with conscientious painters who are happy in having conscientious friends—and go away for change and rest. Possibly the remaining pictures will be exhibited next year. As for placing a price on the pictures, it is out of the question. M. Monet is second or third on the list of living French artists whose works bring big prices in the sale rooms. A moderate example by him was sold for £240 yesterday, but some of his pictures have brought as much as £1500 and £2000. With regard to the pictures destroyed, M. Monet thought them worthless. His friends were not so severe, but perhaps some rich *parvenu* now lives who would have paid for them the £20,000 mentioned.

WALTER PACH

SCRIBNER'S MAGAZINE

"At the Studio of Claude Monet"

June 1908

Walter Pach (1883–1958), American post-impressionist painter and critic who played a leading role in the organization of the 1913 Armory Show in New York.

"CLAUDE MONET?" I was told, "oh, you won't get to see him, lots of people have tried. Oh, no, Monet shuts himself up in his studio there in the country, and only his old friends get past the door."

Nevertheless it was from one of these same old friends that I bore a letter to the famous landscape painter, and I had confidence in it. The scheme was to bring Monet to America. A French statesman who had recently visited our country conceived the idea, and laid the matter before his friend, the great veteran of the Impressionist School.

I took the train from the Gare St. Lazare. Westward it sped, and the glimpses of the Department of Eure—now with a view of the Seine, now with fertile meadows, again with low, strongly marked hills and groves of poplars—were a fitting prelude to the landscapes I was to see a little later in Monet's studio. Even more so was the country between Vernon where one leaves the train and Giverny, some three miles away—in which village the painter has his residence. It has become quite a place for artists—this Giverny.

The Seine cuts its broad silver swath through the fields, a line of graceful poplars guards its edge, then comes a narrow strip of grass land, then the high-road—of that clean, smooth type that never fails to delight the traveller in France. Well back from the road and separated from it by the big cheery flower garden with its white fence, stands the house of Claude Monet. It is long and low, a solid, comfortable place.

I entered; a large, light studio was before me—the walls completely hung with pictures whose radiance made the place seem still more light. Madame Monet was there and a young grand-daughter. Monsieur Monet took the letter, read it—sometimes aloud for his wife's benefit when a phrase especially pleased him, and then said: "How nice he is!" Then after consideration—"But I am old, now, to learn another country—one must know a place thoroughly before one can paint it. That's why I stay here in the country where I was born. I know it." So Monet will not go at once to make a record of America, though he expressed a desire to visit it. "The chances of life are many; I should like to see your country—perhaps I shall yet." We spoke of American painting: of the energy of Sargent, of Winslow Homer, whom he knew and admired through that painter's "Nocturne" in the Luxembourg; of Chase, whose fame was well known to him; of Robert Henri, of whom he wanted to know more—writing down the name so as to enquire for his picture "La Neige" [*Snow*] at the national museum. Once more I spoke of the Senator's recommendation that he paint our country, especially "the incomparable harbor of New York and that furnace of human activity, Pittsburgh." I reminded the artist of his views of London. "But I knew London a long time, and had for a long time wanted to paint it. So too with my work in Norway."

Then followed some reminiscences, fascinating you may be sure, as they came from this man who had seen so much and done so much. "I remember, once, as a young man, going through the Salon with Courbet. We saw one canvas after another of the Orient, of the desert, of caravans of camels, Arabs on horseback. Courbet looked at them a long

John Singer Sargent (1856–1925), the gifted American portraitist, was a co-exhibitor with Monet at the 1885 Petit international exhibition and painted landscapes with Monet in Giverny later that same spring.

Winslow Homer (1836–1910).

William Merritt Chase (1849–1916).

time without remark, read the French names of the painters, and finally burst out—'Then those are men without a country!—*Ce sont donc des hommes sans patrie!*' It is difficult to get the spirit of a new land. Why do the Americans come to France to paint? Have they no landscape at home? Why do they go and make all those pictures of Brittany, its costumes and its people—whom they do not understand? Why do you, a painter, come here?"

"There are the museums, we have not those at home. One must not only have the landscape but learn from the masters how to paint it."

"Good—but not in the schools. It is not for the schools that you come?"

"No, not at all."

"Very well, then. The schools are no good—I am against teaching. It is from Nature that we must study. Some time ago, they wrote asking if I would teach an art class, which would come to Giverny. I wrote back—'No; I have, myself, too much to learn for any such amusement as that.' There are two cases: if a young man feel the sacred fire—let him work, let him study Nature." Then a terse phrase in striking words: "*S'il a quelque chose dans le ventre, il trouvera les moyens*"; which an American might have put thus, "If he have something to say, he will find his expression for it."—"On the other hand, if it's a simple desire to be an artist, he can go to school if he likes, see whether that helps him—only the métier, the processes can be taught. When he has learned all that even a good teacher can give him—still the whole question lies ahead."

We went through the studios—for there are two, besides a sort of bungalow immediately on the river: the impression of Nature must be kept fresh, direct.

Monet is an artist who can admire the work of other men. He possesses pictures by Paul Cézanne—cared highly for them long before the world at large did. The walls of the passage way leading to the second studio were closely hung with Japanese prints, fine ones.

The pictures in the first great room were nearly all recent; in this studio (light as the other was) were works of many stages of his progress. On an easel was a picture of a cathedral doorway and part of the façade. "That is one of the Rouen series, is it not?" I asked. "Yes; it will soon go away from me. My first order from the government," he added with a slight smile. "But what does that matter? When Renoir was decorated by the state, I wrote him—instead of congratulations—a letter of jokes. 'Do you think,' I wrote"; (and it was that fraternal *tu* that he used)—" 'do you think that the bit of ribbon you are to wear in your button-hole will help you to wear better that real glory which you know is yours, when you think back over your life and the work you have done in it?'

"Work; that is the thing!" I could well believe he meant that phrase as I looked at these crowded walls, and thought how little, after all, of his production was there. "Work, work—and never think of the money. Unfortunately we have to, at times. When we were young fellows, we often had to sell for a few francs canvases which we should not have let go so easily. But it was necessary then. Renoir had to go through that, and Manet—no, not Manet, for he had means; but Sisley had to, I had to. Ah, we see too much of this thing: the work of a young painter rejected by the buyer—perhaps the very man, who, when the artist has made a reputation, pays a great price for it—out of *snobisme*." (Was the twinkle that came for a moment to the dark, earnest eyes caused by some personal recollection, or by the thought that he, a man "not of the cities," as he had said, was using an English word that is very chic just now on the boulevards?) "But that is what the young painter must expect—to eat tough meat, *manger de la vache enragée*—(and he may be glad to have that)—and work. But there, too, is the reward, a great one. We want our bread for the morrow, but with that and the satisfaction, the happy

One of Monet's Rouen Cathedral *paintings exhibited in 1895 was acquired by the State for the Luxembourg Museum in 1907.*

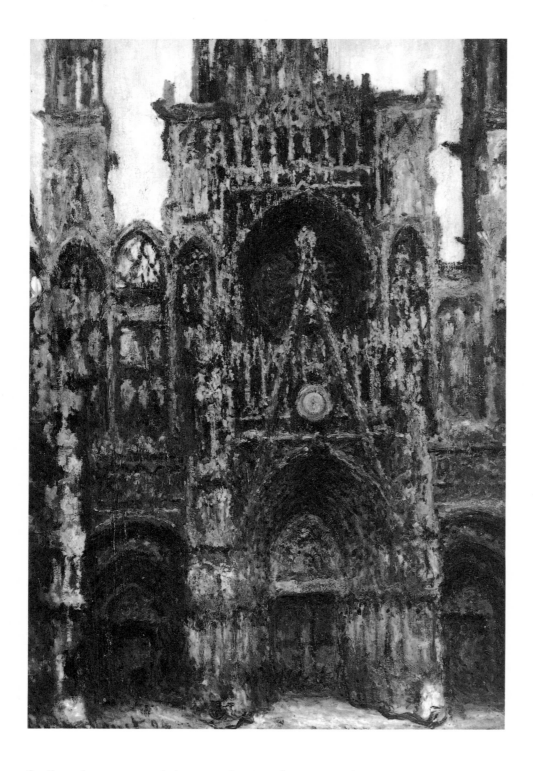

Rouen Cathedral: The Portal Seen from the Front—Harmony in Brown. 1894. 42⅛ × 28¾″ (107 × 73 cm). Galerie du Jeu de Paume, Musée du Louvre, Paris. Photograph: Musées Nationaux, Paris.

feeling that we are doing our best—what more do we want?" It may be that some of the canvases that date from that early period were ones which he had to dispose of before they satisfied him, but one that is now before the public surely never fell within that category. It is a little still-life which hangs in the Decorative Arts Museum of the Louvre as part of the collection of Moreau-Nélaton. It seems as fine as a Teniers. "That little still-life? Oh, that's a very old one; I painted it when I was, I think, either seventeen or nineteen years old!"

Monet knew Whistler. "He was a true artist—of great talent. But it was a petty spirit he showed in saying those brilliant cruel things." More pleasant were the memories attached to a large canvas of his which attracted my attention as being a figure subject—something not common with this painter. The group of ladies whom one sees on the bright green turf and the sandy walk are painted in as pure a light and with as much frankness as it would seem possible to get. The style of their dresses, however, proclaims the picture as belonging to a decade long past. It is

COLORPLATE 3

Étienne Moreau-Nélaton (1859–1927), art historian and painter who exhibited at the Galerie Durand-Ruel. As a collector, he donated an extraordinary group of impressionist pictures, including Manet's Déjeuner sur l'herbe, *to the State in 1906.*

COLORPLATE 9

in fact of the early sixties, and no less important a thing than the painting which represented Monet at the historic Salon des Refusés. Connected with it is a story of Édouard Manet. "It was at a time when the picture hung at a dealer's, that I took a walk one evening, and saw Manet seated at a café on the Place Pigalle. He pretended not to know I was there and said to his friend—'Have you seen that picture that's exhibited in the Rue Auber which makes it seem the old masters were thinking of painting in the open air?'—Nevertheless," and Monet's quiet smile once more illumined his ruddy face, "he painted in the open air himself, later on." Now Manet's picture from that Salon, "*Le Déjeuner sur l'Herbe*" [Luncheon on the Grass], is in the Decorative Arts Museum— most likely a stepping stone to the great gallery. Far hence be the day when the ten years begin for Claude Monet which must intervene between a painter's death and his entry into the Louvre, but if—in time— the works of the two friends are again united in that Walhalla of their country's art, it will be well done.

"The greatness of Impressionism," writes a recent critic, commenting on the nineteenth-century's lack of a tradition, "is to have begun a complete refounding of the technical methods of painting, that it has not stopped with the joy of first results; it is that it has produced a school." And to this result, Claude Monet has contributed probably more than any other man.

ROGER MARX

GAZETTE DES BEAUX-ARTS

"M. Claude Monet's 'Water Lilies' "

June 1909

Roger Marx (1859–1913), journalist and close collector-associate of impressionist and post-impressionist artists. He fought to gain recognition for Cézanne.

Before transcribing one's own impressions, one would like to retrace one's steps and put them in order to give them better definition. One's first reaction to these 48 pictures is bewilderment. In most of them, objections having little to do with painting are the cause of this malaise; they have to do more with the identity of the subject and the number of duplications and with the at first seemingly fragmentary aspect of these pictures. The paintings manifest an authority and independence, an egocentric quality that is offensive to our vanity and humbling to our pride. M. Claude Monet is interested in pleasing only himself. His exertions are directed at recording the multifaceted differences of the pleasures he experiences during the course of the day as he works in one single place: such are the apparently selfish goals of his art, and it suits him to subordinate everything to this end. The value of a theme lies in its potential for increasing the number of sensations aroused in the viewer and enriching their quality. His system is a familiar one, but M. Claude Monet has not heretofore undertaken to push its consequences quite so far.

Rounded haystacks on a level field; poplars standing in ordered sequence against the sky; a Gothic porch displaying its sculptures in dazzling light; a cliff overlooking the ocean; the Seine embracing a wooded islet; water lilies rippling the surface of a serene pond in the park; in London, a bridge pressing its heavy pilings into the deepest part of the

COLORPLATE 99

COLORPLATE 102

COLORPLATE 103

COLORPLATE 104

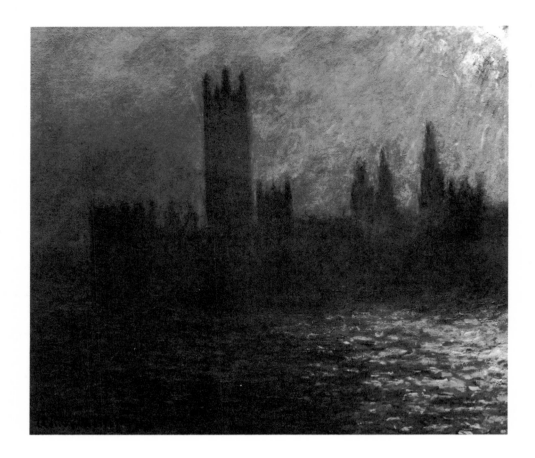

Thames, or the Houses of Parliament looming ghostlike out of the mists—all these are scenes complete in themselves, in which the composition is circumscribed, where lines are harmoniously contrasted, and where the depiction of the subject is determined by the emphasis accorded the theme.

M. Claude Monet has now severed his last ties to the Barbizon School; he is pursuing the renewal of his art according to his own vision and his own means; his manifest preference for a familiar site is conducive to painting different-but-parallel versions of the same subject. These variations on a theme clearly indicate the stages of his progression.

Besides being an artist, M. Claude Monet is also, like Émile Gallé and M. Maurice Maeterlinck, knowledgeable and passionately interested in plants. The paradox of aquatic flora has for a long time intrigued and captivated his imagination; he promised himself he would rise to the challenge and enjoy it. The Epte, near his residence in Giverny, flows silently and peacefully; it was quick work to take advantage of its course and to plant, in small hollows, the water lilies that emblazon the ponds in the summer. From now on this will provide periodic celebrations in honor of the painter; the lilies will be under his very eyes and within daily reach, and, as summer returns every year, he will continue to be eager to fix the ephemeral vision and to immortalize the field of flowered water and the spell it casts.

This is the task he set himself and which for so many years he has performed. The *Water Lily Pond* had already provided the general theme of the "series" that made up the exhibition held in 1900. The group that M. Claude Monet brings together this time, is related to it and is its logical sequel. Let us, in turn, try to subdivide it, not chronologically as the show's catalogue does, but thematically.

One painting serves as a transition between the present and the past. The background is set there as in the landscapes that were exhibited in 1900: tall trees with their melancholy branches, luxuriant and thick vegetation, and the little Japanese bridge covered with lichen and moss. But

Émile Gallé (1846–1904), master glassmaker and cabinetmaker who was intent on making the decorative arts poetic, symbolic, and modern.

COLORPLATE 92

COLORPLATE 93

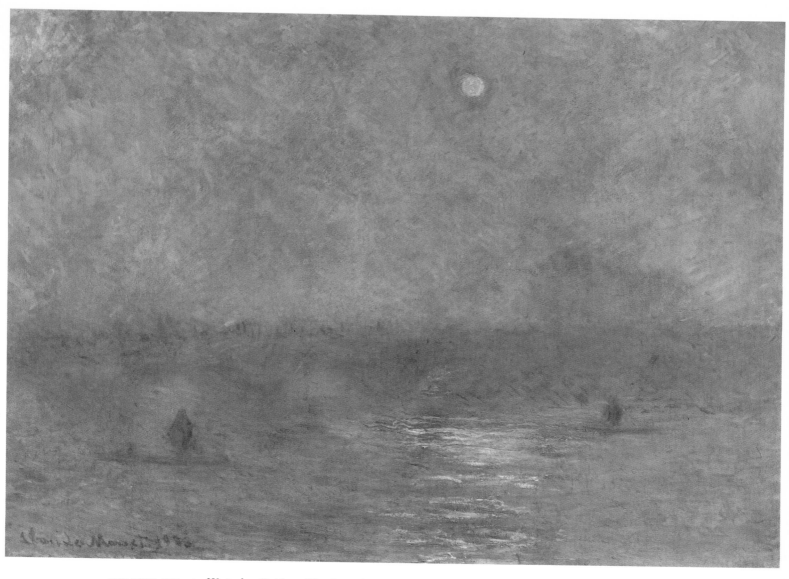

COLORPLATE 97. *Waterloo Bridge: The Sun through the Mist.* 1903. 29 × 39½″ (73.7 × 100.3 cm).
National Gallery of Canada, Ottawa.

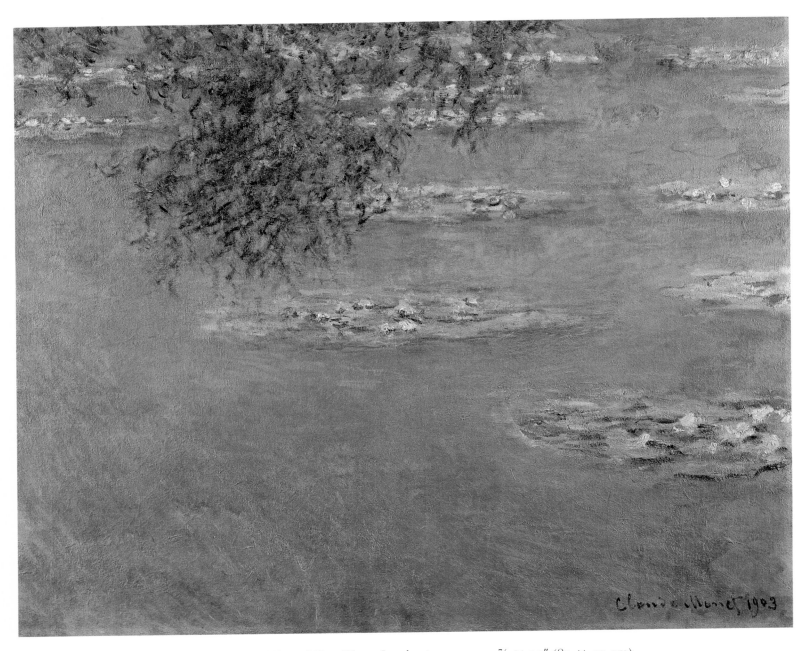

COLORPLATE 98. *Water Lilies: Water Landscape.* 1903. 31⅞ × 39″ (81 × 99 cm).
Bridgestone Museum of Art, Ishibashi Foundation, Tokyo.

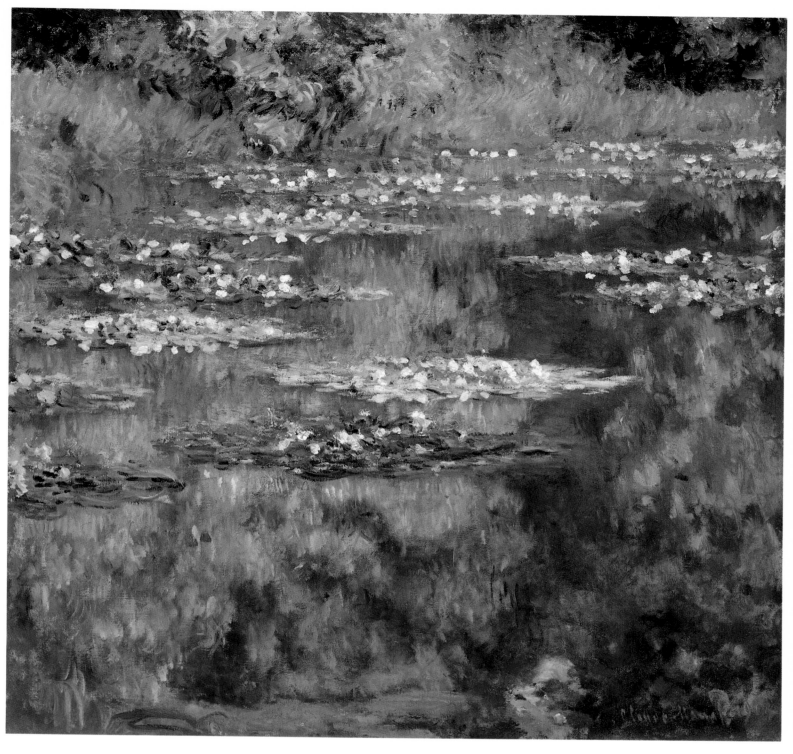

COLORPLATE 99. *Water Lily Pond*. 1904. 35⅛ × 36⅜″ (89.2 × 92.4 cm). Denver Art Museum.

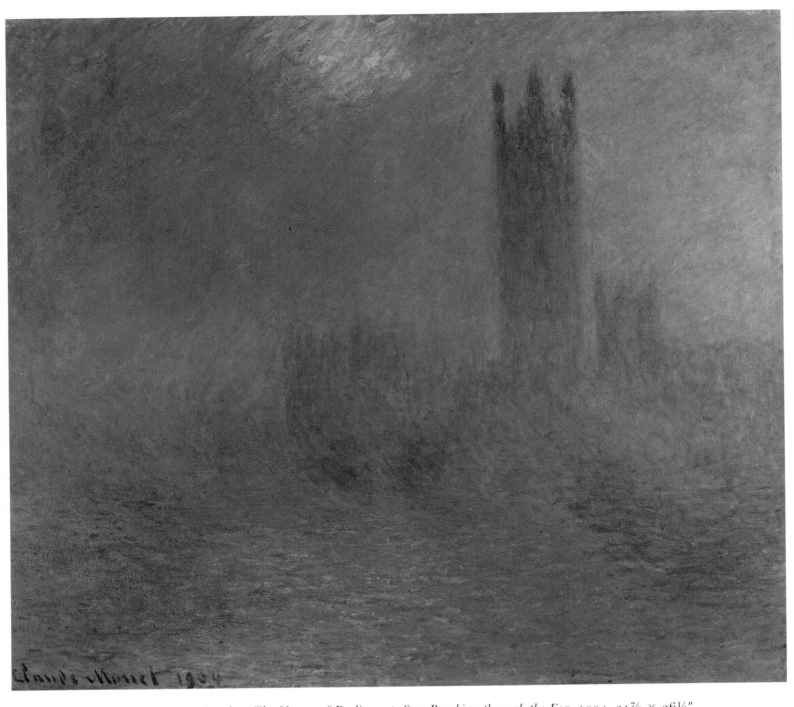

COLORPLATE 100. *London, The Houses of Parliament: Sun Breaking through the Fog.* 1904. 31⅞ × 36¼″
(81 × 92 cm). Musée d'Orsay, Paris. Photograph: Musées Nationaux, Paris.

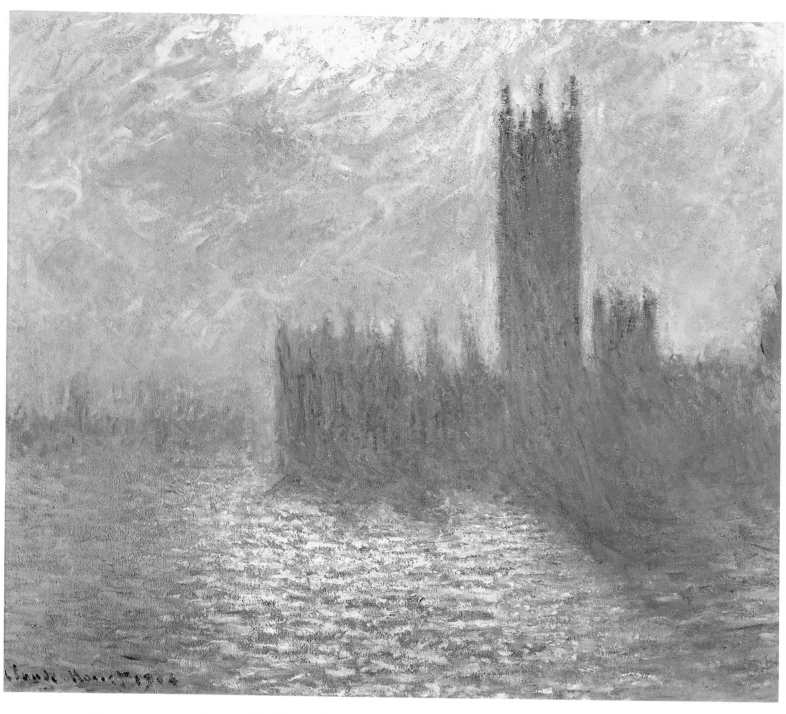

COLORPLATE 101. *London, The Houses of Parliament: Stormy Sky.* 1904. 32⅛ × 36¼″ (81.6 × 92.1 cm).
Musée des Beaux-Arts, Lille. Photograph: Musées Nationaux, Paris.

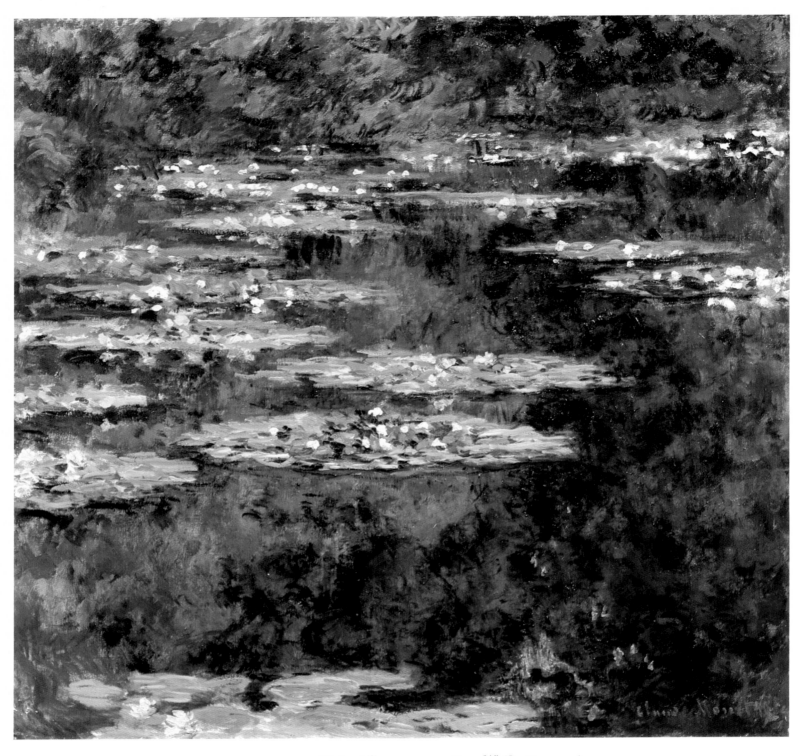

COLORPLATE 102. *Water Lilies.* 1904. 35 × 37⅜″ (89 × 95 cm).
Musée des Beaux-Arts, Le Havre. Photograph: Musées Nationaux, Paris.

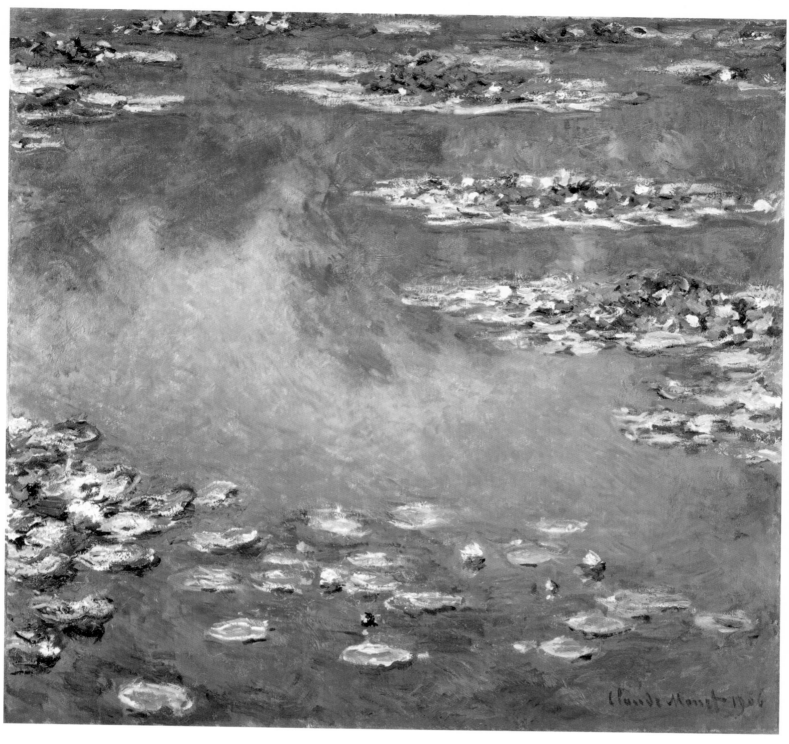

COLORPLATE 103. *Water Lilies*. 1906. 34¾ × 36¼″ (88.3 × 92.1 cm).
The Art Institute of Chicago; Mr. and Mrs. Martin A. Ryerson Collection.

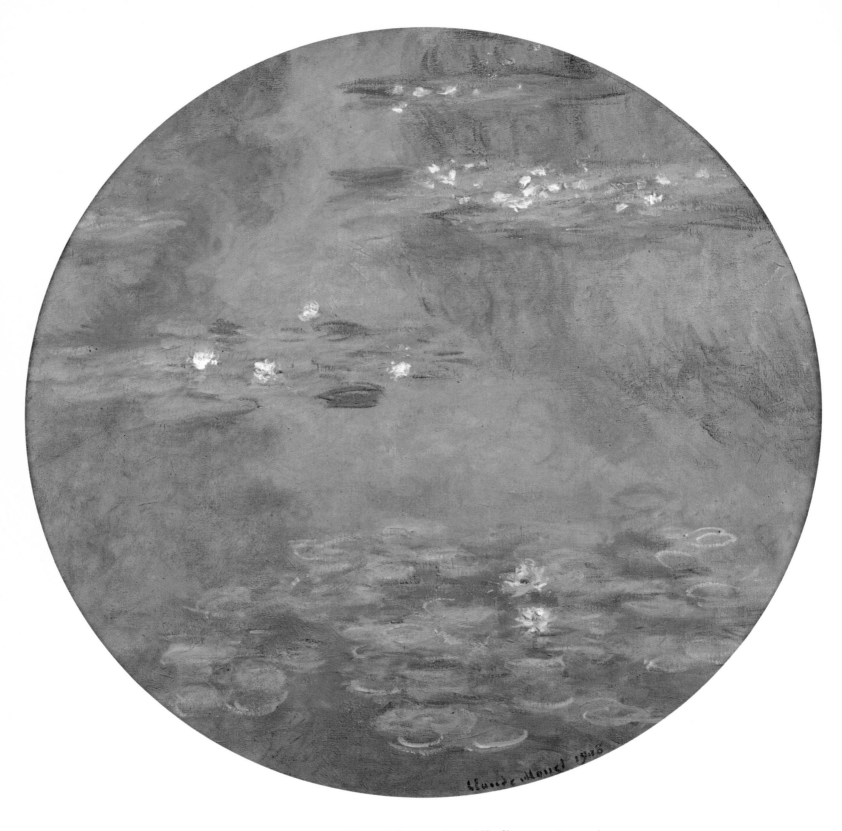

COLORPLATE 104. *Water Lilies*. 1908. 35½″, diameter (90 cm).
Musée Municipal Alphonse Georges Poulain, Vernon. Photograph: Musées Nationaux, Paris.

this is only an isolated reminder, perhaps even a fortuitous one. Let us move along. A new intention immediately surfaces: M. Claude Monet intends to do away with the terrestrial setting that delimited the horizon, enclosed and "fixed" the composition. He changed his viewpoint with the result that the shore moves back and very soon is obliterated. It is scarcely visible at the top of the early pictures: a narrow strip of land encircles with verdure the slight thinning of the wooded area, which the floating clusters streak with speckled moiré. No more earth, no more sky, no limits now; the dormant and fertile waters completely cover the field of the canvas; light overflows, cheerfully plays upon a surface covered with verdigris leaves. The water lilies emerge from these and proudly stretch their white, pink, yellow, or blue corollas to the sky, avid for air and sun. Here the painter deliberately broke away from the teachings of Western tradition by not seeking pyramidal lines or a single point of focus. The nature of what is fixed, immutable, appears to him to contradict the very essence of fluidity; he wants attention diffused and scattered everywhere. He considers himself free to place the small gardens of his archipelago wherever he pleases: to the right, to the left, at the top, or at the bottom of his canvas. In this context, within the necessary boundaries of their frames, these "eccentric" representations are reminiscent of some light-colored "fuokusa," printed with bouquets scattered as capriciously as clouds that are interrupted by the folds of the hem.

M. Claude Monet's decision was a wise one and tends to justify even more the subtitle given to this series: *Water Landscapes*. We would imagine shores forever receding and the painter's inspiration confined within a narrow field. Far from it. The magical evocation of the reflections supplements the evidence of reality; it is these reflections that evoke the vanished shores. Here once more are the poplars, quivering and inverted; the tall willows with their weeping branches; and here, among the trees, is the clearing, the path of light on which shines the gold and purple sky. The blazes of dawn and sunset fire the transparent mirror, and such is the brilliance of these lights of apotheosis—that their reflection makes it difficult at first to distinguish the humble plants lost in the shadows, which extend along the surface of the waters.

In addition to these moments that bestow magnificence upon nature, there are others equally poetic, less sublime perhaps but more enduring and grandly suggestive. These are the hours that in the summertime mark the middle of the day. Their charm counteracts the violence of the contrasts; these hours are redolent of harmonious languor and gentle voluptuousness. One's soul relaxes in the beneficence of daydreams. The afternoons are blessed with a profusion of dazzling light, a powdering of iridescent brightness; the rays of the sun become volatile, contours soften, elements merge and mingle. At the height of the heat, near the ponds, nature appears to be floating in the moist air, fading away and promoting the play of imagination. These are mirages transposed to a minor key of bluish and ash-colored hues, reflected in the lily pond, which is now like a soft azure cover. It is dappled by flecks of pale green foam highlighted here and there by flashes of topaz, ruby, sapphire, or mother-of-pearl. Through the incense of soft vapors, under a light veil of silvery mist, "the indecisive meets the precise." Certainty becomes conjecture, and the enigma of the mystery opens the mind to the world of illusion and the infinity of dreams.

The artist protests:

What diabolic ideal torments you, and why tax me with being a visionary? Do you really think that the excitement and ecstasy with which I express and fulfill my passion for nature simply leads to a fairyland? You mustn't assume that I have labyrinthine, visionary plans. The truth is simpler; the only virtue in me is my submission to instinct; it is because I

Perhaps Monet recalled that Courbet had referred to his own marine paintings as "paysages de mer."

rediscovered and allowed intuitive and secret forces to predominate that I was able to identify with creation and become absorbed in it. My art is an act of faith, an act of love and humility. Yes, humility. People who hold forth on my painting conclude that I have arrived at the ultimate degree of abstraction and imagination that can be found in reality. I should much prefer to have them acknowledge the gift, my total absorption in my work. I applied paint to these canvases in the same way that monks of old illuminated their books of hours; they owe everything to the close union of solitude and silence, to a passionate and exclusive attention akin to hypnosis. I have been denied the liberty of concentrating on a single motif and of drawing it under all possible conditions, at all times of the day, in all the infinite variety of its successive charms. Yet sparing oneself the effort required to broach a new theme is one way of conserving one's strength; it is also the means of capturing the ephemeral changes of atmosphere and light that are the very essence of painting. The subject doesn't matter! One instant, one aspect of nature is all that is needed.

I have set up my easel in front of this body of water that adds a pleasant freshness to my garden; its circumference is less than 200 meters. Looking at it, you thought of infinity; you were able to discern in it, as in a microcosm, the presence of the elements and the instability of a universe that changes constantly under our very eyes. Nonetheless, to exile my painting "anywhere, out of the world" is going too far. This leads, I know, to the inevitable comparison with Turner. What would be the fate of art criticism without the prop of comparisons? Claude Lorrain was no master of mine; I never built, along distant shores, unlikely palaces with terrace upon terrace climbing to an oriental sky. My landscapes would fail as a backdrop for the tragic gesture of Salammbô or Akëdysséril. The richness I achieve comes from nature, the source of my inspiration. Perhaps my originality boils down to being a hypersensitive receptor, and to the expediency of a shorthand by means of which I project on a canvas, as if on a screen,

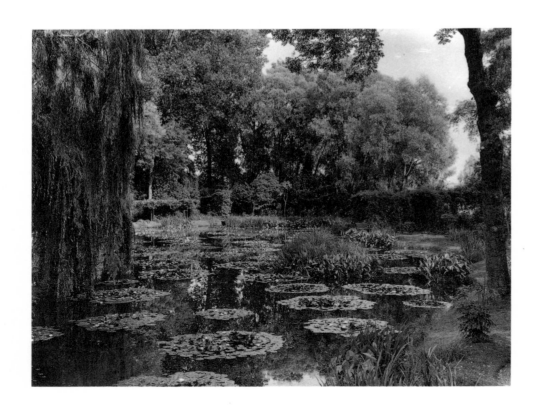

The Water Lily Pond. *Country Life*, London.

impressions registered on my retina. If you absolutely must find an affiliation for me, select the Japanese of olden times: their rarified taste has always appealed to me; and I sanction the implications of their esthetic that evokes a presence by means of a shadow and the whole by means of a fragment. Bring out my affinity, if you like, to our own eighteenth-century painters, with whom I recognize a close kinship of sensitivity and technique.

But how much wiser it would be not to cut myself off from my own period, a period to which I belong with every fiber of my being! It would be much more accurate to describe me—a disciple of Courbet and Jongkind—as a contemporary of Stéphane Mallarmé and Claude Debussy. I agree with them and with Baudelaire that all the arts have points in common, that there are harmonies and concerts of color that are self-sufficient and that affect us just as a musical phrase or a chord can strike us deeply, without reference to a precise and clearly stated theory. The indeterminate and the vague are modes of expression that have a reason for existing and have their own characteristics; through them sensations become lasting; they are the key to symbolism and continuity. I was once briefly tempted to use water lilies as a sole decorative theme in a room. Along the walls, enveloping them in the singleness of its motif, this theme was to have created the illusion of an endless whole, of water without horizon or shore. Here nerves taut from overwork could have relaxed, lulled by the restful sight of those still waters, and to whosoever lived there, the room would have offered a refuge for peaceful meditation at the center of a flowering aquarium. This makes you smile; the name of des Esseintes is on the tip of your tongue. Isn't it a pity, really, to deny strength the right to express something fragile and to be so ready to declare the search for refinement incompatible with robust health? No, des Esseintes is not my prototype, it's closer to Maurice Barrès' Philippe who "methodically cultivates spontaneous emotions." I have half a century of experience and soon I shall have passed my sixty-ninth year, but my sensitivity, far from diminishing, has been sharpened by age, which holds no fears for me so long as unbroken communication with the outside world continues to fuel my curiosity, so long as my hand remains a ready and faithful interpreter of my perception. One of your colleagues, and not the least among them, said: "When looking at water, sky, mountains one feels they are forever young, untouched by events; they are as they were at the beginning. Confronted by their strength, our weakness vanishes." I have no other wish than to mingle more closely with nature, and I aspire to no other destiny than to work and live in harmony with her laws, as Goethe prescribed. Nature is greatness, power, and immortality; compared with her, a creature is nothing but a miserable atom.

"Granted," we answer, "but nature cannot do without man; her beauty, which is quite subjective, would not be apparent without the thought that defines it, without the poetry that sings her praises, without the art that portrays her. She has never before been shown in such sumptuous and new variety. Supper guests at Madame Faustin's claim that the French language "has not, in the past, striven for precision, whereas at the present time it is cultivated by the most sensitive people, by those most eagerly seeking to convey indescribable sensations. . . ." This is also true of painting, and M. Claude Monet is not one to be satisfied with the lack of precision of his predecessors. He differs from them

Claude Debussy (1862–1918), impressionist composer. For an account of this composer's feelings about Monet, see Emmanuel Bondeville, "Claude Monet—Claude Debussy" in Aspects of Monet, *edited by John Rewald and Frances Weitzenhoffer (New York: Harry N. Abrams, 1984).*

Des Esseintes is the reclusive, hedonistic hero of the Huysmans novel, Against the Grain *(1883); Philippe is a sensualist character in a novel by Maurice Barrès (1862–1923).*

by his hyperesthesia and also by the contradictions inherent in his temperament. With a cold but passionate eye he can examine his impulses and reason them out; he is obstinate and lyrical, coarse and subtle; his art throbs with all the fires of enthusiasm; serenity flows from it. Dedication to his art does not hinder his search for a range of soft hues. In some paintings the medium, which has been lovingly applied, bestows upon the surface of the canvas the porous feel of a dull granite, which one longs to caress. Never, in all the years since mankind has existed and men have painted, has anyone painted better or quite like this. As I looked at length, making notes in the exhibition catalog, an artist with a foreign accent accosted me: "You are writing about this exhibition, sir. Say that we are all ignorant. Proclaim that, compared with this, the pictures in the Salons, all the Salons, are just daubs, nothing but daubs." And he continued on his way, his arms raised to heaven.

It seems to us that this is proof of a high level of technical knowledge, and that this great mastery reveals an approach to landscape painting in tune with our times and essentially characteristic of its author. Painters in the past attempted to separate the eternal from the transitory. They distinguished elements, bodies, substances in an effort to be specific about volumes and planes. The temper of the era, its tenets, its leisurely pace encouraged these artists to take their time in perfecting their work. The rush to live and to produce was alien to a serene period when calmness prevailed. M. Claude Monet belongs to a quite different age, one in which dizzying speed is the rule, where the creative person wants instant awareness of the universe and of himself through quick and violent impressions. The question is no longer a matter of fixing what is there but of seizing what is going by. The concrete reality of things is less important than an interdependence established by impermanent relationships. A number of artists took pride in depicting a palpable reality, whereas the atmosphere that envelops it is what defies the minutiae of transcription. This is the very thing M. Claude Monet aspires to do and does so well. He is the painter of air and light, of affinities and reflexes, of clouds fleeing, of mists dissipating, of shafts of light displaced by the earth as it turns. He is also the painter of atmosphere and harmonies, not so much of the solemn harmonies so dear to de Lamartine, but to those "pleasant and light" ones celebrated by the saint of Assisi in his "Canticle of the Creatures." M. Claude Monet's heart beats responsively as soon as he comes into contact with the intimate life of the out-of-doors. His enthusiasm animates his vision; he causes us to know and to love beauty everywhere, a beauty that eludes both a casual glance and scientific examination with lens and compass. It would be difficult to resist the appeal of an artist of such extraordinary sensitivity, who is so steeped in his work that he succeeds in making us share his own emotion, joy, and humanism. We are reminded of the criteria Novalis sets forth: "constant contact with everyday life; free association of ideas; close attention to even the minutest details; an inner poetic life; a simple soul." Without these, the title "harbinger of nature" is not merited. So, the more one thinks about it, the more he seems to merit it.

ANDRÉ ARNYVELDE

JE SAIS TOUT

"At Home with the Painter of Light"

January 15, 1914

It is five kilometers from the Vernon train station to the village of Giverny, where the painter has made his home for the last several years. The car that M. Claude Monet was kind enough to send to collect me at the Vernon station is whisking me across the countryside. Here is the Eure; only a few ruined, moss-covered piers of the old bridge rise from the riverbed. A church, a chalk cliff, brown hills where sheep graze . . . At the end of a narrow and winding track, the car stops before an old wooded gateway painted green, somewhat decrepit and crowned by a gentle stone arch. Beyond the gate I follow a short path past an open garage with three cars, and then past a rustic red-and-white house. The side of the house overlooking the path appears to be one immense window. This is the window of the painter's studio. I find myself at the foot of a small wooden staircase. A few steps up, a door stands ajar. Behind the door, another set of stairs, this one narrow. On either side of the stairs, the walls are covered with Japanese prints. Another dozen stairs and I am at another door, that of the atelier proper. I knock.

"Come in."

Philosophers say that time doesn't exist, and to most of us, this is true only in a metaphysical sense. In practice, we experience—all too vividly, and sometimes bitterly—the concrete reality of years, days, and minutes. . . . Nevertheless, as I cross the threshold into the atelier, I feel obliged to affirm the validity of this metaphysical principle. I know that Claude Monet is seventy-four years old, but that's hard to believe. The painter is standing there, bearing himself magnificently, almost rigidly, in his gray jacket, as sturdy on his legs as Donatello's Saint George in his armor. But the painter's thick, almost massive, majestic, and slightly daunting beard quickly modifies this impression of that divine Florentine adolescent. Instead, he is a grand country gentleman, a rough sharecropper, a hunter of wolves and boars, the unbending descendant of ancient, unmixed stock.

There, standing in his studio, is Claude Monet.

Brightness pours through the high window, flooding the room. Canvases from every period of the artist's career cover the walls, and some others are propped against the wainscoting. Under the window extends a large couch covered in ivory silk, and beneath it lies a thick rug of animal skins. The couch, a table, a glass-fronted cabinet, a desk with an armchair, and the easel comprise all the furniture in the atelier. What fills the vast room instead is the great light of the Giverny sky; it washes across the paintings, which are dizzying flashes of all earthly light, shouts, hymns, games, bacchanals.

Claude Monet informs me that he is prepared to answer any questions about the large number of his works soon to be hung in the Louvre with the Camondo bequest, but that he will refuse any other kind of interview. His tone is very churlish.

"The word *interview*," I reply, "is a useful one and a common one, *maître*, but somewhat weak to express the admiration and homage that my visit represents and the account of it that will appear."

Count Isaac Camondo (1851–1911), banker in whose collection of Oriental and eighteenth-century art were interspersed impressionist paintings. Bequeathed to the State in 1908, his collection went on public view at the Louvre eight years later.

caption
Portrait of Monet in 1922.

"I receive almost no one anymore," Monet says, in a gentler voice. "I almost never leave this place. I don't work much anymore. . . . For three years of horribly cruel mourning, I didn't work at all. I only began painting again about two or three months ago."

I ask about the paintings in the Camondo collection. There are some twenty of them: landscapes, cathedrals, Westminster—works from every period of his life, a few from his youth: Argenteuil, a cart in the snow. . . .

An Irresistible Vocation

I interrupt him. "Do you still like these works from your youth, *maître*?"

Claude Monet smiles, hesitates, and says, almost timidly, "They're not too bad."

I want to know if he has memories from the time when those pieces were painted.

At that, he looks me straight in the eyes, somewhat annoyed: "I can see what you're after. You're going to make me tell my whole life story. . . ."

He pulls a cigarette case from his pocket, takes a cigarette, rolls it be-

270

tween his fingers briefly, and lights it. Then he gets the armchair by the desk, carries it to the easel, and rests his two strong hands on its back.

"I would never presume," I reply discreetly, avoiding his fierce gaze—the gaze of a feudal lord that holds me as he tries to read my innermost purpose. "I only want to ask, for example, as long as we're talking about your youth, if there were any signs in your childhood that foretold your future impressive career."

"Oh, sure! I always drew," replies Monet. "Even as a small child, I was very good at caricatures. I drew them on my notebooks in class—I didn't pay much attention to the lessons. This was in Le Havre, where I grew up—"

He interrupts himself. "While we're on this subject, you should know that I'm a Parisian. They've always had me born in Le Havre. I was born in Paris, in 1840.

"My parents were manufacturers, based in Le Havre, and they always fiercely opposed my being a painter. In any event, I amused myself drawing caricatures. Everywhere and anywhere—at the theater, in cafés, at the homes I visited. At first, I just gave the drawings to the people they represented. Then, when they began to argue over them, well, my word! I started charging for them!

"A Le Havre picture framer often used to put my work in his shop window, and people would come to see them. They talked about them; they laughed. Along with my work, the framer sometimes showed paintings by a painter named Boudin. The people of Le Havre laughed as much at Boudin's paintings as they did at my caricatures, but it was a different kind of laughter. The laughter Boudin aroused was snide. They thought he was crazy or that he was joking. And I was of the same opinion as the people of Le Havre. At that time I had been imbued with academic art.

"One day, a client comes up to me in the framer's shop and says, 'Your drawings are interesting; they show clear strengths. You should try something besides caricatures. Come see me, and I'll give you a few pointers. We'll work together. . . .'

"Somewhat taken aback, I thanked him. When he left, I asked who he was.

"It was Boudin.

"I burst out laughing. And I took care to value the friendly offer of the artist that all Le Havre derided.

"But I ran into Boudin again at the framer's. 'So,' he said, 'you don't want to come along with me.'

"What did I have to lose? It would be amusing; I told myself it would be fun.

"So, one day I joined Boudin in painting outdoors. I began to daub my canvas. Then I watched him paint. And suddenly, I was overcome by a deep emotion . . . More, I was enlightened. Boudin truly initiated me. From that moment on, my way was clear, my destiny decreed. I would be a painter, come what may. And, as it turned out, my parents were dead set against it.

"When I came of age for the draft lottery, it was understood that if my number was called, I would go, that my parents wouldn't buy me a replacement. My number was called, and I had to go. I chose Algeria because of its sky.

"Being in uniform wasn't too bad. A painter . . . The officers took advantage of my talents a great deal, and that was good for some favors. After two years, I fell ill and was granted sick leave. Once I was home again, it seemed terrible to go back, especially because a tour was for seven years in those days. But my parents hardly wanted to pay for a replacement for me. I had to go back to Algeria.

"I had to make a choice. Without reluctance, I fell ill again before long, determined to go home on sick leave—and never come back.

"Back in Le Havre, I worked so furiously that my parents were finally won over. They bought me a replacement and gave me permission to learn my craft in Paris. They chose the painter Toulmouche to stand *in loco parentis*.... Do you know his work?"

The Early, Dark Days

I make a vague gesture....

"In 1862, he was an enormous success," continues Claude Monet. "Toulmouche had married a cousin of mine, so it was to him that I went. He looked at the paintings I had brought, then declared that I was 'very gifted' but that I needed a 'studio.'

"He had me enroll with old Gleyre. Do you know Gleyre any better than you know Toulmouche?... He did the *Lost Illusions* that is in the Louvre. I honestly tried to work under him. After a month, I said to myself, 'What they do here is stupid.' Renoir and Sisley were my studio mates, and I took them with me. I said, 'Let's go paint outdoors.'

"But when my parents found out that I'd quit the atelier that Toulmouche had gotten me into, it was quite simple: they cut me off.

"Things were hard after that....

Spring Flowers. 1864. 46 × 35⅞" (116.8 × 91.1 cm). The Cleveland Museum of Art; Gift of the Hanna Fund.

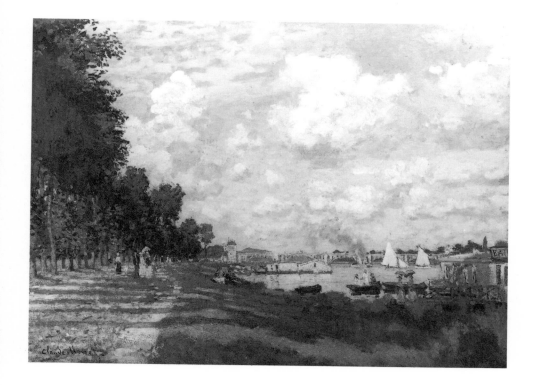

The Dock at Argenteuil. 1872. 23⅝ × 31⅞″ (60 × 81 cm). Galerie du Jeu de Paume, Musée du Louvre, Paris. Photograph: Musées Nationaux, Paris.

COLORPLATE 5

COLORPLATE 8

"My friends and I lived solely from the sale of our paintings. Needless to say, these sales were not always sufficient.

"I exhibited for the first time in the Salon of 1865: two paintings, two seascapes, *Sainte-Adresse* and *Honfleur.* They were well placed and somewhat well received.

"The next year, I sent *Woman in the Green Dress.* It was a great success, and because of it, I met Manet."

At this point, Monet pauses, lights another cigarette, then puts his hands back on the armchair's backrest. I am about to hear the epic tale of impressionism's early days.

"Renoir, Sisley, Pissarro, Bazille, and I—we were some of those bound by a common artistic direction. As long as we sent our work in to the Salon individually, we still had a chance of being shown. But once we exhibited privately as a group, we were labeled a 'gang' and turned down regularly.

"The judges didn't hesitate to give the reason behind their implacable ostracism: 'They're a "gang" with pretensions to a new and revolutionary art. A few are undeniably talented. If we seal their union with our approval, if we appear to attribute some value to their collective effort . . . *it will mean the end of great art and of tradition.*' "

Claude Monet offers me this phrase with neither laughter nor indignation. This great artist, his fame now secure and luminous, long ago renounced any bitterness.

"After the Salon rejected us," Monet continues, "life was terrible. No one wanted to show us. No one bought. War broke out. Pissarro and I were in London in 1871, and we didn't know quite what to do. I was lucky enough to meet Daubigny, who saw my paintings and thought I had some talent.

" 'Do you have any money?' he asked.

" 'Not a penny.'

" 'I'll take you to a dealer who'll be interested in your work.'

"The dealer was Durand-Ruel, who had set up shop in London.

" 'Not bad,' Durand-Ruel said. 'I can't pay you much. . . . You'll have to work hard,' he added.

"From that moment on, Durand-Ruel supported all of us. It was a heroic venture. Someone should study the role of this great dealer in the history of impressionism.

"At one point, things were so bad that Durand-Ruel—thanks to whom we were able to show our work—decided to go to America, to create a movement there, and to return with the wherewithal to continue the struggle.

"What would we do without him? Things looked bleak again.

" 'Be patient,' Durand-Ruel told us.

" 'But we'll go hungry! We can be patient, but how will we eat?'

"In 1877 [sic—1875], we were finally reduced to organize an auction of our own works at the Hôtel des Ventes. It was an amazing day. The police were called in to keep order. People made it an event; they came to ridicule our work. And did they laugh! The joke was to pass our work around upside down, as if to say that it was unintelligible any way you looked at it."

Claude Monet goes to his desk, takes out a thin gray-covered brochure, and pages through it.

"Here's the catalog for that sale. See for yourself. . . ."

In turn, I leaf through the catalog. What a precious relic! In pencil, alongside each entry, Monet had noted the prices bid on that epic day.

Skimming, I notice the following:

Renoir (Auguste)	19.	*Head of a Young Girl*	50 fr.
	23.	*Head of a Young Woman*	47 —
	29.	*Landscape, Autumn*	100 —
	33.	*A Soldier*	100 —
	34.	*Pastel*	55 —
Sisley	38.	*The Seine at St.-Cloud*	141 —
	45.	*Banks of the Seine*	120 —
[etc.]			

I am reminded of an anecdote that M. Théodore Duret included in a remarkable book, *Les peintres impressionnistes*:

In 1873, Daubigny bought one of the Dutch views by Claude Monet, *Canal at Saardam* [sic—Zaandam], from M. Durand-Ruel, for the sum of 400 francs . . . In May of 1878, after Daubigny's death, the contents of his studio were put up at auction. I knew *Canal at Saardam*, and thought it one of Monet's best works; I decided to bid for it. The sale took place—but there was no sign of this painting. I assumed that the heirs had kept a work they could appreciate. Two weeks later, on a Sunday, I happened to be at the Hôtel des Ventes, on rue Drouot. I went into one of the rooms and found some amorphous sketches and some old, dirty canvases, some of them barely scumbled with color. On the floor, a pile of easels, palettes, brushes—in short, all the paraphernalia of a studio. And there, all alone, Claude Monet's *Canal at Saardam*. You could have knocked me over with a feather. There was no name on the tag. Upon investigation, I learned that the room contained the odds and ends from Daubigny's atelier, displayed anonymously, as if it were something to hide. The heirs had left Monet's painting there, excluding it from the sale; they felt the painting would have disgraced it. I got it at the auction for 80 francs. When, in 1894, circumstances led to my selling my collection, M. Durand-Ruel bought *Canal at Saardam* for 5,500 francs. He sold it to M. Decap, who sold part of his collection—including this painting—in April of 1901. He withdrew it at 30,000 francs. If the painting does not enter a permanent museum collection, it will be interesting to see how high the price will climb at future sales.

COLORPLATE 19

274

There are so many similar anecdotes about Claude Monet that I cannot ask the painter himself to tell them. And after all, besides Théodore Duret, M. Camille Mauclair (in a very fine book, *Impressionism*), Octave Mirbeau, Clemenceau, Gustave Geffroy, and Georges Lecomte tell a hundred similar stories, in books, newspaper articles, catalog prefaces. . . .

I preferred to devote my visit to Giverny to the contemplation of Claude Monet himself, his person, his gestures, the feelings he expresses, his love for flowers, the serenity of his life in the country. . . .

He dispenses with the strictly biographical memories in just a few words: after Durand-Ruel's departure, inexorable necessity to support himself led Monet to show at Petit's, after earlier having rejected Petit's advances: "No. We will all remain faithful to Durand-Ruel. We are morally bound to show with no one else."

But Durand-Ruel was a long time in returning. In the end, Monet was obliged to go to Petit: "I'd like to sell you two or three canvases. . . ."

The paintings were shown in a large international show at Petit's. "There were even some works by Bonnat," Claude Monet tells me, with a slight smile.

The public stopped laughing the day Petit's legitimized impressionism. One show followed another. The reversal was complete. Claude Monet estimates "that it started to take off" around 1880.

"It was a craze," he says. (I am quoting him faithfully.) "A ridiculous craze. Snobbery, you know. . . . You see, I miss the days when someone would painstakingly save a hundred francs, buy a painting from the artist, and carry it off, trembling with happiness. Now, they pay fifty thousand francs . . . and don't know anything about what they're buying. They say they love painting . . . ; I don't believe it. I have to go along with it, but I'm often ashamed to receive a huge sum for work done for joy."

These are Monet's words, and this rough voice—yes, rough—is neither joking nor dramatic.

And, speaking of his wealth, he adds, "Probably I should say that in the old days we had to sell our paintings the minute they were finished, one after the other. But now, with the prices that paintings bring, it makes it difficult for me . . . to work better."

The painter is silent. I go up to the paintings on the walls. I ask Monet's permission to lose myself for a few moments in my wonder. All the

Léon Bonnat (1883–1922), the fashionable portrait painter.

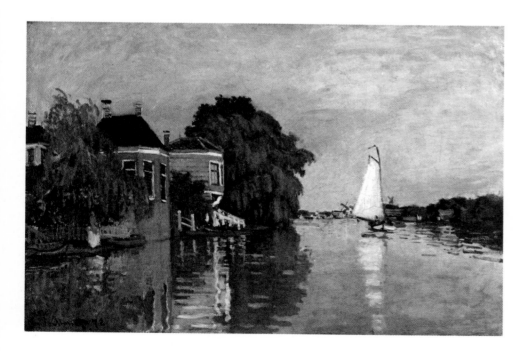

Landscape near Zaandam. 1872. 17^{15}/$_{16}$ × 26⅜″ (44 × 67 cm). The Metropolitan Museum of Art; Robert Lehman Collection, 1975.

colors in the world dance and sing along the walls in a passionate blossoming of joy and freedom. It's Venice and it's the Thames, and these are meadows, gardens, trees, and lakes. . . . Here are the preliminary sketches for all the master's great series, or their sister pieces that the painter has kept: Haystacks, Poplars, Cathedrals, Water Lilies . . .

My host allows me to let my gaze wander here and there about the studio. Then he leads me to the glass-fronted cabinet, and, with a smile, shows me a yellowed envelope placed on a little easel. The address is in the following form:

> Monsieur Monet, whom winter nor
> Summer his vision can allure,
> Lives, while painting, in Giverny,
> Close to Vernon, in l'Eure.

"And it arrived!" the painter tells me. "Stéphane Mallarmé sent it to me."

We leave the studio. Monet heads toward another building, the main house. The first room we enter is sumptuous, although the furniture is simple. This is the old studio. My admiration is instantly drawn by a work of dazzling beauty on an easel—a *View of Vétheuil* under the snow.

COLORPLATE 44

"Do you like it?" asks Monet. "There's an amusing story about this painting. The singer Faure sometimes used to buy my paintings. One day I went and offered him this one. 'My dear Monet,' he said, 'I wouldn't give you 50 francs for this. Look! It's a piece of canvas you've put a little white on. You can't be serious.'

"Discouraged, I left and offered this *View of Vétheuil* to a few dealers; their response was the same as Faure's. It was a bad moment. I needed to sell my painting.

"I finally did sell it. A few years later I was able to buy it back. One day, Faure came to visit me. He saw this *View of Vétheuil*:

" 'Oh!' he exclaimed. 'That's very good. Will you let me have it?'

" 'I offered it to you once before, and you wouldn't give me 50 francs for it.'

" 'That's impossible. It must have been another one,' Faure said, somewhat abashed. 'Will you take 600 francs for it?'

" 'I wouldn't take 6,000,' I replied. 'I'm keeping it.' "

Laughing at these memories and chain smoking, Claude Monet takes me into his garden. It's the one where he had a pond dug, which was the model for his *Water Lilies*. At this time of year, the green leaves sleep nonchalantly on gray water, while the flowers the painter portrayed in his unforgettable series are hidden, gestating within the mysterious web of their sap.

The hour is getting late, and night is rising slowly in the immense horizon that spreads beyond the garden where we stand, across the flat meadows where cows graze, over the poplars that edge the meadows and seem, from here, to be confiding a thousand tiny secrets through the tips of their dancing leaves as they lean toward one another. Claude Monet turns back toward the house. As I follow, I watch him walk, and though my eyes are filled with beauty, and after so much wondering happiness, I revel further in the joy of admiring the august sight of his robust and graceful step. At this moment I feel, irresistibly, that all the colors of the sky, the rustling trees, the slow swaying of the few flowers still vivid against their beds, and the majestic silence of the multicolored countryside, all pulse to the cadence of his step and form a retinue for their lord.

LUCIEN DESCAVES

PARIS-MAGAZINE

"At Home with Claude Monet"

August 25, 1920

Lucien Descaves (1861–1949), novelist, playwright, and journalist who, in 1900, became one of the ten members of the Académie Goncourt, founded in 1896 to make an annual literary award. Monet was friends with many of the members, including Mirbeau and Geffroy.

Were I to be invited—and what a tempting invitation it would be—to come up with the name of our most unalloyed contemporary artistic treasure, I would reply without hesitation: Claude Monet.

The man is eighty years old and looks to be around sixty. The painter has remained the most youthful of all the moderns, and the reason is that he has always lived bathed in light. His last submission to those art markets (covered ones, in this instance) known as Salons was made, if memory serves, in 1868. He has not been honored with any decoration. He belongs to no academy. He has never held any official post or performed any official function.

At seventy-five years of age Claude Monet came to the conclusion that he might not have exerted all his energies or used all his abilities to the fullest, and he set out to accomplish the prodigious work whose progress we have been following for six years. Life being short, there was no time to waste. The painter, totally familiar as he is with the play of light, the shifting times of day, is still trying to plumb deeper into their secrets. He is obsessed by his quest, he even told me that he dreams about it.

* * *

How understandable it is that light should continue to haunt his dreams, this man who goes to bed with the prayer "Will I find her again tomorrow where I left her, as lovely as today?" His entire life has been that of a lover and, if he seems not to age, it is because his eyes have always rested upon his beloved, the light, and in his eyes she is always young.

* * *

I recall my amazement one day in June of 1915 when, with my colleagues of the Académie Goncourt—Mirbeau, Geffroy, Henrique—I went to have lunch at Monet's home in Giverny: he was the only nonmember who had ever joined the Ten for their monthly meeting.

A surprise—and what a surprise!—awaited us in his studio. Monet had returned to work on the water lilies paintings that he had shown before the war, entitled *Water Lilies*, but now on a vastly greater scale. He was setting his impressions down upon huge canvases some two meters high and three-to-five meters wide. He had already covered some of them, and he was having a studio built solely to house the series, upon which he hoped to continue working.

We were surrounded by what seemed to be a celebration of water flowers. Mirbeau, who was already ill, suddenly seemed to return to his former self, and we all stood silently, entranced. In the presence of such painting there is nothing to say, other than, "It's beautiful!" Paintings that will one day be the pride of some collection or hang in some great museum will have time enough to hear foolish comments.

And at Monet's the miracle has not been wrought indoors in the studio alone. Before building, he planted. The dream garden in which he

COLORPLATE 109

COLORPLATE 114

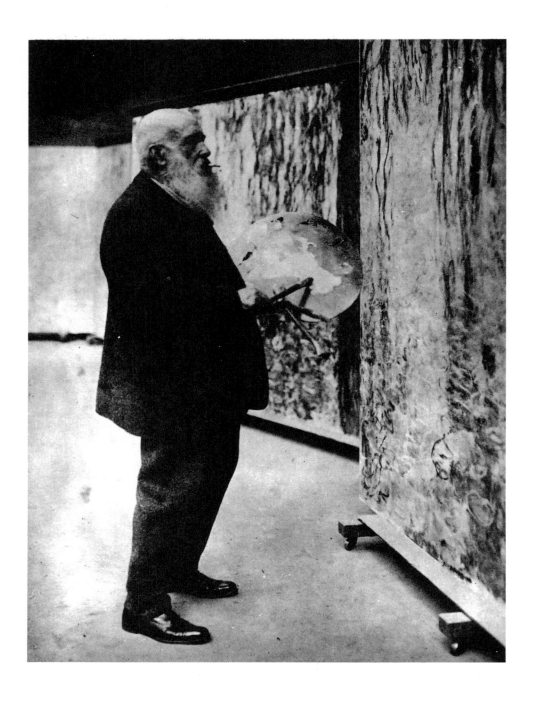

Monet painting in the water lilies studio on his eightieth birthday, 1920. Collection Viollet, Paris.

lives and works is also his work. He has created it all. He drew from the tiny branch of the Epte the water he needed to fill the pond he had dug and then said, "Let this water bear flowers!" And the water obeyed. Tendrils sprang up and stretched out, and each of those frail stems bears its own full blossom. Monet also planted the weeping willows, and here they stand as living contradictions to the connotation of mourning imputed to them: when I saw them again the other day, bathed in sunlight, the willows of Giverny were bent smiling over the mirroring water.

For I have recently seen them again, both on the banks of the pond and on canvases, hanging on the walls of the studio in which Monet's genius has enclosed them. The *Water Lilies* cover 170 meters of painted canvas, canvas painted by the artist who probably knows best what painting means. A twofold miracle: once again Monet has diverted the waters to the place he has planned for it. It had been too far away. In order to reach it, one had had to cross the garden and then the railway line, of which Clemenceau was so envious ("He even has his own train!"). Claude Monet has made the distance disappear by painting a replica of the pond that is too far away [to see from the house]. Now, it is always before him. The water lilies have accompanied the water, and the light

has accompanied them both. The painter is surrounded by his universe. Encircled by the charming pond with its precious flowers, all lit as if for some outdoor festival, Claude Monet is like some antique Doge, secure in the serenity of his glory, his kingdom now reduced to his works . . . one work, but his own.

Because he no longer comes to Paris, some of his friends visit him from time to time, Clemenceau among them. The first visit he paid upon his return from Egypt was to the hermit of Giverny. Gustave Geffroy accompanied the author of *Le grand Pan* as he stood in the center of the studio and turned slowly around to take it all in, intoxicated by the painting; until suddenly he exclaimed: "But the door, that's what bothers me . . . ; instead of coming in through the door you should be able to be deposited by some kind of elevator right in the middle of the studio!"

And Clemenceau was right: a panoramic setting is needed to contain this poem of blossoming water, each panel a verse of the most beautiful hymn to light that Monet has ever composed.

It was conceived in joy, but what trauma it was to cause him after that first vision! The elderly artist often destroyed canvases with which he was not satisfied. He is like Renoir, who continued to learn until the day he died. He is living proof of the words of Dr. Lippmann, which I once read in an album: "Truth is hidden in the Light"—and well hidden, for many painters have never been able to discover it.

Today I cannot say where or how Monet's masterful work will be shown. I can only say with certainty that when it is displayed, French art will have won a dazzling victory, a victory that the best of painters in any other country cannot hope to equal.

Gabriel Lippmann (1845–1921), renowned physicist who invented a process for color photography.

FRANÇOIS THIÉBAULT-SISSON

LA REVUE DE L'ART ANCIEN ET MODERNE

"Claude Monet's Water Lilies"

June 1927

It was early February 1918, and yet it was already spring. On both sides of the highway along which I was driving toward Giverny the twisted candelabras of the elm trees, fifty, sixty feet high, were covered with golden dots, new buds that made a fitting adornment of lightness, discreet richness, freshness. The gentle warmth of the brilliant sun and a sky of a radiant, joyful, and unclouded blue added to the charm of the day, and it was by that perfect light that I saw for the first time, although not yet finished, those vast *Water Lilies* the painter was to present, three years later, to the state, and which the state has now installed in the former Orangerie of the Tuileries in a setting of flawless taste and utter simplicity. The eight canvases that make up this marvelous whole are now housed in two large oval rooms with fairly low ceilings, the walls just high enough to create a band of gray-beige around the paintings. The art of tapestry never produced any hangings so sumptuous or of such newness and originality.

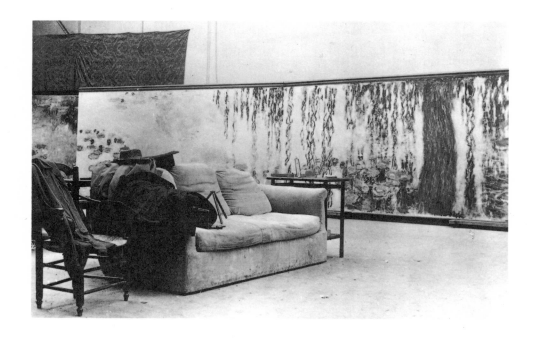

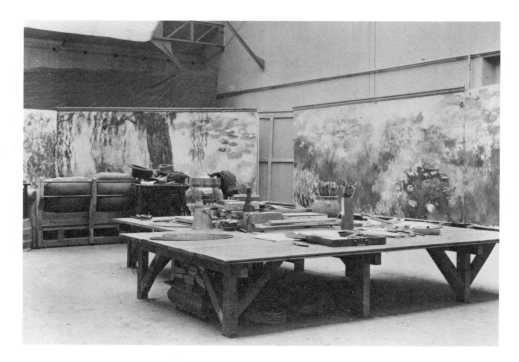

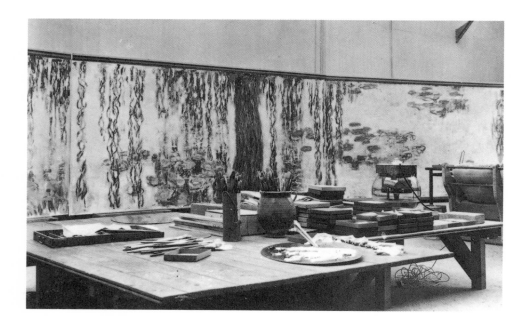

Several views of the third studio,
Giverny, in 1917. Photographs
Courtesy Galerie Durand-Ruel.

COLORPLATE 105. *Garden at Giverny*. C. 1910. 28½ × 39″ (72.4 × 99.1 cm). Galerie Beyeler Basel.

COLORPLATE 106. *Venice: The Doge's Palace Seen from San Giorgio Maggiore.* 1908.
25¾ × 36½″ (65.4 × 92.7 cm). The Metropolitan Museum of Art, New York;
Gift of Mr. and Mrs. Charles S. McVeigh, 1959.

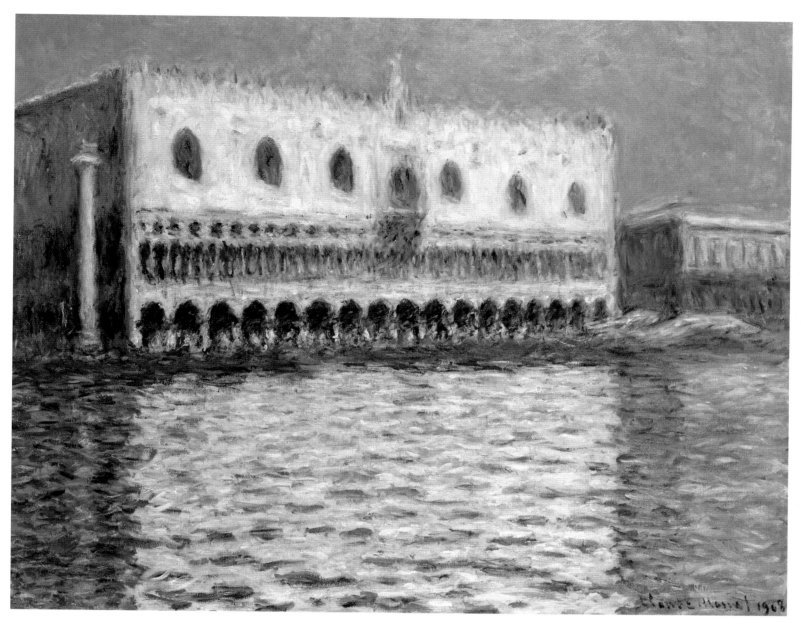

COLORPLATE 107. *The Ducal Palace, Venice.* 1908. 32 × 39⁹⁄₁₆″ (81.3 × 100.3 cm).
The Brooklyn Museum; Gift of A. Augustus Healy.

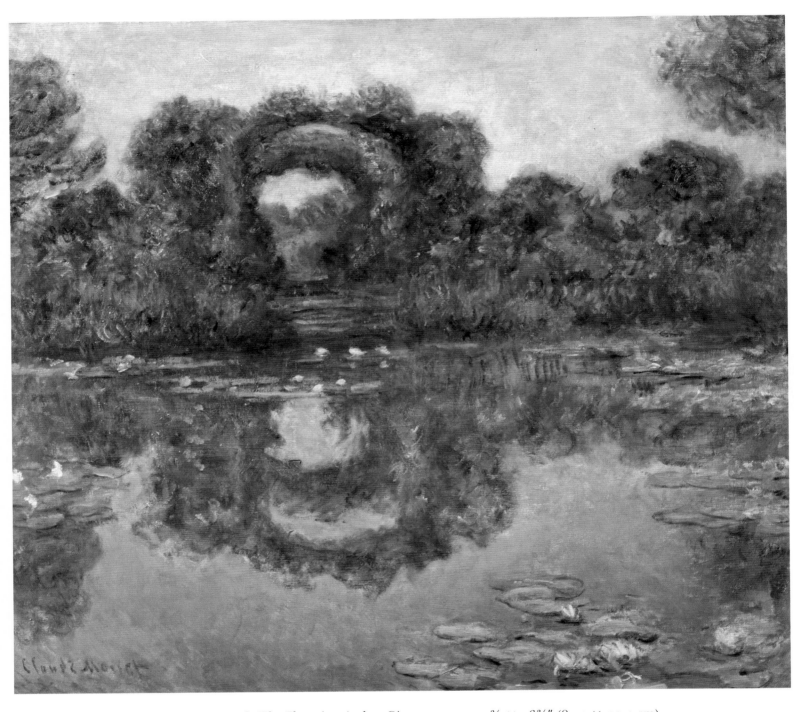

COLORPLATE 108. *The Flowering Arches, Giverny.* 1913. 31¾ × 36⅜″ (80.9 × 92.4 cm).
Phoenix Art Museum; Gift of Mr. and Mrs. Donald D. Harrington.

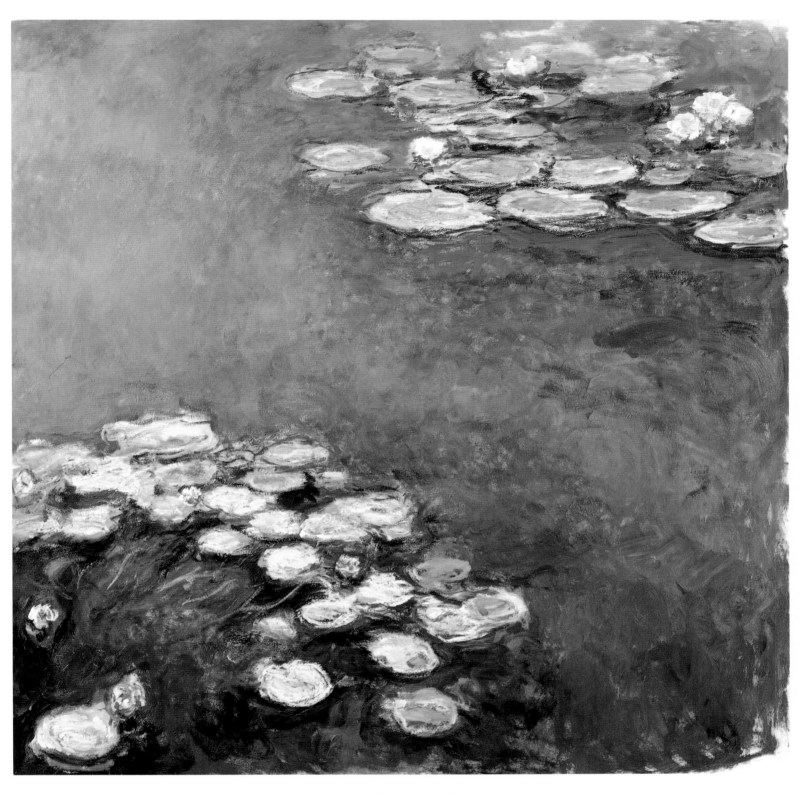

COLORPLATE 109. *Water Lilies*. Undated. 78¾ × 79⅛″ (200 × 201 cm).
Musée Marmottan, Paris. Photograph: Georges Routhier, Studio Lourmel, Paris.

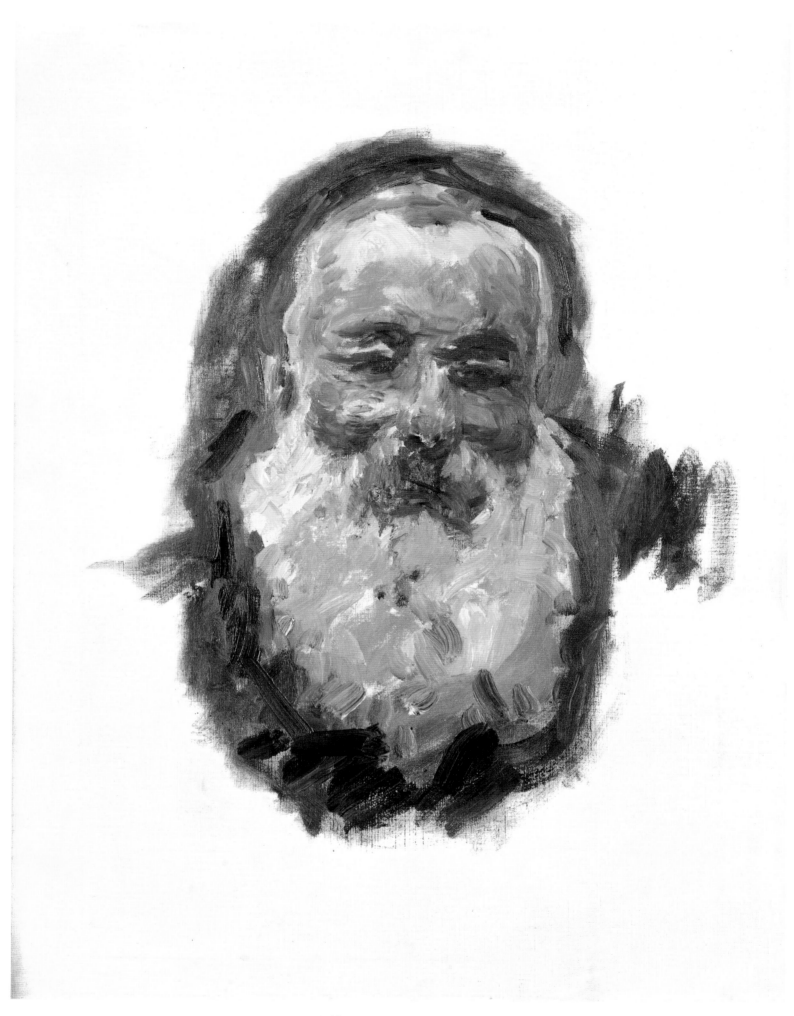

COLORPLATE 110. *Self-Portrait*. 1917. 27½ × 21⅝″ (70 × 55 cm).
Galerie du Jeu de Paume, Musée du Louvre, Paris. Photograph: Musées Nationaux, Paris.

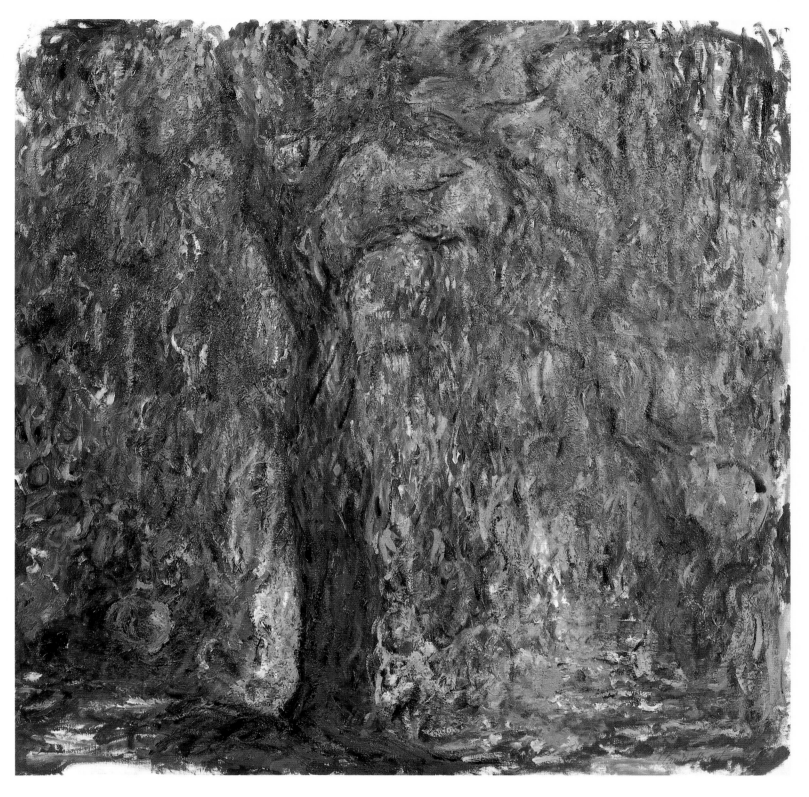

COLORPLATE 111. *The Weeping Willow.* 1919. 39⅜ × 39⅜″ (100 × 100 cm).
Musée Marmottan, Paris. Photograph: Georges Routhier, Studio Lourmel, Paris.

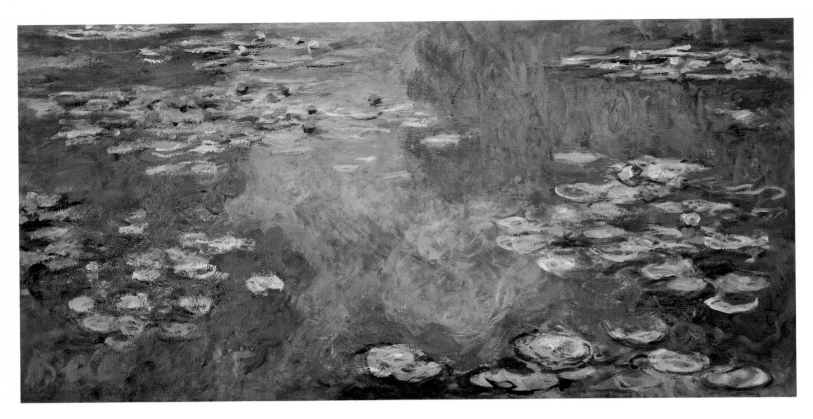

COLORPLATE 112. *Water Lilies.* 1919. 40 × 80″ (101.6 × 203.2 cm).
Collection of Mr. and Mrs. Walter H. Annenberg. Photograph: Malcolm Varon.

But let their creator speak freely, as he did in our conversation.

Having been forewarned of my visit, Claude Monet was waiting for me at the door. He welcomed me as only he knows how, when he is in a good mood—smiling, his gaze bright and cheerful, his handshake most hearty and cordial. His 78 years have neither weighed him down nor changed him. He still moves with the same nervous vivacity; he is still extremely alert; his attire is still just as carefully thought out. His hands emerged from the sleeves of his jacket, thin, fine-boned, the wrists encircled in an old-fashioned way with a filmy cloud of ruffled tulle. Only his long beard, with its almost total lack of dark hairs, framing his face, which is like that of an aged, eagle-nosed sheikh, attested to the passage of the years.

"Let's have lunch first," he said. "Serious things after lunch." And in the dining room, whose lemon yellow paneling is outlined in blue and hung with watercolors and Japanese drawings, he gave proof of a hearty appetite and drained his glass like a man who appreciates the good things of life and savors them slowly. After coffee we went into the garden, and from the garden we crossed the road and the railway tracks—along which trains no longer run—and entered the realm of the *nymphéas*.

As we strolled he described how he had put the whole thing together. From a completely empty meadow devoid of trees but watered by a twisting, babbling branch of the river Epte he had created a truly fairy-tale-like garden, digging a large pond in the middle and planting on its banks exotic trees and weeping willows, whose branches stretched their long arms at the water's edge. Around the pond he had laid out paths arched with trellises of greenery, paths that twisted and intercrossed to give the illusion of a vast park, and in the pond he had planted literally thousands of water lilies, rare and choice varieties in every color of the prism, from violet, red, and orange to pink, lilac, and mauve. And, finally, across the Epte at the point where it flows out of the pond, he had constructed a little, rustic, humpbacked bridge like the ones depicted in eighteenth-century gouaches and on *toile du Jouy*. All the money he had made since paying off his property and the costs of the repairs and new buildings he had made to improve it, once he had felt able to let himself go, had gone into this costly fantasy worthy of a wealthy *ancien régime* landowner. However, as he remarked complacently, the canvases inspired by his "last love" had more than compensated for the money he had laid out.

"Here," he told me, "you see all the motifs that I treated between 1905 and 1914, aside from my impressions of Venice. I have painted so many of these water lilies, always shifting my vantage point, changing the motif according to the seasons of the year and then according to the different effects of light the seasons create as they change. And, of course, the effect does change, constantly, not only from one season to another, but from one minute to the next as well, for the water flowers are far from being the whole spectacle; indeed, they are only its accompaniment. The basic element of the motif is the mirror of water, whose appearance changes at every instant because of the way bits of the sky are reflected in it, giving it life and movement. The passing cloud, the fresh breeze, the threat or arrival of a rainstorm, the sudden fierce gust of wind, the fading or suddenly refulgent light—all these things, unnoticed by the untutored eye, create changes in color and alter the surface of the water. It can be smooth, unruffled, and then, suddenly, there will be a ripple, a movement that breaks up into almost imperceptible wavelets or seems to crease the surface slowly, making it look like a wide piece of watered silk. The same for the colors, for the changes of light and shade, the reflections. To make anything at all out of all this constant change you have to have five or six canvases on which to work at the same time, and you have to move from one to the other, turning back hastily to the first as soon as the interrupted effect reappears.

"It's exceedingly hard work, and yet how seductive it is! To catch the fleeting minute, or at least its feeling, is difficult enough when the play of light and color is concentrated on one fixed point, a cityscape, a motionless landscape. With water, however, which is such a mobile, constantly changing subject, there is a real problem, a problem that is extremely appealing, one that each passing moment makes into something new and unexpected.

"A man could devote his entire life to such work—I did, for eight or nine years, and then I suddenly stopped, filled with a kind of uncommunicable anxiety."

"Why was that?" I asked.

"The colors no longer had the same intensity for me; I was not painting the effects of light with the same precision. Reds had begun to look muddy, pinks were paler, and the intermediate or deeper tones I couldn't capture at all. Forms—those I could still see just as clearly, and I could draw them with the same precision.

"At first I wanted to keep going. Time after time here by the little bridge, just where we are now, I used to sit for hours under the baking sun, under the shelter of my parasol on my folding chair, forcing myself to go on with my interrupted task and to regain the vanished freshness of my palette! All in vain. My painting was getting more and more darkened, more and more 'old-fashioned,' and when finished with my trial, I would compare it to former works. I was overtaken with a fit of rage and slashed all my canvases with my penknife.

COLORPLATE 119

"Of course, I needn't tell you that in the meantime I had consulted every good ophthalmologist I could find. I was dismayed at the contradictory opinions I got. Some told me that it was old age and the resultant progressive weakening of the organs; others—and I think they were the ones who were right—gave me to understand with considerable hemming and hawing, that I was developing a cataract and that in the course of time an operation might be able to cure me. However, they were careful to tell me that the slow progress of my symptoms showed that my affliction was going to take time to develop and that it might be years before an operation would be possible. Both sides agreed on one point, however: the need for complete rest.

"I've lived through many unhappy moments in my life, but I have never lived through any as painful as the ensuing five or six months. However, a day finally came, a blessed day, when I seemed to feel that my malady was provisionally checked. I tried a series of experiments destined to give me an account of the special limits and possibilities of my vision, and with great joy I found that although I was still insensitive to the finer shades and tonalities of colors seen close up, nevertheless my eyes did not betray me when I stepped back and took in the motif in large masses—and that was the starting point for the compositions you are about to see in my studio.

"A very modest starting point, of course. I was very hesitant, and I didn't want to leave anything to chance. I began slowly to test my strength by making countless rough sketches that convinced me, first, that the study of natural light was no longer possible for me; but they also reassured me by proving to me that even if minute tonal variations and delicate transitions of color were no longer within my power, I still saw as clearly as I ever had when dealing with vivid colors isolated within a mass of dark tones.

"How was I going to make out of that an advantage?

"Gradually I reached a decision. Ever since I had turned sixty I had always had in the back of my mind a plan to take each of the categories of motifs I had worked on over the years and to create a kind of synthesis, a kind of summing up, in one or perhaps two canvases, of all my former impressions and feelings. I had abandoned that notion, however, because it would have taken a lot of traveling and a lot of time to

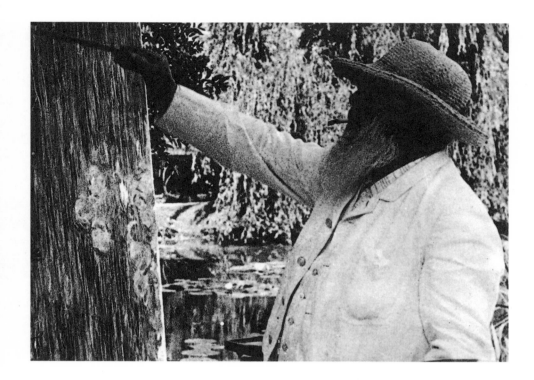

Monet painting in his garden, Giverny.
Bibliothèque Nationale, Paris.

revisit the various sites of my life as a painter, one after the other, re-capturing my past emotions. And nowadays traveling tires me. Even short two or three-day automobile trips do me in. What would a journey of several months do to me? And besides, I wanted to stay put here, where I'm happy. I've grown used to the flowers in my garden in the spring and to the water lilies in my pond on the Epte in the summer-time: they give flavor to my life every day. So I had abandoned the proj-ect. My cataract caused me to return to it. I had always loved the sky and the water, greenery, flowers. All these elements were to be found in abundance here on my little pond. Sometimes, in the morning or in the evening—I had given up working during the brilliantly lit hours, and in the afternoon I only come here to rest—while working on my sketches, I said to myself that a series of impressions of the ensemble, done at the times of day when my eyesight was more likely to be precise, would be of some interest. I waited until the idea took shape, until the arrange-ment and the composition of the motifs gradually became inscribed in my brain, and then, when the day came that I felt I had sufficient trumps in my hand to try my luck with some real hope of success, I made up my mind to act, and I acted.

"I've always been a decisive man once I've made up my mind. On the spot, I sent for the mason, an honest man with a small firm, conscien-tious, knowing his job. We drew up a plan, a very simple one, for an un-usually large studio—twenty-five meters long, fifteen wide. Solid walls, no opening aside from one door. Two thirds of the roof was to be glass. The workmen began digging the foundations on the first of August. Then came the general mobilization and the war. My contractor had no more workmen. The building materials could no longer be brought to the site. It took six months for my man to reach the point where he could begin construction. It wasn't finished until the spring of 1916. Then, when the work was barely completed, I set to work. I knew what I could do and what I wanted. In two years I have completed eight of the twelve panels that I had planned to do, and the other four are now under way. In a year I'll have finished to my satisfaction, that is if my eyes don't be-gin acting up in the meantime."

We had arrived at the new studio. We entered, and my eyes widened in wonder. Claude Monet had enlarged his original motif with a nobil-ity, an amplitude, and an instructive sense of decor that were totally un-

COLORPLATE 121

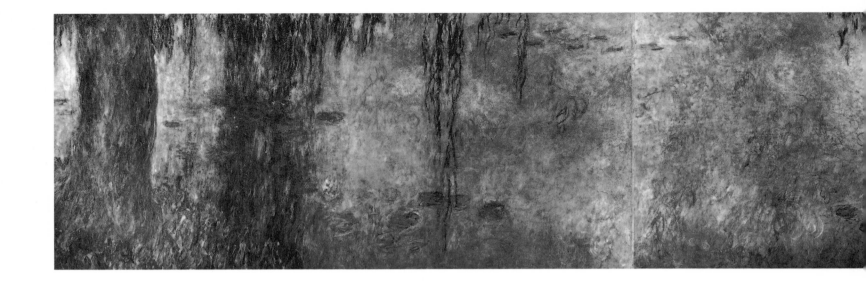

expected. Utilizing a compositional process whose simplicity was one of the happiest of inspirations, he had depicted the water-lily pond from the perspective of the path that encircles it, and each of the vantage points he had selected was enclosed in the framework of one of the canvases. They were all of the same height—approximately 1.80 meters. The widths varied—some were four meters, others 6 to 8 meters. As overall settings he had taken more or less what nature offered him. In some of the paintings the view of the surface of the water was framed by the gnarled trunks of two weeping willows, and in others, where nature gave him no need to limit the boundaries of his canvas, he had eschewed all artifice and had concentrated the viewer's attention on the water itself. None of the paintings had been executed in the full light of noon. The effects were all either those of misty daybreak or mid-morning with a very soft light and no mist, or of afternoon with the setting sun, or of fading daylight, twilight, or night. This alone was enough to allow the motifs to be seen in an unimaginable variety of aspects. As for the color effect, it was literally prodigious. On a base of either light or dark—almost black—shades of green, the artist's careful placement allowed the purples and yellows, amethysts and pinks, lilacs, violets, and mauves to play their roles to perfection. Resting on their large flat leaves, the water lilies discreetly raised their corollas surrounded by their green cupules, and the center of the composition was almost always empty, but in a very relative sense, for it was there that the painter had deployed the play of lights and reflections on the surface of the shimmering or calm water, water wrinkled or crimped with tiny wavelets. There, the reflection of the small cumulus clouds passing across the sky seemed to float gently, tinged with pink or fire, or one saw the trailing scarves of the mist risen in the dawn. The whole scene shimmered with the brilliance of an already fading sun whose last rays were refulgent as floods of gold in a pearl gray and turquoise sky.

COLORPLATE 115

And the whole thing was all of an unbelievable sumptuousness, richness, and intensity of color and life. For a moment I thought the old man must have been teasing me when he told me of his fading eyesight. I was to find proof to the contrary, however, when I accompanied him to his everyday studio and examined twenty-five or thirty works he had cast aside, works dating back to the time when, after having experienced the onset of his infirmity, he had still attempted to go on working. Their color notations were horribly out of tune, and although the artist was still present in the drawing, the talent for composition and the overall appeal of the work, the colorist seemed to have disappeared. It was still impossible to plumb the mystery of his wonderful achievement. "Don't

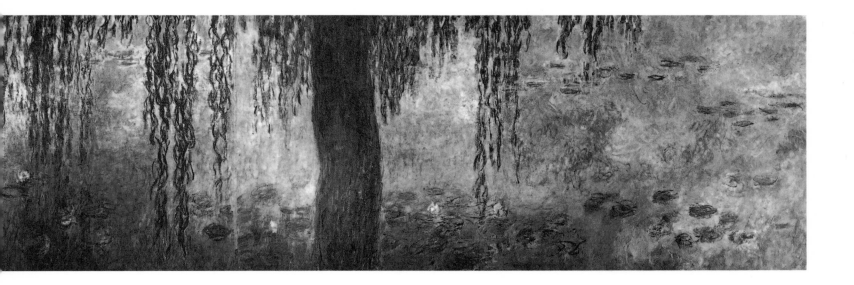

bother your head about that," Monet said to me. "If I have regained my sense of color in the large canvases I've just showed you, it is because I have adapted my working methods to my eyesight and because most of the time I have laid down the color haphazardly, on the one hand trusting solely to the labels on my tubes of paint and, on the other, to force of habit, to the way in which I have always laid out my materials on my palette. I soon grew used to it, and I've never made a mistake. I should add that my infirmity has sometimes gone into remittance and that on more than one occasion my color vision has come back as it was before, and I have profited from those moments to make the necessary adjustments."

Thus, it is to his nascent blindness much more than to any preconceived plan that we owe the compositions that Camille Lefèvre has set in such eminently suitable and fitting surroundings, in a framework so utterly tasteful and pure. The elliptical spaces created by the national museums' architect are not those first conceived by Monet. He had envisaged a vast rotunda in which his canvases would be set into the walls like a panorama, and it took many long discussions between himself and his "director" before he agreed to go along with the architect's ideas. He did not have the joy of seeing his work affixed to the walls before his death, and thus he was not able to see it take on its full meaning, its full suggestive power. But at least he died secure in the knowledge that, whatever its quality, his work would be displayed to the public under the most favorable conditions, and that knowledge in itself was the finest of rewards.

Let us conclude with an anecdote Georges Clemenceau related to me on the day of the private opening. "Once, the two of us were coming out of the Louvre, and I said to Monet, 'If I had permission to carry off one painting, I would take Courbet's *Burial at Ornans*.' 'Not I,' he replied. 'I would take *The Embarkation for Cythera* of Watteau.'"

That simple sentence fully sums up Monet's career as a painter and its ultimate evolution. Like Watteau, this pure realist unceasingly strove toward the ideal, and that is why there is so much magic in his art.

Water Lilies: Morning. 1916–26. 6′5½″ × 39′4½″ (197 × 1600 cm). Musée d'Orsay, Paris. Photograph: Musées Nationaux, Paris.

Camille Lefèvre (1876–1946) was a state-appointed architect in charge of renovating the Orangerie rooms for installation of Monet's Water Lilies *murals.*

Courbet's Burial at Ornans, *the vast and controversial group-portrait genre painting first exhibited at the Salon of 1850–51, was given to the State by the painter's sister in 1881 and entered the Louvre in 1888.*

293

MICHEL GEORGES-MICHEL

DE RENOIR À PICASSO

1954

Michel Georges-Michel (b. 1883), art critic.

It was Georges Clemenceau who led me to Claude Monet's house at Giverny.

*　　*　　*

Clemenceau's car had stopped at the bottom of the hill, and I can still see the great polemist climbing up the small path that led to the painter's house without losing his breath, his "frivolous" little hat such as painters wore then slightly tilted over his prominent forehead, his moustache leading the way, as he assisted himself with his cane.

He rang the bell at the gate. A servant told him that Monet was working near the "new pond."

"Very well," Clemenceau said, while the little door across the path was opened for us.

We crossed the railroad, circled the tall trees, and, from the back, saw Monet stroking a large canvas with his brush, facing his water lilies. He didn't turn around, probably thinking that we were simply members of the household.

We stopped, a few feet behind him. Clemenceau motioned to me not to move. Then, when he saw that Monet was pausing he slowly approached and gently embraced the painter.

Monet turned around. He was shorter than Clemenceau, stocky, and wore a velvet jacket on which I saw move a big, luminous beard.

"What a motif!" he said to Monet.

"Yes," answered the painter, "all that will be pink, orange. They're slowly evolving flowers. But when it will be ready . . . Come with me."

We followed Monet, crossed the path, and he opened the large gate where Clemenceau had rung.

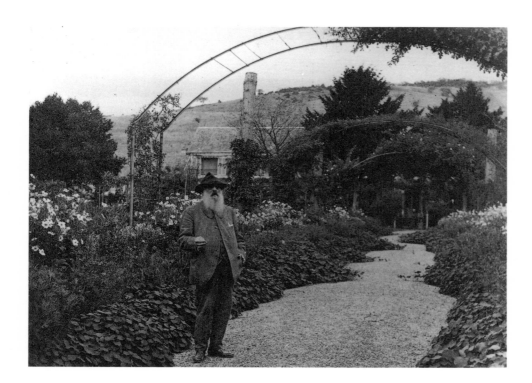

Monet on the path to his house, Giverny, 1926. Musée Marmottan, Paris.

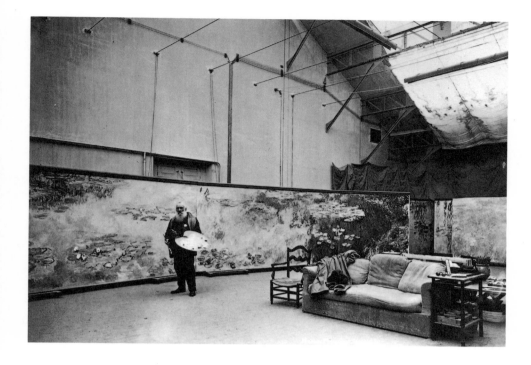

Henri Manuel. *Monet in the water lilies studio.* Circa 1924. Photo collection. Durand-Ruel, Paris.

On the left and on the right of a long path there were two patches of stunning flowers, cared for by gardeners. At the end of the path there was a low pink house with green shutters.

We didn't go in there at first, but rather into a sort of big hangar, where we saw two of the immense *Water Lilies* panels.

"I'm going to put them all around," Monet said, pointing to the walls. "It'll be as though one were in the middle of a pond."

Leaning slightly backward on his cane, his hat in his hand, Clemenceau looked with his large eyebrows raised.

Then, suddenly:

"Well, Monet, the Academy—"

But right away, even before Monet's reaction, Clemenceau shook his hand at the end of his extended arm:

"No, no, I didn't come as a delegate. . . ."

Monet answered in a soft, serious voice, slightly grumbling, but without the slightest trace of bitterness:

"The Academy . . . Look," he said while showing us his garden, "I've already refused to be decorated. So, the Academy . . . To sit in a room making small talk, precisely with those who fought against us, who still don't understand us—well, if they are beginning to believe in our painting . . . What attitude should I take with the people in that group? In a room . . . Aren't I a painter of the outdoors? Wasn't Boudin one? and Cézanne? No, no, no . . . Without any play on words, I'm too old for that."

"What are you going to do with that?" Clemenceau asked, in front of the large panels attached with unfinished wood sticks to the wall.

"Let me finish ten at least! I'm even thinking of building a big octagonal workshop on the other side of the house, after completing the ensemble that I want."

"Wouldn't you like to donate them to the government . . . in exchange for that chair?" Clemenceau added, laughing.

"To the government? That's something else. It would be better than at a 'collector's.' First, I'll keep them for myself. Then, if they don't put them in a government warehouse . . ."

"Oh, hah!" went Clemenceau. "Would I allow that to happen?"

"If you handle it," said Monet to the one who thrust Manet's *Olympia* into the Louvre. "But, have you had lunch? Let's go in and refresh ourselves."

Clemenceau, a member of the Institut de France since 1918, was apparently referring to Monet's stubborn refusal to accept an offer of membership extended to him in late 1920.

Purchased by subscription in 1890, thanks to Monet's efforts, Manet's Olympia *was given to the Luxembourg Museum, which normally transferred a work to the Louvre ten years after its creator's death. In Manet's case, however, the Louvre refused to accept* Olympia *until Clemenceau, then Premier, ordered the transfer in 1907.*

FRANÇOIS THIÉBAULT-SISSON

LE TEMPS

"Claude Monet"

April 6, 1920

On the right bank of the Seine, 25 kilometers from Mantes-la-Jolie and five kilometers from Vernon, lies the village of Giverny. Situated at the base of a steep hill between two winding roads, a hundred or so rustic shanties unpretentiously intermingle with several bourgeois houses. It is here that 36 years ago Claude Monet, after already having planted his tent in Argenteuil, Vétheuil, and Poissy, moved his penates. It is there that he produced, even while traveling for several months each year, the greatest segment of his work. It is from Giverny that so many of the strong and brilliant pictures, which are now scattered all over the world, originally come. Their theme is always the infinite enchantment of light and the reflection of its rays on all different types of things, and at all different hours of the day, from the misty dawn up until the moment of silence, when all the different lights, like belated sheep at the call of the night shepherd, become engulfed in the twilight's fold.

While riding the other day toward the home of the master, on a fresh and radiant morning, I mentally reviewed all of his work: from the views of Paris, Le Havre, Honfleur, and the coast of Normandy, with which he awoke to a consciousness of himself; to the sights of the Saint-Lazare train station and the barges and sailboats floating in the sunlight near the Argenteuil bridge; to the numerous views of Vétheuil, where red-roofed pyramids, watched over by an imposing Gothic bell tower, saw their glistening reflections blurred on the tranquil river waters; to the dramatic effects of snow, flood, and the breakup of ice, which he interpreted during the same years. All this was followed, after the arrival of the artist in Giverny, by those famous compositions, in series in which the same motif is represented in half a dozen examples, varied according to different atmospheric states and different degrees of light intensity, ranging from morning's icy pallor to the glaring radiance of midday to the golden tepidness of the sunset.

At once as veracious as official statements and as bold and lofty as poems, these studies of poplars, haystacks, cathedrals, and reefs sing the song of life with unprecedented modulations, using notes that are clear and happy or powerful and somber. These paintings reveal to the spectator an entire world of suprising observations and true revelations. In the Poplars he perceived the passionate, whistling gusts of wind and the light, whispering breezes that blow through the branches, those shifting draughts of the high region that dim or exalt the azure, herd or disband the clouds, unleashing sunshine or rain. The Haystacks illustrate the incessant struggle between a ray of sunlight and a drop of water suspended in midair. Vaporized by the heat of the day, transformed into fog during the night, and turned into dew the following morning, the water drop is in turn reabsorbed by the sun, sometimes in floating mists, sometimes in a heavy and opaque haze. The *Cathedrals*, with their iridescent facades, silver or streaked with tones of fawn, betray, by amplifying before our very eyes, the action of the solar rays against the stone, where clouds of dust and tiny molecules appear to light up, flashing on and off in a magic variegated pattern. The roar of the frothing, tumultuous, and wild sea surrounding the *Rocks at Belle-Île* renders with un-

Poplars near Giverny: Overcast Weather.
1891. 36¼ × 28¾" (92 × 73 cm). Private
Collection. Photograph: A.C. Cooper
Ltd., London. Courtesy Christie's,
London.

forgettable images the ocean in all its austere grandeur, the contrast
between the atmosphere's sunny serenity and the uproar of the furious
waves, evoking the memory of India's cosmogonies, in which good and
evil oppose one another in a ferocious and continual war. On top, a con-
cert of angels is depicted; beneath, a burning chorus of demons.

While painting this last series, Claude Monet was certainly not both-
ered by Ahriman and Ormuzd, nor by Zarathustra. However, given that
the world is the place that it is, and that the antagonism of the elemen-
tary forces of nature, which inspired Zoroaster to his simplistic and short
philosophy, is such as it is, they must have quite naturally inspired Mo-
net's grandiose renderings—those renderings that emit an impression of
nature so profound that for us the philosophical interpretation mixes
inevitably with artistic sensation.

Without constantly thinking it, the artist nevertheless suggests these
types of comparisons. It is one of the curiosities of his temperament, that
this sharp analyst who delights in his observations—to note the air's
shivers, the light's palpitations, and the most imperceptible modulations
of color—would also be a prestigious, powerful, and audaciously syn-
thetic conjuror. Young painters make me smile with their manifestos
(because for painters they write quite a bit) when they oppose the ne-

cessity of synthesis to the misuse of analysis, for which they hold impressionism responsible—as if the artist who is truly worthy of his name must not start with a scrupulous and slow analysis in order to bring about these more and more powerful effects of synthesis.

It is this course that Monet's genius followed. His *Poplars* and his *Haystacks*, his *Rocks* and his *Cathedrals* were the outcome of an already long career, where analysis was the artist's means of investigation and not his goal. The analysis would from time to time, after a series of observations of the same nature, bring together stronger impressions of the ensemble. After the *Cathedrals* and the *Rocks at Belle-Île* he returned to the cliffs of Normandy, which he had hardly studied at the outset of his career, except for in analytic notes. He reinterpreted these in freer and larger renderings, and it was precisely this new breadth that was stressed and became the characteristic trait of Monet in the magnificent work he brought back with him from successive travels in Norway and London, during those first years of the century. The cliffs bordering the fjords and the misty mirror of the Thames under the bridges or near the Parliament, with its imposing square tower in the night fog, penetrated here and there by livid clarity, offered such enchanting plays of light. Venice came next, and was interpreted in the same way, with its prevailing Whistlerian colors of incomparable grace. This new series of impressions ended with the *Water Lilies*, whose success was not yet exhausted when the war arrived.

Remember those dazzling compositions with their amazing variety of effects, although they all embroidered upon a single theme—a pond populated by an unbelievable variety of water flowers, reflecting on its limpid mirror all the colors of the spring sky, moving and changing like the breezes that continually disrupt its azure surface.

While these paintings are remembered, it is less well-known that the artist himself created the motif that inspired him. By enlarging his domain with a meadow where a tiny stream flowed, he opened up the abundant waters of a peaceful and spacious outlet, just moments before it would rush headlong toward the Seine. Enshrined in the middle of the pool grew a bed of bamboo, whose tapered dark leaves contrasted

Rocks at Belle-Île. 1886. 23⅝ × 28¾″ (60 × 73 cm). Ny Carlsberg Glyptotek, Copenhagen.

The Custom House at Varengéville. 1897. 26 × 36½" (66 × 92.7 cm). The Art Institute of Chicago; Mr. and Mrs. Martin A. Ryerson Collection.

with the light verdure of the weeping willows, which bordered the banks of the little lake, strewn with clusters of irises. And everywhere on the water's surface, carried on rafts of round leaves, were water lilies, those cups of white or pink, purple or mauve, yellow or red, orange or lilac. What a symphony of reflections to record!

And with the impetuosity that was his nature, Monet recorded them, without respite. At the Durand-Ruel and Bernheim-Jeune galleries the paintings followed one another by the dozens, before a surprised and charmed public.

The artist was not yet weary of his production when 1914 arrived, the time when the countryside as well as the city sent away to war all their able-bodied men. For weeks on end, having taken his part in the common agony, he was not able to concern himself with anything else, and did not keep up his work. However, during this momentary interruption, caused by such poignant preoccupations, his brain, whether he realized it or not, did not remain inactive. He had pushed it to realizations of such magnitude that even he hesitated to undertake them. It was his old friend Clemenceau, who visited him from time to time, that lifted any scruples he had: "As long as you are not tired, you are young enough to take even the longest project to term. Go ahead, don't beat around the bush any longer."

Coming from such a man, who felt no less than Monet did the weight of old age, the encouragement was precious. The artist took it to heart. To execute a project that would require about a hundred canvases about 2 meters high and 3, 4, or 5 meters wide, he would need a new studio, as big as a storage space for theater decors. He put laborers to work on it right away. One year later the new building was ready. Today it is completely filled with that monumental series, which covers the walls from end to end, and creates a wonder-struck amazement when seen. Using the same motifs as in the *Water Lilies*, this series is presented on an entirely different scale, with an altogether new boldness of execution, with a variety of effects, with a richness of color and a breadth of thrilling impressions. Monet complained about the weakening of his eyesight to those who would listen to him, but this weakness was so slight that no one but an artist would have even perceived it. It was quantitative and not qualitative. His vision had become less piercing, and those minute details he used to grasp from a distance would now escape him. But he perceived atmospheric and tone values with the same certainty

Galerie Bernheim-Jeune: one of the major galleries in Paris that specialized in impressionist and post-impressionist art around 1900, as a result of the enthusiasm of Josse (1870–1941) and Gaston (1870–1953) Bernheim. Founded in 1863.

Reference to the 1909 exhibition of Monet's Water Lilies *at the Galerie Durand-Ruel and to the 1919 exhibition sponsored jointly by Durand-Ruel and the Galerie Bernheim-Jeune: The latter also included Monet's more recent treatments of the theme.*

as before, reacting with even more vigor to the strong and powerful notes. This resulted in the painter's broader manner and in an exaltation of those colorful harmonies that belonged to the prodigy. The only view of these paintings is a view of enchantment, which I would like to see shared by all those for whom the sight of beauty is a thing of joy. Imagine the effect that they would produce, reunited together in the hall of the Grand-Palais, and ask yourself how much this spectacle would enhance throughout the world the prestige of France.

The day when these beautiful paintings, still brand-new, were shown to me for the first time, we had had a long chat. Under a divine sunlight, seated near that pool of water, where the water lilies would be in bloom in two months, surrounded for the time being by clusters of daffodils, jonquils, and giant cowslips, Monet unfolded his past before me. His youth and middle years were already spent. A loyal friend who did not easily forget favors, he spoke with a vibrant enthusiasm for Courbet, who had been so kind and hospitable to his younger colleagues. The man who incarnated, during the Second Empire, the struggle against *pompier* art, was never too arrogant to visit these young painters in their studios, to see their work in process, and to give advice when they had lost the grip—advice that was always paternal and always accurate. In the studio of the 25-year-old Monet there was a large canvas—*Luncheon on the Grass*—which had been executed under the influence of the master and which already betokened a profound originality. Monet intended it for the Salon. After having suggested several modifications, Courbet dissuaded the young artist from submitting to the jury his painting before it was brought to perfection: "Don't give those people the excuse of imperfections as a pretext to exclude you. And never let any scrap leave your studio unless it completely satisfies you. You don't have the time to perfect this one here. Save it for next year, and send a painting to them at the Palace of Industry with more modest dimensions that you will be able to paint well and quickly at one go."

His advice was followed. In a week or two Monet painted the *Woman in Green*, which was accepted at the Salon of 1866. He never completed the *Luncheon on the Grass*.

COLORPLATE 8

"If I had shown it," he told me, "and it had been accepted, who knows, maybe my existence as a painter would have been oriented in a different direction. Having set it aside, I moved on to other exercises that led me further than I had expected. I became infatuated with light and reflection. From that moment on I had no reason to return to a painting conceived and executed with different methods. And there you have it," he said with a smile: "the way in which I ruined my career."

We have lost a masterpiece, for that six-meter painting, which all in all is lacking very little, is an exquisite harmony of muted notes, painted with such determination and breadth! It is true, however, that in its place Monet has given us so many other masterpieces that the regret over this one is greatly assuaged.

Let us return to Courbet.

The summer of that same year, 1866, Monet, as was his custom, spent several weeks in Le Havre, where his parents lived. His first outing after his arrival was a visit to the enticing sea. He had not taken more than two steps on the pier when he found himself face to face with Courbet. The demonstrative and good-natured master immediately put his arm through his protégé's and took him on a long walk. A friend had just told Monet that Alexandre Dumas (père) was in town. "Let's go and see him," cried the painter from Ornans.

"But I don't know him!"

"All the more reason to go."

"Is he one of your friends?"

"We have never actually met each other, but we know each other by reputation. And we admire each other. He will be delighted by our visit."

Alexandre Dumas, père (1802–1870), dramatist and novelist, best remembered for The Three Musketeers *(1844).*

Henri Manuel. *Monet.* Circa 1920. Photo collection, Durand-Ruel, Paris.

And off they went, checking all the hotels where this renowned writer might possibly have been staying, but they were unable to find him. In the end they learned that, caught unawares by the total depletion of his savings, making times hard and resources scarce, Dumas had checked into a very modest boardinghouse. They went there and rang the bell, which was answered by a very plump matron. "He's not here!" she cried.

"Tell him M. Courbet is calling. Then he will be here!" the man from Ornans snapped back, and the plump matron acquiesced and went back inside.

A moment later an enormous man wearing pants and an unbuttoned shirt revealing a hairy chest, came bursting through the door. He grabbed Courbet by the shoulders. The two men looked at each other, hugged each other, kissed each other, and then simultaneously burst into tears. They both felt themselves to be a kind of *index* of the society of their era, one because of his opinions, even more than the revolutionary aspects in his painting; the other because he had opened his purse up to everyone, and just like a lavish child, had saved nothing for his old age. It was this similarity of reciprocal situations that had so profoundly drawn them to each other. This emotion, however, did not last long. A few moments later, the writer, faced with these newcomers, whom he had invited for dinner, displayed an artless pride in his culinary talents. The

lunch was exquisite and the wine superb. Dumas spent the rest of the day, much to the amazement of the Le Havre townspeople, strolling the streets arm in arm with his two guests.

Monet never stopped talking about Manet and Cézanne, who were, along with Bazille, his closest friends. His affection for them was accompanied by a boundless admiration for their marvelous talents as painters. He has not yet forgiven Zola for depicting Cézanne as a failure in the novel he wrote about art, entitled *L'Oeuvre*. He probably forgives him even less for having turned his back on the attempts he had made, which lasted for more than ten years, towards installing Manet's *Olympia* in the Louvre. The story of these attempts is a bitter one, and the old fighter rebelled against it. He used harsh words when telling it to me, words aimed at several figures who were of no small importance at the end of the last century, and during the beginning of this one. It can be said of Monet that he knew, more so than anyone else, how to love his friends as he loved his art, with a generous passion and a courageous candor. He went even further: he was, all along, their patron. His personal collection includes many Degases, Renoirs, Manets, Cézannes, Boudins, and Jongkinds, even some of their early works, which in the end is the best proof of his support for their art; he not only gave his word but he also opened his purse—which is a rare occurrence among painters.

The great genius also had a great heart.

FRANÇOIS THIÉBAULT-SISSON

LE TEMPS

"A Gift of Claude Monet to the State"

October 14, 1920

The painter Claude Monet has just given the state an inestimable gift.

It is known that he has spent all of his time since 1914 with a reprise, enlarged and adapted for a purely decorative destination, of the motifs of his *Water Lilies* series. The thirty or forty compositions executed in this manner, on canvases 2 meters tall and 4 meters wide, divide up into eight or ten series of which each is consecrated to a different color and light effect. M. Claude Monet is conferring four of these series upon the state—numbering in total twelve paintings.

The artist's decision is all the more generous in that he has been assailed for six months with offers to buy all or part of this work. Since the completion of this gigantic work had been announced in North America, where the master's genius is particularly in esteem, merchants, collectors, and museums had asked him to grant them one or many series. What is more, just recently he had received at his Giverny property a visit from someone who lives in Chicago, accompanied by an architect and a museum curator, one responsible for erecting, the other for putting in order after the construction is finished, the collections that are to have their place there, all of which is at the visitor's expense. The latter had told Monet that he would consider himself fortunate to stay on the upper floor of his museum, in premises whose plans would be inspired by

Although Zola had written prophetically in 1867 that Manet's Olympia *was destined for the Louvre, when Monet sought his support to purchase the work for donation to the State in 1890, Zola refused on the grounds that such a donation would amount to publicity-seeking.*

For the fullest account of this venture, see Robert Gordon and Charles F. Stuckey, "Blossoms and Blunders: Monet and the State," Art in America (January–February 1979) and Robert Gordon and Andrew Forge, Monet *(New York: Harry N. Abrams, 1983).*

Monet and Clemenceau on Japanese footbridge. Elder, *Monet à Giverny.* frontispiece, 1924.

the artist, a grouping of these large paintings, which would suffice to constitute a complete vision of the spectacle the artist had intended to recall. As for the price, the museum founder accepted the conditions laid down by the painter in advance.

These offers, however flattering they may have been, had all been temporarily declined. M. Claude Monet reserved for himself the right to follow up on them only on the day when he would be satisfied with his work.

Once this day arrived, M. Claude Monet had, on his own, made known his intentions to the state. It's only right, however, to add that the thought of this gift had been suggested to him by his old friend M. Georges Clemenceau, who is also privy to communicating the artist's wishes to the state and who, at his last visit, triumphed over M. Monet's ultimate hesitations. For M. Claude Monet, even at the present moment, despite the very clear judgment formulated by all those of his friends whom he had allowed to examine this marvelous ensemble, did not regard it as being yet brought to perfection and planned to inform the state of his plans only when he was satisfied with it.

Thanks to M. Clemenceau, the agreement is as of now concluded. All that is left to do is to go to a notary for an exchange of signatures. As soon as the Chambers have returned from recess, the government will submit a funding proposal to build, on the grounds of the Hôtel Biron, a special construction to house the Claude Monet donation. In this structure, which will be in the form of a rotunda, the twelve canvases will be placed end to end on the walls in series so as to give viewers the impression of a single canvas. The series will be separated by relatively narrow intervals, which will serve as entrances and exits, or it will symmetrically face the entrance and exit. The glazed ceiling will be sufficiently high to accommodate a wide enough space for decorative motifs, between the lower edge of the window and the top of the canvases, which M. Claude Monet will furnish and which will separate the series. The artist even plans to decorate the vestibule preceding the rotunda with a rather large composition.

Having taken a place at the center of the room at noon on a sunny summer's day, the visitor will have the illusion of being on the small island, peopled with quivering bamboo, that occupies the center of the water-lily pond at the artist's property in Giverny. In the middle of the little lake, which feeds off the waters of the Epte river, one will see the sky and its clouds reflected in the smooth mirror of the calm water, in spots of azure and gold or of pink-tinted white; the water lilies will hold up their corollas on the wide, round leaves that carry them, sometimes yellow, sometimes white, and sometimes purple, pink, or violet. On the banks, weeping willows with solid and rough trunks will rise up here and there, and their tresses will fall down in long, disconsolate threads—and one will marvel at the spectacle of this luminous fairyland, characterized by harmonies of dark blue, pink and white, green and gold.

If, as is likely, Parliament ratifies the government's proposition, work will begin immediately; it could be completed by spring. We can congratulate ourselves, and congratulate the fine arts director who has taken this matter to heart and leads it at a marching pace, for this record-setting rapidity.

MARC ELDER

À GIVERNY, CHEZ CLAUDE MONET

1924

Marc Elder: pseudonym for Marcel Tendron (1884–1933), novelist.

8 May 1922

All winter I closed my door to everyone. I felt that without doing this, each day would be diminished, and I wanted to profit from what little eyesight I had left to bring some of my decorations to conclusion. And I was very wrong. For, in the end, I had to acknowledge that I was ruining them. That I was no longer capable of making anything beautiful. And I destroyed several of my panels. Today I am almost blind and I should renounce all work. It's hard, but that's how it is: a sad ending in spite of my good health! . . .

I saw the frames in the back of the workshop against the wall, those big frames on which Claude Monet fixed those ephemeral confessions

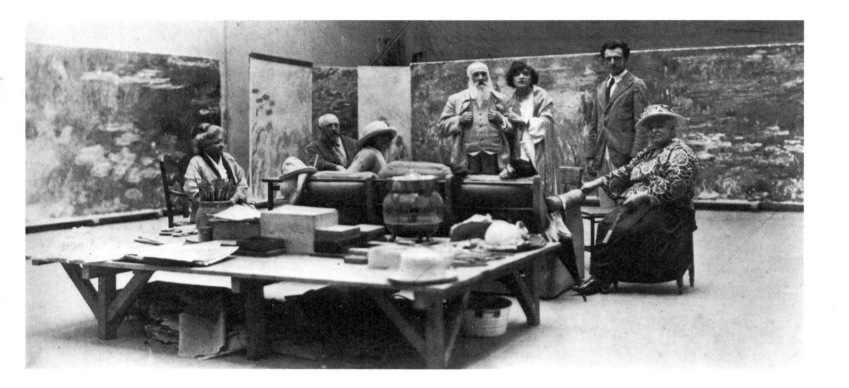

of his water lily pond. Shreds of torn canvas hung on the edges. The trace of the knife is still alive, and the painting bleeds like a wound. The nails are in place; the canvas is still stretched. A raging hand, strong and upset, lacerated the panels without bothering to patiently take the canvas off as one would with a precious rug being put away. Suffering guided the gesture; a spiteful exaltation accomplished it. The hands that I behold, those supple, sweet hands, somewhat softened by the veins jutting out, as character is by experience, are those that massacred their work. It is a tragic moment in which the artist grabs his own throat and breaks, with his own effort, the breath that betrays him!

Under the table is the pile of canvases that the servants have been ordered to burn.

Monet with members of his family and Marguerite Namara. From Muriel Ciolkowska, "Monet: His Garden, His World," *International Studio*, February 1923.

RENÉ GIMPEL

DIARY OF AN ART DEALER

1918–1923

René Gimpel (1881–1945), art dealer.

August 19, 1918 / At Claude Monet's

In the train taking us to Vernon, Georges Bernheim told me that I was responsible for the trip to Giverny, and that Monet might not receive us. Like Renoir, he doesn't like to be disturbed when he is working. I asked him if he knew Monet well, and he replied: "Yes, and on a certain occasion I treated him better than he's treated me recently."

"When was that?"

"You see, Monet had married for the second time—a widow, or perhaps it was a divorcée. She had a son who, on his mother's death, sold me eight of his stepfather's canvases for 8,000 francs."

Georges Bernheim, private dealer, was a cousin of the Bernheim-Jeune brothers.

"Why so cheap, when he couldn't be ignorant of their value?"

"They weren't signed, and the boy was not on good terms with Monet and could not get the painter to put his signature on them. They were nonetheless worth 40,000 francs with my testimonial. Monet heard of the transaction and sent me my cousins, the Bernheim brothers, to tell me he would like to buy back the eight pictures and to ask me the price. I wrote to him: 'M. Monet, you have only to send me a check for 8,000 francs and take the canvases.' He sent the check, promising me a present. I waited for it. Two years, three years passed. I decided to go and see him, and I said to him: 'M. Monet, I'm not asking you for any presents, but sell me some paintings.' He let me have twelve for 120,000 francs, and threw in a thirteenth. I had sold him eight for 8,000 francs. It was a rather expensive present, but then he's a very hard man. So a year ago I went to his house with my colleague Hessel, with whom I had gone half-and-half on a very bad Monet, and we took it along to him. He remembered the canvas and exclaimed: "'What a monstrosity!' 'Since it doesn't do you credit,' we told him, 'give us another in its place.' 'Not on your life,' he cried. 'There isn't in all my studio a single painting worth as little as yours.' Then we suggested effecting an exchange at a price, and pointed out a landscape and asked him the price. He replied that he wanted 10,000 francs for it, and we accepted. Monet took our painting and split it with one huge kick."

It was 1:30 when we arrived in Vernon.

* * *

Monet said: "Ah, gentlemen, I don't receive when I'm working, no, I don't receive. When I'm working, if I'm interrupted, it just finishes me, I'm lost. You'll understand, I'm sure, that I'm chasing the merest sliver of color. It's my own fault, I want to grasp the intangible. It's terrible how the light runs out, taking color with it. Color, any color, lasts a second, sometimes three or four minutes at most. What to do, what to paint in three or four minutes? They're gone, you have to stop. Ah, how I suffer, how painting makes me suffer! It tortures me. The pain it causes me!"

* * *

As the conversation touched on landscape, I said: "You and your colleagues of the nineteenth century, you're the masters who brought the art of landscape to heights never before attained." Monet cried: "Don't call me a master; I don't like it." Protesting that I hadn't called him a master, I added: "You remind me of Renoir, who won't hear the word 'master' uttered." "I suppose," he observed, "that those Dutch didn't see nature as all yellow. Their colors must have changed. When we were young, we went around the Louvre comparing our cuffs with the linen of Rembrandt's people, and decided that his canvases were far from the original colors. Rubens, now, did beautiful landscapes."

Georges Bernheim mentioned Corot, and Monet said: "He didn't put enough paint on his canvases. I don't know what will become of them with time, varnish, and cleaning. I wonder what will be left of them. Very little, I'm afraid!"

Like Renoir, Monet is very much concerned with the chemical evolution of colors, and he admits that he thinks about it constantly while he's painting.

"Have you heard," Bernheim asked him, "that Rosenberg has bought your *Woman with Japanese Fans?*"

COLORPLATE 36

"He wrote me about it. Well, he's got himself a piece of junk."

"Junk?" repeated Bernheim, in astonishment.

"Yes, junk; it was only a fantasy. I had exhibited *The Woman in Green,* which had had a very big success, at the Salon, and it was suggested that

COLORPLATE 8

I try to repeat it. I was tempted when they showed me a marvelous robe with gold embroidery more than an inch thick."

I asked the painter if he was serious, and he replied: "Absolutely." He showed us a photograph of the painting; I admired the head and found it beautiful. He told us with a certain artistic pride: "Look at those materials!" He informed us that it was a portrait of his first wife, who was a brunette and who put on a blond wig that day.

Bernheim had told me about an immense and mysterious decoration on which the painter was working and which he probably wouldn't show us. I made a frontal attack and won the day: he took us down the paths of his garden to a newly built studio constructed like a humble village church. Inside there is only one huge room with a glass roof, and there we were confronted by a strange artistic spectacle: a dozen canvases placed one after another in a circle on the ground, all about six feet wide by four feet high: a panorama of water and water lilies, of light and sky. In this infinity, the water and the sky had neither beginning nor end. It was as though we were present at one of the first hours of the birth of the world. It was mysterious, poetic, deliciously unreal. The effect was strange: it was at once pleasurable and disturbing to be surrounded by water on all sides and yet untouched by it. "I work all day on these canvases," Monet told us. "One after another, I have them brought to me. A color will appear again which I'd seen and daubed on one of these canvases the day before. Quickly the picture is brought over to me, and I do my utmost to fix the vision definitively, but it generally disappears as fast as it arose, giving way to a different color already tried several days before on another study, which at once is set before me—and so it goes the whole day!"

* * *

November 28, 1918 / My second visit to Claude Monet

"Now, M. Monet, look at this other canvas, your own of *The Church of the Calvary at Honfleur* [," said Bernheim.] The master looked at it, remembered it, and commented with a big smile, "A work of my youth." He was delighted to come upon it again. "The church is well painted," he said. "Corot did it too. I don't like the trees there on the left; I'd cut them, cut them, cut them." "Impossible," replied Bernheim, "this canvas belongs to Jacques Charles, the manager of the Casino de Paris, and he

The Chapel of Notre-Dame de Grâce, Honfleur. 1864. 20½ × 26¾″ (52 × 68 cm). Private Collection. Fondation Wildenstein, Paris.

wonders if you'd sign it." "I would indeed," said Monet, "but it will be right of center, to show him where to cut it. But it's split there on the left, so it's a Ville-d'Avray canvas." I asked him what he meant by a Ville-d'Avray canvas, and this is what he told me: "I was living in Ville-d'Avray and owed three hundred francs to a butcher who sent the bailiff around to me. When they were about to impound my things, I took a knife and slashed the two hundred canvases I had there. I left for Honfleur and some time after, when I'd had some success, my father sent me the money to settle my debt. I wired Sisley at Meudon, announcing my arrival, and we hurried over to Ville-d'Avray, but they'd all been sold. I went to the bailiff's to try to pick up the trail of my paintings, and he said to me: 'How can you expect to follow up anything so trifling? It's impossible! Your canvases were sold in lots of fifty, and each lot brought in an average of thirty francs.'"

<p style="text-align:center">* * *</p>

"Painting makes me suffer: all my old work with which I'm not satisfied, and the impossibility of doing well every time. Yes, each time I begin a canvas I hope to produce a masterpiece, I have every intention of it, and nothing comes out that way. Never to be satisfied—it's frightful. I suffer greatly. I was much happier when I sold my canvases for 300 francs. How I miss those days! And they were genuine, sincere—those people who paid 300 for my canvases. It was hard for them to spare those three notes. It's much easier for today's snobs to give me 20,000 francs." He turned brusquely to Bernheim: "Look, tell me, do you know where the study of the woman in green is? I'd love to find it again, it's one of my 300-franc canvases." Georges didn't know. He asked the painter to sell him a picture of flowers in a vase. The painter refused. Georges persisted for more than a quarter of an hour. The old man remained adamant, and when I queried him about his refusal he said: "So many canvases are memories, and some I consider too good and others not good enough to part with." At that moment Bernheim gave me the signal for leaving; we had to return to Paris. Night was drawing in swiftly, and he asked Monet to sign *The Church at Honfleur*. "Gentlemen," said Monet, "I don't have my tools here. Come with me into the big studio, and let's all put on our coats and hats to cross the garden." The painter's daughter-in-law followed us as far as that stable crammed with the immense canvases he painted during the war. Bernheim wanted to buy one. "Won't you sell me one?" he said. "Impossible," replied Monet. "Each one evokes the others for me." I looked at them and took pleasure in seeing them again. They are the more beautiful for being viewed one after another. The effect each time is a triple symphony of water, sky, and light.

So that Monet could sign, Bernheim removed the varnish with his index finger. The old painter claims that the ancients didn't use varnish (he is mistaken), and that varnish yellows a painting. There he is right. "Yes," he said, "varnish has yellowed all the Rembrandts. As young painters, we used to go to the Louvre and put our cuffs up close to the Rembrandt collars; originally white like our cuffs, they had gone terribly yellow." Bernheim had finished his scraping, and Monet laid the canvas flat on an enormous rectangular trestle raised only about a foot from the ground; then he got down on his knees and signed it. On the white wood of that board some forty·cardboard boxes, each containing a dozen large tubes of paint of the same color, were laid out very precisely. There were more than fifty very clean brushes in a glazed earthen pot, and perhaps twenty-five others in a second pot. Still more were lying about, all three quarters of an inch to an inch wide. There were two palettes, remarkably clean; they looked like new. One was covered with colors in little spaced-out daubs: cobalt, ultramarine blue, violet, vermilion, ocher, orange, dark green, another very clear green, and lastly a

lapis-lazuli yellow. In the center, mountains of white like snowy peaks. "I don't see any black," I commented to Monet, who replied: "I gave it up when I was quite young. One day the American painter Sargent came here to paint with me. I gave him my colors and he wanted black, and I told him: 'But I haven't any.' 'Then I can't paint,' he cried and added, 'How do you do it!' " Bernheim returned to the attack: "M. Monet, won't you sell me a painting." His daughter-in-law murmured to him: "You are hard!" I came into it, saying: "Sell Bernheim something; ask him a big price for the flowers." Then Monet relented: "Oh well, 20,000."

* * *

February 1, 1919 / At Claude Monet's, with Georges Bernheim

We returned to the big studio where the master's last large canvases are, and he said: "Dr. Gosset wants several for a place he's built in the country. I've told him I'd let him have them only if he'd place them in full light. I've begun getting offers, but I don't think I'll sell. I shall work until my death: it helps me to get through life, work has already enabled me to pass the hard times of the war. I get exercise, I can assure you, in this studio. Only a few years ago I was getting up at three in the morning, now at six, and I go to bed at nine. This life has preserved me. I've always enjoyed my food, which hasn't done me any harm. I eat less now, drink plenty, and smoke from morning till night. The work on these large pictures fascinates me. Last year I tried to paint on small canvases, not very small ones, mind you; impossible, I can't do it any more because I've got used to painting broadly and with big brushes."

COLORPLATE 112

* * *

October 11, 1920 / Visit to Claude Monet

Bernheim mentioned a fake Renoir which he saw shown in the shop window of a dealer right on the rue Miromesnil. Monet told us about the fake Monets he has seen, on which the signature is always very good, better than the painting. Georges is of the same opinion. He considers that Renoirs are imitated better because people work at it harder, whereas they *think* it's easy to do a Monet!

"Is it true," Georges asked the artist, "what I've heard at the Rodin Museum?" "Perfectly true, I'm going to give the Hôtel de Biron twelve of my last decorative canvases, each measuring some four and a half square yards, but they'll have to build the room as I want it, according to my plan, and the pictures will leave my house only when I am satisfied with the arrangements. I'm leaving these instructions to my heirs, for I've painted these pictures with a certain decorative aim, and I want it to be attained. They will build on the boulevard des Invalides side, where there is more daylight, and even there I'll be up against the light, which has always defeated me. I ask myself how a Ruysdael or even a Holbein saw nature, and I don't manage to understand. Hobbema sometimes divined the light, as in his pathway in the National Gallery, but the great landscapist is Corot." "The *good* Corot," interrupted Georges Bernheim. "The *good* Corot," said Claude Monet. "I don't know about that, but what I do know is that he was very bad for us. The swine! He barred the door of the Salon to us. Oh, how he slashed at us, pursued us like criminals. And how all of us without exception admired him! I didn't know him. I knew none of the 1830 masters; they didn't want to know us. One day at the Robinson ball a storm broke out and people took shelter under the awning. Millet was pointed out to me. I said to a friend: 'I admire him so much, I must speak to him.' My friend stopped me. 'Don't go. Millet is terribly antisocial, full of pride, he'll tear you to pieces.' Daumier was as frightful as Corot to us; only Diaz and Daubigny defended us, the latter energetically. He was on the jury, and he resigned because we were turned down."

* * *

I questioned Monet on his past. At twelve, he lost his mother, but already she had urged him to draw and had praised his plaster models. "I was expelled," he said, "from all the schools in Le Havre. I covered all my books with sketches—worse, all my friends' books. Later my father was opposed to my vocation."

Monet showed us the photograph of one of his canvases portraying his father looking at the sea; the picture is said to be in America. He sold it for 400 francs to Pratt, whose widow sold it for 40,000 to Durand-Ruel, and Monet wanted to buy it back from the dealer. He pointed out the pole with a flag on either side of the composition, and mentioned that at the time this composition was considered very daring. "I'm very fond of flags," he added. "On the first national holiday on June 30th, I went out with my working equipment to the rue Montorgueil; the street was decked out with flags and the crowd was going wild. I noticed a balcony, I went up and asked permission to paint, which was granted me. Then I came down again incognito. Ah! it was a good time, a good time, although living wasn't always easy. Durand-Ruel was our guardian angel, but as his admiration for us brought him to the worst financial disasters, he was obliged to move to America. For some time there was no longer anyone to buy our canvases from us, and then I sought out Georges Petit. It wasn't easy to persuade him. His father had done us a lot of harm. People who hadn't wanted impressionists on the rue Laffitte bought them on the rue de Sèze. Competition arose between the two streets and was very profitable to us. I remember, one day, going to Arnold and Tripp with two canvases under my arm, but I wasn't admitted to the back of the shop, where the two partners and their employees examined what I had brought. They were having a big laugh. I heard: 'It's Monet, the impressionist, what a scream!' And the laughter got worse than ever. Lifting the curtain, they saw me, and they laughed in my face as they handed back my two canvases.

"Three of us, Degas, Renoir, and I have had our revenge. We can say we have had a happy life, the others died too young—Sisley misunderstood, and Jongkind too! The latter was not even known in his own country. I have often mentioned him to Dutch people who have told me: 'We don't know who that painter is; he's certainly not one of our countrymen.' The greatest of the misunderstood was Delacroix; oddly enough he was misunderstood by successive generations too. He's one of my idols." "But," said Bernheim, "I've sold a Delacroix, *The Battle of Poitiers,* to the Copenhagen Museum for 300,000 francs." Monet replied, "Three million is what it's worth!"

The conversation shifted to living painters. Monet admires Vuillard but finds Bonnard, whom Renoir so much admired, very uneven. I'm going to meet Vuillard soon, and I'll tell him Monet's opinion, and Vuillard will blush fiercely.

* * *

July 17, 1923 / With my wife, at Claude Monet's

After these ten years during which we have come to Monet for many paintings, there is not really a great deal left, apart from two women, who are, I believe, his daughters-in-law, standing with parasols; and a picture as beautiful as a Vermeer, a woman passing before a french window in a wintry landscape. My wife discovered the poplars in a pile of other paintings. He told us that these trees were at Limay, near Giverny, and that one day he saw them marked with red paint. "They're going to be auctioned off and felled," he told himself, "and it'll be the sawmill nearby that will buy them." He hurried round to the owner, to ask what price he was going to buy them for. "Go higher," he said to the timber

COLORPLATE 13

Pratt: should be Victor Frat, a friend of Bazille's.

COLORPLATE 41

COLORPLATE 66

COLORPLATE 67

COLORPLATE 27

Poplars. 1891. 35⅜ × 36⅝″ (90 × 93 cm). Fitzwilliam Museum, Cambridge, England.

merchant. "I'll pay the difference, but let me have the time to paint them."

Monet's daughter-in-law told me that the pictures of the boats date from about 1887 or 1888. Monet informed me that since my last visit he has destroyed perhaps sixty canvases, though his daughter-in-law says fewer. It is she who starts by making an incision in the canvas with a knife and detaching a piece of it, then they are burned in their entirety and Monet stays by the fire so that nothing may escape destruction. But although his daughter-in-law approves his gesture in principle, she has moments of reaction when she grows nervous and agitated; Monet notices and the work is postponed to the next day. Monet showed me some very beautiful flowers which he was going to destroy. He took advantage of my last purchase to take down all his canvases again, and we found him in his studio, where he was busy rearranging them. We talked of modern painting; he knows very little about it. Of what he has managed to see, he said: "I don't understand it, but I'm not saying that it's bad. For I remember those who didn't understand my works and who said 'It's bad.'" My wife asked him if he knew Manet and he replied: "Yes, he was a great friend, a great friend. I saw him two days before his death. He had phlebitis and it had been necessary to cut off his leg, but he hadn't been told. When I approached his bed, he said: 'Now watch out for my leg. They wanted to cut it off, but I said they mustn't and I've kept it. Watch out.' And he died without knowing that in fact it had been amputated. It was just when I was settling in at Giverny here. His brother sent me a telegram, I believe I received it the first Sunday I spent in this house."

As my wife and I were walking with his daughter-in-law, I said to her: "Then, Claude Monet can no longer paint because of his eyes, but does he take pleasure in walking in his garden?" "Why, no," she said, "his eyes are very good, or, rather, very good with glasses. He has spectacles for seeing close up as well as for distance, but it's energy he lacks. He no

longer has the strength to paint, it drains him. He had a bout of tracheitis this winter which made him suffer frightfully for two months. It upset everything inside him, even his stomach, which used to be so strong. He wasn't eating any more; now he eats but no longer smokes, as right away it chokes him. He can no longer take alcohol. He has a lot of trouble seeing close up. Signing is worse for him than painting."

This woman's devotion to Monet is marvelous. She took me aside, anxious to know if I thought he looked better than a fortnight ago. She seemed to think he did; she must be right. She keeps track of him minute by minute. But on the other hand she doesn't seem to care very much about Monet's son.

He lives there, she said, at the other end of the house and doesn't work. She gave the impression of being fed up with him. He is very spoiled by his father. I had never seen him except here, at this luncheon. Without his daughter-in-law, Monet would live in a seclusion that would kill him; it is she who keeps him alive for us; posterity must not forget it.

* * *

September 23, 1923 / On Claude Monet

I went to see the Durand-Ruels. Grandfather Durand-Ruel one day bought for perhaps a hundred francs a canvas signed "Monet," an Algerian scene with camels, very much like Fromentin as to composition and execution. Some time afterward he showed it to Monet, who said: "It's not by me; I've never done any camels." This couldn't be; at the time Durand-Ruel bought it, fake Monet's weren't being done, the painter had no value. Grandfather Durand-Ruel was somewhat surprised at this statement, but when he was about to go, Monet said to him: "I should like to keep that canvas; I'll give you another in exchange." Durand-Ruel realized that Monet must have painted it in Algiers at the time of his military service, that needing money he had done a kind of fake Fromentin, but he had failed to sell it and had signed it later on.

Around 1889 he had decided, so to speak, to give up landscapes. He had discussed the matter with Renoir and his other friends, who had strongly advised him to study the human figure. He had come to Paris to look for a model and found and engaged a very good-looking young girl, who agreed to come and live at Giverny; but when he returned home his wife said to him: "If a model comes in here, I walk out of the house." That's why we're missing a Monet who paints portraits and the human figure. He did of course do some: for instance, Durand-Ruel showed me a portrait of a man, painted at Bordighera, which may be lacking in solidity and construction but not in life, not at all. The blood flows in the face somewhat in the manner of Hals, but it is a more dilute, swifter blood, sunny like the Midi and like the painter's landscapes. Durand-Ruel added: "Painters are always injured—their talent suffers—when they marry social women: they don evening clothes, go out too much, work less; the fashionable world doesn't allow them to do beautiful things, only pretty ones, and they work against their instinct. A society woman won't let her husband paint their maid, and the maid would often be the best of models."

We talked of the exhibition of works from Monet's studio, soon to take place at the Jeu de Paume. I said that nothing can hurt the artist but that the exhibition will be rather regrettable; on my last visit I had great difficulty in finding two good pictures. We all went back to the studio and I had to choose canvases from some series of water lilies and poplars, nothing out of the ordinary. I told Durand-Ruel how between my two visits a fortnight apart he had burned so many canvases. And he informed me that prior to doing a series the artist would do a good seventy studies of each before finding a definitive form, and all these sketches he destroyed.

GEORGES TRUFFAUT

JARDINAGE

"The Garden of a Great Painter"

November 1924

Georges Truffaut (d. 1948), botanist, soil scientist, and author of gardening books.

In 1883, the eminent painter Claude Monet created a series of gardens in Giverny, near Vernon, which have become justifiably famous and have enabled him to compose his best-known pictures now unfortunately scattered in America and in Germany.

The Giverny gardens are made up of three groups: the Norman yard, the water garden, and the vegetable garden.

It was in the cheerful Epte valley that the painter, beguiled by the rounded chalk hills and the hardy aspen that frame the river as it meanders between branchy old willows and through clay fields, conceived and carried out his great dream.

Nickolas Muray. *Claude Monet, Housekeeper, and Friend.* Circa 1926. Gelatin-silver print 9⁹/₁₆ × 7½″. Collection, The Museum of Modern Art, New York; Gift of Mrs. Nickolas Muray.

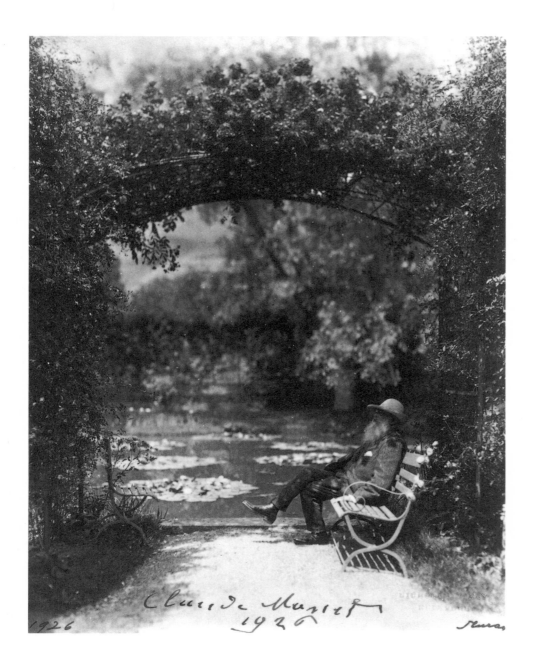

Claude Monet
1926
1926

Nickolas Muray. *Claude Monet.* Circa 1926. Gelatin-silver print 9⁹⁄₁₆ × 7½". Collection, The Museum of Modern Art, New York; Gift of Mrs. Nickolas Muray.

He diverted the course of the river, dug a vast pond fed by clear, rapid-flowing water, and arranged several channels that meander capriciously. He planted a framework of Babylon willows with golden boughs lightly skimming the waters.

On one shore, forming a backdrop, there is a cluster of briary plants among which ferns, kalmia, rhododendrons, and holly predominate. Shade along the water's edge is provided by hardy rose trees or roses climbing along existing trees. In order to achieve this he made special use of an extraordinarily hardy rose called la Belle Vichyssoise, which grows 21 to 24 feet high and produces long clusters of small scented blooms.

Every known variety of water lily was planted in the pond. Beginning in June this reflecting mirror, shaded by willows, framed by tall aspen, covered with flowers of every color, becomes the very magic of the Giverny gardens.

There are abundant irises of all varieties along the edges of the pond. In the spring there are *Iris siberica* and *virginica* with their long, velvety petals; later, Japanese iris (*Iris kaempferi*) abound and impart an oriental touch, which is further enhanced by such plants as Japanese tree peonies. Numerous specimens of these were sent to Claude Monet 20 years ago and have adjusted perfectly to the climate of Normandy.

Toward the end of May, when the herbaceous peonies with large raggedy flowers in colors varying from yellow-spattered white to bril-

liant reddish purple are in bloom, surmounted by golden clumps of laburnum, one would think oneself in a Yokohama suburb. A large grove of many varieties of bamboo adds to the illusion. These bamboos have grown to tree size, 21 to 24 feet high, and form a dense wood in which the painter has provided attractive vistas.

At some places on the water's edge, the bamboo wood is hidden by plants with enormous leaves, *Petasites*, and at one celebrated spot, for it has often been painted by the master, a Japanese bridge, marvelously decorated with mauve wisteria at the top and white wisteria with long clusters at the bottom, spans the pretty river.

The stream weaves about, serpent-like, amid the bamboos: *Bambusa metake,* a species with hardy shoots; *B. mitis; B. nigra,* violet-streaked bamboo, and many other species of *Phyllostachys.* In no other part of France is there such a remarkable growth of bamboos.

At the water's edge, there are beds of meadow rue with leaves as lacy as those of some ferns, with pink and white fluffy flowers; multistemmed wisterias; inulas; and numerous types of avens, some of which form borders of a charming slate pink. There are also vanhouttei spiraea with white flowers mingling with tamarisks, whose pink and light blooms are as graceful, in May, as ostrich plumes. Needless to say that salsify and water spiraea flourish under these conditions.

In some corners of the garden there are rhododendrons mingled with Chinese and North American azaleas in colors ranging from shrimp red to pink to pure white.

Long-stemmed rosebushes and bush roses with garlands of blooms forming a frame are everywhere. The overall impression created is that of a delightful fairyland, one that arouses an uncommonly intense awareness of artistry.

Unfortunately, a railway track separates the jewel of Giverny—the water garden—from the garden once known as the Norman yard. Initially the latter had been just a courtyard or a Norman apple orchard, which the master once thought of planting with flowers. He did this on his own without any help and without a gardener. It was here that he conceived the polychromatic fairyland that has exerted so great an influence on his art and has brought him worldwide recognition.

In early spring, as one enters this old-fashioned Norman courtyard, which has unfortunately lost a great number of apple trees, one is dazzled by a profusion of narcissus, especially the yellow kind with large trumpets, emperor narcissus and poet's narcissus.

A week or two after this vision of early spring, the tulips come out. There are long rows of early Dutch tulips in all hues, then come the Rembrandt tulips with their striped and mottled petals that throw off brilliant spots of color, and finally, in mid-May, the Darwin tulips on their tall stems ring out their brilliant note.

To get an idea of the beauty of the early flora one must see, amid the violet borders of aubretias, the yellow rows of retroflex tulips emerging from the pink and red clumps of leopard's-bane that form an airy inflorescence of molten gold.

What strikes the visitor most forcibly is the harmony resulting from the judicious choice of the contrasting colors that create a framework for these floral marvels.

Clever use has been made of the *Clematis montana,* a climbing type with relatively small but profuse blooms. There are at least two varieties of this clematis, one a greenish white, the other, a rosy white, both extensively used in Giverny as cover on a kind of trellis. The general effect of the arrangement of these espaliered clematis on their light supports is quite remarkable: they form airy garlands with ends free-floating in the wind, thus creating an effect of lace curtains.

Under these clematis there are different kinds of common plants, which have been vastly improved in Giverny, for example, white mul-

lein, belonging to the genus *Verbascum,* which has become an ornamental plant. There are varieties of this that range in color from pure yellow to purplish pink, blooming on loose, graceful spikes that form a strong contrast to the heavy bracteal poppies or oriental poppies, planted in great profusion on the lawns of the Giverny yard.

These poppies come in a wide range of tones, from a bright vermilion to shades of a striking slate gray.

The garden paths are all uniformly lined with edging plants; saxifrage with light, white blooms—commonly known as painter's despair—and wall campanulas are the most abundant.

During the course of the summer a quite rare plant with blue flowers, *Plumbago larpentae,* appears.

But in the spring especially, as I have already mentioned, purple aubretias predominate. There are also some *Viola cornuta*. Imagine, if you can, a profusion of long, unichrome flower beds framing, for example, enormous clumps of stocks or columbines or leopard's-bane or tulips, and you will get some idea of what these floral compositions are like in the spring, under apple and cherry trees in bloom, with laburnum and wisteria scattered everywhere.

In June, roses predominate; roses in all shapes and sizes: varieties of cluster roses (even stemmed ones), bush roses, standard roses. But hardly any long-stemmed roses that have been grafted onto eglantines are to be found in Claude Monet's garden.

Iris germanica or orchid irises are in bloom at this time. They are always planted in long, wide beds, some of them over three feet wide. These thousands of flowers of a single variety in a monochrome border produce quite an effect.

A few corners of the garden are planted with free-growing carnations, those pink carnations that our forefathers cultivated.

Elsewhere there are hollyhocks, which are hardy even in the poor soil of Giverny, and digitalis, and finally in August there are vast numbers of flame-colored nasturtiums, phlox planted in large beds, and the distinctive flower of Claude Monet's garden, pentstemons. Any gardener seeing the Giverny pentstemons would want to grow some.

In September, at the beginning of autumn, quite special effects are achieved by the use of thick beds of dahlias, especially cactus dahlias of every type, and new varieties grown from seeds of Étoile de Digoin; their loosely branched, airy and graceful clusters of flowers are very fashionable now.

At the end of September, sunflowers, goldenrod, and Japanese anemones, which are especially hardy in the Giverny gardens, begin to bloom. Gigantic *Helianthus sparsifolius,* whose golden flowers loom over thousands of clumps of asters, put the final touches to autumn.

During the summer, Claude Monet placed here and there particularly interesting plants such as *Plumbago capensis,* with their enormous masses of blue flowers, and ipomoea whose little sky-blue bells stand out in relief against a backdrop of yellow-toned blooms.

From May to the end of October these gardens are like a veritable display of fireworks. People walking along the road that separates the two halves of Claude Monet's property, as they stop to admire those masses of color, must yearn to visit this fairyland, one of the most attractive estates and perhaps the most sumptuous one in France.

Few, perforce, are chosen, for the master is aged and needs quiet; he could not stand large crowds.

I, for one, was deeply impressed by the great artist, one of the first to show his compatriots that it isn't only the English who know how to use flowers as a decorative motif. He surpassed any possible conception of what can be done with splashes of color. Many of the displays that have been so successful, especially in the gardens of the Champs de Mars, are only pale copies of Claude Monet's creations.

He is a great painter and certainly the greatest of floral decorators. It is to be hoped that amateur gardeners will somehow be inspired to acquire a sense of color and composition as well as the love of plants and the sort of technical knowledge that made it possible to improve and use flora best suited to the climate and poor soil conditions of the Giverny gardens.

Claude Monet's most beautiful work, in my opinion, is his garden. In any event, it is the one that has most appealed to his senses for the past forty years and to which he owes his greatest joys.

MARTHE DE FELS

LA VIE DE CLAUDE MONET

1929

Marthe de Fels (b. 1898), writer of books on artists, religious figures, and travel.

Apart from the conversations that he had with his flowers, Monet was hardly talkative. When asked, "Does Cézanne have talent?" he looked at the questioner, his mouth opening wide: "Ha! Ha! Ha!" In an exhibit, in front of his Venice works, a journalist exclaimed, "It's better than Ziem!" and from the back of the room was heard Monet's "Ha! Ha! Ha!" If a friend, in front of a work of art, allows himself great gestures of admiration or excessively banal appreciations, he immediately hears himself being corrected by the pitiless "Ha! Ha! Ha!"

Félix Ziem (1821–1911), successful painter of views of Venice and Istanbul.

* * *

Monet would often read out loud. His favorite book was Delacroix's *Journal*. He raved over the painter's genius, and he loved recalling that once, on the road at Fontainebleau, he had seen the great man, sick and all bundled up, walking with difficulty between two friends. But he was even more struck by a recollection from his youth. He was at the time sharing a workshop with Bazille. From their seventh floor, the two

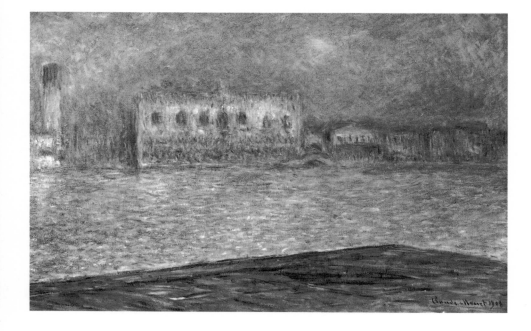

The Doge's Palace, Venice. 1908–12. 26 × 39⅜" (66 × 100 cm). Kunsthaus Zürich; Lent by a private collection.

painters could see the garden where Delacroix's atelier was. They couldn't see the master, but they could make out his hand moving over his canvases, in constant motion, and the two friends looked in this movement for the life that animated Delacroix.

Monet was very concerned about how long his work would last. One day M. Raymond Koechlin saw thick smoke coming from the garden. "What, a fire?" "Yes," answered Monet, "a fire, a big fire." And, coming closer his friend saw piles of paintings in ashes. "There," Monet said, "what do you expect; I had Manet's example. I'll explain. After the painter's death, the antique dealers all rushed to grab up his works. They grabbed everything, even his least little sketches. I got worried and preferred to destroy while still living everything that I didn't like. In that way, I won't have anything to regret."

Raymond Koechlin (1860–1931), professor, collector, and president of the Société des amis du Louvre.

For a discussion of the fate of Manet's artistic estate, see Charles F. Stuckey, "Manet Revised — Whodunnit?" Art in America (November 1983).

* * *

M. Raymond Koechlin had come to see him. "I'm leaving," Monet said to him, giving him a piece of paper. It was a long letter from a German doctor, promising to give him back his eyesight if ever he would come to Frankfurt for treatment. The painter, convinced, or rather desperate, was going to have one last try. With prudence, Monet's friend advised him to find out more about it. "What's the use? I'm leaving," Monet said. But, in the meantime, M. Raymond Koechlin had obtained information about this doctor, a notorious charlatan, it seemed. Monet answered him with irritation: "Why take away my last hope for health?"

TRÉVISE

LA REVUE DE L'ART ANCIEN ET MODERNE

"Pilgrimage to Giverny"

January 1927

February 1927

The Duc de Trévise (b. 1883) owned an important collection of French paintings and drawings.

On 5 December 1926, Claude Monet closed his eyes to the light whose full splendor he had given utterance to.

Because the *Revue de l'art* has so often written about this great artist, today we can devote only a brief obituary notice to him.

But to commemorate the charming manner in which this aged man, who had remained so young and active, welcomed a few privileged visitors, we are publishing the account written by a man well qualified to observe and comment.

In 1920, the Duc de Trévise went to Giverny twice, most importantly, on the occasion of the painter's eightieth birthday. The article that follows, written immediately after conversations with the master, and the excellent photographs taken by M. Choumoff while the artist was talking, create the illusion for a few moments that Claude Monet is still among the living.

Editorial note

To the painter Albert André, who was good enough to submit my notes to Claude Monet for approval and editing.

<div align="right">E.T.</div>

One could undertake a symbolic but not very convenient pilgrimage to Giverny by leaving Paris in the early morning, just as Monet himself did (for this famous Norman was born on rue Laffitte); first stop, Argenteuil, where he lived before 1870; next, Vétheuil, where he painted his *Dèbâcles* in 1879; and finally the neighborhood of Vernon, amid the peaceful fields through which the Epte flows. He has been living here since 1886 [sic—1883], celebrating in turn haystacks, poplars, and water lilies.

This is really the way one should approach the man one thinks of as the impressive yet fragile deity of the Seine. However, it is simpler to take the one o'clock train from Saint-Lazare and comfort oneself with the thought that the scene is the same as the one in the picture in the Caillebotte Room of the Luxembourg Museum. Claude Monet had the courage to put on canvas the nice little trains of old that appear to be smoking a pipe under the slanting windows of a studio.

One wonders which of these two ways of going to see him the master would prefer. For there must be two quite opposite sides to his nature: on the one hand, a sensitive dreamer, an intimate of what is fugitive, delicate like no other, a lyric poet, sometimes elated, sometimes downcast; on the other hand, a man whose immense and orderly output suggests uncommon vigor and calm good sense, and leads one to expect a simple, cogent, and level-headed conversationalist. Regardless of what my perception may turn out to be, I cannot reread the penciled invitation I have just received without a feeling of excitement. What a rare opportunity to see a living immortal whose advanced age and long retreat from the world have isolated him in the mist. Likewise, one cannot believe that his appearance, while giving precision to it, could possibly surpass the noble idea one has of him.

This is the case however. The master looks like a leader: full of vigor, simplicity, authority. In front of his entrance hall, framed by his door, which he opens, he beams like a beautiful portrait. The effect is so satisfying and surprising that some of the details are missed at first—the immaculate beard, the majestic bearing: these are the tokens of longevity without its weaknesses. He looks like a poet's vision of old age. When he doffs the carefully dented little hat he usually wears, his head appears to be without wrinkles; it is quite round and white, with the perfect contour of a snow-covered cupola. His eyes are bright as agates, darting a wild flash. Added to his naturally distinguished air, he has artfully chosen clothes that are neither commonplace nor casual, but are discreetly picturesque. It is noticeable, when he extends his hand, that it emerges from the wide, pleated cuff of his shirt, and one cannot help but approve the fact that if a hand must issue from a corolla, it should be one that has painted so many flowers. The legs of his trousers are secured above low boots in a style befitting an artist who has worked more often amid tall grasses than on a studio floor. His habitual stance, his way of throwing back his head and chest with his arms at the ready while his feet remain solidly on the floor, this tough stance serves to remind us that painters are great fighters who size up the strength of an adversary who remains invisible to the ordinary person: nature.

"It's a beautiful day. Shall we take a turn in the garden right away?" As I hesitate to accept the painter's suggestion, I am encouraged to do so by his daughter-in-law, the good fairy always to be found in the shadow of this magician.

"Don't worry about tiring him! No day goes by without his taking

Albert André (1869–1954), follower of Renoir who exhibited works at the Galerie Durand-Ruel.

COLORPLATE 40

three or four turns along his paths when he doesn't actually settle down to paint there."

"Even though I shall very soon be eighty years old . . . I shall have to take precautions all the same!" Monet adds.

The first garden, the one next to the house, is a little like a French-type orchard, if I may so describe it. Underneath and edging the fruit trees that have been saved, there are masses of flowers, and several gardeners are busy tending, pruning, changing them several times during the season. Along with the Japanese prints, it is one of the only luxuries indulged in at Giverny. "More than anything, I must have flowers, always, always," says their owner. I have been told that on the days when they are being rotated, when the ones dug up are thrown on the scrap heap, stealthy neighbors beg, "Monsieur Monet, can I gather them?"

The flowers are all arranged impeccably; on the edge of a path stralidziae form a blue border that looks painted in a single solid color, while in the middle of the square flower beds, tulips, selected from the finest catalogs from Holland and England, are scattered, seemingly at random but actually united by shades as tenuous as feeling, like those observed by the primitives.

A few simple, tall triumphal arches made of iron have just been erected above the central alley; roses will soon entwine them brightly. One truly feels the presence of a skilled organizer. Logically, the gardens of a painter should be easier to imagine than those of a writer, because the former copies and the latter describes. Nonetheless, I pictured Rostand's garden just as it was, with its arabesques and its verdure-covered latticeworks, but not Renoir's. I imagined he would like his corner of nature to be well groomed, his shrubs to have smooth, tidy leaves somewhat like the feathers of some species of birds; I certainly did not expect slovenliness, such as weeds in the gravel. And I should have thought that Claude Monet, absorbed as he often was with leafy tangles, lived in a springtime jumble; yet the most beautiful orderliness prevails. Here everything is within bounds, even exuberance; everything is artfully arranged, even the wildflowers. Those fragile water lilies, compared with which the lily pads in our region seem crude, are a product of the master's knowledgeable persistence. On the other side of the road, in an uninteresting bit of field, he gradually planted large willows, some of which have already died of old age and which he himself replaced. He altered the course of a branch of the Epte and, knowing the current would be too strong for his flowers, he tamed it with a grill placed in the water, much like a comb in a head of hair. The Japanese bridge was his idea; he later finished it with an arbor in the Japanese style. Thus, when everything has been carefully put in place, when in the morning his special gardener, working from a small boat, has finished soaking every water lily pad in order to remove the dust, then the owner settles down and is once more pure artist, energetically painting the site he had patiently put together.

Completely master both of himself and of his house, M. Monet also directs the conversation, but it would be impossible to imagine a more charming listener; he interrupts only to clarify a point. Except when he encounters unabashed inquisitiveness, no one could show greater pleasure in telling stories, in showing a more smiling courtesy, even when the photographer who was with me demanded complete immobility. Toward the overcurious he has only one recourse: withdrawal, and I am told that if the intruder persists, he rebuffs him, tersely and politely but with finality. As we shall see, for my part, I was among the chosen, but our first exchange was as brief as it was amusing.

Not knowing how to begin, I opened up with one of those deplorable gambits I had hoped to avoid: "You know how much you are admired."

"People exaggerate."

See Geneviève Aitken and Marianne Delafond, La Collection d'estampes japonaises de Claude Monet *(Giverny: Maison de Monet, 1983).*

Edmond Rostand (1868–1918), poet and playwright best remembered for Cyrano de Bergerac *(1898).*

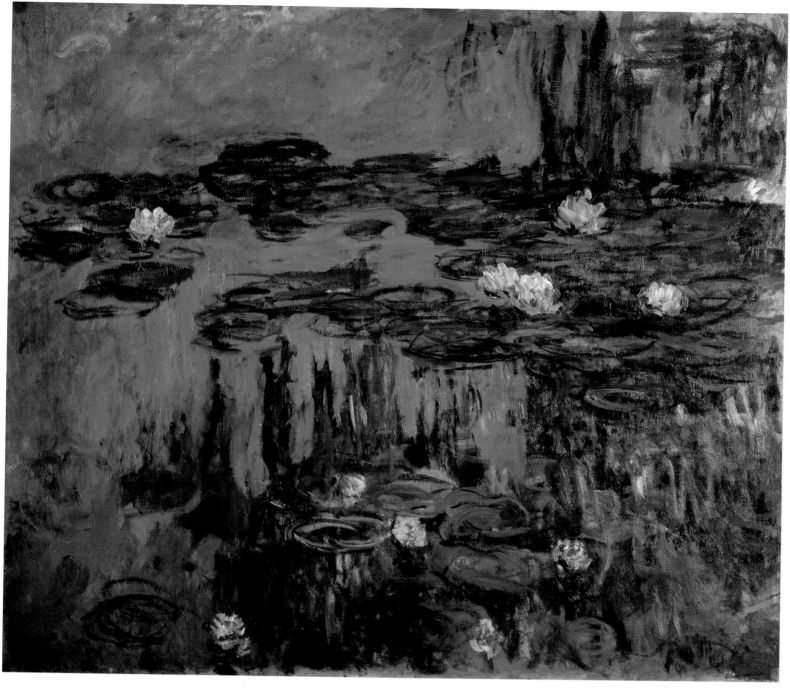

COLORPLATE 113. *Water Lilies.* C. 1914. 63¼ × 71⅛″ (161 × 182 cm).
The Portland Art Museum; Helen Thurston Ayer Fund.

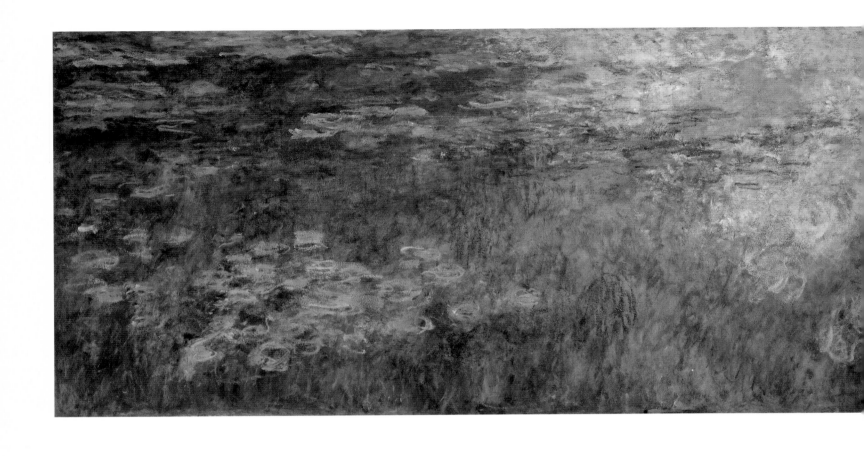

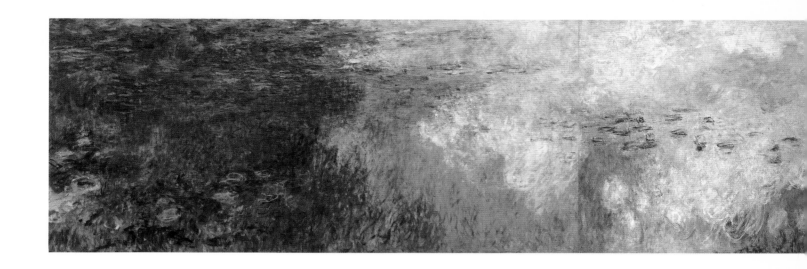

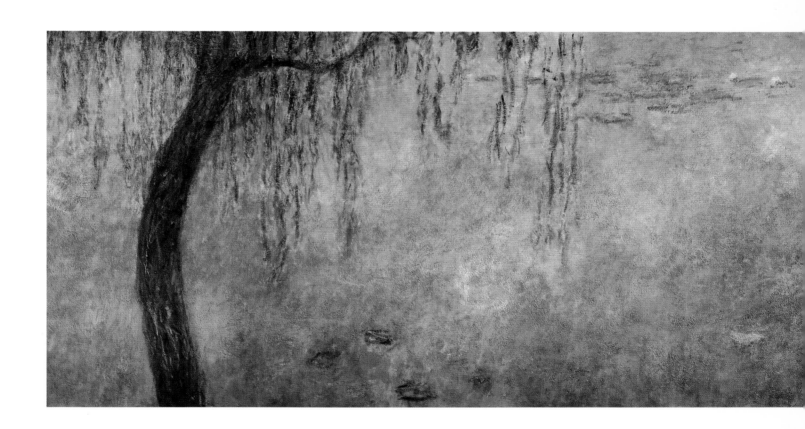

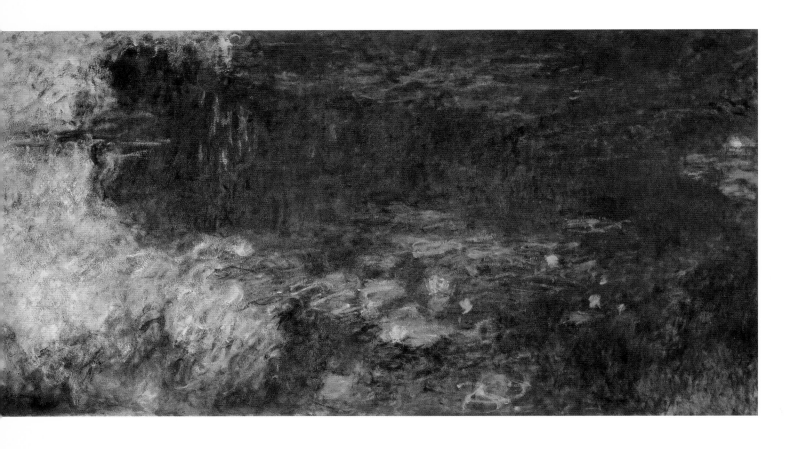

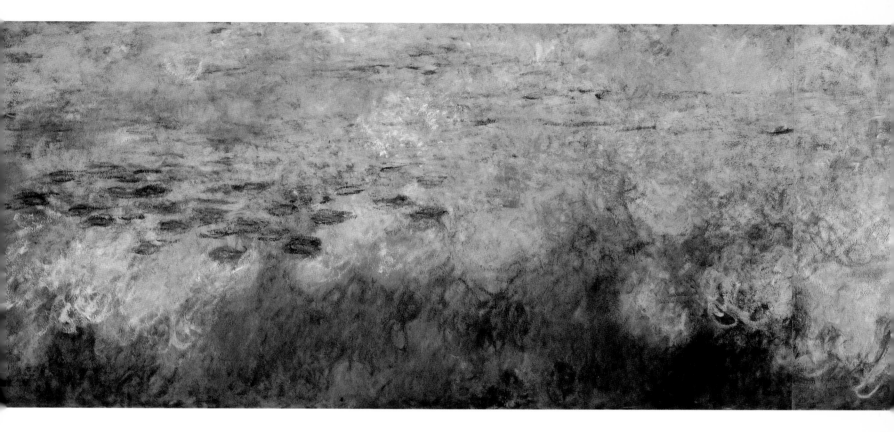

COLORPLATE 114. *Water Lilies*. C. 1920. Triptych; total dimensions: 6'6" × 42' (198.1 × 1280.1 cm).
The Museum of Modern Art, New York; Mrs. Simon Guggenheim Fund.

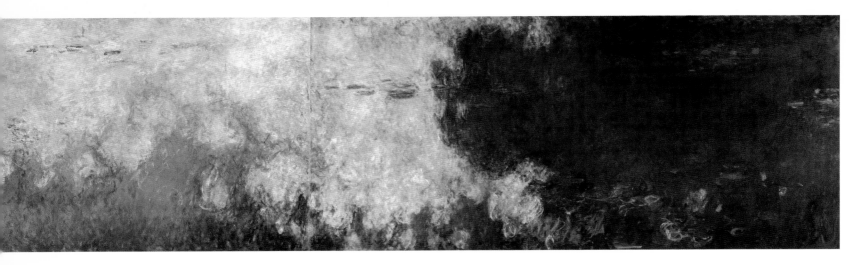

COLORPLATE 115. *The Clouds.* 1922–26. Triptych; total dimensions: 6′5½″ × 41′9″ (197 × 1271 cm). Galerie de l'Orangerie, Musée du Louvre, Paris. Photograph: Musées Nationaux, Paris.

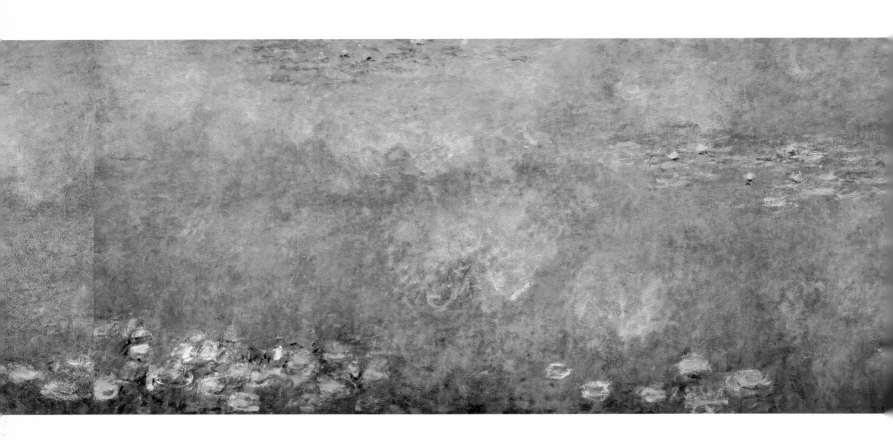

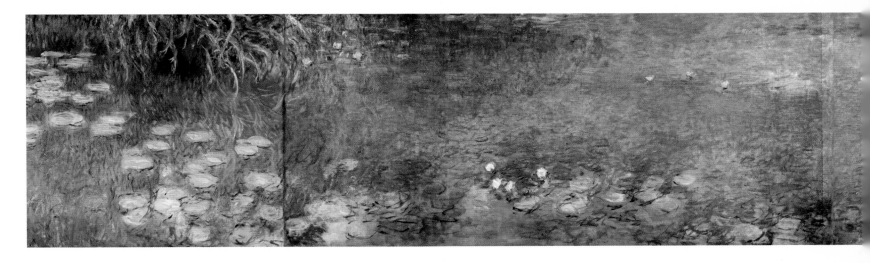

COLORPLATE 116. *Morning.* 1916–26. Four-part mural; total dimensions: 6'5½" × 39'8¾" (197 × 1211 cm).
Galerie de l'Orangerie, Musée du Louvre, Paris. Photograph: Musées Nationaux, Paris.

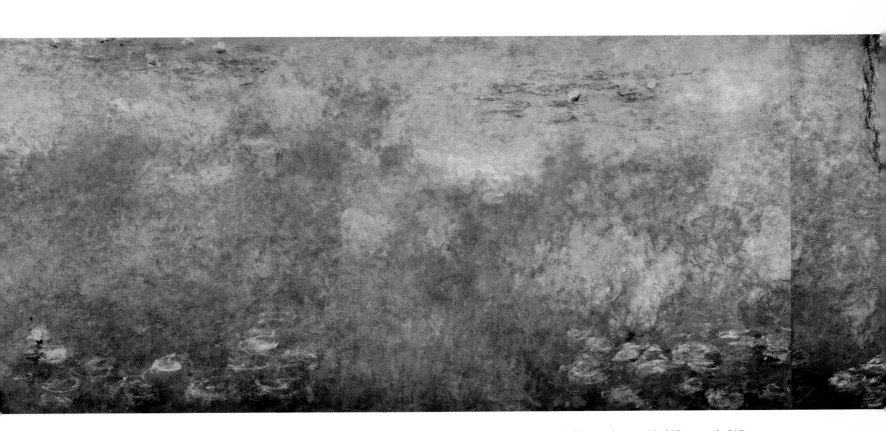

COLORPLATE 117. *The Two Willows.* 1924–26. Four panels; total dimensions: 6'5½" × 55'5⅜"
(197 × 1690 cm). Galerie de l'Orangerie, Musée du Louvre, Paris.
Photograph: Musées Nationaux, Paris.

COLORPLATE 118. *Water Lilies.* Undated. 39⅜ × 118⅛″ (100 × 300 cm).
Musée Marmottan, Paris. Photograph: Georges Routhier, Studio Lourmel, Paris.

COLORPLATE 119. *The Japanese Footbridge*. C. 1912–15. 35 × 36¾″ (88.9 × 93.4 cm).
The Museum of Fine Arts. Houston; John A. and Audrey Jones Beck Collection.

"Have you any doubt about your influence?"

"People are painting with lighter colors than they did in my youth, but painting is still just as bad."

I was already at a loss, but the master rescued me. "Your parcel arouses my curiosity; does it contain little studies of yours that you want to show me? I'll be glad to look at them providing you don't ask me for advice. I give none of it to anyone. I'd be tempted to say: 'Do as I do,' and that would be stupid!"

"Say that it would be asking a good deal!"

We interrupt our walk for a few moments. M. Monet carefully examines each drawing in complete silence. Of the Padua Cathedral he simply says, "How beautiful it must have been!" Then, when the parcel is tied up again, he speaks volubly.

"My studio recollections are brief. I spent perhaps two weeks altogether at Gleyre's; his first critical commentary was, 'How does it happen, Monsieur, that seeing a model with sturdy legs you paint them as they are?! What you're painting is fine, but it's too much like the original. Think about antiquity!' As I listened I said to myself, 'You'll not see me again very often, my good man,' and when the teacher had left I said to my pals Bazille, Alfred Sisley, and a few others, 'What are we doing here?' "

"In short, you broke with the school because it distorted the structural concept and not because it tried to impose one of its own. It is obvious when one looks at your sketches, even the most incomplete ones, that you not only love drawing, but have the gift for it."

"Drawing . . . what do you mean by that? Drawings of black on white? Yes, of course, when I was little I had to do some like everyone else! Since then, a number of reviews have asked me for sketches of my pictures, but I've never liked to separate drawing from color. That's my way of seeing; it's not a theory."

"So that if a follower—since you probably would not use the word *pupil*—were to come to you with a problem about putting together his composition and also giving it the charm of color, what advice would you give him?"

"I'd tell him, 'You must begin by drawing, if that feels safer. You have to do a lot of drawing, as did the masters; that's obvious. For one or more classes out of the weekly six, just draw in charcoal, pencil, anything, and pay particular attention to contours, because you can't be sure you'll keep to them when you start to paint.' "

"Do you attach much importance to the 'chemistry' of painting, to the technical details?"

"Well, I'm a little like you," the master replied with a smile. "I've always done what I saw without worrying too much about the process. I don't say that I have always been right. Some of the things I have painted have not kept well. At first, because of lack of funds, I used a terrible chrome that faded a lot. And then, is the silver white that I use because it covers so well as stable as zinc white, which I have never used? I have always insisted on painting on a white canvas so as to establish my scale of values, whereas Courbet used to say to me, 'Do like me! I prime my canvases in brown; the slightest touch of light creates an effect on them.' Actually, he was wrong. How many of his works have turned quite dark! I was startled by this when I visited the Louvre, whereas Manet's *Olympia* has kept its freshness. Manet was self-demanding; he worked painstakingly; he always wanted his picture to look as though it had been done with no touching up, but often, in the evening, he would scrape off with a palette knife what he had spent the whole day painting. Not everything, perhaps, but the impasto. He kept only the first layer, a truly light and delicate one over which he improvised again. I wasn't able to be so careful. Some of my things were all right when I started, then they went wrong, then improved again as I kept making corrections, but without my

ever having scraped off the first layers; as a result, the canvases on which I did the most work may deteriorate, whereas my successful sketches don't change. I notice, among my works, that those pictures that were successful at the first go are the ones that last best."

How modest are these comments about his canvases! And not one word of praise for the miraculous, airy quality of his painting! This is partly from diffidence but also, and chiefly, because of his preoccupation with the faithful rendering of his own vision. Monet has always compared the works of others and his own with nature and not with other pictures. Renoir said that when he was quite young he commented about a Canaletto he was looking at in the Louvre: "He didn't even paint the reflections of the boats!"

Although he is cultivated, interested in literature, especially in his friend Mirbeau's; although he still reads out loud for pleasure to himself in his room in the evening, nonetheless, as soon as he starts to paint, M. Monet loses all intellectual drive.

"Would you like to see the first studies I did in the studio I gave up?" M. Monet asked me.

We went into a pretty pavilion with a large open room on the second floor. Framed paintings of slender gentlemen in light-colored jackets, ladies in crinolines evoke the Second Empire. Somewhat more recent canvases show young women in boats—fleeting pink nosegays between the greens of the shore and the dark water. The master cuts in.

COLORPLATE 70

"Pay no attention to that; I am not satisfied with it! I just want to show you two pictures composed entirely differently; this one, the earlier one, is a *Picnic* which I did after Manet's. At that time I did what everyone else did; I proceeded bit by bit with studies done from nature which I would then put together in my studio. I am much attached to this piece of work that is so incomplete and mutilated. I owed my rent so I gave it as security to my landlord who rolled it up in his cellar. I was finally able to redeem it. You can see how long it moldered."

Pausing before *Women in the Garden*, he went on: "This is not the same thing. This picture was actually painted from nature, right then and there, something that wasn't done in those days. I had dug a hole in the ground, a sort of ditch, in order to lower my canvas into it progressively as I painted the top of it. I was working in Ville-d'Avray where every once in a while Courbet, who used to come and see me, gave me some advice. One day he said to me: 'How is it, my child, that you are not working?' I replied: 'Can't you see that there isn't any sun?!' 'That doesn't matter; all you have to do is touch up the landscape.' This was a bit much; but perhaps he said it ironically."

COLORPLATE 9

I couldn't help interrupting M. Monet. "Do you think that would have bothered him?"

"Hm, hm! In any event he would have painted something beautiful."

"You seemed like a revolutionary in those days, M. Monet, and indeed you were one! It is said that your method of always and only painting out-of-doors appealed to Manet."

"At first he was shocked. Actually, I had exhibited this picture at a small dealer's on rue Auber when Manet noticed it. He went into his usual restaurant, Tortoni's, and started to make fun of me. 'I've just seen a picture by Monet entitled *Women Out-of-Doors*. Can you imagine? Whoever heard of painting out-of-doors?!' Manet had no idea he was saying this in front of me, because he didn't know me; he had even less idea that he was going to become, for a while, the owner of that canvas that he didn't much like. As a matter of fact, I had sold it to my friend Bazille, who had money and who had given me 2,500 francs for it, 100 a month, which was a good price for it. In 1870, after he was killed, his father went to one of our group shows and there he saw a portrait, a very

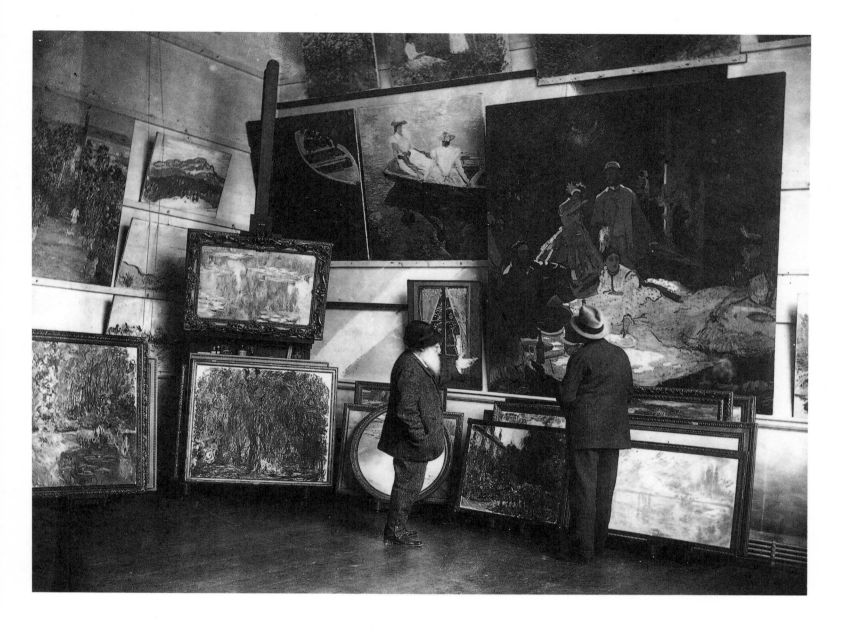

Monet in his studio with the Duke of Trévise in 1920 examining *Luncheon on the Grass* (central section). Photograph: H. Roger-Viollet, Paris.

good likeness, of his son. He asked about it and found out that the painting, by Renoir, belonged to Manet. Manet, who was very sensitive, told him, 'I don't want to sell it to you; I want to give it to you in exchange for a memento of your son, who was my friend.'

"The father replied, 'Alas! I can think of nothing of his I can give you; I cherish even the slightest of his works; but we have at home a large canvas of Monet's which gets in the way; would you accept it?'

"The deal was made and my painting went to Manet's, where it did not remain for long. One day we had a disagreement, he and I, that left us on bad terms (you have no idea how irascible nice old Manet could be). He said to me: 'You have a small study of mine at your place; give it back to me. I'll have that large picture of yours taken back to you, as I don't want anything of yours!'

"I took him at his word, delighted to get my canvas back, which did not prevent me, when we were on speaking terms again, to be the first to say to Manet: 'Let's start the exchange again!'

"'So sorry,' Manet replied; 'in the interim I found a buyer for my study.' And that is how my picture happens to be still at my place. You know that, later, when Manet started painting out-of-doors, he began by sketching the little studio-boat I had at Argenteuil. But I am taking too much time; they are waiting for us; shall we have tea?"

We went up to the house, a light-filled, serene, low building abutting on a wall and looking out over the garden; a typical family house, clev-

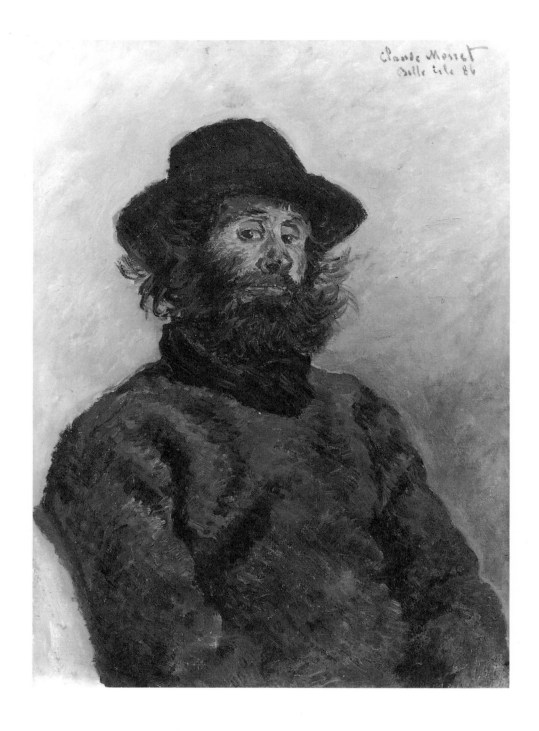

Portrait of Poly, Fisherman at Belle-Île. 1886.
29⅛ × 20⅞″ (74 × 53 cm). Musée
Marmottan, Paris. Photograph: Georges
Routhier, Studio Lourmel, Paris.

erly designed and elegant, our kind of house. It was added to here and
there as the children got married. It was here that the father became a
grandfather, so he doubled the size of the original studio that still serves
as a living room. A second marriage, which took place before Monet set-
tled in Giverny, prolonged his daily comfort and enjoyment until these
last years. Departures and deaths would have emptied the house had it
not been for the unwavering affection and talent of Mme Blanche
Monet.

Entering this studio/living room is tantamount to staying out-of-doors;
nowhere does one feel shut in. The low furniture does not reach above
the chair rail, and the walls, because they are covered with a great many
luminous paintings, become insubstantial. These pictures, even when
only lightly sketched, have so accurate a balance of values that when we
photographed M. Monet in front of them, his silhouette blended into the
atmosphere of one of the landscapes. Fresh flowers in vases here and
there form an additional transition between living quarters and nature
seen through the large bay window. On the wall there are a ghostly,
bluish cathedral, a shimmering Vétheuil, the castle in Dieppe, a beach

on which boats are at rest, a sinuous alley of poplars, the foliage of which forms a tracery in the shape of an S against the sky. These samples of different periods could well be described as an enchanted garden in which flowers of almost every season survive.

Nonetheless, their author states, "There's not much left. Even though I don't want to sell, dealers can be awfully persuasive. For a long time I held on to the best of each 'series' as a memento."

"It can't have been easy to choose."

"Why ever not? It had to be the one the dealers didn't want. Now they want everything. I'm keeping very little. . . ."

"Enough to dazzle me. I notice that beginning at a certain period you stopped putting figures in your landscapes; the only one I see here, standing on this hill with her white parasol, knows she's the last one; she appears to be waving good-bye to us."

COLORPLATE 66

COLORPLATE 67

"You're wrong; look, here is a portrait of the sailor in Dieppe who carried my gear. Since then, it is true, I have done only one portrait, mine, which I gave to Monsieur Clemenceau. I had done several studies of myself which I must have destroyed, except that one."

"How could you bear to give up that kind of luminous and simple composition that included people? It was so innovative."

"Well, I was driven to it for a simple reason: posing bores people."

"Master, critics in the future will put forth every possible explanation except that one; but they will be at an even greater loss to explain your famous 'series'; to make people understand that you composed entire collections of canvases on a single motif. Philosophers will claim that it is philosophy. . . ."

"Whereas it is honesty. When I started, I was just like the others; I thought two canvases were enough—one for a 'gray' day, one for a 'sunny' day. At that time I was painting haystacks that had caught my eye; they formed a magnificent group, right near here. One day I noticed that the light had changed. I said to my daughter-in-law, 'Would you go back to the house, please, and bring me another canvas.' She brought it to me, but very soon the light had again changed. 'One more!' and, 'One more still!' And I worked on each one only until I had achieved the effect I wanted; that's all. That's not very hard to understand.

"Where it became especially difficult was on the Thames; what a succession of aspects! At the Savoy or at St. Thomas's Hospital, from which I looked out, I had up to one hundred canvases under way, all on the same subject. Searching feverishly among those sketches I would choose one that was not too different from what I saw; in spite of that, I would alter it completely. When I had finished working, I would notice as I shuffled my canvases that the one I had overlooked would have suited me best, and I had it right under my hand. How stupid!"

"I beg to differ with you. You are so sensitive to the slightest change of light! Anyway, did nature really present you with an exact pictorial equivalent of a view you had already sketched? Were you really able to work five to ten times on a single canvas, painted from exactly the same vantage point?"

"Certainly—even twenty or thirty times; it was simply that some took longer than others."

"Does this mean, because you handle so many studies simultaneously, that you worked for hours on end?"

"Hours on end! That is, often I would get up at four o'clock in the morning and work until sunset. Many times one is lucky enough to have the same light, as in Holland, when I started painting my tulips. Tulips are beautiful but they are impossible to render. When I saw them I said to myself that they could not be painted. And then, for twelve days running, I had pretty much the same weather; what luck! You don't like fields of tulips; you think they are too uniform? I love them, and when the flowers are in bloom, are picked and piled up all at once on the little

COLORPLATE 72

canals, they form rafts of color, yellow spots on the blue reflection of the sky. . . ."

This was one of the only two occasions when M. Monet spoke passionately. The other time was, when in all humility, I confessed to him that although Cézanne's research interested me, its results often baffled me. Speaking unequivocally, he said, "A great master, believe me! Cézanne! I have fourteen Cézannes in my room!"

Infinitely courteous, skillful in dealing with questions, detached about himself, Monet becomes eloquent only when defending other painters. And so it was that he participated in a discussion about art only when the Louvre did not want to accept Manet's *Olympia*. His intervention won the day.

"Have you visited the new studio?" Mme Blanche Monet asked me. "Monsieur Monet had it built during the war, when he noticed that the one you've come from, near the garage, wouldn't house the large decorations he undertook, the *Water Lilies*."

My insatiable curiosity took over at these words. I know that the eminent critic, M. Vuillard, recently said to my friend, Albert André: "They defy description; they must be seen. They are great water poems."

From what little he had heard about them, the now-aged Renoir had been intrigued. Water in large quantities, he thought; what could that be? Yet Monet knows what he is doing. The timeless magician, Renoir, in his studio in the south of France, where he remained immobilized until his death, regretted being unable to experience that enchantment himself.

I was not as worthy as he of this feast for the eyes, but would I be luckier than he? As I looked at the group formed by the grandfather and Mlle Salerou, his granddaughter, who had sweetly gone to his side, I was filled with impatience, so I hazarded a timid allusion to the master's activity. Under what circumstances had he begun that work?

Germaine Salerou (1873–1968), Monet's youngest stepdaughter.

COLORPLATE 106

COLORPLATE 107

"After the tragedy of my life, and after my illness, I stopped painting. I had done nothing since the exhibition of the Views of Venice at Bernheim's. I had the beginning of a cataract, a threatening veil that, although it did not grow, nonetheless remained. It was my old friend Clemenceau who pulled me through my bereavement. I discussed with him a kind of decoration that I had once wanted to do. He said, 'That's a superb project! You can still do it—do it!' And I did. You'll see it because today is Sunday, the only day when I have free time. Not all the series are finished, not by a long shot. I paint in the daytime and, because I dream about it, I paint even at night. But I don't see my mistakes then. When I arrive in the morning, they leap out at me and I am stricken."

What a fortunate combination: only a Clemenceau could have encouraged a Claude Monet. In the same way, only a creature who was the quintessence of poetry could have inspired him: a faraway lady, a foreigner, an Italian—one who could easily have enchanted Rostand, Verlaine, Musset, all of them! I was told about this bit of telepathy: just as Monet was having doubts about his powers, an unexpected correspondent had specified, unknowingly, the project dear to the artist's heart. She wrote to him, more or less in the following words: "What would you say to an almost circular room, which you would decorate, surrounded by a beautiful horizon of water?" The description went on and contributed, it seems, to breaking down the painter's last, lingering doubts. It was not without some emotion that he later showed the writer of the letter—who had been totally disinterested—the realization of her wish.

Paul Verlaine (1844–1896), symbolist poet.

Alfred de Musset (1810–1857), leading romantic playwright.

The identity of Monet's female correspondent remains an intriguing mystery.

Authentic as the story may be, we can forget it as we enter the studio, for it serves no real purpose; the painting is as it had to be. It is the supreme blossoming of all the flowers in bloom Monet ever painted. In the studio, which is as vast as an empty stage, the artist-turned-laborer moves the heavy-wheeled easels on which are placed, almost level with the floor, long panels. I soon find myself as if in the middle of an en-

chanted pool; not one brushstroke, no matter how rough, is out of tune. Everything there is essential. It is a boundless fairyland created by Monet, just as one might have dreamed it. The cast of characters: reflections of clouds, ripples of water, water lily petals. The subject: the subtle interplay of air and water under the fiery rays of the sun; the earth, which is too gross, is excluded; the shore lies beyond the frames. How was it possible, with so few elements, to fill such large spaces? How was it possible, with so much shimmering, to achieve such delicate harmonies?

"And so, master, after your wonderful life out-of-doors, you have finally come home, closed your eyes, and each of the aspects you had once captured came back when summoned?"

"What a courteous conjecture, but don't you believe it! Even when one knows a little bit about nature it is better not to do anything 'chic.' "

He showed me vast and disconcerting studies done out-of-doors during the past few summers. Skeins of kindred shades that no other eye could have unraveled, odd assortments of diaphanous wool-like substances, enabled the painter to convey gradations of each effect.

"You haven't seen everything yet," he added, and he shifted the fabulous partitions around several times, enclosing me within them. The theme varied; at times it was the bronze tone of a sunset cloud, at others a clear or overcast sky. What an extraordinary skill to be able to apply paint in a whole range of thicknesses, from the lightest, comma-like brushstrokes to coils of impasto to the most stubborn mound of paint! He concluded; "Don't you think that I must have been quite mad to paint all this? Of what possible use could it be?"

"Nonetheless, it does seem to me that the owner of one of your series would not have anything to complain about. It wouldn't require a great deal of imagination to erect on his lawn a spacious pavilion to house

Henri Manuel. Monet standing in front of two *Water Lilies* panels holding his palette. Circa 1924-5.

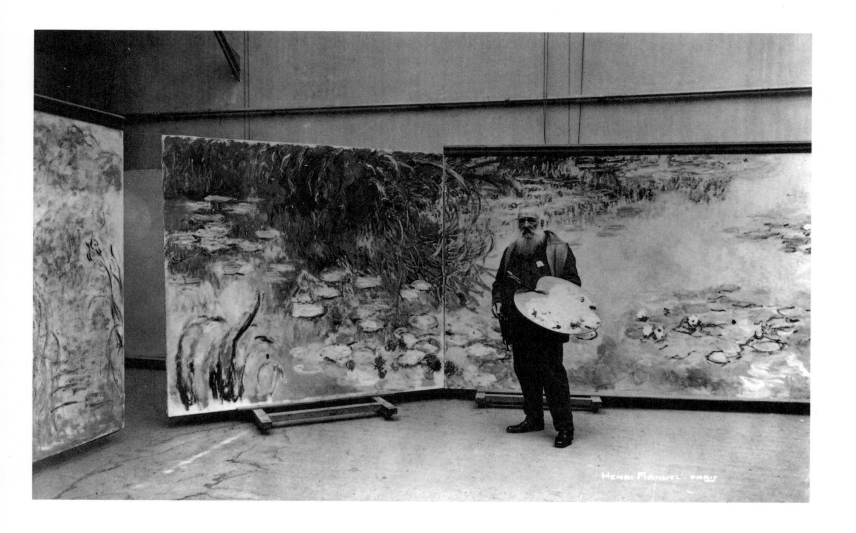

the paintings; above them would be the calm gray of walls, surmounted by some sort of flowered frieze. . . ."

"That's precisely what I had in mind; I'll even show you the first garlands for the frieze; I am using wisteria for it."

"Well then, I don't see what is delaying the installation."

"And I, dear sir, do. I am bequeathing my four best series to the French government, which will do nothing with them!"

"Whatever made you come to such a bold decision?"

"Because I didn't like the idea of all my paintings leaving the country. In spite of dealers' pleas, I am donating these and spelling out my conditions. After all, am I not entitled to do so? I need a site in the center of Paris (otherwise why not the abattoirs?), a circular shape for which I'll make the specifications (otherwise why not a circus?—all that would be lacking would be Monsieur Loyal with his whip). Let's hope we shan't have to end up with a debate in the Chamber of Deputies! The trouble is that for the inauguration I shall be obliged to return at least once to Paris. All that talk and gossip nauseates me; nothing else would force me to go there—nothing."

"Master, a little while ago you spoke about the painter Bazille. Did you know that the Luxembourg, for the fiftieth anniversary of his death, is planning to exhibit his splendid *Family Portrait* which he painted near Montpellier?"

"Bah! What are you telling me! A picture by Bazille! Enough to entice me to Paris!"

To put the final touches on my visit to the amiable misanthrope, I must include a few more details. Although not much time was left us, we could not leave without going up, if only for a second, to the master's room for a quick look at the paintings he had chosen, done by his friends. It looked as though each of them had outdone himself in his honor: Renoir's picture of the multicolored swarm of an Algerian festival was outstanding; the bodies of his bathers shimmered more than ever. Cézanne had constructed terraced suburban plots of ground with smoother, more abstract tones. Next to the Sisley, which seemed alive in this light-filled room, Manet had used in his picture a more transparent white on the boat at Argenteuil.

On the ground floor I did not want to miss the dining room, for here the rarest of Japanese prints, simply framed, placed at carefully studied intervals, with their delightful curves and their half-mourning tonalities, are a collector's delight.

"Look closely at this flower with its petals turned by the wind: is it not Truth itself?" asked the master colorist. "And here, near this Hokusai woman, look at *The Bath*; look at these bodies whose consistency you can feel; they are made of flesh, and yet only their contours convey this. What we Westerners have particularly valued is the bold manner in which subjects are outlined. These people have taught us a different way of composing, no doubt about it."

And thus two new chapters are begun just as our visit comes to a close. It would be interesting to report what Monet thinks of his contemporaries and of the few faithful ones he welcomes with a fatherly kindness; and also to hear him speak about Japan and the discoveries he made during a memorable period!

"If you've enjoyed your visit, you'll have to come back!" Such was his kindly farewell to me, and here I sit in the train on my way back, less at ease than when I came, for then I had foreseen only two possible facets of the master, but now I found myself leaving a many-faceted man, the most enterprising one I have ever seen. His invisible presence seems to animate the car in which I sit jotting down, between jolts, some of his words. It is easy to record them verbatim, for one could no more flesh them out than one could complete one of his sketches. But how to choose? In my haste I feel as though I were taking dictation from sev-

COLORPLATE 115

COLORPLATE 116

COLORPLATE 117

COLORPLATE 121

Monsieur Loyal was a celebrated ringmaster, immortalized in Toulouse-Lautrec's At the Cirque Fernando *(1887), now in The Art Institute of Chicago.*

Hokusai (1760–1849), Japanese artist whose 46 views of Mount Fuji had great influence upon artists of Monet's time.

eral people around me all of whom are speaking simultaneously. But gradually these voices begin to speak in unison, all their features are reduced to a single great face—that of a worker.

What a disappointment is in store for the lazy! Monet's works certainly create the illusion that they have come into being effortlessly; or if need be, one could always assume that his exceptional talent spared him the necessity of conforming to the general rule: hard work. But one neither could nor would assume this, for this rule confers honor upon man. The last words of our conversation were: "When one wants to paint, one must give oneself up to it altogether. I am becoming increasingly self-demanding. When I didn't have enought to live on, I sold the study I was working on as soon as it was finished. Sometimes it was a good one, sometimes it was not. When I no longer had to sell, I was able to work. Now I think I can be as self-demanding as I want."

M. Monet may not wish to give lessons, but in spite of himself he gives the best possible one: his example.

FRANÇOIS THIÉBAULT-SISSON

LE TEMPS

"About Claude Monet"

December 29, 1926

In speaking about Claude Monet right after his death, we have only been able to relate a sketch of his life, hardly sufficient to link all the stages of such a full and active career. We would have liked it to be much more ample and elevated in tone, enriched by the various details that shed light on character and establish the essential traits of disposition and temperament. Today, let us attempt to complete this sketch and enliven it with several anecdotes collected first-hand from the artist or from one of his dearest friends, M. Georges Clemenceau. In this way, the man will be fully revealed and we will understand the painter better.

It is generally unknown that Monet was a soldier in his youth. It was the year 1860. For eighteen months, the artist had been enjoying the life of Paris. However, out of principle and with distaste for the art forms, so far removed from reality, that were rampant during the Second Empire, he had refused to conform to the practices observed by the artists who enjoyed the public's favor. One of his father's friends was acquainted with a painter of genre scenes and little, minutely detailed portraits of women, whose reputation was at least equal to that of Alfred Stevens, the baron, and of all the amiable artists of the time. His name was Toulmouche. Asked to keep the family informed about the inclinations of the young prodigy from Le Havre and to send them periodical bulletins about his progress, the good Toulmouche had accepted. However, he only saw Claude Monet once, the day following his arrival in Paris. From the moment Claude Monet was introduced into the artist's studio, the sight of the paintings caused him to be immediately horrified by the man who was to advise, and if need be, censure him. "Can you imagine me being corrected by Toulmouche and accepting his guidance?" he asked me forty years later. "I never set foot in his lair again, and right away I was scolded by my father. He gave me formal notice to leave Paris and return to Le Havre, failing which he would cut

Alfred Stevens (1828–1906), Belgian painter and student of Ingres who turned to realism, became Manet's friend, and ultimately found success as a modern-life genre painter.

Apparently a reference to Baron Henri Leys (1815–1869), successful Belgian history painter.

off my allowance. This is what he did, for I obstinately refused to leave. How did I survive from that day on, and how did I avoid starving to death?—painting the portraits of workmen for 100 sous or 10 francs, sometimes for even 50 francs, including the frame, and drawing some illustrations. I did a bit of everything, and that helped me through the hard years that followed. But I had picked a bad time to quarrel openly with the author of my days. At the draft lottery I drew a bad number. Since my family refused to pay for a substitute, I was asked to go to Algiers to join a regiment of African infantrymen. This appealed to my sense of adventure. In any case, the uniform was elegant, which appealed to me even more, and the thought of trotting along on a lively little horse beneath the African sun, with foot soldiers kicking pebbles along the road as they labored to carry their packs, did not seem at all disagreeable to me.

But I had never mounted a horse before, and the hours of training seemed so tiresome. It seemed so wearisome to be confined to the barracks or camp until such time as I became a skilled cavalier that, finally, one fine day, I just exploded. Noticing one of the pack mules straying in the courtyard, I caught the animal by surprise, heaved myself quickly onto its back and urged it into a quick gallop by kicking it hard in the sides with my heels. With a bit of guidance from the reins, the mule thundered out of the camp and we escaped through the olive groves of Sidi-Moustapha. I wanted to lead my Bucephalus to easier terrain, but it was all in vain. The animal had taken the bit between its teeth, and it was all I could do to maintain my balance and avoid breaking my head against the low branches under which the distracted beast hurled itself. I eventually ran out of breath and fell fainting to the ground. Unburdened of my weight, the mule stopped of its own accord and wandered lazily back to the barracks. A search party found me that evening, unconscious and in a most pitiful state. My uniform was in shreds and my entire body was covered with cuts and bruises. I awoke confined to a cell by orders of the military police and accused of desertion and destruction of military property. The next day, I was taken to prison and I again lost consciousness. I was spared the military tribunal and taken to the hospital, where I was diagnosed as having typhoid fever. After three weeks, the fever finally abated, leaving me in an extremely weakened state, which caused my parents to have pity on me. When, two months later, I was sent home to rest and recover, I was greeted like the prodigal son, with much tenderness, and this time my father paid for a substitute. In my happiness at never again having to see a country that had left me with so many awful memories (I had not even thought of painting for an instant), I promised to do as everyone wished and returned to Paris to work in Gleyre's studio. You know how little time I remained there. This new infraction set me at odds with my father once again, and I returned to the same makeshift life I had known before my military service. But I was already exhibiting paintings at the Salons in the spring. Some collectors took notice of me and I began to sell. I managed to survive fairly well from these profits as well as from the small sums of money that my mother sent me in secret.

It was during this time, around the year 1863, that M. Georges Clemenceau became acquainted with the painter. "When I met him for the first time, it was in the Latin Quarter," the illustrious octogenarian informed me. "He could be seen there from time to time, hunting down 100 sous to buy paints. He was almost always accompanied by Pelloquet, an occasional journalist, bright but nonchalant, who made fun of everything and everyone, including himself, with a biting and delicious irreverence. In his spare time, Pelloquet dealt with art criticism, vigorously supporting the young, a fact that had endeared him to Claude Monet. How was contact established between myself and the painter? I can no longer recall. We caught a fleeting glimpse of one another and

Théodore Pelloquet (d. 1867), wrote a guide to the Louvre (1856) and a dictionary of contemporary artists (1858).

The Journalist, Théodore Pelloquet. Circa 1860. 12⅝ × 9⁷/₁₆″ (32 × 24 cm). Black pencil on grey paper. Musée Marmottan, Paris. Photograph: Georges Routhier, Studio Lourmel, Paris.

did not see each other again for a quarter of a century. We were far too self-centered and preoccupied with our own interests to become attached to one another. To tell the truth, we had nothing at all in common. Only politics mattered to me, and Monet lived solely for art. We did not hit it off, and this lasted until I founded *La Justice*. Until then, I preserved the memory of him as a spirited character, with large fiery eyes, a curved nose that looked slightly arabic, and an unkempt black beard."

"From 1864 to 1870, no painter sold as much as I did in the suburbs of Paris," Claude Monet told us one day as we strolled along the Epte river in the shady garden he had filled with water lilies. "It was not because the cost of living was so high. For 6 or 8 hundred francs per year, one could rent peasant cottages between Versailles and St.-Germain, surrounded by pretty gardens and more graceful in their rusticity than the costliest villas of the rich bourgeois. But one had to stay fed, and I was a real gourmet. I also liked to invite friends like Pissarro, Sisley, and Renoir over for a good dinner. So as cheap as it was to buy cutlets, Saint-Emilion, Vouvray, Beaune, and Chambertin, and as great an amount of credit as I was given by the grocer and the baker, the time would eventually arrive when the bills had to be paid. When we could not pay them, we would be forced to vacate, bringing along only what was absolutely

necessary, and leaving behind the furniture, cooking utensils and all the paintings which had not yet been sold. This is how I lost over 200 paintings, both signed and unsigned, in a six-year period. They were sold cheaply by my creditors in Ville-d'Avray, Gauches, Louveciennes or Bougival and other places as well. What has become of them? Are they being used to adorn a wine merchant's hutch, the back room of a grocery store, or a meat market? Or have they fallen into the hands of people with taste? From the day when Boussod and Valadon joined Durand-Ruel to sell my possessions, several dealers became aware of this and set out to search the region for these lost children. I only know of one man who purchased a certain number of my paintings. It was the brother of van Gogh, the painter. I learned of this because he brought them to me to sign. Cézanne was even more fortunate. He would always leave a large number of paintings with which he was not entirely satisfied at various inns near the banks of the Seine, between Vétheuil and Vernon, where he would spend his summers. One day I revealed this fact to an astute merchant. The next day he traveled through the region by car and picked up, for very low prices, all that the good Cézanne, whose humility was unequaled by any painter, had called his "little daubs." And this proved to be the start of a very nice fortune.

"From 1868 to 1873, when the excellent Durand-Ruel was tagging behind the impressionists, we all lived at the expense of Caillebotte, our friend and colleague. The son of a rich family with a yearly income of 6 or 8 thousand pounds, the good old boy never asked any of us for money. On the contrary, at crucial moments, he would always find the means with which to buy one or sometimes two of our paintings, thus saving us from hunger and our creditors. The collection that he donated to the Luxembourg Museum and which was almost refused by the state—they accepted only a fraction—was composed of the purchases he made out of compassion. How many millions it would be worth today! When he had no money, he would set out to sell our paintings for us. The collectors with which he dealt, who were almost all family relations, were not always willing to cooperate. He would therefore think of a thousand ways to appeal to their vulnerabilities, encouraging them to think of the purchase of our paintings as an investment which would one

Monet's Garden at Argenteuil. 1872. 24 × 28½″ (61 × 72.4 cm). The Art Institute of Chicago; Mr. and Mrs. Martin A. Ryerson Collection.

day yield some very nice profits. They were bought, but how? I met, through an intermediary, a maker of pots and pans who always wanted to pay me with merchandise, just like Molière's Harpagon. I had to get angry and red in the face in order that at least half of the 100 or 150 francs (which I asked for my paintings after a great deal of haggling) be given to me in cash.

"Caillebotte had such a heart of gold, and how much we have mourned him! If he had lived on, instead of dying prematurely at the age of 45 following a series of chills, he would have benefited from the same successes as us, for he was very talented. He created still lifes that are worthy of the greatest successes of Manet and Renoir, and he painted remarkable portraits of women. He had as much talent as he had consideration, and when we lost him, he had only begun his career."

This is how Claude Monet overflowed with lively and picturesque memories from every period of his life. . . .

FRANÇOIS THIÉBAULT-SISSON

LE TEMPS

"About Claude Monet"

January 8, 1927

"There are some painters," Claude Monet said to me, "who experience a morbid satisfaction in doing that which goes against nature. When such a habit is developed at an early age, one is apt to think that this manner of seeing things is the result of some sort of defect or the consequence of bad eyesight. But when they began by reproducing nature as it is, when, for a significant part of their careers, they have interpreted it in the clarity of the light, in the rich brilliance of tones, and then all of a sudden, without apparent reason, we see them turn their backs on reality, one can not help but be filled with an inexpressible sadness.

"You knew Ribot. You know that before working in darkness he had produced charming decorative paintings in the style of the eighteenth century, and following these years of preparation, he had an initial personal period characterized by deliciously light studies of the nude and the figure. They probably did not sell well. The fact is that having quite accidently come to know a lively success with kitchen interiors where the cook's helpers, dressed in white, emerged from restrained light and curious penumbral effects, he was thus diverted, in the span of a few years, towards darkness and ended up by painting nothing but motifs in which the flesh stood out in white against inky black backgrounds. I had always wondered if he had come to this following a weakening of his eyesight. When I settled in Argenteuil, I was surprised to discover that his technique was the result of a preconceived will, engendered by an immoderate passion for the effects of contrast.

"The house where I lived had formerly been the residence of Ribot. The studio, which was only a rather large annex with large windows through which light should have flooded, had been converted by him into an obscure dungeon. He had covered all the windows with black paper, and the outside light could only enter through a round hole the diameter of an ordinary eyeglass cut out of the paper covering one of the windowpanes. This procedure must have been inspired by the study

Théodule Ribot (1823–1891), realist still-life and genre painter.

of certain portraits by Rembrandt, where only the head is illuminated, while the rest is lost either in opaque darkness or at least in impenetrable shadow.

"Do I need to tell you that my first concern was to rid the windows of this screen of black paper? It is in this studio, from which I could see everything that passed along the Seine at a distance of 40 or 50 paces, that I produced my first nautical scenes of Argenteuil, until the day when a lucrative sale filled my pocket with enough money to buy myself a barge and have it outfitted with a cabin made of boards. There was just enough room to set up my easel. What delightful hours I spent with Manet on this little boat! He painted my portrait there. I painted one of his wife and one of him there. Those lovely moments, with all their illusions, their enthusiasm and their fervor, should never have ended."

COLORPLATE 37

Argenteuil had some drawbacks for a painter. With the exception of the Seine, there was not one motif worthy of interest. As for the Seine itself, it was only during the summer that it was lively, animated, and filled with the interplay of various effects of the light. What could one do the rest of the time? Monet took the road to Paris to look for suitable themes. This was not only the period of the astounding *Gare Saint-Lazare* series, but also of vistas of an incomparable nobility, amongst which we find the *Jardin de L'Infante* in front of the Louvre, the Panthéon dome in profile against the grays of the sky. Certainly, the views of Paris by Pissarro and Renoir are of an undeniable sensitivity and always full of charm, but one would be looking in vain for the instinct for grandeur which characterizes Claude Monet's views of Paris. The difficulty that drives others away attracts him. He flings himself impetuously and impulsively at the obstacle, removes it, and produces a masterpiece of style as well as a sudden emergence of reality.

COLORPLATE 12

Was it the end of his stay in Argenteuil or the beginning of the time he spent in Vétheuil that served as the setting for an anecdote that demonstrates with what ardor and determination he did not allow himself to be stopped by any hardship, whether financial or technical, as he undertook the interpretation of nature? When he recounted it to me seven or eight years ago, the artist was incapable of placing it within a precise frame of time.

"It was," he told me, "around the period when I felt the need to enlarge my field of observation and refresh my vision before new sights, to detach myself momentarily from the region where I lived, and to undertake excursions for weeks at a time to Normandy, Brittany, and elsewhere. It was a period of relaxation and rejuvenation for me.

"I left without a preconceived itinerary, without a program outlined in advance. I would stop wherever I found nature inviting. Inspiring motifs could be chanced upon. A sky at its most elegant or most brutal, or a rare effect of the light, determined the course of my work. It is thus that, having stopped for a day at Vernon, I discovered the curious silhouette of a church, and I undertook to paint it. It was the beginning of summer, during a period that was still a bit brisk. Fresh foggy mornings were followed by sudden bursts of sunlight, whose hot rays could only slowly dissolve the mists surrounding every crevice of the edifice and covering the golden stones with an ideally vaporous envelope. This observation was the point of departure of my *Cathedrals* series. I told myself that it would be interesting to study the same motif at different times of day and to discover the effects of the light which changed the appearance and coloration of the building, from hour to hour, in such a subtle manner. At the time, I did not follow up on the idea, but it germinated little by little in my brain. It was much later, ten or twelve years afterwards, that, having arrived in Giverny following a ten-year stay in Vétheuil and having noticed iridescent colors in the morning fog, pierced by the first luminous rays, I began my series of *Haystacks* with the same sense of observation. The series of *Cathedrals* followed after a five or six

COLORPLATE 85

COLORPLATE 96

year interval. It is thus that, without seeking to do so, one discovers newness, and this is much better. Preconceived theories are the misfortune of painting and painters. Nature is the most discerning guide, if one submits oneself completely to it, but when it disagrees with you, all is finished. One cannot fight nature."

And Monet told me how one day, finding himself in Étretat during the equinox, he had been determined to reproduce every detail of a storm. After finding out exactly how far up the waves could reach, he planted his easel on a ledge of the cliff, high enough to avoid being submerged. As a further precaution, he anchored his easel with strong ropes and attached his canvas securely to the easel. He began to paint. The sketch was already anticipating something marvelous when a deluge of water fell upon him from the sky. At the same time, the storm became doubly violent. Stronger and stronger waves rose in furious spirals, drawing imperceptibly closer to the indifferent artist. Monet was working furiously. All of a sudden, an enormous wall of water tore him from his stool. Submerged and without air, he was about to be swept out to sea when a sudden inspiration caused him to drop his palette and paint brush and seize the rope that held his easel. This did not keep him from being tossed about like an empty barrel, and he would have dined with Pluto had chance not brought two fishermen to his rescue.

This unfortunate adventure made him lose the taste for observing the equinox storms too closely, and when he attempted to depict the capricious waves once again, it was during calm weather. His series of the *Rocks at Belle-Île,* where waters crash against the cliffs in some places, and slip slyly into coves to form dangerous whirlpools in others, was painted during July and August, when it was so hot that the artist worked in duck pants and a shirt at the foot of the rocks of Port-Goulphar. This place is incomparably majestic, seen as a whole, yet it is little known among tourists. I do not know if there is even a hotel there today. Then, there was only a tiny inn where customs officers came to "drain a few glasses" both in the morning and the evening and where lost hikers could find a place for the night after a comfortable and simple dinner.

Monet had settled there for the duration of his visit. One lovely evening, after an exhausting day, he climbed the short, steep path leading

Rocks at Belle-Île. 1886. 25½ × 31½″ (64.8 × 80 cm). The Art Institute of Chicago; Gift of Mr. and Mrs. Chauncey P. Borland.

from the bottom of the cove to the top of the cliff and returned to the inn with his things on his back. All the tables were occupied. Glimpsing an empty place across from one of the diners, the artist sat down. The diner was as bearded as he was, with a serious, almost sullen demeanor. Monet would not have spoken if the man across from him had not broken the ice and initiated a conversation about painting. After a while, Monet introduced himself. "But I know you," replied the stranger, "I have even drawn my sword for you at the *Justice*." "Clemenceau's newspaper!" cried out the surprised painter. "Well then, you must be Gustave Geffroy." "Exactly!" And the two dinner companions cordially shook hands.

This meeting would not only lead to a solid and devoted friendship between the artist and the critic, but it renewed the broken ties between M. Georges Clemenceau and Monet, and the two men, who had previously regarded one another with disdain and indifference back in the Latin Quarter, now have a great fondness for one another. These magnificent fighters understood and valued one another. Their war made the bond between them even stronger, and when the politician retired, sickened by the ingratitude of the public, their associations became increasingly frequent. Whenever M. Clemenceau stayed in Paris, from autumn to the start of summer, not a month would go by without him rushing to Giverny on Sundays. In the dining room that Mr. Monet had painted lemon yellow with blue trimmings, the two men dined in the company of the painter's daughter-in-law and his son, Michel. Politics never entered into their conversations. Art, for which M. Clemenceau had slowly developed a taste during his days as a journalist, occupied all their time. Strolling together along the garden paths or along the paths leading to the park of water lilies when the weather permitted, the friends chatted about the current artists, exchanging their ideas. Their discussions were spiced with occasional disagreements, since both could be quite caustic—though the discussions were always resolved with smiles—and so it followed that one died in the arms of the other.

"I knew he was fading," M. Clemenceau said to me, "and I came every Sunday to distract him from his pain as much as possible. To tell the truth, he did not suffer very much. There were some moments of crisis when Monet suspected that he was ill, but he did not want to stay in

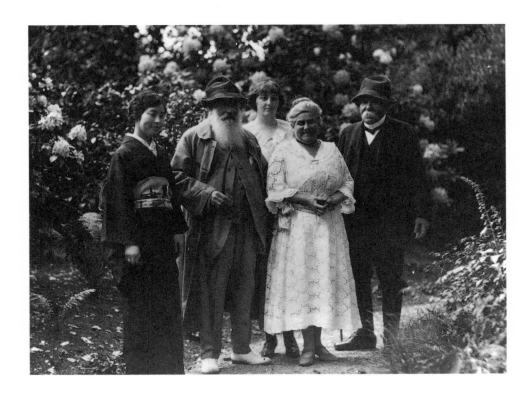

Mrs. Kuroki, Monet, Lily Butler, Blanche Hoschedé-Monet and Clemenceau in the garden near the lily pond in 1921. The photograph was taken by Mr. Kuroki, a collector of Monet's paintings.

bed. Fifteen days before he died, we were still dining together at the table. He had spoken to me about his garden. He had told me that he had just received an entire stock of lily bulbs from Japan, the flower he loved best of all, and that he was waiting for two or three cases of very expensive seeds that would produce beautifully colored blossoms. 'You will see all of this in the spring,' he told me, 'I will no longer be here.' But one could tell that he did not really believe it, and he was really hoping to be there in May to rejoice at the spectacle. But he began to weaken more rapidly. He was confined to his bed. On the day of his death, feeling his breathing become more and more labored, I took his hand. 'Are you suffering?' I asked him. 'No,' he replied, in a barely audible voice. A few minutes later, he gasped very feebly, and that was all."

HENRY VIDAL

FRANCE-MARSEILLE

"Remembering Claude Monet"

February 19, 1947

Henry Vidal (1895–1959), Parisian-born painter and architect.

Twenty years ago he died, surrounded by these flowers. He had just finished that forever famous "suite" of water lilies.

One morning in Paris we heard the news, and we also heard that the painter had arranged it so that hardly anyone knew the date of his funeral. He wanted to leave the world all alone, and without a good-bye, on a foggy morning. With his servants, the town mayor, and the pall-bearers, we were not even twelve, that morning in his Giverny studio.

The Normandy countryside wore the dress that its painter would have wished: those immobile pink, mauve, and golden specks in the river waters which became his palette; that mysterious pink, mauve, and gold of the unobtrusive poplars and the hazily outlined hills were all reflected on his palette. Normandy was a Monet. . . .

On a table in his studio lay the last books the painter had thumbed through, because the "coarse peasant," the "wildman" read the poets: Théophile Gautier and Baudelaire. A book of poems by Baudelaire was opened to "The Stranger," at the page which says:

> Tell me, enigmatical man, whom do you love
> best, your father, your mother, your sister, or
> your brother?
> I have neither father, nor mother, nor sister,
> nor brother.
> Your friends?
> Now you use a word whose meaning I have
> never known.
> (. . .)
> Then what do you love, extraordinary stranger?
> I love the clouds . . . the clouds that pass . . . up
> there . . . the wonderful clouds!

A black cloth with silver borders was draped over his coffin; some-one entered and abruptly tore off this funereal garb while exclaiming, "No! Not that! Not that!" That someone, in whose eye a tear was form-

Théophile Gautier (1811–1872), romantic novelist and art critic disposed against history painting, was editor of L'Artiste. *Baudelaire dedicated his controversial* Flowers of Evil *to him.*

ing for perhaps the first time ever, that someone was Clemenceau, his friend, the only friend the painter had.

He tore down an old cretonne curtain, a colorful print with periwinkles, forget-me-nots, and hydrangea, a curtain with subdued colors—the colors of Monet's skies—and he redraped the coffin with it.

It was beneath this old piece of finery that the splendid painter, who had stolen its secret from the pearl, was put to rest in Giverny's cemetery.

GEORGES CLEMENCEAU

CLAUDE MONET

1929

The *Water Lilies* panels show him desperately reaching to achieve the impossible. Volleys of luminous transparencies leap from his pulsing hand and bring forth new flaming radiances with loaded pigments. In the way his brushes attack the canvas there is no less genius than in the mixtures of his multicolored palette, with which Monet—in a single, determined gesture—suddenly captures the luminous dewdrops which he offers as alms to the elements that did not take care to preserve them themselves. From close up, the canvas appears to be the prey of a bacchanal of incongruous colors; from the proper distance, these arrange themselves, fall in line, and combine to become a delicate construction of interpretative shapes within the precise and certain luminous order. We will discuss this phenomenon further later on.

One day I told Monet, "It is humiliating for me. We see things completely differently. I open my eyes and I see shapes and nuances of color, which, until proven otherwise, I take to be the transitory aspects of things as they are. My eye stops at the reflecting surface and goes no farther. It is different with you. The steel ray of your vision pierces the shell of appearances and you penetrate to their deeper substance in order to break that down into luminous media, thence to reconstruct the substance with your painter's brush. Subtly, you recreate the effect of sensations upon our retinas in very nearly all its vigor. When I look at a tree, I see only a tree, but you, you look through half-closed eyes and think, 'How many shades of how many colors are there within the nuances of light in this simple tree trunk?' Then you set about breaking down those values in order to rebuild and develop the ultimate harmony of the whole—and all for us. And you torment yourself, seeking that keen analysis that will allow you to approximate the interpretative synthesis best. And you doubt yourself, you are unwilling to understand that you are hurtling like a missile toward the infinite, and that you must be satisfied to come only close to a goal that you will never achieve completely."

"You cannot know," replied Monet, "how close you are to the truth. What you describe is the obsession, the joy, the torment of my days. To the point that, one day, when I was at the deathbed of a lady who had been, and still was, very dear to me, I found myself staring at the tragic countenance, automatically trying to identify the sequence, the proportions of light and shade in the colors that death had imposed on the immobile face. Shades of blue, yellow, gray, and I don't know what. That's

COLORPLATE 48

350

what I had become. It would have been perfectly natural to have wanted to portray the last sight of one who was to leave us forever. But even before the thought occurred to memorize the face that meant so much to me, my first involuntary reflex was to tremble at the shock of the colors. In spite of myself, my reflexes drew me into the unconscious operation that is but the daily order of my life. Pity me, my friend."

Monet's eye was nothing less than the whole man. A felicitous chart of the most delicate retinal sensibilities that ordered all the sensory responses to the plays of supreme harmony, wherein we find an interpretation of universal correspondances. This phenomenon seems to be the prime quality of all the master painters. What strikes us in Monet is that all the movements of life came to subordinate themselves to it.

* * *

We have a self-portrait of 1884[1] (40 years old), which reveals the man in all the dazzling force of his simplicity. Nothing could be less conventional, less contrived, less "stylized" than this image of the worker at work, intent upon developing the personal sensations that he seeks to express. Since, for him, the world is correctly interpreted only in the final manifestation of light waves, he cannot abandon the consciousness that dictates what he makes when he places himself at the heart of the drama of interpretation. His simplicity manifest in the determination of his gaze, the good "seer," serene and sure, stands in wait of a vision of what lies beyond. This vision transports all his being, imbued with a holy flame, toward the conquest of a world passionate with light. The creases of his brow proclaim the soaring of an entire life lived without faltering. No gesture is indicated: the man is completely self-possessed, on the

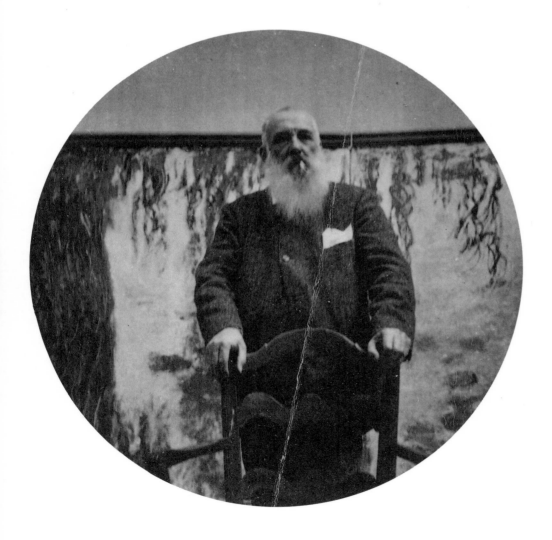

Monet in the water lilies studio, Giverny, around 1917. Photo collection, Durand-Ruel, Paris.

verge of action. He has seen, he has understood, he has decided, he is on his way toward a final destination.

<p style="text-align:center">* * *</p>

Before the *Water Lilies*, he had done three other self-portraits (in 1917); he was always reluctant to speak of them, perhaps because in them he saw the highest expressions of his final vision, and believed that in the course of what remained of his life, he would be unable to surpass them. Two of these paintings showed his face fully lit, emerging from beneath a big straw hat. When he showed me them, it amused him to denigrate them:

"I could do better than these," he exclaimed disdainfully. "But I won't be granted the time."

I foresaw—all too clearly—what was to come. He had, some time previously, acquired the dreadful habit of slashing with his scraper, kicking to tatters any piece that did not satisfy him. There are some roughly sketched panels in his studio that display the wounds he inflicted upon them in his fits of rage, rages in which he berated himself mercilessly.

I cannot speak coolly of the last portrait (the one in the Louvre), so accurately does it portray the ultimate state of Monet's soul, blossoming in anticipation of the ultimate triumph—before he was tragically stricken with the fearsome threat of blindness. There is no question, for those who knew Monet's profound life, his intense terror of ultimate failure, and his explosions of joy when he felt he had overcome a problem: this portrait is his inner consecration of the artistic impulse that was to come to soaring fruition in the *Water Lilies*. The two portraits that were destroyed should be perceived primarily as preparations, albeit advanced ones, for this triumphal piece. Here victory is assured, even before the battle. It is the fanfare—in advance—of the soldier who wins the day.

COLORPLATE 110

The sturdiness of this brow that the catapults of the "Philistines" could not disturb tells all the tragedy of his glorious life. Between the broad, high temples, his cranial energies have left the mark of his great struggle toward the Ideal. It is the site of Command, the imperious seat of Idea, of Authority. The eyes, half-closed, the better to savor the inner dream. The nostrils quivering, his throat alive with an irrepressible explosion, the master-laborer has just discovered in his deepest self the clear perception of an ultimate achievement, foreshadowed even in the nimbus of his glinting, white, flowing beard, the *labarum* of Charlemagne, emperor of a new world.

<p style="text-align:center">* * *</p>

The historical interest of this painting is that it shows us a man who has realized his dream in a storm of happy passion. All the radiance of labor triumphant is written in this countenance in the grips of a dazzling inner vision; Monet seems, finally, to have routed the terror of a success less than the one he sought. And destiny permitted us to receive this triumphal radiance in the highest, most luminous exaltation ever to come from Monet's brush.

Monet had been possessed by the idea for the *Water Lilies* for some time. Every morning, he spent hours in silence on the banks of his pond, enchanted as clouds and patches of blue sky passed in procession over his garden of water and of fire. With a burning intensity, he examined the outlines, the combinations, the degree of penetration in the turbulence of the flaming light. That which he had conquered with personal assimilation as he pursued a more comprehensive interpretation he now sought to fix by determining the barely perceptible aspects of the inner light of momentary things, that light that radiates endlessly into the universe.

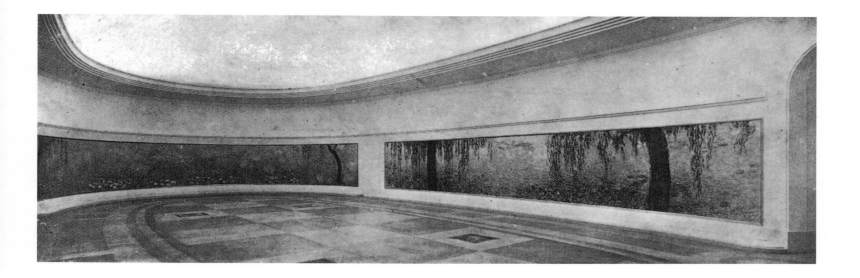

From this magnificent endeavor—to which his moving studies bear witness—the *Water Lilies* now in the Tuileries emerged. Monet only finally resolved to undertake the adventure of the panels after a long period of contemplating them, criticizing them, confronting them in a thousand different ways in his "water garden." He began by having his large studio built (1916). When he gave the word, it meant he had taken his decision, and for that decision to be taken, the painter had not only to overcome the objections of his severest critic, but to feel the touchstone of execution for one last time.

Many canvases covered with water lilies preceded the *Water Mirrors* series, which was to reach its full greatness in the "winner-takes-all" of the Tuileries. In the end, the present panels reveal a far greater accomplishment than do the first attempts that saw the light of day in the large atelier. There were some very beautiful ones, some more detailed, but unfortunately they were destroyed as he lost confidence in his early works. It was inevitable that occasionally an effect would elude him to some degree. Since in friendship all is permitted, there were times when I presumptuously hazarded an opinion. Sometimes I received a grunt in reply; this meant: "We shall see." Other times, his only reply was silence. Nevertheless, from one visit to the next, I observed that certain labored effects—where the brush had proved recalcitrant—had become wonderfully "aerated".

For a long time, one criticism that I never dared voice concerned the clouds, parts of which seemed to be heavy to me. One day—surprise!—an explosion of clouds that were but weightless vapors. No speeches. Then I saw whimsical wisps of clouds unraveled little by little by the winds. Monet's way of looking at things was so intense that he only grudgingly admitted the justice of the criticisms of others. Yet, he himself constantly reconsidered, corrected, and refined his text. Refining his scruples, did he not let vaguely formed animal shapes loose among his clouds, like those Hamlet conjured up before Polonius's frightened gaze? Conscientiousness can go no further.

Far from succumbing to the seduction of his first impulses, Monet ceaselessly reproved his original inspirations, always finding in them a pretext for damning his alleged inadequacies. He was never slow to berate himself violently, relentlessly, swearing that his life was a failure and that there was nothing for him to do but shred all his paintings before he died. Some first-rate studies went under in these fits of rage. Many, now highly esteemed by his public, were saved, happily, thanks to Mme Monet's efforts. As I mentioned earlier, two very fine self-portraits in full sunlight perished in a single unfortunate day. It was luck that saved the one in the Louvre. He was railing evilly against this matchless piece one

Claude Monet. Orangerie installation view. Photograph: From *L'Architecture*, June 15, 1927.

COLORPLATE 114

COLORPLATE 115

day; as I was leaving, he went to get it and threw it in my car. "Take it away," he said roughly, "and never mention it to me again."

It was almost as if he were trying to save it from the madness of one of his summary executions. And when I told him that the day the panels would be inaugurated we would go arm-in-arm into the Louvre to see this painting:

"If we have to wait until then," he retorted, "then it's goodbye forever to this painting."

Alas! That happy visit was not to be: he refused to deliver the *Water Lilies* before his death. And so we are left with two portraits by his hand, executed at two dates that correspond to the painter's leaps toward the zenith of his vision: the *Haystacks,* the *Water Lilies.*

It was then that the dreadful catastrophe of his double cataracts befell him. No words can describe that tragedy! Thanks to an operation and the skillful medical attention that followed, the fearful drama of total blindness was avoided for the moment. I was for radical treatment, but Monet was unwilling to risk losing his sight. And so he remained in a state of half-sight that allowed him to finish the *Water Lilies.*

This was little less than a miracle, for the values of light and darkness that now registered on his altered retina were different from what they were when he began his task. My only fear was that a painting would be entirely lost. For reasons that cannot be explained, however, the work was completed most successfully, without the transition from one retinal state to another bringing any untowardness. As it happened, the changeable fortune that contracts debts to all great lives accidentally made good that debt. In his case, Monet seems to me to have been the beneficiary of a "providential" watching over.

An even more extraordinary phenomenon was to occur. All those around Monet used to plead with him to consider his work on the panels as finished, for there was all too good reason to fear that an unfortunate brushstroke could spoil everything. But he just let us talk and shook his head without replying.

Time passed, until one day he took me by the hand and led me to one of the canvases where the infinite spectacle of light plays on the surface of the sleeping water, diluted with bluish glimmers lost in fields of rose tints.

"So what do you think of this one?" he exclaimed maliciously. "You did not dare to criticize. But I knew the water was pasty. It looked thick enough to cut with a knife. The whole play of light had to be redone. I didn't dare. And then I made up my mind to do it. This is to be my last word. You were afraid that I would ruin my painting. So was I. I don't know how, but in the midst of my sorrow a confidence came to me, and despite the film over my eyes, I saw so clearly what needed to be done to stay within the succession of relationships that confidence sustained me. . . . Now, look. Is it better or is it worse?"

"I was wrong. You are so truly a painter that even with eyes out of tune, you are able to complete the visual harmonies to which you were led by eyes open to color's supreme chords."

"It is an accident."

"An accident the unhappy Turner was not to know."

"It is over. I am blind. I no longer have any reason to live. And yet, you understand that as long as I live, I will not allow these panels to leave here. I have reached a point where I dread my own criticisms more than I do those of more qualified eyes. Most likely, what I am attempting will be beyond my powers. Well, then I am ready to die without knowing the outcome that fate has in store for me. I have given my paintings to my country. And I will let my country judge me."

* *. *

I must begin by stating my feelings: most of the Paris public still does not know about the Tuileries' *Water Lilies*. I am not naive enough to be surprised: the crowd goes first to what is within their reach. It has taken a long time to bring the general public to the museum masterpieces, and still, today, if you tell a taxi driver to take you to the Louvre, he will most certainly take you to the department store of that name. I concede that the museum of the Orangerie is not suited to the popular eye. But I don't see why the eye of some shoddy Croesus has become more or less familiar with the paintings of the major auction houses, whereas an ordinary Frenchman should be expected to resist Monet's appeals.

The fact is that a passive conspiracy has silently formed, unconsciously supported by administrative negligence. On the cantwall of the Tuileries' terrace, a small gray plaque only slightly larger than the bottom of my hat pretends to inform the public that there is something there. Last month, a few steps away, a gigantic sign announced a dog show. The public did not hesitate in its choice. Is this giving the proper due to an exhibit such as the civilized world has never seen, nor will see again for some time?

The directors of the Beaux-Arts Ministry and the gifted architect M. Camille Lefèvre have displayed Monet's work in masterly fashion, a fashion worthy of the work and of the country it honors. All that remains to be done is to let the daily public know that they can find plenty there to marvel at. I have learned on my strolls that visitors who see the exhibit once always return. Our Parisians need to learn that there is, in the heart of Paris, more than the simple solution to an artistic problem—there is the world itself to contemplate, to analyze, to understand. To that end, a guidebook should be made available to the public. I am told one is currently being prepared.

But now we are over the threshold, and only a few steps away—all is enchantment. How does one proceed? In what order is one to approach these walls, these gateways to fairylands?

What do we see first? A field of water laden with flowers and leaves in the varied profusion of the sun's explosive rays. A double echo between the celestial screen and the mirror of water, it diffuses the subtle sensory perceptions through which, it seems, we come ever nearer to true objectivity. All the radiating energies of sky and earth are here simultaneously conjured up before us, the ineffable astonishment of a scene that mingles the joys of dreaming with the freshness of primordial sensation. A breath of Infinity sustained by the most delicate sensations of tangible reality and fusing, from reflection to reflection, with every supreme nuance of the imperceptible: this is the theme of the panels.

It takes the miracle of a retina formed for this purpose by evolution itself—and the miracle of a painter who can capture the very elements of light and the shades of color. Of what value is the boldness of a sensitive brush that is yet firm in its intention, when the painter reveals, as clearly as an ultramicroscope, elemental depths that without him we would never have experienced! Are we not thus close to a visual representation of Brownian motion? Certainly the gap between science and art is bridged here. But at the same time, we find here the whole unity of cosmic phenomena. Instead of showing us directly, however, the artist offers us an interpretation crowned with an overwhelming feeling of beauty to which mere understanding can accede only through lengthy and searching observation.

As the *Water Lilies* of the *Water Garden* transport us from the liquid plane to the clouds traveling through infinite space, we leave the earth and her sky and rejoice fully in the supreme harmony of all things that lies far beyond our little planetary world and experience the full flight of our emotivity. The scientist has shown us the elemental motion, has enabled us to understand it, to act upon it, to live it in Nature, but he has left to us the task of translating it into art—if there exists an artist

COLORPLATE 115

COLORPLATE 116

COLORPLATE 117

COLORPLATE 121

capable of evoking our emotivity. There is no schism between the scientist and the artist: we need both, if we are to be completely ourselves.

On the water's surface, borne by the powerful palettes of their leaves, the motionless water lilies await the fulfillment of destinies. It is a subject worth meditating upon. It has no limits, no beginning, no end: we have but to gather the vision in its moment, to find its evolution from one painting to the next.

We need to know first that Monet himself indicated the order he desired for his paintings. But what his guiding principle was, he never told me. So I will merely follow the natural course of a visitor's observation after entering. I would not be surprised if Monet's idea simply was gradually to train the eye that finds itself suddenly thrown into an explosion of direct and reflected light.

The *Water Garden* that we have come to see is the very painting that Monet chose to be the first one the visitor sees. It is the starting point, a purely classical exposition of a theme. It demands no effort whatever on the part of an observer, as long as his vision is normal and he is familiar with museums. No critical angle, no sky, no clouds. Just peaceful junctures of direct light and a minimum of reflections. The water is limpid and heavy, in a classical light (forever five o'clock in the afternoon). On the water, a benign Providence has cast a most learned scattering of round, floating flowers, their great leaves happy to act as settings for lovely and vivid flowers, gentle flames of white and rose-pink. Over all, Monet has spread a peace of medium tints, which envelop, like an offering to heaven, this rich earthly blossoming. No vision could be easier to grasp. And the poetry of it is so simple and so clear and, at the same time, so elevated that any viewer of even average culture is soon won over.

The starting point, as I said. A normal example of museum light; since this is what we are accustomed to, we automatically compare all other optical sensations to it.

But the sky darkens. Two heavy masses of shadows—one of them still in chiaroscuro—break onto the scene, perhaps to join in an instant, and unleash a storm. Yet the sun still reigns, throwing upon the restless waters, in a clearing of azure, thick flakes of cloud, among which a mysterious flash emerges victorious, while the wounded water lily, throbbing with the danger of existence, foreshadows the coming catastrophe.

And yet these are still no more than the inevitably contrasting oppositions. After the threatening storm, we discover in the next canvases light's festive splendors, the sun's clear, glowing brightness. There are no fewer than four paintings on this one dazzling theme, in variously composed symphonies of light. There are rows of water lilies in the tranquil gleams that stream from a friendly willow, which filters every fiery shaft and spreads its blaze, between sky and water, in reflection after reflection after reflection, to the ineffable ecstasy of our humanness. The cloud's image encircles the water lilies; flowers and leaves appear to be borne into space by the irresistible forces that surge beneath the trembling waters, wherein mingle all the fluidities of earth and sky as they answer the call of flowers, intoxicated by life's most sensual pleasures.

And thus does art bring to life, before our very eyes, the happy trembling of the liquid sward, of the blue sky, of the cloud, of the flower, and all have something to tell us that they could not tell us, were it not for Monet. These are the ethereal aspects of the eternal drama that the world plays out for itself, with man as partner and spectator.

I have sometimes gone to sit on the bench from which Monet saw so many things in the reflections on his water garden. My untrained eye had to work hard to follow Monet's brush—and then only from afar—to the furthest reaches of his revelations. Unlike the monkey in the fable, he has showered torrents of light onto his magic-lantern screen. Too much so, one could almost say, if one could complain of an excess of luminous

COLORPLATE 120. *Water Lilies at Twilight*. 1916–22. 6′6¾″ × 19′8¼″ (200 × 600 cm). Kunsthaus Zürich.

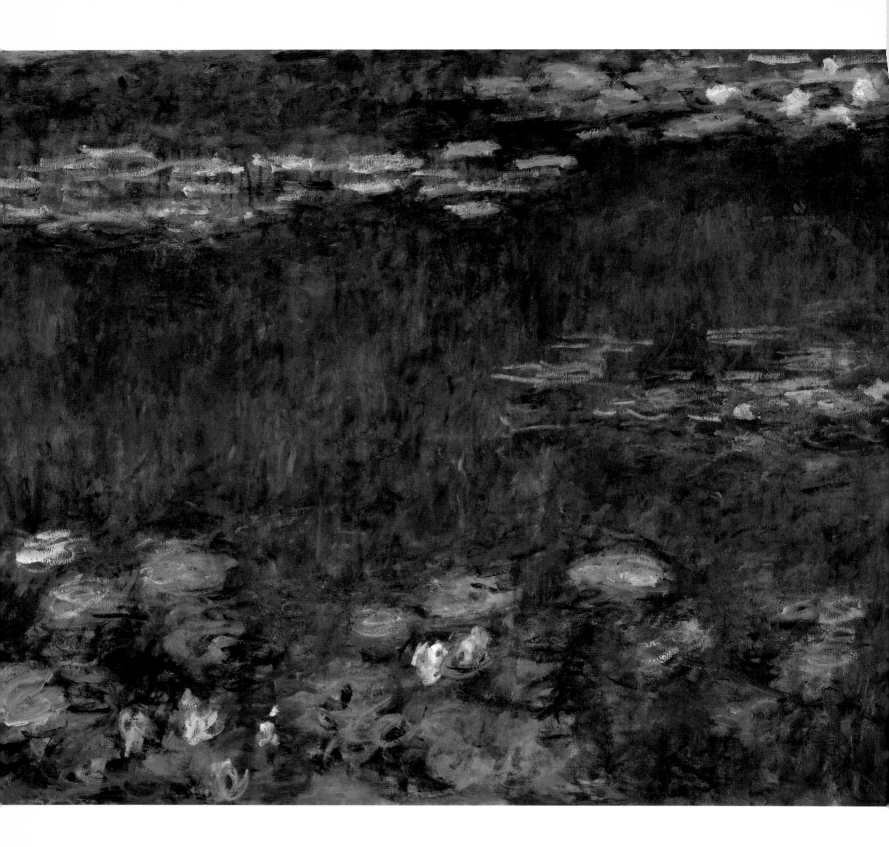

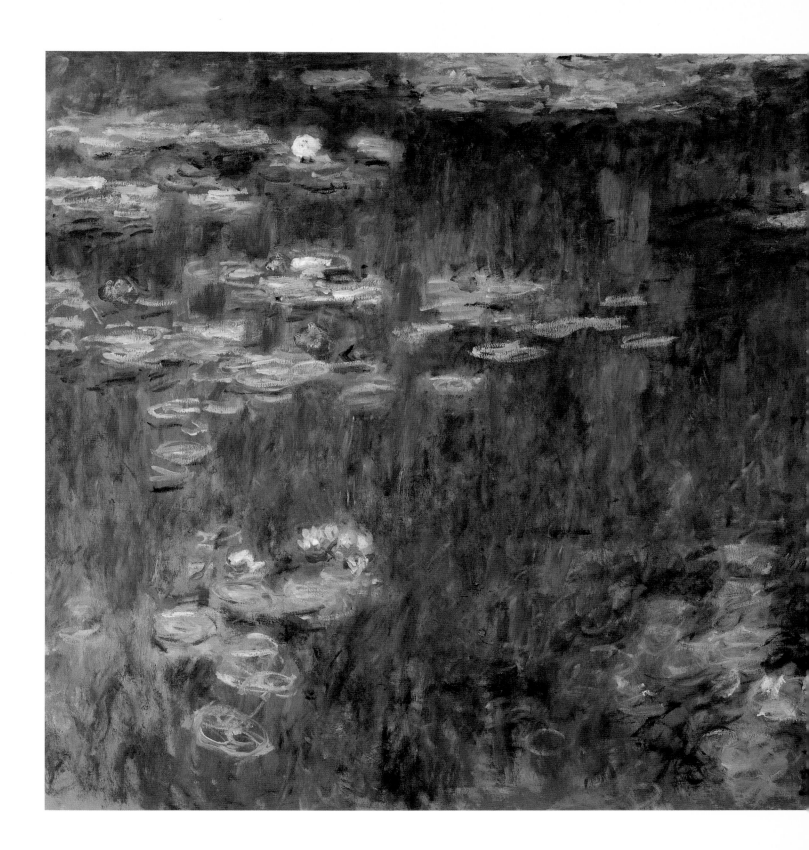

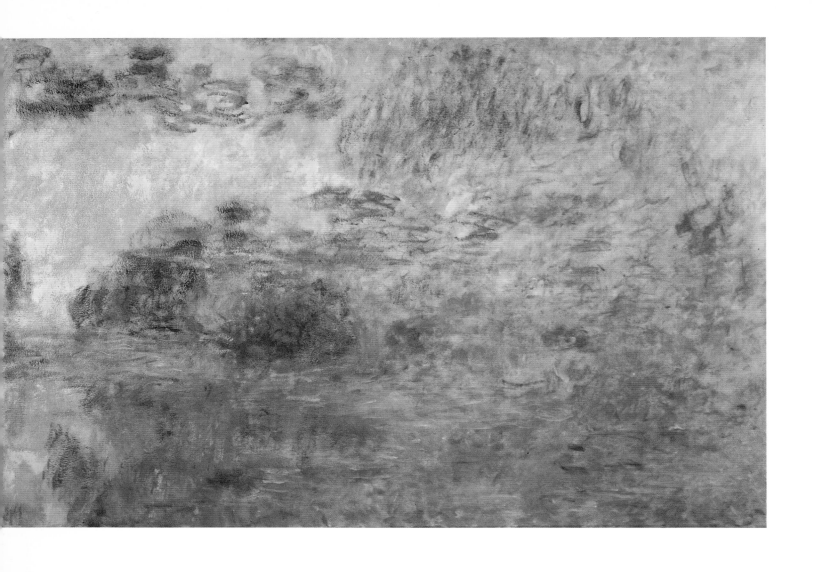

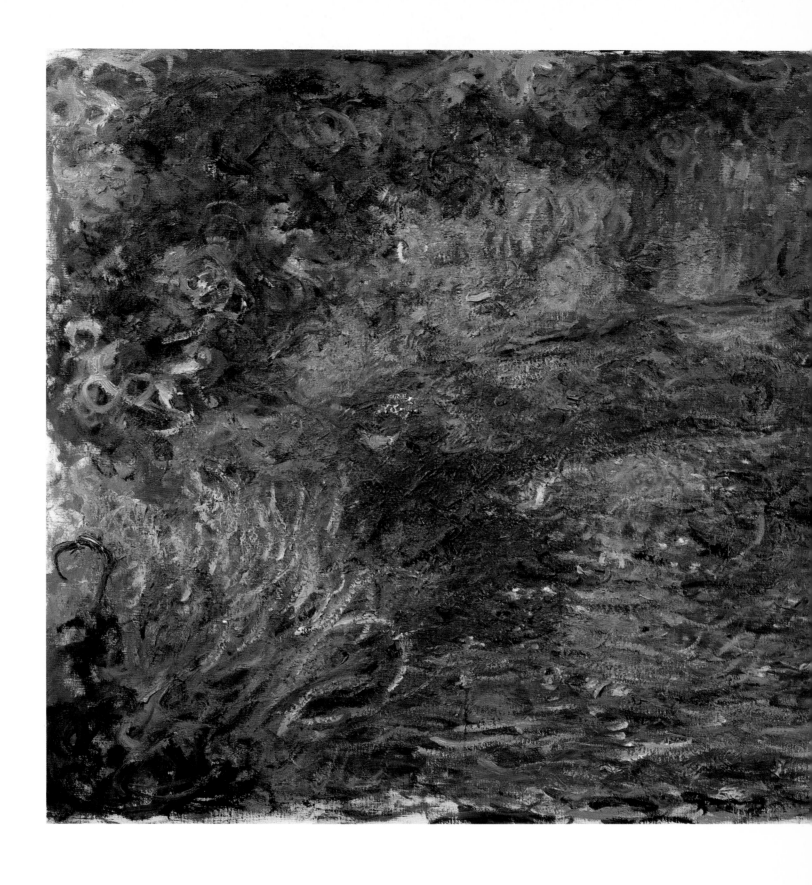

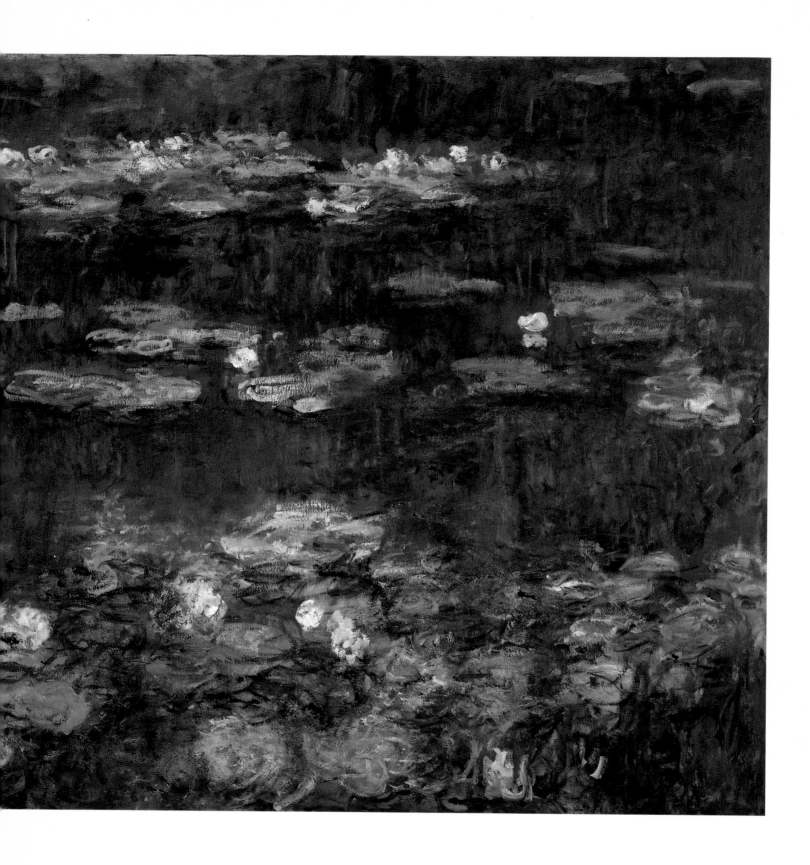

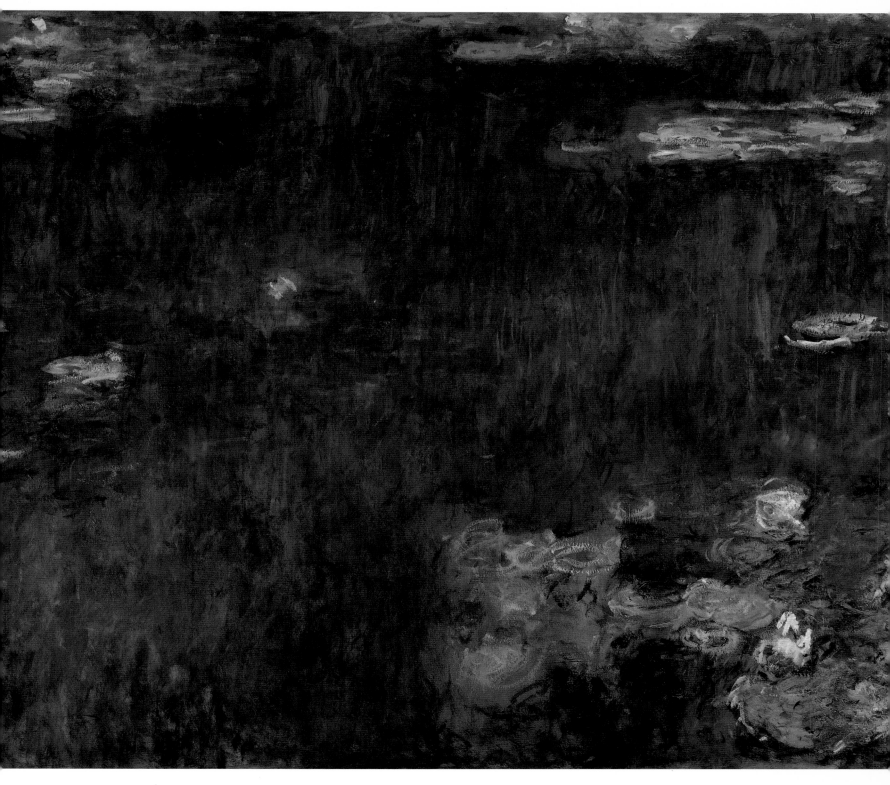

COLORPLATE 121. *Green Reflections.* 1914–18. Diptych; total dimensions: 6′5½″ × 27′9½″ (197 × 847 cm).
Galerie de l'Orangerie, Musée du Louvre, Paris. Photograph: Musées Nationaux, Paris.

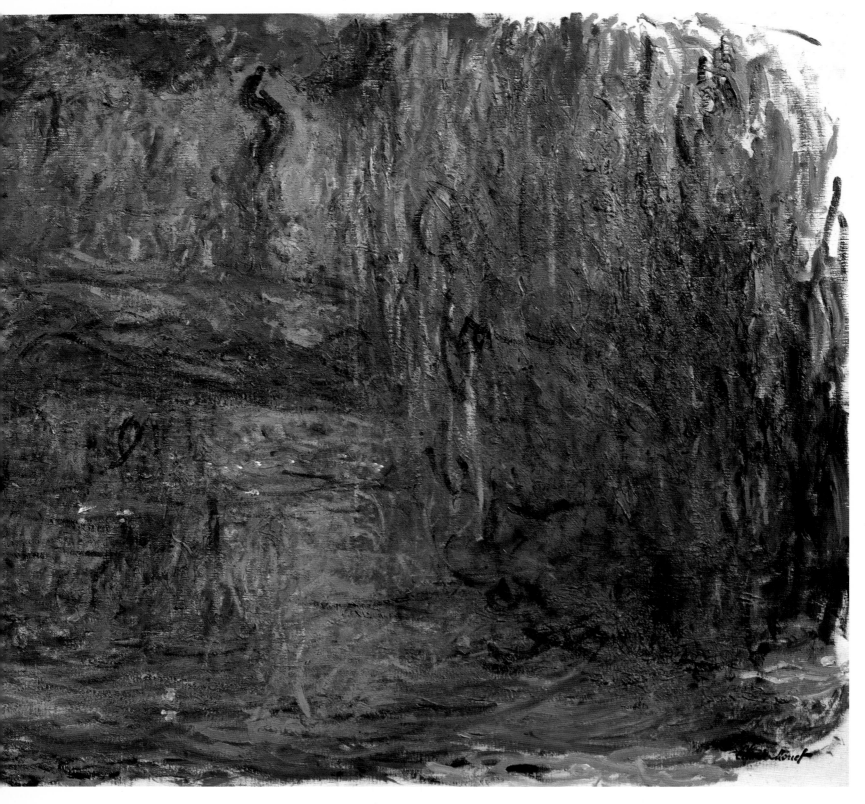

COLORPLATE 122. *The Bridge with Water Lilies.* C. 1919. 39⅜ × 78¾″ (100 × 200 cm).
Musée Marmottan, Paris. Photograph: Georges Routhier, Studio Lourmel, Paris.

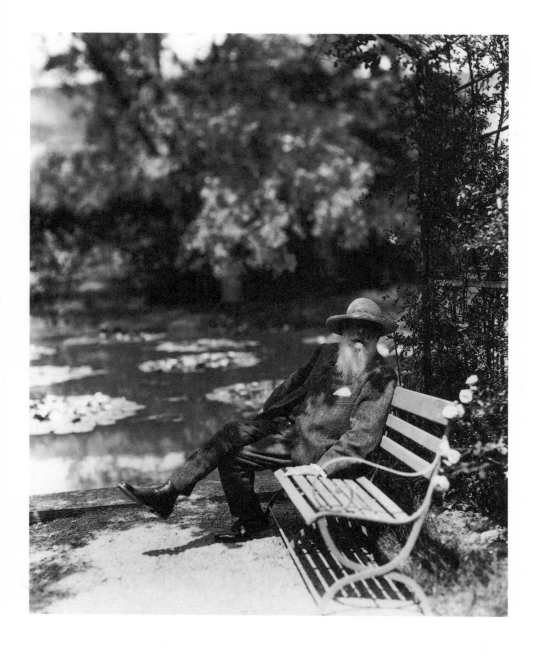

Nickolas Muray. *Claude Monet.* Circa 1926. Gelatin-silver print 9⁹⁄₁₆ × 7⁵⁄₈″. Collection, The Museum of Modern Art, New York; Gift of Mrs. Nickolas Muray.

vibrations beneath the transparent sheets of galaxies tempting us with the dazzle of Infinity.

Following Monet's prescribed order—whatever lies behind it—the water lily serves only as witness to the universe, among the flights of colors whose wings carry us beyond imagination's heights. See how, to complete the scene, the soothed ardor of the sleeping, still waters is revealed between the leaves, in order to heighten the contrast of the water garden in flames with storms of light from dazzling sky to blazing earth, and from blazing earth to dazzling sky.

It is a matter of life and death, and in the battle between sun and flower, the radiance of growing things will be conquered by the power of the universal blaze. Under the willows' shelter, the clusters of water lilies sustain, for a time, the brilliance of their triumphant blossoms. But the fine down of the clouds, pierced by the atmosphere's fiery shafts, envelops leaves and flowers in its reflected image and victoriously bears them off, supreme plunder, to the very pinnacles of the blazing air, while dark patches of vegetation, in symphonies of mauve, blue, rose-tinted mists speak the struggle between the gentle, quotidian earth and the eternal, glowing fire.

For the action on this battlefield is life itself, luminously translated, the elemental rivalry for successive frames of transitory sovereignty. It is the setting for the drama that the *Water Lilies* play out on the stage of

the infinite world, through man's consciousness, whose alternations of mastery and submission make up the substance of the eternal record. In the ocean of extension and duration, where all the torrents of light rush to attack our sight, storms of rainbows collide, penetrate each other, burst into sparkling powders, only to become gentler, to dissolve, disperse, and meet again, reviving the universal turbulence in which our senses exult. This ineffable hurricane—in which, through the artist's magic, the universe shocks our maddened eyes—is the problem of the inexpressible world, revealed through our senses. And those who do not understand are on the path to understanding. All will be revealed in the course of time.

There is more. A new scene. The supreme surge of the sun's triumph hurtles us into the agitation of indescribable sensations, in the iridescent transparencies of a languid brightness of no single tonality, where sky and earth hold one another in a languid embrace, amidst scattered flowers and happy clouds. This is the fragile, yet irresistible masterpiece of the world's sated ecstasy, meeting the highest pitch of the senses. The supreme fulfillment of a vision of art, upon which Monet, smiling, left the sensual languor of a final brushstroke. We have recently learned that cosmic waves have voices: we can now imagine concerts of sound and sight joining in harmonies of universal symphony.[2]

Yet, when you turn, you see gloomy visions of blue-tinted night; here, ghostly vegetations follow upon the triumphant blossoming of the transformation scene. Finally, near the exit, the supreme vision: the spectres of faded water lilies beneath the flames of a setting sun seen through the broken reeds herald the momentary completion of the myriad, cyclical chain.

Thus does Monet present us with the abundance of a new vision which calls upon the natural evolutions of our organs of sight to grasp the artist's translation of the energies of the universal sensibilities. A sequence of delicate transitions leads us from the direct image to the reflected and over-reflected image, through diffusions of transposed light, whose values merge and part in a single harmony. It is a matchless field of brilliant exchanges between sky and earth, crowned by a feeling for the world that lifts us to the heights of the unending communion of things, in the supreme fulfillment of the senses.

I still hear the gently overbearing accents of my friend's voice, faced with nature's mighty show in his water garden: "While you seek the world-in-itself in philosophy," he said, with his warm smile, "I simply turn my energies to the greatest number of phenomena possible, since these are in strict correlation with the unknown realities. When one is on the plane of harmonious phenomena, one cannot be far from reality, or at least from what we can know of reality. All I did was to look at what the universe showed me, to let my brush bear witness to it. Is that nothing? Your error is to seek to reduce the world to your size, whereas the greater your understanding of things, the better your understanding of yourself. Give me your hand, and let us help one another to observe ever better."

[1] At Giverny

[2] M. Georges Grappe has written: "Claude Monet handles light waves like a musician handles sound waves. The two kinds of vibrations are similar. Their harmonies obey the same ineluctable laws, and two tones are painted side by side, according to imperatives as rigorous as those that rule two notes in harmony. And more: the different episodes of a series follow one another like the different parts of a symphony. The pictorial drama develops according to the same principles as musical drama."

WILLIAM SEITZ

COLLEGE ART JOURNAL

"Monet and Abstract Painting"

Fall 1956

William Seitz (1914–1974), pioneering historian of abstract expressionist artists.

Among the great precursors who put forth the premises which culminated in abstract painting, none has been so reduced in stature by short-sighted judgments, begrudging praise and absurd generalizations as has Claude Monet. Although he was all but deified by the generation which included his friends Georges Clemenceau, Stéphane Mallarmé, Rodin and Cézanne, who saw his late work as a final consummation, these same canvases were rejected by the French avant garde of about 1905[2] as formless and without structure. The ensuing critical taste, nurtured in the atmosphere of Cubism, turned away from Monet as it did from academic Impressionism.

But today, certain of the constituent elements of modern art have, so to speak, merged. The optical qualities of Impressionism, which appeared so antithetical to abstract painting twenty years ago, are integral to the abstract painting of the forties and fifties. In America, this reintegration came about with the expressionistic aggressiveness of the forties, but in the fifties it has become increasingly lyrical, and more and more identified with nature.[3] Because of this, it is once again possible to appreciate Monet's *individual* achievements, and to see his importance for the art of the twentieth century.[4]

Monet once wished he had been born blind, in order to experience sight suddenly: to see the world naively, as pure shape and color.[5] To Cézanne, he was greater than Constable and Turner, the most "prodigious" optical sensibility in the history of painting.[6] But he was so much more besides! His painter's eyes were opened in 1856, by Boudin, before the roll of sea and sky at Le Havre. "I want to be always before [the sea] or on it," he said to his friend Geffroy, "and when I die, to be buried in a buoy."[7] Spiritually, Monet was a man of nature; not of its ob-

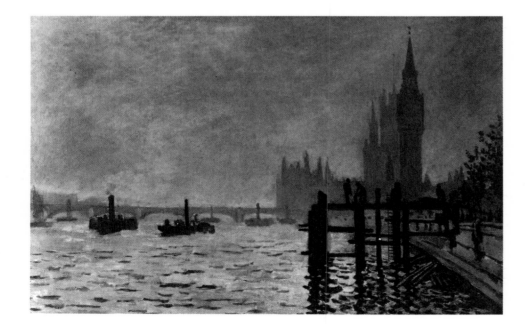

The Thames below Westminster. 1871. 18½ × 28¾" (47 × 73 cm). National Gallery, London.

jects, like Courbet, but of its mysterious processes: storm, wind, rain, fog, darkening and lightening. And he made the final renunciation of the thoroughgoing pantheist—that of the self before the universe.

Could Monet's painting, *Impression: Sunrise* (which christened the group that exhibited together in 1874),[8] possibly be further from the manner afterwards associated with the term "Impressionism"? Though painted at dawn, perhaps from a boat, the subdued poetry of its illumination resembles that of Whistler's Nocturnes. It is similar in mood, subject, and in an extreme simplification—one could say *abstractness*—like that of the Japanese prints which both artists loved. The Nocturnes, in the limited number of their formal elements and their planear geometric structure, were revolutionary. In contrast with Monet's *Sunrise*, Whistler's *Nocturne In Blue and Gold—Old Battersea Bridge* calls attention to the polarity, hard to avoid in studying abstract art, between a naturalistic, freely curvilinear form and an emphasis on horizontals and verticals. The *Sunrise* is looser and more open—closer to Jongkind or Turner.

COLORPLATE 24

But in other works of the same period, Monet shows an even keener interest than Whistler in the opposed horizontal and vertical, notably in a view of the Thames of 1871, in which the structural members of a pier, their staccato rhythm pointedly emphasized against the water, provide the motif for a passage as geometrically abstract as Piet Mondrian's pier-and-ocean pictures. Here, also, is the prototype for the methodical river paintings of the Neo-Impressionists.[9]

After 1880, Monet had fewer contacts with the impressionist group. His art became more personal and his visual concentration more acute. His process of painting, athough it still began with a searching visual analysis, now was followed, to a far greater degree than during the seventies, by a creative translation of the motif into a heightened pictorial equivalent. The diagonals of linear perspective, and the volumetric space which they hollow out, were either *avoided* in the selection of subjects or rigorously controlled. No matter how far into depth the background receded, the picture was compressed into a shallow, laterally organized space. And during this same period, under the sun of the Midi and along the coast of Normandy and Brittany, he worked out the bold color and assertive brushwork which the Fauves were to adopt twenty years later.

The audacity and astonishing variety of Monet's brushwork has not been studied. It has nothing to do with divisionist theory; it cannot be typified by any one work or group of works, and it will not fall into a neat evolution from large to small strokes, thin to thick pigment, or flat areas to broken touches. To fully apprehend the number of stroke-types which he used, it would be necessary to seek out every one of his paintings and examine each, in the original, area by area. There can be only one source for such rhythmic variety: it is a transposition of the multiplicity of nature.

Monet spoke of man as only an atom in comparison with the universe, and advised a lady painter to "remember that every leaf on the tree is as important as the features of your model. I should like just for once," he said, "to see you put her mouth under one eye instead of under her nose!"[10] Man, seen as an object, is a part of nature. It is when the self turns *inward* that a break occurs. Monet did not allow such a rupture to take place within his art. The explanation for this cannot be found, however, in the "objectivity" of his personality. He was neurotically emotional, subject to periods of desperate psychic agony and, like Mallarmé, to convictions of his own failure and creative sterility. At such times (in the language of perception which he used so naturally) he saw "everything black."[11]

The magnificent seascapes of 1885 and 1886, done at Étretat and Belle-Île, tremble on the razor edge where vision mediates between the world "out there" and the inner experiences of the mind, sensibilities and emotions. As a nature poet, Monet's psychic state was more determined

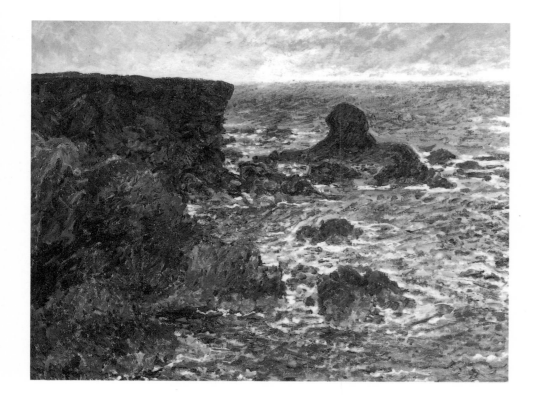

Rocks at Belle-Île (Lion Rock). 1886. 26 × 32½″ (66 × 82.6 cm). Des Moines Art Center; Coffin Fine Arts Trust Fund, 1961.

by the *weather* than by any other influence. When coastal rains continued day after day, when the time and money assigned for work in a particular locality began to run out, when the painting of flowers indoors became tedious, his self-doubt was insanely magnified; he saw himself as a man doomed, and only wished to get his hated canvases out of sight.[12]

But he could become depressed also by weather which, in his words, was "a little too beautiful";[13] he longed for "rain and even cold"[13] in order to return to work. To Monet, the most frightful tempest was beautiful; such weather was bad only because it prevented him from painting outdoors.[14] "I am enthusiastic about this sinister region," he wrote to Durand-Ruel from Belle-Île, "and justly, for it takes me away from what I am in the habit of doing, and moreover, I confess . . . [I] have a great deal of difficulty in rendering that sombre and terrible aspect. It is pointless for me to be a man of the sun. . . ."[15]

By 1886 (the year van Gogh arrived in Paris) Monet had initiated the method which expressionist landscape was to follow. At what degree of intensity, or at what stage in the transformation of natural rhythms into human gestures, would the focus of these works change? At what point would the churning impastoes and writhing contours by which the sea, rocks and storm are pulled forward toward the picture plane express man's, rather than nature's anguish?

Beside the simultaneity of pattern, depth and live brushwork in these pictures, the tension of some of them is heightened through the stark opposition of tortuous curves to geometricity. Both qualities of form exist in nature, and both have their psychological complements in the opposed human predispositions either to passion or structural order.

By the time of the famous Haystacks, which occupied Monet at various periods between 1884 and 1893, he had become obsessed with the most fugitive atmospheric effects, and began concentrating his successive work periods into increasingly short spans of time. But the method of replacing canvases with the changing light did not begin as a theoretical program. Monet repeatedly emphasized his antipathy—his "horror"—of formulated methods, systems or doctrines.[16] He insisted that it made not the slightest difference what pigments he used,[17] and he refused to teach.[18] Quite literally, he was *driven* by nature to multiply his

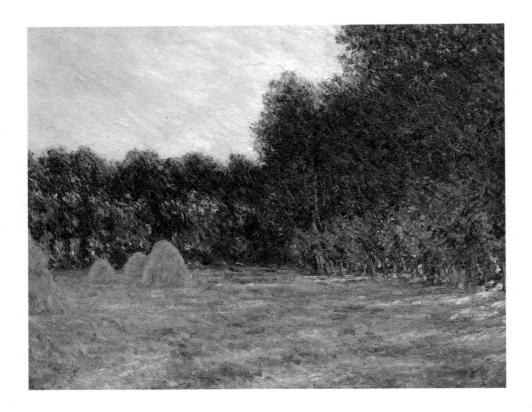

Meadow with Haystacks at Giverny. 1885.
29⅛ × 36¾″ (74 × 93.5 cm). Museum of
Fine Arts, Boston; Bequest of Arthur
Tracy Cabot, 1942.

canvases because, as he said, "the sun goes down so fast that I cannot
follow it."[19] The "instantaneity" that he wanted was first of all a principle
of *harmonious unity:* the permeation of the entire scene with an identical
quality of light and color.[19] He was trying to *stop* time, not hurry it along.

No one had ever probed so deeply into the experience of unquali-
fied *seeing* before the Haystacks, and it comes as a shock to find the se-
ries described as "the worst offender" among Monet's "poorest efforts."[20]

This opinion would not have been shared by Wassily Kandinsky who,
on seeing one version exhibited in Moscow, felt that "suddenly, for the
first time in my life, I found myself looking at a real painting."[21] In re-
lationship with the music of Wagner and the sunsets of Moscow, this was
the pivotal event which impelled him toward a purely abstract, musical
art. "It seemed to me, that, without a catalogue in my hand, it would have
been impossible to recognize what the painting was meant to repre-
sent."[21] It showed him the "previously unimagined, unrevealed and all-
surpassing power of the palette."[21] Until the Bauhaus period, Kandin-
sky was a naturalist, working at the extreme pole of organic abstraction.
With such predilections, he perhaps failed to note that haystacks, often
built to resemble houses, are a form of *architecture;* but, like Monet, Piet
Mondrian responded to their structural form. In his transition from *Ju-
gendstil* curves to a geometric style he also utilized haystacks as a motif.

In the paintings of poplars (1891), and especially in the façades of
Rouen Cathedral exhibited in 1895, Monet's architectonic interest is ap-
parent. According to Lionello Venturi, he failed in an attempt to pre-
serve the form of the building and hence the series is "the most evident
indication of Monet's creative decadence."[22] Others regard the Cathe-
drals as theoretical acrobatics—the *reductio ad absurdum* of impressionist
doctrine. To Monet's admirers, however, they were seen as a great sym-
phony of changing light, with "movements" in gray, white, gold and blue.
But beyond this, Clemenceau saw drawing which was "tightly con-
structed, clean, mathematically precise," and "the geometric conception
of the whole."[23]

The fluctuating planear structure initiated in the Cathedrals reached
its climax in the Venetian series. During the nineties Monet had begun
to paint more and more from windows and balconies rather than out-

doors, and the period of retouching in the studio was greatly expanded. Though less than three months was spent in Venice during 1908, the year in which the series is dated, Monet was *still working on it in 1912*, cuing one composition from another.[24]

It was at this time that Piet Mondrian began the studies of church façades which link his earlier drawings of the sea with the later pier-and-ocean and plus-and-minus compositions. He began these studies outdoors, before the motifs, but continued to distill them in the studio: "I still worked like an Impressionist,"[25] he later said. In structure, they are closer to Monet's *Palazzo da Mula*, in the National Gallery at Washington, than they are to most cubist works. The symmetrical pyramid of Cubism is rejected for a flatter, more uniformly active field which, in the interest of reducing physical mass, is pushed forward and strongly articulated in the *upper* portion of the composition and weakened, like a reflection, in the lower portion. The pulsation which Monet achieves by vibrating color, brushstroke, and architectural lines is paralleled, in Mondrian's studies, by the free rendering of similar horizontal and ver-

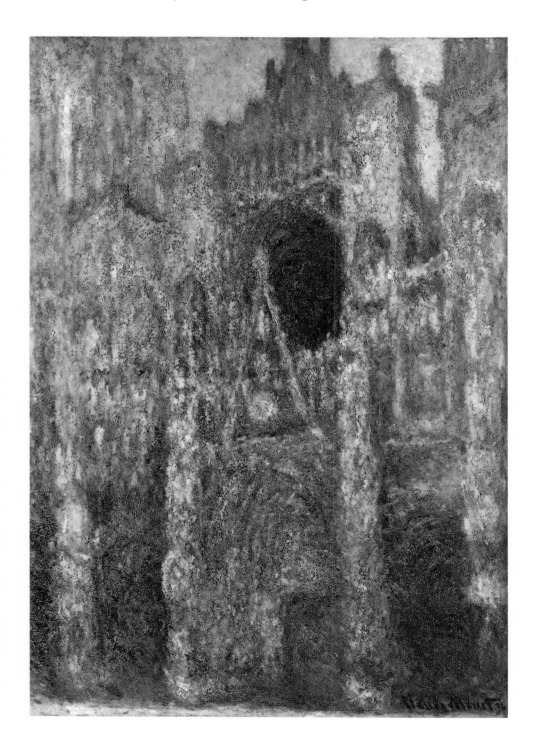

Rouen Cathedral: The Facade in Sunlight. 1894. 41 13/16 × 29" (106.3 × 73.7 cm). Sterling and Francine Clark Art Institute, Williamstown, Massachusetts.

tical accents—an effect which he characterized as "the emotional restlessness of the Impressionists' technique."[26]

The stages in Mondrian's evolution toward a fluctuating picture plane also relate the two painters. For both, haystacks, façades and trees served as motifs. Both, moreover, loved and painted the sea and found their reality in a natural rhythm. "Seeing the sea, sky and stars," Mondrian wrote, "I represented this through a multiplicity of crosses. I was impressed by the greatness of nature. . . ."[27] Their criticisms of Cubism, furthermore, focus on an identical point. Monet, late in life, decried the "new movements" which rejected Impressionism in the interest of the "solidity of unified volumes."[28] Mondrian objected to the Cubist's "volume in space."[29]

But Monet's paintings of his water garden at Giverny led him to the opposite formal pole. In 1890 he was undertaking to represent things, as he wrote, "admirable to see," but "impossible to do: water with plants which undulate at the bottom."[30] Reflections of willows, clouds and sky mingle with the forms of water plants both on the surface and below it. But by 1905, as the painter's eye moves closer to the motìf, trees, bridge and shoreline—the tangible reference points which distinguish physical mass from its mirrored image—are eliminated. The merging reflections form one shimmering segment of a world shorn of solid objects.[31] In the *Nymphéas,* or *Water Landscapes,* Monet's spirit, impelled toward appearances which are mysterious and enveloping, is close to the poetry of Mallarmé or the music of Debussy.

In the Orangerie of the Tuileries a group of huge water landscapes forms a unique and monumental cycle. Still dismissed, in 1950, as Monet's "gravest artistic error,"[32] André Masson, in 1952, called the Orangerie the "Sistine Chapel of Impressionism."[33] Completely without precedent, these paintings combine a globular, enclosing space with flat-

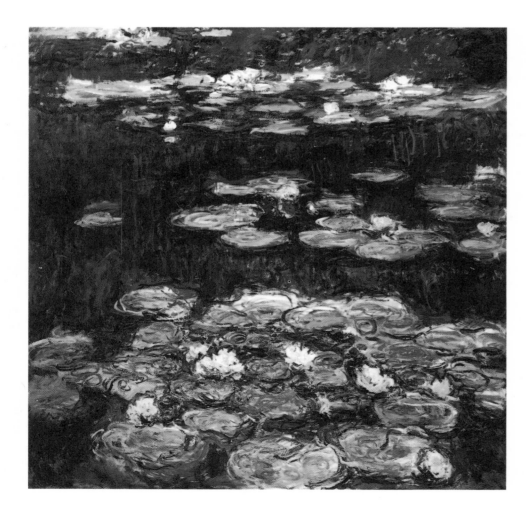

Yellow and White Water Lilies. Circa 1916. 78¾ × 78¾" (200 × 200 cm). Kunstmuseum, Winterthur.

ness and bold brushwork. In content, they stop just short of Symbolism, Expressionism or pure abstraction. Happily, we are able to experience something of their great beauty in America, through the eighteen-and-one-half-foot canvas recently acquired by the Museum of Modern Art.

At Giverny, in the water garden, Monet explained the aims of this final period to his philosophically-minded friend Clemenceau: "I am simply expending my efforts upon a maximum of appearances in close correlation with unknown realities. When one is on the plane of concordant appearances one cannot be far from reality, or at least from what we can know of it. . . . Your error is to wish to reduce the world to your measure, whereas, by enlarging your knowledge of things, you will find your knowledge of self enlarged."[34]

In any attempt to assess the contributions of those great painters who formed the presuppositions of abstract art, Monet must appear as a primary figure. More than anyone else, he epitomizes the optical, and hence psychological, sensibility of his period and ours. As an instinctive pantheist, he never imposed either his own emotional projection or a geometric grid on nature, but in probing the essences of his motifs, pulling them forward toward the picture plane, and interpreting them in rhythmic brushstrokes and coloristic pulsation, he was instrumental in establishing the relativistic and vitalistic principles of abstract painting as we know it today.

And just as important: his belief in a nonmaterial reality constituted an essential stage in a development from the physicalistic theory of Courbet toward the metaphysical naturalism which motivated the early painting of Mondrian and Kandinsky, and which is so much alive at the present moment.

[1] This paper began a restudy of Monet's career, his aims and methods, the development of his style, his philosophy, and his position in the growth of modern painting. At present, no catalogue of his work exists. I should therefore appreciate information concerning the locations of specific works, or other material bearing on his art and life.

[2] Marcel Duchamp, in a televised interview, implied that Impressionism was an avant-garde style in 1902, when he painted his *Chapel at Blainville*, but that by 1904 it was already becoming retardataire.

[3] It was this cessation of aggression, in concurrence with the growth of a "new" naturalism, which has led to the substitution of "Abstract Impressionism," as a goal, for "Abstract Expressionism."

[4] Meyer Schapiro's essay, "Matisse and Impressionism" was an early and a significant contribution to this end, though it regarded Impressionism as a group style. See *Androcles*, I (Feb., 1932), 1, pp. 21–36.

[5] Quoted by Lilla Cabot Perry, in *The American Magazine of Art*, XVIII (March 1927), 3, p. 120: ". . . try to forget what objects you have before you, a tree, a house, a field or whatever. Merely think, here is a little square of blue, here an oblong of pink, here a streak of yellow, and paint it just as it looks to you, the exact color and shape, until it gives your own naive impression of the scene before you."

[6] Quoted (in reminiscence) by Joachim Gasquet, *Cézanne*, Paris, 1921, p. 90: "Mais Monet est un oeil, l'oeil le plus prodigieux depuis qu'il y a des peintres. . . . Il ira au Louvre, allez, à côté de Constable et de Turner. Foutre, il est encore bien plus grand." Cf. Gustave Geffroy, also quoting Cézanne (*Claude Monet*, Paris, 1922, p. 198): "Le plus fort de nous tous. . . . Monet! je l'ajoute au Louvre!"

[7] Quoted by Geffroy, *op. cit.*, p. 5: "Je voudrais être toujours devant ou dessus, et quand je mourrai, être enterré dans une bouée."

[8] Reproduced in *The French Impressionists in Full Color*, London (Phaidon), 1952, pl. 12, and Jean Leymarie, *Impressionism*, Lausanne (Skira), 1955, vol. 1, p. 106.

[9] The period from 1863–1872 is of special interest in its concentration of the rectilinear and planear structure of the Poussinist and Italian classical traditions (Degas and Manet), the surface qualities of Spanish painting (Manet), the combination of these sources with analogous qualities found in Japanese prints (Manet), and pure Japanese influence (Whistler), toward modern compositional solutions incipiently abstract.

[10] Quoted by Perry, *op. cit.*, p. 120.

[11] Monet to Bazille, 1868. In G. Poulain, *Bazille et ses Amis*, Paris, 1932, p. 149.

[12] For one such instance see Monet to Durand-Ruel, Pourville, Sept. 18, 1882. In Lionello Venturi, *Les Archives de l'Impressionnisme*, Paris, 1939, Vol. I, p. 236: "Le doute s'empare de moi, il me semble que je suis perdu, que je ne pourrai plus rien faire, il me tarde de recevoir votre envoi afin de boucler malles et valises et ne plus voir mes horribles toiles."

[13] Monet to Durand-Ruel, July 19, 1901. In Venturi, *op. cit.*, p. 382.

[14] Monet to Durand-Ruel, Étretat, Oct. 28, 1885. In Venturi, *op. cit.*, p. 297: "Je suis désespéré du temps: depuis quelques jours c'est effroyable, beau sans doute mais il est impossible de travailler. . . ."

[15] Monet to Durand-Ruel, Kervilahen, Belle-Ile, Oct. 28, 1886. In Venturi, *op. cit.*, p. 320: "Je suis enthousiasmé de ce pays sinistre et justement parce qu'il me sort de ce que j'ai l'habitude de faire, et du reste, je l'avoue, je dois me forcer et ai beaucoup de peine pour rendre cet aspect sombre et terrible. J'ai beau être l'homme du soleil, comme vous dites, il ne faut pas se spécialiser dans une seule note."

[16] Monet to John Charteris, Giverny, June 21, 1926. In J. Charteris, *John Sargent*, New York 1927 p. 131: ". . . j'ai toujours en horreur des théories enfin que je n'ai que la mérite d'avoir peint directement devant la nature en cherchant à rendre mes impressions devant les effets les plus fugitifs. . . ."

[17] Giverny, June 3, 1905. In Venturi, *op. cit.*, p. 404: "Quant au couleurs [que] j'emploie, est-ce si intéressant que cela? Je ne le pense pas, attendu que l'on peut faire plus lumineux et mieux avec une toute autre palette."

[18] Geffroy, *op. cit.*, p. 114: "Mais je ne professe pas la peinture, je me borne a en faire."

[19] Geffroy, *op. cit.*, p. 189. Monet's solution to the problem of changing light was already implicit in an essay—still the best existing discussion of the psychology of Impressionism—written by the poet Jules Laforgue in response to an Impressionist exhibition held in Berlin in 1883. See Jules Laforgue, *Oeuvres Complètes*, Paris, 1923, pp. 133–145. A translation appears in *Art News*, LV (May, 1956), 3, pp. 43–45.

[20] Bernard Myers, *Modern Art in the Making*, New York, 1950, p. 162.

[21] *Wassily Kandinsky Memorial*, New York, 1945, pp. 53f.

[22] Lionello Venturi, *Impressionists and Symbolists*, New York, 1950, p. 65.

[23] Georges Clemenceau, *Claude Monet: The Water Lilies*, New York, 1930, p. 132.

[24] See correspondence during 1911 and 1912 in Venturi, *Archives de l'impressionnisme*, Vol. I, concluding with Monet to Durand-Ruel, Giverny, Jan. 30, 1912, p. 430: ". . . j'espère avoir prochainement terminé mes toiles de Venise."

[25] Quoted by Michel Seuphor, in *Magazine of Art;* XLV (May 1952), 5, p. 219.

[26] James Johnson Sweeney, *Piet Mondrian*, New York, 1948, p. 7.

[27] Seuphor, *op. cit.*, p. 219.

[28] Rewald, *op. cit.*, p. 434, fn. 59. From Geffroy, *op. cit.*

[29] Sweeney, *op. cit.*, p. 16.

[30] Monet to Geffroy [Giverny] June 22, 1890. Geffroy, *op. cit.*, p. 188.

[31] See Karl Hermann Usener, "Claude Monets Seerösen-Wandbilder in der Orangerie," *Wallraf-Richartz-Jahrbuch*, XIV (1952), pp. 216–225.

[32] Venturi, *Impressionists and Symbolists*, p. 63.

[33] In *Verve*, VII (1952), 27 & 28, p. 68: ". . . il me plaît, très sérieusement, de dire de l'Orangerie des Tuileries qu'elle est la Sixtine de l'Impressionnisme . . . un des sommets du génie français."

[34] Clemenceau, *op. cit.*, pp. 154 f.

CLEMENT GREENBERG

ART NEWS

"Claude Monet: The Later Monet"

1957

Clement Greenberg (b.1909), influential critic and art historian, perhaps the first to recognize the importance of the abstract expressionist artists.

Monet is beginning to receive his due. Recently the Museum of Modern Art and Walter Chrysler, Jr., have each bought one of the huge *Water Lilies* that were painted between 1915 and 1925, in the same series as those the French government installed in the Paris Orangerie in 1926. An avant-garde painter like André Masson and a critic like Gaston Bachelard write about him admiringly. A collector of very modern art in Pittsburgh concentrates on his later works, and the prices of these are rising again. Even more important, their influence is felt—whether directly or indirectly—in some of the most advanced painting now being done in this country.

The first impulse is to back away from a vogue—even when one's own words may have contributed to it. But the righting of a wrong is involved here, though that wrong—which was a failure in appreciation—may have been inevitable and even necessary at a certain stage in the evolution of modern painting. Fifty years ago Monet seemed to have nothing to tell ambitious young artists except how to persist in blunders of conception and taste. Even Monet's own taste had not caught up with his art. In 1912 he wrote to the elder Durand-Ruel: "And today more than ever I realize how factitious the unmerited [*sic*] success is that has been accorded me. I always hope to arrive at something better, but age and troubles have exhausted my strength. I know very well in advance that you will find my canvases perfect. I know that they will have great success when shown, but that's indifferent to me, since I know they are bad and am sure of it." Three years later he was to begin the Orangerie murals.

In middle and old age Monet turned out many bad pictures. But he also turned out more than a few very good ones. Neither the larger public, which admired him unreservedly, nor the avant-garde of that time, which wrote him off without qualification, seemed to be able to tell the difference. As we know, after 1918 enlightened public as well as critical esteem went decidedly to Cézanne, Renoir and Degas, and to van Gogh, Gauguin and Seurat, while the "orthodox" Impressionists, Monet, Pissarro and Sisley, fell into comparative disfavor. It was then that the "amorphousness" of Impressionism became a received idea. And it was forgotten that Cézanne had belonged to, and with, Impressionism as he had belonged to nothing else. Monet's life spanned eighty-six years, began in commercial Le Havre, ended in the vine-hung, pond-filled gardens of Giverny where for some forty-five years he lived and worked, evolving the diffuse, almost abstract style which is having special influence on painters today. Born the same month as another epochal modernist, Rodin, Monet numbered among his last friends, pall-bearers at his funeral, the painters Bonnard and Vuillard, and the statesman Clemenceau. The latter, in sensitive remembrance of the artist's lifelong love of color, there replaced the traditional black coffin-pall with Monet's own bright-hued bedspread. The new righting of the balance seems to have begun during the last war with the growing appreciation of the works of Pissarro's last decade. Our eyes seemed to become less insensitive to a general greying tone that narrowed or attenuated contrasts of dark and

light. But Pissarro still built a rather clearly articulated illusion in depth, which led critics hypnotized by Cézanne to exempt him from many of the charges they still brought against Monet and Sisley. The general pallor—or else general dusk—to which Monet became addicted in his last phase permitted only hints and notations of depth to come through, and that in what seemed to be—and very often was—an uncontrolled way. Atmosphere gave much in terms of color, but it took away even more in those of three-dimensional form. Nothing could have meant less to the good taste of the decades dominated by Matisse and Picasso.

Sixty and seventy years ago Monet's later manner both stimulated and met—as did Bonnard's and Vuillard's early work—the new appetite for close-valued, flat effects in pictorial art. His painting was enthusiastically admired by *fin-de-siècle* esthetes, including Proust. But in a short time its diaphanous iridescences had gone into the creation of that new, candy-box ideal of "beauty" which supplanted the chromo-lithographic one of Victorian times in popular favor. Never before or since the 1900s, apparently, did the precious so quickly become the banal. By 1920 popular and academic diffusion had reacted upon Monet's later art to invest it with a period flavor that made it look old-fashioned even to eyes not offended by what the avant-garde found wrong in it. Only now—when the inter-war period, with its repudiation of everything popular just before 1914, is beginning to be repudiated in its own turn—are these extrinsic associations starting to fade.

Worldly success came earlier to Monet, and in larger measure, than to any of the other master Impressionists. All of them desired it, and most of them, like Monet, needed it in order to support themselves and their families. Their attitude to the public was never intransigent. They worried about how to make an impression on the art market and were not above trying, up to a point, to satisfy the demands of prospective buyers. Cézanne, as we know, wanted all his life to make the official Salon, and few of them were ready to reject official honors. Yet the Impressionists, even after their "consecration," continued to be revolutionary artists, and their integrity established an example for all subsequent avant-gardes.

By 1880, Monet had marked himself off from his fellow Impressionists as a self-promoter, a publicity-seeker and a shrewd business man. This last he, who had been the most penurious of them all in the beginning, remained to the end; his sense of timing in raising the prices of his pictures was better than that of his dealers. This does not mean that he compromised in his work. Nor did he ever get enough satisfaction from success to feel satisfied with his art. On the contrary, after 1880, when the original momentum of Impressionism slackened even as the movement itself began to win acceptance, he became increasingly prey to self-doubt.

The Impressionists were neither worldly nor innocent, but transcended the alternative, as men of ripened individuality usually do. It is remarkable how few airs they gave themselves, and how little they wore of the *panache* of the artist. Formed by the 1860s, which was a great school in radicalism, resoluteness and mental toughness, they retained a certain hardness of head that prevailed over personal eccentricities, even in Cézanne's and Degas' cases. Among them, Monet, Pissarro and Cézanne seem at this distance to form a group of their own—less by reason of their art or personal association than by their way of life and work. We see them—all three, stocky, bearded men—going out every day to work in the open, applying themselves to the "motif" and registering their "sensations" with fanatical patience and obsessive regularity—prolific artists in the high nineteenth-century style. Though men of fundamentally sophisticated and urban culture (Monet had the least education of the three), by middle age they were all weatherbeaten and a little

Lilla Cabot Perry Papers. 1889–1909.
Archives of American Art, Smithsonian
Institution, Washington, D.C.

countrified, without social or any other kind of graces. And yet how un-naïve they were.

The personalities of painters and sculptors seldom are as pointedly reported as those of writers. But Monet dead may be easier to approach than Monet alive. We get the impression of an individual as moody as Cézanne, if with more self-control; given to fits of discouragement and to brooding and fretting over details; absolutely unpretentious and without phrases, indeed without very many ideas, but with definite and firm inclinations. And though supposedly a programmatic painter and for a time held to be the leader of the Impressionists, he had even less than Sisley to put into words, much less theory, about his art. There was a kind of force in him that was also a kind of inertia: unable to stop when once at work, he found it equally difficult—so he himself says—to re-sume after having been idle for a length of time. Usually, it was the weather that interrupted him, upon which he was more dependent than a peasant. Sisley alone was a more confirmed landscapist.

Like most of the other Impressionists, Monet was not in the habit of waiting for the right mood in order to start working; he turned out painting as steadily and indefatigibily as Balzac turned out prose. None-theless, each new day and each new picture meant renewed doubts and renewed struggle. His life's work contained, for him, little of the com-

forts of routine. It is significant that Monet undertook works that had the character of planned, pondered, definitive, master- or set-pieces only at the very beginning and the very end of his career; otherwise, it was dogged, day-in, day-out painting. Certainly he produced too much, and it belonged to his way of work that the bad should come out not only along with the good, but in much greater quantity. And at his worst he could look more than bad—he could look inept. Yet I feel that it was to the eventual benefit of his art that he did not settle at any point into a manner that might have guaranteed him against clumsiness. The ultimate, prophetic greatness he attained in old age required much bad painting as a propaedeutic. Monet proceeded as if he had nothing to lose, and in the end proved to be as daring and "experimental" an artist as Cézanne.

That he lacked capacity for self-criticism was to his advantage in the long run. A nice taste in an artist can alienate him from his own originality, and inhibit it. Not that Monet did not try to exercise taste in his work—or at least in finishing it. He would fuss endlessly with his pictures before letting them go, and rarely complete one to his satisfaction. Contrary to what he himself gave people to understand, he did not stop painting when the motif was no longer before him, but would spend days and weeks retouching pictures at home. The excuse he gave to Durand-Ruel at first was that he had to meet the taste of collectors for "finished" pictures, but obviously it was his own taste and his own conception of what was to be considered finished that played the largest part. One can well imagine that more paintings were spoiled than improved in the process, given the tendency of self-doubts such as those that afflicted Monet to suppress the effects of spontaneity once the stimulus of the motif was no longer there. When he stopped correcting himself obsessively and became more slapdash, "realization," it seems to me, became more frequent, and greater in scope.

If Monet was the one who drew the most radical conclusions from the premises of Impressionism, it was not with truly doctrinaire intent. Impressionism was, and expressed, his personal, innermost experience, doctrine or no doctrine. The quasi-scientific aim he set himself in the 1890s—to record the effects of light on the same motif at different times of day and in different weather—may have involved a misconception of the ends of art, but it was more fundamentally part of an effort—compelled by both his own experience and his own temperament—to find a principle of consistency for pictorial art elsewhere than in the precedent of the past. Monet could not bring himself to believe in the Old Masters as Cézanne and Renoir did—or rather, he could not profit by his belief in them. In the end he found what he was looking for, which was not so much a new principle as a more comprehensive one: and it lay not in Nature, but in the essence of art itself, in its "abstractness." That he himself could not consciously recognize or accept "abstractness"—the qualities of the medium alone—as a principle of consistency makes no difference: it is there, plain to see in the paintings of his old age.

The example of Monet's art shows how untrustworthy a mistress Nature can be for the artist who would make her his only one. He first sank into prettiness when he tried to match the extravagance of Mediterranean light while keeping his color in key according to Impressionist methods: an incandescent violet would demand an incandescent yellow; an incandescent green, as incandescent and saccharine pink; and so on. Complementaries out-bidding each other in luminosity became the ruin of many of his paintings, even where they were not handicapped to start with by the acceptance of an over-confined motif, such as a row of equidistant poplars all of the same shape and size, or one—i.e. two or three lily pads floating in a pond—that offered too little incident to design. Here a transfiguring vision was required, and Monet seemed to paint too

much by method and trust himself too much to a literal honesty within his method.

But this was not always the case, and literal honesty, to his own sensations rather than to Nature, could at times save a picture for art. Monet had an adventurous spirit, rather than an active imagination, that prompted him to follow, on foot and analytically as it were, wherever his sensations led. Sometimes the literalness with which these were registered was so extreme as to become an hallucinated one, and land him not in prettiness, but on the far side of expected reality, where the visual facts turned into phantasmagoria—phantasmagoria all the more convincing and consistent as art because without a shred of fantasy. This same fidelity to his sensations permitted Monet to confirm and deepen Impressionism's most revolutionary insight, which has also been its most creative one: that values—the contrasts and gradations of dark and light—were indispensable neither to the representation of Nature nor to the integrity of pictorial art. This discovery, made in an effort to get closer to Nature, was later to be turned against her, and by Monet first of all.

After the period of his classical Impressionism, his main difficulty was in the matter of *accentuation*. His concern with unity and "harmony" and the desire to reproduce the equity with which Nature distributed her illumination would lead him to accent a picture repetitiously in terms of color. He would be too ready to give "equivalences" of tone precedence over "dominants"—or else the last would be made altogether too dominant. The intensity of vision and its registration could become an unmodulated, monotonous one and cancel itself out, as in some of the paintings of the Rouen cathedral. At times the motif itself could decide otherwise: the sudden red of a field of poppies might explode the complementaries and equivalences into a higher, recovered, unity; but Monet seems to have become more and more afraid of such "discords."

There was good reason for his, and Pissarro's, obsession with unity. The broken, divided color of full-blown Impressionism—which became full blown only after 1880, in Monet's and Sisley's hands—tended to keep the equilibrium between the illusion in depth and the design on the surface precarious. Anything too definite—say, a jet of solid color or an abrupt contrast—would produce an imbalance that, according to the Impressionist canon, had to be resolved in terms of the general tone or "dominant" of the picture (this was analogous to traditional procedure with its insistence that every color be modeled in dark and light), or else by being made to reflect surrounding colors. Off and on Monet painted as if the chief task were to resolve discords in general, and since these would often be excluded in advance, many of his pictures ended up as resolutions of the resolved: either in a monotonously woven tissue of paint dabs or, as later on, in an all-enveloping opalescent grey distilled from atmosphere and local color. The solution of the difficulty lay outside the strict Impressionist canon; a definite choice had to be made: either the illusion in depth was to be strengthened at the expense of the surface design—which is the course Pissarro finally took—or vice versa.

In 1886 Pissarro observed that Monet was a "decorator without being decorative." Lionello Venturi comments that decorative painting has to stay close to the surface in order to be integrated, whereas Monet's, while in effect staying there, betrayed velleities towards a fully imagined illusion of depth in which the existence of three-dimensional objects required to be more than merely noted or indicated, as they were in his practice. In short, Monet's decorative art failed because it was unfulfilled imaginatively. This is well said, but as if it were the last word on Monet's later painting. In a number of pictures, not so infrequent as to be exceptional, and not all of which came just at the end, Monet did decisively unify and restore his art in favor of the picture surface.

As it happens, Cézanne and the Cubists made painting two-dimen-

Water Lilies. Undated. 78¾ × 70⅞″ (200 × 180 cm). Musée Marmottan, Paris. Photograph: Georges Routhier, Studio Lourmel, Paris.

sional and decorative in their own way: by so enhancing and emphasizing, in their concern for three-dimensionality, the means by which it had traditionally been achieved that three-dimensionality itself was lost sight of. Having become detached from their original purpose by dint of being exaggerated, the value contrasts rose to the surface like decoration. Monet, the Impressionist, started out from the other direction, by suppressing value contrasts, or rather by narrowing their gamut, and likewise ended up on the surface: only where he arrived at a shadow of the traditional picture, the Cubists arrived at a skeleton.

Neither of these ways to what ultimately became abstract art is inherently superior to the other as far as quality is concerned. If architectonic structure is an essential ingredient of great painting, then the murals in the Orangerie must possess it. What the avant-garde originally missed in the later Monet was traditional, dark-and-light, "dramatic" structure, but there is nothing in experience that says that chromatic, "symphonic" structure (if I can call it that) cannot supply its place. Sixty years of van Gogh, Gauguin, Seurat, Cézanne, Fauvism and

Cubism have had to pass to enable us to realize this. And a second revolution has had to take place in modern art in order to bring to fruition, in both taste and practice, the first seed planted, the most radical of all.

Venturi, writing in 1939, called Monet the "victim and gravedigger of Impressionism." At that time Monet still seemed to have nothing to say to the avant-garde. But today those huge close-ups which are the last *Water Lilies* say—to and with the radical Abstract Expressionists—that a lot of physical space is needed to develop adequately a strong pictorial idea that does not involve an illusion of deep space. The broad, daubed scribble in which the *Water Lilies* are executed says that the surface of a painting must breathe, but that its breath is to be made of the texture and body of canvas and paint, not of disembodied color; that pigment is to be solicited from the surface, not just applied to it. Above all, the *Water Lilies* tell us once again that all canons of excellence are provisional.

It used to be maintained that Monet had outlived himself, that by the time he died in 1926 he was an anachronism. But right now any one of the *Water Lilies* seems to belong more to our time, and its future, than do Cézanne's own attempts at summing-up statements in his large *Bathers*. Thus the twenty-five years' difference in dates of execution proves, not to be meaningless—and the twenty years by which Monet outlived Cézanne turn out not to have been in vain.

Modern art, dating from Manet, is still too young to let us rest on our judgments regarding it: the rehabilitation of the later Monet has already had an unsettling effect. It may not account for, but it helps clarify an increasing dissatisfaction with van Gogh, as it helps justify impatience with an uncritical adoration of Cézanne. Van Gogh is a great artist, but Monet's example serves better even than Cézanne's to remind us that he may not have been a *master*. He lacked not only solidity and breadth of craft; he also lacked a settled largeness of view. In Monet, on the other hand, we enjoy a world of art, not just a vision, and that world has the variety and space, and even some of the ease, a world should have.

INDEX